Copper and Bronze in Art

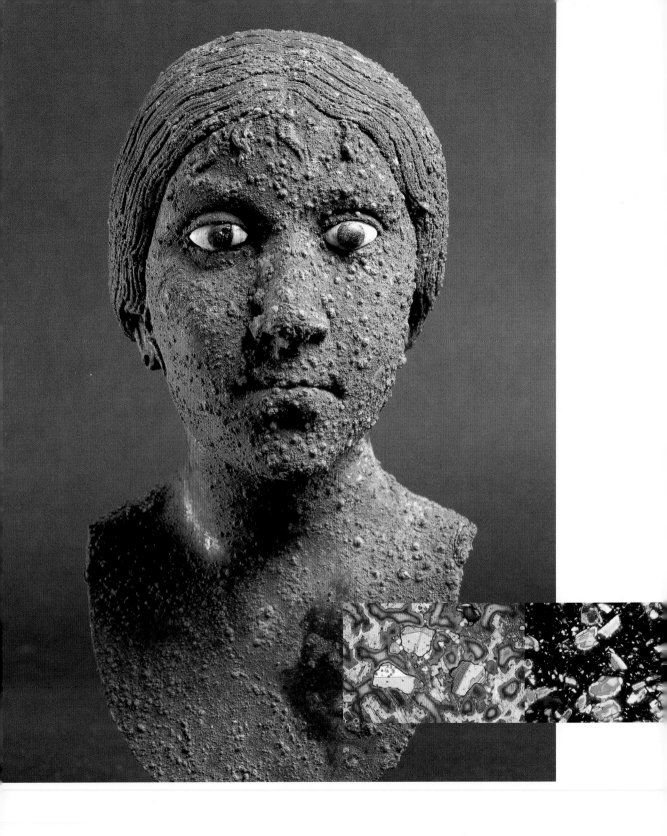

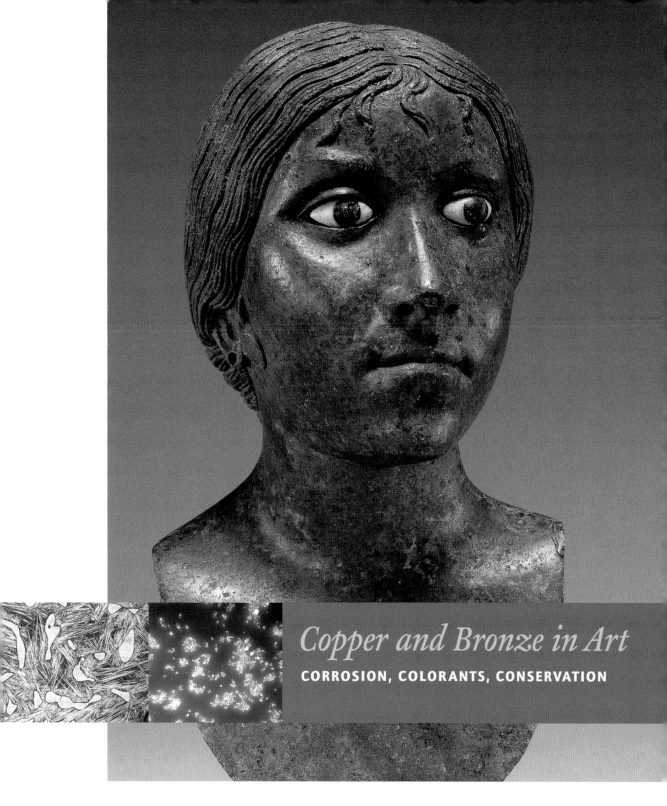

Copper and Bronze in Art
CORROSION, COLORANTS, CONSERVATION

David A. Scott
The Getty Conservation Institute
Los Angeles

Dinah Berland, *Editorial project manager*
Elizabeth Maggio, *Manuscript editor*
Amita Molloy, *Production coordinator*
Jim Drobka, *Designer*
Typography by G & S Typesetters, Inc.
Printed in Hong Kong by Imago

Getty Publications
1200 Getty Center Drive, Suite 500
Los Angeles, California 90049-1682
www.getty.edu
© 2002 The J. Paul Getty Trust

10 9 8 7 6 5 4 3 2 1

Cover: Statuette of a Dead Youth [detail]. Greek,
ca. 480–460 B.C.E. Bronze with copper inlays.
Malibu, J. Paul Getty Museum (86.AB.530).

Frontispiece: Miniature Portrait Bust of a Woman.
Roman, 25 B.C.E.–25 C.E. Bronze with glass-paste
inlay. Before conservation treatment. Malibu, J. Paul
Getty Museum (84.AB.59).

Title page: Miniature Portrait Bust of a Woman.
After conservation treatment.

Library of Congress Cataloging-in-Publication Data

Scott, David A.
 Copper and bronze in art : corrosion, colorants,
 conservation /
David A. Scott.
 p. cm.
Includes bibliographical references and index.
 ISBN 0-89236-638-9
 1. Copper—Corrosion. 2. Copperwork—Conserva-
tion and restoration. 3. Bronzes—Conservation and
restoration. I. Getty Conservation Institute. II. Title.
 TA480.C7 S26 2002
 739.5′11′0288—dc21
 2001000435

For Lesley and our children, Daniel, Ellie, and Kieran

Contents

xi Foreword
 Timothy P. Whalen

xii Preface

1 Introduction

10 | **CHAPTER 1**
 CORROSION AND ENVIRONMENT

11 *The Anatomy of Corrosion*
 The electrochemical series

16 *Some Historical Aspects of Copper and Corrosion*
 Primitive wet-cell batteries?
 Early technologies with copper and iron
 Early history of electrochemical plating
 Copper in early photography
 Dezincification

32 *Pourbaix Diagrams and Environmental Effects*
 The burial environment
 The outdoor environment
 The indoor museum environment
 The marine environment

72 *Copper in Contact with Organic Materials*
 Positive replacement and mineralization
 of organic materials

77 *The Metallography of Corroded Copper Objects*

79 *Corrosion Products and Pigments*

81 | **CHAPTER 2**
 OXIDES AND HYDROXIDES

82 *Cuprite*
 Properties of cuprite
 Natural cuprite patinas
 Intentional cuprite patinas
 Copper colorants in glasses and glazes

95 *Tenorite*
 Tenorite formation

98 *Spertiniite*

98 *Conservation Issues*

100 | **CHAPTER 3**
BASIC COPPER CARBONATES

102 *Malachite*
Decorative uses of malachite
Malachite as a copper ore
Nomenclature confusion
Mineral properties
Malachite as a pigment
Malachite in bronze patinas
Isotope ratios to determine corrosion
environment

108 *Azurite*
Azurite as a corrosion product
Azurite as a pigment
Conservation issues for azurite

111 *Formation of Copper Carbonates in Solution*

113 *Decomposition of Malachite and Azurite by Heat*

113 *Artificial Malachite and Azurite*

114 *Blue and Green Verditer*
Use of blue and green verditer in art
Synthesis of blue and green verditer

116 *Mixed-Cation Copper Carbonates*
Mixed copper-zinc carbonates in corrosion
Synthetic pigments with copper and zinc salts

117 *Chalconatronite: A Sodium-Copper Carbonate*
Synthesis and use of chalconatronite
Chalconatronite as a corrosion product

122 | **CHAPTER 4**
CHLORIDES AND BASIC CHLORIDES

122 *The Copper Chlorides*
Nantokite
Atacamite
Paratacamite (anakarite) and clinoatacamite
Botallackite

125 *Copper Chlorides and Bronze Disease*
Bronze disease research
Role of chloride ions in corrosion
Pitting corrosion

134 *The Basic Copper Chlorides as Pigments*
Synthetic pigments
Pigment morphology

139 *Other Basic Copper Chlorides*
Connellite
Calumetite
Anthonyite
Cumengite and mixed copper-lead chlorides
Mixed copper-zinc chlorides
Other mixed-cation copper chlorides

145 | **CHAPTER 5**
BASIC SULFATES

146 *Historical References to Copper Sulfates*

147 *The Basic Copper Sulfates*
Brochantite and antlerite
Posnjakite
Other basic sulfates

154 *Environment and Corrosion*
Atmospheric sulfur dioxide
Microenvironment and corrosion

159 *Case Studies of Exposed Bronzes*
The Statue of Liberty
The Great Buddha at Kamakura
Gettysburg National Military Park bronzes
Brancusi's *Infinite Column*

164 *Sulfate Deposition in Burial Environments*

165 *Basic Sulfates as Pigments*

169 **PLATES**

224 | **CHAPTER 6**
COPPER SULFIDES

226 *The Chemistry of Copper Sulfides*

227 *Corrosion Environments and Copper Sulfide
Production*
Sulfide formation in reducing environments
Sulfide formation from atmospheric exposure
Sulfide formation from pollution in the museum
environment

235 *Copper Sulfides and Niello*
Niello recipes
Artifacts decorated with niello
Niello chemistry

240 | **CHAPTER 7**
**COPPER PHOSPHATES AND
COPPER NITRATES**

240 *The Copper Phosphates*
Copper phosphate chemistry
Copper phosphate corrosion in different
environments
Sampleite and the arid environment
Pseudomalachite: A copper phosphate pigment

246 *Turquoise*
The chemistry and mineralogy of turquoise
The history of turquoise

250 *The Copper Nitrate Minerals*
Copper nitrate corrosion products

252	**CHAPTER 8** **COPPER SILICATES**
253	*Chrysocolla* Chrysocolla as a pigment
255	*Dioptase*
255	*Copper Silicates and Glasses*
257	*Egyptian Blue and Other Synthetic Copper Silicates* Geographic distribution of Egyptian blue Lost and found secrets of Egyptian blue Chemical formulation of Egyptian blue Egyptian green Terminology Pigment deterioration mystery
266	*Han Blue and Han Purple: Synthetic Pigments* *from China*
268	**CHAPTER 9** **THE ORGANIC SALTS OF COPPER**
269	*The Copper Formates*
270	*The Copper Acetates* The chemistry of verdigris The history of verdigris
279	*Early Verdigris Recipes* Recipes from Pliny the Elder Variants of verdigris Problems with verdigris
294	*The Copper Resinates* The chemistry of copper resinates Copper salts of higher acids Copper proteinates
299	*Organic Salts of Copper and Bronze Corrosion* Corrosion problems in the museum environment
303	*Conservation Treatments* Treatment residues and the formation of copper salts
306	*Copper Salts as Pigments* Green copper pigments Brown copper pigments Copper phthalocyanine

317 **CHAPTER 10**
COPPER AS A SUBSTRATE
FOR PAINTINGS

317 *Early Coatings and Fabrication Methods*
Analytical techniques

321 *Enamel on Copper*

322 **CHAPTER 11**
SOME ASPECTS OF BRONZE PATINAS

323 *Changing Views of Bronze Patinas*

327 *Some Patina Variations*
Arsenic coating as a patina
Lead and patinas
Black patina in the aqueous environment

329 *Patinas in the Renaissance*
Other coatings on Renaissance bronzes
Unraveling an object's patination history

333 *Patination during the Nineteenth Century*

334 *Two Detailed Studies of Patina and Corrosion*
Roman bronzes
Chinese bronze mirrors

349 *Some Finishes and Preserved Structures*
Traditional finishes on scientific instruments
Tool marks preserved in patinas

352 **CHAPTER 12**
CONSERVATION TREATMENTS
FOR BRONZE OBJECTS

353 *Understanding Treatment Histories*

353 *Some Past Conservation Treatments*
Patina-stripping techniques
Drying and sealing methods
Other early treatment methods
Preservation without treatment

357 *Mechanical Cleaning*
Preserving evidence of the past
Mechanical cleaning techniques today
Unanswered questions

362 *Chemical Cleaning Treatments*
General treatments
Localized chemical treatments
Cleaning reagents

369 *Cleaning Marine Finds*
Stabilization problems and techniques

374 *Repatination of Cleaned Surfaces*
Outdoor bronzes
An "indoor" bronze outdoors

376 *The Use of Corrosion Inhibitors*
Benzotriazole
AMT as a corrosion inhibitor

382 *Coatings for Copper Alloys*
Shellacs and lacquers
Resin coatings
Incralac
Ormocer and other polymer coatings
Problems with coatings
Need for research

391 *Passive Stabilization*

392 *Nondestructive Testing*
Radiographic examination
Ultrasonic scanning
Infrared imaging
Acoustic emission analysis
Other techniques

398 APPENDIX A
Some Aspects of the Chemistry
of Copper and Bronze

404 APPENDIX B
Recipes

418 APPENDIX C
Some Copper Minerals and Corrosion Products

424 APPENDIX D
X-Ray Diffraction Studies

456 REFERENCES

488 NAME INDEX

496 SUBJECT INDEX

512 ILLUSTRATION CREDITS

515 ABOUT THE AUTHOR

FOREWORD

The use of copper dates back to the Neolithic period, ten thousand years ago. In the millennia that have followed, the alloying of copper to make bronze and the employment of copper compounds as pigments have been central aspects of the human use of metallic materials.

The pervasive use of copper and bronze through time—from the Bronze Age to the present—has left us with a wealth of cultural objects that demand attention if they are to survive into the future. Among the challenges for the conservation field is finding the means to arrest the corrosion that threatens copper and bronze artifacts and works of art. The success of that effort requires comprehensive insight into how and why the corrosion process occurs.

Since its establishment, the Getty Conservation Institute has studied materials used in art to better understand their character and the factors responsible for their deterioration. The objective of that research is the development of conservation approaches that can slow deterioration of materials and prevent further damage.

The principal aim of this book is to provide an in-depth survey of the relevant literature produced over the last two centuries that relates to the corrosion of copper and bronze in different environments; the use of some of these corrosion products as colorants, especially the brilliant blue and green pigments of antiquity; and various conservation treatments used to treat copper alloy objects from ancient times to the present.

As a member of the Institute's scientific staff since its early years, David A. Scott has devoted considerable energy and effort to the study of ancient and historic metallic materials, including copper and bronze. The author presents a personal view of the subject, drawing salient issues from this large body of information across a broad spectrum of fields that are often kept separate. The result is a comprehensive, interdisciplinary review that is certain to be of interest as well as practical use to conservation scientists, conservators, mineralogists, art historians, and students.

This publication is part of an ongoing effort by the Getty Conservation Institute to offer resources to those charged with preserving our heritage. I hope this volume will provide conservation professionals with an additional tool to help them sustain a treasured portion of that heritage.

Timothy P. Whalen
Director
The Getty Conservation Institute

PREFACE

Actually the use of copper was discovered before that of iron, because it is more easily handled and in more plentiful supply. With copper they tilled the soil. With copper they whipped up the clashing waves of war, scattered a withering seed of wounds and made a spoil of flocks and fields....Then by slow degrees the iron sword came to the fore; the bronze sickle fell into disrepute; the ploughman began to cleave the earth with iron, and on the darkling field of battle the odds were made even.
—LUCRETIUS[1]

Copper has played a crucial role in human development. Just as the compounds of copper found in nature made possible the extraction of the metal, so corrosion may slowly return these same copper objects to the minerals from whence they came. This book had its origins as a review of the literature on this fascinating metal, focused specifically on the corrosion of copper and copper corrosion products or minerals used as colorants. From there, it gradually expanded into a more ambitious and personal account of the subject, which now includes a review of the environmental conditions to which copper alloys may be exposed and the methods used to conserve them, together with some information on ancient and historical technologies and on the nature of patina as it pertains to copper and bronze. This book is not intended as a reference text in the sense of a Smithells (1983) or the *CRC Handbook of Chemistry and Physics* (Weast 1984), nor does it cover the smelting, extraction, mining, or alloying of copper, a huge body of information that would rightly form the subject of a book in itself.

Pigments, corrosion products, and minerals are usually considered separately, either as painting materials or as the deterioration products of metals, even though they are often the same compounds. One of the aims of this book is to integrate the information relating to these materials across a broad spectrum of interests that are all too frequently compartmentalized.

Corrosion can be thought of as an integral part of conservation practice, since the purpose of conservation is to arrest continued corrosion and the processes of change. Conservation treatments are therefore reviewed here from a chemical perspective rather than from a consideration of the individual artifact, which might have quite different ramifications. Treatments are also considered here somewhat in isolation as a means of reviewing the kinds of approaches taken rather than the variety of artifacts conserved.

Since the subject matter of this book is rooted in copper, alloying elements are dealt with more briefly. Indeed, the word *bronze* is used here in a catholic sense—as an ersatz alloy—to encompass all of the copper alloys commonly employed in the ancient world, much as the term *Renaissance bronzes* covers a diversity of alloys that are, in fact, often brass ternary or even quaternary mixtures of copper, lead, tin, and zinc. When writing about bronze, it is difficult, therefore, to fix boundaries to the multifarious alloys that may be found and to the vicissitudes of their corrosion. The deterioration products of the subsidiary elemental components are mentioned here, but they are not comprehensively described.

Gilding and the use of gold coatings over copper is another important topic, although it is usually considered from the point of view of the gold, rather than the substrate. This subject is not considered in depth here, since a detailed review of the subject of gilded surfaces on metal has recently been published (Drayman-Weisser 2000).

There is a romance to bronze in that it can be used so readily for both ornamental and utilitarian purposes. It can assume many aeruginous forms, from the meretricious yellow imitation of gold to the black of jet, from the pale green of olives to the lustrous gray green of the sea. It can have a surface as reflective as silver or as red as the color of cinnabar, varying in luster from subfusc to erythemic to golden or salmon pink. Unlike bronze, gold does not alter, nor does iron gain an attractive patina. No other alloy possesses so many attributes: bronze is the sonorous bell metal, the delicate rail of a curving stair, the grace of a Bronze Age youth, the weighty silence of a polished Buddha, the untold history of an encrusted sword blade; bronze is a symbol of strength and beauty from ax blade to breastplate.

Bronze, which is principally made of copper, is also one of the few metals we are prepared to admire covered completely with corrosion products; many observers even preferring the appearance of a patinated surface, whatever the hue, to the original color of the metal. As it corrodes, bronze becomes evidence of time past and time passing, and we value it for the authenticity of its interaction with oxygen, water, carbon dioxide, and soil. The variety of minerals that can form on bronze over time is enormous, the subtleties infinite. Whether deliberately patinated or polished, corroded or cleaned, bronze possesses an allure that comes from its longevity and its appeal to so many different tastes and fashions. It will outlive us all and will still be admired by generations to come, just as bronzes created many hundreds or even thousands of years ago continue to be admired today.

The inspiration for this book was a 1963 article by Rutherford J. Gettens for the Smithsonian Institution in which the author reviewed the state of knowledge at the time in regard to metallic corrosion products on antiquities (Gettens 1963a). As of this writing, thirty-seven years have passed since Gettens's work was published, and our knowledge of the subject has expanded considerably, yet much remains for future investigation. Now, at the beginning of the twenty-first century, we can look back at the distribution of publications that were used in writing this review of the literature and begin to see some trends. As shown in FIGURE 1, a noticeable rise in the number of publications on the subject of copper conservation begins around the 1860s, then decreases shortly before World War I. After some recovery during the 1920s and 1930s, the number of useful publications declines precipitously with the advent of World War II. The establishment and development of the conservation profession in the aftermath of that war is revealed by an exponential increase in the number of publications from the 1950s to the 1980s. This rise may now be leveling off, however, as indicated by the fact that about 170 publications cited in this book date from 1980 to 1990 and about the same number from 1990 to 1999, the year in which this review of the literature was completed.

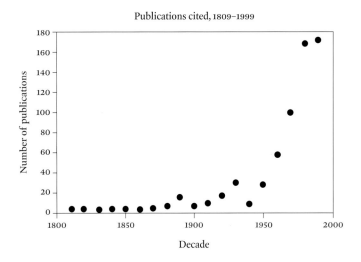

Publications cited, 1809–1999

FIGURE 1 Chart showing the range of publications cited in this
book, by date and by quantity, from 1809 through 1999.

For obvious reasons, only a fraction of the actual number of published papers that could be germane to the topic at hand are represented in this book, but the random spread of publication dates for those that were cited is sufficiently meaningful to express some degree of validity. Since the number of pertinent papers is unlikely to decrease significantly in the years to come, the conservation profession can look forward with interest to the developments in knowledge that the future will bring, including both an ever-increasing sophistication concerning the contributions of the past and the further refinement of scientific investigation, conservation practice, and documentation.

ACKNOWLEDGMENTS

I would like to thank my wife, Lesley Ann Moorcroft, for her support throughout the four years during which this book was written. Many people provided help with illustrative material, and others read parts of the text and made useful suggestions. Early drafts were read and commented on by Arthur Beale, director, Department of Objects and Textiles Conservation and Scientific Research, Museum of Fine Arts, Boston; Gerhardt Eggert, professor, Department of Objects Conservation, Academy of Fine Arts, Stuttgart; Andrew Lins, head of conservation, Philadelphia Museum of Art; and John Twilley, formerly senior research chemist, Conservation Center, Los Angeles County Museum of Art, now consultant conservation scientist, Los Angeles. Their comments and perceptive suggestions were of great value to the content of this book.

Permission to reproduce photographic material was provided by a number of institutions and individuals, who are acknowledged individually at the end of the book. First and foremost, I would like to thank the photographic department of the J. Paul Getty Museum, especially Jackie Burns, Louis Meluso, and the late Charles Passela, for their unfailing assistance and work in providing many of the negatives used for reproduction here. I also extend my thanks to the conservation staff at the Freer Gallery of Art, Washington, D.C., specifically W. Thomas Chase, Paul Jett, and Elizabeth West Fitzhugh, who were wonderfully supportive and kindly provided some of the illustrations. I would also like to thank Shigeo Aoki, head of Metal and Stone Research, Department of Restoration Techniques, Tokyo National Research Institute of Cultural Properties, for slides of the Great Buddha, Kamakura; the British Museum photographic service department and the Trustees of the British Museum for their permission to reproduce photographs of objects in their collections; Helen Ganiaris of the Department of Conservation, Museum of London, for photographs of excavated bronzes from London waterfront sites as well as photographs of sampleite corrosion crusts from Egypt, which are reproduced with permission from the Egypt Exploration Society; Dana Goodburn-Brown, independent researcher and conservator, for the scanning electron photomicrographs of corroded brass and of the etched surface of a bronze from the Museum of London excavations; Pieter Meyers, Conservation Center, Los Angeles County Museum of Art, for photographs and information on objects from the Shumei Cultural Foundation collections in Japan; and Lyndsie Selwyn of the Canadian Conservation Institute for photographic material from the Ottawa outdoor bronze research project. Encouragement and personal communication was gratefully received from Nigel Seeley, Keeper of Conservation, National Trust, London. A sample of gerhardtite was provided by Tony Kampf, curator, Los Angeles Museum of Natural History; a sample of trippkeite was provided by the Museum of Natural History, Smithsonian Institution, Washington, D.C.; and several other mineral samples, including libethenite, botallackite, and paratacamite, were provided by the Royal School of Mines, Imperial College, University of London and by the British Museum (Natural History), South Kensington, London, during a study of the minerals at the Institute of Archaeology, University of London in 1985.

Several graduate interns completing their studies carried out some of the practical recipes described in this volume: Aniko Bezur, Arizona State University, Tempe; Evelyne Gill Godfrey, Department of Archaeological Sciences, University of Bradford, Bradford, West Yorkshire, U.K.; and Yoko Taniguichi, National University of Fine Arts, Tokyo. Bezur also carried out a scanning electron microscope study on a sample of nauwamite corrosion from the Wallace collection, London; Taniguichi carried out an extensive series of powder X-ray diffraction analyses with the author to further characterize the verdigris compounds that were made during the course of the studies. Avron Spector, volunteer researcher, provided welcome assistance with the Minolta CM-1000 color spectrophotometer. Eva Sander, during 1985, and Francine Wallert,

during 1994, provided help with the translation of some German manuscripts. Ellen South, staff assistant at the Getty Conservation Institute (GCI) Museum Research Laboratory, helped with the organization of the illustrations and tables and also carried out a considerable amount of correspondence work and permissions assistance. I would also like to thank the following members of the scientific staff, past and present, at the Getty Conservation Institute, although the list is by no means complete: Francesca Bewer, Eric Doehne, Eric Hansen, William S. Ginell, Herant Khajian, Narayan Khandekar, Michael Schilling, Dusan Stulik, Alberto Tagle, and Arie Wallert. In addition, Valerie Greathouse and Thomas Shreves of the GCI Information Center were unreservedly helpful in locating difficult references through the Getty databases and other library resources. I would also like to thank the following people at the J. Paul Getty Museum for their valuable help: Jane Bassett, Brian Considine, Maya Elston, Joe Godla, Abby Hykin, Jerry Podany, and Lisbet Thoresen.

I am particularly grateful to Neville Agnew, principal project specialist at the Getty Conservation Institute, who, as group director of Information and Communications at the GCI, readily accepted the idea of publishing this book when the manuscript was still in gestation. Ultimately, for their continued support, I am most grateful to Timothy Whalen, director of the Getty Conservation Institute, and to Miguel Angel Corzo, the Institute's former director, for approving the publication; and to Deborah Gribbon and John Walsh, director and former director of the J. Paul Getty Museum, respectively, for allowing access to relevant museum departments. To all, I feel fortunate to have had the benefit of their presence and advice.

Finally, I would like to extend my appreciation to members of the staff of Getty Publications and the consultants who worked with them to bring this book to light, particularly Dinah Berland, publications coordinator, who skillfully managed the myriad editorial aspects of this project; Elizabeth Maggio, who copyedited the text; Scott Patrick Wagner, who input revisions and edited the references; Amita Molloy, who coordinated the book's production; and Jim Drobka, who designed the book.

A book such as this can never represent more than the personal preferences of the author when working on such a broad canvas. As new work is published and new research on this wide-ranging topic continues to be generated, some portions of the text may appear to undergo accelerated aging, but hopefully the majority of the text will serve as an informative review for many years to come.

Note

1 Lucretius *De rerum natura* (On the nature of the universe), ca. 50 B.C.E. (Lucretius 1961:1).

Introduction

Bronze vessels that have been interred under the earth a thousand years appear pure green the colour of kingfisher feathers ... those that have been immersed in water a thousand years are pure emerald in colour with a jade-like lustre. Those that have not been immersed as long as a thousand years are emerald green but lack the lustre ... those that have been transmitted down from antiquity, not under water or earth but through the hands of men, have the colour of purple cloth and a red mottling like sand, which protrudes when excessive, and looks like first-quality cinnabar. When boiled in a pan of hot water the mottling becomes more pronounced. —Zhao Xigu[1]

During the Song dynasty (960–1279), when the connoisseur Zhao Xigu was writing, ancient Chinese bronzes were already being excavated and studied. Indeed, these antecedents of Chinese art were a source of inspiration and fascination long before an interest in the appearance of ancient bronzes arose in the West. This early appreciation of patinas is shown by the fact that Zhao Xigu was prepared to undertake experimenal work on them, boiling them in water to observe the slightest reaction or change in appearance.

It is this spirit of empirical inquiry that forms the basis for this book, which seeks to extend this time-honored tradition by reviewing the existing literature on copper and copper compounds, especially as it relates to art and archaeology. The chapters that follow explore the chemical processes involved in the development of patina and corrosion products in various

FIGURE 2 Native copper: A, typical dendritic mass from the Great Lakes, L: 15.8 cm; B, photomicrograph, showing typical microstructures, such as very long twin lines, subtle banding within the twinned grains, or regions of very fine precipitation; etched in alcoholic ferric chloride (magnification ×180). Since native copper is often formed and shaped under very high stress, concentrations of strain lines can often be seen undulating within the recrystallized grains (Scott 1991). Collection of the author.

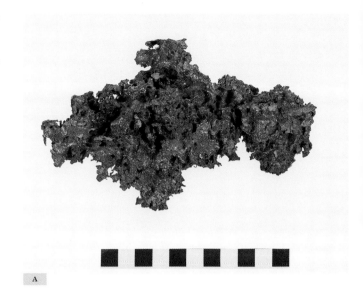

A

environments, as well as the ancient and historical technologies developed for the manufacture of colorants based on copper and its compounds.

Like many metals, copper is an essential element in our daily lives. An unusually good conductor of electricity and heat, copper literally surrounds us in the form of copper pipes and electrical wiring. Other copper products in common use today include copper cookware, decorative fittings and fixtures, copper bracelets for arthritis, copper roofs, and copper-based coinage, as well as copper compounds used as pigments and colorants for glass, special lubricants, and new materials such as copper barium yttrium oxide, $Cu_3YBa_2O_7$, and related compounds that are gaining importance as superconductors (Nagano and Greenblatt 1988).

Copper may not be of paramount importance in industry now, yet it remains an essential commodity, just as it is an essential element for biological life. Although copper is only present overall at 70 ppm in the earth's crust and 0.001–0.02 ppm in seawater, the copper that is present as a trace element in our bodies helps to catalyze hemoglobin formation; it transports oxygen in the hemocyanin of blue-blooded mollusks and crustaceans (the same role that iron plays in the hemoglobin of red-blooded animals) and is present in the ashes of seaweeds, in many sea corals, and in the human liver.

The chemical symbol for copper is Cu, the element is number 29 in the periodic table, and it has an atomic weight of 63.5. The atomic weight of copper is derived from the occurrence of two natural isotopes, ^{63}Cu and ^{65}Cu, with relative natural abundances of 69.17% and 30.83%, respectively.[2]

A sample of dendritic native copper from the Great Lakes region of eastern North America is shown in FIGURE 2A. The microstructure of some native copper, used millennia ago for

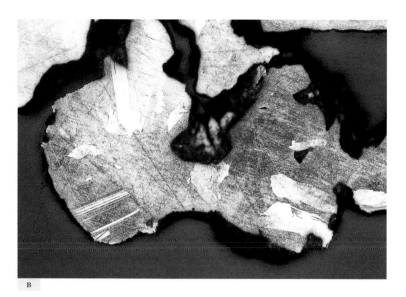

B

simple ornaments and blades, shows such distinctive features as very long twin planes and, in some samples, unusual growth features along slip planes in the solid metal, or patterns of corrosion of the copper metal that are atypical for melted and smelted copper (FIGURE 2B).

Disregarding for the moment alloys of copper with arsenic, which were the first important copper alloys used by both Old World and New World cultures, the most commonly encountered copper alloys are those with tin, called "tin bronze," or simply "bronze." The term *bronze* will be used here to cover a multitude of different copper alloys in cases where the composition of the metal is either unknown or not relevant to the discussion at hand. Often lead was added to the mixture of copper and tin, producing a series of ternary alloys of copper-tin-lead with lower melting temperatures, making the bronze easier to cast and helping to increase the bulk of the casting. This economized on the use of tin, which was relatively expensive in the ancient world.

Copper and mythology | The Latin word for copper, *cuprum*, evolved from *aes Cyprium*, meaning metal from Cyprus, a region famed in Roman times for its supply of smelted copper. In his *Natural History* (ca. 77 C.E.), Pliny the Elder wrote that "in Cyprus, where copper was first discovered, it is also obtained from another stone also, called chalcitis, copper ore."[3] Even Roman mythology links copper and Cyprus through the symbol ♀, a modified Egyptian ankh, which signifies copper and is also the zodiacal sign for the planet Venus. In Roman mythology, Venus was the successor to Aphrodite, the Greek goddess who maintained Cyprus as her principal place of worship. In modern times this connection between copper and Cyprus has been retained in the chemical abbreviation for copper, Cu.

The ancient use of copper is enshrined in Mesopotamian mythology. These tales told of many gods who lived deep in the bowels of the earth and were independent of the gods in heaven. Their leader was Enmesarra, or Nindara, a warrior god whose special mission was to combat demons, monsters, and plagues. Enmesarra, Lord of the Ghost World, was also the god of hidden metallic and mineral treasures. Covered in a skin of solid copper, he came from the mountains where this metal was manifest. Enmesarra was the night sun hidden during half his course, as was the ancient Egyptian god Ra in the form of Atum. Like the sun, Enmesarra waited to come out of the earth to reveal the splendor of metallic copper to the world of humans (Partington 1935).

At this early stage in human technology, copper was indeed a utilitarian as well as a decorative metal, easily extracted and worked into small ornaments, pectorals or *tupus* (South American cloak pins), or useful halberds (medieval weapons), palstaves (ax blades), or knives. Indeed, fire setting in the mountains could be used to bring forth metal: gold, for example, could be melted from deposits by setting fire to the vegetation on a hillside, the heat of the conflagration producing rivulets of metal.

The transubstantiation of minerals to copper metal and the early use of native copper has long been a source of fascination: Gordon Childe talked of "homotaxis," or modes of development, with this primary period of copper use corresponding to "mode zero" of our development over time, while Glyn Daniel talked of an "eochalcic episode." These neologisms, which now seem rather artificial, have faded into obscurity. More colloquially, and meaningfully, a whole age of humanity's past has been designated the Bronze Age, signifying the great importance of copper and copper alloys in a crucial stage of our development from hunting-and-gathering communities to settled villages. This change is associated with the increasing use of metals, first copper and bronze, and later iron.

EXPLOITATION OF COPPER

Old World developments | The use of native copper goes back in time at least ten thousand years and must have occurred in most geographic areas at a very early period in human prehistory. When Neolithic cultures first began using it, around the eighth millennium B.C.E., they fashioned the metal into small ornaments and simple copper blades. The first undisputed evidence for human exploitation of native copper deposits comes from the aceramic Neolithic site of Çayönü Tepesi in southeastern Turkey, where beads of malachite and native copper were found that date back 8,750 to 9,250 years before the present day. In addition, worked copper dating from the eighth to the seventh millennium B.C.E. has been found in both Anatolia and Mesopotamia. Even at this early period, some of the copper objects had been heated to anneal them so they could be hammered into shape, ready ductility being one of the chief assets of native copper (Muhly 1986).

Evidence for the smelting of copper, in the form of primitive slags, has been found at such Anatolian sites as Catal Hüyük, dating to the sixth millennium B.C.E. The deliberate or accidental smelting of copper ores with arsenic resulted in the first primitive versions of copper-arsenic alloys with golden color and good hardening properties; some of these early alloys were perhaps derived from the smelting of mixed copper-arsenic minerals such as olivenite, $Cu_2(AsO_4)(OH)$, or clinoclase, $Cu_3(AsO_4)(OH)$ (Rapp 1986).

True alloys of copper with tin began to be made in the Old World from the fourth to the third millennium B.C.E. and were pervasive and universal during the Bronze Age. Since tin is found normally as cassiterite, SnO_2, however, the advent of tin bronze still holds many mysteries as to its sources and the development of knowledge needed to mine and extract the tin and use it to alloy with different metals.

| *New World developments* | The use of native copper was common in the New World, especially in the period known as the Old Copper Culture of North |

America, which lasted from about 3000 to 1000 B.C.E. and produced ornaments and axes of native copper. Examination shows that New World metalworkers had discovered how to work and anneal copper. The Hopewell Culture of Mound City, Ohio, is one of the best known examples of these traditions.

Because native copper was especially plentiful in the New World, it was still being used during the Christian era by the indigenous peoples of North America and Alaska from the time of the Spanish conquest of the Americas in the fifteenth century onward. Only in South America, however, did the cultural development make possible the smelting of copper, copper-arsenic alloys, and later, tin bronze. The use of arsenical copper probably began in the first few centuries B.C.E. in areas such as present-day Peru, with the knowledge of metallurgy spreading to other regions at later dates.

True bronze alloys with tin were made in the New World during the early centuries C.E., much later than corresponding developments in the Old World. The different timescales attest to the independent development of copper metallurgy in the Americas. Tin bronze in the New World is especially associated with Inca hegemony from the thirteenth to the fourteenth century, but some antecedents are found in regions where tin was plentiful, as in present-day Bolivia, Argentina, and Chile.

| *Development of brass* | Brass, the alloy of copper and zinc, was restricted in early usage, because to smelt zinc, the temperature used must exceed the |

boiling point of the metal. By co-smelting zinc and copper ores, brass did become important during the Roman period, and the Romans produced brass coinage from 45 B.C.E. The early history of developments in metal mining and production is the subject of a detailed review by Craddock (1995); smelting and alloying are discussed by Tylecote (1976).

Extraordinary early brass objects have been found at Taxila in Pakistan. Brass coinage began to appear in Bithynia and Phrygia in southwest Asia from the first century B.C.E. The color of brass containing 10–20% zinc is very much like gold, and the presence of zinc confers hardness and strength much as arsenic and tin provide to bronze. Brass was especially popular in India, where it has been in continuous use for two thousand years for temple roofs, furniture, and cooking and storage vessels (Lambert 1997). By the Renaissance, many objects identified as bronze were, in fact, cast from leaded brass alloys, which continue to be used.

The alloys of copper and zinc were highly valued for their golden color and could be mistaken for gold. Those alloys that most counterfeited gold were given particular names, such as ormolu, prince's metal, Mannheim gold, or pinchbeck.[4] Gold-colored brass alloys could be beaten into thin foil or leaf, which is often called by the misnomer "bronze powder." If carefully lacquered and untarnished, such items could be distinguished from gold only by chemical analysis.

As early metalworkers discovered, the addition of arsenic, tin, zinc, or lead to copper can dramatically alter the color of the metal as well as its physical and chemical properties; it can also change the type and degree of corrosion of objects made from these alloys, whether the objects are cast or wrought into shape.

COPPER MINERALS AS PIGMENTS

The natural copper minerals malachite and azurite were important pigments from the sixth millennium B.C.E. onward, becoming gradually supplanted by synthetic copper compounds because of the relative scarcity of these green- and blue-colored mineral deposits. Long before the beginning of the Christian era, this scarcity led to attempts to make stable green and blue pigments for use in wall paintings and tombs, and later in manuscripts and paintings. In the process, many interesting copper-containing compounds were discovered, and techniques for the chemical synthesis of pigments, such as verdigris, were refined and transmitted from one generation to another.

Pigments and colorants based on copper are very closely related to copper corrosion products. Because of the varied and distinctly brilliant blues and greens that could be produced, the deliberate corrosion of copper and copper alloys was often employed to make artificial pigments. In later periods, recipes for producing specific colors became an important part of the corpus of painting materials. In many cases, these copper-based blue or green pigments are not easy to identify. One aim of this book is to provide currently available background information concerning these compounds, supplemented where possible with additional analytical, technical, and historical information.

ANCIENT BRONZES AND PATINA

Art historians, scholars, collectors, and scientists have long been drawn to the aesthetic qualities of ancient bronzes, with their varied green patinas, and intrigued by the technical skill shown by the unknown artisans who made them. Two bronzes from the collections of the J. Paul Getty Museum illustrate some aspects of patina: the finely cast Greek bronze Statuette of a Dead Youth (PLATE 1) that preserves a patina of cuprite and malachite spotted with reddish blisters from past eruptions of pitting corrosion, probably from "bronze disease" (discussed in CHAPTER 4), and the well-preserved Herm (PLATE 2) with a patina containing both malachite and azurite over a finely developed cuprite layer. FIGURE 3 shows some possible variations in copper alloy surfaces due to corrosion.

Early scientific analyses | The scientific examination of ancient bronzes includes studies by many eminent chemists, such as the research done by the French scientist Balthazar-George Sage in 1779 and by John Davy (brother of the noted English chemist Sir Humphry Davy), who in 1826 described his examination of a bronze helmet recovered from the sea near the Greek island of Corfu. Using wet chemical analysis, Davy determined that the metal was an alloy of copper and tin. He also identified the corrosion products: the ruby red suboxide of copper (cuprous oxide, or cuprite); the green rust of the carbonate (basic cupric carbonate, or malachite); submuriate of copper (one of the copper trihydroxychlorides, probably paratacamite or atacamite); crystals of metallic copper (which can be redeposited from solution during the corrosion of bronze objects); and a dirty white material, tin oxide (stannic oxide, or cassiterite). This was an impressive study for the time. Davy was also aware that some of his work was potentially important for the authentication of ancient bronzes, as evidenced by his presentation to the Royal Society of London.

> Permit me to lay before the Royal Society, the results of some experiments and observations on the incrustations of certain ancient alloys of copper, which I trust may not be undeserving of notice, whether considered in connexion with the arts of Ancient Greece, or in relation to the slow play of chemical affinities acting during a long period of time. (Davy 1826:55)

Modern analytical techniques | A range of physical methods are used today to analyze the composition of metals and their corrosion products. These techniques include X-ray diffraction (XRD), inductively coupled plasma-mass spectrometry (ICP-MS), scanning electron microscopy (SEM), electron microprobe analysis (EPMA), Fourier transform infrared spectroscopy (FTIR),[5] X-ray fluorescence spectroscopy (XRF), and optical metallography, particularly polarized-light microscopy (PLM).

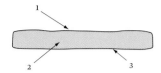

1 "patina" (oxide, sulfide, grease, lacquer, etc.)

2 sound metal

3 original surface

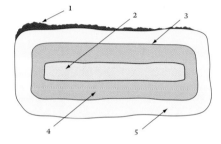

1 soil minerals, accretions, replaced organic materials, etc.

2 sound metal

3 original surface

4 mostly cuprite

5 secondary corrosion products, such as malachite, cuprite, basic copper chlorides, etc.

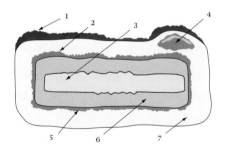

1 irregular surface with soil minerals, etc.

2 original surface, now disrupted

3 sound metal

4 corrosion pustule with cuprous chloride beneath

5 cuprous chloride

6 mostly cuprite with some copper chloride

7 secondary corrosion products, such as malachite, cuprite, etc.

FIGURE 3 Cross-sectional drawing showing variations in the preservation of copper alloy surfaces as a result of corrosion: A, preservation of shape in corrosion; B, disruption of surface by corrosion; and C, sound metal with patina.

Why is it necessary to identify the corrosion products or colorants derived from copper alloys, a subject that occupies much of this text? There are many possible reasons. First, it is very useful to know what compounds are present in an object to determine its authenticity and to decide if it is stable and suited to certain kinds of conservation treatments. The removal of corrosion products without this knowledge could obliterate important historical information or fine surface features, and might even destroy the original shape and detail of the object. Information about corrosion products may also assist in choosing the best environments for objects in storage, on open display, or in display cases. Second, corrosion products may be the only available clue to the composition or origin of an object that may have become completely mineralized. Third, the corrosion products may preserve information about the past environment of the object and the events that transformed it into a partially corroded matrix. This book is designed to serve as a helpful resource for all of these purposes.

PRESENTATION OF INFORMATION AND OTHER RESOURCES

Information on copper compounds provided in this book includes the mineral name, common chemical name (not necessarily following the International Union of Pure and Applied Chemistry, IUPAC, convention), chemical formula, density, color, mineral system, file number assigned by the International Centre for Diffraction Data (ICDD), and relative molar volume. Not all of this information is discussed in all instances, especially where standard references exist to provide primary mineralogical data. Such references include the *CRC Handbook of Chemistry and Physics* (Weast 1984); the ICDD Mineral Reference File (1989), *Gmelins Handbuch der anorganischen Chemie* (Gmelin 1965), and *A Comprehensive Treatise on Inorganic and Theoretical Chemistry* (Mellor 1928). A listing of some of the compounds discussed in this book, together with their ICDD reference file numbers, is provided in APPENDIXES C and D.

All percentages given in the chemical recipes, alloy compositions, and corrosion studies are weight percent unless otherwise stated.

Notes

1 Zhao Xigu (Kerr 1990:70). The thirteenth-century Chinese chemist, writing here in 1230, was evidently observing the darkening of cuprite, perhaps due to hydration, as it was boiled in water.

2 Little attention has been paid to these isotopes in archaeometric studies. Gale and colleagues (1997), however, recently developed techniques for the relatively precise isotopic determination of copper and found isotopic anomalies in copper from certain minerals and ores.

3 Pliny the Elder *Natural History* 34.2 (Pliny 1979).

4 The alloy pinchbeck was named around 1725 after the jeweler Christopher Pinchbeck and became synonymous with any cheap gold-colored alloy imitation.

5 In some cases, corrosion products or pigments may be poorly crystalline and give X-ray diffraction patterns that are unsatisfactory for identification. In this event, FTIR is very useful, since the anions or chemical groups can be characterized, even if the precise composition of the compound responsible for these groups cannot be determined. X-ray diffraction analysis, however, is preferable to FTIR. It is a more powerful tool for mineral differentiation, and the database of more than sixty-five thousand minerals maintained by the International Center for Diffraction Data is not equaled by FTIR data for inorganic compounds.

Corrosion and Environment

Things made of copper get covered with copper-rust more quickly when they are kept rubbed clean than when they are neglected, unless they are well greased with oil. It is said that the best way of preserving them is to give them a coating of liquid vegetable pitch. —PLINY THE ELDER[1]

Strictly speaking, *patina* and *corrosion* are different words for the same surface alteration. Here the term *patina* will be used to describe a smooth, continuous layer that preserves detail and shape, while the term *corrosion* will be used to describe mineral deposits that do not form a continuous and smooth layer. Surface accretions may represent a third state, in which soil minerals, textiles, wood, charcoal, and so on, may be bonded to a surface with copper corrosion products, or even partially replaced by them. Corrosion may be termed the process of chemical attack of an environment on a material, while patina could be defined as the accumulation of corrosion products and other materials from the environment. One person's patina, however, may be another person's corrosion, so a certain ambiguity is inherent in both words.

THE ANATOMY OF CORROSION

It is not possible to adequately discuss aeruginous (copper rust) corrosion products without introducing several principles of corrosion and descriptions of minerals. For these, see useful textbooks by Evans (1960); Jones (1992); Dean and Rhea (1982); Schumacher (1979); Palache, Berman, and Frondel (1951); Tite (1972); Roberts, Rapp, and Weber (1974); and Brown and colleagues (1977). Dispatching the subject of corrosion is very much like dispatching a multi-headed hydra: if one head is eliminated, there are always others that remain a source of consternation or bewilderment. Microbially influenced corrosion (MIC), for example, has recently begun to make an appearance in standard textbooks as a very important aspect of metallic corrosion, even in the corrosion of submerged copper alloys, yet the influence of microbes was once thought to be so minor that the subject was not even mentioned in older texts. This represents another hydra head in the process of being slain, and there will undoubtedly be others to come.

The behavior of the common alloys of copper with tin, zinc, arsenic, antimony, or lead is important, but it is not always known or properly understood. These alloying elements may produce subtle or major changes to the behavior of copper in different environments. In the most commonly encountered patina to form on buried bronzes, for example, there is an enrichment of tin in the outer corrosion layers due to the formation of cassiterite, SnO_2, or hydrated tin oxides with variable degrees of crystallinity. These tin minerals afford enhanced protection of the metal under the developed patina and are largely responsible for the smooth, lustrous surface on ancient bronzes that is known as "water patina." With Chinese bronzes, for example, these patinas occur quite often and are much admired and usually carefully preserved by collectors or museums.

Brasses with substantial amounts of zinc, however, may become destabilized compared with a bronze. They can lose zinc through a process called *dezincification,* which is discussed at length later in this chapter. Dezincification results in plugs or pits in the alloy where the object has been greatly weakened by the process. Protective patinas are usually not very well developed on these brasses, if present at all, since compared with destannification, or loss of tin, the preferential corrosion of the zinc does not result in a uniform deposition of zinc oxides. An inadequate amount of work has been carried out on the corrosion of arsenical copper alloys, which appear to survive quite well in burial environments, compared with the relatively large amount of information available for tin bronzes. Current understanding of corrosion is therefore limited and based on certain models that may or may not be applicable to the particular corrosion event being studied. An understanding of the major concepts of pH, Eh,[2] Pourbaix diagrams (discussed later in this chapter), and kinetic and thermodynamic principles, as well as possession of the requisite chemical background knowledge, is essential for a more detailed understanding of the subject. Pertinent basic information can be found in Pourbaix (1973), Moore

(1968), Leidheiser (1979), and Samans (1963). A few selected topics of particular relevance are briefly discussed later in this chapter.

The corrosion of copper compounds may be classified in many ways, and the organization chosen strongly influences how the events that cause the corrosion and the resulting corrosion products are discussed. One approach to categorizing corrosion products is to link them to their environmental milieus as follows:

1. products formed during burial
2. products formed during exposure to the atmosphere
3. products formed in the indoor museum environment
4. products formed in marine conditions
5. products manufactured in the laboratory environment for use in patination or as pigments

The first four of these topics are discussed in this chapter. The fifth one is covered in CHAPTER 9.

There are certain areas of overlap among the different types of environments listed here, since one set of conditions does not exclude the same product from forming in another. For example, marine exposure, land burial, or even atmospheric attack may all produce the same corrosion products.

Robbiola (1990) has proposed that ion migration should be considered as a unifying principle in the corrosion of bronzes. He divides corrosive events into two groups:

1. corrosion under cationic control
2. corrosion under anionic control

During corrosion under cationic control, the cations, such as copper or tin ions, diffuse to the surface of the metal and control the rate of the corrosion reactions. This is often a slow process that tends to produce patinas, especially cuprite layers, that may preserve the shape of the original object.

Under anionic control, corrosion proceeds with a greater change of volume at the corrosion interface; thicker and less coherent corrosion products may form as a result. Highly mobile ions, such as chloride ions, may contribute to processes under anionic control because these travel easily from the environment to the metal surface as anions, accelerating the rate of corrosion and producing corrosion layers that are more disruptive.

Chase (1994) used the concept of ion migration to examine the corrosion of some Chinese bronzes. In processes equated with cationic control, which Chase calls "Type II corrosion," a smooth water patina enriched in tin oxides occurs on the surface. Cross-sectional studies show that the alpha phase of the bronze has dissolved away, leaving behind uncorroded islands of alpha + delta eutectoid (see APPENDIX A, on bronze). In some cases, these well-preserved patinas may occur on bronzes that were intentionally colored or patinated in antiquity before being

preserved in a burial environment. Chinese mirrors, for example, have been found with patinas of two different colors on the surface. The origin of these patinas is still not understood, but they may represent a natural patina that formed over an artificial one.

During corrosion under anionic control, removal of the tin-rich phase can occur, forming a surface corrosion layer of tin oxide, or tin oxide mixed with cuprite, often with malachite or azurite as well, leaving behind the alpha phase of the alloy to corrode last. Gettens (1969) documented this type of corrosion, which is often associated with a cuprite marker layer and with chloride attack; it leads to the presence of cuprous chloride in pits or under the more stable mineral growth as the patina develops.

The concept of ionic migration may be a useful one, since the effects of ionic transport may predominate regardless of the natural environment. The environment per se is actually less crucial than the chemical species involved in the corrosion, since they determine what kind of corrosion products may form.

The chemical processes by which these corrosion layers may grow are also of interest in the conservation of the object and the possible preservation of the original shape of the object within the corrosion crust. These events are influenced by the transformations that may take place between the original metal or corrosion product and subsequent chemical changes. As these minerals grow or develop, they can be grouped into events, which are

1. epitactic,
2. topotactic, or
3. reconstructive.

In epitactic transformations, there is a direct relationship between the crystallography of the initial layer and the structure of the layer that may grow or develop from it. For example, cuprite may preserve the pseudomorphic dendritic structures of the cast copper alloys as the corrosion penetrates into the metal. The preservation of structure within the corrosion may originate from an epitaxial relationship between substrate and product, with a corresponding retention of shape. Once a chemisorbed film of copper (I) benzotriazole has formed on a copper surface, for example, subsequent layers of this copper complex are deposited epitaxially to produce a relatively thick, oriented film with good protective properties.

Topotaxy results from the solid-state transformation of one corrosion product into another; the crystal lattice of the original product may be changed, and the replacement product may not have any direct structural relationship to the original material. Possible changes in this category include the disruption of copper sulfide layers and their alteration to copper sulfates or other products, and the alteration of cuprite to tenorite. Many topotactic relationships exist, as, for example, between the iron oxyhydroxides (such as goethite) and iron oxides (such as hematite or magnetite).

In reconstructive events, the original corrosion product is completely dissolved or chemically altered to form a new product that is entirely different from the original. For example, cuprite may be dissolved by chemical solutions of low pH and low partial pressures of oxygen, resulting in the deposition of metallic copper in place of cuprite. This metallic copper may have a twinned crystal structure (Scott 1991); it grows as cuprite dissolution proceeds (Chase 1994).

Alternatively, we could view the reactions involved in corrosion product formation as either

1. chemical—involving a transfer of electric charge that takes place only locally between atoms; or
2. electrochemical—involving a nonlocal transfer of electric charge through a conductor that connects the anodic and cathodic areas.

Chemical corrosion reactions are those in which chemical species alone are predominant in terms of the reaction or series of reactions.[3] Electrochemical corrosion reactions are those controlled by a potential difference in the reaction process that leads to a flow of ionic species from one region or surface to another. Most corrosion processes are primarily electrochemical because both anodic and cathodic sites are usually present. The utility of thinking of them in terms of either chemical or electrochemical categories is therefore rather limited.

More important perhaps, corrosion reactions can also be viewed as dominated by either

1. thermodynamic principles, or
2. kinetic principles.

In thermodynamic terms, all natural, spontaneous processes must proceed with a negative Gibbs free energy of reaction.[4] An example is the reaction of cupric oxide with moisture and sulfuric acid to form antlerite given by the following equation:

$$3CuO + H_2SO_4 + H_2O = CuSO_4 \cdot 2Cu(OH)_2 \qquad \text{1.1}$$

The relevant thermodynamic data are readily available from a number of sources. The calculation for the reaction given by equation 1.1, based on the data of Weast (1984), shows a Gibbs free energy of formation of -19.5 kcal/mol. This reaction proceeds from left to right, with the dissolution of cuprite and the formation of antlerite. This is observed in the corrosion of outdoor bronzes exposed to rain of low pH, which is associated with industrialized regions of the world.

Kinetics investigates how fast a chemical reaction will occur. If a particular reaction or step in a series of reactions is very slow, thermodynamic equilibrium may never be attained. In corrosion processes, for example, polarization effects may limit the ability of hydrogen atoms to be discharged as hydrogen gas. The result of this delimitation is that the corrosion process involved may come to a standstill because the hydrogen cannot be discharged. Hence, kinetic factors may be as important as thermodynamic ones. For corrosion processes that take place over hundreds or thousands of years, however, the kinetic factors are not easy to model.

The electrochemical series is important in determining the preferential corrosion of metals in an alloy. The reduction potential for the reaction of copper (II) with two electrons is +0.340 V (on the E° scale where the reduction of hydrogen is zero), as shown in the following equation:

$$Cu^{2+} + 2e^- = Cu \qquad \text{1.2}$$

Corrosion products and corrosion potentials, however, are not related to the equilibrium potential of the respective elements. The same reaction for zinc occurs with a potential of -0.783 V:

$$Zn^{2+} + 2e^- = Zn \qquad \text{1.3}$$

In a brass alloy, therefore, although copper and zinc may be randomly substituted in the alpha solid solution, there is still a considerable driving force for the corrosion of zinc as the anodic component while the copper may be retained uncorroded. By comparison, the same reaction with tin has a much lower negative potential of -0.136 V; tin is still anodic to copper but substantially less so. The corrosion of tin normally results in the accumulation of the insoluble tin oxides; this impedes the further anodic process of destannification, or tin dissolution. In some circumstances, copper may be corroded while the tin compounds remain behind, and therefore a prediction made on the basis of the electrochemical series as to which elements will be most corroded or dissolved away cannot be made, unless the wide range of environmental and chemical factors that may influence the corrosion can be evaluated.

The general principles of the electrochemical series must be understood, however, since any argument for exceptions to the order of elements in the series must be based on the initial behavior predicted. For example, there is a considerable difference between the initial corrosion outdoors of a 10% tin bronze and that of a 15% zinc brass. The bronze is much more corrosion resistant, which is predicted by the electrochemical series for these freshly polished alloys. Within a year, the brass will have darkened considerably while the bronze may be practically unchanged. The brass is influenced by the electropotential difference between copper and zinc, resulting in a more general corrosion of the surface at a much faster rate than that of the tin bronze.

In addition to zinc and tin, the common alloying elements of lead, arsenic, or antimony may also behave anodically to copper, at least in theory. Since lead is insoluble in copper at room temperature, it is usually present in the form of discrete globules as a separate phase from the copper alloy. This segregation can result in severe corrosion of the lead phase. The globules are surrounded by a largely cathodic copper region; this can cause the lead to become oxidized to the basic carbonates or oxides. Organic acids, such as those found in unsuitable storage conditions, may interact preferentially with these lead globules, producing a whitish surface haze to the bronze, or more severe corrosion excrescences. In some cases, a combination of copper

corrosion and lead corrosion may result in mixed copper-lead mineralization on the surface. Similar events may occur with arsenic and antimonial alloys of copper, although here the elements form solid solutions of various types. Segregation is still possible, especially if due to casting, which may result in dendritic segregation and coring of the intradendritic regions. The compositional gradients between these regions may result in an electrochemical potential, producing enhanced corrosion of one phase or component of the alloy. Thus arsenical compounds may be present in the corrosion of copper-arsenic alloys and antimonial ones with copper-antimony alloys. The literature on such compounds in the archaeological context is sparse, and further research is needed to identify all of the arsenates and other salts that are undoubtedly present as corrosion products.

When a metal is placed in seawater, a number of different oxidation and reduction reactions can occur on the surface, and the metal assumes a potential (E) that is dependent on the combined effects of all these possible reactions. The defined potential for an environment is its corrosion potential, E_{corr}. All reactions with E more positive than E_{corr} will participate in reduction and form cathodic sites on the metal, while all reactions with E more negative than E_{corr} will be oxidative and form anodic sites. For an inert electrode, the measured potential will depend solely on reactions between solution species; this potential is referred to as the Eh seen in Pourbaix diagrams, discussed later in this chapter. In seawater, for example, the alloy known as admiralty brass, of composition 71Cu28Zn1Sn, behaves in a more noble way than a yellow brass of composition 65Cu35Zn, and both of these are more cathodic than a low-carbon steel. Some relationships are shown in Hack (1987). These reactions are important since the galvanic coupling of different metals is well known to cause severe corrosion to the anodic component. Such effects were already exploited in the nineteenth century for the protection of copper hulls by galvanic coupling with zinc or magnesium. The zinc or magnesium would corrode preferentially, thereby protecting the copper.

SOME HISTORICAL ASPECTS OF COPPER AND CORROSION

The corrosion chemistry of copper was exploited in the past, sometimes unwittingly, to create new technologies; some of those discoveries are briefly described here. For further information on a particular topic, see the literature cited.

Primitive wet-cell batteries? A crude wet-cell battery can be made by pushing iron and copper rods into a lemon and then touching the rods with the tongue, which elicits the sensation of an electric tingle. This simple act, or a similar one, could have lead to the accidental discovery of electrochemical phenomena more than fifteen hundred years ago, as certain mysterious artifacts seem to suggest. These puzzling objects date to the Sassanid or Persian dynasties (226–641) of ancient Iraq; some date to as early as the first century.

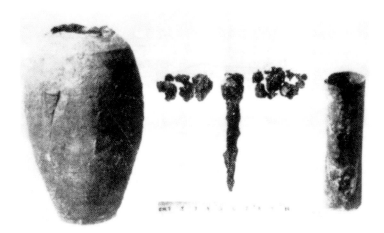

The first published report of these finds was by Waterman (1931), although he was at a loss to explain what they were. The objects consisted of a number of common, unglazed jars containing a bronze or copper cylinder 7.62 cm (3 in.) long and 3.18 cm (1.25 in.) in diameter. Asphalt seals and iron rods were also found with these jars. Similar but larger and more elaborate finds were unearthed during excavations by König (1938) at Khuyut Rabbou'a, southeast of Baghdad. Among the finds made by König was a clay jar fitted with a copper cylinder containing an iron rod that was held in place with an asphalt stopper.[5] Such objects may have once functioned as batteries long before the work of Volta and Galvani, but their purpose remains unknown. Electrical insulation of the iron rod from the copper would ensure that anode and cathode were kept apart, and, if a salt or acidic solution were introduced into the jar, the battery would theoretically produce a potential on the Standard Hydrogen Electrode (SHE) scale from the sum of

$$Cu^{2+} + 2e^- = Cu \qquad +0.34 \text{ V (SHE)} \qquad\qquad 1.4$$

$$Fe^{2+} + 2e^- = Fe \qquad -0.44 \text{ V (SHE)} \qquad\qquad 1.5$$

This would represent a maximum voltage of 0.777, but only in 1 molar solutions of each ionic type, and a fairly weak current of about 1 mA. Because of difficulties with the electrolyte, it is doubtful if the voltage of 0.777 could be achieved in practice. FIGURE 1.1 shows one of these objects disassembled.

A replication experiment by Keyser (1993) found that a sodium chloride solution rapidly corroded the iron, polarizing the cell and resulting in a voltage drop to 0.4 V within less than one minute. Citric acid from freshly squeezed grapefruit, or strong vinegar, was preferable, producing 0.49 V with slow polarization. The current flowing is readily detectable on the tongue or

skin, especially in cuts or puncture wounds, and may have been beneficial in acupuncture, with the current applied to the needle, or may have been of ritualistic use in shamanism. The current from electric fish was already in use by the first century C.E. in the Greco-Roman world as an analgesic. In the mid-first century, Scribonius Largus first recorded the practice of applying the fish *Torpedo ocellata* as an analgesic for headaches and gout. Keyser (1993) speculates that wet-cell batteries may have functioned as substitute ichthyoelectroanalgesia or have been used for thaumaturgical effect. Eggert (1996) observed, however, that König (1938) had referred to similar finds from Seleucia (bronze cylinders containing papyrus relics) and from Ctesiphon (rolled bronze sheets). These latter Sasanian finds were discussed in detail by Paszthory (1989). Eggert draws attention to the problem of sustaining the flow of electric current. The small initial current is due to the reaction of oxygen dissolved in the electrolyte. Since most of the parallels to the finds from Khuyut Rabbou'a are not tightly closed copper cylinders, the whole vase would be filled with an electrolyte. The walls of the earthenware vase are porous, and oxygen from the air could diffuse steadily into the electrolyte, which would help to sustain the current flow for a longer period. Despite this possibility, Eggert agrees with Paszthory that it is more probable that the containers may have represented magical jars for blessings or incantations written on parchment or papyrus, which would account for the discovery of papyrus fragments in some of these containers. The work by Eggert (1996) should be consulted for the most current bibliography of thirty papers that these mysterious objects have generated.

There is a natural tendency for writers dealing with chemical technology to envisage these unique ancient objects of two thousand years ago as electroplating accessories (Foley 1977), but this is clearly untenable, for there is absolutely no evidence for electroplating in this region at the time, and the medical or magical world must be invoked.

Early technologies with	The electropotential difference between iron and copper is
copper and iron	important in displacement reactions: copper, for example can
	be displaced from solution by iron; an iron rod immersed in a

solution of copper sulfate rapidly becomes covered with a thin coating of dull reddish yellow copper metal. Corfield (1993), in reviewing the methods used to coat iron with copper, mentions that in 1873 Spon had already described numerous methods for the plating of iron with copper for commercial use; of course, this kind of plating was already known in medieval times as well.

The first reference to this kind of process in Europe was in the eighth-century Lucca manuscript, *Compositiones variae*, from Lucca, Italy (Johnson 1941), whose antecedents derive from a Spanish text dating from 725, which in turn is descended from a manuscript dating to 650, which is a transliteration from an even earlier Greek text (Burnham 1920). The Lucca manuscript therefore contains information that may trace its lineage back to the early centuries C.E. One recipe discusses the treatment of an iron surface with a mixture of corrosive salts

containing copper as a preliminary to gilding, which would have deposited a coating of copper over the iron. A similar process is also mentioned in the ninth-century *Mappae Clavicula* (Smith and Hawthorne 1974).

A solution of copper sulfate in sulfuric acid was found to produce a coating of copper quite rapidly, although the plated copper surface did not have good adhesion. The galvanic replacement of iron with copper was used historically for the recovery of copper from waste mine waters, and, as is well known, the knowledge was also used for thaumaturgical purposes, the process of transmutation of the elements—from iron to copper or from copper to gold—being very much a part of the alchemical tradition. In the primary extraction of copper from waste, the galvanic deposition of copper from aeruginous mine waters even produced a minor industry in the form of Herrengrund ware, made in the town of that name in Erzgebirge in Bohemia. Some examples are illustrated in Smith (1971).

Ingenious metallurgical techniques have been applied to the coating of iron with either copper or copper alloys, some of which are simply based on mechanical cladding or dipping the iron object into molten copper or copper alloy. The earliest technique was simply to wrap copper sheet over the shaped iron object, carefully hammering together any seams or joins in the copper. Corfield (1993), for example, illustrates an Early Iron Age bridle bit from a hoard discovered at Llyn Cerrig Bach, Anglesey, Wales, originally excavated by Fox (1946), which was fabricated by this technique.

The fusion plating of copper onto iron was also common and is described by the German monk Theophilus (1961) in his *De diversis artibus* (ca. 1110–40) as part of the manufacture of barrel padlocks. Theophilus tells of using an alloy of 66% copper and 33% tin, which was crushed, mixed with flux, and heated in charcoal. A related technique was reported by Arwidsson and Berg (1983) for coating iron bells from Viking Scandinavia. The bells would be covered with strips of copper inside and out and heated in dung to fuse them together. The electrolytic plating of iron with brass alloys was already well known in the late nineteenth century. Phillips (1911) describes the galvanic deposition of brass from an electrolyte of copper and zinc salts in cyanide solution, and producing variations in the color of the brass plating by adjusting the exposed brass anode area in the solution. An alternative technique was to first plate a coating of copper, followed by one of zinc, then sandwich it with another layer of copper before heating the plated metals to alloy them together. Copper alloys are still used in industry today for plating iron and steel; for example, mild steel can be plated with a binary brass by using an electrolyte of copper and zinc salts in the ratio 6:4 dissolved in aqueous sodium cyanide. It is surprising that bronze and high-tin bronze alloys can also be plated from solution (Silman and Averill 1978), because one element will usually be plated out before the other, and specially designed solutions must be employed to achieve satisfactory alloy electrodeposits.

When copper is immersed in a solution of a noble element such as gold or platinum, these elements will plate out and the copper will go into solution. This technique is often referred to as electrochemical replacement plating, which is thought to have been used during the early centuries C.E. by the Moche culture for the plating of gold onto copper objects (Lechtman 1979), a technology unknown in Europe until many centuries later when strong mineral acids were available. This remarkable achievement of the Moche relied on the fact that it is possible to slowly dissolve native gold dust in corrosive natural minerals such as salt, alum, and potassium nitrate. It is also possible that gold could be dissolved by cyanogenic glycosides derived from plants, but in any event the evidence strongly suggests that gold was brought into solution and, after mixing with soda or sodium bicarbonate, could be rubbed over cleaned copper.

For the plating of gold to take place, some of the copper must enter into solution in a process of electrochemical exchange; gold ions from solution are reduced to metallic gold when in contact with the copper while at the same time some copper atoms corrode as their part of the anodic reaction and dissolve in the plating solution. The coating thus formed is only 1–2 μm thick, and microscopic imperfections will be present in this surface layer from the anodic dissolution of copper. Features of this extraordinary galvanic technique were fully replicated by Lechtman (1979), confirming that it was indeed possible to produce such a coating without the use of strong mineral acids, such as hydrochloric or nitric acid. A conceptual subtlety is the need to raise the pH of the plating solution into the alkaline region before gold will deposit from the solution at all. The solution of gold in potassium nitrate, potassium aluminium sulfate, and sodium chloride is very acidic, forming chloroauric acid in solution, $H(AuCl_4) \cdot H_2O$. If copper were immersed in this solution, it would be rapidly attacked, developing a layer of basic copper chlorides and other salts on the surface, which would ruin an attempt to deposit gold galvanically, since the optimum pH for deposition of gold is 9. In her replication experiments, Lechtman (1979) achieved this more favorable pH by the addition of sodium bicarbonate followed by immersion of cleaned copper sheet in the slurry for about fifteen minutes. Although this electrochemical plating is poorly adherent to the copper, heating in charcoal between 500 °C and 800 °C for a few seconds may be enough to form a gold-copper diffusion bond, providing a metallurgical join between coating and substrate.

There are essentially two forms of galvanic deposition of another metal on copper, which can be referred to as "electroless" plating, that are often used for chemical or industrial processes and for "electrochemical replacement." In electroless plating the solution contains its own reducing agent, and corrosion of the copper substrate is not essential for the reaction to occur; in electrochemical replacement processes the copper surface must provide discrete anodic and cathodic areas, for the plating of gold is a consequence of the corrosion of copper,

which occurs at the same time. When the anodic regions are covered in gold the reaction comes to a standstill, and the gold coating is not satisfactory unless the anodic regions slowly shrink in size while general cathodic deposition of gold occurs over the rest of the cleaned surface.

Some evidence exists to suggest that small anodic pits formed in the copper under the surface layer are the remnants of anodic sites in these gold-plated Moche objects. The existence of these extraordinary gold (and silver) coatings over copper does not seem to have generated great interest among scholars dealing with Old World technology, and the whole subject deserves further research and attention. An interesting application of electrochemical plating from a completely different period and culture is that used on the cast sculptural group of *Medea Rejuvenating Aeson* in the collections of the J. Paul Getty Museum. This group, shown in PLATE 3, exemplifies a common Neoclassical theme of vestal virgins and rejuvenating scenes much loved by French artists in the eighteenth century. In the course of the examination of this work, surface analysis of the metal composition by X-ray fluorescence spectroscopy showed that the sculpture was cast in a leaded brass alloy, rather than a bronze, and that the thin, glossy surface, which was dark brown or steel gray in color, consisted of a platinum coating (Bewer and Scott 1996).

This platinum patina could have been applied by an electrolytic technique, by the use of a mercury-platinum amalgam, or by application of a chemical solution; in this case, a platinum salt solution was used. The platinum coating process for the surface treatment of bronzes was greatly facilitated by the research carried out in France by Alfred Roseleur (d. 1879) (Roseleur 1872). Prior to this, attempts to coat bronze objects with platinum had resulted in the deposition of a very thin film that was unsatisfactory as a surface deposit. The first historical report of a deposition technique for platinum without the use of electric current is that of Stodart (ca. 1760–1823), which dates from 1805. Stodart dissolved platinum in aqua regia and extracted the salt (platinum chloride) in ether. If polished iron, steel, or brass is immersed in this solution, it becomes coated with platinum, a technique Stodart probably used on surgical instruments that he manufactured (Smeaton 1978).

Hiorns (1892) records that successful and attractive surface coatings could be achieved with platinum salt solutions, and the recipe employed was successfully reproduced in the laboratory:

> [T]here is one chloride, however, which is not subject to variation by the action of light, but the shade is blackish, and altogether different to the beautiful light browns produced by certain other soluble chlorides. This difference is due to the deposition of a thin film of metal on the copper instead of a metallic compound. (Hiorns 1892:97–98)

The process is one of electrochemical replacement plating; as copper or zinc atoms are attacked by the platinum salt solution, they enter into solution, and platinum is simultaneously deposited on the surface of the copper alloy as a coherent steel gray–colored film.

The deposition of other metals, especially on scientific brass instruments, was often used during the eighteenth and nineteenth centuries. Bronzing solutions based on arsenic oxide deposit a thin adherent film of arsenic, as recorded by Fishlock (1976).[6] Patination solutions based on mercury salts were the most common but also created problems with corrosion of the copper alloy substrate. Bright red mercuric oxide can often be observed under blisters on deteriorated surfaces coated with mercury, for which Hiorns (1892) provides a practical recipe.[7]

ELECTROTYPING The electrolytic deposition of copper for the production of electrotypes and the electrolytic dissolution of copper corrosion products for the cleaning of copper objects represent two different applications of the same electrochemical principles. In the first case, cathodic deposition of copper is used to build up a replica of an object; in the second, the cathodic dissolution of corrosion products, using stainless steel anodes, is used to reveal the remaining metallic surface or core of an object under treatment.

During the period when electrotyping was at its zenith in the nineteenth and early twentieth centuries, many copper objects were produced from the deposition of copper from solution, using electric current with copper (II) solutions and copper anodes to replenish the solution. Opinions vary as to when the first galvanic decomposition of a metal salt solution was achieved, but the discovery of the voltaic pile by Volta in 1796 made possible the application of current to salt solutions. The first application of galvanic deposition did not occur, however, until about 1839, followed by the development of its practical application during the 1840s (Beale 1975).

A colorful array of characters were involved in the early developments of electrotyping. One of these was Duke Maximilian Hertzog von Leuchtenberg (1817–52), son-in-law of Czar Nicholas I of Russia, who founded the St. Petersburg Electroforming, Casting, and Mechanical Plant, a firm that produced copper electroforms, as well as copper horses for the Bolshoi Theatre and copper statues for the Hermitage (Hunt 1973). The *Encyclopaedia Britannica* (1898) states that one of the most important activities in electrotyping in England at that time was to

FIGURE 1.2 Box Mirror with Modern Relief Protome. Mirror: Greek, fourth century B.C.E. Relief Protome: 1930. DIAM: (mirror) 15.5 cm; (case) 15.3 cm. Bronze. The profile of a head on the back of this mirror appears perfectly acceptable, but it is an electrotyped addition. Malibu, J. Paul Getty Museum (85.AC.87).

produce copper duplicates of engravings on wood. The method of production was to take a cast of the block in wax or in gutta-percha and then to coat the surface of the mold with graphite. The prepared mold was then suspended in a bath of copper sulfate, and a wire was connected to the mold and to a battery; in essence the technology has not really altered over the last one hundred years. The encyclopedia entry continues:

> [I]n the course of a few hours a sufficiently thick plate of copper is deposited. The copy, on removal from the mould, is strengthened by being backed with type-metal.... For rotary printing machines the electrotypes are curved, set-up type is also sometimes copied thus instead of being stereotyped, the electro-deposited copper being harder than the stereo metal. Copper is sometimes thrown down as a thin coating upon plaster busts and statu-ettes, thus giving them the appearance of solid metal. In Paris too, it is now common to give a thin coat of electro-deposited copper to exposed iron-work such as gas-lamps, railings, and fountains. The iron is first painted, then black-leaded, afterwards electro-coppered and finally bronzed. Cast-iron cylinders used in calico-printing are also coated with copper by a single-cell arrangement. (*Encyclopaedia Britannica* 1898: s.v. "electro-metallurgy")

A lithograph showing the kind of quaint Parisian lamppost that would have been coated with copper is illustrated in Smith (1977). Ingenious solutions were developed to create elec-trotype copies in the round with a continuous operation by making an underlying copper anode in the shape of the final completed object. After half the copper had been coated into the mold, the mold could be removed and the second mold positioned around the other half of the wire-anode framework; a diagram of the process is shown in Roseleur (1872).

The electrodeposition of copper was a common feature of Victorian industrial processes. Napier (1857) records the use of copper in the coating of glass or porcelain, cornice carvings, cloth, flowers, and other small objects. Molds of ferns and leaves were obtained using gutta-percha softened in boiling water, or wax might be used instead, and prepared for electrotyping by deposition of a dilute solution of silver nitrate on the surface of the mold. Some of these cop-per replicas could afterward be coated with gold or silver, or "bronzed" by application of a solu-tion to corrode the surface and turn it green. A more unusual recipe called for cleaning the object with caustic alkali, brushing some black lead over the surface, and then heating it on an iron grate. The final treatment involved haematitic iron ore with an "unctuous" feel, which was brushed over the surface to produce a fine brown patina.

A Greek cased bronze mirror in the collections of the J. Paul Getty Museum, shown in FIG-URE 1.2, provides an amusing example of the use of electrotyping to improve the appearance of an otherwise plain mirror case by the addition of a "bronze" relief protome of a Greek head. Sus-picions were first aroused by the fact that the patina on the case, which is quite genuine, was very different in appearance from the cuprite patina on the portrait (Podany and Scott 1997). When the relief protome was removed and examined, it was found to be an electrotype, a fact

confirmed by metallographic examination of a cross section through the copper, shown in PLATE 4. Beneath the portrait head, the restorer had penned additional information for this conceit: "A. P. Ready, Restorer, British Museum 1930."

Galvanic deposits of copper usually show columnar or twinned crystal structures, often completely unlike anything that can be produced by either the casting or the hammering and annealing of pure copper. Growth features in the deposit may be evident, and in these cases there is usually a columnar aspect to the microstructure. The structures are often twinned because, for some rather mysterious reason, this must represent the system of lowest energy requirement for the transition of dissolved copper species to metallic deposition as a solid, assuming that columnar growth is not dominant. Very often, copper that is redeposited from solution during the corrosion of bronzes is also twinned. However, the twin lines in some electrotypes may occur as markings within columnar structures that are quite unique to electrotyped copper; some of these details can be seen in the photomicrograph of the modern relief protome (see PLATE 4).

Another useful approach to the identification of electrotypes is that of Laüe back-reflection X-ray diffraction. Wharton (1984) was able to show that many electroformed reproductions could be identified by this technique. Since the inception of Renaissance medals—introduced in 1438 by the Italian painter Antonio Pisano, known as Pisanello (1395–ca. 1455)—various cast or electrotyped copies have been produced from struck originals; Wharton's research sought a nondestructive method to distinguish between them. In the Laüe back-reflection X-ray diffraction technique, a flat-plate camera is used with a beam of X rays in the back-reflection mode. The number of spots that appear on the film then roughly correspond to the number of grains that have diffracted the X rays. In Wharton's study, medals were placed 3 cm from the film in a Laüe diffraction cassette using an exposure of 35 KV, 15 mA for fifteen minutes. Since the divided, columnar-type structure of most electrotypes comprises many discrete grains, the corresponding Laüe pattern shows a much finer array of small spots than the struck or cast equivalent. Obverse and reverse faces of the electrotypes do not necessarily show the small degree of grain refinement, and a set of controls of cast and struck forms is an essential part of any detailed investigation. The technique is an old one, and is well-known in the X-ray diffraction community, but there appears to have been little application of the method in the conservation field following Wharton's seminal paper.

The microcrystalline nature of electrotyped copper is sensitive to a plethora of variables, ranging from current density, presence of dirt or particulate matter in the solution, distance from anode to cathode, temperature, degree of agitation, and the presence or absence of certain additives; any of these could have a profound effect on the micromorphology of the deposited copper. For example, it has been found over many years of empirical observation that complexing reagents such as thiourea have a very beneficial effect on the grain refinement and compaction of the resulting deposit, ensuring a better quality reproduction of surface detail. The

amperage per square centimeter must also be kept within certain limits, otherwise the deposit is too coarse because it is laid down too fast, altering the grain morphology; such deposition does not reproduce good detail.

In the majority of museum laboratory processes, copper anodes are used with copper sulfate and sulfuric acid, with small additions of ethanol as a wetting agent and thiourea as a complexing agent. The principal ions in solution are Cu^{2+}, H^+, and SO_4^{2-}. On the surface of the cathodic object, the positive charge of the copper (II) cations is discharged by the electrons supplied by the current at a potential of +0.34 V for the reaction (see equation 1.4).

It should be noted that hydrogen ions are also attracted to the cathode, but these are discharged at a different potential (0.0 V), and it is the copper cations that are discharged first, although the whole process is very complex and much more involved than equation 1.4 would indicate. In aqueous solutions, the ion $[Cu(H_2O)_6]^{2+}$ is present. In electrolytes containing hydrated metallic cations, the concentration of dischargeable metal ions is usually high, and for the precipitation of copper from hydrated ions, dehydration is involved as a preliminary reaction. This removal of water molecules occurs mainly in the outer diffusion zone of the Helmholtz double layer and is composed of several individual steps. The final stage of this process occurs when the dehydrated copper ion passes through the double layer to the cathode where it is neutralized and absorbed as soon as it touches the surface as an adatom. This neutral adatom diffuses to become a part of the crystal lattice, the field strength within the double layer having no effect on this part of the process. The hydroxide and sulfate anions travel to the anode, where they are discharged if the voltage is sufficient. The copper anode is gradually dissolved and delivers to the electrolyte the same quantity of copper ions as are deposited at the cathode; this is the principal anode reaction. If the potential is raised, the reaction of water can result in the production of oxygen, as follows:

$$2H_2O - 4e^- = 4H^+ + O_2 \qquad \text{1.6}$$

Normally, the sulfate anions are not discharged, since this reaction would require a much greater potential than that normally used in museum electrotyping work. These technical aspects are often glossed over, making it appear that electrotyping is a completely simplistic operation, but this is not the case, and the practical details of successful laboratory practice are well described in the handbook by Larsen (1984).

A good example of the traditional craft of electrotyping is provided by the conservation work on a Romano-British bronze parade helmet carried out by Shorer (1979).[8] Work by Larsen (1984) has also led to a revival of interest in electrotyping for tool marks, fabrication studies, and copies. In another modern application of electrotyping, Bertholon and coworkers (1995) reported on their conservation re-treatment of the copper Dead Sea Scroll from Qumran, Jordan, that was first conserved in England in 1955. The re-restoration work consisted primarily of additional consolidation and the construction of a new support. X-radiography of

twenty-three cut fragments allowed a digital image of the scroll to be created. Silicon rubber molds were taken of each of the fragments, which had been flattened out so a copper electrotype could be made. The original scroll was then reconstructed using this electrotype.

Some extremely important commissions were made in electrotypes, such as the "bronzes" that adorn the Opera, Paris, and the 320 cm high statue of Prince Albert and four accompanying figures, erected behind the Albert Hall in London as a memorial to the Great Exhibition of 1851. The Prince Albert statue was electrotyped by Elkington & Company of Birmingham, England, in 1861 and has recently been restored. Many German sculptures were made by this technique as well. Haber and Heimler (1994), who examined several nineteenth-century German sculptures, were able to show that until the advent of World War I many of these were made by electrotyping. Two methods were used in production: first, electroplating copper onto an isolated plaster core; and, second, electroforming of hollow objects in negative forms. Large objects would be electrotyped in several pieces, which were then soft-soldered together, followed by a recoating with copper to disguise the join. Extensive corrosion has been observed especially on electrotyped statues that still retain their plaster cores and iron armatures.

Copper in early photography | The use of copper sheets with galvanic coatings of silver was an important part of the first practical photographic process, named the daguerreotype process after Louis Jacques Mandé Daguerre (1789–1851), who perfected it in 1833. The copper plates used were initially coated with silver by galvanic deposition, which had recently become of commercial importance, followed by washing the plate in acid to remove surface impurities and then carefully polishing it. The plate was then placed in an enclosed box where it was subjected to iodine vapor. The sensitized plate was then exposed in a special camera, with exposure times as long as thirty minutes, after which the plate was enclosed in a second box and exposed to the fumes of heated mercury. The image now appeared and was fixed in sodium thiosulfate and often toned in gold chloride. By the 1840s, plates were made commercially by silversmiths, who brazed a silver coating onto the copper, although individual operators would often add galvanically deposited silver to the copper plate to improve the smoothness of the product after polishing. The nature of the daguerreotype technique produced an inverted, or mirror, image of the subject photographed.

A remarkable use of the principals of electrotyping was employed in taking a replica of the surface of a daguerreotype to produce a new "photographic" image. The product, sometimes known as a tinthotype, required great skill in order to produce a satisfactory result. One interesting feature of the resulting tinthotype copy is that the image is inverted again, producing a correction of the dageurreotype original.

According to Hill (1854), the first electrotyped copies were made by Armand-Hippolyte-Louis Fizeau (1819–96). Hill states that before the experiment is attempted, the daguerreotype must be free of all traces of sodium thiosulfate and perfectly fixed by gold chloride. The method

requires the attachment of a wire to one edge or side of the dageurreotype, which is connected to the positive, or zinc, couple of the Daniel or Bunsen cell, as the original technology would have been. The back of the plate is covered with a beeswax coating to avoid copper deposition, since the electrodeposited copper would otherwise coat every exposed surface. A cold, saturated solution of copper sulfate was used as the electrolyte and the electrode of copper was connected to the negative terminal; the plate was immersed in the solution and immediately became covered with a copper deposit. When this deposit was of sufficient thickness, that of stiff cardboard, the plate was removed, rinsed in water, and dried. The separation of the electrotype from the original dageurreotype was obviously the most difficult part of the process, and Hill (1854) cautions that any copper sulfate solution that touched the surface of the copy would irretrievably stain it. It was sometimes difficult to separate the two, and cutting shears would then have to be employed to trim the edges and effect a separation.

Because of oxidation, caution had to be taken to protect the copper plate from air and dust as soon as possible by placing it in a frame and never touching the surface with bare hands. It is interesting that this early recipe calls for a cold, saturated solution of copper sulfate, since this is not what we would employ today for this process; now additions of both sulfuric acid and thiourea are commonly used, and the copper sulfate solution is not saturated. The very subtle surface texture of the dageurreotype is reproduced perfectly in the electrotyped plate, as a tinthotype by Fizeau in the collections of the J. Paul Getty Museum, shown in FIGURE 1.3, illustrates.

Dezincification

As mentioned earlier, brasses with substantial amounts of zinc may become destabilized and lose the alloying element through the process of dezincification. This is an interesting example of the galvanic corrosion of a binary copper-zinc alloy during which zinc is preferentially lost from the brass, often with intergranular corrosion and severe penetration of corrosion into the metallic matrix. Brasses with over 15% zinc are susceptible to dezincification, according to current theory, but this does not necessarily pertain to ancient specimens because of casting segregation and because of the difficulty of modeling the long-term effects associated with archaeological materials based on data from modern short-term studies. Two-phased alpha+beta brasses, which contain more than 30% zinc, are more prone to zinc loss, as would be expected, especially if the beta phase is continuous. (Most ancient and historical brasses contain less than 30% zinc and are single-phased alpha brasses.) Slow-moving or stagnant solutions in the environment—as in brass pipes, water heaters, or ships' fittings—augment the corrosion process: uniform dezincification is more common in high chloride ion environments or where the pH of the solution is very low. Lucey (1972) exposed brass samples to a saturated solution of copper(II) chloride with a small addition of zinc(II) chloride and measured the potential between the sample and an electrode of pure copper. A large potential difference was found to correlate with dezincification.

FIGURE 1.3 Armand-Hippolyte-Louis Fizeau,
(French, 1819–96), tinthotype copy, ca. 1840–43, of a
daguerreotype of the dome of St. Louis-des-Invalides,
Paris. H: 17.6 cm; W: 11.2 cm. One advantage of the
electrotyped tinthotype was that it corrected the
reversed image of the daguerreotype. Los Angeles,
J. Paul Getty Museum (84.XT.265.5).

Langenegger and Callaghan (1972) found that the rate of dezincification could be correlated with the oxidizing power of the solution. The addition of tin to the alpha+beta brasses helped to inhibit attack on the alpha phase and gave the alloys reasonably good resistance to dezincification in marine environments. The single-phased admiralty brass (71Cu28Zn1Sn) resisted dezincification if small amounts of phosphorus, arsenic, or antimony were present. Since most ancient brass alloys contain small amounts of impurity elements, or have some tin content, their behavior under long-term corrosion conditions is generally far superior to modern binary copper-zinc alloys.

Dezincification can occur by two possible reaction sequences: (1) zinc may simply be selectively leached out of the brass, leaving a weak assembly of copper grains; or (2) both copper and zinc may dissolve in solution, and the more noble copper may be redeposited. Extensive research indicates that both processes can occur in separate but overlapping potential regimes. Selective leaching of zinc requires solid-state diffusion of the zinc atoms, and this appears to be a rather slow process. In modern alloys, dezincification can occur by simultaneous dissolution and redeposition, with selective dissolution also occurring but in a subsidiary fashion. In ancient alloys, there may be an accumulation of basic zinc salts, which represent the corrosion of the more zinc-rich regions of cast brasses. General dezincification may occur in worked brasses without the formation of plugs of dezincified copper alloy.

FIGURE 1.4 shows some of the potential regions for the corrosion of alpha brass alloys in 0.1 M chloride solution. The thermodynamic half-cell electrode potentials are also shown in the figure. Below 0.0 V on the Standard Hydrogen Electrode scale, copper metal is stable and will not dissolve. Above -0.90 V, zinc can dissolve by selective dissolution, but the reaction is slow. Above 0.0 V, copper begins to dissolve, and the rate of dissolution increases as the potential increases while the rate of loss of zinc also increases. Between 0.0 V and +0.2 V, copper (II) ions that have accumulated in solution can redeposit on the surface as copper metal. At higher potentials, copper and zinc dissolve at equivalent rates, but no dezincification occurs. The following individual reactions, although somewhat difficult to follow, are of importance in the corrosion:

$$Zn = Zn^{2+} + 2e^{-} \tag{1.7}$$

$$Cu + 2Cl^{-} = CuCl_2^{-} + e^{-} \tag{1.8}$$

$$CuCl_2^{-} = Cu^{2+} + 2Cl^{-} + e^{-} \tag{1.9}$$

$$Cu = Cu^{2+} + 2e^{-} \tag{1.10}$$

$$CuCl = Cu^{2+} + Cl^{-} + e^{-} \tag{1.11}$$

$$Cu + Cl^{-} = CuCl + e^{-} \tag{1.12}$$

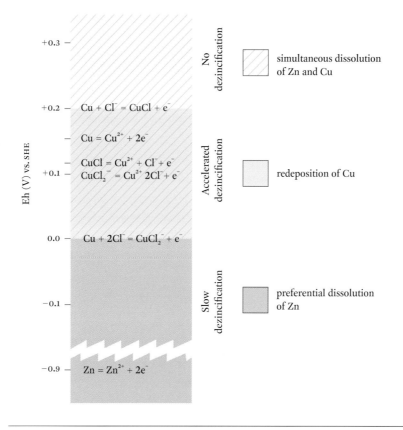

FIGURE 1.4 Potential regions in chloride solutions for dissolution of copper and zinc from alpha brass and for redeposition of copper in chloride solutions (from data of Heidersbach and Verink 1972).

At potentials above -0.90 V, the dissolution of zinc proceeds by equation 1.7, leaving behind a copper-enriched surface. The reaction with chloride ion (equation 1.8) is then thought to initiate the dissolution of copper above a potential of -0.03 V, which is not far removed from the experimentally determined value of 0.0 V. As the complex ion $CuCl_2^-$ accumulates in solution near the surface, Cu^{2+} ions are generated (equation 1.9). The copper(II) ions that are formed can be reduced to copper directly, as shown in equation 1.8, or by equation 1.11 acting together with equation 1.10. If the copper(II) concentration increases, the half-cell electrode potentials of equations 1.9, 1.10, and 1.11 move to more noble values. Whether copper(II) can accumulate at the surface without immediate conversion to metallic copper depends on the reaction rates of equations 1.8, 1.9, 1.10, and 1.11. As the copper(II) concentration increases, nantokite, CuCl, becomes stable when the potential of equation 1.9 becomes more noble than that of equation 1.8. The deposition of metallic copper has been verified experimentally below +0.2 V

in solutions containing excess copper(II) ions (Jones 1992). Selective dissolution of zinc from alpha brass, which requires solid-state diffusion of zinc, is too slow to account for the usual corrosion penetration of brass alloys. The redeposition of copper seems to be important in the corrosion of most of these brass alloys.

Brass alloys are also particularly susceptible to stress-corrosion cracking in which small amounts of corroding material may create cracking of the alloy in the presence of any applied stress; the penetration may be intragranular or intergranular. Brass instruments or highly stressed sheet brass are two possible types or groups of objects that may be susceptible to stress-corrosion cracking. Some of the copper-ammonia complexes are implicated in this process, including $[Cu(NH_3)_5H_2O]^{2+}$, which is the highest ammonia complex that can exist in aqueous solution. These cupric complexes can react at the surface of the brass alloy to form cuprous complex ions as shown in the following:

$$[Cu(NH_3)_4(H_2O)_2]^{2+} + Cu = 2[Cu(NH_3)_2H_2O]^{+} \qquad 1.13$$

These cuprous ions are then unstable in solutions containing oxygen and ammonia so that

$$2[Cu(NH_3)_2H_2O]^{+} = [Cu_2(NH_3)_4(H_2O)_2]^{2+} \qquad 1.14$$

The process will be autocatalytic and has been demonstrated in ammonium hydroxide for unstressed sheet specimens of copper and of brass with a composition of 70% copper and 30% zinc. The copper content of this ammoniacal solution increases with immersion time at an increasing rate. Zinc can also enter into solution as the stable complex $Zn(NH_3)_4^{2+}$. After about one hundred hours in the ammonia solution, the dissolution rate drops because a film of corrosion products develops; the film is primarily cuprite. The tarnish film that forms on brass alloys in many different tarnishing solutions is due to the deposition of an epitaxial film. While this film is growing, a range of interference colors, which depend on the thickness of the film, may be visible. The tarnish consists of small platelets that are about 500 Å in diameter and 100 Å thick. These platelets are similarly oriented and grow epitaxially from the brass surface. Cuprite exists in this tarnish film, which penetrates into the metal. When unstressed 70–30 brasses are immersed for long periods in tarnishing solutions, they become extremely brittle. Intercrystalline fracture, due to penetration of the corrosion along the grain boundaries, is seen in all cases. The fact that thick corrosion films do not form on pure copper under the same conditions shows that the zinc content is important. The presence of zinc in the solid phase is the most salient factor.

Stress-corrosion cracking of brass alloys is often observed in moist, contaminated air, where shallow layers of condensed water can form on the metal surface in the presence of oxygen and ammonia. There are probably undocumented occurrences of such deterioration in musty, antiquated museum collections, particularly of musical instruments or other stressed objects. The small water volume in moist-air deposition implies a high concentration of

complex ions; this generates intercrystalline failure in tarnished samples and transcrystalline cracking in untarnished ones. These events also depend on the ammonia concentration and on the zinc content of the alloy. In general, most ancient copper alloys have less than 30% zinc content and are much less susceptible to stress-corrosion cracking than to general corrosion. General corrosion produces a range of basic zinc salts, such as chloride, sulfate, or other products. This is generally beyond the scope of this book, although some of the mixed compounds containing both copper and zinc are discussed in relevant sections of later chapters.

POURBAIX DIAGRAMS AND ENVIRONMENTAL EFFECTS

A Pourbaix diagram can be thought of as a kind of map that shows how oxidizing or reducing, acidic or alkaline an environment can be. It provides a plot of the redox potential (Eh) of the system (its ability to act in either an oxidizing or reducing manner) against its acidity or alkalinity (pH). A Pourbaix diagram could show, for example, that peat bogs are both somewhat acidic and reducing, suggesting that this environment may be better at preserving different groups of materials than, say, a brackish stream, which is alkaline and oxidizing. These diagrams can also be very useful in relating the environmental conditions to the corrosion products or compounds that are predicted to form on the basis of the thermodynamics of the system, as indicated by the diagram.

The basis for Pourbaix diagrams is that electrochemical reactions are the result not only of chemical species but also of electrical charges. One of the important measurements for studying these electrochemical reactions is the electrode potential. This potential is obtained with a reference electrode of known potential, such as a hydrogen or calomel electrode, that is placed in an electrolyte solution containing the metal species being studied. This provides a measure of the oxidizing or reducing power (Eh) of the system for that particular metal and is shown on one axis of the Pourbaix diagram. The system's pH is shown on the other axis. In this way, a diagram can be built that describes how a particular metal will (or should) behave in a certain type of chemical environment, which must be precisely specified for each diagram. These diagrams, combined with information about environmental conditions, such as the concentration of chloride or sulfate ions, make it possible to plot stability regions for different mineral species on the same Pourbaix diagram. The concentration of soluble species must be defined for each plot, and thus many different plots may be necessary for the same system. The number of plots needed depends on the concentration of species at a given temperature.

Two instructive Pourbaix diagrams are shown in FIGURES 1.5 and 1.6. A series of plots of natural aqueous environments is shown in FIGURE 1.5, which indicates which equilibrium region different environments may occupy. FIGURE 1.6 is a plot of the distribution of thousands of Eh and pH measurements taken from natural aqueous environments. The vast majority of these measurements show an aqueous pH between 4 and 8, and a range of environments from

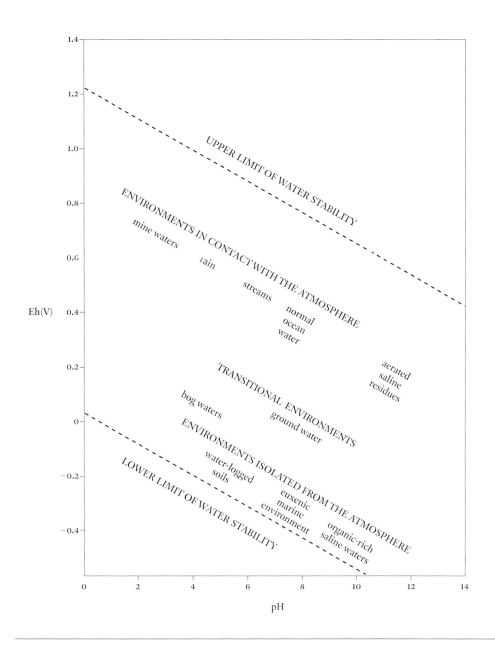

FIGURE 1.5 Pourbaix diagram showing plot of natural aqueous environments with characteristics in different regions of Eh and pH (Schweizer 1994:fig. 8).

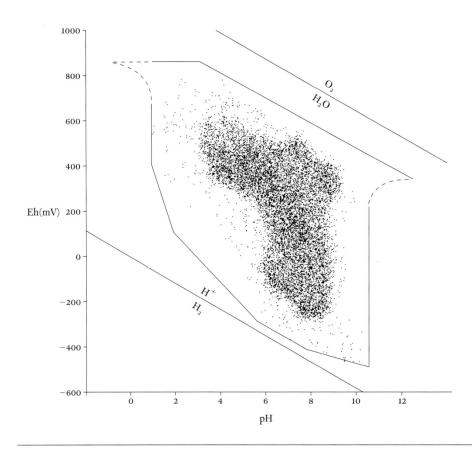

FIGURE 1.6 Pourbaix diagram showing distribution of natural aqueous environments, which can be seen to cover a considerable range of Eh and pH conditions. The dotted area represents the major concentration of many thousands of Eh and pH measurements, while the surrounding irregular box represents the boundary for all measurements (after Baas Becking, Kaplan, and Moore 1960).

reducing to oxidizing. Copper is not oxidized by water per se, meaning that the presence of a more powerful oxidant, usually oxygen, is necessary for corrosion to occur. The Pourbaix diagram supports this. Aerated waters tend to be more oxidizing, and these are found in the upper regions of the diagram; isolated, reducing solutions occur, appropriatcly, toward the lower regions.

Many environments may have local conditions that can be specified on the diagram using in situ measurements or other data. A number of these diagrams are shown in the text and are briefly discussed. Pourbaix diagrams do have their limitations. For example, kinetic factors cannot be taken into account in the formulation of the diagrams, and, if particular environmental conditions pertain to only certain regions of the diagram, then the overall impression may be misleading in regard to what happens in practice. In some cases, products are listed as present in the Pourbaix diagram but are not empirically found in the environment being studied

because the reaction is not kinetically favorable (Bockris 1971). This is particularly obvious in the case of tenorite, CuO, which has a region of stability shown on some of the diagrams but, in practice, is rarely encountered. The product usually found in contact with copper metal is cuprite. Tenorite is not kinetically favored and is usually found only in burned burial environments. Corrosion or the growth of patina appears strongly influenced by the presence of cuprite and by the growth of minerals that can occur from subsequent reactions with cuprite or with copper ions. Whatever the precise argument for the thermodynamic rationale, the practical consequence is that the region of stability of tenorite shown in Pourbaix diagrams rarely has any practical validity in predicting the appropriate phase to be formed in a specific environment. It is difficult to model the kinetic phenomena that may influence the deterioration of copper alloys over very long periods of time, and therefore less work has been done on this subject.

The burial environment | Burial in soil or in barrows, tombs, or cemeteries is the most common event in the life of most bronze artifacts, which, after excavation, suffer the indignity of being catalogued, packed, conserved, and displayed or stored. They are rarely discarded. An outer layer incorporating soil minerals, quartz grains, associated burial material, organic residues, and so on, may be present on top of the corrosion products derived from the copper alloy. Burial, often over hundreds or thousands of years, may produce corrosion effects that cannot easily be modeled or accurately predicted from a breakdown of a typical set of soil parameters, such as moisture content, pH, percent air voids, bulk density, chloride-ion content, soil type, degree of aeration, calcium content, bicarbonate-ion activity, cation exchange capacity, or other factors. Multivariate statistical analysis is often used in soil studies to try to correlate these variables with observed effects because the parameters influencing corrosion are so numerous and the data so complex (Miller, Foss, and Wolf 1981).

SOIL PROPERTIES Practically all bronzes buried in soil form a cuprite crust that is adjacent to the metal and overlaid with malachite, but exactly how corrosion processes can differ so markedly from one burial to another is often far from clear. Corrosion in a particular soil is often attributable to several soil properties that interact to make the soil more or less corrosive to buried copper. Many of the soil properties responsible for corrosivity are the same as those used to divide the soil continuum into definable groups, such as sandy loam, dense clay, silt, humus-rich stony soil, and so on. The National Bureau of Standards (NBS) and the now-defunct British Non-Ferrous Metals Research Association (BNFMRA) have published evaluations of the burial corrosion of copper in terms of corrosion rates, as shown in TABLE 1.1. These empirical results are from corrosion tests on unalloyed copper in the soil carried out in the United States by Romanoff (1957), in the United Kingdom by Shrier (1977), and in Sweden by Camitz and Vinka (1992). The tests covered exposure periods of fourteen, five to ten, and seven years, respectively. The average rate of attack in most soils was found to be 0.05–3.9 μm per year, but for the most corrosive soils, rates as high as 35 μm per year were recorded.

Leidheiser (1979) summarizes chemical and physical data, covering a wide range of copper alloys together with corrosion rates, for seventy National Bureau of Standards test sites across the United States. The data are for variables of drainage, resistivity, pH, percent air-pore space, moisture equivalent, volume shrinkage, apparent specific gravity, and water composition in terms of total acidity, sodium, calcium, potassium, magnesium, carbonate, bicarbonate, chloride, and sulfate. A less extensive British study was also carried out using test conditions similar to those of the NBS program, with results that were broadly comparable. The NBS study showed losses in wall thickness of copper pipe to be from 0.06 to 5.2×10^{-2} mm per year; the British study showed from 0.06 to 6.9×10^{-2} mm per year. Copper and copper alloys were not found to undergo appreciable pitting, except in moist acid-clay soils and wet acid peat, where localized attack occurred sporadically.

These conclusions are very useful for the general modeling of the corrosion rates of buried copper, but for archaeological material buried for thousands of years, the general rate derived from these short-term studies may be inadequate. They illustrate the difficulty in modeling extremely long-term events by short-term experiment, even on a single-phase substrate. In archaeological contexts, unalloyed copper usually corrodes much more slowly than tin bronze, arsenical copper, or brass alloys. An example is provided by some very early copper scraps and ornaments from an important Greek Neolithic ditched enclosure. The pieces were examined at

TABLE 1.1	**ANALYSIS OF CORROSION IN SOILS**			
AGENCY[a]	**SOIL TYPE**	**YEARS**	**CORROSION** (μm/year)	**MAXIMUM PITTING** (mm/year $\times 10^4$)
BNFMRA	5 least corrosive	10	0.5–2.5	uniform: no pits
BNFMRA	4 least corrosive	5	5.0–25	0.040
NBS	9 least corrosive	14	4.0–25	0.043
NBS	2 next most corrosive	14	25–130	0.033
BNFMRA	acid clay/acid peat	10	53–66	0.046
BNFMRA	2nd series:[b] cinders	5	66	0.32
NBS	3 most corrosive: rifle peat/ tidal marsh	14	160–355	0.115

[a] BNFMRA = British Non-Ferrous Metals Research Association (now defunct); NBS = National Bureau of Standards.

[b] 2nd series = second attempt to derive accurate results for this set of data.

the Getty Conservation Institute Museum Research Laboratory as part of a technological study of the material (Scott 1999). These copper fragments date from about 4000 B.C.E., making them six thousand years old. They are smelted copper, relatively pure, with only a few parts per million of typical elemental impurities, such as silver, arsenic, gold, antimony, and lead; yet the corrosion penetration through the copper averages only about 30 μm. The corrosion consists of a thin layer of cuprite and a thinner layer of malachite. This patina translates into a corrosion rate of 0.005 μm per year, and in some cases, less than that. Even in the most benign soils, this is a substantially lower rate than would be inferred from the recent experimental work. One possible explanation is that, in undisturbed contexts, the rate of corrosion of unalloyed copper progressively decreases as the cuprite layer develops and impedes further attack on the copper, slowing the corrosion processes to levels far below those experimentally predicted, particularly for soils low in chloride-ion content.

Groundwater flowing through igneous bedrock accumulates insignificant quantities of chloride ion but may gain appreciable concentrations of SiO_2, F^-, Na^+, HCO_3^-, and Ca^{++}. Such groundwater may be slightly acidic. In sedimentary and metamorphic rocks, the ions present may include substantial Cl^-, $SO_4^=$, Ca^{++}, $CO_3^=$, Fe_2^+, Al_3^+, and NO_3^-. Here the water may be neutral or alkaline (Baas Becking, Kaplan, and Moore 1960). Plants and bacteria may contribute about 550–2750 ppm of chloride ions in regions of dense vegetation. Chloride ions in groundwater may also be derived from the atmosphere, from evaporites such as halite, and from the decomposition of certain micas.

Highly organic soils or soils over calcareous bedrock have high carbon dioxide contents and may be chemically very aggressive because the carbon dioxide may react with water to form carbonic acid (Garrels 1954), which may attack metals directly and prevent the formation of a protective film on the metal surface (Wilkins and Jenks 1948). Calcareous soils may also act in a quite benign fashion, however, especially if carbon dioxide and water produce the soluble calcium bicarbonate. This may act to protect the bronze from corrosion: since calcium bicarbonate is a salt of a weak acid, its aqueous solution is alkaline, and by binding with carbon dioxide, it prevents the extensive dissolution of copper (I) ions (Geilmann 1956). At values of pH > 8, calcium bicarbonate precipitates as carbonate, and, in subsequent acidic conditions, this may dissolve instead of copper (II) compounds. The overall pH in dilute natural groundwater is principally controlled by this $CaCO_3 - H_2O - CO_2$ equilibrium (Garrels and Christ 1965).

The groundwater in soils may have a significant phosphate content, which may be deleterious to buried bronzes, although this is frequently controlled by the aluminum content of the soil (Lindsay 1979). The phosphate activity may also be dependent on the speciation of the phosphorous. For example, the chemical nature of dissolved phosphate may be principally PO_4^{3-} at pH > 12 or $H_2PO_4^-$, between pH 2 and 7.5, so even in this case, it is not possible to predict all the effects of soil phosphate content simply by knowing how much phosphate is in the soil.

SOIL HORIZONS Soil is normally considered to have three horizons: The uppermost A horizon is a zone of intense leaching and chemical and biological activity. The middle B horizon often contains reprecipitated minerals and is less intensely altered. The C horizon, at the base of the soil profile, contains partially altered and fresh bedrock (Garrels and Mackenzie 1971). The rates of evaporation and percolation control the structure and composition of each horizon. When evaporation exceeds percolation, the products of soil alteration become concentrated in the A horizon; in the opposite case, all altered materials, including copper corrosion products in some cases, may be completely leached away. If evaporation and percolation rates are nearly equal or subject to seasonal fluctuations, much altered material will be deposited in the B horizon.

Clearly, even within one soil horizon, the possibility of encountering very different corrosive effects on copper alloys buried for long periods is quite likely. Soils that are very compact, such as pure clay, limit the supply of oxygen and moisture; under these conditions the corrosion of bronzes may be quite restricted, as long as sulfate-reducing bacteria are not active. In soils with a mixture of clay, gravel, and sand, the different access to oxygen, moisture, and groundwater in different regions may produce severe corrosion. Differential oxygen concentration cells may act locally under these circumstances, with the oxygen-deficient regions becoming anodic and the other areas cathodic, providing a more favorable condition for corrosion processes.

CORROSION MECHANISMS IN COPPER ALLOYS The ability of clay particles to act as ion-exchange media with other chemical species present in the environment may assist in the dissolution of some alloying elements such as nickel, cobalt, lead, and zinc from copper alloys; arsenic and antimony are often preserved to some extent as oxides. As noted previously, however, some burials in clay may be very well preserved. Tin also oxidizes but tends to remain as tin(IV) oxide. Stambolov (1985) speculates that the presence of any hydrogen sulfide from biological activity would create a yellowish precipitate of tin(IV) sulfide, which, after subsequent oxidation to sulfate, would decompose to form hydrated tin(IV) oxide, also known as stannic acid. Stambolov (1985) explains how a corrosion crust of stannic acid could retain the original shape of the bronze object:

> Stannic acid is an amorphous mass of a very large specific surface. Hence its extraordinary adsorption capacity; material transport through its bulk is also possible. Alkaline conditions cause the release of hydrogen ions from the stannic acid and thus, if carried far enough will charge the particles equally negative. Due to mutual repulsion they might disperse but, as the concentration of ammonia needed for this charge is unlikely to be found in soils, such dispersion seldom occurs. Therefore the amount of stannic acid tends to increase continuously with respect to the copper concentration of the bronze which, in contrast, due to greater solubility tends to migrate to the environment. Accordingly as the corrosion proceeds, stannic acid by being immobile, maintains the initial form of the bronze object. (Stambolov 1985:16–17)

This represents only one possibility. Another is that the initial form of the bronze object is maintained by the corrosion of copper to cuprite, which remains as a pseudomorphic remnant of the original copper or bronze surface. Tin compounds, such as tin(IV) oxide or hydrated tin oxides, may be incorporated into this layer, representing an important part of the patina. In cases where very extensive corrosion of the copper has occurred, all that may be left of the bronze is a fragile relict of tin oxides that may look like a piece of bone. The shape of the object is, however, remarkably preserved in many cases of this type of advanced corrosive deterioration.

The circumstances of burial and corrosion of bronze objects, as opposed to unalloyed copper, present an extraordinary panoply of events: copper alloys may be completely mineralized; they may be almost uncorroded; they may be bloated with an extensive corrosion crust incorporating soil minerals; or they may be covered with a delicate patina that requires very little cleaning. Even the least corrosive soil category in the BNFMRA study cited earlier may be converted into a potent corrosive agent in archaeological contexts due to the disturbance of the soil and the resulting alteration of the natural environment that may result. Association of copper objects with a human cremation or burial site may result in increased corrosion of the copper because of the leaching of numerous substances from the human remains into the surrounding soil. On the other hand, bronzes may show very good preservation if the burial is in a relatively dry environment, several meters below present-day ground level, where oxygen or bacterial activity is absent. Disturbance of the stratigraphy of a site may result in some objects from the same level being very well preserved while neighboring objects only a meter away may be in terrible condition. Only a very detailed analysis of the finds from a particular site and of the site environment can, hopefully, provide an answer to the question of differential preservation.

| THE HUMAN ELEMENT Human habitation increases soil levels of phosphate and, often, calcium and iron, although the interpretation of elevated levels of phosphorus may not be straightforward. Some phosphorus sources, such as bone, are inorganic; other sources, such as human excrement, animal dung, or food waste are principally organic. The interesting phenomenon of "soil silhouette"[9] at a site in the United Kingdom is described by Keeley, Hudson, and Evans (1977), who showed that levels of iron and manganese were present in the altered soil at levels well exceeding those originally present in the interred body. One possible explanation is that iron and manganese are accumulated by microbial activity. In another study, Lambert (1997) showed that soil adjacent to well-preserved skeletons from the Middle Woodland period in west-central Illinois was depleted in iron and aluminum, while the skeletons had gained significant amounts of these elements; calcium was also enriched in the soil and depleted in the bone. All of these chemical alterations will affect the corrosion of buried bronzes associated with a habitation site; in some cases, soil disturbance will encourage the formation of local electrochemical cells, resulting in greater corrosion than that produced in virgin soil.

Swedish researchers recently carried out a detailed statistical study that examined aspects of bronze corrosion and the burial environment for artifacts from the Bronze Age, the Viking period, and the early Middle Ages (Mattsson et al. 1996). The study, which used 170 parameters for the statistical analysis, is one of the most detailed investigations of its kind to be published to date. The researchers found that four important factors that correlated with accelerated corrosion of the artifacts were the presence of chloride ions, soil moisture, phosphates, and carbonized material in the burial environment.

The chloride content of the soil at Birka, Sweden, was found to promote corrosion of the artifacts at that burial site. This soil had a pH of about 8. In contrast, bronzes from the burial sites of Fresta, Valsta, or Sollentuna, where the soil pH ranged from 4 to 5, were in better condition, although localized pitting corrosion had occurred on the Fresta material. The Swedish researchers suggest that the corrosion products may not be very stable at pH 8, although it is not immediately obvious why this should be the case. It is possible that a solid chloride-containing crust may form at the lower pH values and so impede further corrosive attack. The severe localized pitting of the bronzes from Fresta might be due to chlorides from salt used on the modern road that crosses this cemetery site.

It is interesting to note that basic copper sulfates, mixed iron-copper sulfides, and copper phosphates were found in many places on this recently excavated material. The copper sulfates are not necessarily recent phenomena, however. This is shown by analyses that identified basic copper sulfate on some of the 182 bronzes excavated between 1871 and 1879 from the Birka site. Many of these finds were made of brass rather than bronze, and most of the finds studied were of Viking age, dating from about the tenth to the thirteenth century.[10]

Soil moisture was shown in the Swedish statistical work to be a significant influence on copper deterioration in burial environments. This corrosion is promoted in artifacts by deep burial (but still above the water table); by burial at low height above sea level for coastal material; by small pore size in the surrounding soil; and by burial in a barrow (burial mound). The state of preservation of Bronze Age or Viking age materials in barrow burials was evaluated by comparing the recently excavated materials with previously excavated objects kept in museum storage. From basic corrosion principles it is known that the corrosivity of the soil is greatest where the soil pores are partially filled with water, allowing exposure to both oxygen and groundwater in the burial environment.

Bronzes excavated from 1993 to 1994 revealed that a burned burial context, in which artifacts were associated with soot or cremated remains, was also deleterious. Similarly, artifacts found near paths between houses, in areas where wastes of various kinds may have been deposited, were more corroded than those bronzes buried inside or contiguous with house structures.

The Swedish study also found a statistical correlation between the degree of corrosion and the presence of phosphates in the soil. This finding may seem surprising at first, since phosphates are often used as passivating agents and corrosion inhibitors in modern treatments. In this case, however, the relative molar volumes of the phosphates were quite high, and the copper phosphate minerals tended to form a noncoherent corrosion crust. This situation may exacerbate corrosion processes because of uneven exposure of the corroding metal surface and possible effects due to differential oxygen concentrations and galvanic reactions.

The study showed that the bronzes from the Malaren region, however, had a lower degree of deterioration compared with bronzes from the west coast of Sweden, where the acidification of the soil is more extensive. Statistical analysis showed that recently excavated bronzes from the Malaren region, however, were in a worse state of preservation than the same type of bronzes from the same site excavated from 1871 to 1879 and kept in museum collections. What appears to be accelerated corrosion over the last hundred years is ascribed to the increased acidity of the soil due to acid rain and pollution.

This is a disturbing conclusion. If artifacts are going to deteriorate at the accelerated rates found in the Swedish study, at least for regions of the Swedish environment, the finding implies that reburial of extant material may be deleterious compared with indoor storage and, further, that excavation may actually be preferable to leaving buried bronzes in situ.

The association between increased soil acidity and increased corrosion is echoed in a supplemental report by Fjaestad, Nord, and Tronner (1997). The researchers reported a significant statistical correlation between advanced deterioration of buried bronzes and elevated concentrations of sulfates and phosphates in Swedish soils. A similar observation regarding recent accelerated deterioration of bronzes was made by Scharff and Huesmann (1997), who concluded that many freshly excavated German bronzes were more deteriorated than similar material excavated fifty to a hundred years earlier. A large number of coins of Celtic auxiliaries from the Roman camp of Delbrück-Anreppen, recently excavated in Westphalia, were in worse condition than the same material excavated in 1968. A possible cause is increased soil acidity in later years. Since 1970, liquid animal waste with an ammoniacal content was used as manure in the area. Apart from acid rain, this could account for the increased acid levels in the soil, which is sandy with a very limited buffering capacity. Although lime has been added to the fields in Anreppen in recent years, the soil pH measured 4.2 – 4.8 in 1997. Indeed, Wagner and colleagues (1997) alarmingly conclude that the acid buffering capacity of many European soils has either been exceeded or will be within a few decades.[11] Although it is impractical to suggest that it would be better to excavate archaeological sites in such regions than to leave them alone, there now may be a greater imperative for monitoring these sites and, in particular cases, selecting some for excavation.

BUFFERING CAPACITY OF SOILS Soils vary greatly in their buffering capacity, and there is a range of factors responsible for this, from carbonate buffers at pH > 6.2 to ferrihydrite buffers at pH < 3.2. The most poorly buffered soils are those originating from the weathering of siliceous bedrock, such as quartzites, feldspathic gneisses, and granites; these soils have a low capacity to replenish base cations lost in acid neutralization reactions. They also have a low ability to retain sulfate, which explains why Scandinavia was the first European area to suffer widespread acidification of lakes—its geology is dominated by gneiss, schist, and quartzite.

Central European soils have been more resistant to acidification, but with sulfur-deposition rates up to ten times greater than in the past, their buffering capacity is in jeopardy. If the agricultural use of the land ceases, the addition of lime may also cease, reducing the pH level from 6 to 5 in clay soils, or to about 4–4.5 in sandy soils. At the same time, draining wetlands may cause dramatic acidification of soils because of the quantities of sulfur compounds that would be released and the resulting oxidation of sulfides.

Some soil components are still not well understood. One of these is soil humus, which influences buffering capacity, metal-binding capacity, and water retention, as well as the absorption of hydrophobic organic compounds. The study by Geilmann (1956) is a classic account of the influence of humic acid on bronze corrosion (see CHAPTER 11). The complex structure of humus has only recently been elucidated. According to Wershaw (1992), it consists of ordered aggregates of amphiphiles, which are molecules with separate polar and nonpolar parts composed mainly of relatively unaltered plant polymer segments attached to carboxylic acid groups. These react with soil mineral grains to form membranelike coatings with highly charged exterior surfaces that act as separate ion-exchange phases.

PROBLEMS FOR CONSERVATION RESEARCH The difficulties of either inferences based on soil conditions or on deductions derived from the examination of objects is well illustrated by the work of Chase and Quanyu (1997), who studied a suite of excavated bronze fragments from the site of Tienma-Qu in China (Western Zhou dynasty, 1000–650 B.C.E.). Some of these bronzes were totally corroded while others were quite well preserved. The authors were unable to assign these differences to particular tombs or environments by examination of the soil samples. This is not an isolated case. Highly detailed statistical studies along the lines of the Swedish study would be necessary to accurately characterize and correlate soil corrosivity with artifact condition.

The work by Wagner and coworkers (1997), funded by the European Environment Programme of the Directorate General XII for Science, Research and Development under the general aegis of research for the "Protection and Conservation of the European Cultural Heritage," is currently at an early stage of development. It will be interesting to see what develops from this collaborative project and whether the research will augment the findings of the Swedish study coordinated by Mattsson.

Corrosion events associated with outdoor exposure of artifacts may appear to be somewhat daunting, as Plutarch (46–120 C.E.) so eloquently describes in the *Moralia*:

> Then since we urged him on, he continued and said that the air in Delphi being thick and dense and having vigour because of the repulsion and resistance it encounters from the mountains, it is also thin and sharp…therefore penetrating and cutting the bronze because of its thinness, it scrapes a great quantity of earthy patina from it, but holds it and tightens it again, the density not allowing the diffusion, the deposit blooms and takes sheen and splendour on the surface.[12]

In fact, outdoor corrosion events are much less complex than those that may occur during burial; consequently, it is possible to assess to some extent exactly how corrosive certain aspects of the outdoor environment may be to exposed copper alloys. During the past two hundred years or so, the emergence of atmospheric pollutants has changed the environment in the West. Before then, exposed bronzes may have slowly acquired a cuprite or light green patina with a sulfate and, possibly, a carbonate component. With the increase in sulfur-containing contaminants, patinas in urban areas began to turn different shades of green. Atmospheric soot and smoke darkened the surfaces of bronzes, creating subfusc (brownish) or blackish crusts, which, when attacked by low pH fog or mist, might produce continued corrosion and a surface streaked with light green rivulets that disfigured the patina.

ATMOSPHERIC POLLUTION Complaints about the insidious effects of smoke were already being voiced in imperial Rome during the early centuries C.E. By the 1800s, it was recognized in England that air pollution was injurious to health and also to materials, particularly architectural stone. Voelcker (1864) investigated the deterioration of limestone buildings and found the crust to be of calcium sulfate, which formed from the original calcium carbonate by reaction with the sulfurous polluted air. This was recently confirmed by numerous studies into the cause of building-stone decay in the outdoor environment.

The development of patina on exposed copper alloys depends on atmospheric gases, pollutant gases, particulate matter, rain, wind, sun, soot, and, in some cases, proximity to the sea or to industrial activity. These factors are fundamentally more significant in corrosion than the nature of the alloy substrate, although this, too, can play an important role. Because of these diverse factors, the surface appearance of exposed bronzes may vary markedly. A typical, streaked copper-alloy patina on a version of Auguste Rodin's *The Thinker*, 1888, at the Musée Rodin, Paris, is shown in PLATE 5. This bronze, like many others, would originally have been patinated by the foundry before being placed outside. Such artificial patinations, however, do not necessarily provide long-term protection and are themselves subject to chemical change with time, gradually becoming converted to the basic copper sulfates, especially in urban areas.

TABLE 1.2 TYPICAL MODERN CONCENTRATIONS OF ATMOSPHERIC GASES

NAME	FORMULA	CONCENTRATION (ppb)
ozone	O_3	50–200
hydrogen peroxide	H_2O_2	10–30
nitrogen dioxide	NO_2	10–45
nitric acid	HNO_3	1–10
hydrogen sulfide	H_2S	0.1–0.5
carbonyl sulfide	COS	0.5–0.6
sulfur dioxide	SO_2	5–24
carbon dioxide	CO_2	$(3-6) \times 10^5$
formic acid	HCOOH	0.2–1
acetic acid	CH_3COOH	0.2–1
oxalic acid	$(COOH)_2$	not detected
formaldehyde	HCHO	4–15
acetaldehyde	CH_3CHO	1–8
hydrogen chloride	HCl	0.5–2

TABLE 1.3 CONVERSION FACTORS FOR CONCENTRATIONS OF SOME POLLUTANT GASES IN PARTS PER BILLION (ppb) AND MICROGRAM/m³ (μg/m³)

NAME	CONVERSION FACTOR[a]	
	ppb to $\mu g/m^3$	$\mu g/m^3$ to ppb
acetic acid	2.45	0.41
formic acid	1.88	0.53
acetaldehyde	1.80	0.56
formaldehyde	1.23	0.82
hydrogen sulfide	1.39	0.72
carbonyl sulfide	2.45	0.41
ammonia	0.70	1.44
sulfur dioxide	2.62	0.38
nitrogen dioxide	1.88	0.53
ozone	1.96	0.51

[a] The general expression is microgram/m³ × conversion factor = ppb. All measurements are at standard temperature and pressure, with temperature assumed to be 25 °C.

Some relevant concentrations of modern atmospheric pollutants are given in TABLE 1.2, which shows that sulfur dioxide, nitrogen oxides, and ozone are the principal agents involved. Levels of these pollutants can range from thousands of parts per billion (ppb) in heavily polluted urban areas to less than 1 ppb in very remote regions, although most of the world's bronze sculpture is not found in such isolated areas. The concentration of pollutant gases is often measured in parts per billion or parts per trillion (ppt), but these units have tended to become replaced with the unit microgram/m^3 (μg/m^3). The conversion factors for gas concentrations of some common atmospheric pollutants in parts per billion and microgram/m^3 are given in TABLE 1.3.

Over the past two centuries, while most bronze sculptures have been standing outdoors, significant changes have taken place in the composition of urban air, particularly in sulfur dioxide concentrations. Data from 1880 for New York City suggests an SO$_2$ concentration of 5–10 ppb; this increased during the 1950s to about 50 ppb and subsequently declined to about 20 ppb following environmental legislation in the 1970s.[13] In London, where the urban radius increased from approximately 3 km in 1580 to 15 km in 1900, the extensive use of coal resulted in very high levels of pollution, reaching an estimated 150–180 ppb during the period from 1800 to 1900. These pollutant levels, combined with heavy concentrations of particulate matter, resulted in most exposed bronzes becoming very dark in color.[14]

In some cities of the world, the levels of SO$_2$ and NO$_2$ pollution are still rising and are a cause of concern, not only for exposed bronzes but for exposed citizens as well. The presence of SO$_2$ in the atmosphere accelerates the corrosion of many metals, but the initial interactions with copper are quite complex and depend on the relative humidity and the SO$_2$ concentration. This could explain why Tidblad and Leygraf (1995) and Tidblad, Leygraf, and Kucera (1991) found no correlation between the increase in weight of the corroded copper samples and the levels of SO$_2$ concentration in the environment. Where low levels of pollutants were found, a substantial weight gain on the exposed samples was observed, and cuprite was a principal corrosion product (Strandberg, Johansson, and Lindqvist 1997). Ericsson and Sydberger (1977) found that the initial corrosion products in humid air with 10 ppm and 100 ppm SO$_2$ were a sulfite, Cu(I)$_2$Cu(II)(SO$_3$)$_2$·2H$_2$O; and a sulfate, CuSO$_4$·5H$_2$O; and not cuprite. Eriksson, Johansson, and Strandberg (1993) exposed copper sheets to 500 ppb SO$_2$ at 70% and 90% RH. After four weeks, the appearance of the copper had not appreciably altered, although the sheets exposed at 90% RH were a darker hue. Strandberg and Johansson (1997c), however, noticed that copper plates exposed to an SO$_2$ concentration of 69 ppb or less at 90% RH often turned black after only twelve hours from the development of a cuprite film. Formation of this black film depended on the relative humidity, SO$_2$ concentration, and the pretreatment of the copper sheets. Formation of a black patina on copper exposed outdoors has been observed many times, but this study was the first to describe it indoors. At RH values greater than 75% with 4–69 ppb SO$_2$, a dull black cuprite patina forms after twenty hours of exposure. When the concentration of SO$_2$ is

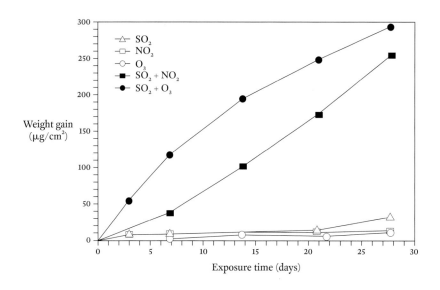

FIGURE 1.7 Graph of exposure time in days against weight gain for copper samples exposed to SO_2, NO_2, O_3, SO_2 with NO_2, and SO_2 with O_3. There is a strong synergistic effect for mixtures of SO_2 with NO_2, and SO_2 with O_3 (Strandberg and Johansson 1997a).

higher than 69 ppb, or the humidity is lower than 75%, the copper remains shiny. FIGURE 1.7 shows a graph of exposure time in days against weight gain for copper samples exposed to sulfur dioxide, nitrogen dioxide, ozone, sulfur dioxide with nitrogen, and sulfur dioxide with ozone. Strandberg and Johansson (1997a) showed that there is a strong synergistic effect with mixtures of sulfur dioxide and nitrogen dioxide, and with sulfur dioxide and ozone, and that this results in a substantial increase in the corrosion rate. The development of the black patina was influenced neither by these mixtures nor by the degree of cold-working of the copper.

The results are explained by the development of a passivating chemisorbed sulfite film at high SO_2 concentrations; at low concentrations and high humidity, the adsorbed sulfite is destroyed by the formation of soluble species and by oxidation to sulfate. The thin oxide layer is attacked by the acidic surface; copper is anodically dissolved; oxygen is cathodically reduced; and cuprite is precipitated forming a dull black layer 200–300 nm thick. It is not clear why this layer is black rather than red.

Although SO_2 levels in the West are generally declining, levels of nitrogen oxides are slowly increasing. Estimates indicate that at the end of the nineteenth century annual emissions were less than 1×10^{12} g. A century later, in the 1980s, they had increased to approximately 18×10^{12} g. In urban areas, ozone levels doubled over the same period, from about 20 ppb during the 1880s to about 40 ppb in the 1980s. An analysis by Graedel (1987a) suggests that

increasing atmospheric concentrations of nitrates or organic acids may not have much effect on the development of copper patinas, while a decrease in the sulfate or chloride-ion concentration may be reflected in reduced rates of patina formation. Whether Graedel's hypothesis is correct can be determined only after newly exposed bronze sculpture has been kept outdoors for many years. Other environmental pollutants, such as carbon dioxide, have not had a particularly noticeable effect on exposed bronzes despite the fact that global carbon dioxide emissions have increased from an estimated 60 billion metric tons in 1860 to 380 billion metric tons in 1997 (*Guardian Weekly* 1997). Increased ozone concentrations can act as a catalytic agent for bronze corrosion, and complex interactions are possible with nitrogen oxides as well. Both gases are found in present-day photochemical smog, which is generated by the reaction of sunlight with automobile exhaust and industrial pollutants; undoubtedly, smog will prove to have a deleterious effect on exposed statuary. Strandberg and Johansson (1997a) point out that the presence of both ozone and nitrogen oxides results in increased synergistic effects with sulfur dioxide. Ozone in combination with sulfur dioxide results in a strong synergistic effect on the corrosion of copper, producing cuprite and a variety of basic copper sulfates. At 70% RH, the effect of ozone is considerable, whereas the nitrogen oxides do not have an effect. Ozone accelerates corrosion at 70% RH by increasing the oxidation of adsorbed sulfite and, thereby, the rate of sulfur dioxide deposition.[15] Ozone in combination with NO_2 and SO_2 inhibits cuprite formation, and a crust of the basic sulfates tends to form. This is a good example of how complex the initial series of reactions are, since with SO_2 alone, a massive cuprite crust is formed.

| CORROSION STUDIES The deterioration of a copper-zinc-tin-lead alloy exposed to sulfur dioxide, nitrogen dioxide, and sodium chloride was investigated in laboratory simulations by Eriksson, Johansson, and Gullman (1993). For periods ranging from twenty-four hours to twelve weeks, small samples of the alloy were placed in controlled environments of SO_2, NO_2, and NaCl; the gases were added to purified air kept at 90% RH and with extraneous additions of sodium chloride to the ambient environment. Both polished and artificially patinated samples were used in the study, which showed that nitrogen dioxide is more corrosive to the bare alloy surface than is sulfur dioxide alone. Exposure of the polished samples to the mixed gases resulted in a substantial increase in the rate of corrosion; a similar synergistic effect was found on samples pretreated with sodium chloride and then exposed to the nitrogen dioxide. In this study, $HNO_2(g)$ was released from the polished metal surfaces after exposure to NO_2. In earlier experiments, Eriksson, Johansson, and Strandberg (1993) found that the reaction of SO_2 with NO_2 on a metal surface could produce nitrous acid:

$$SO_2 + 2NO_2 + 2H_2O = 2H^+ + SO_4^{2-} + 2HNO_2 \qquad 1.15$$

The sulfuric acid also formed by this reaction will tend to increase the corrosion rate of bronze by dissolving any passivating film and forming a solution of hygroscopic metal sulfates.

The metal ions in this solution will be chiefly copper and zinc. In the presence of sodium chloride, there is a large increase in the deposition rates of sulfur dioxide on the metal surface. Eriksson, Johansson, and Strandberg (1993) suggest that this accelerated deposition rate could be connected to electrochemical corrosion processes on the alloy surface where the anodic dissolution of zinc and copper is balanced by oxygen reduction; in nitrogen dioxide environments, it is balanced by the formation of nitrous acid. No information is available to date that quantifies the corrosion of copper with other atmospheric agents, such as peroxyacetyl nitrates (PAN) and carbonyl sulfide (COSH). In some countries, such as Brazil, the levels of PAN are quite high because of the change from gasoline to ethanol for automobile fuel. Further research is required to determine if these compounds also show synergistic effects on the corrosion of copper.

COMPOSITION OF PATINAS IN THE OUTDOOR ENVIRONMENT

It has often been assumed that the patina that formed on exposed copper roofs or bronze statues consisted primarily of malachite, despite the fact that Gustav Magnus (1802–70) voiced suspicions as early as the 1860s that the primary minerals might be copper sulfates. He was followed by conservator Friedrich Rathgen (1862–1942), who came to the same conclusion in the 1890s. Nonetheless, textbooks on general inorganic chemistry published up to 1996 still mention malachite as the principal product formed under these circumstances. It had long been known that exposed copper roofs gradually develop a patina of cuprite and that this reddish patina would imperceptibly turn green over long periods (thirty to seventy years or more) of exposure to the atmosphere. No studies, however, had been carried out before World War I to establish what minerals were actually formed or what corrosion processes were at work.

An impressive corpus of observations was made by a group of German scientists who investigated the deterioration of exposed bronze statuary in Berlin beginning in the 1860s and continuing through the 1890s. Their series of experiments, initiated by the Berlin Society for the Encouragement of the Arts and directed by Magnus, examined the effects of oil on the preservation of exposed bronzes (Magnus 1864). This was the first serious acknowledgment that there was a problem in this regard. Some of the results of that work are summarized by Hiorns (1892). In the experiments, a series of bronze busts were placed in different areas of Berlin where the air was polluted and bronze surfaces were turning black. The observers noticed, however, that on the bronze busts that had been accessible to handling, an attractive green patina had formed; they inferred that this alteration was due to the effects of human skin oils. In another series of experiments, the group placed four test bronzes outdoors: one was washed daily and rubbed thoroughly with bone oil once a month; the second was washed daily and rubbed with oil twice a year; the third was washed daily with no application of oil; and the fourth was kept unwashed and untreated as a control. The results of these experiments showed that the bronze washed daily and oiled monthly developed a fine green patina; the bronze oiled twice a year had less satisfactory appearance; the bronze that was washed but not oiled did not develop any green patina; and the control was dirty and unattractive. The scientists recommended rubbing exposed

bronzes with oil twice a year as a practical conservation treatment. They cautioned, however, that any excess oil should be rubbed from the surface to avoid the accumulation of dust and dirt. In 1913 a new committee to study patina was established in Germany. One of its members was Rathgen, who placed the bronzes he examined into five empirical groups (Rathgen 1924):

1. bronzes with a blackish, rough-surfaced patina
2. bronzes with a blackish, mostly matte surface with gray to yellow-green patchy areas
3. bronzes covered one-third to one-half with a green patina
4. bronzes that were extensively, but not completely, covered with a green patina
5. bronzes covered with a shiny patina, primarily in brownish tones

Rathgen made some interesting observations on the corrosion of four bronzes on the Rhine bridge in Cologne. Differences in patina were so notable that one might assume the sculptures were cast in different alloys, but, in fact, they were all cast in an alloy of 86% copper, 4% tin, and 10% zinc. Rathgen noted that there was, however, a salient difference: the two bronzes by Louis Tuaillon (1862–1919) on the west bank were rough sand castings without further working, and they had developed a rough, dark patina. In contrast, the bronzes by Johann Friedrich Drake (1805–82) and Gustav Bläser (1813–74) on the east side had been meticulously chiseled and were covered with a smooth green patina. Rathgen writes:

> [I]t is understandable that a rough surface offers a larger surface open for attack by atmo-spheric components. It especially offers the soot the possibility to attach itself, whereas it is washed off by the rain from smooth surfaces. Soot holds a danger, as it contains in its fine pores large amounts of sulphuric acid.... [W]ith the exception of a statement by Magnus, the influence of sulphuric acid is hardly addressed in earlier publications. From the stone base of the sculptures it can be seen, however, that by the combined action of sulphuric acid and humidity, the copper of the bronzes is transformed into the water-soluble copper sul-phate. Thus the five metre high base of the sculpture on the Cologne Rhine bridge has a green colour where the copper solution runs down during rainy weather. This happens as the soluble copper salts convert, with the carbonic acid of the stone into insoluble copper carbonates, which are retained in the pores of the stone and into soluble calcium salts which are washed away. (Rathgen 1924 : 46–47)

The conclusions reached by Rathgen were quite accurate, since the basic copper sulfates are soluble in acidic rainwater and may be converted to hydrated copper (II) sulfates by a variety of routes. For example, brochantite may react with sodium chloride to become atacamite, and this in turn may react with sulfur dioxide to form soluble copper salts, such as the hydrated sulfates. Rathgen's observations of the dissolution of the previously formed patina by later acidic depo-sition have been confirmed by recent research. Rathgen also drew attention to the importance

TABLE 1.4 **VERNON CORROSION DATA FOR COPPER ROOFS**[a]

LOCATION	AGE IN YEARS	COLOR	SO_4	CO_3	Cl	S	$CuSO_4$	$CuCO_3$
Australia House	12	black	19.9	2.4	nil	2.4	33.0	4.9
British Museum	70	yellow green	10.0	5.8	nil	2.6	16.6	11.9
Bodleian Library	100	green	18.0	1.1	trace	0.35	28.0	2.3
Brighton Pavilion	100	green black	14.9	4.6	0.3	0.84	nil	9.5

From Vernon 1932a,b.

[a] Chemical results in weight percent.

of copper sulfates as a patina component, although at the time these were often assumed to be copper carbonates.

Another valuable review at the turn of the twentieth century was prepared by Vanino and Seitter (1903). They discuss the corrosion of exposed bronzes, referencing some of the earlier German literature and providing recipes for artificial patination, which was dealt with in greater detail by Hiorns (1892).

Studies by Vernon between 1923 and 1934 conclusively discredited the assumption made in many English publications that malachite was the principal product on exposed bronzes. Vernon showed that most of the corrosion products that developed, often over an initial cuprite patina, were composed of basic copper sulfates, such as brochantite and antlerite (see CHAPTER 5 for a detailed discussion of these). Vernon and Whitby (1930) concluded from extensive observations of the behavior of copper sheets exposed at South Kensington, London, that corrosion progresses through the following five phases:

1. An initial brown film forms on the surface.
2. After several months, crystals of copper sulfates develop.
3. The surface becomes dull black.
4. After 225 weeks of exposure, basic sulfate with some sulfide content forms.
5. A green patina is stabilized on the surface.

CuCl$_2$	Cu$_2$S	PbSO$_4$	PbS	Al$_2$O$_3$	Fe$_2$O$_3$	INSOLUBLE MINERAL	INSOLUBLE SOOT	ORGANIC ACIDS
nil	12.0	nil	nil	2.1	2.7	1.9	5.9	11.3
nil	13.0	nil	nil	6.6	4.2	1.1	5.8	10.0
trace	nil	3.4	2.6	1.0	4.2	0.7	0.8	1.0
0.6	nil	47.9	6.3	1.9	0.7	1.6	4.8	2.5

The copper roof of Australia House, the London residence of the Australian ambassador, still appeared black in 1930, after twelve years of exposure. In contrast, all the copper roofs in the study that had been exposed for more than thirty years had developed green patinas. A representative set of analytical data from the work of Vernon (1932a,b) is shown in TABLE 1.4, which well illustrates the complexity of patinas formed in outdoor exposure. Vernon's work showed that alloying elements such as lead, whose compounds are very insoluble, may make a substantial contribution to the buildup of salts on the surface. These salts may have originated from the use of a leaded bronze alloy or have come from contiguous lead sheeting on the roofs.

Insoluble sooty material and organic acid radicals were present in all of the patinas studied. Some or all of this soot, which is derived from air pollutants, represents particulate matter incorporated into the patina; the organic fraction may represent copper oxalates and other copper carboxyl compounds. The direction of the wind was an important factor in patina formation: the surfaces facing south or southwest, the direction of the prevailing winds, formed a more perfect patina; those most exposed to washing by rain produced a streaked patina; and those in sheltered areas tended to be black or dark in color.

A nice juxtaposition to Rathgen's patina observations is the summary provided by Strandberg (1997), who studied fourteen sculptures in Göteborg, Sweden, and noted the following:

1. Black smooth surfaces, occasionally with a green or brown hue, best represented the "original surface"[16] of the bronze, with a cuprite crust beneath. Patina samples from these black areas contained cuprite and atacamite.

2. Black crustal zones, often with a light green layer beneath and cuprite below that, contained soot particles that may exfoliate as hard crusts. Analysis showed that these black crusts always contain quartz, atacamite or paratacamite, feldspars, and occasionally brochantite and antlerite.

3. Brown and orange patinas are cuprite, which is observed on recent sculptures. Some sculptures from the 1950s had orange vertical streaks, perhaps due to active leaching of the patina and surface dissolution of the outer layers.

4. Black islands on the patina were observed, each surrounded by a light green area that appeared to be corroded. These isolated islands of black crust on the surface were similar in composition to the black crusts described in point 2.

5. Light green zones on the surface occurred on horizontal and inclined areas where rain impacted the sculpture. These areas appear etched and rough, and the patina consisted of brochantite and some cuprite. Vertical areas exposed to strong wind were also light green.

Many of these observations agree with those of Rathgen made seventy years earlier, particularly those relating to the formation of rough, blackish crusts on the bronze surface. These crusts have been observed on bronze surfaces for many years, and most of the affected outdoor bronzes examined by Strandberg in 1998 had been exposed outdoors for more than fifty years.[17]

| RATES OF CORROSION IN THE OUTDOOR ENVIRONMENT After World War II, corrosion scientists became interested in rates of corrosion, and numerous exposure trials of copper alloys were begun. Tracy (1951) examined the corrosion of English-made copper sheets from the roof of Christ Church, Philadelphia. The roof had been exposed for 213 years. A corrosion rate of 0.20 mg/dm^2 per day was calculated; this is equivalent to 0.816 μm per year. This low rate of corrosion is attributable to relatively clean air during the early years of the copper roof's exposure. Rajagopalan, Sundaram, and Annamalai (1959) compiled corrosion rate data from different geographical regions, and selected data are given in TABLE 1.5. Most of these corrosion rates are similar to those found by other studies, although the rate for marine atmospheres in Panama appears rather high compared with other results.

Observations based on modern laboratory testing simulating outdoor corrosion conditions are useful in providing further evidence for the events that occur in patina formation and for the variations that may occur in different environments; such tests make it possible to measure and record the parameters of corrosivity. Holm and Mattsson (1982) summarized some of the available data for corrosion rates of exposed copper in different environments. The following

outlines their findings, which are presented here in the more helpful units of micrometers per year of exposure:

0.5 μm per year in rural atmospheres
1.0 μm per year in marine atmospheres
1–2 μm per year in urban atmospheres
2.5 μm per year in industrial atmospheres

In their own work, carried out over sixteen years, Holm and Mattsson (1982) exposed thirty-six different copper alloys in sheet and rod form to atmospheric weathering at rural, marine, and urban sites. Greenish patina formed on most of these alloys after six to seven years at the urban and marine sites. At the rural site, however, no distinct green patina formed on any alloy—only different shades of black or brown—after sixteen years of exposure. The amount of patina retained on the copper alloy surfaces increased substantially during the exposure period from seven to sixteen years. The patina that developed was more protective in the marine and rural environments than in the urban one. The average penetration levels of the copper alloys were 0.3–0.5 μm per year for the rural site; 0.5–0.9 μm per year for the marine site; and 0.9–1.3 μm per year for the urban site. Rates such as these apply only to the first few years of exposure when a patina is starting to develop; once a corrosion film has formed, the rate of corrosion drops substantially, usually after the first ten years.

The usual minerals that form on these exposed copper alloys are copper sulfates, but in a number of cases, the alloying elements themselves contribute to the patina. Zinc sulfate or basic zinc sulfate form on some brasses, and lead sulfate or basic lead sulfates form on free-cutting phosphor bronze and on some leaded brasses. In Holm and Mattson's work (1982), silica formed on silicon bronze in marine atmospheres; copper phosphate on some of the phosphor bronzes in urban atmospheres; copper arsenates on arsenical copper and on some arsenical

TABLE 1.5 **REGIONAL CORROSION RATES**

ALLOY	ENVIRONMENT	CORROSION RATE (μm/year)		
		Europe	USA	Panama
copper	rural	1.75		1.2
copper	city	1.5–2.7		
copper	industrial	3.02–4.0	1.50	
copper	marine	3.8	1.3	13.8

Based on data from Rajagopalan, Sundaram, and Annamalai 1959.

brasses; and nickel sulfate on nickel-silver alloys in urban atmospheres. In an interesting German study, Riederer (1972a,b) examined the corrosive deterioration of more than two hundred bronze statues erected before the end of the nineteenth century. The study found that leaded bronzes were more rapidly attacked, while the common statuary alloys of copper-tin-zinc were more resistant.

Holm and Mattsson (1982) found that brasses with high amounts of zinc (24–40%) were susceptible to dezincification; the most severe attack was found in the urban atmosphere, the least severe in the rural atmosphere. For brasses with less than 15% zinc and for arsenical alpha brasses, no significant dezincification was found. Deeper loss of zinc was noticed in the alpha+beta brasses, mainly in the beta phase, as would be expected, compared with those brasses that were in either the alpha range or the beta range of composition. The depth of attack in the alpha brasses did not show any significant decrease with decreasing zinc content, but the type of corrosion attack gradually changed from selective to general corrosion of the surface with zinc contents below 15%. For the majority of copper and copper alloys, the decrease in ultimate tensile strength was found to be less than 5%, and in elongation, less than 10%. Around the time when Holm and Mattsson began their study in Sweden, Costas (1982) began an atmospheric study at thirteen different test sites in the United States for periods lasting from fifteen to twenty years. Although this study does not appear to amplify the conclusions reached by Holm and Mattsson, it found that the rate of corrosion of the copper alloys at four locations after these time periods varied from a maximum of 2.3 μm per year to a low of 0.22 μm per year. The corrosion rate was the highest at the industrial sites, and the green sulfate patina developed there only. Rural and urban sites developed cuprite patinas only after twenty years; and the basic copper chloride, paratacamite, was detected in patinas that developed in marine locations. These studies, while useful, present only a simple, linear picture of corrosion development compared with the more complex development of the corrosion crusts that are found on bronze statues exposed for much longer periods of time, as the data from Vernon's work in the 1930s illustrates (see TABLE 1.4).

A useful study of thickness profiles of patina development over time was initiated by Franey and Davis (1987), who examined the thickness of copper alloy patinas sampled in the New York City metropolitan area. The samples were taken from copper alloys that had been exposed for periods from one to almost one hundred years, during the period of 1886–1983. The data show that most of these patinas achieved a thickness of approximately 12 μm in about fifty years, and probably not much more than that in one hundred years. This gives a corrosion rate for urban areas of 0.12–0.24 μm per year, substantially less than the initial corrosion rates determined experimentally over shorter periods of time and, incidentally, far lower than the rate observed by Tracy for the Christ Church roof in Philadelphia. Deducing corrosion rates from patina thicknesses developed during outdoor exposure may be misleading, however, since the mass loss from the corrosion events is not known, especially over long periods of exposure.

Studies of the condition and conservation of the Statue of Liberty, notably those sponsored by AT&T Bell Laboratories (now AT&T Labs), generated a number of interesting reports on patina formation in the outdoor environment. One of these studies is by Graedel (1987a), who summarized data for fifteen atmospheric pollutants to which this famous landmark was exposed. Many of these compounds are present only at the parts-per-billion level, but their dissolution in fine droplets of fog or mist will, on evaporation, substantially increase the relative concentration of some of these chemicals. Graedel also reported the concentrations of reactive components in fog, rain, and snow. The data show that concentrations of these reactive components in urban fog are noticeably greater for important anions such as sulfate, chloride, and nitrate, while the pH may vary from 2.2 to 4; thus, fog can potentially initiate corrosion in the urban environment.

A simulated rain study was used by Graedel, Nassau, and Franey (1987) to investigate some of the primary patina components that might form when a copper alloy is exposed to rainwater carrying various concentrations of sulfate, chloride, nitrate, and sodium ions and having a pH ranging from 3.4 to 4.7. In nearly all cases, cuprite formed, followed by brochantite, $CuSO_4 \cdot 3Cu(OH)_2$. Atacamite formation was not observed, which is consistent with the concentration–pH stability diagram. The reduction of cuprite to metallic copper, which is not very common in outdoor bronze exposure, was also observed. The conclusions that can be drawn from this study are rather limited, since the experiment was conducted for only fourteen days, which is insufficient time to allow for a meaningful result. The work is useful, however, in showing that once a patina has formed, changes in rainwater chemistry are unlikely to affect its mineral content, unless very acid conditions where pH $<$ 2.5 are encountered. Sweden may represent this extreme condition. The rainwater there has increased in acidity tenfold since the 1950s; consequently, the protons may be dissolving the brochantite patina ten times faster today. Outdoor conditions are not an equilibrium system, as assumed by Graedel, Nassau, and Franey (1987), which limits the predictive ability of these types of studies.

The stability regions for the formation of antlerite and brochantite can be gauged from FIGURE 1.8, a stability diagram for the copper-sulfate-water system with the superimposed domains of typical urban fog and rain. The diagram shows that brochantite should be the most favored phase to develop in outdoor exposure to rain; fog produces more antlerite and even dissolution of the patina at low pH levels. Individual stability diagrams have limited applicability because of the complex system involved. They do show, however, that brochantite should be the major corrosion product to form in outdoor exposure and that basic copper carbonates and chlorides should be minor or absent, a prediction that has been verified empirically.

| COMPONENTS OF EXPOSED PATINAS The work of Vernon (1932a) clearly reveals that exposed copper patinas may contain a variety of organic components that are difficult to characterize. In a recent study, Muller and McCrory-Joy (1987) used gas chromatography–mass spectrometry and ion chromatography to characterize water- and

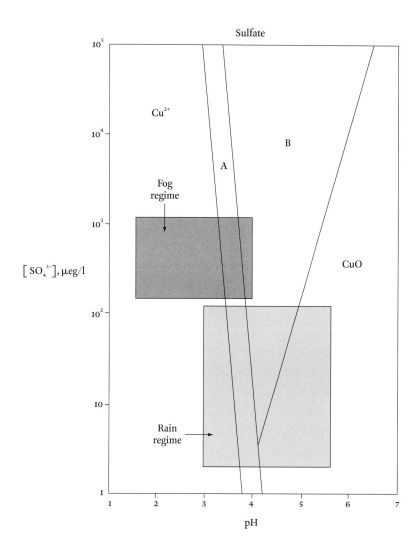

FIGURE 1.8 Stability diagram of the system $Cu-SO_4-H_2O$ with fog and rain areas shown for urban atmospheres. Area A = atacamite stability; area B = brochantite stability. Although the diagram over-simplifies the actual situation, it does show that brochantite should form in outdoor exposure and that antlerite may form in more acidic conditions (Graedel 1987a).

acetone-soluble components in exposed copper patinas on the Statue of Liberty and at AT&T Bell Laboratories in Murray Hill, New Jersey. Copper sulfates, nitrate, chloride, acetate, formate, and oxalate were found in a water extract from the Statue of Liberty patina. The acetone extract revealed the presence of several monocarboxylic acids, alkanes, and polynuclear aromatic species. A sample from the Murray Hill location showed the presence of acetate and formate ions distributed throughout the patina layer; that is, they were not confined to the outermost surface. Although present at very low concentrations, usually much less than 1% by weight, these organic fractions may act as binders, helping the patina to form a cohesive layer. Even at these very low concentrations, more than fifty monolayers of these copper organometallic compounds may be present, and this could create a significant binding capacity to hold parts of the patina together.

The complexity of these natural patinas formed in the atmosphere makes it difficult to simulate corrosion reactions in the laboratory. For example, many exposure trials in laboratory-controlled atmospheres containing known amounts of SO_2 and NO_2 have been carried out with interesting and relevant results. The correspondence with natural corrosion processes in the atmosphere, however, has been mitigated by the discovery that small amounts of ozone greatly accelerate the corrosion of copper. This casts doubt on the validity of predictions based on exposure to SO_2 and NO_2 alone, regardless of the relative humidity values used.

Although many patinas on outdoor bronze sculpture comprise a thin layer of cuprite overlaid with a green corrosion crust of basic copper sulfates, many individual studies show more complex patterns. For example, Mach, Reinhardt, and Snethlage (1987–88) examined the distribution of copper, iron, phosphorus, lead, and sulfur in the corrosion layers of some bronzes in Austria. The distribution patterns showed that the copper content decreased toward the surface while the iron content increased, which is what would be expected. With increased thickness of the corrosion layers, the migration of copper ions is severely reduced; consequently, elemental species from airborne particulates are more prevalent in the outer corrosion layers. The deposition of these pollutants not only prevents a further homogeneous accretion of the protective patina, but it may even weaken the patina layer through chemical and physical processes taking place in the outer corrosion layers. In the opinion of Vendl (1999), this may impair the protective effects of the patina. This is a difficult issue to evaluate, and the situation will vary greatly from one bronze to another. There is no doubt that in some patinas, typical spherical carbonaceous soot particles and ash become incorporated into the corrosion crust. The differential galvanic activity of these particles and the disruption of subsequent patina growth must result in the surface acting as a potentially active corrosion agent—if mist or fog of very low pH, for example, is absorbed by this crust. Consequently, even if the patina of a bronze is retained during conservation, some surface cleaning is always undertaken because soot and particulate deposition is very damaging to the surface of the object.

ASSESSING THE CORROSIVITY OF THE ENVIRONMENT The International Organization for Standardization (ISO)[18] has adopted a series of criteria for evaluating the corrosivity of the environment based on (1) measurements of the atmospheric gases (sulfur dioxide, nitrogen oxides, ammonia, ozone, and hydrogen sulfide); (2) measurements of particulate matter; and (3) the rates of corrosion of a series of control samples of copper, zinc, iron, and aluminum. An important measurement concerning relative humidity and precipitation is time-of-wetness (TOW), which was first measured with a sensor of platinum foil on a zinc panel (Sereda, Croll, and Slade 1982). Time-of-wetness is the time period during which the potential of the galvanic couple exceeds 0.2 V. This serves to express the rate of corrosion in terms of milligrams per square decimeter per day of wetness (sometimes abbreviated as MDDw), which can, in fact, be correlated with the rate of corrosion. Other, more sophisticated sensors have since been developed to take this measurement. TOW can also be determined from temperature and relative humidity data for a specific set of measurements, which are taken as part of any detailed assessment of outdoor bronzes. TOW is closely related to corrosive events, and, therefore, any projections regarding the maintenance of a bronze or the aggressiveness of the environment to which it is subjected should include a TOW measurement. A measure of the corrosivity of the environment, based partly on data for sulfur dioxide and sodium chloride pollutants, was proposed by Knotkova-Cermakova and Barton (1982).

The simple model for TOW calculations, which are so critical to understanding metallic corrosion events, has come under scrutiny recently, resulting in a much more sophisticated model being proposed by Tidblad, Mikhailov, and Kucera (1998). They suggest that dose-response relationships can be improved by using the original climatic data for temperature and relative humidity, instead of TOW measurements. To accomplish this, however, it is necessary to account for the nonlinear temperature effect by, for example, subdividing the data into cold and warm temperature regions prior to analyzing the information. Another difficulty with the time-of-wetness concept is that different corrosion processes may be going on in different areas of an outdoor bronze statue—as, for example, in areas exposed to or sheltered from rain—which results in limited utility for this parameter. More important is the RH, the amount and pH of precipitation, and other ionic species and gases in the environment.

ASSESSING THE CORROSIVITY OF THE METAL SPECIES In addition to environmental data, standard test panels of iron, copper, aluminum, and zinc can be used to assess the corrosivity of a metal species in ambient conditions. These panels, measuring 10.16 cm by 15.24 cm by 0.5 mm (4 by 6 by 0.02 in.), are used as controls for the particular metals to be tested or for coatings placed on them. Duplicate panels are withdrawn from the rack for evaluation after periods of one, two, four, and eight years of exposure. The testing rack is usually inclined 30° to the horizontal, facing south, and held in place with insulated plastic grommets with stainless-steel screws to avoid any galvanic effects with the superstructure of the

apparatus. As part of a United Nations initiative to evaluate atmospheric corrosion, various testing sites have been set up across the world, including one established by the Getty Conservation Institute (GCI) in the Brentwood area of Los Angeles in 1997. The GCI site includes a United Nations (U.N.)–approved testing rack for both sheltered and unsheltered exposure. The first set of detailed U.N. reports was scheduled to be published after four years of exposure, in late 2001.

| *The indoor museum environment* | One of the most pervasive topics in art conservation at present is the subject of the indoor museum environment. There is not enough space here to review in detail all of the recent work |

undertaken concerning the characterization of, the management of, and the problems associated with the museum environment. For metals, this environment is characterized by a range of pollutants, relative humidity, and temperature problems that are not encountered in burial contexts, for example. These problems can result in the corrosion of metallic works of art, particularly those made of lead, silver, or copper and its alloys.

Brimblecombe (1990) reviewed some of the relevant literature, which is summarized in TABLE 1.6. The most common gaseous pollutants in museums are NO_X, SO_2, H_2S, O_3, HCOOH, CH_3COOH, and HCHO, all of which potentially interact with copper alloys, either directly or as catalytic agents. The expected range of corrosion products is, therefore, nitrates, sulfates, sulfides, oxides, formates, acetates, and salts of higher carboxylic acids; these are, indeed, the kinds of products found in contaminated environments.

Emanations from display cases, furnishings, and other fabricated products in museums may give rise to elevated levels of simple ketones, aldehydes, alcohols, esters, phenol, and toluene, in addition to the skin particles, fibers, and dust introduced by visitors. The principal problem with particulate matter is its deposition on metallic surfaces, followed by entrapment of water vapor or the formation of localized higher humidity associated with the particles. This situation, coupled with particles that have a high-surface area and the presence of sulfate, chloride, or other ions in some particulates, may increase corrosion. Localized increases in humidity on metallic surfaces can initiate corrosion, which may result in greater deposition velocities for particles at that site, and hence corrosion may be greatly accelerated. In display cases and storage areas, the use of unsuitable fiber composites, wood, glues, foam, felts, fabric, rubber, paint, sealants, or plastics is a continual problem because high levels of organic acids and aldehydes can be released from them. Levels may reach the hundreds of parts per million, which are damaging to art objects. Hydrogen sulfide levels are usually in the low parts per trillion level in the indoor museum environment, but even parts per billion, which may be found in unsuitable display cabinets, can be very damaging especially to silver objects, as well as to copper and bronze. The only recourse is to ensure that all materials used in display case construction and in storage and display areas are tested for suitability.

TABLE 1.6 **CONCENTRATION OF AIR POLLUTANTS IN MUSEUMS AND LIBRARIES**

BUILDING	SO$_2$ (ppm)	O$_3$ (ppm)	NO$_x$ (ppb)	NO (ppm)	DATES
National Gallery, London		0.25			
Victoria and Albert Museum, London	3–42				1983
Tate Gallery, London	<4				1980–83
Sainsbury Center, Norwich, U.K.		40 (max)			1981
National Archives and Records Administration, Fort Worth, Texas	2–25	<42	10–252		
National Gallery, Washington, D.C.	<1	low	7–50		
Library of Congress, Washington, D.C.	<0.5	low	4–145		
Baxter Gallery, Pasadena, Calif.		120			1982
Los Angeles County Museum of Art, Los Angeles		<10			1982
Huntington Gallery, San Marino, Calif.		<10			1982
Scott Gallery, San Marino, Calif.		31	92	32	1964
Huntington Library, San Marino, Calif.			75	37	
Rijksmuseum, Amsterdam	1–5				1974
Summer measurements					
Rijksarchief, The Hague	<1	<1	30		1986
Rijksarchief, Arnhem	1	2	16		1986
Rijksarchief, Leewwarden	<1	<1	~7		1986
Winter measurements					
Rijksarchief, The Hague	1.5		49		1986
Rijksarchief, Arnhem	4.5		39		1986
Rijksarchief, Leewwarden	<1		~46		1986

After Brimblecombe 1990.

There are a number of tests available to assess material damage. A common and useful series of evaluations are the so-called Oddy tests for general material damage to metallic coupons of lead, copper, and silver. This is supplemented with the sodium azide test for sulfides, the chromotropic acid test for formaldehyde, and the indicator-paper test for pH measurements. Further details concerning these techniques can be found in Oddy (1973), Daniels and Ward (1982), Green and Thickett (1995), and Lee and Thickett (1996). Lee and Thickett provide a particularly easy to read and comprehensive account of the subject. A number of surveys of museum pollutants, primarily of organic acids and aldehydes, have been conducted by the Getty Conservation Institute. The critical indoor pollutant concentrations below which corrosion can be assumed to be very slow or nonexistent are difficult to establish for metallic antiquities. The work of Grzywacz (1993), however, suggests that the concentrations of organic acids and aldehydes should be kept in the range of 10–20 ppb. If the concentration reaches 100 ppb, this is generally considered to be too high. For hydrogen sulfide, the levels are in the low parts per trillion, but since detection of this gas in the museum environment is always a worry because of its very high reactivity with works of art, it is doubtful if there is any acceptable level of hydrogen sulfide.

| ASSESSING CORROSION RATES IN INDOOR ENVIRONMENTS Rice and colleagues (1981) made indoor corrosion rate measurements on copper and other alloys at eight locations in the United States; pollutant and relative humidity data were recorded from six of them. The tests were carried out for only two years, however, from 1973 to 1975, and this is not really long enough to gauge long-term effects. The pollutants measured included sulfur dioxide, nitrogen dioxide, ammonia, reduced sulfur gases (H_2S, S, and CH_3SH), chlorine gases, and airborne dust. The corrosion rates found for copper showed a general decrease with time, particularly for the less corrosive environments. The indoor copper corrosion rate distribution for the measurements was a lognormal function with an excellent correlation coefficient of 0.97.[19] The rate of corrosion indoors is usually orders of magnitude less than the rate outdoors, unless high levels (hundreds of ppb) of organic acids are generated in the indoor environment. The functional dependence of the corrosion rate, r, on relative humidity, RH, is of the form $r = ae^{4.6RH}$, with little evidence for a critical relative humidity in a complex environment.

Sulfur dioxide and ozone were shown to have a significant influence on the rate of corrosion, while nitrogen oxides, chlorine, and ammonia had substantially less influence. Although the study by Rice and coworkers (1981) provides a useful insight into indoor corrosion rates, it is too theoretical for application to museums. Careful routine observation of objects, combined with testing of all materials used in museum construction, display, and storage, is a practical approach to dealing with corrosion possibilities engendered by museum pollutants.

More recent studies have attempted to classify indoor atmospheres by degrees of corrosivity. The Instrument Society of America (ISA-S71.04), for example, proposes an evaluation based

on exposure of copper samples to various liquid, solid, and gaseous contaminants. The thickness of the corrosion products that develop on the copper after one month of exposure is determined using electrolytic cathodic reduction, establishing four levels of corrosivity. Other organizations may divide the levels differently, but the principal information is basically the same. The lowest level of severity, labeled G1, may typically have an H_2S concentration of less than 3 ppb; SO_2, less than 10 ppb; Cl_2, less than 1 ppb; NO_X, less than 50 ppb; and O_3, less than 2 ppb. Some of these levels may be considered high for the museum environment. The G1 rating of 3 ppb is too high for objects, and palliative measures are often taken at exposure levels of 100 ppt. Likewise, nitrogen oxides are often regarded with suspicion if levels as high as 50 ppb are found inside the museum. The lowest possible values are desirable for any of these pollutants. Levels of NO_2 at the St. Vitus Cathedral in Prague, for example, reached 15 ppb, but ammonia levels were substantial at 20 ppb. These ammonia levels could begin to have an effect on exposed copper and brass, so it is impossible to consider anything in isolation. Johannson, Rendahl, and Kucera (1998) and Johannson (1998) report on an interesting research project that applied atmospheric corrosivity measurements to forty-two indoor sites, including nine museums and churches; these reports should be consulted for further information.

DEPOSITION OF PARTICULATE MATTER Particulate pollution, arising from tobacco smoke, asbestos, suspended particulate matter, and particles large enough to be precipitated, is especially important as a corrosion initiator on polished metal surfaces. In metropolitan areas today, most of the sulfur acquired by surfaces is not supplied in gaseous form from reactions with sulfur dioxide but rather as dry deposition. Lobnig and colleagues (1993) draw attention to the bimodal distribution of airborne particulates; predominating the distribution are fine particles smaller than 2.5 μm in diameter and coarse particles larger than 2.5 μm. For environments with extremely efficient air-filtration systems, the coarse particles are less important, since they can be removed with about 95% efficiency, while the fine particles are removed only at levels between 10% and 70%. The most abundant ions present in these fine particles are sulfate and ammonium ions. Lobnig and colleagues (1993) exposed polished copper to simulated particulate matter consisting of submicron particles of ammonium sulfate. After five days of exposure at 75% relative humidity, which is the critical level for $(NH_4)_2SO_4$, corrosion of the copper had occurred with formation of cuprite and antlerite. There is little doubt that surfaces left uncleaned for a long period of time, perhaps several years, create unsightly corrosion problems that are not well documented in the literature.

Current interest in the subject is driven by the perceived threat of corrosion to copper alloys in electronic materials caused by submicron-size atmospheric particulates. Comizzoli and coworkers (1993), for example, provide data for the average airborne concentration of ionic species and total mass of particles in the air of Newark, New Jersey, together with the average accumulation rates for ions on both vertical and horizontal surfaces. For sulfates, the indoor deposition velocity varied from 0.002 to 0.010 cm/s. Because the rate of deposition of ammo-

nium sulfate particles is also an environmental concern, deposition rates have been measured outdoors as well, and they typically range from 0.1 to 1.00 cm/s. These data suggest that increased rates of indoor airflow will cause greater deposition of pollutants on objects in museums without air-conditioning systems. Some air-conditioning systems in the United States are equipped with filtration systems; for example, the one at the J. Paul Getty Museum uses activated charcoal filters that remove more than 95% of particulate matter.

| CORROSIVE MOLDS The potential for fungi of various kinds to create corrosion problems was shown by Leidheiser (1979), who abstracted data showing that molds grown in gelatin on the surface of brass plates caused rapid formation of deep pits; these pits even occurred with molds commonly found in the atmosphere, although here such attack is probably created by the diffusion of organic acids from the fungi to the metal surface during bacterial growth. The most corrosive molds were *Aspergillus niger, Aspergillus amstelodami, Penicillium cyclopium, Penicillium brevicompactum*, and *Paecilomyces varioti* Bain. Molds produce organic acids while growing on organic electrical insulation, varnishes, and varnished fabrics; corrosion of copper, when in contact with such materials, can be extensive. Jones and Snow (1965) found that after twelve hours of spore germination the following compounds were present in distilled water surrounding the growth medium: alanine, asparagine, aspartic acid, cysteine, cystine, ethionine, gamma-amino butyric acid, glutamic acid, glutamine, glycine, histidine, hydroxyproline, leucine, methionine, phenylalanine, proline, serine, threonine, tyrosine, and valine. The corrosion of copper by these compounds, as well as by enzymatic agents, was studied by Staffeldt and Calderon (1967). Infrared studies showed that organometallic compounds of copper were formed in the presence of innumerable organic acids, even at an acid concentration of 1% weight per volume (w/v). Acids studied were citric, fumaric, glutaric, itaconic, ketoglutaric, maleic, malic, oxalic, pyruvic, and succinic. All solutions turned green after twenty-one days, except pyruvic acid solutions, which were yellow, indicating active corrosion.

| TREATMENT RESIDUES Many corrosion problems are also created by residues of old treatments, particularly salts that have not been completely rinsed off the object; with fluctuating humidity or temperature, vestiges of these solutions may create localized damage. Treatment solutions used in the past were either very alkaline or very acidic. After a solution remains on a copper object for a prolonged period of time, their residues may react with moisture and the object itself to form salts and create fresh outbreaks of corrosion on the surface. Examples of such corroded objects in old museum storage areas are legion.

| THE IMPORTANCE OF MONITORING The ever-increasing rigor and sophistication of monitoring techniques is essential to indoor air research, as a perusal of the latest literature will reveal (see, for example, Del Bino 1997). This trend appears to be particularly active in Europe, and, like the National Acid Precipitation Program sponsored by the National Science Foundation in the United States, the ongoing research can be expected to produce reams of data. Huge numbers of volatile organic compounds in the indoor environment

are being determined in the parts-per-billion range with modern analytical instrumentation, but the significance of these compounds to the deterioration of art objects remains to be demonstrated at this concentration level. For copper alloys, at any rate, the compounds—except for carboxylic acids and aldehydes—probably have minimal or nonexistent effects.

The marine environment | The dissolution of copper in seawater was recognized in the early nineteenth century as creating difficulties for shipping. The English chemist Sir Humphry Davy (1778–1829) was requested by the British Royal Navy board to investigate this problem, and he responded with his report in 1824. In it, he wrote that when a piece of copper is placed in seawater, the first effects observed were

> a yellow tarnish upon the copper, and a cloudiness in the water, which take place in two or three hours; the hue of the cloudiness is first white; it gradually becomes green. In less than a day a bluish-green precipitate appears at the bottom of the vessel, which constantly accumulates; at the same time that the surface of the copper corrodes, appearing red in the water and grass-green where it is in contact with the air. (Davy 1824:152)

Davy determined that the precipitate formed in the seawater was a hydrated submuriate of copper (one of the copper trihydroxychlorides); he also showed that in environments deprived of oxygen, no corrosion of copper would occur. This presages the protection of fragile metal antiquities by preservation in a closed container with oxygen scavengers, or by storage in a nitrogen atmosphere, to arrest further corrosion. For protection of His Majesty's ships of war, Davy recommended attaching an iron or zinc plate to the copper hull, based on his laboratory experiments showing that copper immersed in seawater would not corrode if small zinc or iron plates were attached to it. This protection, by the provision of a sacrificial anodic metal, has continued to be of value in preventing the corrosion of ships for almost the last 180 years.

| THE COMPONENTS OF SEAWATER The most common components of seawater, apart from the water itself, are chloride, sodium, sulfate, magnesium, calcium, and potassium ions, which make up more than 99% of the salt content; important minor components in both seawater and river water include silicon and iron. The salinity of water is usually stated in parts per thousand (‰) of salt. An average value is 35 ‰; higher values are found in such environments as the Mediterranean Sea (38.6 ‰) or the Red Sea (41 ‰). The principal dissolved gases in seawater are oxygen and carbon dioxide from photosynthetic reactions. The equilibrium between dissolved carbon dioxide and carbonate or bicarbonate ions acts as an effective and important buffering system. The pH of seawater is usually between 7.5 and 8.4. Oxygen-rich seawater is strongly oxidizing, whereas seawater depleted in oxygen may be a reducing environment. Because of biological activity, however, copper alloys in a reducing milieu will not necessarily be well preserved.

BIOLOGICAL FACTORS Many artifacts recovered from the sea are associated with shipwrecks. At such sites, marine life, algae, rotting timbers, coral, and so on, may strongly influence the local environment of submerged bronzes; as a result, such artifacts may be heavily covered with concretions. The fact that copper is a natural biocide does not necessarily stop copper alloys from becoming heavily encrusted.

Microbially influenced corrosion (MIC) is an important aspect of the environmental attack on metals, but it is seldom considered in detail. In natural environments, bacteria attach to solids, including metals, where they colonize the surface and produce a biofilm. Microorganisms within the biofilm are capable of producing an environment at the surface of the object that is radically different from the bulk solution in terms of pH, dissolved oxygen, and other organic and inorganic species. The sulfate-reducing bacteria are a particularly important group in the corrosion of metals, since the production of the sulfide ion is usually damaging to metal surfaces and can initiate a number of corrosion events at the metal surface. McNeil and Little (1992) note that in natural environments, various types of bacteria may grow in conjunction with oxygen-using microorganisms that can deplete the local environment of oxygen, driving the biofilm layer toward Eh values that are more electronegative and providing conditions for the growth of sulfate-reducing bacteria. These biofilms may then produce elevated levels of sulfide ions and shift pH levels toward the acid regions, as well as scavenge for chloride ions to maintain electroneutrality. Under these conditions, the microbial corrosion of copper, silver, and their alloys becomes an important event; this may be applicable both to aqueous environments and to land burials, if microbiological activity is very active at the site.

Leidheiser (1979) pointed out that copper concentrations of 10^{-5} to 10^{-6} molar stimulate marine bacterial communities in a seawater-agar gel containing 0.5% peptone and 0.1% yeast extract. In some cases, these colonies tolerate copper concentrations as high as 10^{-3} molar. It is known that certain fungi are very resistant to both high hydrogen-ion concentration and high copper-ion concentrations; in particular, *Acontium velatum* Morgan and a dark green organism belonging to the Dematiaceae family can happily thrive at pH 0.1 in a medium saturated in copper sulfate.

A study by Rogers (1948) on the corrosion of copper pipes in which sewage effluent was used for cooling water showed that bacteria and molds growing in contact with 70Cu30Zn brass accelerated corrosion, resulting in the formation of deep pits below the colonies. Some bacteria tolerated high concentrations of copper salts, and several nonsporing microorganisms withstood copper concentrations higher than 100 ppm. One of these was a nonsporing, gram-negative rod living in large reddish brown colonies; the microorganism appeared similar to others previously isolated from seawater. In another culture, a spore-forming organism removed from copper exposed to infected seawater resisted 2000 ppm of copper. The attack on the brass was invariably intercrystalline, and bacterial nutrients such as mannitol and asparagine accelerated the rate of attack. Samples of seawater known to produce rapid pitting of brass contained

TABLE 1.7 **TYPICAL MARINE ENVIRONMENTS**

MARINE ZONE	ENVIRONMENT	CHARACTERISTIC BEHAVIOR OF COPPER
Atmospheric	Small sea-salt particles carried by wind. Corrosivity varies with height above water, dew cycle, bird droppings, wind, etc.	Partially sheltered surfaces may deteriorate more rapidly than those exposed; top surfaces may be washed free of salt by rain.
Splash	Wet, well-aerated surface; no fouling.	Most aggressive zone for many metals and for protective coatings.
Tidal	Marine fouling present to high water.	Copper may act cathodically at tidal zone.
Shallow water	Seawater saturated with oxygen; pollution, sediment, and fouling may all be present.	Corrosion may be more rapid than in exposed marine zone areas; a layer of hard shell and biofouling may restrict corrosion.
Continental shelf	No plant fouling; some decrease in oxygen, especially in the Pacific, and at lower temperatures.	Copper alloys may be well preserved.
Deep ocean	Oxygen varies, lower here than at surface; temperature near 0 °C; velocity and pH both lower than at surface.	Data for copper alloys sparse, but corrosion is limited.
Mud	Sulfate-reducing bacteria present; bottom sediments vary in origin, characteristics, and corrosion behavior.	Partially buried bronzes corroded most; submerged copper alloys may be severely attacked.

After Schumacher 1979.

an organic sulfur compound that could be repeatedly reduced to a mercaptan and then oxidized back to a disulfide. This oxidation-reduction cycle stimulates the corrosion of the brass.

Work at the British Non-Ferrous Metals Research Association (Leidheiser 1979) suggests that the abnormal pitting of copper condenser tubes is associated with bacteria that produce black or brown pigmentation. Melanin, which was identified as one of these pigments, can be produced by the action of the enzyme tyrosinase on tyrosine; bacteria producing tyrosinase accelerated corrosion in direct relationship to the amount of tyrosine present. Other oxygen-deficient reactions that occur in marine burial include the activities of the sulfate-reducing bacteria and the possible reactions of hydrogen sulfide with copper to form an array of other sulfides—from covellite, CuS, to chalcocite, Cu_2S.

| RATES OF CORROSION IN VARIOUS MARINE ENVIRONMENTS

TABLE 1.7 shows the different aspects of the marine environment divided into seven zones: atmospheric, splash, tidal, shallow water, continental shelf, deep ocean, and mud. Copper alloys can be found in any one of these environmental niches, but in the marine regions, most would be in shallow water, continental shelf, deep ocean, or underwater mud. Based on weight-loss measurements, the corrosion rates of copper alloys over twenty years were found to be from 0.01 to 0.17 mils of penetration per year (mpy) (0.25–4.3 μm/year), with rates of attack higher in tropical regions. In the splash and tidal zones, the behavior of copper alloys is analogous to their performance in the marine atmosphere rather than in immersed conditions (Schumacher 1979). Part of the reason copper alloys do not corrode quickly when immersed in the sea is that a cuprite film tends to develop over the surface. In research on the corrosion of copper condenser tubes, it was found that especially resistant films are often produced on the surface if small amounts of iron are present in the alloy. Similarly, Schumacher mentions that a patent was issued for improving the corrosion resistance of an aluminum brass by the addition of small amounts of iron to the alloy. Some laboratory studies suggest that the ferrous ions are oxidized to lepidocrocite by the dissolved oxygen in water. During the experiments, the lepidocrocite formed a colloidal film that was deposited electrophoretically at the cathode and thus acted as a cathodic inhibitor by polarizing the reduction of oxygen.

In general, the oxygen content of a marine environment is a significant factor in the corrosion of copper, since the depolarization of the cathode by oxygen, the oxidation of $Cu(I)$ to $Cu(II)$, and the film-forming properties of copper are all dependent on it. In polluted seawater, which may be oxygen deficient, the generation of copper sulfides occurs readily since hydrogen sulfide is commonly available as a product of plant decay. The copper sulfide film formed on copper in polluted seawater is more cathodic than the normal corrosion crust formed in clean seawater; if there are any breaks in the film, local attack is greatly stimulated by the large area of the cathode. Some alloys are more resistant to this type of attack: copper-nickel alloys and copper-aluminum alloys, for example, are less affected than copper or a binary copper-zinc brass. If copper is submerged in seawater, the rate of corrosion can range from 0.5 to 2 mpy.

Hummer, Southwell, and Alexander (1968) recorded a rate of attack for copper of 0.20 mpy after sixteen years of exposure in the shallow waters of the Pacific Ocean off the coast of Panama. Some pitting corrosion of the copper occurred, with a maximum depth of 57 mils. Comparing corrosion rates for copper alloys in shallow water and at a depth of 1828.8 m (6000 ft.) showed that the rates of corrosion decreased in both environments in an almost linear relationship with increasing duration of exposure. The corrosion of copper and of silicon bronzes was not affected by changes in the concentration of seawater oxygen during one year of exposure. Further details for the corrosion rates of a variety of copper alloys at different depths are found in the review by Schumacher (1979).

According to North and MacLeod (1987), the corrosion rates for isolated copper samples in oxygenated seawater is about 0.02 mm per year, and this could increase by a factor of 2 for every 10 °C rise in water temperature. This rate may decrease in anaerobic water or in sediments and by galvanic coupling to iron on shipwrecks. There arc, however, a number of complex situations that can result in increased corrosion under such circumstances, apart from the action of sulfate-reducing bacteria. Copper bolts in the hulls of wooden ships, for example, are often partially covered with wood and partially exposed to the open sea (MacLeod 1987b). Beneath the wood, oxygen is depleted, and these regions become anodic; the corrosion reaction may be accelerated by the chemical decay of the wood, which releases acetic acid, ammonia, and amine compounds. These compounds can complex with the copper ions, thus shifting any equilibrium toward the dissolution of copper and thereby accelerating corrosion. The value of Eh from the Pourbaix diagram for copper in oxygenated seawater at 25 °C is 0.691 V. The metal E_{corr} value of 0.09 V would indicate that cuprite should be the stable phase. Given that the usual range of pH in seawater is 6.2–9.2, the formation of cuprous chloride from cuprite is not favored since the reaction

$$Cu_2O + 2H^+ + 2Cl^- = 2CuCl + H_2O \qquad \text{1.16}$$

requires a pH below 5.30 at the normal chloride-ion activity of 0.319 molar.

The pH of the bulk of seawater usually remains near 8, but large variations can occur in restricted environments and under concretions, which means that cuprous chloride can be found as a corrosion product in seawater when the local pH level is low enough to favor its formation (MacLeod 1987a).

Bianchi and Longhi (1973) surveyed the corrosion of copper in seawater based on the relevant Pourbaix diagrams and on stability diagrams, two of which are shown in FIGURE 1.9. Their calculations showed that there may be a competing series of reactions producing atacamite and malachite, which have been found together on rare occasions as marine corrosion products, even though atacamite is usually the much more predominant species. The two minerals may occur together because, compared to malachite, atacamite can be precipitated at slightly more acidic pH and under oxidizing conditions. The ability of chloride ions to migrate toward the

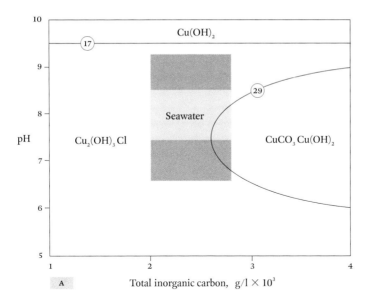

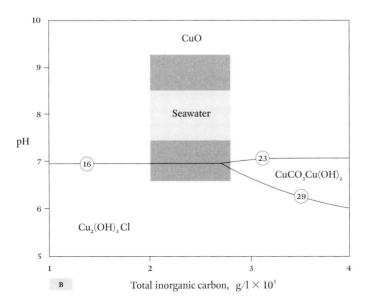

FIGURE 1.9 Stability domains of A, the solid phases of malachite, atacamite, and serpentite in seawater at 25 °C; and B, the solid phases of malachite, atacamite, and tenorite in seawater at 25 °C (Bianchi and Longhi 1973).

metallic surface kinetically favors the formation of one of the copper (II) trihydroxychlorides (atacamite), although this cannot be shown on the Pourbaix diagram, which exists independently of, and is blind to, kinetic factors. This may invoke a guarded response to predictions based on Pourbaix diagrams in the absence of any empirical data, but if the empirical data are available, as well as the Pourbaix diagram, the combination is a powerful tool for evaluating the corrosion process.

In marine environments, the principal cathodic reaction in the corrosion of copper is the reduction of oxygen:

$$O_2 + 2H_2O + 4e^- = 4OH^- \hspace{4cm} 1.17$$

The available oxygen in seawater is temperature dependent so that at 0 °C there is 8.1 ml/l of oxygen, and at 25 °C there is 5.4 ml/l of oxygen. In some sites, biological activity may result in the sulfate-reducing bacteria becoming more important than dissolved oxygen in the corrosion of copper. Corrosion rates in seawater are generally much higher than in freshwater because of the presence of so many different cations and anions. The Eh of the water may fall below the hydrogen evolution potential when oxygen is depleted, in which case the principal cathodic reaction would become

$$2H^+ + 2e^- = H_2 \hspace{4cm} 1.18$$

Copper alloys are common nonferrous metals found at shipwreck sites. Copper- or brass-sheet cladding was used to protect wooden ships from the teredo worm and from fouling by marine organisms. The corrosion products in oxygenated seawater range from cuprite to cuprous chloride and include the isomers of the copper trihydroxychlorides and the copper sulfides; relatively uncommon are the carbonates and sulfates. The value of Eh in normal seawater is 0.691 V, while the metal E_{corr} may vary from 0.04 V to 0.09 V. Some of the basic copper chlorides identified by MacLeod (1987a) from Western Australian maritime sites proved to be more closely related to the X-ray diffraction patterns for synthetic paratacamite and atacamite. Synthetic atacamite, ICDD 25-269, is even assigned a slightly more complex formula than the natural mineral, namely $Cu_7Cl_4(OH)_{10} \cdot H_2O$, although how viable this stoichiometry actually is remains to be established by further research. The occurrence of both malachite and atacamite in the sea burial of copper has been reported by Mor and Beccaria (1972). Evidence for postexcavation changes of marine patinas was reported by MacLeod (1991), who noticed that the red-brown cuprite patina on some copper sheathing from a Western Australian marine wreck turned a deep blue green after transportation to the conservation laboratory. This blue-green formation was characterized as a mixture of synthetic malachite and a basic copper sulfate hydrate, $Cu_3(SO_4)_2(OH)_2 \cdot 4H_2O$ (ICDD 2-107). The precipitation of cupric ions as a basic chloride or basic carbonate is dependent on the salinity of the seawater, temperature, pH, and

the amount of dissolved carbonate, which is strongly influenced by the marine organisms living in the vicinity of the site.

MacLeod (1991) has noted evidence for the presence of cupric hydroxide, $Cu(OH)_2$, in concreted marine copper alloys that were freshly excavated. This compound will usually transform to other products once the object is excavated and allowed to dry because in the presence of chlorides or carbonate anions a reaction will ensue to produce atacamite or malachite. Brass objects are often not extensively corroded, despite the popular assumption that widespread dezincification should be occurring. Perhaps the presence of alloying elements—such as lead, arsenic, or antimony—may inhibit the dezincification process, as suggested by Lucey (1972). For bronze alloys, Campbell and Mills (1977) showed that in deaerated seawater, the eutectoid (alpha+delta) phase was preferentially attacked in a 77Cu20Sn3Pb alloy, leaving the surface enriched in an alpha phase. At higher oxygen levels, the copper-rich alpha phase was preferentially attacked instead, preserving the alpha+delta eutectoid. MacLeod (1991) confirmed this general conclusion, based on an excavated bronze bell from the 1881 wreck of the *Rapid*. Part of the bell's lip and crown was buried in sand and was corroded, with formation of cassiterite, SnO_2, from the tin content of the alloy. The principal copper corrosion product was found to be paratacamite, with the corrosion front extending 7 mm into the metal. The corrosion on surfaces of the same object exposed to the sea, however, was only 1 mm thick, and no destannification had occurred.

Highly leaded bronzes and brasses from these shipwreck sites often show very good corrosion resistance if they were not buried by sediment. McNeil and Little (1992) discuss aspects of the corrosion of copper and silver in near-surface environments and note that the solid-state transformation of cuprite to malachite is possible, while transformation to a copper hydroxy-chloride requires dissolution and precipitation. The significance of this observation requires further research. The corrosion rate of copper-nickel alloys in seawater is much slower than the corrosion of pure copper. The most recent explanation for this is the alteration of the cathodic reduction potential, which is depressed in the copper-nickel alloys.

USE OF TREATMENT SOLUTIONS FOR WOOD-METAL ARTIFACTS

Selwyn, Rennie-Bissaillion, and Binnie (1993) investigated the corrosion rate of copper alloys associated with waterlogged conditions, particularly those alloys in composite wood-metal artifacts that had been impregnated with polyethylene glycol 400 (PEG 400) or treated with a range of other consolidants before burial in marine or waterlogged burial sites. These PEG solutions are mildly acidic, with a pH between 4.5 and 7, and they are capable of causing copper corrosion. In addition, wet wood may corrode contiguous metals because water-soluble wood extracts, such as formic and acetic acids, produce corrosion, especially of copper and lead alloys.

Selwyn, Rennie-Bissaillion, and Binnie (1993) examined the use of a consolidant, Witcamine RAD 1100,[20] based on an oxyalkylated rosin amine in a 15% volume per volume (v/v) solution as an alternative treatment for copper-wood composites. Also studied was the effectiveness of

adding to the PEG solution a corrosion inhibitor, Hostacor KS1, based on an alkanolamine salt of an aryl (sulfon)–amido carboxylic acid.[21] The corrosion of copper alloys significantly increased in PEG 400 solutions (pH 5.6) compared with immersion in distilled water; rates between 25 and 41 µm per year were determined. The corrosion rate in the amine-based polymer was lower than in PEG—between 5 and 17 µm per year. Because it is amine-based, this polymer may form a soluble copper complex, which would increase the corrosion rates of brass alloys, especially compared with their rates of corrosion in distilled water. Copper and wood components in copper-wood test pieces treated with the same consolidant were stable six years later. In seawater with 15% v/v addition of this amine-based polymer, the corrosion of copper alloys was significantly reduced to 0.4 µm per year; this is a lower corrosion rate than that observed in distilled water or seawater alone, where the rates were 3 µm and 6 µm per year, respectively. It is difficult to assess by laboratory experiment just how effective this consolidant would be in the treatment of copper alloys covered with a thick corrosion crust. There is no ready way to evaluate this without long-term treatment of waterlogged composite material.

COPPER IN CONTACT WITH ORGANIC MATERIALS

I have heard it said that bronzes that have been in the soil a long time are deeply impregnated with the essence of the earth, and that this will maintain the beauty of flowers in their freshness and brightness. Buds will open out more quickly and will wither more slowly. This nurturing strength comes from the vase itself.—YÜAN HUNG-TAO [22]

Copper ions, through their biocidal character, play an important role in the preservation of associated burial materials, such as textiles, feathers, bone, wood, and leather. Copper may even enhance the preservation of buds, as the Chinese literary theorist Yüan Hung-tao (1568–1610) notes, but it is doubtful that they will open more quickly, as he suggests. The organic matrix of material buried with copper may also be replaced, in part or in whole, by copper salts. This is the process of mineralization, which is the combination or replacement of the organic matrix with an inorganic one (Gillard et al. 1994). The metallic ions of copper, iron, lead, and silver are reported to be the principal inorganic corrosion species that participate in pseudomorphic replacement processes.

Positive replacement and mineralization of organic materials	In positive replacement, copper (or other) ions penetrate the fiber of organic materials and coordinate with the organic matrix. These coordination sites create additional nucleation areas that attract more copper ions. Corrosion products then

gradually replace the fiber as it decays, forming a positive fiber cast composed primarily of copper corrosion products, typically the basic chlorides or carbonates. Negative casts form when the corrosion products deposit on the surface of the fiber, which then decays and leaves resid-

ual copper corrosion products as a negative impression of the original material. Since copper ions are strongly biocidal, their impregnation of the organic material may preserve it from biodeterioration during burial.

Positive pseudomorphs are much more common with copper than, for example, with iron. Gillard and coworkers (1994) examined mineralization processes using samples of both cellulosic and proteinaceous material. Cotton, linen, silk, and wool were examined after aluminum potassium sulfate mordanting, followed by exposure to solutions containing cupric sulfate, cupric chloride, copper powder, or 6% tin bronze. Mineralization of wool samples had already begun after two days of exposure. Wool was the most reactive natural fiber because of the large number of reactive sites in the protein helix. Silk was almost as responsive; like wool, it bonds to copper at the carboxyl and amide linkages. The more easily degraded wool is influenced by the reactive disulfide linkages in the cystine residue, which is predominant in the amorphous regions of the wool fiber (Alexander, Hudson, and Earland 1963). The rate of mineralization for silk and cellulosic fibers is slower than that of wool. This can be attributed to the greater crystallinity of silk and cellulose, since regions of crystallinity are more resistant to attack. Cellulosic materials bind to copper primarily through the hydroxyl groups, although the details have not been elucidated. During these studies, the addition of sodium chloride to the reactants caused a fine mineral layer to be deposited on the fabric surface. The mineral proved to be botallackite, which rapidly recrystallized to atacamite; on continued exposure, this was further recrystallized to paratacamite—probably clinoatacamite, in fact (see CHAPTER 4 on botallackite).

Exposure of raw wool samples to copper powder and sodium chloride for one and a half years resulted in almost complete mineralization: a carbon loss of 89% occurred with paratacamite formation. Malachite was also found in some simulated-wool samples as well as in material from archaeological contexts. As for cellulose fibers, breakage by hydrolysis can occur under acidic conditions at the ether linkages.

Proteinaceous materials, however, are joined by peptide linkages. In wool, the resulting polypeptide chains are bound by hydrogen bonding, carboxyl and amide end-group interactions, and disulfide linkages. Gillard and Hardman (1996) carried out electron-spin resonance (ESR) studies that showed that where the pH $<$ 9, the bonding of copper to wool is predominantly due to cupric carboxyl complexes. Cupric ions catalyze the oxidation of disulfide bonds but bind elsewhere. The smallest peptide unit exemplifying these reactions is biuret, $NH_2CONHCONH_2$, which, with mildly acidic copper ions, forms a blue-green, bis-biuret copper (II) dichloride complex. The biuret molecule acts as a bidentate chelating material via its amide oxygen atoms; distorted octahedral coordination is maintained by chloride ions. This work suggests that a positive mineralization cast of the original fiber develops during corrosion in two stages: First, copper ions infiltrate the fiber at certain positions in the organic matrix to

A

form copper-organic complexes. Second, when all available sites are filled, controlled mineral deposition occurs, initiated by the already occupied sites. In contrast, the formation of negative casts relies on higher concentrations of copper ions sufficient to exceed the solubility product of the deposited mineral. This process is therefore more random in effect than the formation of positive pseudomorphs. Studies using Fourier transform infrared spectroscopy show that mineralized fibers are rarely totally mineralized; they often retain sufficient organic components to allow fiber identification and, in some cases, dye characterization.

Copper is used today to facilitate commercial mordant dyeing processes. It is especially useful for dyeing polyacrylonitrile fibers (Orlon), which cannot be mordanted with traditional cations such as aluminum. Copper in the cuprous state complexes with the nitrile groups and penetrates the fibers, providing dyeing sites for anionic dyestuffs (Roberts and Caserio 1964).

Chen, Jakes, and Foreman (1996) examined X-ray diffraction data for copper mineralization of plant fibers. They found differences in the physical microstructure between modern and mineralized fibers; the crystallite sizes of the mineralized fibers were larger than those of modern examples of the same fiber. The presence of malachite within the fiber was determined by X-ray diffraction.

Some examples of the preservation of organic materials are shown in PLATE 6 and in FIGURE 1.10. PLATE 6 shows the preservation of a marine organism over the corroded surface of a copper alloy object retrieved from the Mediterranean Sea. The marine organism had formed

FIGURE 1.10 Wood fragments preserved on a Greek copper tablet from the sixth century B.C.E., shown in A, photomicrograph (magnification ×245); and B, scanning electron photomicrograph (magnification ×1250), illustrating the typical cellular structure of a softwood, such as pine, that has survived biodeterioration by being in contact with copper corrosion products on the surface of the tablet.

itself closely to the contours of the copper alloy surface. FIGURE 1.10 shows two different magnifications of positive fiber pseudomorphs of wood preserved on the surface of an inscribed tablet of hammered copper containing an early Greek text from the seventh century B.C.E. The biocidal environment of the copper had even preserved wood fragments, which remained essentially unmineralized during burial.

The degradation of wood and other cellulosic material by verdigris and other copper pigments has been extensively studied. Verdigris, like all copper acetates, is slightly soluble in aqueous solution and consequently easily absorbed by cellulose fibers. Mairinger and colleagues (1980) attributed the degradation of paper to autooxidation of cellulose accelerated by the presence of copper ions in a free radical process; the amount of damage was increased by high levels of light, relative humidity, and sulfur dioxide. In their work on paper, Banik, Stachelberger, and Wächter (1982) showed that copper ions are concentrated in the lumen of the fiber where concentrations of copper can reach 8–10% by weight.

The degradation of wood and cellulosic material was studied by Banik (1989), who found that the stability of cellulose impregnated with verdigris could be enhanced by immersing the material in magnesium bicarbonate solutions. Banik (1990) also found that paper showing signs of deterioration contained copper in both the univalent and divalent oxidation states, noting that the presence of univalent copper could only be explained by a reduction of the copper ion in the original copper pigment on the paper. The cellulose in damaged areas of the paper

samples was depolymerized, with the level of polymerization ranging from 60 to 80, compared with 200–500 in undamaged areas. This difference in polymerization levels can be explained by the cellulose chain being split at the gluocidic linkage. The cellulose is attacked by the copper ions under both alkaline and acidic conditions. Under acidic conditions, the new end groups are aldehydes; under alkaline conditions, the new end groups are carboxyl groups with the amorphous regions of the cellulose fibers attacked first.

According to studies by Shahani and Hengenihle (1986), transition metals such as copper are capable of catalyzing the oxidation of cellulose over a wide pH range. This interaction of copper ions and cellulose occurs under both acidic and alkaline conditions, with the cellulose absorbing copper ions. The copper ions are exchangeable with protons of the carboxyl groups of partially oxidized cellulose (Bicchieri and Pepa 1996). The binding of copper by cellulose is also possible by complex formation with hydroxyl groups. According to Blattner and Ferrier (1985), the absorption of copper increases with the formation of carboxyl groups in cellulose; this results from oxidation under alkaline conditions. The chemical interaction of copper with polysaccharides, such as cellulose and cellulose derivatives, forms a variety of complexes; additional references to this are found in Gmelin (1966).

Williams (1967, 1993) and Williams and da Silva Frausto (1996) did extensive research on the compounds that may form between copper (and other metallic ions) and proteinaceous materials, and their cited works should be consulted for further background information. Inorganic ions such as copper facilitate the decarboxylation of RCOO- groups in proteins, thus inducing deterioration. Guthrie and Laurie (1968) studied the reactions of cupric ions with mohair keratin, whose amino acid components show relatively high amounts of aspartic and glutamic acids. Their results indicate that the side-chain carboxyl groups are the principal binding sites for cupric ions in keratin, with some possible amide contributions through nitrogen atoms. Daniels and Leese (1995) studied the effects of verdigris on silk and calculated an activation energy for the resulting degradation, noting that the copper pigment must be in direct contact with the silk for the deterioration to be accelerated. The direct action of copper ions on a silk substrate may be slowed by suspending the verdigris in a gum binder. For example, alum-deerskin glue is commonly found as a binder in Japanese paintings on silk, and this may play a role in preserving the verdigris pigment used in these works. The gelatin in the glue on sized silk paintings may act as a scavenger for copper ions, since the -S-H groups form a strong linkage—as was noted earlier for wool—and this may help prevent the chemical interaction between the silk and copper ions. Daniels and Leese found that benzotriazole and aqueous solutions of magnesium bicarbonate were both effective in helping to stabilize the degradation of damaged silk fibers. Since magnesium bicarbonate proved effective in previous conservation treatments of other fibers, the researchers recommend it as the preferred choice for stabilization of silk.

The pervasive influence of copper ions on degradation reactions extends to proteinaceous paint media. Khandekar and Phenix (1999) studied molecular-weight changes in egg tempera films to which lead white, vermilion, azurite, or verdigris pigment had been added, followed by artificial aging. All samples containing azurite had crosslinked to a greater extent than those containing vermilion, with those samples exposed to azurite having molecular weights above 250,000. The effect of verdigris on the egg tempera medium was very different: only low-molecular-weight components, with weights under 14,000, were found, indicating that the verdigris had initiated a breakdown of the proteins. This is probably due to verdigris being more soluble than azurite.

Copper in an acidic environment gradually degrades amino acids until they are no longer detectable by high-performance liquid chromatography (HPLC) (Halpine 1996). Masri and Friedman (1974) found that wool, which contains about 3.5% sulfur, readily adsorbs copper ions by reaction with the -s-h groups to form copper mercaptides.

Copper is involved in the polymerization rather than the degradation of Oriental lacquer, an oil-in-water emulsion that makes up the sap of the lacquer tree, *Rhus verniciflua*. Copper is found in the enzyme laccase, which initiates drying. Laccase, which has four copper atoms per molecule, is a copper glycoprotein, p-quinol-O_2-oxidoreductase, with a molecular weight of 120,000. A subsidiary copper glycoprotein, stellacyanin (molecular weight 20,000), is also present in the sap, although its function is not known. Polymerization of the sap is initiated by the laccase-catalyzed oxidation of urushiol to a semiquinone radical; this is accompanied by the reduction of Cu (II) to Cu (I) in the laccase. Subsequent or continuing oxidation of the urushiol requires the oxidation of Cu (I) in the laccase by air and oxygen as follows:

$$Cu^+ (laccase) + \tfrac{1}{2}O_2 + 2H^+ = Cu^{++}(laccase) + H_2O \qquad \text{1.19}$$

This process explains why Oriental lacquer is cured in a chamber with high relative humidity, which encourages the diffusion of moisture and oxygen into the sap. The chemistry of these reactions is reported in detail by Kumanotani (1981, 1982, 1988).

THE METALLOGRAPHY OF CORRODED COPPER OBJECTS

Corrosion products on many ancient objects may be the result of deliberate patination at the time of manufacture, or they can result naturally from burial or exposure to the atmosphere. Many books on the subject do not discuss how corrosion processes, often multiple ones, can transform ancient metals into practically composite materials consisting of metallic remnants and mineral alteration products. Corrosion products, therefore, should not be cleaned from the surface of antiquities before metallographic examination, if feasible. Loose material or soil, and soil and mineral concretions, should be removed, however, because their continued loss during polishing could create a badly scratched surface that would interfere with microscopic

examination. It is usually possible to polish corroded samples in much the same way as more robust specimens, although if the material is very friable, vacuum impregnation with a low-viscosity epoxy resin should be considered before mounting; alternatively, the entire sample should be mounted in resin under vacuum.

It is most important to examine all features of the corrosion products before etching a specimen, since many corrosion products are badly attacked by chemicals used to etch metal surfaces, and they may be dissolved completely. For example, cuprite and malachite are strongly attacked by alcoholic ferric chloride solutions or acidified potassium dichromate, which are often used in the examination of microstructure. Under normal bright-field, reflected-light microscopy, most corrosion crusts appear gray. Examination under reflected polarized light, however, often reveals the true pleochroic colors of the corrosion products. This not only aids considerably in the interpretation of many microstructures but also plainly reveals many crystalline or other morphological details. PLATE 7 shows some typical microstructures incorporating different corrosion features.

During metallographic examination of a corroded metal, the interface of interest may not be only between the metal and the primary (or remaining) corrosion products. Important information may also be preserved in some interfacial event between layers of corrosion products of different composition or structure. It is sometimes possible to retrieve valuable structural information concerning the authenticity of an object from metallographic examination of corroded metallic fragments, even small chips. This is often because part of the structure is selectively corroded, leaving one phase uncorroded, or because the phases have undergone pseudomorphic replacement by corrosion products.

POLISHING TECHNIQUES When a corroded sample is mounted for polishing, difficulties may be encountered in preparing a scratch-free surface. Abrasive particles, which frequently become embedded in corrosion products, can be dislodged during polishing and may scratch the metal. At the other extreme, some corrosion layers may retain the diamond polishing compound and loosened particles, resulting in an exceptionally good polish to the cross section. Many other variables may also intervene.

Prolonged polishing with intermittent etching or ultrasonic cleaning in acetone or alcohol to remove loose or embedded particles may help to produce a better finish. A danger, though, is that small specimens will become rounded at the edges, causing part of the corrosion crust or edges of the metallic constituents to be out of focus during optical examination. It still may be possible, however, to view these specimens with an electron microscope, which has a greater depth of field. The polishing hardness of corrosion products is usually quite different from that of the metal that formed them. Surface relief effects are therefore common when examining corroded samples. The author has found that detail in corrosion products is more sharply preserved when diamond polishing compounds rather than alumina compounds are used.[23]

CORROSION PRODUCTS AND PIGMENTS

Corrosion products and pigments can be characterized as minerals only if they correspond to naturally formed substances previously identified in nature by mineralogists and geologists. Some products may closely resemble synthetic substances produced in the laboratory rather than the natural mineral version. In some cases, there are very distinct differences between these synthetic and natural minerals; in others, the differences are so slight that the distinction is meaningless. Although there are some exceptions to this generalization, unidentified corrosion products will remain as such unless an equivalent in nature or the laboratory is found.

In the following chapters, corrosion products and pigments are discussed, along with any relevant environmental distinctions, in the following general order:

- oxides and hydroxides
- basic carbonates
- chlorides and basic chlorides
- basic sulfates
- sulfides
- phosphates
- nitrates
- silicates
- organic salts
- bronze patinas and corrosion processes

Notes

1 Pliny the Elder *Natural History* 34.21 (Pliny 1979).

2 Oxidation-reduction power, or redox potential, abbreviated as Eh.

3 The following spot test for the presence of copper(II) ions provides a useful example of a chemical corrosion reaction. To the unknown, one drop of a 5% solution of potassium ferrocyanide, $K_4Fe(CN)_6$, is added followed by one drop of a 10% aqueous solution of hydrochloric acid. The released copper(II) cations react with the ferrocyanide to form cupric ferrocyanide, which has a brick-red color, confirming the presence of copper. This is described by

$$K_4Fe(CN)_6 + 2Cu^{++} = Cu_2Fe(CN)_6 + 4K^+$$

4 A Gibbs free energy of reaction is the difference in free energy between the products and reactants. It is expressed as $\Delta G = \Delta H - T\Delta S$, where ΔH is the change in enthalpy, T is the absolute temperature, and ΔS is the change in entropy. If the

ΔG value is negative, the reaction will proceed, unless the rate of reaction is so slow that no practical change occurs.

5 The neck of the jar had been removed, and a circular break in the clay showed traces of asphalt. A copper cylinder, 98 mm in height and 26 mm in diameter, was found inside the jar with a round copper sheet soldered to the bottom. A heavily oxidized iron rod, 77 mm in length, was found inside the copper cylinder, held firmly in place by an asphalt stopper that had been fitted into the top of the cylinder. When discovered, the rod extended 10 mm above the stopper, and the cylinder protruded slightly from the asphalt seal, allowing access to both the copper and iron surfaces at the top of the jar. An asphalt layer about 3 mm thick covered the base of the cylinder, preventing the rod from coming into contact with the base of the cylinder. To make a working battery, it would have been necessary to prevent the iron

from touching the copper. The placement of asphalt would have been of practical use if this object had been used as a battery. A number of similar finds have been made in Iraq, though none with an iron rod present.

6 A typical recipe for arsenic plating, given by Fishlock (1976), consists of 370 g of arsenic trioxide, 284 ml of hydrochloric acid, 71 ml of sulfuric acid, and 4550 ml of water. The surface is usually protected with lacquer or wax after patination.

7 Hiorns (1892) gives the following recipe for mercury plating: 9.7 g of mercuric chloride, 9.7 g of ammonium nitrate, 99 ml of water, and enough ammonium hydroxide added until the precipitate that forms just redissolves.

8 To make electrotyped duplicates for study, the objects were first cleaned in acetone and coated with a nitrocellulose lacquer. A system of fiberglass-polyester resin pads and tubes was constructed to hold the metallic fragments in position on a carved wooden base. The shape of the objects was completed with Plasticine, and missing decorations were remodeled. A mold was then taken from the assembly, and an electrotyped copy was made.

9 An impression in the soil left by a completely decomposed body.

10 It is slightly surprising that so many of the Viking-age Birka finds proved to be copper-zinc alloys. This could be explained by the reuse of Roman scrap, as was done, for example, during the Anglo-Saxon period in England. This does result in the presence of zinc in some of these alloys because of the earlier Roman cementation technique for making brass.

11 In a related article by Meijers et al. (1997), the term "conservability" is introduced. It is not exactly clear what this word encompasses; one possibility is that it may refer to the ability of the object to be "conserved," or to the measurement of the benign or aggressive tendencies of the soil in which the object was buried, or to the combined effects of deterioration on the treatment options available for a particular class of materials being considered.

12 Plutarch *Moralia, the Oracles at Delphi no longer given in verse* 5.351c–438e (Plutarch 1984).

13 The Clean Air Act was passed by the U.S. Congress in 1970.

14 The formation of these dark patinas influenced London's aesthetic approach to the maintenance of the city's exposed bronzes beginning in about the 1950s, at least. In this process, corrosion excrescences are removed, and the bronze surface is treated with lanolin, beeswax, or paraffin wax, often in a mixed formulation. This results in a shiny, opaque, very dark green, brown, or black patina. Harris (1994) claims that many treatments in the United Kingdom involve restoration practices that can cause extensive damage or are not supportable on aesthetic grounds. Clearly more information is required regarding what exactly has been done to these bronzes since the early part of the twentieth century.

15 Deposition is the process by which a pollutant reacts with the surface of a material. This can vary greatly, depending on how the material is finished.

16 The so-called original surface is the discrete, recognizable boundary often preserved at the interface between the corrosion material that has developed on the object and the corrosion that has occurred within it. Many objects now in museum storage were cleaned in the past down to their metallic remnants, resulting in significant loss of shape of the original artifact. This cleaning was undertaken in the mistaken belief that any remaining corrosion implied long-term instability. It is now known that this is not necessarily the case.

17 Helena Strandberg, letter to the author, 8 September 1998.

18 ISO standards, as well as those of the American Society for Testing and Materials (ASTM), are of interest in helping to evaluate the effects of corrosion, particularly in outdoor exposure trials, on metallic materials, or on organic coatings. The use of these standard protocols enables different laboratories to achieve some degree of comparability in the evaluation of description of the sample or corrosive events that may have occurred.

19 The data from previous studies were incorporated here to give a composite indoor distribution function, and a lognormal approximation was found to be an appropriate fit.

20 Witcamine RAD 1100, manufactured by Witco Corp., Ontario, Canada.

21 Hostacor KS1, manufactured by Hoechst AG, Frankfurt, Germany.

22 Yüan Hung-tao, 1605 (Kerr 1990:68).

23 See Scott 1991 for additional information on the preparation and metallography of ancient metals.

Oxides and Hydroxides

Let our next subject be ores, etc., of copper and bronze....Antiquity
shows that the importance of bronze is as old as the city — the fact
that the third corporation established by King Numa was the Guild
of Coppersmiths. — PLINY THE ELDER [1]

During the corrosion of historic and ancient metalwork, the predominant oxide of copper to form is cuprite, Cu_2O, a red suboxide of copper (cuprous oxide) that occurs over a very wide range of conditions. In addition to being both a common mineral and a common corrosion product of copper and copper alloys, cuprite is also an important colorant in ancient glasses. It has never found any obvious use as a pigment, however, because the subfusc red color of ground cuprite could easily be obtained with natural ocher and sienna, which were far more readily available than the pure mineral. The other, less common oxide of copper is tenorite (cupric oxide), CuO. The hydroxide — spertiniite, $Cu(OH)_2$ — may be a common intermediate product in many corrosion processes but is rarely isolated as a stable mineral phase. Characteristics of these minerals are briefly described in TABLE 2.1.

TABLE 2.1

CHARACTERISTICS OF SOME COPPER OXIDE AND COPPER HYDROXIDE MINERALS

MINERAL NAME	FORMULA	CRYSTAL SYSTEM	COLOR	MOHS HARDNESS
cuprite	Cu_2O	cubic	submetallic red	3.5 – 4
tenorite	CuO	monoclinic	metallic gray black	3.5
spertiniite	$Cu(OH)_2$	often amorphous	blue green	1–2?

CUPRITE

Properties of cuprite

Cuprous oxide typically has a dark red to orange-red color and a sometimes adamantine luster. If finely crystalline, cuprite may also appear orange yellow. In fact, cuprite may exhibit a range of colors—yellow, orange, red, or dark brown—depending on its impurities, nonstoichiometry, and particle size (Gmelin 1965). The mineral has a Mohs hardness of 3.5–4 and is insoluble in water. Cuprite crystallizes in the cubic system, and cubes or interpenetrating cubes are often seen on the surfaces of corroded bronzes. Sage (1779) was the first to equate the cuprous oxide corrosion product of ancient copper alloys with the natural mineral cuprite. By the 1820s several workers—Noggerath (1825), for example—were also aware that the corrosion product on copper and the natural mineral were one and the same.

When metal reacts with the gaseous environment, metallic oxides are the first interface to form, developing into a thin film or thick scale over the exposed metal surface, thereby slowing the rate of further oxidation. These oxide layers are often interference films, in which light is reflected back from the top and bottom of the film. The oxidation temperature may alter the plasticity of oxide films.[2]

During the growth of copper oxide films, oxygen atoms migrate inward and metal atoms outward, with the mode of migration dependent on the defect structure of the oxide lattice. A cuprite film contains slightly less copper than the formula Cu_2O suggests. The oxygen lattice is stoichiometric, but there are a small number of vacant sites in the copper lattice. To maintain the electrical neutrality of the oxide as a whole, some copper(II) ions may be present in the Cu_2O lattice. Cuprite is, therefore, a defective oxide structure; the missing electrons make cuprite a p-type semiconductor, since each missing electron is equivalent to a positive hole in the electron band structure. This structure is important for cuprite's role in the corrosion of cop-

per alloys, since cuprite allows the oxide film to conduct electronically. It does this by transferring an electron from a cuprous ion to a cupric ion — in effect, by migration of the positive holes. Ionic conduction in cuprite occurs, therefore, by migration of the vacant sites in the copper lattice, and oxidation takes place by the migration of copper through the film to the surface. Corrosion processes are facilitated because O^{2-} and Cl^- can be transported toward the metal, and Cu^+ can travel outward.[3] Despite these defects, cuprite often preserves important detail of the original surface of an object by acting as a marker layer (Organ 1963a,b; Chase 1994).

Some buried bronzes preserve a patina that is principally cuprite, such as the patina on the bronze head of the Emperor Hadrian from the second century (PLATE 8), now in the collections of the British Museum. A predominantly cuprite patina under vestigial malachite covers the bronze casting of the Egyptian god Horus (PLATE 9) from the collections of the Shumei Cultural Foundation, Japan.

There is often an epitactic relationship between the growth of the cuprite layer and the orientation of the copper-alloy substrate, and this helps to preserve pseudomorphic detail within the corrosion. The dendritic pattern of cast bronze, for example, may be preserved within the structure of a cuprite crust as the corrosion replaces the metallic phase. Twinned crystal structures in worked and annealed objects can also preserve faint traces of the grain boundaries or twin lines within the corrosion layer.

Cuprite can form on a bronze by exposure to moist air, by tarnishing in use, or during burial. For the majority of bronzes, cuprite is the corrosion layer within the metallic surface layers and immediately overlying the original metallic surface. When bronze alloys corrode, the most common event is the formation of cuprite within the immediate surface layer of the alloy. As the corrosion process develops and copper ions migrate outward, the cuprite may grow over the originally developed corrosion and present a number of different layers when examined in cross section. Some of the cuprite will be seen to have developed below the original surface, often still preserved within the corrosion, and some will have developed above this original surface, embedding the marker layer within the cuprite crust.

Cuprite can also occur, however, as a primary component of the metal itself. It can result from oxygen absorption and the formation of copper-cuprous oxide eutectic, or it can appear as small globules of cuprite from the original melt. Cuprite may show strong polarization colors when viewed under crossed polars; this is one method of distinguishing between inclusions of cuprous oxide and those of cuprous sulfide. The two most common nonmetallic inclusions in ancient bronze alloys are copper oxides and copper sulfides, which may be distinguished by polarized light microscopy. The oxide is usually cuprite and shows strong polarization colors when viewed under crossed polars. With primary cuprite inclusions, a stationary cross may often be observed. Copper sulfides, such as chalcocite (Cu_2S), however, remain black under crossed polars and do not reveal any anisotropic characteristics or pleochroism.

Sulfide inclusions originate from impurities in smelted copper ores, which are frequently derived from sulfidic ore bodies or copper-sulfarsenide ores. Cuprite can originate from reactions that occur when copper is melted, since copper absorbs both oxygen from the air and hydrogen from the decomposition of water vapor. When the copper cools and solidifies, the oxygen is precipitated in the form of cuprite and the hydrogen expelled. The expelled hydrogen may then react with the cuprous oxide, producing steam that may become entrapped in the metal. Wooden poles were once used to stir molten copper to deoxidize it, which left about 0.05–0.06% oxygen in the metal to form cuprite. In this way, the production of steam balanced the natural shrinkage of the metal, and a casting pipe was avoided (Smithells 1937).

Cuprite can also be formed as a result of interaction with organic compounds that can be easily oxidized, such as aldehydes, in Benedict's and Fehling's solution (a classic use of cuprite in a chemical test), and so on. This may have an indirect bearing on possible reactions with decaying organic matter in burial, where the organic material may be oxidized and the copper salt reduced to cuprite.

In PLATE 10, a photomicrograph of a typical bronze patina viewed under polarized light illustrates the pleochroic colors of the corrosion crust. The red-and-yellow cuprite layer is clearly visible under a malachite crust containing soil minerals, with sound metal below the cuprite.

PLATE 11 shows a polished cross section of a Han dynasty (206 B.C.E.–220 C.E.) buckle viewed under polarized light. The fine pseudomorphic retention of the dendritic structure of the cast bronze is visible in the cuprite corrosion that has replaced the metal. A faint dendrite pattern can even be seen in the malachite crust over this cuprite layer and appears to be exceptionally well preserved in this example. It is uncommon for malachite to preserve pseudomorphic structural detail, and few examples of such structures have been published. They do occur, however, especially in bronzes from China, where the burial conditions appear to be favorable for this kind of preservation.

PLATE 12 shows a cuprite crust on a small Bronze Age ax from Ireland. The cuprite layer has preserved fine lines that represent the strain lines of the original copper grains. Such strain lines result from heavy cold-working of the ax to harden its edge, which was a common fabrication technique. Other comparable metallographic studies confirm that this edge hardening is due to deliberate cold-working on the part of the metalsmiths and not from hardening that occurs during use (Allen, Britton, and Coghlan 1970).

Infrared spectroscopy reveals that metal oxides are usually nonabsorbing above 1000 cm^{-1} but show at least one strong absorption band and several weaker ones in the 300–900 cm^{-1} region. Cuprite shows a very strong absorption band at 615 c^{-1} due to lattice vibrations (O'Keeffe 1963; Carabatos, Diffine, and Sieskind 1968). Giangrande (1987), who confirmed that

these data apply to archaeological material, also found weaker absorption bands, probably due to impurities, as well as a band at 3360 cm^{-1} from the presence of adsorbed water. Another band at 1100 cm^{-1} was previously reported by Pasterniak (1959), who ascribed it to the presence of silicon impurities in the cuprite lattice.

Natural cuprite patinas

PRESENCE OF COPPER CRYSTALS Metallic copper is sometimes seen in the cuprite patina on a corroded bronze. One mechanism for the deposition of copper is from the dissolution of cuprite inclusions within the bronze or corrosion from the dissolution of cuprite crusts formed during burial. In some bronzes, these redeposited copper crystals, usually twinned, occur together with a cuprite region or cuprite inclusion from the original melt. The redeposited copper may occur together with cuprite since, during corrosion, voids or intercrystalline regions of the grains may be converted to cuprite at some depth in the alloy. The cuprite inclusions may, in some cases, also originate from oxidation during casting or from cuprite inclusions in the melt. As a result, there may be partial alteration of these cuprite areas to redeposited copper. The cuprite layers that develop as a result of subsequent corrosion may also be subject to reductive processes, with formation in some areas of redeposited copper.

Davy, writing in 1826, may have been the first to observe such deposits in cuprite patinas. He noted that "red crystals were found to be formed of octahedrons of the red oxide of copper, intermixed with crystals of the same form of metallic copper. These crystals were most distinct at the surface" (Davy 1826 : 56–57).

The prevalence of copper crystals on the surface of an object is often observed on ancient bronzes, especially where the cuprite layer is exposed to view (i.e., not covered with a secondary layer or cleaned away). There is no doubt that this redeposited copper is an effect of corrosion and not of incomplete melting of the alloy. Understanding the genesis and formation of this redeposition, however, requires further research. Chase (1994) notes that cuprite is the stable phase in the presence of carbonate, chloride, and sulfur at pH 8 and at an oxidation potential of 0.1 V (Pourbaix 1973). If the pH or oxidation potential drops, the Pourbaix diagram for this system moves into a region where copper metal is the stable phase. In natural corrosion, where the processes may be very slow, some patinas show in cross section a uniform transformation of cuprite to copper. Also, where inclusions or voids filled with cuprite below the surface have undergone alteration, there may be a rim or outer zone where the cuprite has been transformed into redeposited copper, some of these showing unaltered cuprite cores. This transformation occurs when a bronze alloy contains lead that is present as small globules. A probable scenario in this process is that corrosion of the lead globules leaves behind spaces that are then filled with cuprite; in response to slowly changing burial conditions, this cuprite is then altered into redeposited copper.

McKee and colleagues (1987) show interesting cross sections that reveal growth planes in some redeposited copper globules in a thin film of patina on a Chinese bronze ritual vessel from the Rewi Alley Collection at the Canterbury Museum in New Zealand. Scanning electron microscopy indicates that the thin film contained copper, tin, sulfur, and lead. The patina film may have formed during corrosion in a selective reaction of the alloying elements tin and lead with sulfate or sulfide ions in the groundwater. This was followed perhaps by renewed corrosive events in which copper redeposition occurred in the form of discrete particles within the patina.

McKee and coworkers also suggest that, in some cases, redeposited copper could fill the spaces formerly occupied by lead globules in leaded tin-bronze alloys. The photomicrograph in PLATE 13 shows redeposited copper at some depth in a ceremonial ax dated to about 500 B.C.E. from the Luristan region of Iran. The sample was color etched in acidified thiosulfate etchant (Scott 1991), revealing that corrosion had occurred in the alpha I delta cutectoid phase, which resulted in deeply corroded channels within the otherwise sound alpha-phase matrix. As a result of the corrosion of the tin-rich part of the alpha+delta eutectoid, redeposition of copper occurred in regions of the ax many thousands of microns below the patina. Redeposited copper was also found in the junction or space between the blade and the cast-on handle, indicating that redeposited copper can fill voids as well as replace particular phases or regions.

Chase (1994) discusses an interesting example in which redeposited copper has replaced the cuprite marker layer on a Chinese zodiacal mirror from the Sui dynasty (581–618) in the collections of the University of Michigan. This is a rare event, and only a few objects are known to show this kind of pseudomorphic replacement by copper. Sometimes there is no pseudomorphic preservation of structure at all, particularly where the cuprite has formed euhedral crystals or has developed as a spongy and sometimes porous layer.

| BANDING IN CUPRITE PATINAS Cuprite corrosion may exhibit banding. Sometimes this is impressively developed with multiple layers of cuprite and malachite sandwiched together in a structure reminiscent of Liesegang phenomena, first reported by the twentieth-century German chemist Raphael Eduard Liesegang in 1896. This phenomena may be understood as follows: If two reactants are mixed together, a banded or sequential array of chemical reactions can be created in liquid-phase homogeneous systems that are collectively known as the Belousov-Zhabotkinskii reactions. The possible reactions between liquid and solid phases, which are classed as heterogeneous systems, can then give rise to periodic precipitation of the products, which is commonly referred to as Liesegang phenomena (or Liesegang rings).

Typical examples are shown in PLATE 14. The interlayered deposition of malachite and cuprite from a corroded bronze pin in the collections of the Iran Bastian Museum, Tehran, is shown in PLATE 14A. Some thick lines and many fine ones are visible in this photomicrograph,

corresponding to different deposition conditions in the cuprite as it formed during the corrosion of the object. PLATE 14B shows the finely layered corrosion crust of malachite, cuprite, and tin oxides in a British bronze palstave from Kent.

It is difficult to prove that such multilayered structures are, in fact, attributable to Liesegang phenomena, since the spacing of the layers rarely follows any mathematical equation that relates to Liesegang structures. The principle, however, is surely applicable. Although the layered structures do not correspond to typical periodic cycles, such as years or seasons, they probably follow the slow cycle of interpenetration and deposition of corrosion products that occurs during burial. In this process, the carbonate ions reach a level for precipitation as a solid crystal phase; the zone of depleted carbonate or bicarbonate ions allows cuprite to re-form; and the cycle can then be repeated (Scott 1985).

| ENVIRONMENTAL DISRUPTION OF CUPRITE PATINAS Cuprite growth on bronze statues exposed to the outdoor environment in coastal areas may be exacerbated because of the higher concentration of atmospheric chlorides in these regions. In fact, it has been demonstrated experimentally that cuprite patinas can be disrupted by sulfide ions and chloride ions found in the soil and in marine environments as well. When copper plates are exposed to a cupric chloride solution, a thin cuprite crust usually develops, with a green paratacamite layer on top. It is possible that the presence of additional or thickened cuprite layers on outdoor bronzes may be associated with continued corrosion in a similar manner; further research to clarify this issue is needed.

| CUPRITE REMOVAL Cuprite layers may resemble sugar if the crystal size is large, or they may be dense and compact if finely crystalline. These dense layers can be shaved off with a scalpel when bronzes are mechanically cleaned. Some of these layers may be quite difficult to remove or to reduce in thickness, however, and this often leaves clearly visible damage to the finer, protective cuprite layer beneath them if the work is not skillfully executed.

Chemical dissolution of cuprite layers without substantial attack on the metal or other desirable surface products is difficult because most of the chelating agents employed will attack cuprite only very slowly. This is often an advantage, since the fine layer of cuprite that is usually adjacent to the bare metal surface should not be removed. In some cases, however, a cuprite corrosion crust may be unwanted, particularly if it has developed over gilding or silvering. In such cases, it may be necessary to mechanically or chemically remove it. On gilded bronzes, a 10% aqueous solution of formic acid in water is a useful reagent to use initially, if mechanical cleaning would cause too much disruption to the surface. Even with this solution, the dissolution of the cuprite crust is still very slow and may have to be aided by light rubbing with a cotton swab dipped in the reagent.

The calculation of relative molar volumes (RMV) may be potentially of value, since it provides a measure of the increase in volume that occurs when a metal transforms to another product, such as an oxide, during corrosion. The concept of relative molar volume, first used by Pilling and Bedworth in 1923 (Evans 1960), is defined as

$$RMV = \frac{(MW \text{ of product}/\text{density of product})}{(n)(AW \text{ of element}/\text{density of element})} \qquad 2.1$$

where n is the number of metal atoms in the product, MW is the molecular weight of the product, and AW is the atomic weight of the element. For cuprite, the RMV is 1.67; for tenorite, 1.75. Both of these relative molar volumes are small compared with other copper corrosion products. Oxides often have quite low molar volumes, which can assist with the preservation of the shape of the object during corrosion. This is one reason why cuprite is able to preserve epitactic information, since the volume expansion on cuprite formation from the metal is not great.

Robbiola (1990) demonstrated by direct-current polarography and alternating-current impedance studies that the oxidation film formed on a bronze containing 7.5% tin showed an overvoltage for oxidation compared with that of pure copper. This implies that greater energy needs to be applied to the system to create corrosion on the bronze surface as compared with pure copper. Chase (1994) believes that this additional protective effect of the cuprite layer may be a consequence of the incorporation of tin into the cuprite, as $Sn_xCu_{(1-x)}O_2$. This may be a possibility since recent sol-gel work shows that mixed oxides of copper and tin can be prepared. Fang and colleagues (1996), for example, made nanocrystalline powders of SnO_2-CuO and characterized the product by X-ray diffraction.

Intentional cuprite patinas | The existence of deliberately patinated copper alloys (discussed in greater detail in CHAPTER 11) has been known from antiquity, and the story of their extensive use by many different cultures is told by Craddock and Giumlia-Mair (1993). Of particular interest is their description of the well-known Corinthian bronze alloy, famous in the ancient world for its lustrous black patina.

Alloys with patinas that have been intentionally applied for aesthetic reasons often contain small additions of gold, arsenic, or other metals that influence the patina's formation. For example, Craddock and Giumlia-Mair discuss ancient Egyptian bronzes known as *hsmn-km* that have a black patina. Some of these bronzes contain about 4% gold, 1% arsenic, and 1% silver; X-ray diffraction studies have determined that the principal patina component is, indeed, cuprite. Metalworkers in ancient times discovered that it was possible to grow cuprite films of mixed composition. Research by Murakami, Niiyama, and Kitada (1988) on Japanese *shakudo* alloys (made from the earliest centuries C.E. up to the nineteenth century) confirmed the ability of cuprite to include other metallic components, such as gold. *Shakudo* alloys are generally

made from copper containing from 1% to 3% gold. X-ray diffraction studies show that the black patina is cuprite, but transmission electron microscopy studies indicate that gold atoms are also present in the cuprite layer, forming dispersed clusters. These aggregates of gold atoms, in a superlattice-type structure, must be responsible for the alteration of cuprite from red to black, although precisely how is not understood. Murakami (1993) suggests that the fine gold particles or clusters may be of a critical size to absorb the red portion of the visible spectrum, resulting in a black color. Murakami notes that a variant of the Japanese term *shakudo* can be translated as "crow gold" or "black gold." The type of *shakudo* used in the Edo period (1600–1868), however, sometimes contained small amounts of silver instead of gold, indicating that silver was also used as a deliberate alloying addition.

A copper alloy containing more than 10% gold is known as *shi-kin*, "purple gold." This particular alloy may be related to a Chinese copper alloy, called "purple sheen gold," that contains small deliberate additions of gold, often 1–3% (Needham 1974). Like the Japanese *shakudo*, these Chinese alloys also have an artificially patinated surface that is principally of cuprite.

One of the earliest publications describing experimental work on Japanese *shakudo* is that of Uno (1929), who had determined that copper with about 5% gold could produce these black patinas. Uno prepared a large number of test alloys and treated them with several different patination solutions. His laboratory work showed that various minor alloying elements, such as arsenic or antimony, could also influence the patinated color. Giumlia-Mair and Lehr (1998) investigated the effects of small additions of gold, silver, arsenic, iron, tin, and lead on the surface color of the alloy after a number of different patination procedures. Giumlia-Mair (1996) encountered lustrous, dark patinas on copper objects from ancient Egypt that did not contain any gold but rather small amounts of arsenic, tin, iron, and lead.

It is difficult to know if certain alloys were produced deliberately with trace elements to influence surface coloration. Many ancient bronzes with low tin content might qualify as a special composition, since iron, arsenic, lead, and antimony are the trace impurities most commonly found in copper alloys. For example, the magnificent Chalcolithic bronze hoard found at Nahal Mishmar, Israel, includes many objects made in a copper alloy with high amounts of arsenic and antimony (Shalov and Northover 1993). The objects display a lustrous, dark plum-colored patina. Because of their ancient origins, however, no one would suggest that these alloys had been deliberately made with a special composition to influence the coloration.

There is strong evidence, however, that alloys with different compositions were sometimes used to manipulate the surface color of objects. Gold may always be viewed as a deliberate addition. For example, Giumlia-Mair and Quirke (1997) examined a Syro-Palestinian sword from Balata Shechem, Israel, now in the Ägyptische Sammlung Museum in Munich, that had a blade made of bronze with about 12% tin, and a blue-black midrib of copper alloy containing about 0.5% gold and 3% arsenic. Examples of black-surfaced Egyptian bronzes from the collections

of the British Museum are discussed by Craddock and Giumlia-Mair (1993). As research progresses, numerous other examples are being discovered, such as the mid-nineteenth-century B.C.E. statuette of Amenemhet III from al-Fayyum, Egypt, and a bronze crocodile from the same period in the Ägyptische Sammlung Museum, Munich (Giumlia-Mair and Lehr 1998).

| SURFACE TREATMENTS TO INFLUENCE PATINA DEVELOPMENT

A variety of surface treatment techniques were used in antiquity to influence the kind of patina that would develop on an object. Giumlia-Mair and Lehr report a Greek process for patination that calls for quenching red-hot copper alloy in aqueous solutions, for example. The principal patina expected from this kind of heat treatment and quenching would be one of copper oxides, either cuprite or tenorite.

Using a verdigris, copper sulfate, and alum mixture to chemically treat copper alloys containing small amounts of added gold produces a lustrous black cuprite patina containing small amounts of gold; pure copper treated in this way would show only the red coloration of cuprite. The use of this kind of patinating solution in Japan, where it is known as *nikomi-chakushoku,* can be traced back at least six hundred years. Replication work for this technique is described in APPENDIX B, RECIPE 1.

Allusions by Plutarch (ca. 46 — ca. 120 C.E.) to black-patinated bronzes were not understood for many years. This passage from his *Moralia* is much easier to grasp today:

[H]e did however, admire the patina of the bronze, for it bore no resemblance to verdigris or rust, but the bronze was smooth and shining with a deep blue tinge. . . . [I]t was not by art, as they say, but by accident that the Corinthian bronze acquired its beauty of colour; a fire consumed a house containing some gold and silver and a great store of copper, and when these were melted and fused together, the great mass of copper furnished a name because of its preponderance.[4]

PLATE 15 shows an example of a black-surfaced Egyptian bronze of the god Ptah in the collections of the Ashmolean Museum, Oxford. Its attractive red color indicates that cuprite may have been deliberately prepared from copper for such uses, and others of a more practical nature, as this extract from Pliny the Elder suggests:

The flower of copper also is useful as a medicine. It is made by fusing copper and then transferring it to other furnaces, where a faster use of the bellows makes the metal give off layers like scales of millet, which are called the flower. However when the sheets of copper are cooled off in water they shed off other scales of copper of a similar red hue — this scale is called by the Greek word meaning "husk."[5]

Pliny also describes burning corroded copper and pounding it in a mortar of Theban stone, washing it with rainwater, pounding again with more water, leaving it until it settles, then

repeating the process several times until it is reduced to the color of cinnabar.[6] Cuprous oxide was clearly being produced by this oxidation and washing process.

| MODERN ARTIFICIAL CUPRITE PATINAS Cuprite may be present as an intentional patina on the surface of objects made of copper or bronze. The attractive reddish brown patina is generally found in very thin layers. Formulas for such patinas are given in Hughes and Rowe (1982). In addition to application for aesthetic purposes, deliberate oxidation patinas have been used for conservation. For example, Socha and coworkers (1980) employed such a patina for the protection of the bronze column of King Sigismund III in Warsaw, as described in APPENDIX B, RECIPE 2. There is, of course, no guarantee that a new cuprite patina will protect a bronze against further corrosion; alteration of the cuprite to a basic sulfate or chloride may occur unless protective maintenance is provided.

| IMITATIVE CUPRITE PATINAS Pigments have been used in the past to imitate cuprite patina on bronze objects, as is demonstrated by the gypsum-plaster *modello* for the shrine of Pope Benedict XV.[7] The white gypsum model had been painted green with a terre verte, "green earth." Under the green layer, however, the plaster had first been covered with occasional patches of brass gilding metal that had, in turn, been painted over with a red ocher, closely simulating a cuprite patina. Finally, the green layer had been applied, presumably to imitate the secondary green corrosion products of copper, such as malachite or brochantite, with the red "cuprite" and occasional patches of a brassy metallic surface showing through.

Copper colorants in glasses and glazes Reduced colloidal copper particles and red copper (I) oxide have been skillfully employed over the millennia to create beautiful decorative effects in faience, glass, and ceramic glazes.[8] Copper is a bright blue in an oxidized alkaline ceramic glaze but becomes greenish and may even turn clear if the firing creates reducing conditions (Kingery and Vandiver 1986). In fact, the common ceramic term *copper green* is used to describe the slightly bluish green color derived from using copper salts; it is one of the principal ceramic colors.

In *sanggam* celadon ware, a variety of inlaid celadon developed in Korea in the thirteenth century, the incised design is infilled with white or black slip, and additional decoration in copper oxide glazes is used over the slipped decoration (Savage and Newman 1985).

| OPAQUE RED GLASS The opaque red glasses of antiquity have generated considerable interest. When colored a deep red by cuprite, the material was sometimes called *haematinum* or *haematinon* glass and was used during the early Egyptian and Roman periods for making enamels and mosaics as well as glassware.

Freestone (1987) examined examples of opaque red glass from Egypt and the Near East that dated to the first and second millennia B.C.E. Some of the second-millennium examples from the Near East are based on soda-lime-silica glass with no lead content and relatively high levels

of magnesium and potassium; the latter are thought to come from plant ash or possibly from evaporated river water that could have been used as a source of alkali. The antimony content may be as high as 3%, but the colorant is cuprite, from 5% to 10% by weight. The first-millennium glasses from Nimrud and Toprak Kale, Assyria, are fundamentally different and contain about 25% lead as PbO. The concentrations of silica, lime, and soda are low compared with those of the earlier samples, but this glass, too, is colored with about 10% of cuprous oxide. These high-lead glasses are a lustrous opaque red and contain branched dendritic structures of cuprite, along with common relict quartz grains, occasional large copper metal droplets, and some diopside.

The cuprite in the low-lead glasses is much less well developed, and crystallites of cuprite may be less than 10 μm in size. Very small droplets of metallic copper may also be present. Some of these glasses from Alalakh, Assyria, differ from the others in having metallic copper as a significant phase in equant subangular grains up to 10 μm in diameter. The major colorant in these glasses is cuprite, although it has been suggested that the fine grains of metallic copper could be responsible for the coloration of many other opaque red glasses from antiquity.

Growth of the very fine copper particles in ruby glasses that make the glass opaque also tend to dull the red color somewhat. In addition, a glass that precipitates metallic copper will also enter the field of cuprite stability so that coloration of ruby glasses thought to be colored by copper may actually be due to cuprite. Later work by Freestone and Barber (1992), however, showed that Chinese glazes can also be colored by very fine copper deposits.

For glasses that are colored by cuprite, the size and shape of the particles can influence the resulting color considerably. For example, if the particles are finely crystalline, the color of the cuprite can change to a yellow or reddish yellow. This alteration was investigated by Stranmanis and Circulis (1935) in their article on yellow cuprous oxide. Typical microstructures for some of these cuprite-colored red glasses include dendritic cellular cuprite zones outlined by copper particles. In cross section, the cuprite appears red and the copper yellow.

An unusual example of the dichroism of cuprite, reported by Twilley,[9] is shown in PLATE 16. The thin sections are of a fifteenth-century Chinese cloisonné enameled vessel from the collections of the Los Angeles County Museum of Art. Dark red-brown cuprite crystals in the red enamel are visible when viewed under crossed polars (see PLATE 16A); without bright field plane polarized light, the dichroic character of cuprite is revealed, and the crystals now appear blue (see PLATE 16C). This effect is not often observed for cuprite.

To make an opaque red glass colored by cuprite, care needed to be taken to keep the copper in the cuprous state so it could form cuprous oxide rather than producing the glass in the cupric state, which would discolor the final product. The most probable method of production was to maintain the copper in the cuprous state during melting and heat treatment. This approach is supported by archaeological finds, including a blanket of charcoal found on some

ingots from Nimrud, Assyria, and references in cuneiform glassmaking texts from the library of King Assurbanipal (668–627 B.C.E.) that specify the use of crucibles with sealed lids, which would have helped prevent oxidation (Oppenheim et al. 1970). Some of these instructions were quite elaborate, for example:

> [Y]ou place ten minas of "slow" copper compound in a clean dabtu pan. You put [it] into a hot chamber kiln and close the door. You keep a good and smokeless fire burning until the copper compound glows red. You crush and grind finely ten minas of zuku glass. You open the door of the kiln and throw the glass upon the copper compound. As soon as the zuku glass becomes mixed into the surface of the copper compound you stir it a couple of times with the rake until you see some drops of liquid glass form at the tip. When the "metal" assumes the colour of ripe [red] grapes, you keep it boiling for a while, then you pour the "metal" on a kiln-fired brick. This is called *tersitu* preparation. (Oppenheim et al. 1970 : 35)

Oppenheim and coworkers provide many different recipes for making glass colored by copper, bronze, or copper compounds.

RED GLAZES Freestone and Barber (1992) examined the red glaze of a saucer/dish from the British Museum collections that proved to be a Qing dynasty (1644–1911) imitation of an early Ming dynasty (1368–1644) vessel. The researchers discovered that the red color was concentrated in the bottom layer of the glaze, which contained very fine particles, less than 1 μm in size. The layer itself was less than 100 μm thick. Examination of this layer with the transmission electron microscope revealed that the particles were metallic copper, rather than cuprite, present in two size groups: fine polygonal crystals 50–100 nm in size and coarser spherical droplets 200–300 nm diameter. These copper particles probably nucleated and grew from cuprous oxide in the molten glaze. According to modern nanoparticle-calculation theory, the initial particle size of the copper precipitate would be less than 50 μm. As the particles increase in size, less light would be transmitted through the glass, which would become brownish, dull, and eventually opaque (Freestone and Barber 1992). The Chinese artisans showed great skill in making this glaze, which depends on producing a very thin colored layer containing reduced-copper particles beneath a colorless zone. Even more remarkable is that there is not much difference in copper content between the colorless and red-colored layers in the glaze. It may be that the copper is still in the cuprous state in the colorless layer but reduced to metallic copper in the bottom layer.

Ceramic objects colored with glazes containing reduced metallic copper are often referred to as copper lusterware, exemplified by a type of iridescent ceramics from Spain. There is also an English ceramic with a glaze in which the reduced copper metal imparts a natural copper color. Gold foil on a brown-glazed ceramic ground was also used to create an effect similar to that of bronzed copper (Savage and Newman 1985).

The ceramic glazes sometimes known as *sang de boeuf,* "oxblood," were brilliant red with dark red patches resembling coagulated oxblood. This effect often occurred where the glaze accumulated on the shoulders of vases or close to the base. The coloring agent was cuprous oxide formed in a reducing atmosphere. The glaze was developed in China during the Qing dynasty, and the most outstanding examples are often attributed to a particular family of potters. At first, the formulation for these *sang de boeuf* glazes was discovered by chance; by the end of the eighteenth century, however, the effect was carefully controlled. According to Savage and Newman (1985), variations on this kind of glaze were called *flambé* glazes, and objects so glazed were known by the Chinese term *pien yao,* "variegated glaze" or "mottled glaze." Another variant of the reduced-copper red glazes used in China during the eighteenth and nineteenth centuries is *sang de pigeon,* "pigeon blood." Henderson (1991) notes that red glass enamels of the Roman period were also colored by very fine copper particles.

OTHER COLORED GLASSES Copper and cuprite have also been used as dispersed colorants in stained glass, creating what has been called "silver stain yellow glass," "gold glass," or "copper ruby glass." The technology used to produce this glass is complex; it usually requires heating the glass to cause the color to appear. In traditional glass technology, this treatment is called a "strike."

So intense is the coloration created by cuprite in stained window glass that a layer of only 3 mm will block light transmission and turn the glass black. In the twelfth and thirteenth centuries, a good ruby-colored window glass was developed by using multiple, very thin layers of copper-colored glass applied to clear glass. The technique is extremely subtle, and it is not known, even now, exactly how the final effect was achieved (Newton and Davison 1987). From the fourteenth century onward, an easier process was used that involved flashing a thin layer of red-colored glass onto the clear glass; the colored layer was often only 0.5 mm or less in thickness.

The name "aventurine" is given to transparent glass flecked with copper or other metallic particles; this type of glass is similar in appearance to brownish aventurine quartz. The earliest form of brownish glass with copper content of this kind was called "gold aventurine." It was first made in the seventeenth century, and its manufacture is attributed to a glassmaking family from Murano, Italy.

COPPER FOR REPAIR AND DECORATION In addition to being a colorant in glass and glazes, copper is used for the modern conservation of broken glass and ceramics of historical importance. For example, broken window glass is sometimes restored with copper strips instead of lead cames. The edges to be joined are coated with a thin strip of self-adhesive copper foil and then soft-soldered together with lead-tin solder.

During the Song dynasty (960–1279), thin bands of copper were used to decoratively bind the rims of plates and bowls of Chinese porcelain, especially *ting yao* ware.

TENORITE

Tenorite, sometimes called melaconite in older textbooks, is usually a dull black. The ICDD files describe the color a metallic gray black, possibly grayish white in reflected light. The mineral has a Mohs hardness of 3.5. Like cuprite, tenorite is insoluble in water. The type locality for tenorite and other important copper minerals is Mount Vesuvius near Naples, Italy.

Tenorite crystallizes in the monoclinic system and may occur as a crystalline deposit on the surface of corroded objects. The difference in the crystal lattice between copper and tenorite, however, makes it much more difficult to retain pseudomorphic information concerning the structure of the original artifact.

Tenorite formation | Tenorite forms when copper is slowly heated in air. At first, the copper develops a cuprite film that, as it thickens, exhibits a succession of interference colors up to the fourth order. As the film continues to grow, small black spots of tenorite appear, giving the film a sooty appearance. As the thickness increases beyond the interference color range, the black tenorite layer spreads over the entire surface of the copper. A chip of this patina would reveal that the initial red cuprite layer is retained below the tenorite (Evans 1960).

The oxidation of most copper compounds in air will eventually produce tenorite on heating; the compounds will decompose to cupric oxide between 400 °C and 600 °C. One of the ways that Egyptians made black eye paints during the Old Kingdom period (2649–2575 B.C.E) was by roasting malachite to obtain tenorite (Partington 1935).[10]

Tenorite is a rare component of natural patinas. In most terrestrial, marine, and exposed environments, the red cuprite layer is the first to form. When tenorite is present as a patina constituent, it usually indicates that the object has been subjected to heating (by fire, conflagration, etc.) before or during burial. PLATE 17 illustrates a first-century Roman *thymiaterion* (incense burner) in the form of a comic actor seated on an altar. X-ray diffraction studies of this object, which is of bronze with silver inlay, revealed substantial amounts of tenorite in the patina. This would be expected because heat from the burning incense would have produced the conditions necessary for tenorite formation.

Pourbaix diagrams suggest that tenorite should be found in many different environments. In nature, however, the paucity of tenorite occurrences is controlled by kinetic and other factors that limit the mineral's formation to a few specific conditions—for example, high-temperature oxidation and high pH.

MacLeod (1991) found only two instances of tenorite formation in more than five thousand objects examined from Australian shipwreck sites. Tenorite was the primary corrosion product on a copper nail from the *Rapid*. The ship had been burned to the waterline, and the nail was surrounded by charred oak. In the second instance, tenorite was identified on the copper bore of a composite cannon, which had been fired, from the wreck of the *Batavia*.

Tenorite may form by alteration of other compounds, as shown by Gutscher and coworkers (1989), who investigated the transformation of azurite (copper carbonate) into tenorite in wall paintings. X-ray diffraction studies of the paint film revealed an agglomeration of tenorite particles growing on the azurite, which had been used as a pigment. This mineral complex was in close proximity to calcite, $CaCO_3$, which was also present in the paint film along with two different calcium silicates, $Ca_2SiO_4 \cdot 0.3H_2O$ and $Ca_2SiO_4 \cdot 0.35H_2O$, and traces of calcium oxide, CaO.[11] The presence of the calcium compounds implies the existence of a high local pH, which is one of the conditions favoring tenorite formation. Replication experiments showed that the mineral azurite could be altered into tenorite if mixed with calcium oxide in the presence of moisture. The conversion of azurite to tenorite has also been observed on a polychrome sculpture excavated from an alkaline environment.

FIGURE 2.1 shows Pourbaix diagrams for the system $Cu-CO_2-H_2O$ at 25 °C with CO_2 at levels of 44, 440, 4400, and 44,000 ppm. Based on these diagrams, alteration of azurite to tenorite is expected at levels of 4400 ppm and 44,000 ppm, as shown in FIGURES 2.1C and 2.1D, respectively. These carbon dioxide levels are greater than ambient concentrations, which are approximated by the Pourbaix diagram for 44 ppm CO_2, as shown in FIGURE 2.1A. Azurite pigment particles were found near carbonates in the paint layer on the polychrome sculpture, again suggesting that even at ambient CO_2 levels, localized areas of higher carbon dioxide concentration can occur and promote tenorite formation. Where environments are in contact with the atmosphere—for example, at about 0.8 Eh and at a pH between 8 and 14—tenorite, rather than malachite or azurite, is the expected stable phase. The alteration of malachite to tenorite in wall paintings under these conditions has not been reported, as far as the author is aware, but could be expected to occur under the highly alkaline conditions reported by Gutscher and coworkers.

One of the earliest reports describing the blackening of copper pigments in wall paintings that could be related to tenorite formation was by Lucas (1934), who studied the color change of trefoil marks on a painting of a couch in the form of a cow from the tomb of Tutankhamun. He described the markings as being "now of a very dark brown, almost black colour which manifestly were blue originally and still show a little blue underneath the black" (Lucas 1934: 286).

Orna, Low, and Baer (1980) proposed that the original pigment in the painting examined by Lucas may have been covellite, CuS, which is a light-to-dark indigo blue and can be found as a natural mineral. There is no evidence, however, that covellite was ever used as a pigment in Egyptian wall paintings; the traditional colorant was Egyptian blue. Another example of pigment alteration given by Lucas is from wall paintings in the tomb of Amenophis II,[12] where the blue coloration had darkened in places and become almost black. Lucas noted that this blackening was not due to smoke or carbon, but he did not supply an analysis of the altered materials. It is quite possible that the color change in some of these wall paintings is due to the formation of tenorite rather than discoloration of the Egyptian blue pigment.

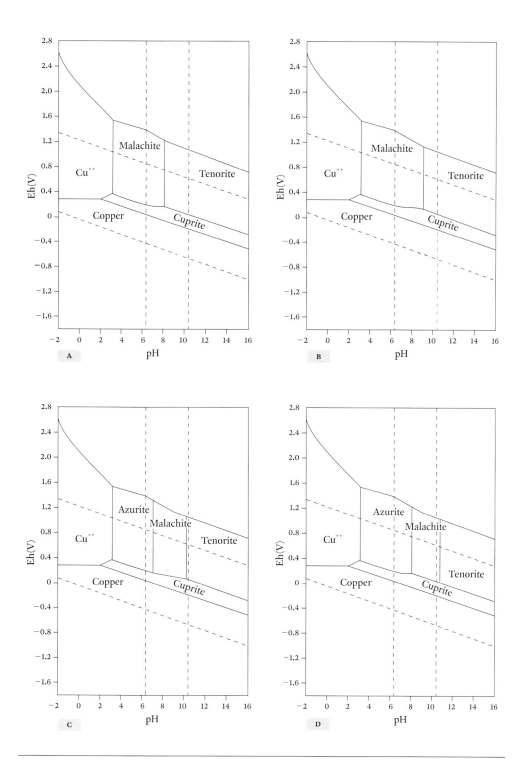

FIGURE 2.1 Pourbaix diagrams for the system $Cu-CO_3-H_2O$ at carbon dioxide concentrations of A, 44 ppm, B, 440 ppm, C, 4400 ppm, and D, 44,000 ppm (after Pourbaix 1977).

SPERTINIITE

The copper hydroxide mineral spertiniite, $Cu(OH)_2$, rarely occurs as a stable mineral phase. It is primarily a transitory, intermediate product that forms during corrosion. Spertiniite is an amorphous or poorly crystalline solid or gel, colored a duck-egg blue, and is transformed to other compounds with relative ease.

MacLeod (1991) reported finding spertiniite as a marine corrosion product of copper alloys from shipwrecks. Once it was allowed to dry, the gel-like precipitate transformed into atacamite. MacLeod, however, did not provide detailed analysis of the material he called spertiniite, and there is the possibility that it was not copper hydroxide but the rare mineral georgeite, an unstable basic copper carbonate (see CHAPTER 3).

CONSERVATION ISSUES

An old conservation treatment for cleaning corroded bronzes used sodium hydroxide, but this method has been abandoned because of the damage it can do to an object. The treatment reduces secondary copper corrosion products, such as malachite or cuprous chloride, to cuprite or tenorite. The powdery, black product that forms was usually stripped from the surface of the bronze, leaving bare metal without its original patina.

Dei and colleagues (1998) reported that copper hydroxide can form as an undesirable alteration product during conservation treatments on wall paintings. Such reports are not uncommon. Copper hydroxide formation has even been noted when historical recipes were used to make light blue pigments.

Weisser (1987) suggested using a localized treatment for bronze disease (discussed in CHAPTER 4), based on the application of an aqueous sodium carbonate solution. One disadvantage of this treatment noted by Weisser was the occasional formation of black spots on the surface following treatment. Pollard, Thomas, and Williams (1990b) investigated the reaction between the cuprous chloride corrosion product and the aqueous sodium carbonate cleaning agent. They found that adding $Cu(II)$ chloride to the cleaning solution produced an initial blue, amorphous precipitate of georgeite.[13] When cuprous chloride was added instead, the reaction proceeded slowly with formation of cuprite, then tenorite. The formation of tenorite was responsible for the black spots noted by Weisser.

The reaction of cuprous chloride with 5% w/v solutions of carbonate will often result in tenorite formation as the end product of cuprous chloride removal. To avoid this, treatment should be arrested following the conversion of cuprous chloride to cuprite, though this is difficult to control in practice. The treatment is not so objectionable that it should be discarded, however, since the light green pustules of copper trihydroxychlorides characteristic of bronze disease are often so aesthetically displeasing that the possibility of tenorite formation may be worth the risk.

Notes

1 Pliny the Elder *Natural History* 34.1 (Pliny 1979).

2 Copper gives smooth parabolic oxidation curves at 800 °C and discontinuous breakaway curves at 500 °C, where the oxide growth is brittle. These curves are derived from plots of the weight increase (in milligrams) against time (in minutes).

3 Chlorine ions, along with O^{2-}, are the most common corrosive agents contiguous with the metal.

4 Plutarch *Moralia, the Oracles at Delphi no longer given in verse* 5.351c–5.438e (Plutarch 1984).

5 Pliny 34.24.

6 Pliny 34.22.

7 Research by the author.

8 The copper in turquoise-blue glasses, and in the glazes often used on Egyptian faience, occurs in the cupric state rather than as cuprite.

9 John Twilley, letter to the author, 14 September 1998.

10 This is the first account the author has been able to find on the use of tenorite as a pigment. Its use was probably always restricted because of malachite's importance as a copper ore.

11 The presence of the calcium silicates needs to be confirmed, and the calcium oxide may actually have been calcium hydroxide, $Ca(OH)_2$.

12 Greek name for Amenhotep II, pharoah of Egypt from ca. 1426 to 1400 B.C.E.

13 Kinetic rather than thermodynamic control appears to be dominant in this reaction since, if the solution is not stirred, the initial precipitate settles out and chalconatronite and georgeite form. Recrystallization of both dimorphs of $CuCO_3Cu(OH)_2$ occurs if they are left in contact with the blue solution of bis(carbonato)cuprate(II) ion, $[Cu(CO_3)_2]^{2-}(aq)$.

Basic Copper Carbonates

CHAPTER 3

The blue pigment is a sand. In old days there were three varieties: the Egyptian is thought most highly of; next the Scythian mixes easily with water and changes into four colours when ground, lighter or darker and coarser or finer; to this blue the Cyprian is now preferred. To these were added the Pozzuoli blue, and the Spanish blue, when blue sanddeposits began to be worked in those places. — PLINY THE ELDER[1]

O nly two of the copper carbonate minerals are important both as corrosion products and as pigments; these are malachite, $CuCO_3 \cdot Cu(OH)_2$, and azurite, $2CuCO_3 \cdot Cu(OH)_2$. Both minerals have been known since antiquity, although the ICDD files credit Beudant in 1824 with the first formal description of the properties of azurite. The two minerals can be principal components of bronze patinas formed during land burials; minor phases in corrosion products formed during outdoor exposure or sea burial; and postexcavation alteration products of other minerals. Typical crystal forms for azurite and malachite are shown in FIGURE 3.1. The exotic and unstable mineral georgeite, $CuCO_3 \cdot Cu(OH)_2$, has recently been shown to be an isomer of malachite. Chalconatronite, $Na_2Cu(CO_3)_2 \cdot 3H_2O$, is a mixed sodium-copper carbonate often associated with Egyptian bronzes and is more common than the remaining three mixed copper-zinc basic carbonates: rosasite, $(Cu,Zn)_2CO_3(OH)_2$; aurichalcite, $(Cu,Zn)_5(CO_3)_2(OH)_6$; and claraite, $(Cu,Zn)_3(CO_3)(OH)_4 \cdot 4H_2O$. TABLE 3.1 summarizes the physical properties of these basic copper carbonate minerals.

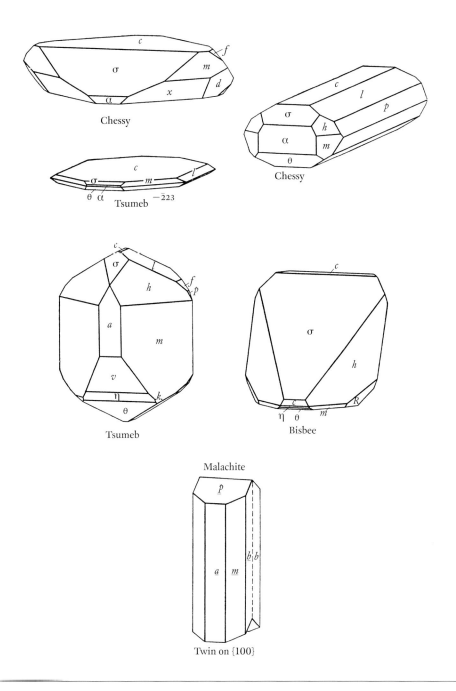

FIGURE 3.1 Illustration of natural azurite and malachite crystal forms (Palache, Berman, and Frondel 1951).

MALACHITE

The exploitation of malachite was extensive. The mineral is not only an important copper ore, but it was widely used as a green pigment and as a coloring component in glazes and glass. In addition, it occurs as a corrosion product on buried bronzes. Where the natural mineral was locally available or obtainable by trade, malachite was carved into beads or used for inlay by both Old and New World cultures. Etymologically, the word *malachite* is related either to the Latin *molochites*, which was used by Pliny to describe a green jasper, or to the Greek *malache* (mallow), because its color resembles that of the mallow leaf. PLATE 18 shows a good-quality sample of the natural mineral.

Felice Fontana (1730–1805), the founder of toxicology, was the first to show that malachite is a carbonate of copper (Fontana 1778). As a natural mineral, malachite can occur in quite substantial deposits, often mixed with cuprite, azurite, or chrysocolla (copper silicate). *Dana's System of Mineralogy* (Palache, Berman, and Frondel 1951) describes vast deposits of banded malachite at the Demidoff copper mines in Siberia. During the early 1800s, this ore was mined and cut into slabs for tabletops and large decorative pieces, such as the huge ornamental vases that adorn the Winter Palace, former home of the Russian czars in St. Petersburg (formerly Leningrad). Later, Fabergé used malachite for many of his exquisite *objets de vertu* (painted eggs) (O'Neil 1971).

Georgeite is now recognized as an unstable isomer of malachite. It is a pale blue, amorphous, gel-like compound that was first identified by Bridge, Just, and Hey (1979) from a copper mine in Western Australia. Georgeite was originally assigned a more complex chemical formula than malachite, with six waters of hydration, $Cu_5(CO_3)_3(OH)_4 \cdot 6H_2O$, until Pollard, Thomas, and Williams (1991) synthesized it and clarified its composition, as described in APPENDIX B, RECIPE 3.

TABLE 3.1 **CHARACTERISTICS OF SOME BASIC CARBONATE MINERALS**

MINERAL NAME	FORMULA	CRYSTAL SYSTEM	COLOR	MOHS HARDNESS
malachite	$CuCO_3 \cdot Cu(OH)_2$	monoclinic	pale green	3.5–4
azurite	$2CuCO_3 \cdot Cu(OH)_2$	monoclinic	vitreous blue	3.5–4
georgeite	$CuCO_3 \cdot Cu(OH)_2$	monoclinic	pale blue	?
chalconatronite	$Na_2Cu(CO_3)_2 \cdot 3H_2O$	monoclinic	greenish blue	3–4
rosasite	$(Cu,Zn)_2CO_3(OH)_2$	monoclinic	bluish green	4.5
aurichalcite	$(Cu,Zn)_5(CO_3)_2(OH)_6$	orthorhombic	pearly pale green	1–2
claraite	$(Cu,Zn)_3(CO_3)(OH)_4 \cdot 4H_2O$	hexagonal	translucent blue	2

Decorative uses
of malachite

Some of the earliest dated beads from Babylon were made of malachite (Moorey 1994); those found in the area of Ergani on the upper Euphrates River date from around 7000 B.C.E. The use of malachite for beadwork started to disappear in this area around 4000–3000 B.C.E. when copper smelting become an important technology. Malachite was still being used for ornaments until much later in other parts of western Asia; for example, it was used as an inlay on pendants from a Middle Assyrian necklace from Assur (Maxwell-Hyslop 1971).

Because of its beautiful coloration, malachite was used for ornaments, decoration, and even cosmetics in ancient Egypt. Malachite and turquoise (a basic hydrous copper aluminum phosphate; see CHAPTER 7) were both known as *mafek* because of their similar green color (Partington 1935). The goddess Hathor, whose face was painted with the green pigment, is known as the "lady of mafek," and Sinai, an important source for malachite, was known as the "land of mafek." There is a record of Amenhotep III (1411–1375 B.C.E.) using nearly 540 kg of mafek for inlay work at the temple at Karnak. Malachite was used as eye paint in Egypt as early as the Badarian period (early part of the fourth millennium B.C.E.). It continued to be used throughout the predynastic periods (ca. 3500–3000 B.C.E.) and into at least the Nineteenth Dynasty (1307–1070 B.C.E.) (Lucas 1934).

In China, malachite, known as *kongqueshi*, was often used as an inlay on metal objects beginning around the sixth century B.C.E., during the Eastern Zhou dynasty (770–221 B.C.E.) (White and Bunker 1994). An exquisite example of this artisanship is the bronze *fang lei* (wine vessel) shown in PLATE 19 (for further discussion of this object, see CHAPTER 12). A good-quality banded malachite was available for the decorative inlay in this piece, similar to that used on some belt ornaments found in Yunnan province dating from the second to the first century B.C.E. of the Western Han dynasty (206 B.C.E.–24 C.E.). A handsome circular belt ornament from this period, decorated with jade and malachite, is in the Shumei Family Collection, Japan. Tiny circular beads of malachite are attached with resin to the front surface of the ornament, imparting a sheen resembling green fish scales.

Malachite can be ground up and used to make a paste inlay, a common technique fully exploited in China. The use of paste inlays of malachite, as well as turquoise or azurite, on bronze was highly developed by the fifth to the fourth century B.C.E., during the Eastern Zhou dynasty. These inlays may represent a transition from the pseudocopper, red-pigmented, paste inlay that was used on certain pictorial bronze vessels of the late-Spring and Autumn Period (770–476 B.C.E.) of this dynasty (Le Bas et al. 1987).

There are references to ancient Roman necklaces being strung with malachite beads, but the identification of the stone is usually wrong, according to Ogden (1982). He examined one such necklace in the Victoria and Albert Museum in London and discovered that the beads are not made of a copper mineral but chrysoprase (green chalcedony) and green feldspar. Malachite

BASIC COPPER CARBONATES

beads have been found in a late Bronze Age jewelry workshop in Greece, but Ogden notes that later Greek or Roman use of the mineral in jewelry is rare.

In South America, malachite and turquoise were commonly used as an inlay in pre-Hispanic metal objects, especially in ancient Peru during the Moche, Recuay, or Chimu cultures from the early centuries of the common era. The decorative use of these minerals extended into the Inca period up to 1450. Malachite is also used as a veneer on the doors of the Chapultepec Palace in Mexico City.

Malachite continues to be used in contemporary jewelry, often polished into cabochons or carved for use as flat brooches or pendants (Newman 1987).

Malachite as a copper ore

Malachite was valued primarily as a copper ore in ancient Egypt, where there is evidence for the beginnings of copper smelting as early as the fourth millennium B.C.E. At around the same time, copper smelting was becoming an important technology in Babylon. In China, malachite was probably mined for copper ore quite early on as well. During the Tang dynasty (618–907) it was mined in Daizhou in northern Shanxi province and, by the eleventh century, from Xinzhou in eastern Jiangxi province.

The Sinai peninsula was an important source of malachite in ancient times. The ore was found in the form of nodules within veins in the rock. Rothenberg (1990) carried out detailed surveys and excavations of mining locales at Timna and elsewhere in the Arabah region of the Sinai.

Malachite, mixed with either quartz or iron oxides as flux, depending on the nature of the gangue minerals (impurities), is relatively easy to smelt with charcoal to produce metallic copper. Early Bronze Age bowl furnaces often produced a mixture of sintered minerals together with copper prills. To extract the prills, the unreacted malachite (or other copper ore) and charcoal together with slag would be broken up and crushed, allowing the copper prills to be extracted. These could then be combined in a crucible and smelted to produce metallic copper. A laboratory experiment by the author showed that when a graphite crucible is filled with crushed malachite, quartz, and charcoal, then fired at 800 °C, prills of metallic copper are readily produced.

Nomenclature confusion

Confusion about copper carbonates and copper silicates (e.g., chrysocolla) was common in early texts about these minerals. The Greek physician and pharmacologist Pedanius Dioscorides (40–ca. 90 C.E.), for example, may have been referring to malachite when he wrote:

> Chrysocolla, that of Armenia is the best, very much resembling leeks in ye colour, but that of Macedonia is ye second, then the Cyprian, and of this the pure is to be chosen.... [T]he

aforesaid is to be washed, thus: having beaten it, cast it into a mortar, and having poured on water rub it strongly with ye palm of thine hand against ye mortar, then having suffered it to settle, strain it; and pouring on the other water, rub it again and do this by turns, till it be pure and sincere.[2]

Grinding, washing with water, and straining are essential steps in preparing many pigments from natural mineral deposits, and the process has remained unchanged over the two thousand years since Dioscorides' time.

In his *Natural History,* Pliny lumps together various green stones, including malachite, under the umbrella "smaragdus." He refers to this word in a passage in which he describes stone from Cyprus as the

> chalcosmaragdus or copper smaragdus which is clouded by veins resembling copper. Theophrastus records that in Egyptian records are to be found statements to the effect that to one of the kings, a king of Babylon once sent as a gift a smaragdus measuring four cubits in length and three in breadth.[3]

This "copper smaragdus" from Cyprus is most probably an impressively banded malachite ore of unusual attractiveness. Pliny also mentions that this copper smaragdus can be associated with the color blue, and the only blue and green minerals of this type that are commonly found are malachite and azurite. Some of Pliny's information is derived from *On Stones,* the fourth-century B.C.E. Greek treatise by Theophrastus (372–287 B.C.E.). In writing about smaragdus, Theophrastus (1956) mentions that the stones are easy to reach and occur primarily in the copper mines of Cyprus and on the island lying off Chalcedon, an ancient city in Turkey. He adds, "They are not often found large enough for a seal, but most of them are smaller in size; for this reason the stone is used for soldering of gold, since it solders like chrysokolla." This "chrysokolla" was said to occur in native "kyanos," which is azurite, suggesting that in this case "chrysokolla" probably refers to malachite.

| *Mineral properties* | Well-formed crystals of malachite are rare, and untwinned crystals are practically unknown (Palache, Berman, and Frondel |

1951). Crystal faces are often striated. The mineral is monoclinic and has a Mohs hardness of 3.5–4. Under the microscope, malachite particles may be a strong or weak green and often show sharp internal and external angles due to cleavage planes. Larger particles are often fibrous and pleochroic. The birefringence is high, allowing first-order red or second order blue colors to appear. The extinction is oblique or parallel and varies from distinct to undulose (Mactaggart and Mactaggart 1988).

As a corrosion product, malachite can occur in various forms: as rod-shaped crystals; curved, fibrous crystals; botryoidal masses; fibrous aggregates; or bundles of tiny parallel fibers

in whiskerlike crystal growth. Some examples of these different forms are shown in PLATE 20. Even on the same object, well-formed crystals may display a variety of crystalline habits. On the cased Greek bronze mirror discussed in CHAPTER 1, for example (see CHAPTER 1, FIGURE 1.2), crystals had signs of elongation that were optically positive or optically negative (Scott 1991). Fibrous malachite, which has been found growing as curly, fiberlike crystals on bronze antiquities (Scott 1991), has been observed to consist of parallel aggregates of finely elongated malachite crystals, as shown in PLATES 21 and 22.

Malachite as a pigment | There is no evidence that malachite or azurite was used as pigment for Paleolithic rock art (Ucko and Rosenfeld 1967). The minerals, however, were used extensively for painting in many different media from antiquity until relatively recently.

Malachite and azurite must be ground quite coarsely to retain a good color for pigment use; the minerals become progressively paler as the particle size is reduced. Malachite is most effective as a pigment in tempera. Although it is a bright green, malachite covers poorly in oil and not very well in watercolor. Gettens and Fitzhugh (1966) describe the color, reflectance spectra, infrared data, notable occurrences in paintings, and other characteristics of malachite used as a pigment. *Art and Archaeology Technical Abstracts (AATA)* [4] provides more than five hundred references to the identification of malachite in paintings, especially in Asia, where its use in Japan, China, and Korea has been extensive.

Malachite in bronze patinas | Although malachite is only a minor constituent of patinas that develop on exposed bronze objects, it can be a significant component of patinas that develop during the corrosion of copper alloys buried in the soil, where the first product to form adjacent to the metal is cuprite; malachite usually forms over this initial cuprite layer. The uniform growth of this corrosion accounts for the attractive patina seen on many bronze antiquities.

The natural transition of metal to cuprite to malachite is very difficult to replicate in the laboratory. In fact, most of the recipes for producing artificial green patinas on copper alloys, such as those compiled by Hughes and Rowe (1982), do not result in malachite formation over a cuprite layer. Consequently, the existence of this type of corrosion, supported by analytical and metallographic studies, is a good indication of the authenticity of an artifact.

| BANDING A striking feature sometimes seen in polished sections of corroded bronze antiquities is a corrosion crust with multiple, alternating layers of malachite and cuprite. This structure is reminiscent of Liesegang phenomena described in CHAPTER 2.

The processes behind the banding of malachite with cuprite were explored experimentally by Krishnan and colleagues (1982), who examined the anomalous stratification of copper car-

bonate in agar gel and found that small amounts of impurities affected its development. To study the phenomenon, the researchers added sodium carbonate solution to an agar gel containing dissolved copper(II) acetate. An impressive array of copper carbonate bands developed as the carbonate solution diffused through the agar. The authors explain the periodic precipitation of copper(II) carbonate as the formation of a precipitate by flocculation of preformed peptized sols. The copper carbonate precipitate forms because the colloid is coagulated by an excess of the diffusing electrolyte. The carbonate is absent when the colloidal sol in the vicinity of the precipitate is coagulated and adsorbed by the precipitate.

Similar processes may be occurring to produce the complex corrosion crusts of banded malachite and cuprite. In some cases, as many as seventy alternating layers of the two minerals have been observed in bronze corrosion crusts. This strongly suggests that sols or gels form during corrosion underground, allowing this unusual diffusion phenomenon to occur.

Isotope ratios to determine *corrosion environment*	Ratios of the stable carbon and oxygen isotopes, $^{13}C/^{12}C$ and $^{18}O/^{16}O$, in malachite corrosion crusts were investigated by Smith (1978) in a pilot study to see if they could be used to deter-

mine the burial environment of bronzes. Patina samples containing malachite were examined from bronzes found in British Bronze Age hoards; from Etruscan bronzes from Polledrara, Italy; from Roman objects found in Sabratha, Libya; and from Shang dynasty and Han dynasty bronzes from China.

The results were complex but showed that all the British bronzes had delta ^{18}O results[5] between -1 and -4 ‰, while the other samples showed a wide spread in values from 0 to -11 ‰ with no correlation between patina and site.

When corroded by waters containing oxygen and carbon dioxide, the copper that is attacked by the water and that goes into solution is mostly in the form of cupric bicarbonate (Ives and Rawson 1962). Fractionation can occur between the carbon dioxide and the bicarbonate ions, resulting in ^{13}C becoming more concentrated in the bicarbonate solution. Consequently, malachite deposited from bicarbonate solutions might have delta ^{13}C ratios more positive than the biogenic CO_2 values of -26 ‰. This was confirmed by Smith's pilot study. The degree of corrosion of the bronze objects studied and the delta ^{13}C of the malachite patina appeared to be related: severely corroded objects had the most negative delta ^{13}C ratios, and moderately corroded objects the least negative. This would indicate that the consistency of the British data is related to the CO_2 concentration in the soil.

Smith (1978) suggests that one possible application of these isotope ratios would be to assist with authenticity studies. Comparing the delta ^{18}O and delta ^{13}C ratios of malachite from the patina of an unknown bronze object with the same ratios from an ancient bronze of known provenance might make it possible to draw some conclusions about origins. This application, however, has yet to be verified by any practical studies.

AZURITE

Azurite is less common than malachite as a corrosion product, although it has been used extensively as a blue pigment. In some older texts, azurite is also known as chessylite, a name derived from a noted occurrence of the natural mineral in Chessyl, France.

In natural deposits and in corrosion products, azurite is usually associated with malachite, and often with cuprite as well. Azurite belongs to the monoclinic system and has a Mohs hardness of 3.5–4. Natural azurite may form by the action of carbonated waters on other copper minerals or by the reaction of copper chloride or copper sulfate solutions with limestone or calcite.

Azurite as a corrosion product | Both malachite and azurite form as corrosion products principally when copper alloy comes in contact with soil waters or with water formed by surface condensation and charged with carbon dioxide (Gettens 1963a). Azurite is less stable than malachite and may be converted to it in the presence of moisture through loss of carbon dioxide. Lewin (1973) showed that this transformation is promoted by an increase in temperature in the presence of alkali.

Azurite as a corrosion product rarely forms a coherent patina, although it is known to happen. More commonly, discrete crystals or patches of azurite are found in association with malachite and cuprite. When mounted for polarized-light microscopy, particles of azurite corrosion or pigment should show a good blue color with distinct angular edges. The particle size is usually 5–40 μm. The mineral is strongly birefringent, and second-order colors can be seen (Mactaggart and Mactaggart 1988). Strongly colored particles may be pleochroic. A mounted preparation of azurite crystals viewed under plane-polarized light and under crossed polars is shown in PLATE 23.

Azurite as a pigment | Azurite's primary use since prehistoric times has been as a pigment.[6] Although Ucko and Rosenfeld (1965) state that blue and green pigments were never used in Paleolithic cave art, it is possible that some of the black pigments observed on such drawings today could have been malachite or azurite pigments that decomposed into tenorite by heating (a transformation described later in this chapter). The first known example of Neolithic use of azurite pigment was found at Catal Hüyük in Anatolia, dating from 6000 B.C.E. (Mellart 1967). Lucas (1934) reports the find of azurite from a shell container used as a palette that was found at Medūm, Egypt, and that dates to the Fourth Dynasty (2575–2465 B.C.E.). The artificial pigment Egyptian blue (calcium copper silicate) was also used frequently starting around this period because of the limited supplies of azurite.

The ancient Chinese were also familiar with natural deposits of azurite and malachite. Detailed observations of malachite in nodular form with large holes and in stratified form with

azurite have been found in Chinese texts dating to about 400 B.C.E. (Needham 1974). Azurite was used in wall paintings of the Song (960–1279) and Ming (1368–1644) dynasties and remains a commonly used pigment in Chinese art today.

Azurite was the most important blue pigment in Europe beginning in the Middle Ages, particularly from the fourteenth to the seventeenth century. In easel painting, azurite was often used as an underpainting for natural ultramarine. Germany was the principal supplier of azurite during the sixteenth century, with mines in Saxony, Tyrol, and Saarland; the last source was known from Roman times (Burmester and Krekel 1998). Laurie (1914) identified many examples of azurite use on manuscripts from the mid-thirteenth to the mid-fourteenth century, such as the Luttrell Psalter manuscript, East Anglia, England, which dates to 1340. At this time, azurite became more commonly used as a pigment than ultramarine, but after the mid-fourteenth century, ultramarine reasserted itself. The Culross manuscript of 1470, which is thought to have originated in Scotland, was found to contain natural green malachite and a very bright blue azurite that was distinctly different in color from the azurite found on manuscripts from the thirteenth and fourteenth centuries. Laurie (1914) claims that this represents the first appearance of this bright blue azurite, which is characteristic of late-fifteenth-century manuscripts and continued to be used for this purpose through the early seventeenth century.

One of the principal sources of azurite during the medieval period was Hungary. As reported by Laurie (1914), the art writer Francisco Pacheco (1564–1644)[7] noted that supplies of this important pigment had been seriously disrupted in the fourteenth century due to the invasion of Hungary by the Turks and that some azurite, possibly from a different source, was then obtained from Venice.

Mactaggart and Mactaggart (1988) discovered that azurite had been used to paint seventeenth-century harpsichord soundboards, as well as being used as a general blue pigment for buildings and works of art. After this period, the popularity of the pigment waned in Europe, while in the East, both malachite and azurite were much more extensively used and were still being employed by Japanese artists after World War II (Mactaggart and Mactaggart 1988).

In North America, azurite was used by the Indian peoples of the American Southwest for wall paintings and possibly also for body painting. In South America and Mesoamerica, azurite was used in numerous wall paintings, especially those from the Maya culture, and acquired special importance during the Mesoamerican classic period (300–900). Azurite, along with so-called Mayan blue,[8] has been found at many Maya sites of that period in Mexico, including Bonampak, Chiapas; Chichen Itza, Yucatan; Ichmac, Campeche; and Xulen, Quintana Roo. Good-quality mineral azurite can be found in deposits of the Central Altiplano, Mexico; and the murals of Teotihuacán show frequent use of azurite pigment (Magaloni 1996). The tradition of azurite pigment use continued during the Spanish colonial period, especially for paintings in missions and churches.

Because of its inherent interest as a pigment, analyses have been carried out on natural azurite to determine the mineral's common trace elements, such as gold, holmium, samarium, rhenium, palladium, and mercury. Nothing appears in the literature on the use of these trace elements for investigating the provenance of particular samples of azurite, so this may not be achievable. Recent developments in laser ablation–inductively coupled plasma–mass spectrometry have made possible the determination of many additional trace elements, however, some of which may help future researchers "fingerprint" the azurite used by a particular artist or originating from a certain source or type of deposit.[9]

Conservation issues
for azurite

Azurite can be altered to other products by environmental factors, impacting the conservation of materials that incorporate this mineral. For example, azurite can be darkened by exposure to sulfur fumes, perhaps due to sulfide formation, as seen especially in mural paintings. Gettens and Stout (1966) reported cases of suspected azurite alteration to malachite or, rarely, to paratacamite (probably clinoatacamite); and Riederer (1985) found that azurite pigment from the facades of the elder temple of Aphaia at Aegina, Greece, had been partially transformed to paratacamite. Thick layers of azurite in oil paintings often become greenish or dark with age. This probably results from the reaction of the copper with the oil medium, producing a variety of copper organometallic compounds, such as copper resinates or oleates.

Gutscher and colleagues (1989) investigated the alteration of azurite into tenorite in wall paintings, a conversion that has also been reported on polychrome sculpture excavated from an alkaline environment. The alteration of azurite to copper trihydroxychlorides, such as atacamite, in wall paintings is not uncommon and is probably due to the slow ingress of saline solutions or groundwater. This process will decompose azurite, probably with the formation of atacamite or, in some cases, of clinoatacamite—the newly identified fourth isomer of the copper-trihydroxychloride system (Jambor et al. 1996). Clinoatacamite, in fact, may be the mineral alteration that is identified as paratacamite in the earlier literature on azurite transformation in wall paintings. Bolingtoft and Christensen (1993) examined a color change in early Gothic wall paintings dating to around 1275 from the Danish village of Gundsømagle. They found traces of azurite on the paintings. This information, together with the known color scheme, allowed the authors to infer that areas of the painting that are now green were originally blue, and that the color change represented the alteration of azurite to atacamite due to attack by high pH, moisture, and chlorides.

Dei and colleagues (1998) discovered that the use of ammonium carbonate and barium hydroxide as a treatment for gypsum-encrusted wall paintings caused potentially deleterious chemical changes to azurite pigments that had altered to a green form—either to malachite or

to one of the copper trihydroxychlorides.[10] This undesirable color change was observed on the fourteenth- to fifteenth-century wall paintings depicting San Antonio Abate in the church of San Pietro at Quaracchi, near Florence, Italy. Rosi (1987) reports the harmful effects that occurred with this treatment during the restoration of a pietà by Florentine artist Masolino da Panicale (1383–1440?), who painted this work around 1425 for the baptistry of the Collegiata at Empoli. After the final barium hydroxide solution was applied, the green degradation products of azurite changed to a dark blue; after two years, this blue changed to green again. This demonstrates that the conservation treatment had created chemical alterations and that some of these alterations were unstable.

At first it was thought that the treatment had changed the green degradation product (a copper trihydroxychloride) back to blue azurite, but Dei and coworkers show that a different reaction was occurring. The extremely high pH of the barium hydroxide treatment had transformed the basic chloride to spertiniite, $Cu(OH)_2$, a highly unstable compound that underwent further reaction with chloride-containing water to become a basic chloride again. Dei's group attributes this chloride to paratacamite, but it probably needs to be reassigned to clinoatacamite.

Azurite and malachite pigments are also sometimes altered by this conservation treatment to black tenorite, CuO, again because of the high pH of the barium hydroxide solution.

FORMATION OF COPPER CARBONATES IN SOLUTION

Malachite and azurite are precipitated from copper(II) sulfate solutions—the most common solution in which copper is simply dissolved—and complex salts of copper(II) by reaction with bicarbonate ions (Lindgren 1933). They may also be produced directly from the reaction of copper(I) oxide with carbon dioxide and water. If azurite is hydrated or exposed to an atmosphere deficient in carbon dioxide, it is gradually converted to malachite (Garrels and Christ 1965). Chalconatronite may be formed by direct precipitation from saturated solutions of the highly soluble $Na_2Cu(CO_3)_2$ complex. The presence of this sodium-copper carbonate prevents the precipitation of malachite, creating instead an alteration of the reaction process from malachite to chalconatronite (Applebey and Lane 1918).

The Pourbaix diagrams for the copper–water–oxygen–carbon dioxide system illustrate the conversion of azurite to malachite in carbon dioxide–poor atmospheres. Azurite does not appear on these diagrams until the carbon dioxide level reaches 4400 ppm, whereas malachite is present at a carbon dioxide level of 44 ppm. With increasing carbon dioxide concentration, malachite stability increases at the expense of tenorite and cuprite at higher pH values. The copper solubility in this system is limited by the precipitation of malachite. If chloride and sulfate ions are absent from the solution, then malachite is the phase that limits copper solubility. In solutions containing sulfate and carbonate ions, antlerite and brochantite limit the solubility of copper at low pH values (Mann and Deutscher 1977).

McNeil and Mor (1992) discuss the application of Pourbaix diagrams to copper, where the chloride ion concentration is representative of seawater, and the carbonate ion is in equilibrium with air. Under these conditions, minerals such as azurite and georgeite do not appear on the stability diagrams, since there are no stability constants for georgeite, and azurite is not stable unless the carbon dioxide concentration is raised to levels above those in equilibrium with the air. Regions for the formation of cuprite, malachite, and paratacamite occur, together with regions of the dissolved phases $CuCl_2^-$ (aq) and Cu^{2+} (aq), at pH levels below 5. From pH 8 to 11, malachite is stable in oxidizing environments; there is a small region of cuprite stability toward intermediate values of Eh. Since the normal range of pH variation in seawater is about 7–8, it is theoretically possible that some malachite could form in marine burial environments. Such an occurrence must be the exception rather than the rule since most marine corrosion products on copper, apart from cuprite, are the copper trihydroxychlorides.

MacLeod (1987a) found only one example of malachite formation in the Western Australian marine sites he studied, but the mineral may have a postexcavation origin. Mor and Beccaria (1972) reported the occurrence of both malachite and atacamite from a marine burial environment, but this juxtaposition is far from common, and no further reports of both minerals being found together have been published to date.

MacLeod (1987a) explains that the following competitive precipitation reaction occurs between malachite and copper trihydroxychlorides, such as atacamite, in the well-oxygenated seawaters off the Australian coast:

$$Cu_2(OH)_3Cl + CO_3^{2-} = CuCO_3 \cdot Cu(OH)_2 + Cl^- + OH^- \qquad \text{3.1}$$

In normal seawater, which has a carbonate activity of 2.4×10^{-6} M at pH 8, the formation of malachite is favored, at least in theory. A site's local conditions will affect the relative concentrations of carbonate and bicarbonate ions; this, in turn, will strongly influence the nature of the corrosion products formed.

The Pourbaix diagrams that illustrate four Eh–pH charts for the Cu–CO_2–H_2O system at 25 °C (see CHAPTER 2, FIGURE 2.1) can be used to investigate why azurite rather than malachite forms under these conditions. Although the diagrams neglect various kinetic factors, they do provide useful information concerning conditions for the formation of the two minerals.

For water at pH 5.8 with 440 ppm of dissolved CO_2 (see FIGURE 2.1B), the Pourbaix diagram shows that a mixed product should result; that is, a patina on copper would consist of malachite with some tenorite, CuO. As discussed previously, however, it is doubtful that tenorite will form at all. In natural corrosion crusts, cuprite—not tenorite—is found contiguous with the copper metal.

Malachite is stable in water of approximately pH 8 containing 44 ppm of dissolved CO_2 (see FIGURE 2.1A). This means that such water will line a copper pipe with malachite. As the amount of dissolved carbon dioxide increases, however, the stable minerals that form can

change to include both malachite and azurite under certain conditions (see FIGURE 2.1D). For example, slightly acidic water with 4400 ppm of dissolved CO_2 will favor the formation of azurite rather than malachite (see FIGURE 2.1C). If dissolved salts produce bicarbonate ions, such as $Na^+HCO_3^-$, the pH will rise higher than 7, producing alkaline conditions that favor the production of malachite rather than azurite. The same is true for carbonate ions, such as $Na_2^+CO^{2-}$, which also tend to produce malachite. As the amount of dissolved carbon dioxide increases, azurite becomes the stable product rather than malachite (see FIGURE 2.1D). Conditions for azurite stability, therefore, will be favored in aqueous environments in which the pH is low and the carbon dioxide content of the water is high.

DECOMPOSITION OF MALACHITE AND AZURITE BY HEAT

Interest has been shown in the decomposition temperatures for malachite and azurite because of their use in wall paintings that may have been affected by fire. Rose (1851) found that malachite begins to decompose at 220 °C, and by 300 °C a considerable change in weight has occurred. Rose reported that azurite transformed into tenorite at 300 °C. Simpson, Fisher, and Libsch (1964) revised the data after concluding that the decomposition temperatures initially reported for azurite and malachite were influenced by different heating rates. They found that both malachite and azurite will begin to decompose at 200 °C, with azurite losing 2.76% by weight over forty-five days at 190 °C.[11] Both minerals readily transform into tenorite over a 300–400 °C temperature range. In a more recent review, Rickerby (1991) examined existing data on decomposition temperatures reported for malachite and azurite and found that they varied over a wide range of temperatures—from 200 °C to 500 °C. Rickerby's own studies showed that azurite was not altered at 200 °C but that it transformed into tenorite at temperatures greater than 300 °C. Malachite decreased in luminosity at 200 °C, turned brown at 300 °C, and transformed into tenorite at 400 °C and greater. As with all carbonates, these reactions depend on the partial pressure of the carbon dioxide and water that the malachite or azurite liberates when it begins to decompose.[12]

Rickerby studied wall paintings done in the fresco technique and showed that even if such paintings are affected by fire, significant information about the pigments used may still be available. By studying cross sections of samples from damaged wall paintings, he found that large pigment particles are still visible at the bottom of the cross sections and were the least altered by the heat.

ARTIFICIAL MALACHITE AND AZURITE

Supplies of malachite and azurite were never plentiful or universally accessible. Starting around the fifteenth century, synthetic green and blue pigments were produced to replace these natural copper carbonate minerals. By the seventeenth century, the artificial versions were replacing

bluish green verdigris, a copper acetate and one of the earliest artificial pigments, for use in manuscripts (Laurie 1914).

The synthetic version of malachite is green verditer. It has the same powder X-ray diffraction pattern as the natural form, and it usually forms as a precipitate in the shape of spherulites. Some of these globular particles may exhibit a dark cross when viewed under crossed polars. Gettens and Fitzhugh (1974) identified this globular form in a cross section of a painting of St. Vincent Ferrer by Francesco del Cossa (ca. 1435– ca. 1477), which dated to about 1472. This confirmed that green verditer was already in use at that time. Because the synthetic product is rather pale, however, its use became less common in Europe starting around the eighteenth century (Harley 1970). Fitzhugh (1979) studied the Utagowa School of Japanese paintings dating from the sixteenth to the nineteenth century in the collections of the Freer Gallery of Art, Washington, D.C. A green, copper-containing pigment was identified as malachite by X-ray diffraction, but it did not have the typical microscopic appearance of the natural mineral. The particles were rounder than usual but not the typically rounded spherulitic particles found in the artificial version, so the origin of this pigment is still in question.

There is ample evidence that recipes for making artificial copper pigments go back to medieval times. By around 1910, the recognized way of making synthetic azurite, known as blue verditer, involved adding lime and potassium carbonate to copper sulfate, then treating the precipitate for a number of days with sal ammoniac (ammonium chloride) and copper sulfate. This process was described in the manuscript of Jean Lebègue (1368–1457), who compiled much information concerning pigment manufacture and use during the Elizabethan era (Laurie 1914). Sometimes the resulting product contained impurities of calcium sulfate and copper sulfate. Laurie found that the artificial pigment could be distinguished from azurite because it was not birefringent, and when immersed in oil of cassia, its refractive index was lower than that of azurite.[13] Some recipes, such as the one described here, will produce complex products. Most of these recipes are discussed in the section dealing with verdigris compounds (see CHAPTER 9).

BLUE AND GREEN VERDITER

Use of blue and green verditer in art

Because azurite and ultramarine were so expensive, artificial blue copper pigments were used extensively in medieval painting. They were probably more significant at that time than all other blue pigments together (Thompson 1932).

Laurie (1914), who notes that blue verditer was once synthesized in England in large quantities, identified this artificial azurite in various English illuminated manuscripts—for example, in folio 1826 of the *Coram Rege Rolls,* which dates from 1672. Laurie (1935) also mentions that blue verditer was used throughout the eighteenth century in oil paintings; he identified it in *Madame de Pompadour* by François Boucher (1703–70) in the National Gallery, Edinburgh.

Synthetic malachite (green verditer) has been identified in several fifteenth-century Italian panel paintings in the collections of the National Gallery, London (Roy 1993). Technical examination of a fifteenth-century polychrome terra-cotta relief from Siena, Italy, at the National Gallery of Art, Washington, D.C. (Edmonds 1997), reveals that synthetic spherical malachite was used throughout. The major period during which this synthetic pigment was introduced, therefore, seems to be the fifteenth century, although where it was being made and by what process is still unclear. Blue and green verditer were also frequently used as pigments for decorative facades. In a 1769 portrait by John Zoffany (1733–1810) of Sir Lawrence Dundas sitting in his library at Arlington Street, London, much of the wallpaper is depicted as green. Assuming that the artist was representing the actual wallpaper color, Bristow (1996) suggests that the only green pigment available at the time for such decorative purposes was green verditer, as described in APPENDIX B, RECIPE 1.

| *Synthesis of blue and green verditer* | Blue verditer can be synthesized by adding calcium carbonate to copper sulfate. Mactaggart and Mactaggart (1980), who prepared both blue and green verditers, showed that the blue basic |

carbonate precipitated at low temperatures and under more controlled conditions than those for the formation of green verditer. The crystal size of the blue precipitate was much finer than that of natural azurite, with a corresponding paler color, but X-ray diffraction data show it is essentially identical to the natural mineral. The verditers made by the author at the Getty Conservation Institute Museum Research Laboratory were highly birefringent, with a dark cross visible when viewed under crossed polars. Preparations of green and blue verditer viewed with polarized light microscopy are shown in PLATES 24 and 25.

During the nineteenth century, a synthetic azurite known variously as English blue ashes, copper blue, or mountain blue[14] was made by pouring a solution of commercial potash (potassium hydroxide) into a solution of copper (II) sulfate. Riffault, Vergnand, and Toussaint (1874) report that this formed a precipitate of copper carbonate.[15] The precipitate was then ground with lime (calcium hydroxide) to which a small amount of sal ammoniac (ammonium chloride) was added. Lime decomposes sal ammoniac into an ammoniacal copper salt with a deep blue color.

Naumova, Pisareva, and Nechiporenko (1990) were able to prepare a synthetic malachite by adding sodium bicarbonate, either as a powder or a solution, to a copper sulfate solution. At a concentration ratio of HCO_3^{2-} to SO_4^{2-} greater than 3, an emerald-green precipitate formed, consisting of spherulitic malachite with a diameter of 10–20 μm. The same researchers identified synthetic malachite from frescoes in the Cathedral of the Nativity of the Virgin at Ferapontov Monastery in the Vologda region of Russia. The pigment, which consisted of small spherulites, was found in background areas painted green. These green areas also contained

large quantities of blue lumps, which consisted of very thin, anisotropic plates with spherulites inside. Examination with a scanning electron microscope revealed that the principal elemental composition of these plates was copper and calcium, with admixtures of iron, magnesium, and aluminum. These plates are very likely an intermediate product formed during the synthesis of artificial malachite pigment.

MIXED-CATION COPPER CARBONATES

There are a number of mixed-cation copper carbonates, some of which have been identified as corrosion products and some of which have also been used as pigment additives.

Mixed copper-zinc carbonates in corrosion

Although zinc is often selectively lost in the corrosion of brass alloys, leading to plug dezincification and serious corrosion failure, it is possible to find a mixed copper-zinc mineral forming during the corrosion of brass objects or bronzes containing zinc. One of these minerals is rosasite, $(Cu,Zn)_2CO_3(OH)_2$, which can occur as mammillary, botryoidal, or warty crusts with a fibrous to spherulitic structure. This monoclinic mineral is somewhat brittle, has a Mohs hardness of about 4.5, and is sky blue to bluish green.

Rosasite has been identified on a Chinese bronze canister from the Han dynasty (206 B.C.E.–220 C.E.). It was also identified on another Chinese bronze, known as a *tui*, from around 300 B.C.E. (Gettens 1963a), but there is some doubt about this age, since zinc is not known to have been used as an alloying element at that time. One possibility is that the piece is a later copy from the Song dynasty. The only recent identification of rosasite as a corrosion product is in the patina on the Great Buddha in Kamakura, Japan (Matsuda and Aoki 1996).

Two other mixed copper-zinc basic carbonate minerals may be found: aurichalcite, $(Cu,Zn)_5(CO_3)_2(OH)_6$, and claraite, $(Cu,Zn)_3CO_3(OH)_4 \cdot 4H_2O$. Only aurichalcite, however, has been identified as a corrosion product; the one example is on a Roman coin of a copper alloy that contains zinc. The coin is in a private collection. Aurichalcite occurs as delicate needlelike crystals that are very soft (Mohs hardness 1–2) and pale green or greenish blue. Claraite is an important member of this series of minerals, though there are no published accounts of claraite as a corrosion product.

These mixed basic carbonate minerals arise from the substitution of copper atoms in the crystal lattice with some zinc. Although each mineral phase has an assigned ICDD file, some variation in composition, and hence in d-spacings, may be particularly evident with these carbonates. Chemical analyses of aurichalcite, for example, show that copper and zinc can substitute for each other over a considerable range: Cu:Zn = 1:3.16 and Cu:Zn = 1:1.57 are cited by Palache, Berman, and Frondel (1951). For rosasite, Cu:Zn ratios ranging from 3:2 to 2:1 have been reported.

Pourbaix diagrams for the three mixed basic carbonates are not yet available, and an understanding of the likelihood of formation of these products will need to wait until such stability diagrams are established.

Synthetic pigments with copper and zinc salts	Because of their availability and low cost, zinc salts were frequently used as additives in nineteenth-century commercial pigment preparations based on copper. Riffault, Vergnand, and

Toussaint (1874), for example, describe the synthesis of a "mineral green lake," which, the authors point out, is a misnomer because it is not precipitated onto an inert base like a dye. The pigment was prepared from a mixture of copper and zinc oxides obtained from a saturated solution of copper in 1 part nitric acid and 3 parts hydrochloric acid combined with a solution of zinc in concentrated nitric acid. Potassium carbonate was used to precipitate a light green product of mixed carbonates. This precipitate was washed, dried, powdered, and then heated in a crucible until the "carbonic acid" (an early name for CO_2) was expelled, and the product acquired a fine greenish hue. Ground very fine, the durable pigment was used for watercolors and for oil colors.

Depending on the proportions of copper and zinc salts dissolved in the acidic solutions, the precipitated carbonate might represent any of the mixed copper-zinc salts discussed here.

CHALCONATRONITE: A SODIUM-COPPER CARBONATE

Chalconatronite, $Na_2Cu(CO_3)_2 \cdot 3H_2O$, is the best known sodium-copper-carbonate mineral. It was first identified by Frondel and Gettens (1955) as a bluish green, chalky crust found in the hollow interior of an Egyptian bronze figurine of the deity Sekmet from the Saite-Ptolemaic period (663–630 B.C.E.) in the Fogg Museum of Art, Boston. The mineral was also identified on an Egyptian bronze group of a cat and kittens in the Gulbenkian Collection in Lisbon and on a Coptic censer, dating from about the seventh century, in the Freer Gallery of Art, Washington, D.C.

Chalconatronite was subsequently identified on a copper pin from St. Mark's Basilica in Venice (Staffeldt and Paleni 1978). Shortly thereafter, Horie and Vint (1982) found chalconatronite crystals on Roman copper and iron armor from a site at Chester, England. The armor had been conserved many years earlier, and the authors suggest that the chalconatronite is a by-product of that treatment. In addition, the author (Scott 1999) identified chalconatronite as an alteration product on a New Kingdom Egyptian gilt-bronze figurine of Osiris in the collections of the Department of Near Eastern Studies, University of Southern California. The alteration had penetrated to a considerable depth, with whole regions of the preserved surface being transformed to chalconatronite.

Synthesis and use
of chalconatronite

One way to synthesize sodium-copper carbonate is to precipitate the crystals from a concentrated solution of sodium carbonate containing bicarbonate and copper ions.[16] This explains the chalconatronite that Horie and Vint had identified on the Roman armor: the excavated metalwork from this site had been treated with a sodium sesquicarbonate solution, and a reaction must have occurred between the solution and the copper ions in the corrosion material. Substantial layers of chalconatronite have been found on a number of other bronze objects known to have been conserved with sodium sesquicarbonate. The mineral is apparently deposited during the long treatment regime designed to extract chloride ions from corroded bronze objects.

When viewed under a polarized light microscope, chalconatronite crystals appear as angular, colorless, crystalline fragments; in a melt-mount with a refractive index of 1.662, the crystals appear in clear relief because all three refractive indices of chalconatronite are well below that of the mounting medium. Under crossed polars, the crystals show a gray-white birefringence, with some particles showing a second-order straw yellow and red-purple tinge; most particles have a clear extinction. Chalconatronite synthesized in the laboratory has optical properties that are similar to those of the naturally occurring mineral, with the exception that extinction is usually undulose and sometimes feathery, in the manner of anhydrite.

There is evidence that a green pigment synthesized in China during the early centuries C.E. and referred to as synthetic malachite (Needham 1974) is, in fact, synthetic chalconatronite. Needham mentions a text by the early Chinese writer Sun Ssu-Mo who gives instructions for making this green pigment:

> [T]o get a fine green pigment from copper one must calcine the rust [to make a copper oxide] and then boil it with white alum in a sufficient amount of water. After it has cooled it will be green, and one must add some natron solution [a naturally occurring mixture of sodium carbonate, sulfate, and chloride] which will precipitate the green colour called hsiao lu se. This is used in painting for the colour of plant and bamboo leaves. (Needham 1974 : 244 – 45)

Needham equates this color to a green verditer (synthetic malachite), which is the same as Chinese *thung lu*. The reaction was replicated by the author in the laboratory, using cuprite as the calcined copper rust and potassium aluminum sulfate for the alum solution. After several hours of gentle boiling, the cuprite had partially dissolved, forming a blue-green solution with a deposit of unreacted cuprite. The alum in this recipe reacts to form aluminum sulfate, aluminum chloride, or other salts that stay in solution; aluminum hydroxide is not precipitated. The exact nature of the precipitated reaction products that form when natron is added to the cooled solution probably depended on the composition of the natron used in the ancient recipe. For

example, if the natron was primarily a mixture of sodium carbonate and sodium bicarbonate, then a gelatinous duck-egg blue precipitate forms. If the natron also contained some sodium chloride and sodium sulfate, then blue-green crystalline deposits are obtained from the precipitate by filtering and drying. Recent analyses of samples labeled "natron" at the British Museum indicate that in many cases, the natron is, in fact, principally composed of sodium chloride.

Under the polarized light microscope, two different crystalline reaction products can be distinguished when natron containing sodium chloride, sulfate, carbonate, and bicarbonate is used in the recipe: one product consists of pale blue crystal fragments, and the other contains spherical particles with radial markings in the spherical crystalline precipitate. Both products are highly birefringent. In a melt-mount of refractive index 1.66, the crystalline fragments have lower refractive indices, indicating that these grains could not be malachite. In fact, this precipitate produces an X-ray diffraction pattern that matches that of chalconatronite, as shown in APPENDIX D, TABLE 1. This replication of an ancient Chinese recipe manifestly demonstrates the possibility of finding synthetic chalconatronite on very old works of art as an original pigment and not as an alteration product of another mineral.

Banik (1989) reports identifying green pigment on a sixteenth-century illuminated manuscript as a mixture of pseudomalachite and chalconatronite. This indicates that chalconatronite (probably synthetic) could have been used as a pigment more commonly than the current literature suggests. Magaloni (1996) made a recent and surprising identification of chalconatronite (probably natural) as a pigment in wall paintings from two Maya sites in Mexico: Bonampak and Las Monjas. This finding is intriguing; further research into the etiology of these salts is needed to determine if they are original pigments or alteration products.

Chalconatronite as a corrosion product

Even when sodium sesquicarbonate cleaning is not suspected, residues from aqueous cleaning solutions may produce chemical alterations. For example, a gilt-silver[17] stag (ca. 1680–1700) by Johann Ludwig Biller the Elder (1656–1732) at the J. Paul Getty Museum was observed to be producing small green pustular nodules on the surface. The object was made with a silver alloy that was found to contain copper. Remnants of cleaning solutions used in the past must have created incipient corrosion of this copper content, resulting in the small green pustules. These were identified by scanning electron microscopy–energy dispersive X-ray analysis to contain sodium and copper. They were identified by Debye-Scherrer powder X-ray diffraction as chalconatronite (Scott 1997a).

One cleaning method that can cause such alteration is immersion in a 5% solution of sodium sesquicarbonate, $NaHCO_3 \cdot Na_2CO_3$. Although it is not known if Biller's stag was treated in this manner, the method was recommended as an early treatment to remove chloride from both iron and bronze artifacts (Scott 1921). The sesquicarbonate solution has a pH of about 10;

at this level of alkalinity, cuprous chloride is unstable and can be converted to cuprite. The hydrochloric acid released is then neutralized by the carbonate, forming sodium chloride.

The technique was ingenious, if not entirely desirable, since immersion in solution might last for years, and the patina could thus be subject to complex alterations. The method was in use in the Department of Conservation at the British Museum for a considerable period of time until, in 1970, Oddy and Hughes felt the need to reassess it. They found that the long periods of immersion that were recommended succeeded in washing chloride ions out of the corroded bronze surfaces, as expected, but the treatment also caused mineralogical changes to the patina. A secondary layer of malachite was sometimes found to occur as a precipitate, even though the ion $[Cu(CO_3)_2]^{2+}$ is stable in the presence of the bicarbonate ion. Reactions leading to the formation of malachite could be regarded as follows:

$$2CuCl + H_2O = Cu_2O + 2HCl \qquad\qquad 3.2$$

$$2HCl + Na_2CO_3 = 2NaCl + H_2O + CO_2 \qquad\qquad 3.3$$

$$Cu_2O + H_2CO_3 + H_2O = CuCO_3 \cdot Cu(OH)_2 + H_2 \qquad\qquad 3.4$$

Conservators were advised to change the solution if the precipitation of malachite occurred, but it was difficult to adequately monitor the treatment during a process that could take years.

When cuprous chloride is allowed to react with water, a steady increase in chloride ion concentration occurs in solution as a function of time, although the reaction is slow. The solid products, confirmed by X-ray diffraction, are cuprite and paratacamite. With added sodium sesquicarbonate, however, the OH^- ion concentration is higher than in water alone:

$$2CuCl + OH^- = Cu_2O + 2Cl^- + H^+ \qquad\qquad 3.5$$

Consequently, there may be some cuprite formation as well as dissolution of cupric chloride and the production of chalconatronite. Frondel and Gettens (1955) connect the formation of chalconatronite in the natural environment to copper alloy reacting with surface or subsoil waters carrying alkali carbonates in solution: the water could produce chalconatronite either by direct attack of the copper alloy or by reacting with intermediate alteration products, such as malachite or atacamite. Atacamite, α-quartz, cuprite, and chalconatronite were identified by X-ray diffraction on the outer part of the concretion covering the Riace bronzes (see CHAPTER 11) that had been submerged for many centuries at a depth of 8 m at the bottom of the Ionian Sea (Formigli 1991). This is of interest because chalconatronite is not usually considered as a marine corrosion product, and there must be a possibility that it formed after excavation.

Notes

1 Pliny the Elder *Natural History* 33.57 (Pliny 1979).

2 Pedanius Dioscorides *De materia medica* 5.17 (Dioscorides [1933] 1968).

3 Pliny 37.19.

4 A journal published by the Getty Conservation Institute in association with the International Institute for Conservation of Historic and Artistic Works, London.

5 Values of the isotopic ratios in carbonates are expressed in deviations, in parts per thousand, from standard physical data, where delta = $[(R_\text{sample}/R_\text{standard}) - 1] \times 1000$. In this equation, R is either the ratio of $^{13}\text{C}/^{12}\text{C}$ or $^{18}\text{O}/^{16}\text{O}$.

6 Evidence of other early uses of azurite has been found as well. Beads made of azurite, turquoise, and a variety of other minerals were found at the ancient Mesopotamian site of Yarim Tepe, dating from the sixth millennium B.C.E. (Moorey 1994). Carved azurite has also been found in the form of two early cylinder seals from ancient Babylonia.

7 Pacheco was father-in-law of the Spanish painter Diego Velázquez (1599–1660).

8 Mayan blue is the most important synthetic blue pigment invented in ancient South America and consists of indigo absorbed into a good quality clay. The combination of the dye and clay proved to be remarkably resistant to fading and deterioration.

9 Andrew Watling, conversation with the author, Los Angeles, 14 March 1998.

10 There is uncertainty about the characterization of the basic chloride alteration products of azurite because Fourier transform infrared spectroscopy is not sufficiently precise to differentiate among the many possible end products.

11 A very slight weight change observed at this temperature may be due to loss of some bound water or slight deterioration, so it is not clear at this temperature that decomposition has yet occurred.

12 Understanding the heat alteration of malachite also provides practical insight into the process of reaction soldering. In this metallurgical joining technique, gold granules are adhered to a substrate metal (also usually gold) using malachite and an organic-glue binder. On heating, the malachite decomposes, loses water, and by 600 °C, transforms into tenorite. The carbonized glue acts as a reducing agent that then transforms the tenorite into copper metal, which diffuses into both the gold granules and the gold substrate, creating a metallurgical join. This soldering technique is also known as "reaction hard soldering," or the "Littledale process," because it was rediscovered by the English jeweler Littledale in the 1920s.

13 It is also quite possible that some of the artificial pigments produced from early recipes are not, in fact, azurite, but other synthetic products; this would explain the low refractive index found by Laurie.

14 In medieval and Renaissance times, "mountain blue" was a synonym for azurite. As supplies of the natural mineral dwindled, this name was later applied to the type of synthetic preparation described here.

15 If potash really had been used, however, the precipitate would actually have been the copper(II) hydroxide.

16 The first laboratory synthesis of the compound to make use of this method was by Jean Achille Deville (1789–1875) in 1852 (Mellor 1928).

17 Silver overlaid with a thin coating of gold.

Chlorides and Basic Chlorides

CHAPTER 4

> *The emerald green incrustations abound in the submuriate of copper, and the red consist almost entirely of the protoxide of copper. These two compounds I have never witnessed spread over the whole of a coin, but more or less mixed with rusts of a different kind, studding the surface in the form of little crystalline elevations.* —JOHN DAVY [1]

THE COPPER CHLORIDES

One of the most troublesome group of minerals for bronze stability are the copper chlorides—the "submuriate of copper" observed on copper coins by Davy (1826). The presence of cuprous chloride, CuCl, as a corrosion product adjacent to the metallic surface can create long-term problems for the stability of an object. The slow, progressive corrosion of bronzes, known as "bronze disease" (discussed later in this chapter), is usually attributable to chlorides.

Some copper chlorides have been used as pigments; some also occur as pigment impurities or components to other pigments and, in certain instances, may be present as a result of the deterioration of an original pigment that has been replaced by one of the copper chlorides.

The most important copper chlorides in bronze corrosion are nantokite (cuprous chloride), CuCl, and the copper trihydroxychlorides: atacamite, paratacamite, clinoatacamite, and botal-

TABLE 4.1 **CHARACTERISTICS OF SOME COPPER CHLORIDE MINERALS**

MINERAL NAME	FORMULA	CRYSTAL SYSTEM	COLOR	MOHS HARDNESS
nantokite	$CuCl$	cubic	pale green	2.5
atacamite	$Cu_2(OH)_3Cl$	orthorhombic	vitreous green	3–3.5
paratacamite	$Cu_2(OH)_3Cl$	rhombohedral	pale green	3
clinoatacamite	$Cu_2(OH)_3Cl$	monoclinic	pale green	3
botallackite	$Cu_2(OH)_3Cl$	monoclinic	pale bluish green	3
anarakite[a]	$(Cu,Zn)_2(OH)_3Cl$	rhombohedral	light green	3

[a] Since recent research suggests that anarakite is actually zincian paratacamite, the name *anarakite* is now regarded as superfluous.

lackite, all of which are isomers of $Cu_2(OH)_3Cl$. Anarakite, $(Cu,Zn)_2(OH)_3Cl$, was originally thought to be a separate mineral but is now accepted as a zinc-substituted paratacamite, properly called zincian paratacamite.[2]

The copper trihydroxychlorides may occur as original corrosion products or as transformation products. Most of the natural occurrences of these minerals are in the oxidized zones of base metal ores in arid climates. Botallackite, however, is relatively rare; it was originally found, along with atacamite and paratacamite, in a mine in Cornwall, England, where the mine workings were below sea level. The periodic percolation of saltwater into the mine had influenced the crystallization of these phases; the subsequent drying out may be particularly involved in the formation of the unstable botallackite. These polymorphs belong to different crystal systems, as shown in TABLE 4.1. A variety of other, relatively rare copper chloride compounds are also discussed later in this chapter.

Nantokite | The mineral nantokite, cuprous chloride, can occur as massive, granular lumps in nature or as tetrahedral crystals in synthesized samples. The pale green mineral is isotropic because of its cubic crystal form; in a melt-mount viewed with the polarized-light microscope, crystals may show an apparently anomalous birefringence, especially at the edges. The refractive index is about 1.930. Nantokite usually occurs on copper alloys as a gray or gray-green, translucent, waxy solid. Because its hardness is only 2.5 on the Mohs scale, it can easily be cut with a scalpel or scraped off with a fingernail. The mineral form was first identified at and named for the copper mines near Nantoko, Chile (Palache, Berman, and Frondel 1951).

Atacamite	Atacamite, the most common of the copper trihydroxychloride isomers, was named for the Atacama Desert in northern Chile

where it was identified in secondary copper ore deposits. Use of the mineral name can be traced back to 1801, according to the ICDD files. Atacamite crystals are orthorhombic and vary in color from emerald to blackish green. The mineral has been observed as a continuous, sugarlike coating of dark green glistening crystals on many bronze objects from Egypt and Mesopotamia (Gettens 1964). These occurrences are similar to those seen on sheet-copper objects from ancient Peruvian cultures, such as the Vicus and Moche cultures dating to the early centuries C.E. It is also not uncommon to see isolated, rather than continuous, patches of dark green atacamite on archaeological material. Artificial patination recipes based on sodium chloride or dilute hydrochloric acid may produce a primary patina of atacamite, but this cannot be confused with a genuine patina, because atacamite is never found as a continuous layer directly adjacent to the metal surface.

Paratacamite (anakarite) and clinoatacamite	Paratacamite, also named for the Atacama Desert, is more often found as a powdery, light green secondary corrosion layer on the patina surface or in pustules from the transformation of

nantokite (cuprous chloride); highly developed crystals are less common. The strength of hydrogen bonding in the copper trihydroxychlorides is highest for paratacamite and lowest for botallackite, corresponding to the greater stability of paratacamite compared with botallackite.

Confusion has surrounded the classification of paratacamite. Jambor and colleagues (1996) made the perplexing observation that the most recent entry for paratacamite in the ICDD files[3] was assigned a monoclinic crystal structure by Oswald and Guenter (1971), despite the fact that the original data from Frondel (1950) placed the mineral in the rhombohedral group. The ostensible discovery by Adib and Ottemann (1972) of a zincian paratacamite, which they called anarakite after Anarak province in Iran, only added to the confusion. Until recently, it had been generally agreed that the original work of Frondel had correctly established that paratacamite was rhombohedral. Synthetic studies by Jambor's group, however, showed that the synthetic end member of the copper-zinc-trihydroxychloride sequence is monoclinic at the copper end and does not, in fact, have a rhombohedral structure. The ICDD files are, therefore, in error, and the description of paratacamite first named in 1905 now needs major revision after nearly a century of untroubled existence. This means that a new mineral name is necessary for the monoclinic form; "clinoatacamite" has been accepted as the appellation and should replace most of the previously reported occurrences of paratacamite. Jambor and coworkers also found that paratacamite and clinoatacamite can coexist in the same formation. Their studies of mineral samples from Chuquicamata, Chile, showed clinoatacamite together with atacamite, paratacamite, gypsum, and alunite on a quartzose matrix.

The X-ray diffraction data for clinoatacamite are slightly more complex than the data for paratacamite. One of the distinguishing features for clinoatacamite is the clustering of four lines at 2.713, 2.339, 2.266, and 2.243; only two lines appear in this range for paratacamite (see APPENDIX D, TABLE 2). Because of the extremely close similarity in the X-ray diffraction data for paratacamite and clinoatacamite, diligent attention will need to be paid in future research to the assignment of d-spacings and intensities to distinguish between these two mineral phases. This is important because with much archaeological material it is difficult to obtain a clear enough powder X-ray diffraction result to be able to determine exactly what phase is present. The analysis included in APPENDIX D, TABLE 2, of a light green, powdery corrosion product is from a totally mineralized bronze rod from the Middle Bronze Age site of Tell Fara, Jordan. This table gives comparative data for anarakite, zincian paratacamite, and clinoatacamite. The data appear to be slightly more in keeping with ICDD file entry 25–1427 for paratacamite, but the corrosion material is probably clinoatacamite, especially since zinc and nickel are absent.

Since many outdoor bronzes contain appreciable amounts of zinc, it is quite possible that some of the reported occurrences of paratacamite are correct, or that this mineral can coexist with clinoatacamite as a corrosion product, as it can in geological formation. The whole story, however, will not be known until further research is carried out on this aspect of the problem.

Botallackite

Of the four copper trihydroxychloride isomers, botallackite is the least stable. This accounts for the rare instances in which it has been identified as a component of copper corrosion products on archaeological material or as a pigment in wall paintings. Botallackite, which is monoclinic, was first identified, characterized, and named by Church (1865) for the Botallack mine at St. Just, Cornwall, England. No occurrences of this mineral on antiquities were reported for nearly one hundred years, until Frondel (1950) found it on the interior of an Egyptian bronze figurine of the deity Bastet in the Fogg Museum of Art, Boston. Gettens (1964) reported an occurrence of botallackite on an Egyptian bronze censer in the Walters Art Gallery, Baltimore; and Schnorrer-Kohler, Standfuss, and Standfuss (1982) identified the mineral in lead slags from ancient mines in Lávrion, Greece (see pages 142–43). The slags were, significantly, in contact with seawater.

COPPER CHLORIDES AND BRONZE DISEASE

Bronze disease is a progressive deterioration of ancient copper alloys caused by the existence of cuprous chloride (nantokite) in close proximity to whatever metallic surface may remain.[4] Cuprous chloride may lie dormant until reaction with moisture and oxygen causes this unstable compound to expand in volume on conversion to one of the copper trihydroxychlorides. This creates physical stress within the object affected, resulting in cracking or fragmentation.

The condition is manifest by light green, powdery excrescences or eruptions within the surface, as shown in PLATE 26, loose material often falling from the object and dropping onto the surrounding area. In extreme cases, very acidic light or dark green liquid may ooze from the bronze and stain surrounding tissue or foam supports. Ultimately, bronze disease can reduce an apparently solid object into a heap of light green powder.

The existence of some chloride-containing corrosion products within the patina of a bronze does not mean that the object is necessarily suffering from bronze disease but may simply represent a localized or superficial chloride corrosion process. Bronze disease, in contrast, is characterized by the accumulation of deposits of cuprous chloride within the bronze itself or underlying the surface patina, causing fundamental instability. Since chloride ions are often driven by electrochemical reactions deep within the surface layers of corrosion, the chlorides may be overgrown with cuprite that has developed as part of the corrosion process; this, in turn, is often overlaid with basic carbonates or chlorides.

Bronze disease research | Bronze disease has aroused a great deal of interest and speculation over the last hundred years or so. In the late nineteenth century, it was believed that bronze disease was microbiological in origin. Mond and Cuboni (1893) attributed this corrosion to the presence of a common fungus, *Cladosporium aeris,* which they were able to isolate from affected corrosion pits. Sterilization at 120 °C for twenty minutes was, therefore, one of the first treatments recommended for stabilization of ancient bronzes. Around the same time, Rathgen (1889, 1898) proposed that bronze disease was due to the presence of corrosive chloride salts, and this gradually gained acceptance as the correct explanation. A useful review of the early history of bronze disease and its treatment is provided by Gilberg (1988).

One of the first scientists to study the problem from the chemical point of view was the French organic and physical chemist Marcellin Berthelot (1827–1907), who recognized that there must be an important cyclical component to the corrosion reaction (Berthelot 1894, 1895, 1901). He also recognized that one of the important products of the reaction was the basic copper chloride atacamite, to which he assigned the formula $3CuO,CuCl_2 \cdot 4H_2O$. The modern basic copper chloride formula is $3CuO,CuCl_2 \cdot 3H_2O$, which is surprisingly close. Berthelot's achievement was remarkable for the chemistry of the time, especially since these basic copper chlorides are not that well understood even today.

Berthelot's explanation for the process suggested that a small quantity of sodium chloride reacted with the atacamite and the metallic copper. A slow reaction supposedly took place, forming a double compound of cuprous chloride and sodium chloride and converting excess copper into cuprous oxide:[5]

$$3CuO \cdot CuCl_2 \cdot 4H_2O + 4Cu + 2NaCl = Cu_2Cl_2 \cdot 2NaCl + 3Cu_2O + 4H_2O \qquad 4.1$$

The double salt was then oxidized by air to produce cupric chloride and atacamite:

$$3Cu_2Cl_2 \cdot 2NaCl + 3O + 4H_2O = 3CuO \cdot CuCl_2 \cdot 4H_2O + 2CuCl_2 + 6NaCl \qquad 4.2$$

The cupric chloride that remained in contact with the air and the copper or cuprous oxide was also converted into oxychloride:

$$CuCl_2 + 3Cu + 3O + 4H_2O = 3CuO \cdot CuCl_2 \cdot 4H_2O \qquad 4.3$$

This completes the series of reactions that, overall, converts copper, oxygen, and water to cuprous oxide and atacamite in a cyclical process. Berthelot maintained that the continual recurrence of this cycle under the influence of oxygen and moisture is the cause of bronze disease, and this conclusion is essentially correct. More is known about the process today, but not all the details of the corrosion chemistry involved are understood.

The equations advanced by Berthelot are not completely accurate descriptions of bronze disease, however. Although the idea of a cyclical reaction is accepted, the principal cause of instability in excavated bronze objects, as we now know, is due to the existence of cuprous chloride, which is formed by corrosion processes during burial. This cuprous chloride is not usually exposed to view but is present as a corrosion product often close to the metal surface.

In more recent studies, Organ (1963) proposed that the main reaction responsible for bronze disease is the production of cuprous oxide (cuprite) by hydrolysis of cuprous chloride:

$$2CuCl + H_2O = 2HCl + Cu_2O \qquad 4.4$$

The hydrochloric acid generated by this reaction will then produce more cuprous chloride:

$$2HCl + 2Cu = 2CuCl + H_2 \qquad 4.5$$

In practice, when cuprous chloride is in contact with copper and a drop of water is added, cuprite formation does not occur; copper trihydroxychlorides are the principal products. The standard method for synthesizing paratacamite is to immerse a sheet of copper in a solution of cupric chloride, which first produces a thin layer of cuprite over the copper, followed by a layer of paratacamite. Cuprite can be formed as a thin layer adjacent to copper if cuprous chloride and copper are mixed together and regularly moistened with water, but this is not the principal reaction that occurs. On copper samples in the laboratory, cuprous chloride slurries develop a pH of about 3.5–4, and the solution forms a green precipitate, which is one of the copper trihydroxychlorides.

The reaction is one of oxidation and hydrolysis of the cuprous chloride. This takes place with a free energy of formation of about -360.9 kcal/mol, which means that the reaction should occur spontaneously, as follows:

$$4CuCl + O_2 + 4H_2O = 2Cu_2(OH)_3Cl + 2H^+ + 2Cl^- \qquad 4.6$$

(This equation has been written using –319.8 kcal/mol as the value of the free energy of formation of paratacamite.)

In reviewing the same series of reactions within the context of a geochemical environment, Pollard, Thomas, and Williams (1992b) came to a different conclusion. They determined that the reaction

$$2CuCl + H_2O = Cu_2O + 2H^+ + 2Cl^-$$ 4.7

will proceed under most oxidizing conditions; that is, that cuprous chloride and water will form cuprite. This reaction has a positive Gibbs free energy of formation under standard conditions of about 13.5 kcal/mol. Pollard, Thomas, and Williams argue that, despite the positive value, this is the principal reaction that is occurring and that it must be an important reaction in burial environments. Once an object is brought into the laboratory and is freely exposed to air, however, the cuprous chloride tends to react to produce one of the copper trihydroxychlorides; cuprite is not formed under these circumstances. In fact, when cuprous chloride is placed on moist filter paper, it slowly changes to produce principally atacamite (Tennent and Antonio 1981).

Sharkey and Lewin (1971) contended that one of the critical factors in determining which copper trihydroxychloride isomer is formed during the possible transformations to atacamite or paratacamite is the concentration of complex cupric chloride ions in solution.[6] Pollard, Thomas, and Williams (1992b) confirmed that paratacamite (actually clinoatacamite) is thermodynamically the most stable phase. They found, contrary to Lewin (1973), that recrystallization of atacamite to paratacamite can take place in aqueous solution at room temperature. With a difference of only 0.26 kcal/mol in the Gibbs free energy of formation between atacamite and paratacamite, however, it is not surprising that they both may form under closely related conditions. Botallackite is the least stable phase. By carefully controlling temperature, solution concentrations, and time, Pollard, Thomas, and Williams found in the same study that it was possible to isolate botallackite in all experimental conditions tested.

The results of the work by Pollard, Thomas, and Williams (1992b) show that crystallization of the copper trihydroxychlorides is controlled by a series of competing steps. Botallackite is the first phase to form, but it recrystallizes rapidly under most conditions to form either atacamite or paratacamite. Botallackite might be expected to form only when the solution responsible for its formation has been removed or has dried out during the reaction. The occurrence of botallackite on an object, therefore, could indicate that the mineral recently formed and has not had time to recrystallize; or that soon after the botallackite formed, the environment dried out, preventing recrystallization.

Studies by Sharkey and Lewin (1971) and by Lewin (1973) suggest that the important factors in determining whether atacamite or paratacamite forms are the hydroxyl-to-chloride ratio in solution or the presence of the higher copper chloride complexes. When the $CuCl^+$ concentration reaches between 20% and 30% of the copper ions in solution at a pH of about 4, then

atacamite is favored over paratacamite. With still higher copper complexes, such as $CuCl_2$, $CuCl_3^-$, and $CuCl_4^{2-}$, paratacamite becomes the favored species. Sharkey and Lewin (1971) found that there was no dimorphic interconversion between paratacamite and atacamite under the conditions they investigated.

It has been suggested that the relative proportions of the copper trihydroxychloride isomers on an artifact could provide clues to the provenance of the object or perhaps to the authenticity of the patina. This is not really feasible, however. As discussed, the proportions of the isomers can vary, depending on whether the object has incipient bronze disease, which may show fresh outbreaks of one of the copper trihydroxychlorides, or whether the original burial patina constituents are being examined, which may show autochthonous chlorides. Even in the laboratory, the mode of production of the basic chlorides is critical. If cupric chloride solution is added to calcium carbonate and stirred, then atacamite is produced; if the solution is left unstirred, then botallackite forms, as demonstrated by the experimental work of Tennent and Antonio (1981).

| Role of chloride ions in corrosion | The factors that control the conditions under which the different copper chloride products form are subtle. Some reactions are more repeatable than others. For example, an experiment |

conducted by the author on the reaction of cuprous chloride, copper foil, water, and air produced mostly paratacamite, in agreement with most previously reported results. The same reaction replacing cuprous chloride with cupric chloride, however, yielded a mixture of paratacamite and atacamite, with more atacamite. This last reaction invariably produces paratacamite (or, rather, clinoatacamite, as is now known). Unless all parameters of the reaction, such as pH, temperature, time, and molar concentrations, are carefully controlled, the end products cannot be predicted with certainty. This was confirmed by the work of Pollard, Thomas, and Williams (1992b), who found that the rate of crystallization of atacamite was greatest in solutions containing high ratios of $(CuCl^+)/(Cu^{2+})$ and $(Cl^-)/(H^+)$ and a lower ratio of $(Cu^{2+})/(H^+)$. They were unable to determine exactly what the critical step of the reaction is, however, and the complete series of reactions is still unknown, despite all the research that has been carried out to date.

The Pourbaix diagrams shown in FIGURE 4.1 have been drawn for a variety of chloride ion activities. FIGURE 4.1B has a chloride ion concentration of 350 ppm, which is roughly equivalent to saline groundwater. At a potential of 0.238 V and pH 3.94, the crystallization of atacamite is much slower than that of paratacamite, and this reaction would be anticipated to proceed via botallackite to paratacamite. To get atacamite to form, a greater concentration of copper and chloride ions at the metal surface is needed, and two different routes can bring this about. First, corrosion can occur in highly saline environments or in fairly arid environments, where a solution can become markedly concentrated on the metal surface as it dries out. Second, differences in electrode potential on the copper surface might cause pitting corrosion, and within the pits

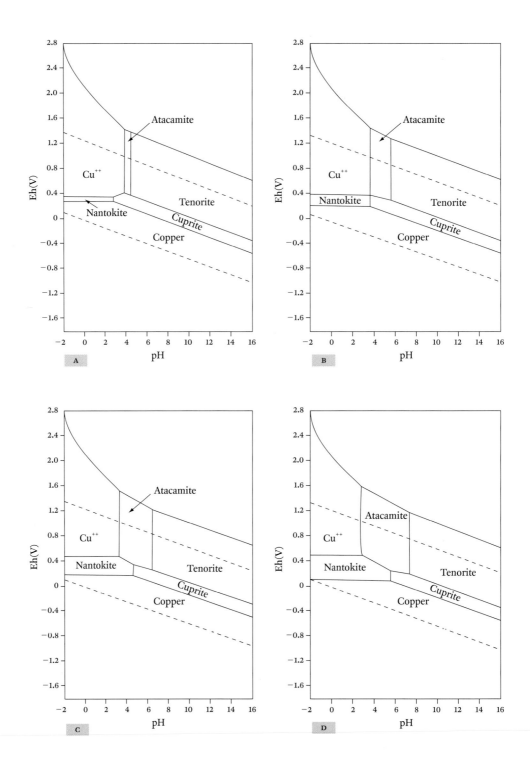

FIGURE 4.1 Pourbaix diagrams for the system Cu–Cl–H$_2$O at chloride concentrations of A, 35 ppm, B, 350 ppm, C, 3550 ppm, and D, 35,500 ppm (after Pourbaix 1977).

there will be an equilibrium between cuprite and nantokite. These anodic pits can maintain charge neutrality by drawing in chloride ions from groundwater, resulting in a solution with higher copper ion and chloride ion activity inside rather than outside the pits. If the pits erupt and release copper and chloride ions, then a mixture of products could form, such as paratacamite and atacamite, or conditions might favor the formation of only atacamite.

THE PRESENCE OF NANTOKITE Nantokite is usually found under the carbonate or soil-encrusted outer zone of the patina, sometimes concealed within a cuprite crust or revealed at the base of pustules when they are shaved with a scalpel during mechanical cleaning. An unusual occurrence of pale, waxy nantokite was observed on the surface of some silver-copper alloy coins in the J. Paul Getty Museum collections. The coins would periodically turn a powdery green until the nantokite was removed by mechanical cleaning (the nantokite did not actually form within a corrosion pit but as a deposit over part of the corroded surface). On some bronzes, especially from the Near East, nantokite may actually penetrate into the metal object, occurring as deep-seated pockets or layers rather than forming only a surface layer. These inclusions of nantokite imply very serious problems for the long-term stability of such bronzes unless the relative humidity is kept below 45% for storage or display. That nantokite may occur at such depth from the outer corrosion interface demonstrates the ability of chloride ions to interact with the metal in primary corrosion processes; the chloride ions are drawn toward the internal regions, balancing the charge for the dissolution of copper cations.

IMPLICATIONS FOR PATINA AUTHENTICITY Lewin (1973) argued, incorrectly, that the concentration of the complex copper ions in solution during natural corrosion processes in the soil would be low. With low concentrations, paratacamite is the most favored product, and Lewin posited that the detection of a mixture of paratacamite and atacamite in a patina implied that the patina could not have formed in a natural burial environment and must, therefore, be fake.

This argument suffered from a number of serious drawbacks. As already discussed, the formation of the copper trihydroxychlorides is not straightforward and depends on a number of factors. X-ray diffraction studies of several natural patinas examined by different laboratories have established that all four isomers may be present and are not limited to paratacamite. In addition, low concentrations of copper chloride ions have not been confirmed by in situ studies. Giangrande (1987), for example, examined samples of corrosion products from several ancient bronzes during conservation treatment at the Department of Conservation and Materials Science, Institute of Archaeology, London. In the cases where the copper trihydroxychlorides were identified, mixtures of paratacamite and atacamite were common.

Pitting corrosion

The investigation of pitting corrosion as a result of industrial failure of commercial copper objects, such as pipes and boilers, provides one of the few scientific insights into the role and formation of cuprous chloride in corrosion of this type. May (1953) observed that when a clean copper surface was exposed to corrosive waters containing dissolved oxygen, there was a brief period of rapid formation of soluble copper corrosion products and the conversion of some of these products to insoluble basic salts, which appeared as a cloudy precipitate in the layer of liquid on the copper surface. Later, a visible film formed on the metal, which reduced the rate of attack. A layer of cuprous oxide can appear under the initial film and may replace it, becoming comparatively thick and often nonuniform. This layer may be more cathodic and therefore favorable to pitting at local defects. The copper inside this defect zone acts as an anode due to depletion of oxygen, and chloride ions are drawn inward, producing porous crystalline cuprous chloride deposits next to the metal.

Lucey (1972) shows that these pits function as electrochemical cells. The cuprite that forms over the cuprous chloride acts as a diffusion barrier, which reduces the loss of dissolved copper ions into the outer zone. The cuprite also behaves as a bipolar electrode, with an anodic reaction taking place on the inner surface of the cuprite and a cathodic reaction occurring on the outer surface. Cuprous ions diffuse through the cuprite and can become oxidized by oxygen in water to form cupric ions, some of which can be lost into the soil groundwater, some precipitated as basic salts, and some reduced back to the cuprous state at the outer membrane surface.

The corresponding anodic reaction is less well understood, and Lucey suggests that the cuprous ions inside the pits are oxidized to cupric ions. This increase in cupric ion concentration disturbs the equilibrium between metallic copper and the cuprous and cupric ions. Copper can then dissolve to maintain equilibrium.

The following equations describe the reactions in aqueous conditions contiguous with a copper surface:

$$Cu + Cu^{2+} = 2Cu^{+} \qquad\qquad 4.8$$

$$2Cu^{+} + H_2O = Cu_2O + 2H^{+} \qquad\qquad 4.9$$

$$4Cu^{+} + O_2 + 2H_2O = 4Cu^{2+} + 4(OH)^{-} \qquad\qquad 4.10$$

Lucey proposes that the balance among these three equations is responsible for the precipitation of cuprous chloride. Under these conditions, the rate of formation of the cuprous ions exceeds the conversion into cuprite or cupric compounds, and a layer of cuprous chloride can then form. He also presents four essential equations describing pit corrosion processes. The first reaction occurs within the mound of corrosion above a pit and can vary depending on whether carbonate ions, chloride ions, or other ionic species are available to interact with the copper:

$$4CuCl + Ca(HCO_3)_2 + O_2 = CuCO_3Cu(OH)_2 + CaCO_3 + 2CuCl_2 \qquad 4.11$$

The second, a cathodic electrode reaction, occurs on the outer surface of the cuprite:

$$Cu^{2+} + e^- = Cu^+ \qquad 4.12$$

The third, an anodic electrode reaction, occurs on the inner surface of the oxide membrane:

$$Cu^+ - e^- = Cu^{2+} \qquad 4.13$$

The fourth reaction is between the anodic product and the copper within the pit:

$$Cu + Cu^{2+} = 2Cu^+ \qquad 4.14$$

The presence of chloride ions within a pit can cause cuprous chloride, CuCl, to form. With higher chloride concentrations, the soluble complexes of $(CuCl_2)^-$ and $(CuCl_3)^{2-}$ can lead to further corrosive reactions. High concentrations of chloride ions can develop because of isolation of the pit from the surrounding environment by the cuprite layer or by the mound of corrosion products accreting over the cuprite crust. As previously noted, the increased concentration of chloride ions in the pits is primarily due to the migration of chloride ions from the groundwater into the pits to maintain neutrality. Because of their higher concentration, chloride rather than hydroxide ions tend to move into these pits; this migration is enhanced by alloying elements such as tin and zinc. Soluble cuprous species from inside the pits can diffuse out through cracks in the cuprite membrane, and these complexes are then oxidized to cupric ions:

$$CuCl_2^- = CuCl_2 + e^- \qquad 4.15$$

While this occurs, the usual oxidant, oxygen, is reduced to hydroxide ions:

$$O_2 + 2H^+ + 4e^- = 2OH^- \qquad 4.16$$

This cathodic reaction causes a localized increase in pH that tends to result in the precipitation of the basic copper (II) compounds. Experimentally, MacLeod (1981) found that about half the copper that has been corroded remains as cuprite in the pit itself. He calculated the influence of chloride ion concentration on the leaching of copper metal, and the results of this study for two sets of anodic and cathodic reactions, which are shown in TABLE 4.2, indicate how the free energy of the pitting reaction can vary with the chloride ion concentration, assuming equilibrium conditions. Since the Gibbs free energy of formation varies significantly with the chloride ion concentration, it can be inferred that a decrease of the chloride ions will stifle the reaction, since the change in Gibbs free energy moves into positive values in deionized water. The standard free energies (from the data of Latimer 1952) in TABLE 4.2 have been calculated with the assumption that the chloride ion activity is equal to the chloride ion concentration and that the concentration of the pit solution is based on a concentrated brine.

Pourbaix (1976) suggested that analogous corrosion pits are formed on copper that has been attacked by domestic water. Not all waters, however, caused this pitting; surprisingly, water from the river Thames in London, for example, produced no corrosion pits. Pourbaix's initial experiments produced a series of peculiar results. In corrosion trials, copper with nantokite would sometimes produce a deposit of metallic copper rather than corroding further. During the first period of laboratory experimentation, the electrode potential of the copper surface showed a low value, from -50 mVSCE to -10 mVSCE (+200 mVSHE to +240 mVSHE), and the copper surface was covered with cuprite. During the second period, the potential increased steadily to about +40 mVSCE (+290 mVSHE), and some malachite formed. During the third period, the potential fluctuated up and down. Illuminating the copper with light did not affect the electrode potential during the first period. During the third period, at 145 days from the start of the experiment, light promoted a considerable potential drop of about 320 mV, to a value of -250 mVSCE (0 mVSHE), but this was only temporary. Pourbaix's detailed environmental analysis (1977), illustrated in FIGURE 4.2, indicates that the equilibrium conditions expected for the pH in corrosion crusts where copper, cuprite, and nantokite are present are quite acidic and can contain potentially high amounts of complex copper chlorides. The reaction conditions, therefore, act contrary to the model proposed by Sharkey and Lewin (1971).

A simplified Pourbaix diagram showing the relevant fields of stability for the mineral phases is shown in FIGURE 4.3, and a listing of selected thermodynamic data for some copper minerals relevant to those discussed here is given in TABLE 4.3.

THE BASIC COPPER CHLORIDES AS PIGMENTS

Reports exist of atacamite, paratacamite, and botallackite having been used as pigments.[7] Usually, these are pale green in color, lighter than malachite, and some may be of a light turquoise hue. It is unclear, however, if these minerals are original pigments themselves or alteration products derived from the transformation of original pigments.

Delbourgo (1980) reported finding atacamite and paratacamite in eighth-century paintings from Dunhuang, the People's Republic of China. Since X-ray fluorescence spectroscopy was used in the study, however, the identifications cannot be considered reliable since this analysis would be able to show only the presence of copper and chlorine and would not be useful in identifying the light green salts. PLATE 27 shows a bodhisattva sculpture from cave 328 of the Mogao grottoes at Dunhuang. Botallackite was also reported by Wainwright and colleagues (1997) from Buddhist wall paintings in these grottoes, but further research is required to ascertain if this and other pigments are original or formed by alteration of malachite, which is the most likely explanation for the botallackite.

Piqué (1992) examined green pigments from a series of wall paintings in the Buddhist cave temples at the Yungang grottoes near Dunhuang. The paintings were commissioned by a

TABLE 4.2 — CHLORIDE ION CONCENTRATIONS AND EQUILIBRIA[a]

CHLORIDE CONCENTRATION IN PPM	SIMILAR AQUEOUS ENVIRONMENT	$Cu^{2+} + Cu + 4Cl^- = 2CuCl_2$ $Cu + 2Cl^- = CuCl_2^{2-} + e^-$ $Cu^{2+} + 2Cl^- + e^- = CuCl_2^{2-}$	$Cu^{2+} + Cu + 2Cl^- = 2CuCl$ $Cu + Cl^- = CuCl + e^-$ $Cu^{2+} + Cl^- + e^- = CuCl$
1	deionized water	+ 75	+ 12
100	Perth tap water	+ 29	− 11
10,000	dilute seawater	− 17	− 34
100,000	pit solution	− 39	− 46

After MacLeod (1981).

[a] All changes in Gibbs free energy are shown here in kcal/mol.

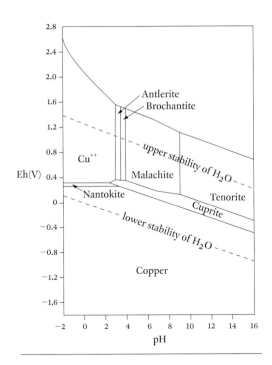

FIGURE 4.2 Pourbaix diagram for the system $Cu-CO_3-SO_4-Cl-H_2O$ for solutions containing 229 ppm CO_2 and 46 ppm SO_3 (after Pourbaix 1977).

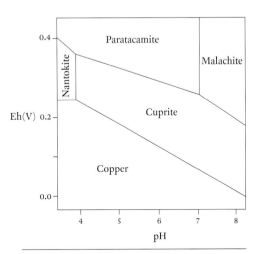

FIGURE 4.3 Pourbaix diagram for the system $CuO-H_2O-HCl$ at chloride ion activity of 10^{-2} and at a partial pressure of $CO_2(g)$ of $10^{-3.5}$ (Pollard, Thomas, and Williams 1992b).

TABLE 4.3 **SELECTED THERMODYNAMIC DATA FOR SOME COPPER MINERALS**[a]

COMPOUND	FORMULA	$\Delta_f G$	REFERENCE
nantokite	$CuCl$	-28.2	Weast 1984
tenorite	CuO	-30.4	Weast 1984
cupric chloride	$CuCl_2$	-49.2	Weast 1984
cuprite	Cu_2O	-34.98	Weast 1984
covellite	CuS	-11.7	Weast 1984
chalcocite	Cu_2S	-20.6	Weast 1984
paratacamite	$Cu_2(OH)_3Cl$	-135.3	Woods and Garrels 1986
atacamite	$Cu_2(OH)_3Cl$	-160.1	Sharkey and Lewin 1971
botallackite	$Cu_2(OH)_3Cl$	-157.9	Sharkey and Lewin 1971
malachite	$CuCO_3Cu(OH)_2$	-215.7	Symes and Kester 1984
brochantite	$Cu_4SO_4(OH)_6$	-434.5	Robie, Hemingway, and Fisher 1978
connellite	$Cu_{19}(OH)_{32}Cl_{14}SO_4 \cdot 3H_2O$	-101.3	Pollard, Thomas, and Williams 1990a
azurite	$2CuCO_3Cu(OH)_2$	-343.3	Robie, Hemingway, and Fisher 1978
chalcanthite	$CuSO_4 \cdot 5H_2O$	-449.3	Robie, Hemingway, and Fisher 1978
antlerite	$Cu_3SO_4(OH)_4$	-345.7	Woods and Garrels 1986
sampleite	$NaCaCu_5(PO_4)_4Cl \cdot 5H_2O$	-1512.9	Pollard, Thomas, and Williams 1991
libethenite	$Cu_2(PO_4)(OH)$	-293.7	Magalhaes, Pedrosa de Jesus, and Williams 1986
pseudomalachite	$Cu_5(PO_4)_2(OH)_4$	-678.8	Magalhaes, Pedrosa de Jesus, and Williams 1986
cornetite	$Cu_3PO_4(OH)_3$	-382.6	Magalhaes, Pedrosa de Jesus, and Williams 1986

[a] Data are in cal/mol; to convert to SI units (kJ/mol), multiply by 4.184.

Northern Wei dynasty (386–535) emperor at the close of the fifth century. Atacamite was identified as a green pigment mixed with malachite and perhaps green earth in the polychromy of cave 6. The atacamite particles were globular, rounded masses with a dark center, typical of synthetic salts that have formed under conditions of alteration. The fact that this chloride was found mixed with malachite leads to the suspicion that it is not an original pigment but an alteration product of malachite. On the other hand, Piqué reports that atacamite is found in wall paintings in the Dunhuang area from almost all dynasties, including the Northern Wei dynasty. She refers to a report of a quarry for atacamite existing or having existed at Dunhuang, so the question of alteration cannot be resolved without further research into the etiology of these pigments. Proudfoot, Garland, and Larson (1988) mention observing "small rounded green particles" in pigment samples from two sculptures of the Tang dynasty (618–907) and the Jin period

(1115–1234) of the Song dynasty, but no X-ray diffraction analysis was carried out on these samples, so it cannot be concluded that they are even basic chlorides.

Atacamite has been found in a variety of Russian paintings from the eleventh to the fifteenth century and in Russian Romanesque frescoes of thirteenth century (Naumova and Pisareva 1994). Frescoes from Rostov, Russia, contained atacamite, although it had resulted from chemical alteration of artificial azurite. Naumova and Pisareva also reported finding atacamite in a fifteenth- to sixteenth-century Russian icon tempera painting. There are no known occurrences of this mineral in oil paintings. Naumova, Pisareva, and Nechiporenko (1990) found atacamite in a thirteenth-century manuscript, on a sixteenth-century icon, and in some seventeenth-century maps. In other studies, atacamite has been found in the wall paintings of Kariye Camii, a Byzantine church in Istanbul (Gettens 1963a), and in some thirteenth-century Austrian churches (Kerber, Koller, and Mairinger 1972). Both atacamite and paratacamite have been found in polychrome sculpture, Egyptian sarcophagi, and Indian paintings (van T'Hul-Ehrenreich and Hallebeek 1972). Basic copper chlorides from painted Egyptian objects in the collections of the British Museum have also been reported by Green (1995). Atacamite was identified mixed with verdigris in the green paint of a Latin breviary of the thirteenth century, while the chloride had decomposed in a medieval Greek manuscript, staining the parchment green.

Fitzhugh (1988) reported the occurrence of basic copper chlorides on one seventeenth-century Indian painting and in several fourteenth- to seventeenth-century paintings from Iran in the Vever Collection, Freer Gallery of Art, Washington, D.C. No single green pigment is widely used in the paintings from this collection; some greens are made with malachite or with a mixture of orpiment and indigo (in Iran) or with indigo and Indian yellow (in India).

A basic copper chloride, either paratacamite or atacamite, was identified by Fitzhugh (1979) during a detailed study of the pigments used by the Utagowa School of Ukiyo-e, a Japanese school of painters that operated from the late sixteenth to the mid-nineteenth century. The paintings studied by Fitzhugh are in the collections of the Freer Gallery of Art. A mounted pigment sample from one of these is shown in PLATE 28. The Ukiyo-e painters do not appear to have used any verdigris, although they may have used other copper-based green pigments that have yet to be fully characterized.

Synthetic pigments	Theophilus, writing in the twelfth century, describes manufacturing *viride salsum* (probably principally atacamite) by

sprinkling common salt over copper plates brushed with honey and then placing the plates over vinegar in a closed container (Theophilus 1961). Kühn (1970) reproduced this preparation and made a mixture of copper trihydroxychlorides and copper acetates. Naumova and Pisareva (1994), who also attempted to reproduce this recipe, found that after two months only blue crystals of a copper acetate (verdigris) had formed; after another two months a light green deposit

El Toro, Lower California Antofagasia Gila Co., Arizona

FIGURE 4.4 Crystalline varieties of atacamite (Palache, Berman, and Frondel 1951).

also appeared. X-ray diffraction studies showed the green material to be atacamite. The successful preparation of *viride salsum* by Theophilus's method is highly dependent on the reaction conditions. If the mixture of copper, honey, and salt is placed over red wine vinegar in a vessel that is then well sealed, a good yield of atacamite can be obtained in a few days. If the reaction vessel is not sealed, however, verdigris is the principal product.[8] The formation of basic copper chloride does not occur in strongly acidic conditions; therefore, it may be that partial evaporation of acetic acid took place during the work of Naumova and Pisareva, resulting in a pH increase that favored atacamite formation. This synthetic atacamite included a spherulitic form, which Naumova and Pisareva state is comparatively rare, although this form is, in fact, common in laboratory preparations. The spherulitic form of atacamite has been observed in only one group of paintings: eighteenth-century frescoes from the Avraamovsky Monastery in Russia.

Pigment morphology | In archaeological material, atacamite is often present as distinct crystals; some typical morphologies are shown in FIGURE 4.4. Photomicrographs of natural mineral atacamite from the collections of the British Museum, Natural History, are shown in PLATE 29. The particles are a pale green with transmitted illumination and have a pale blue birefringence when viewed under crossed polars. Natural mineral botallackite from the Levant mines in Cornwall, England, are illustrated in PLATE 30. Botallackite crystals appear as clear green and have banded features when viewed under transmitted light. By comparison, particles of botallackite identified by Fitzhugh (1988) in a fifteenth-century manuscript from Iran (PLATE 31) are spherical with dark spots toward the center of the

crystals; this suggests a synthetic preparation rather than natural mineral botallackite. The complete folio page from which the sample was taken is reproduced in PLATE 32. PLATE 33 shows paratacamite from a nineteenth-century Japanese painting in the Freer Gallery of Art (Fitzhugh 1988). The pigment particles are rounded, boulderlike crystals with variable green transmittance in bright-field illumination.

OTHER BASIC COPPER CHLORIDES

Connellite

Connellite, $Cu_{19}(OH)_{32}Cl_{14}SO_4 \cdot 3H_2O$, was reported by Otto (1963) to have been found on bronze rings from graves dating to the La Tène culture (mid-fifth century B.C.E.) in southwestern Germany. The bright blue, needlelike crystals were mixed with other copper minerals in the corrosion crust. As a mineral species, connellite was identified from deposits in St. Daly, Cornwall, England. The only other identification of connellite is from the work of MacLeod (1991) on Australian shipwreck sites. On a set of nickel-silver spurs from the wreck of the *Macedon* (1883), connellite was found in association with the unusual zinc-substituted paratacamite, formally known as anarakite and whose nomenclature was discussed earlier. These minerals were found together with the nickel salt nickel hydroxychloride, $NiOH \cdot Cl$, and a basic zinc sulfate, $ZnSO_4 3Zn(OH)_2 \cdot 4H_2O$.

Pollard, Thomas, and Williams (1990a) established that when even small amounts of sulfate ions are present in aqueous solution with chloride ions, the copper trihydroxychlorides can be replaced by other insoluble mineral species, such as brochantite, $Cu_4SO_4(OH)_6$, and connellite. Thomas (1990) found that an unexpected blue crystalline material was produced during attempts to synthesize the copper trihydroxychlorides, and this material was identified as connellite. There appears to be a solid-solution series between connellite and buttgenbachite, $Cu_{18}(NO_3)_2(OH)_{32}Cl_3 \cdot H_2O$. Analyses of buttgenbachite show that the material can exist without sulfate in the lattice (Schoep 1925), although other work suggests that there is a considerable variation in the amount of sulfate and nitrate present (Palache, Berman, and Frondel 1951). End member connellite with no nitrate is known. In the relationship between connellite and buttgenbachite, it is not immediately obvious how two nitrate ions can substitute for one sulfate ion. The structure of the connellite crystal, however, is composed of a three-dimensional network of Cu^{2+}, OH^-, and Cl^- ions that contains large channels parallel to the *c* axis. This creates a zeolitic-type framework where sulfate, nitrate, and water molecules occupy the channels. The sample analyzed by Thomas (1990) has the complex formula of $Cu_{36.8}[(SO_4)_{0.8}(NO_3)_{0.2}]_2Cl_6(OH)_{60}\{Cl_{0.33}[OH_{0.33}(H_2O)]_{0.33}\} \cdot 6H_2O$.

Reexamination of the connellite originally described by Thomas showed that it is, in fact, carbonatian connellite, a new variety of the mineral. The connellite was prepared by reacting a solution of cupric chloride with sodium chloride and sodium sulfate. At first, the transient

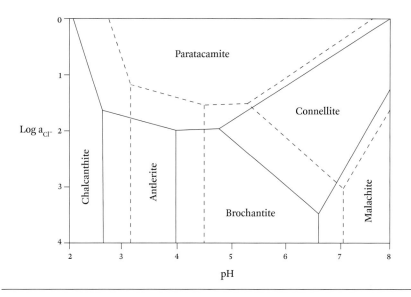

FIGURE 4.5 Stability-field diagram for the copper(II) halide minerals at a partial pressure of $CO_2(g)$ equal to $10^{-3.5}$. The solid and broken lines represent sulfate activities of 10^{-1} and 10^{-2}, respectively (Pollard, Thomas, and Williams 1992b).

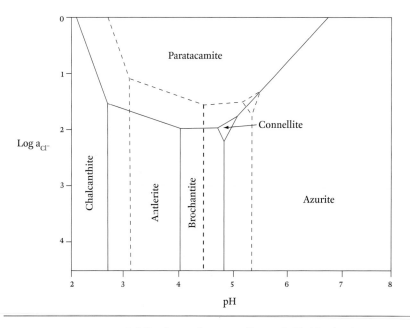

FIGURE 4.6 Stability diagram for some sulfates and chlorides showing regions of stability for six mineral phases, including connellite and brochantite (Pollard, Thomas, and Williams 1992b).

claringbullite, $Cu_8(OH)_{14}Cl_2 \cdot H_2O$, formed, but this was unstable under the laboratory conditions and recrystallized to connellite within two days. (This synthesis is further discussed in APPENDIX B, RECIPE 5.) Connellite occupies a stability field between the mineral phases brochantite, malachite, and paratacamite, as shown in FIGURE 4.5. Pollard, Thomas, and Williams (1990a) suggested that this should result in connellite being much more common as a corrosion product on archaeological material than previously thought as a result of the substantial stability field for connellite at pH 5–8 and a chloride ion activity equivalent to that of some natural environments. A second stability diagram at a higher carbon dioxide concentration (FIGURE 4.6) shows that the connellite stability region becomes very restricted compared with azurite at higher pH values and with paratacamite at higher chloride ion activities. There are still very few identifications published for connellite in the archaeological context. A recent identification was made of this mineral, however, on an Egyptian bronze in the collections of the Fitzwilliam Museum, Cambridge, England. The sample was submitted for analysis by Tennent as part of research into the deterioration of bronzes and other objects in museum storage.[9] The material was originally thought to represent an example of light blue corrosion products originating from poor storage conditions, but the determination of connellite (Scott 1997b) shows that the light blue material is part of the original corrosion encrustation from burial of the object.

The occurrence of connellite together with the copper trihydroxychlorides can be evidence for crystallization in a saline environment, while other associations of connellite in mine deposits occur with both malachite and brochantite. Claringbullite, which has been found in mines with cuprite, is very rare. Since it is probably unstable with respect to connellite, claringbullite has yet to be identified on artifacts or paintings.

| *Calumetite* | The mysterious mineral calumetite, $Cu(OH,Cl)_2 \cdot 2H_2O$, makes rare appearances from time to time. This exotic mineral was |

first identified by Williams in 1963, together with the equally rare anthonyite (discussed in the following section). Naumova, Pisareva, and Nechiporenko (1990) and Naumova and Pisareva (1994) mention that calumetite has been found in fresco paintings and in paintings on canvas, respectively. For example, small flakelike crystals of calumetite were found in eighteenth-century frescoes at the Russian Solovetsky Monastery (commonly called "Solovki") on an island in the White Sea, near the Arctic Circle. The particles examined may be a natural material rather than a synthetic pigment. As with many of the basic copper chlorides, however, there is always the suspicion that their presence could be explained by alteration of the original copper pigment, such as malachite, due to chemical interactions with chloride ions. Nonetheless, calumetite has also been identified as a corrosion product on bronze antiquities. Meyers (1977) reported the mineral in his study of the corrosion products on a bronze mirror in the Norbert Schimmel Collection, New York, that dated to Egypt's Achaemenid dynasty (525–404 B.C.E.).[10] Helmi and Iskander (1985) reported that calumetite occurred with atacamite, paratacamite, malachite,

and patches of azurite on a bronze stove of Ramses II (reigned 1279–1213 B.C.E.) of the Nineteenth Dynasty. Nielsen (1977) examined a third-millennium B.C.E. Chinese bronze ax from the ancient Iranian site of Hasanlu that contained—in addition to calumetite—malachite, atacamite, paratacamite, cuprite, tenorite, cerrusite ($PbCO_3$), and magnetite (Fe_3O_4) in the corrosion crust. The conditions necessary for the formation and stabilization of calumetite remain to be elucidated.

The ICDD files record a variant composition for the compound atacamite, namely, $Cu_7Cl_4(OH)_{10}\cdot H_2O$. This variety, which is listed as a synthetic compound rather than a mineral, needs further characterization to determine if the synthetic material is really different than the natural mineral. The synthetic form of atacamite was reported by Selwyn and colleagues (1996) on exposed bronzes in Ottawa, Canada, and by MacLeod (1991) during his studies of artifacts recovered from shipwreck sites off the Australian coast.

| *Anthonyite* | The rare copper chloride anthonyite, $Cu(OH,Cl)_2\cdot 3H_2O$, has been identified on art objects only by Selwyn and colleagues |

(1996) from their research on Ottawa bronzes. This elusive mineral is very soft, only 2 on the Mohs hardness scale, and insoluble in water but readily soluble in cold, dilute acids. Like the other hydrated basic chlorides, anthonyite is subject to dehydration.

| *Cumengite and mixed copper-lead chlorides* | Gettens (1964) found cumengite, $Pb_4Cu_4Cl_8(OH)_8$, as a corrosion product in the form of deep blue, highly refracting crystals on the stem of an ancient Persian lamp in the collections of |

the Freer Gallery of Art. Cumengite is quite rare and in nature is often associated with boleite, $Pb_9Cu_8Ag_3Cl_{21}(OH)_{16}\cdot 2H_2O$, or pseudoboleite, $Pb_5Cu_4Cl_{10}(OH)_8\cdot 2H_2O$. All three minerals are found together at the type deposit at Boleo, near Santa Rosalía, Baja California, Mexico (Palache, Berman, and Frondel 1951), so it would not be surprising if the other two salts are eventually found as corrosion products as well.

Scott and Taniguchi (1998) examined a light blue corrosion product on a sixth-century B.C.E. bronze-and-iron bed from Lydia, central Anatolia, in the collections of the J. Paul Getty Museum. The light blue corrosion occurs as delicate patches on the outer surface of a malachite patina, but these patches were quite difficult to identify. Analytical studies showed that copper, lead, and oxygen are present, and the best match of the X-ray diffraction data was to diaboleite, $Pb_2CuCl_2(OH)_4$, although the presence of chlorine could not be found by scanning electron microscopy–energy dispersive X-ray analysis.

Interestingly, these mixed copper-lead minerals have been found as alteration products on ancient lead and silver slags from smelting operations in Lávrion (ancient Laurion), Greece (Rewitzer and Hochleitner 1989). The mines were being used from Mycenean and Phoenician

times, as long ago as 2000 B.C.E. During the reign of Pericles, from 460 to 429 B.C.E., the Lávrion mines were intensively worked, producing many tons of discarded lead and silver slags that have, over time, undergone further chemical alteration because of proximity to the sea. The slags are rich in lead, silver, copper, iron, arsenic, antimony, vanadium, nickel, zinc, aluminum, silicon, and sulfur. More than eighty minerals have been identified from the slags; among these alteration products are cumengeite, boleite, pseudoboleite, and diaboleite, as well as atacamite, paratacamite, botallackite, anthonyite, and calumetite.

Selwyn and coworkers (1996) identified yet another rare, mixed copper-lead chloride, chloroxiphite, $CuPb_3Cl_2O_2(OH)_2$, from corrosion on a statue of Queen Victoria on Parliament Hill in Ottawa. Unveiled in 1901, the statue was sculpted by Louis-Philippe Hébert (1850–1917) and cast in Brussels at the J. Petermann foundry before being shipped to Canada. Analyses showed, surprisingly, that the statue itself did not contain any lead, and Selwyn's group concluded that the chloroxiphite had formed because of high local levels of lead pollution near the statue. The source was most likely automobile exhaust during the period when gasoline still contained lead additives, which were phased out in the 1980s.

Mixed copper-zinc chlorides | In 1999 Stock found some mixed copper-zinc salts on the blistered surfaces of reproduction Egyptian antiquities at the Royal Ontario Museum.[11] Data for a white efflorescence on an Ibis figure matched the data for a zinc sulfate chloride hydroxyl hydrate. A blue compound could not be positively identified, but it contained major amounts of copper, zinc, and chlorine, with some sodium and lead. These mixed copper-zinc chlorides probably originated from the artificial patination techniques used on these objects.

Other mixed-cation copper chlorides | A mixed cupro-ammonium salt was described by Clark (1998) from the deterioration products on the cover glass over a photograph made by the wet collodion process. The print was mounted in a gilt frame, and the glass was held together with a bent strip of decorative copper foil. The deterioration products found on the glass included ammonium tetrachlorocuprate(II) dihydrate, $(NH_4)_2CuCl_4 \cdot 2H_2O$, which was determined by Fourier transform infrared spectroscopy. Although an additional analytical method would be useful to confirm the identity of this unique compound, there is no reason to doubt that mixed cupro-ammonium salts could be present in a potentially wide array of different contexts. Undoubtedly, other mixed-cation copper(II) chloride compounds await discovery and publication.

Notes

1 Davy 1826: 57.

2 As a result of the work of Jambor and colleagues (1996), it now appears that the mineral anarakite is, in fact, simply another name for zincian paratacamite. Because of the complexity of the data for this group of minerals, however, there is still some difficulty in deciding exactly what mineral species is present, especially since anarakite is mentioned in the ICDD files, though its separate existence is now considered doubtful. These doubts have been substantiated by Jambor and coworkers' discovery that small amounts of zinc are often present in regular paratacamite specimens. Holotype paratacamite was found to contain about 2% zinc. It appears that replacement of copper by small amounts of other cations, such as nickel or zinc, is either favorable or essential to stabilize the paratacamite structure.

3 ICDD file 25–1427.

4 The remaining metallic core or body of the object, now often preserved within the corrosion products, may have little resemblance to the original appearance of the object.

5 Atacamite would have been part of the original corrosion that had formed naturally over time, and Berthelot suggested that reaction with the sodium chloride would have taken place on excavation.

6 Observations concerning the hydrolysis of cuprous chloride have been made by Knight (conversation with the author, 19 June 2000). A group of axes with well-preserved patina showed some warty corrosion with CuCl under the warts. The axes were treated by soaking in changes of warm distilled water, which slowly hydrolyzed the cuprous chloride. Cuprite was deposited on the glass dish, away from the pits, and no oxidation to Cu^{2+} was observed. A possible explanation is that the cuprous chloride dissolved as a complex salt and that away from the warts these complex anions decomposed with formation of cuprite. The overall reaction would then, in fact, be

$$2CuCl + H_2O = Cu_2O + 2HCl$$

Cuprous chloride can undergo disproportionation into cupric chloride and metallic copper, although that reaction did not occur here. Redeposited copper does occur within the corrosion crusts of some objects, however, either from exposure during corrosion to reducing conditions or from the disproportionation of cuprous chloride.

7 Clinoatacamite was identified too recently to have appeared in the pigment literature to date.

8 Historical recipes for copper verdigris pigments are discussed at greater length in CHAPTER 9.

9 Norman H. Tennent, letter to the author, 16 March 1996.

10 The Persian twenty-seventh dynasty of Egypt was founded by Cambyses II of Persia and named after his family of the Achaemenids.

11 Sue Stock, e-mail to the author, 22 September 1999.

Basic Sulfates

What do you think, said Diogenianos, could be the cause of the colour of the bronze here? And Theon said, when of the things that are considered and really are the first and most natural, fire, earth and air and water, none other comes close to the bronze nor is in contact except only the air, it is evident that it is affected by this and that.—PLUTARCH[1]

The copper sulfates are important primarily as corrosion products of copper alloys exposed to polluted atmospheres in urban environments. General background information related to the outdoor exposure of copper alloys is reviewed in CHAPTER 1. The present discussion provides a more detailed account of how basic sulfates and related compounds form, using data from studies of particular bronzes and from laboratory experiments.

In recent years, valid concerns have been raised that increasingly acidified rain and fog are dissolving formerly stable patinas that had been slowly developing over time. The severe streaking with light green corrosion running down the surfaces of many neglected bronzes suggests that some outdoor statuary is indeed being attacked at an accelerated rate under conditions of very low pH.

In Europe and in North America, atmospheric concentrations of sulfur dioxide are beginning to fall in many places, but they are often replaced with higher concentrations of the

nitrogen oxides, whose effect may not become apparent for many years. Recent studies have identified a large number of corrosion products on exposed statuary, and it is apparent that generalized statements about their formation may represent an oversimplification of a very complex problem. For example, each exposed bronze may be influenced by a special microclimate within the overall climatic parameters of the atmosphere. Consequently, additional studies are needed to piece together all available information and produce a more comprehensive understanding of the deterioration of exposed bronzes.

HISTORICAL REFERENCES TO COPPER SULFATES

Sasyaka (blue vitriol) has the play of colour in the throat of the peacock. Mayaratuttham is an emetic, an antidote to poisons and a destroyer of the whiteness of the skin. —VAGBHATA[2]

Blue vitriol, or what the ninth-century Indian physician and writer Vagbhata calls "sasyaka" (Ray 1956), is copper (II) sulfate pentahydrate. It was well known in antiquity as a mineral whose uses may have included pigment and medicinal preparations, and would have been found in an impure form as a secondary mineral from the leaching of various primary ore deposits. In rich copper mines, particularly in Cyprus, the leaching of copper sulfide ore deposits resulted in a variety of copper (II) sulfate minerals. Blue vitriol was called "chalcanthum" or "chalitis" by other writers from ancient times. From these names come the modern one for this mineral: chalcanthite, $CuSO_4 \cdot 5H_2O$.

Dioscorides describes chalcanthum (chalcanthite) as "appearing as a concretion of liquids that filters drop by drop through the roof of mines. It is for this reason called 'stalacton' by those who work in the mines of Cyprus."[3] This copper sulfate exudate is similar to a compound that Pliny the Elder describes as occurring

> in Spain in wells or pools, the water of which holds it in solution. This solution is mixed with an equal volume of fresh water, concentrated by heat and poured into wooden tanks. From beams fixed permanently over these tanks hang ropes kept taut by stones, and on these the slime deposits in glassy berries, not unlike grapes. This material is taken out and dried for thirty days. It is blue, with a very notable brilliance, and may be mistaken for glass.[4]

This lustrous botryoidal appearance is an apt description for basic copper-sulfate salts that could be either chalcanthite or partially iron-substituted copper sulfates such as pisanite, which is essentially a copper-rich melanterite, $(Fe,Cu)SO_4 \cdot 7H_2O$. Pliny also refers to copper sulfates when he writes, "The Greeks by their name for shoemakers black have made out an affinity between it and copper: they call it chalcanthon, 'flower of copper.'"[5] The allusion to shoemakers' black is not accidental, since using copper sulfate solutions to treat many organic materials, such as felt or matting, will result in a black color.

The use of copper sulfate compounds in medicine was also well known in Greek and Roman times. Around 150 C.E., Galen of Pergamum (129–ca. 199 C.E.), a noted Greek physician and scientist, made several journeys to Cyprus specifically to obtain fine mineral specimens of copper and iron salts (Koucky and Steinberg 1982 a,b; Walsh 1929; Galen 1928). These visits provided Galen with enough material for more than thirty years of research. The Greek scientist describes how he collected different samples from three layers at the Skouriotissa mine: from the lowest layer he obtained "sory"; from the next layer, "chalcitis," and from the highest layer, "misy." When he examined some of the chalcitis twenty years later, he found that it had formed an encrustation of misy. Writers in the mid-sixteenth century, including the Saxon physician and theologian Johann Agricola (1494–1566), made reference to the same naturally occurring copper salts as well as to others, including "melanteria" and "atramentum" (or "atramentum sutorium").[6]

Misy, a golden yellow mineral, is probably copiapite, $Fe_5(SO_4)_6(OH)_2 \cdot 20H_2O$, or metavoltine, $(K,Na,Fe)_5Fe_3(SO_4)_6(OH) \cdot 9H_2O$. Chalcitis ("chalcanthum") may refer to chalcanthite, $CuSO_4 \cdot 5H_2O$; to pisanite, $(Fe,Cu)SO_4 \cdot 7H_2O$; or to romerite $(Fe,Cu)_3(SO_4)_4 \cdot 14H_2O$. Both sory and melanteria are basic copper-iron sulfates such as melanterite $(Fe,Cu,Zn)SO_4 \cdot 7H_2O$. The identity of atramentum (or atramentum sutorium) varies, according to Bandy and Bandy (1955), from melanterite to chalcanthite.

THE BASIC COPPER SULFATES

Today the basic copper sulfates are of interest as corrosion products that have formed on bronze statuary exposed in the outdoor environment for long periods of time. More attention is being given to this type of corrosion as efforts are made to ensure the long-term preservation of these works of art. Some pioneering work was done in Germany during the nineteenth century and in England in the 1920s, but practically all useful research on the subject of copper sulfate corrosion has been carried out since 1960.

The most important basic sulfates that tend to form during outdoor corrosion are brochantite, $CuSO_4 \cdot 3Cu(OH)_2$ or $Cu_4SO_4(OH)_6$; antlerite, $CuSO_4 \cdot 2Cu(OH)_2$ or $Cu_3SO_4(OH)_4$; and, to a lesser extent, posnjakite, $Cu_4SO_4(OH)_6 \cdot H_2O$. Other, less common sulfates are also discussed in this chapter. Characteristics of these compounds are shown in TABLE 5.1.

Brochantite and antlerite | Brochantite is the most stable and usual corrosion product to form on copper alloys exposed to the atmosphere. Since the stability and existence of brochantite as the most stable mineral phase in the patina of exposed bronzes is not in question, the discussion here focuses on the relationship between antlerite and brochantite and the mode of formation of the basic sulfates. De Gouvernain (1875) made an early

TABLE 5.1	CHARACTERISTICS OF SOME BASIC COPPER SULFATE MINERALS			

MINERAL NAME	FORMULA	CRYSTAL SYSTEM	COLOR	MOHS HARDNESS
chalcanthite	$CuSO_4 \cdot 5H_2O$	triclinic	deep blue	2–4
brochantite	$Cu_4SO_4(OH)_6$	monoclinic	vitreous green	2.5–4
antlerite	$Cu_3SO_4(OH)_4$	orthorhombic	vitreous green	3.5
posnjakite	$Cu_4SO_4(OH)_6 \cdot H_2O$	monoclinic	vitreous green	2–3
bonatite	$CuSO_4 \cdot 3H_2O$	monoclinic	pale blue	2–3
Strandberg's compound	$Cu_{2.5}(OH)_3SO_4 \cdot 2H_2O$	monoclinic	pale green	?
langite	$Cu_4(SO_4)(OH)_6 \cdot 2H_2O$	monoclinic	greenish blue	2.5–3
Tutton's salt	$Cu(NH_4,SO_4)_2 \cdot 6H_2O$			
schulenbergite	$(Cu,Zn)_7(SO_4,CO_3)_2(OH)_{10} \cdot 3H_2O$	rhombohedral	pearly light greenish blue	2
synthetic compound	$Pb_4Cu(CO_3)(SO_4)$			
caledonite	$Cu_2Pb_5(SO_4)_3CO_3(OH)_6$	orthorhombic	resinous green / bluish green	2.5–3
beaverite	$Pb(FeCuAl)_3(SO_4)_2(OH)_6$	rhombohedral	blue green	?
spangolite	$Cu_6Al(SO_4)Cl(OH)_{12} \cdot 3H_2O$	hexagonal	bluish green	2
guildite	$CuFe(SO_4)_2(OH) \cdot 4H_2O$	monoclinic	yellow brown	2.5
devilline	$CaCu_4(SO_4)_2(OH)_6 \cdot 3H_2O$	monoclinic	pearly green	2.5
ammonium copper sulfate hydrate	$Cu(NH_4,SO_4)_2 \cdot 2H_2O$			

identification of a basic copper (II) sulfate as a patina constituent on bronzes from Bourbon-l'Archambault in central France. This is the first reference in the literature to a basic sulfate compound in this context; during the late nineteenth and early twentieth centuries, difficulties in the identification of these various compounds often resulted in all of them being referred to as "brochantite."

Brochantite is a vitreous green, monoclinic mineral with a Mohs hardness of 2.5–4, first identified from the Bank mines of Sverdlovsk, Ekaterinburg, in the Ural Mountains of Russia. A melt-mount preparation is shown in PLATE 34.

Antlerite is a vitreous green, orthorhombic mineral with a Mohs hardness of 3.5; it is named after the Antler mine in Mohave County, Arizona. Vernon (1933) appears to be the first to

accurately identify antlerite; he describes it as an alteration product in the patina formed on a copper roof that had been exposed for thirty years, representing more "acidic" conditions. Gettens (1933) mentions antlerite as a predominant species in an exposed bronze patina less than forty years old, and Marchesini and Baden (1979) reported finding the mineral on the Horses of San Marco in Venice. Since then, antlerite has begun to make more regular appearances in the literature. It was identified on Lorenzo Ghiberti's (ca. 1378–1455) gilded bronze *Gates of Paradise* at the Baptistery of San Giovanni in Florence, on the equestrian monument of Marcus Aurelius in Rome, and on the Statue of Liberty in New York (Baboian and Cliver 1986). In Philadelphia, it was found on the statue of William Penn by Alexander Milne Calder (1846–1923) and on *Swann Fountain* by Alexander Stirling Calder (1870–1945), according to Lins and Power (1994), who carried out a detailed study of the formation of these basic copper sulfates on exposed bronzes in polluted urban sites.

Antlerite is often assumed to be present in the corrosion crust of exposed bronzes because the pH of rainwater has become more acidic since the mid-twentieth century. This suggests that antlerite is an indicator of low environmental pH conditions, although this has been disputed. The major problem with low pH rainwater is the potential dissolution of the patina on an exposed bronze, leading to streaking and surface disfigurement. Laboratory studies show that at pH 2.5 both cuprite and copper can react to form chalcanthite, $CuSO_4 \cdot 5H_2O$, or bonatite, $CuSO_4 \cdot 3H_2O$, rather than brochantite or antlerite. At pH levels higher than 4, cuprite dissolution is notably slower than that of the basic sulfates. The results show, however, that acidified copper sulfate solutions are readily produced from corrosion crusts of bronze and copper substrates. These solutions may influence cuprite growth according to the following reaction:

$$Cu + CuSO_4 + 2H^+ + \tfrac{1}{2}O_2 = Cu_2O + H_2SO_4 \qquad \text{5.1}$$

The dissolution of the basic sulfates in the outermost layer of the corrosion crust is initially accompanied by an increase in pH. For antlerite, this is represented by

$$CuSO_4 \cdot 2Cu(OH)_2 = 3Cu^{2+} + SO_4^{2-} + 4OH^- \qquad \text{5.2}$$

or

$$CuSO_4 \cdot 2Cu(OH)_2 + 4H^+ = 3Cu^{2+} + SO_4^{2-} + 4H_2O \qquad \text{5.3}$$

For brochantite, this is represented by

$$CuSO_4 \cdot 3Cu(OH)_2 = 4Cu^{2+} + SO_4^{2-} + 6OH^- \qquad \text{5.4}$$

or

$$CuSO_4 \cdot 3Cu(OH)_2 + 6H^+ = 4Cu^{2+} + SO_4^{2-} + 6H_2O \qquad \text{5.5}$$

Precipitation studies show that after long wetting of a basic sulfate crust, the initial pH of the aqueous phase is overwhelmed by the copper sulfate material, reaching intermediate pH levels of 4–5. It is probable that ionic dissolution reactions rather than electrochemical reactions predominate, since the dissolution of cuprite or copper is hindered by the thickness of the sulfate crust. In the corrosion of the metal itself, a different series of reactions occurs, modified by the chloride ions that often are concentrated in this zone.

Previous models suggest that the bulk aqueous-phase reactions occur throughout the corrosion crust, but Lins and Power (1994) show that the outer sulfate crust will supply ions to the aqueous front and then serve as sites for solidification as the aqueous phase evaporates. Reactions occurring during dry deposition of pollutants are also important; after pollutants are deposited on a bronze patina, hydration and formation of very soluble chlorides and nitrates can occur. This work shows that the transformation of brochantite with acid solutions to form antlerite does not occur easily; the transformation of cuprite to antlerite is also not very likely.

FIGURE 5.1 shows the Pourbaix diagram for the system $Cu-SO_3-H_2O$ at 20 °C with an SO_2 level of 46 ppm. Lins and Power found that the zones of stability predicted for antlerite and brochantite by this diagram did not apply for well-crystallized mineral specimens. The diagram also suggests that there is a large field of stability for tenorite between areas of neutral to very alkaline pH and in moderately oxidizing environments. As noted previously, tenorite is rare; cuprite is the predominant oxide in outdoor exposure. It is likely that weathered corrosion films in polluted atmospheres are not in equilibrium. For this reason, Lins and Power caution that strict adherence to thermodynamic considerations may produce a misleading picture of the sequence and nature of the precipitation and dissolution of these corrosion layers, in which a number of complex hydrated species may exist.

This complexity discourages the usefulness of antlerite as an indicator of corrosivity, although its existence cannot be denied, and it does have a high sulfate content. For example, Selwyn and coworkers (1996) identified antlerite in only 10% of the surface samples from the statues they studied in Ottawa, Canada. The identification was made mostly from statues unveiled between 1901 and 1940, and the surface samples containing antlerite were taken from sheltered or only partially exposed areas. Robbiola, Fiaud, and Pennec (1993) also detected antlerite in sheltered areas on outdoor bronzes. So did Strandberg (1997a) and Strandberg and Johansson (1997c), who found antlerite principally in sheltered black patinas on bronzes that had been exposed for several decades. The present consensus on antlerite is that some traces of the mineral will form over time, even in protected areas.

Lins and Power (1994) used four comparative diagrams to evaluate the stability of basic copper sulfate with that of the basic copper carbonates, chlorides, and nitrates. The suite of diagrams, shown in the Lins and Power report, reveal that the relative insolubility of the basic sulfates is an important factor in their formation. The solubility of the copper nitrates, as well

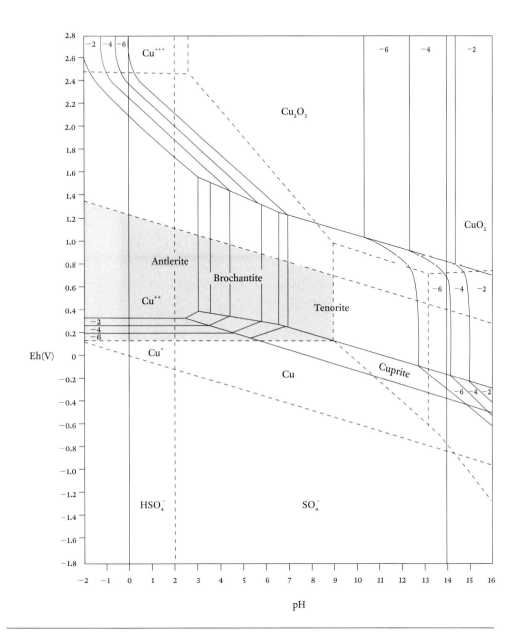

FIGURE 5.1 Pourbaix diagram for the system Cu–SO$_4$–H$_2$O (after Pourbaix 1977).

as the high concentration of anions required for them to precipitate, is evident. The range of values reflects those that might be found in average rain or fog for each anionic species.

McNeil and Mor (1992) attempted to rationalize thermodynamic data on the basis of stability diagrams for four variables: Eh, pH, activity of sulfate ions, and activity of copper ions. The resulting diagram is four-dimensional and difficult to apply to particular cases. Projection into a Pourbaix diagram format allows more than one stable sulfate mineral to be plotted; chalcanthite, antlerite, and brochantite can form depending on the conditions. These diagrams are of interest because they show a more restricted field of stability for antlerite than for brochantite occurring between Eh +0.4 and +1.0, and between pH 3.5 and 4.5. Brochantite can form under a variety of conditions, including those in which water is the most prevalent phase.

ARTIFICIAL BROCHANTITE AND ANTLERITE PATINAS Because brochantite and antlerite are the most stable phases in the outer corrosion crust under many atmospheric conditions, Vendl (1999) has been evaluating the possibility of using these minerals in an artificial patina as a protective finish for outdoor bronzes. Synthetic brochantite or a mixture of synthetic brochantite and antlerite should be much more stable than organic coatings to withstand exposure to the elements; if sufficiently compact, they can provide good protection for the underlying bronze. Since 1996, Vendl has been conducting exposure trials of copper and bronze samples coated with brochantite in Freemantle, Western Australia; in Bangkok, Thailand; in Göteborg, Sweden; and in New York, San Francisco, and Honolulu in the United States. Preliminary results suggest that the brochantite patinas are performing well. They are aesthetically pleasing and show no appreciable dissolution or change in appearance. As would be expected, there are differences in the surface color of the patinas depending on the pollutants in the different exposure environments.

Posnjakite Posnjakite, which is monoclinic like brochantite, is a vitreous green or dark blue mineral with a low Mohs hardness, between 2 and 3. It is not particularly common as a patina component. Essentially a hydrated brochantite, posnjakite was identified as a mineral by Komkov and Nefedov (1967) from the oxidation zone of tungsten mineral deposits in the central regions of Kazakhstan. It was first observed in copper patinas by Biestek and Drys (1974).

Posnjakite is isomorphic with langite, $Cu_4(SO_4)(OH)_6 \cdot 2H_2O$, which has not yet been reported as a corrosion product of bronzes, although it has been identified as a painting pigment (discussed later, under "Basic Sulfates as Pigments"). The existence of a hydrated basic sulfate of copper was first mentioned by Vernon and Whitby (1930), but since posnjakite and langite were unknown at the time, this phase remained unidentified. Posnjakite is identical to brochantite in stoichiometry, except for the water of hydration. Graedel (1987a) thought that posnjakite

may coexist with or undergo transformation to brochantite because of its structural similarity or that it may be a precursor to brochantite. Work by Selwyn and coworkers (1996), however, has cast doubt on this supposition.

There are only two reports to date in which posnjakite has been identified from burial environments: one by Schweizer (1991) on bronzes from a burial in a Swiss lake and the other by Paradies and colleagues (1987) on buried copper pipes where the corrosion consisted almost entirely of posnjakite under a thick, continuous biofilm containing many gram-negative organisms. In both cases, microorganisms were an essential component in the corrosive events.

Posnjakite was identified in patina or as a patina constituent by Selwyn and colleagues (1996) during a study of the corrosion and conservation of sixteen bronze monuments exposed outdoors in Ottawa. One of them, *Monument to Sir George Étienne Cartier* by Louis-Philippe Hébert (1850 1917), is shown in PLATE 35.[7] The surface shows typical vertical streaking due to partial dissolution of the original patina that developed over the approximately seventy years between the statue's unveiling and the time of this study. Posnjakite was found on statues that had been exposed for both short and long periods, such as the statue of Queen Victoria unveiled in 1901 (Selwyn et al. 1996).

Other basic sulfates New sulfates are being identified, and still others, no doubt, await discovery, attesting to the complex nature of these compounds as corrosion products. Bonatite, $CuSO_4 \cdot 3H_2O$, has been reported only once as a patina constituent—along with gypsum, antlerite, brochantite, and anglesite—from an exposed bronze sculpture (Zachmann 1985). It may represent partially solubilized corrosion products mixed with stable mineral varieties. Strandberg and Johansson (1997b) found yet another basic sulfate, $Cu_{2.5}(OH)_3SO_4 \cdot 2H_2O$, as a patina component on outdoor bronze sculptures, although it is probably an intermediate product from the formation of brochantite and other basic sulfates.

Guildite, $CuFe(SO_4)_2(OH) \cdot 4H_2O$, an uncommon $Cu(II)Fe(III)$ basic sulfate, has been reported in a corrosion context only on bronzes recovered from waterlogged environments where sulfides are prevalent (Duncan and Ganiaris 1987); it may represent postexcavation oxidation of a sulfide salt. The only other report of guildite is from its type location at the Union Verde mine near the town of Jerome, Yavapai County, Arizona. The mineral was found there after a fire, along with coquimbite, $Fe_{2-x}Al_x(SO_4)_3 \cdot 9H_2O$, and other sulfates.

A number of other unusual sulfate minerals have not yet been identified as corrosion products. They include krohnkite, $Na_2Cu(SO_4)_2 \cdot 2H_2O$; lautenthalite, $PbCu_4(SO_4)_2(OH)_6 \cdot 3H_2O$; and ktenasite, $(Cu,Zn)_5(SO_4)_2(OH)_6 \cdot 6H_2O$. There is every reason to expect that ktenasite will be found as a corrosion product on brass substrates because a closely related mineral, namuwite,

$(Zn,Cu)_4(SO_4)(OH)_6 \cdot 4H_2O$, has been identified as a corrosion product on brass clocks from the Wallace Collection in London (Scott and Bezur 1996).

Selwyn and colleagues (1996) found the following copper sulfate hydroxide minerals from both sheltered and exposed areas of the statues they studied: $Cu_3(SO_4)_2(OH)_2$, $Cu_5(SO_4)_2(OH)_6 \cdot 5H_2O$, and $Cu_3(SO_4)_2(OH)_2 \cdot 2H_2O$. The existence of these other basic copper sulfate minerals as patina components on exposed surfaces is hardly surprising, given the complexity of the formation conditions for these minerals. Indeed, this complex series of processes was recently confirmed by Strandberg and Johansson (1997c), who carried out research into the mode of formation of the basic copper sulfates. They found that when copper in humid air is exposed to very low (sub-ppm) levels of sulfur dioxide, a new compound forms that has never before been detected and that does not correspond to any of the previously described copper hydroxysulfate salts. An X-ray diffraction pattern of this newly characterized compound, $Cu_{2.5}(OH)_3SO_4 \cdot 2H_2O$, is shown in APPENDIX D, TABLE 4. The formula for this unnamed mineral is similar to the compound $Cu_3(SO_4)(OH)_4 \cdot 2H_2O$, which Pollard, Thomas, and Williams (1992a) proposed based on their investigation of the stability regions for antlerite. In the case of Strandberg and Johansson's research, however, the new compound was fully characterized, and its structure determined. Of all the basic sulfates, this new compound has the highest ratio of sulfate to hydroxide ions, which suggests that the mineral would be stabilized by low pH and high sulfate activity. Strandberg and Johansson found that the mineral decomposes with time, even in solutions with high sulfate ion content, forming brochantite, posnjakite, or antlerite. Finding this compound in the patina of outdoor bronzes could indicate recent and active corrosion, since it is rapidly converted to the other sulfates in humid air.

Strandberg and Johansson (1997d) proposed that this mineral is a metastable precursor in brochantite and antlerite formation. The scarcity of antlerite in rainwashed regions may be explained by the washing away of this precursor, which has a slightly greater solubility than the other sulfates. The researchers had noted that the compound is rarely found in outdoor environments but that it is frequently formed during laboratory studies. In recent developments, however, Strandberg[8] reports finding several occurrences of the new sulfate on exposed bronzes from sites in the province of the former East Berlin.

ENVIRONMENT AND CORROSION

Atmospheric sulfur dioxide | Laboratory studies by Strandberg and Johansson (1997a) and by Strandberg[9] showed that humid air containing only traces of sulfur dioxide formed an opaque black patina consisting principally of cuprite. At high sulfur dioxide concentrations, the surface of copper is passivated, which implies that the deposition velocity of sulfur dioxide on copper increases significantly with decreasing concentration

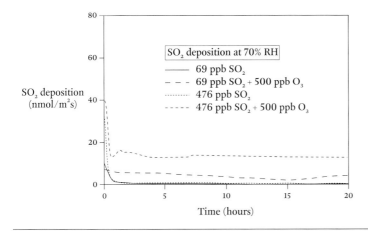

FIGURE 5.2 Sulfur dioxide deposition rates at 70% RH in the presence and absence of ozone. At 476 ppb SO_2 and 500 ppb O_3, the deposition rate is substantially increased over the rate with SO_2 alone (Strandberg and Johansson 1997a).

of sulfur dioxide. FIGURE 5.2 shows typical deposition rates for sulfur dioxide at 70% relative humidity (RH); when some ozone is also present, the rate is increased. This increased rate of deposition helps the sulfur dioxide to form a sulfite on the surface, and this is subsequently oxidized to sulfate, which tends to attack the passive surface layer, thus encouraging electrochemical corrosion. The corrosion of copper with sulfur dioxide is enhanced by the presence of nitrogen oxides and ozone (see CHAPTER 1, FIGURE 1.7).

Strandberg and Johansson (1997b) also carried out a study that related the appearance of copper sheets to the corrosion products that had formed on them after four weeks of exposure to the following conditions:

1. pure air with sodium chloride
2. air with ozone at 500 ppb and sodium chloride
3. air with sulfur dioxide at 476 ppb and sodium chloride
4. air with sulfur dioxide at 476 ppb, ozone at 500 ppb, and sodium chloride

The results of this study are summarized in TABLE 5.2. In three cases, a new basic copper sulfate corrosion product, temporarily called "phase II," developed; it has not been fully characterized. The existence of a new phase in such relatively simple exposure trials is an indication of how much work remains to fully characterize the chemistry of these interactions. FIGURE 5.3 shows the weight gain of copper samples exposed to 70% RH and 90% RH with a variety of pollutant concentrations (Strandberg and Johansson 1997a). The results again confirm the enhanced corrosion at different RH levels of the mixed sulfur dioxide and ozone gases.

TABLE 5.2

**VISUAL APPEARANCE AND XRD ANALYSIS OF CORROSION
PRODUCTS FORMED ON COPPER AFTER FOUR WEEKS OF EXPOSURE
TO VARIOUS ATMOSPHERES**

ATMOSPHERE	RH	NaCl ($\mu g/cm^2$)	APPEARANCE	CRYSTALLINE COMPOUNDS (in order of strongest XRD reflections)
pure air	70%	21.5	Dull rosy/purple with shiny dark spots	Cuprite, Cu_2O; halite, NaCl; tenorite, CuO
	90%	33.5	Dull black/red/orange/purple with green spots	Cuprite, Cu_2O; nantokite, CuCl; tenorite, CuO; malachite, $Cu_2(OH)_2CO_3$; paratacamite, $Cu_2(OH)_3Cl$
O_3	70%	26.0	Dull black/reddish brown with shiny dark spots	Cuprite, Cu_2O; paratacamite, $Cu_2(OH)_3Cl$; tenorite, CuO; botallackite, $Cu_2(OH)_3Cl$
	90%	33.5	Dull black/red/orange	Cuprite, Cu_2O; tenorite, CuO; paratacamite, $Cu_2(OH)_3Cl$
SO_2	70%	20.5	Smooth opaque red/orange	Cuprite, Cu_2O; nantokite, CuCl
	90%	33.5	Dull reddish brown with green spots	Cuprite, Cu_2O; brochantite, $Cu_4(OH)_6SO_4$; phase II;[a] nantokite, CuCl
SO_2+O_3	70%	40.0	Dull reddish brown	Cuprite, Cu_2O; antlerite, $Cu_3(OH)_4SO_4$, $Cu_{2.5}(OH)_3SO_42H_2O$; phase II; nantokite, CuCl
	90%	23.0	Dull reddish brown with green spots	Cuprite, Cu_2O; phase II; antlerite, $Cu_3(OH)_4SO_4$; brochantite, $Cu_4(OH)_6SO_4$; nantokite, CuCl; chalcantite, $CuSO_4 \cdot 5H_2O$

After Strandberg and Johansson (1997b).

[a] Phase II = new basic copper sulfate not fully characterized.

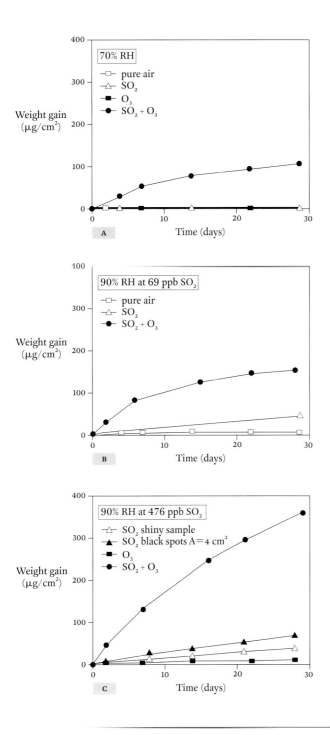

FIGURE 5.3 Weight gain of copper samples exposed to 70% and 90% RH with a variety of pollutant concentrations: A, 70% RH with 476 ppb SO_2, 500 ppb O_3, and 476 ppb SO_2 with 500 ppb O_3; B, 90% RH with 69 ppb SO_2, or 69 ppb SO_2 with 500 ppb of O_3; and C, 90% RH with 476 ppb SO_2 and 500 ppb O_3, or 476 ppb SO_2 with 500 ppb O_3 (Strandberg and Johansson 1997a).

Microenvironment
and corrosion

Selwyn and colleagues (1996) found unusual mixed salts on the outdoor bronzes they studied in Ottawa. One was devilline, a basic hydrated sulfate of calcium and copper, $CaCu_4(SO_4)_2(OH)_6 \cdot 3H_2O$. This mineral, first identified in material from Cornwall, England, is monoclinic with a vitreous pearly green to bluish green color and a low Mohs hardness of 2.5. It was found in a patina that also contained gypsum and probably formed from the evaporation of solutions containing copper sulfates and calcium sulfate. The other compound was an ammonium copper sulfate hydrate, $Cu(NH_4,SO_4)_2 \cdot 2H_2O$, found in a surface sample taken from an exposed area on a statue of Sir George Étienne Cartier that was unveiled in Ottawa in 1885.

Tutton's salt, $Cu(NH_4,SO_4)_2 \cdot 6H_2O$, a mixed basic ammonium sulfate hydrate of copper (II) similar to the one found by Selwyn's group, was reported by Bernardini and coworkers (1992) on two Italian statues located in sheltered areas. This mineral would be expected to be found only in sheltered areas because it is very soluble and would be washed away in more exposed regions of the patina.

Bernardini and colleagues studied *L'incredulità di San Tommaso*, a bronze sculptural group by Andrea del Verrocchio (1435–88) that was erected around 1481 in a niche on the eastern facade of the Orsanmichele church in Florence. The rear of the bronzes is roughly finished; the front is chased and partially gilded. A total of fifty-six different sampling locations were examined with up to four samples isolated from each location. The following discrete layers could be distinguished in the samples: an outer gray-to-black, coarsely textured crustal material; a greenish or yellowish, earthy, predominantly compact layer overlying a thin, reflective patina with reddish grains; a compact reddish or brown layer; and finally the interface between the corrosion and metallic phases. Twenty-one different compounds were identified during the study. The most surprising result was the prevalence of Tutton's salt, determined in fifty samples; and of moolooite (cupric oxalate hydrate), $Cu(COO)_2 \cdot nH_2O$, found in eighty-two samples. Nantokite was found in twenty-eight samples, which suggests that active chloride corrosion of the bronzes may pose a serious problem with long-term stability. This study is a valuable reminder that different compounds can be isolated from discrete regions of a patina, and these identifications were possible because of the large number of samples removed for examination.

The specific microenvironment of exposed bronzes obviously has a tremendous impact on the nature of the corrosion products. The partially protected niche housing the Verrocchio sculpture is potentially more deleterious, as far as corrosion is concerned, than if the bronze group were fully exposed to the elements, since urban pollution in Florence, the proximity of the building, and the presence of bird excrement, rain runoff, and particulate matter will all accelerate corrosion. The appearance of moolooite in substantial amounts and the presence of the calcium oxalates—whewellite, $Ca(COO)_2 \cdot H_2O$, and weddellite, $Ca(COO)_2 \cdot 2H_2O$—clearly

implicate fungal or lichen activity in the corrosion from nearby deteriorating stonework. Particulate matter is represented by numerous identifications of quartz, albite, and gypsum. Bird droppings may also influence the prevalence of Tutton's salt, although there are other possible sources of ammonia in the exterior environment, including ammonium sulfate particulates and atmospheric ammonia.

Antlerite was more abundant in samples from the rear of the bronzes, suggesting once again that the local microenvironment inside the niche is more aggressive than the partially exposed front, due to condensation and stagnant conditions in these types of sheltered areas. This agrees with the findings of Burmester and Koller (1985), who studied the bronze doors of the Augsburg cathedral in Augsburg, Germany, and reported that gypsum and antlerite are more prevalent in protected areas. This finding, however, is disputed and may simply be related to local conditions for gypsum formation rather than to the formation of antlerite or to a more aggressive microenvironment.

The condition of an exposed sculpture's surface may also be strongly influenced by historic coatings. Marabelli, Mazzeo, and Morigi (1991) record that the bronze group of the Neptune fountain in Bologna had been coated with a protective black varnish, commonly applied to bronzes in Italy since the mid-nineteenth century. The constant spray of water had formed a hard layer of salt encrustation, which contained gypsum, over the varnish layer. Areas free of spray had different colored crusts. In the Venice area, where the industrial and marine atmospheres merge, Leoni and Panseri (1972) found that the common patina components on objects coated with black varnish were still copper and lead sulfates rather than chlorides.

CASE STUDIES OF EXPOSED BRONZES

The Statue of Liberty | The Statue of Liberty, shown in PLATE 36, was inaugurated on 28 October 1886 and represents one of the most carefully studied outdoor bronzes.[10] The monument's surface consists of copper sheets hammered to shape and then riveted together. The sheets had an original cuprite patina added during manufacture, but a mostly brochantite patina eventually formed over the cuprite. (The chemical background of this monument is discussed in CHAPTER 1.) By 1900, obvious signs of corrosion had appeared: the copper surface had turned various shades of brown to black as well as pale green. Engineers from the U.S. War Department carried out a detailed condition study in 1905 and concluded that the monument was perfectly safe and could be allowed to form a natural patina without intervention. After a series of minor repairs, the statue was left to weather into the twenty-first century.[11] Thickness data on the maturing patina were obtained by ultrasonic measurements of both protected and unprotected areas of the copper surface, and the rate of corrosion was measured at 0.04–0.06 mils (0.0010–0.0015 mm per year). This was consistent with the data derived from

environmental testing. A program of monitoring the thickness of the copper sheeting was planned. Areas damaged by erosion corrosion or by water that had not been able to drain away were patched with new sheets of copper. By current estimates, the original copper should last for at least a thousand years.

The statue consists of three hundred panels fabricated with more than six hundred sheets of copper, some panels made of more than one sheet, each sheet about 2.54 mm (0.1 inch) thick. Parts of the statue's tablet and the crown rays have the visual appearance of yellow brass. Historical photographs taken in 1965, 1974, and 1983 show that since 1965, large areas on the left side of the statue, facing toward Manhattan, have darkened. Eddy-current measurements showed the thickness of the patina in these darker areas to be 0.1–0.5 of the thickness of the patina in adjacent green areas; wind erosion, aqueous runoff, or both are possible causes.

The overall green patina of the statue is predominantly brochantite, while the green patina on the darkened areas has a high antlerite content. Analysis of the patina on a piece of copper removed from the statue in 1905 showed no antlerite content, so there may have been an environmental change in recent decades to produce the antlerite corrosion crust in places. The brass components in the tablet and crown show varying degrees of localized corrosion, including black deposits and pitting as well as green patina formation, since brass weathers more severely than copper.

The Great Buddha at Kamakura

Many exposed bronzes present a complex picture when examined in detail. Matsuda and Aoki (1996) carried out such a study of the patina on the Great Buddha at the Kotoku-in temple in Kamakura, Japan. This impressive hollow bronze, shown in PLATE 37, was made in 1252; it is 13.35 m high and weighs 120 tons. The statue was cast in sections from separate pours with a variety of joins between the sections rather than simple butt joins. The alloy is 69% copper, 9% tin, 20% lead, 0.04% iron, and 0.08% aluminum (Sekino 1965; Toishi 1965; Maruyasu and Oshima 1965).

The formation of the principal patina components was influenced by the localized environment affecting different regions of the sculpture. The initial patina contains cuprite, which is generally covered with brochantite. Malachite was also detected with the brochantite, suggesting that a malachite patina originally formed and was partially transformed into brochantite by more recent environmental pollution, including increased sulfur dioxide in the atmosphere. Antlerite was detected on the back and west-facing sides of the Buddha, while atacamite was dominant in the south-facing patina.

Besides brochantite, which is the primary component, an unusually wide array of other minerals were also detected in the patina, some of which are listed in TABLE 5.3. A lead chlorophosphate, $Pb_5(PO_4)_3Cl$, was found on the front on the statue. Lead sulfate (anglesite), $PbSO_4$, was identified on the back along with a basic lead phosphate, $Pb_5(PO_4)_3OH$.

TABLE 5.3 CORROSION MINERALS IDENTIFIED ON THE GREAT BUDDHA, KAMAKURA, JAPAN

SAMPLE[a]	COLOR	MAJOR[b]	MINOR	TRACE
15	green	$Cu_2Cl(OH)_3$; Cu_2O; $PbSO_4$	$CuPb_2(PO_4)(SO_4)(OH)$; $Cu_7Cl_4(OH)_{10}\cdot H_2O$	$Pb_3(PO_4)_2$; Fe_2O_3; $Cu_4SO_4(OH)_6\cdot H_2O$; $Cu_4SO_4(OH)_6$
16	pale green	Cu_2O; $PbSO_4$	$Cu_2Cl(OH)_3$; $Cu_7Cl_4(OH)_{10}\cdot H_2O$	$CuCl$; Cu_2S; $FeOOH$; Sn_3O_4; SiO_2; $2Pb(CO_3)Pb(OH)_2\cdot H_2O$
17	dark green	Cu_2O; $Cu_7Cl_4(OH)_{10}\cdot H_2O$	$CuSO_4(OH)_6$; $CuCO_3Cu(OH)_2$; $(CuZn)_2(CO_3)(OH)_2$	$CuCl_2$; $CaCO_3\cdot H_2O$; Sn_5O_6
18	yellow-green	$Cu_7Cl_4(OH)_{10}\cdot H_2O$; $Cu_2Cl(OH)_2$	Cu_2O; $PbCO_3$	$CuSO_4\cdot H_2O$; $FeSO_4\cdot 5H_2O$; Al_2O_3; $CaSiO_3$
19	pale green	Cu_2O	$CuSO_4(OH)_6$; $Cu_4(OH)_6SO_4$; $Pb_5(PO_4)_3Cl$; $PbFe_2O_4$	$Pb_5(PO_4)_3OH$; $CaCO_3$; Al_2SiO_3
20	yellow-green	Cu_2O; $Pb_5(PO_4)_3Cl(OH)_3$	$Pb_5(PO_4)_3OH$; $Pb(FeCuAl)_3(SO_4)_2(OH)_6$	$PbSO_4$; Pb; $CaCO_3Cu_7Cl_4(OH)_{10}\cdot H_2O$; $Cu_2Pb_5(SO_4)_2(OH)_6$
21	dark brown	Cu_2O; $Pb_5(PO_4)_3Cl$	$Cu_2(OH)_3Cl$; $Cu_7Cl_4(OH)_{10}\cdot H_2O$; $Cu_4SO_4(OH)_6$	$PbFe_2O_4$; $CaSiO_4$; Sn
22	dark brown	$Pb_5(PO_4)_3Cl$	Cu_2O; $Pb_3O_2CO_3$; $Cu_4SO_4(OH)_6$; $Pb_5(PO_4)_3OH$	PbO_2; FeO; SnO; $Cu_2Cl(OH)_3$
23	green surface, reddish brown inside	Cu_2O; $Cu_4SO_4(OH)_6$	$PbSO_4$; $Cu_7Cl_4(OH)_{10}\cdot H_2O$	FeS; $FeOOH$; $CaSO_3$; PbO; $Pb_5(PO_4)_3Cl$
24	black	Cu_2O; $Cu_4(OH)_6SO_4$	$Pb_5(PO_4)_3Cl$; $Cu_2Cl(OH)_3$	CuO; $CuCl$; PbO; $FeOOH$; $SnCl_4$; $CaCO_3$; $FeSO_4$
25	white	$Pb_3(CO_3)_2(OH)_2$; $Pb_4(SO_4)(CO_3)_2(OH)_2$	$Pb(SO_4)$	$Pb_{10}(CO_3)_6(OH)_6$; $CaCO_3$
26	white	Pb; $PbCO_2$	$PbSO_4$; $Pb_3(CO_3)_2(OH)_2$	PbO; $PbClOH$; $CaCO_3$; CuO

After Matsuda and Aoki (1996).

[a] Samples taken from different areas of the statue; chemical composition varied depending on orientation to the environment.

[b] The major phases identified were atacamite, cuprite, anglesite, and a variety of lead sulfates, carbonates, and phosphates. $Cu_2Cl(OH)_3$ is either atacamite or paratacamite; $Cu_7Cl_4(OH)_{10}H_2O$ is the formula given in the ICDD files for synthetic atacamite.

A number of mixed-cation, copper-containing compounds were also identified. These salts constitute unique characterizations in several cases and clearly indicate that localized conditions on exposed bronzes can produce an extraordinary variety of substances, even if they are present only as minor patina components rather than major ones. Some of the compounds found on the Buddha were mixed copper-zinc salts: a synthetic copper-zinc-silicon sulfide, Cu_2ZnSiS_4, which is an unusual and perhaps dubious identification; rosasite, a mixed copper-zinc basic carbonate, $(CuZn)_2(CO_3)(OH)_2$; and schulenbergite, a mixed copper-zinc basic sulfate, $(Cu,Zn)_7(SO_4,CO_3)_2(OH)_{10}\cdot3H_2O$, that is rhombohedral with a pearly, light green-blue color. Schulenbergite was first identified in 1984 from the Glücksrad mine, Ober-schulenberg, Harz, Germany. Mixed copper-lead minerals included a synthetic copper-lead chloride, Pb_3CuCl_2; a synthetic copper-lead carbonate sulfate, $Pb_4Cu(CO_3)(SO_4)$; caledonite, a copper-lead basic sulfate carbonate, $Cu_2Pb_5(SO_4)_3CO_3(OH)_6$, which is an orthorhombic mineral with a resinous green or bluish green color, first found in Leadhills, Lanarkshire, Scotland; beaverite, a complex basic lead sulfate with iron, copper, and aluminum, $Pb(FeCuAl)_3(SO_4)_2(OH)_6$. This rhombohedral mineral has an earthy yellow color and was first named in 1911 from Frisco, Beaver County, Utah.

Other minerals identified on this sculpture include a synthetic copper-tin hydrated phosphate, $CuSn(PO_4)_2\cdot3H_2O$; spangolite, a copper-aluminum basic sulfate chloride, $Cu_6Al(SO_4)Cl(OH)_{12}\cdot3H_2O$, which is a vitreous dark green to bluish green mineral; a partially hydrated copper sulfate, $CuSO_4\cdot H_2O$; a calcium-copper oxide, Ca_2CuO_3; a synthetic copper phosphate, $CuPO_3$; the copper sulfides $Cu_{1.96}S$, $Cu_{7.2}S_4$, Cu_2S, and Cu_8S_5; and calumetite (see CHAPTER 4).

It is surprising that such a wide array of compounds should be identified on this particular sculpture. Its sheer size, resulting in different zones of exposure, may explain some of them, but it is not easy to deduce why the rest should form. The sculpture does have a high lead content that has clearly influenced the occurrence of several mixed copper-lead minerals. The selective corrosion of some of the lead globules has resulted in the formation of the primary lead sulfates and phosphates identified in the study.[12] The prevalence of a number of phosphate compounds must relate to a consistent source of phosphorus in the environment—for example, bird droppings. The published analysis of the Buddha statue does not show any zinc, so it is superficially odd that so many mixed copper-zinc minerals should be identified. Aoki wrote that no zinc-containing alloys were used in Japan before the fifteenth century.[13] He noted, however, that the Great Buddha underwent several restorations during the Edo period (1600–1868). The figure was repaired in 1712, parts of the body in 1735, and the hair in 1736. X-ray fluorescence spectroscopy showed that the hair of the Buddha contains zinc, and this explains the origin of the copper-zinc salts.

Gettysburg National Military Park bronzes

The leaching of copper components from the patinas of several outdoor bronzes in the Gettysburg National Military Park, Pennsylvania, was investigated by Block and colleagues (1987). These sculptures ranged in age from fifty to ninety years old. Numerous streaks had developed on the patina surface, disfiguring the bronzes. Patina samples from the statue of General Oliver O. Howard showed a sulfur-rich layer overlying a chlorine-rich layer in intimate contact with the metal surface. Pits were filled with a gray material that the researchers inferred was a combination of various compounds, such as cuprous sulfate. In the absence of X-ray diffraction data for these compounds, however, it is dangerous to assume that scanning electron microscopy – energy dispersive X-ray analysis is capable of distinguishing or characterizing the materials formed in outdoor corrosion. In fact, it is very unlikely that any cuprous sulfate would be able to form as a corrosion product; copper(I) sulfate is very unstable and has never been isolated from corrosion products found on ancient or historic bronze patinas. The study did show, however, that deep-seated chlorides may be present in outdoor bronze patinas close to the metal surface, and this may have implications for future protection of such bronzes if the chlorides are reactive. The work of Selwyn and colleagues (1996) showed that most of the chloride species are probably copper trihydroxychlorides rather than the reactive nantokite.

Brancusi's Infinite Column

Infinite Column by Constantin Brancusi (1876–1957) was the object of an investigative study of the deterioration of a monumental work of art in the outdoor environment (Scott, Kucera, and Rendahl 1999). The sculpture, erected over the period of 1928–37 in Tîrgu Jiu, Romania, is part of a sculptural ensemble to honor the children and teenagers who died defending an important bridge during World War I. Shown in PLATE 38, the sculpture is 29.33 m (96 ft. 3 in.) high. It is shaped with fifteen cast-iron modules over a carbon-steel framework that holds the modules in position. These cast-iron modules were coated with zinc and then thermally sprayed with a brass alloy.[14] In some areas, the sprayed modules had developed a green corrosion of basic copper sulfate, too thin to be easily characterized by sampling.

The work has experienced a number of problems over the years, including a darkening of the exposed brass surface, which would normally be expected to occur. Brancusi was very familiar with hand-finished and hand-polished brass surfaces for his smaller, indoor sculptures, including many smaller versions of the *Infinite Column*. He attempted, unwisely, to apply the same aesthetic to this much larger, outdoor sculpture by using the thermal spray technology to metallize the cast-iron panels with a golden, polished brass finish. Unfortunately, Brancusi was apparently not familiar with the technical difficulties of retaining a shiny golden finish on his outdoor sculpture, and the original finish (approximately 30Zn70Cu) began to darken after only two years. A new supply of a different brass alloy was ordered from Switzerland, and the

sculpture was recoated. This finish also darkened and was replaced with another sprayed-on brass coating after the previous one was removed by sandblasting.

In 1994 the Getty Conservation Institute and the Swedish Corrosion Institute were commissioned to measure the environmental parameters for the *Infinite Column;* to advise on the selection of a new metallic coating to be thermally sprayed over the restored cast-iron modules, which suffered from corrosion beneath the initial zinc coating; and to advise on a polymer coating that would best protect the newly sprayed surface.

Alloy coupons used in the testing regime, together with different organic coatings, included 89Cu5Zn5Al1Sn and 93Cu5Al2Ni, which gave a superior performance during outdoor weathering trials compared with binary brasses of 80Cu20Zn or 63Cu37Zn. The 89Cu5Zn5Al1Sn alloy had been developed as a golden-colored coinage alloy in Sweden and is thought to be partially protected from corrosion by formation of a mixed aluminum-tin oxide on the metal surface. This alloy effectively resists general tarnishing indoors and performed well outdoors, remaining untarnished during three years of exposure trials. During this time, brass samples became almost black, and bronze samples were badly discolored. A Finnish coinage alloy, 93Cu5Al2Ni, was not as effective as the Swedish alloy but is preferable to any binary brass composition.

SULFATE DEPOSITION IN BURIAL ENVIRONMENTS

In burial environments, malachite is the usual compound that forms from the interactions of copper-containing solutions and calcite. In laboratory studies of the same corrosion chemistry, however, the preferred products are sulfates and chlorides. In an attempt to understand this discrepancy, Garrels and Dreyer (1952) examined the conditions for the precipitation of basic sulfates and chlorides on calcite. These authors surmised that if the concentration–pH curves for the precipitation of brochantite and atacamite are known, it is possible to explain why these products form in the laboratory in preference to malachite.

A copper sulfate solution is acid because of hydrolysis:

$$
\begin{array}{cccc}
CuSO_4 = & Cu^+ & + & SO_4^- & \qquad 5.6 \\
& + & & + \\
2H_2O = & 2OH^- & & 2H^+ \\
& \parallel & & \parallel \\
& Cu(OH)_2 & & H_2SO_4
\end{array}
$$

When calcite is placed in such a solution, it begins to dissolve, and the excess hydrogen ions of the solution react with the carbonate ions from the calcite. An equilibrium is probably reached between carbonate ions, bicarbonate ions, and carbonic acid. This reaction then reduces the hydrogen ion concentration at the solid surface where there are also hydrogen ions, hydroxyl

ions, carbonate ions, copper ions, and sulfate ions, among others. The experimental results indicate that the solubility product (K_{sp}) value of brochantite is exceeded, whereas that of malachite is not. Because of these findings, Garrels and Dreyer concluded that most supergene solutions derived from the weathering of primary copper sulfide deposits have a copper ion concentration that is less than 0.001 M; if higher than this concentration, brochantite or atacamite would form.

This finding is of interest because calcium carbonates are often associated with copper objects in sea burial or in land burial, and the work of Garrels and Dreyer helps to clarify the circumstances of their formation. Since the copper ion concentration in concretions surrounding buried objects is always likely to be higher than 0.001 M during corrosion events, the absence of malachite as a corrosion product is predicted by the theoretical data. In copper corrosion crusts from marine burial, the basic chloride atacamite is often found, but malachite is uncommon. In land burial, the basic copper sulfates can occur on copper alloy objects, but these occurrences will always be rare compared with sulfate formation during outdoor corrosion. Mattsson and coworkers (1996) and Schweizer (1994) discuss occurrences of the basic sulfates as corrosion products identified on buried bronzes.

BASIC SULFATES AS PIGMENTS

Both natural and artificial basic sulfates have been used as pigments. Purinton and Watters (1991) found X-ray diffraction evidence for brochantite as the green pigment used in *Zahhak Enthroned with Two Sisters*, a Persian painting from the Bukhara region of central Asia (now in Ozbekistan) that dates to 1615 and is now in the collections of the Los Angeles County Museum of Art. Naumova and Pisareva (1994) reported that various copper compounds were used as pigments in Russian frescoes from the early sixteenth century. They concluded that most historical recipes for pigments do, indeed, refer to the production of copper acetates, with a small number producing atacamite, as might be expected. But they also found that an eighteenth-century recipe for an artificial blue pigment actually produced posnjakite, $Cu_4SO_4(OH)_6 \cdot H_2O$, rather than a carbonate or an acetate. Banik (1989) identified langite, $Cu_4(SO_4)(OH)_6 \cdot 2H_2O$, the isomorph of posnjakite, as a green pigment in a European illuminated manuscript from the sixteenth century. The identification method used by Banik, however, was severely restricted by sample size and type; the pigment needed to be heated briefly to 105 °C to encourage a crystalline product to form for identification by X-ray diffraction analysis. Naumova, Pisareva, and Nechiporenko (1990) did identify langite as a pigment in early sixteenth-century frescoes painted by the gifted Russian master Dionisy (ca. 1440– ca. 1503) in the Cathedral of the Nativity of the Virgin at the Ferapontov Monastery in Russia. They also found langite in *The Holy Family*, a painting by the Italian Mannerist artist Agnolo Bronzino (1503–72) that is now in the collections of the A. S. Pushkin State Museum of Fine Arts, Moscow.

Natural posnjakite, as well as a mixture of synthetic posnjakite and malachite, was found in the paint layers of the fifteenth-century iconostasis from the Kirillo-Belozersky Monastery, near Vologda, Russia. Naumova, Pisavera, and Nechiporenko (1990) found posnjakite in the background paint on some pillars in the monastery. The microscopic pigment particles, or "plates," were blue with a gray interference color and were anisotropic. The plates sometimes reached 1 mm in size, and, when viewed under crossed polars, they consisted of several monocrystals. These were grown together with different orientations and with the appearance of sectors having low interference colors. The researchers note that the optical properties and crystal structure of synthetic and natural posnjakite are identical, although the crystals of each have different morphological features. This was further investigated with laboratory synthesis trials, which showed that a mixture of synthetic malachite and posnjakite can be coprecipitated as a pigment. Details of this synthesis are given in APPENDIX B, RECIPE 6.

Van Eikema Hommes (1998) mentions the use of a mixture of ivory black and "couperose," an old term for a copper compound that would have been added to the ivory black, since the ivory-black oil paint would have dried much more slowly without the addition of this copper-based pigment. It is suggested that the term "couperose" refers to copper sulfate. Perhaps a basic sulfate, such as brochantite, is meant, but the use of copper (II) sulfate pentahydrate would be unlikely.

The copper-based pigment Peligot blue, named after its inventor, the French chemist Eugène-Melchior Péligot (1811–92), began to appear around 1858. Peligot blue may be prepared with any soluble copper salt, but the sulfate is preferred (Riffault, Vergnand, and Toussaint 1874). A very dilute solution of the copper sulfate is treated with an excess of ammonia and then precipitated by potassa (potassium carbonate) or soda (sodium carbonate). Exactly what this recipe should produce is not entirely clear. In a laboratory replication experiment, beginning with copper (II) sulfate and using potassium carbonate as the final addition, a light blue powder precipitated from the solution and was identified by powder X-ray diffraction as a mixture of brochantite and a synthetic copper sulfate hydroxide hydrate (of very similar formula to posnjakite). Further details of this synthesis are also given in APPENDIX B, RECIPE 7.

It is interesting that the recipe for Peligot blue may produce brochantite, and this might help explain why the basic sulfate is sometimes found as a pigment in stock from nineteenth-century art suppliers. It was not uncommon at that time for paints to be fraudulently formulated with copper minerals instead of the genuine pigment that was stated on the label, and this practice may still continue on a smaller scale today. Gettens and Fitzhugh (1974), for example, identified brochantite in a sample of powdered artificial green pigment supplied from old stock by an English "colourman."

Notes

1 Plutarch *Moralia, the Oracles at Delphi no longer given in verse* (Plutarch 1984).

2 Vagbhata *Book of Rasaratnasamuchchaya* (Ray 1956:170).

3 Pedanius Dioscorides *De materia medica* 5.98 (Dioscorides [1933] 1968).

4 Pliny the Elder *Natural History* 34.2 (Pliny 1979).

5 Pliny 34.24.

6 Johann Agricola *De natura fossilum* (Agricola [1546] 1955).

7 The bronze statue was cast in Paris at the Alexis Rudier foundry and unveiled in 1927 in front of the Parliament buildings in Ottawa.

8 Helena Strandberg, letter to the author, 10 September 1998.

9 See note 8.

10 French artist Frédéric-Auguste Bartholdi (1834–1904) and the famous engineer Alexandre Gustave Eiffel (1832–1923) were instrumental in designing and building the monument. For several years, the statue was under the protection of the Light-House Board, and in 1890 authorities proposed protecting the statue by treating it like a light-house and painting the entire monument white.

11 While the exterior of the statue was left alone, the interior was painted with a variety of materials in an attempt to waterproof the structure. The galvanic reaction that might have occurred between the copper and the wrought iron armature was originally prevented by using asbestos cloth soaked in shellac. When the monument underwent restoration (1988–94), a stainless steel armature—steel type 316L (UNS S3160)—was employed to replace the wrought iron, and a layer of Teflon was placed between the copper and the steel. The force of the corrosion of the original wrought iron had pulled several rivets through the copper sheets; pressure also caused the copper skin to bulge outward. This cannot be repaired now without damaging the external patina.

12 Lead in cast bronzes is present as a series of discrete globules since lead is not soluble in copper or tin as the bronze cools; the lead is distributed as small globules in interdendritic regions of the bronze casting. In cases where gravity segregation has occurred, there may be some settlement of the lead toward the lower areas of the casting.

13 Shigeo Aoki, letter to the author, 15 February 1998.

14 The thermal spraying technology was originally developed in Switzerland around 1900. It utilizes a metallizing process in which a compressor thrusts metallic powder into an oxyacetylene flame, and the semimolten metallic particles are then sprayed onto the substrate to be coated. This process is still used in industry today, although more sophisticated facilities usually employ a plasma-spraying apparatus; thermal spraying is still utilized by smaller operators.

Plates

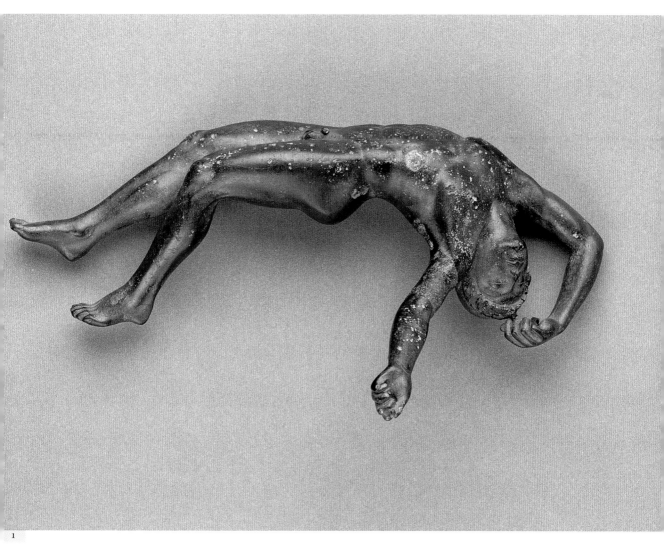

1

PLATE 1 Statuette of a Dead Youth, Greek, ca. 480–460 B.C.E. Bronze
with copper inlays. W: 7.3 cm; L: 13.5 cm. The sculpture was solid cast in tin
bronze by the lost-wax method. Shown here after mechanical conservation
cleaning, the patina is mostly malachite over cuprite, with a blistered surface,
now pitted, but originally with pustules of corrosion. Malibu, J. Paul Getty
Museum (86.AB.530).

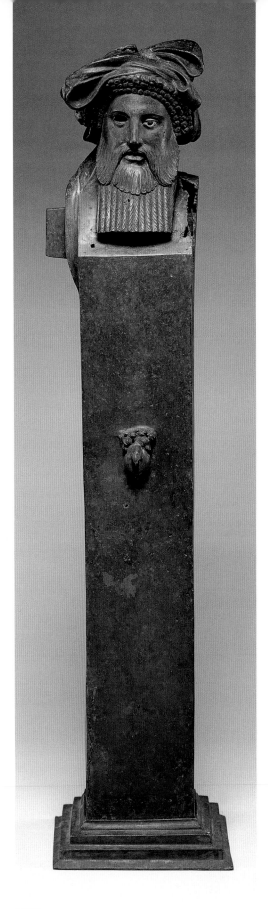

PLATE 2 Herm, attributed to Boethos, Greek, late Hellenistic period, ca. 100–50 B.C.E. Bronze with ivory inlay. H: 103.5 cm; W (base): 23.5 cm. The sculpture is shown after conservation cleaning, which revealed a malachite and azurite patina over cuprite. Malibu, J. Paul Getty Museum (79.AB.138).

PLATE 3 Simon-Louis Boizot (French, 1743–1809), *Medea Rejuvenating Aeson,* model 1785–90, probably cast later. Platinum-coated cast brass. H: 67; W: 57.2; D: 35 cm. The brass sculpture was originally sand-cast in many parts. The surface was finished with a thin coating of platinum deposited from solution by electrochemical replacement to create a brown-black patina. Los Angeles, J. Paul Getty Museum (74.SB.6).

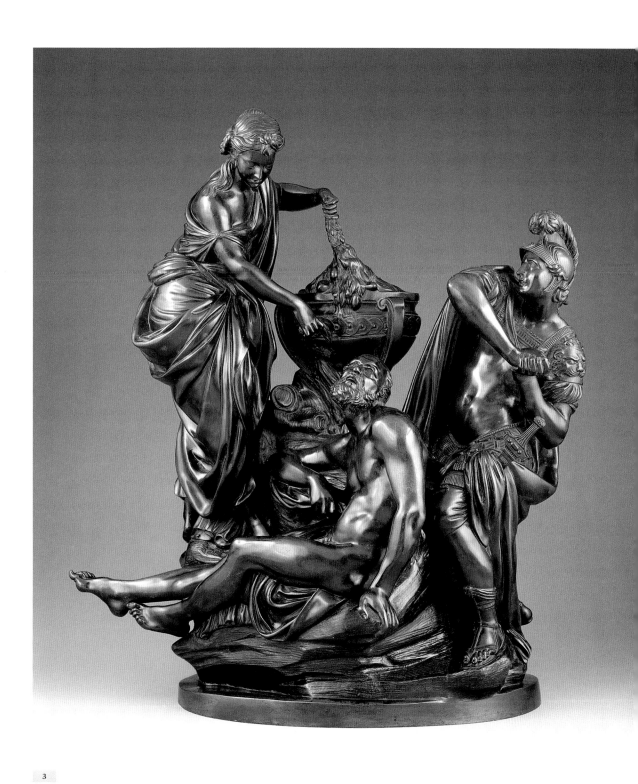

4

PLATE 4 Photomicrograph of sample from a modern relief protome (portrait head) on a fourth-century B.C.E. Greek box mirror (see FIGURE 1.2), showing microstructure typical for electrodeposited copper. The copper displays a columnar morphology in which the columnar grains have markings perpendicular to their length; some of these grains show smaller crystalline regions or have subgrain features. Etched in alcoholic ferric chloride (magnification ×689).

PLATE 5 Auguste Rodin (French, 1840–1917), *The Thinker*, 1888. Bronze. H: 71.5 cm; W: 40 cm; D: 58 cm. Streaked surfaces, such as this one on Rodin's famous sculpture, are typical for bronzes that have begun to corrode in the outdoor environment, disrupting their original patina. Conservation intervention is required to stabilize the surface, and maintenance is needed to ensure long-term protection. Musée Rodin, Paris.

LE PENSEVR

6

PLATE 6 Photomicrograph of a marine organism preserved on corroded copper. The preservation of a variety of organic materials on copper or bronze objects is not unusual, due to the biocidal action of copper ions (magnification ×78).

PLATE 7 Photomicrographs of four corroded bronze objects: A, polished and etched section of a bronze ceremonial ax, ca. 500 B.C.E., from the Luristan region of Iran, showing redeposited copper in corroded matrix of alpha, copper-rich dendrites and alpha+delta eutectoid phase, which was replaced with the redeposited copper during corrosion (magnification ×217); B, polished section of an Iranian toggle pin, dated to the Middle Bronze Age, showing curved boundary representing the original surface of the object within the corrosion crust (magnification ×122); C, banded Liesegang-type structures within a cuprite corrosion crust on an Iranian bronze fragment (magnification ×650); and D, corroded grain structure of a small Bronze Age pin, showing remnant grains in a corroded matrix (magnification ×217).

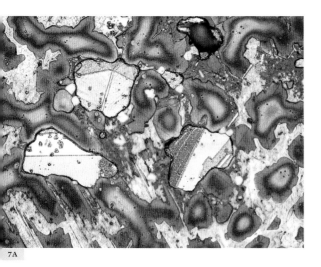

7A

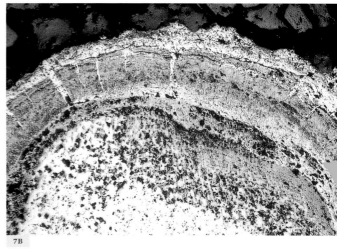

7B

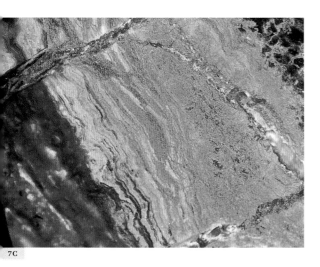

7C

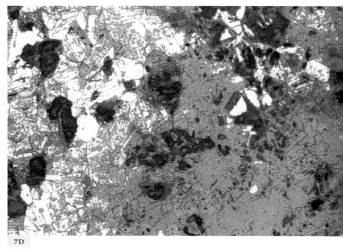

7D

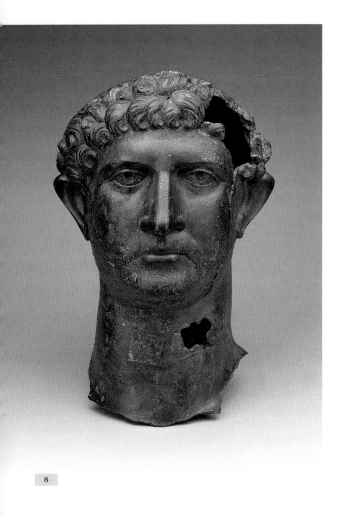

8

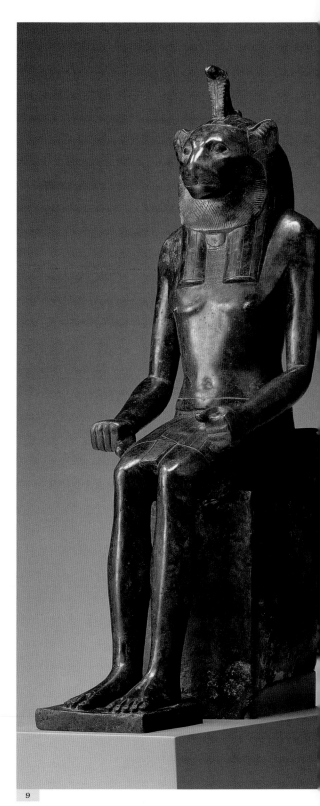

9

176

10

PLATE 8 Head of the Emperor Hadrian, Roman, second century C.E. Bronze. H: 39 cm. Found in the river Thames at London Bridge, this head was once part of a colossal hollow statue. Shown after conservation cleaning, it is an excellent example of a well-preserved cuprite patina. Collections of the British Museum, London.

PLATE 9 Statuette of the God Horus with Lion-Headed Aspect, Egyptian, ca. 690–525 B.C.E. Bronze. H: 67 cm; W: 17.5 cm; D: 32.5 cm. This cast-bronze figure illustrates a well-developed cuprite patina preserving surface detail. Collections of the Shumei Cultural Foundation, Shigaraki, Shiga, Japan (SF2-048).

PLATE 10 Photomicrograph of a typical bronze patina on a British Bronze Age palstave from Kent, ca. 1000 B.C.E. The cross section shows sound metal below yellow and red cuprite layers and a malachite crust with soil minerals above. The jagged, dark particles represent the remaining uncorroded alpha+delta eutectoid phase of the bronze (89% copper, 8% tin, 0.5% arsenic). Viewed under crossed polars (unetched, magnification ×325).

PLATE 11 Photomicrograph of a Chinese bronze buckle from the Han dynasty (206 B.C.E.–220 C.E.), showing the pseudomorphic dendritic remnant structure of the original bronze casting to be exceptionally well preserved entirely in cuprite. Patterning in the outer corrosion layer as well indicates the pseudomorphic structure continuing into the malachite. The sample was viewed under crossed polars (unetched, magnification ×435). Private collection, London.

11

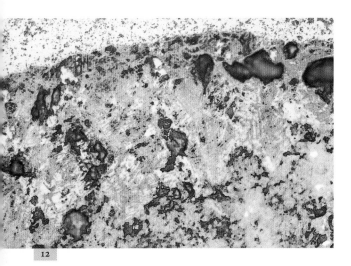

12

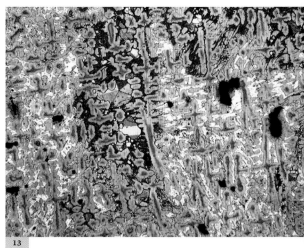

13

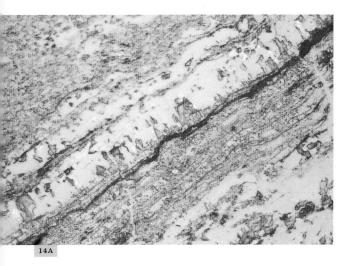

14A

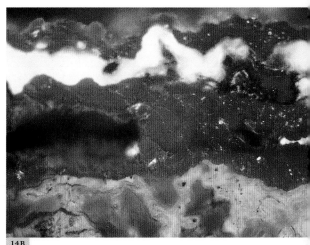

14B

PLATE 12 Photomicrograph of a cuprite crust on a Bronze Age plain ax (unsocketed) from the area of Dublin, Ireland. The fine lines retained in the cuprite layer represent strain lines of the original copper grains produced during heavy cold-working of the metal to harden the cutting edge. The lighter-colored cuprite layer at the top of the image does not preserve any pseudomorphic remnant structure (magnification ×625).

PLATE 13 Photomicrograph of a color-etched fragment from a bronze ceremonial ax (see PLATE 7A) from the Luristan region of Iran. The alpha + delta eutectoid phase, visible at the center of the image, has darkened due to corrosion; redeposited copper appears as twinned crystalline phases, which are visible in this matrix as yellow, red, and orange crystals. Note that the redeposited copper grows around the cored alpha-phase dendrites and does not disturb the alpha phase, which is etched a yellow orange with reddish centers due to coring. The uncorroded eutectoid phase appears blue and silver between the dendrites (etched in acidified thiosulfate, magnification ×625).

PLATE 14 Photomicrographs of two bronze objects: A, cross section of a completely corroded toggle pin from Iran (see PLATE 7B), showing major and minor stratification of the cuprite layers with malachite (unetched, magnification ×950); and B, an example of a finely layered corrosion crust of malachite, cuprite, and tin oxides from a British bronze palstave from Kent (unetched, magnification ×760; see also PLATE 10). The fine spacing within the malachite layering of the toggle pin is strongly suggestive of Liesegang banding, which results from the slow precipitation of solid phases during the corrosion process.

PLATE 15 Statuette of the God Ptah, Egyptian, ca. 664 – 525 B.C.E. Bronze. H: 17.8 cm (not including base). The figure shows two types of patination: parts of the head and staff are black-patinated, and the body presents a typical cuprite patina. Assuming that this sculpture has not been re-treated in modern times, it represents one of the most interesting examples of a black-patinated bronze to be found. Such bronzes usually contain small amounts of gold or other elements, such as arsenic, antimony, or iron; gold and silver are the impurities or deliberate additions associated with "Corinthian bronzes." Collections of the Ashmolean Museum, University of Oxford (1986.50).

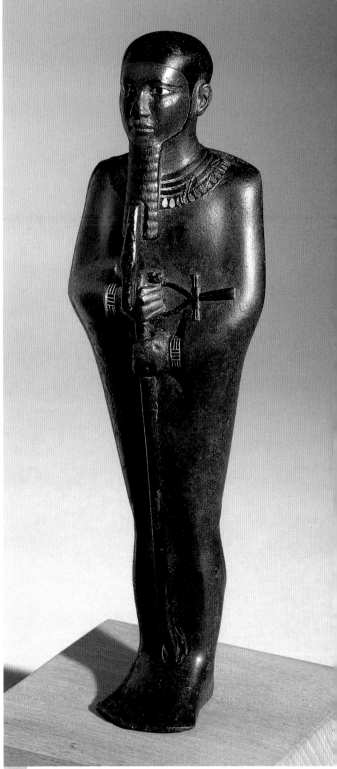

16A

16B

16C

PLATE 16 Three thin sections from a fifteenth-century Chinese cloisonné enameled vessel: A, viewed under crossed polars, showing cuprite crystals in the enamel; B, viewed under partially crossed polars; and C, viewed under standard illumination, showing blue dichroism of the cuprite crystals (all at magnification ×270).

PLATE 17 Thymiaterion (incense burner) in the Form of a Comic Actor Seated on an Altar, Roman, first half of first century C.E. Bronze. H: 23.2 cm; W (base): 13.3 cm. Shown after mechanical conservation cleaning, this sculpture reveals a patina that contains both chalcocite and tenorite over a thin cuprite layer. The figure is hollow cast, and the altar is pierced underneath for ventilation. When incense was burned inside the figure, the smoke would have emerged through the actor's mouth. The presence of tenorite is possible because of this heating. Collections of the J. Paul Getty Museum (87.AC.143).

PLATE 18 Cut malachite from Arizona, showing typical banded morphology, a common feature of malachite formation.

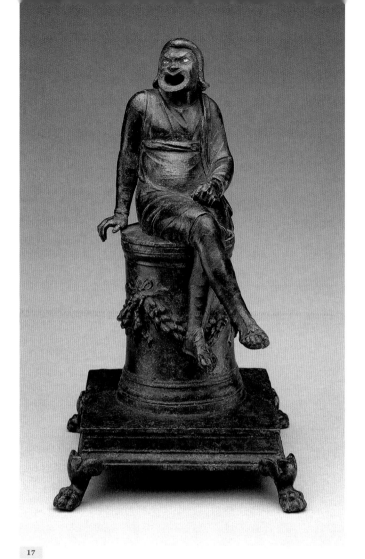

17

18

20A

PLATE 19 *Fang lei* (wine vessel), Eastern Zhou dynasty (770–221 B.C.E.). Bronze with copper and malachite inlays. H: 31.8 cm. The surface decoration, based on an ancient Chinese cloud-and-thunder motif, was produced with a primary inlay of copper strips set into precast recesses, which were then used as the framework for the inlays of malachite. Originally, there would have been a contrast in colors between the golden bronze, reddish copper, and green of the malachite, but after corrosion of the bronze, a malachite patina developed, resulting in a very subtle gradation in color among the three surface components. The Shinji Shumeikai Collection, Kyoto, Japan (SS 1223).

PLATE 20 Two views of malachite crystals from the corrosion crust of a Greek box mirror (see FIGURE 1.2): A, plane polarized view; and B, polarized view, in which the fibrous character of the malachite can be seen (both at magnification ×1035). In the plane polarized view, the malachite is often slightly fibrous in appearance and also shows internal detail due to cleavage planes; small malachite particles (< 5 μm) may be almost colorless, but larger ones are usually green. In the polarized view, birefringence is often high enough for first-order red or second-order blue to appear under crossed polars.

PLATE 21 Photomicrograph of the surface of the Roman bronze statue of Roma or Virtus (see PLATE 71) showing fibrous malachite occurring as curled crystals. These crystals are unusual in their luxuriant growth and could easily be mistaken for textile fibers (magnification ×80).

20B

21

183

22

23A

23B

24

25A

PLATE 22 Photomicrograph of a sample from the
reverse of a Roman bronze, *Victory with Cornucopia*
(see PLATE 74), showing fibrous malachite when
viewed under crossed polars (melt-mount RI 1.662).
The morphology of these crystals is very similar to
that of the malachite crystals shown in PLATE 21,
which could provide evidence that both objects were
taken from the same burial deposit (magnification
×750). Cleveland Museum of Art, Leonard C. Hanna,
Jr. Fund (1984.25).

PLATE 23 Two photomicrographs of a mounted
sample of azurite crystals: A, plane polarized view;
and B, view under polars crossed at 80°, showing typ-
ical birefringence. Azurite usually appears as a clear,
pale blue color in crystalline fragments, and the par-
ticles tend to show strong pleochroism. Second-order
colors are often seen, and the extinction is distinct
(magnification ×347).

PLATE 24 Photomicrograph of spherical particles
of synthetic malachite (green verditer), viewed under
crossed polars. Some particles have the dark cen-
ter and slightly radiating structure characteristic of
synthetic malachite (melt-mount RI 1.662; magnifi-
cation ×347).

PLATE 25 Photomicrographs of a sample of blue
verditer: A, viewed with polars crossed at 85°;
B, viewed under bright-field illumination, showing
pale blue-green particles with some spheroidal
character; and C, viewed with crossed polars, show-
ing typical fine-grained structure of the particles
with some growth features radiating toward the
center (all in melt-mount RI 1.662, magnification
×347). Samples produced by Peter Mactaggart.

25B

25C

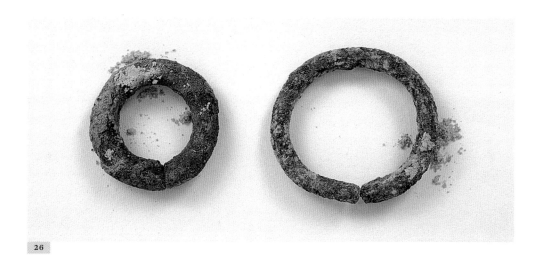

26

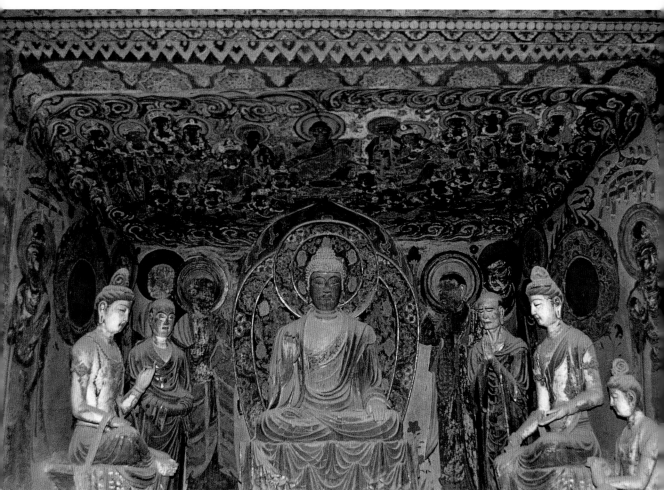

27

28

PLATE 26 Two small penannular bronze nose ornaments from the site of La Compañia, Ecuador, dated to about the tenth century C.E., showing the light green, powdery eruptions typical of bronze disease.

PLATE 27 Worshipping bodhisattvas, cave 328, Mogao grottoes, Dunhuang, People's Republic of China, early Tang dynasty (618–704). Polychromed stucco. The statues are covered with fine dust that blows down from the Mingsha dunes, obscuring the sculptures and wall paintings. A variety of copper-based pigments have been identified from these caves, including malachite, synthetic malachite, and botallackite (probably an alteration product of the original pigment, most likely malachite).

PLATE 28 Sample of basic copper-chloride green pigment (atacamite or paratacamite) from an eighteenth-century Japanese painting, viewed under bright-field transmitted illumination (mounted in Aroclor RI 1.662; magnification ×270). Freer Gallery of Art, Smithsonian Institution (acc. no. 00.112).

PLATE 29 Photomicrographs of atacamite natural mineral specimen: A, viewed with uncrossed polars, showing some rather pale green crystalline fragments with some slight internal fibrous character and other fragments that vary in color from very pale to darker green; and B, under crossed polars, showing subtle blue homogeneous birefringence. Some fibrous directional character to these clear particles can still be seen (both in melt-mount RI 1.662; magnification ×347). Collections of the British Museum, Natural History.

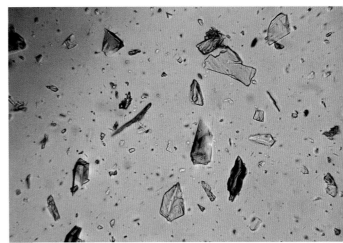

29A

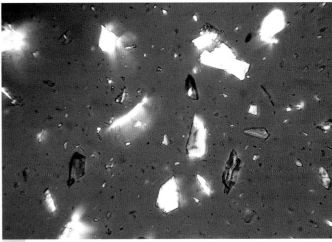

29B

187

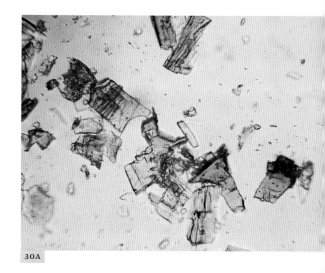

30A

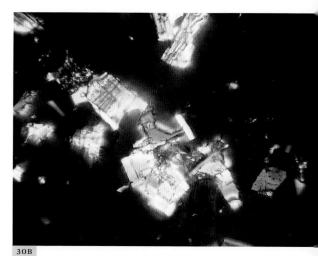

30B

PLATE 30 Photomicrographs of botallackite natural mineral specimen from the Levant mines, Cornwall, England: A, viewed with plane polarized light, showing clear green crystals with prominent banding and growth features; and B, viewed under crossed polars showing highly birefringent particles with banding clearly evident (both in melt-mount RI 1.662; magnification ×347). Collections of the British Museum, Natural History.

PLATE 31 Photomicrograph of a green pigment, possibly synthetic botallackite, from a fifteenth-century Persian manuscript (see PLATE 32). Bright-field transmitted illumination (mounted in Aroclor RI 1.662; magnification ×325).

PLATE 32 Firdawsi, "Rustam before Kay Khusraw under the Jeweled Tree," folio from *Shahnama* manuscript, Iran, fifteenth century. Opaque water-color on paper, plant gum medium. The green pigment sample shown in PLATE 31 was taken from this work. Arthur M. Sackler Gallery, Smithsonian Institution (S1986.0159).

31

188

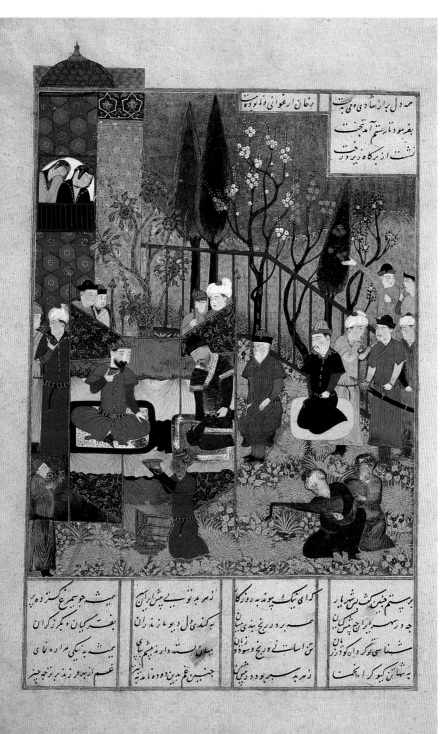

32

33

34A

34B

PLATE 33 Photomicrograph of a sample of paratacamite as a green pigment, from "A prostitute of the highest class (*oiran*) in a garden," Japan, Ukiyo-e school, style of Toyohiro (1773–1828). Paper, animal glue medium. Bright-field transmitted illumination (mounted in Aroclor RI 1.662; magnification ×325). Freer Gallery of Art, Smithsonian Institution (F1998.94).

PLATE 34 Photomicrographs of brochantite mineral specimen, showing A, deep green tabular crystals with homogeneous structure when viewed with uncrossed polars; and B, highly birefringent particles visible when viewed with crossed polars (both in melt-mount RI 1.662; magnification ×347). Collections of the Royal School of Mines, South Kensington, London.

PLATE 35 Louis-Philippe Hébert (Canadian, 1850–1917), *Monument to Sir George Étienne Cartier*, Ottawa, Canada, unveiled 1885. Bronze. Approx. 1.5 times life size. This 1987 photograph shows the typical vertical streaking of the brochantite patina caused by the runoff of rainwater.

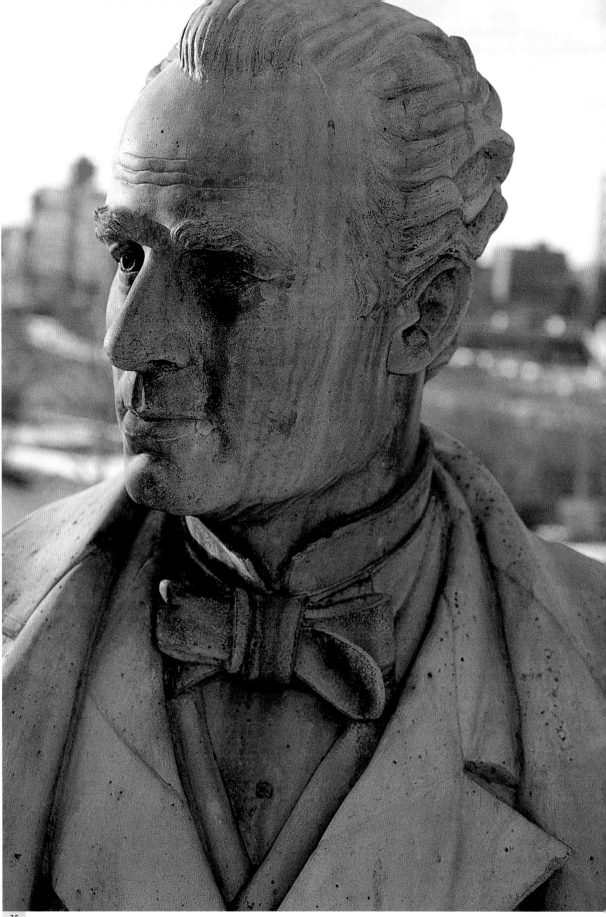

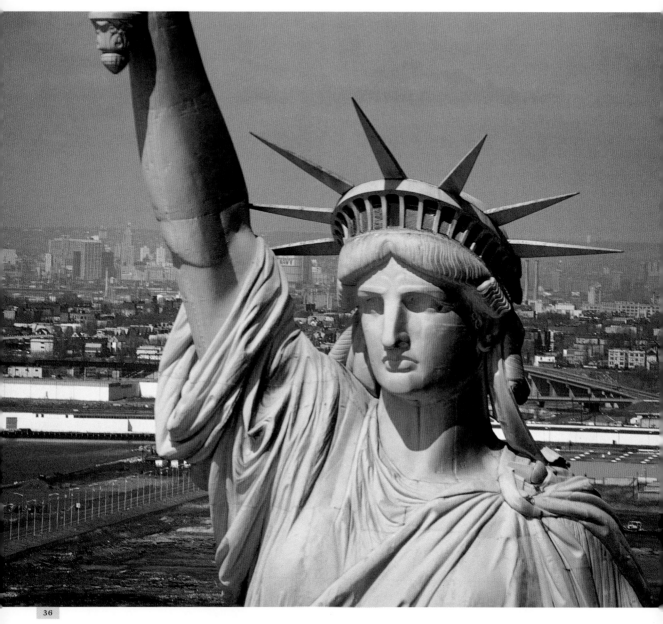

36

PLATE 36 Statue of Liberty, 1886, New York City. Copper with brass elements.
H: 15.24 m; W: 5.18 m. Shown before conservation, the statue illustrates the typical
appearance of a brochantite patina. Some streaking and staining are visible on the
patina moving down from the ear and also over the proper right hand (not shown).

PLATE 37 Great Buddha, 1252, Kotoku-in Temple, Kamakura, Japan. Hollow bronze.
H: 13.35 m. The general patina is brochantite on the back and west-facing sides,
atacamite on the south side.

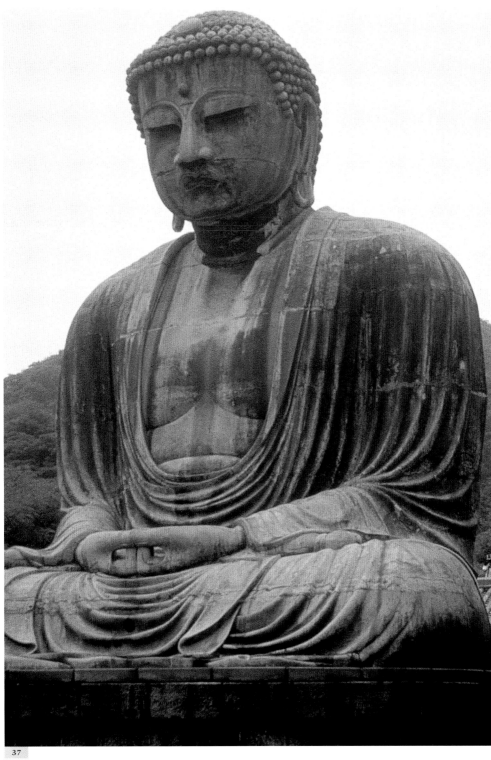

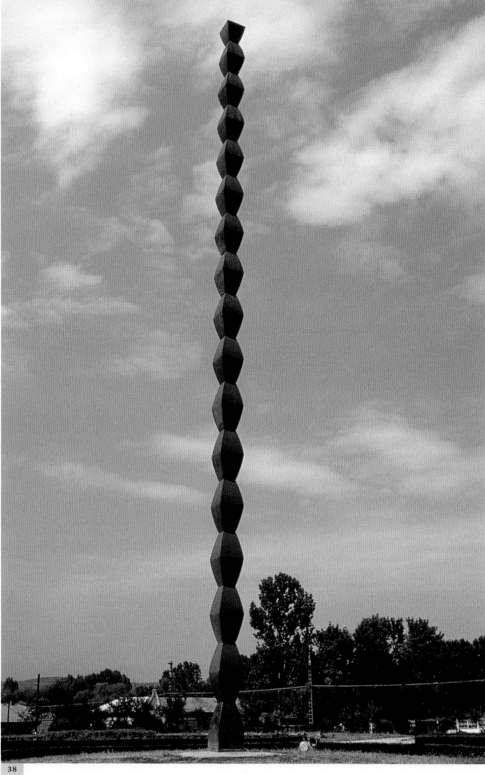

PLATE 38 Constantin Brancusi (Romanian French, 1876–1957), *Infinite Column*, 1937, Tîrgu Jiu, Romania, photographed in 1994, before re-restoration. Cast-iron modules over carbon-steel superstructure. H: 29.33 m; W: 90 cm. The cast-iron modules were thermally sprayed with a binary brass coating of approximate composition 70Cu30Zn.

PLATE 39 Conservators at work recovering artifacts from the 1811 shipwreck of the *Rapid* off the coast of Western Australia, photographed in 1979, showing underwater examination of a pall trace from the capstan.

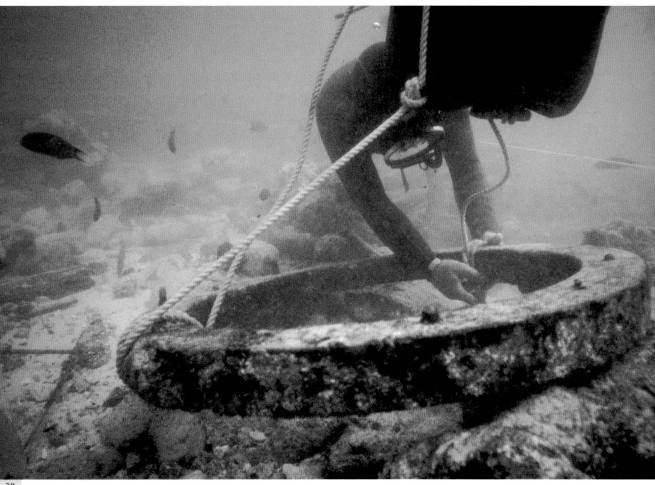

39

40

41

42

PLATE 40 Scanning electron photomicrograph of a concretion on a leaded brass nail from the *Rapid* site (see PLATE 39), showing a variety of copper sulfides, principally covellite and chalcocite, together with lead sulfides, wood remnants, and calcite (width of photomicrograph = 1000 μm). Western Australian Maritime Museum (reg. no. RP1812).

PLATE 41 Detail of a fourteenth-century bronze trumpet. Close-up of the soldered join shows the surface immediately after excavation from the river Thames in 1983. The yellow metal surface is revealed with occasional patches of tenacious black copper sulfides.

PLATE 42 Roman coin excavated in 1986 from the waterfront area of the river Thames. Partial cleaning revealed a top skin of chalcopyrites overlying a black powdery layer of copper sulfides directly over the bare metal surface, an extraordinary example of this type of corrosion.

PLATE 43 Medieval copper-alloy key excavated in 1981 from waterfront area of the river Thames. Botryoidal chalcopyrite corrosion overlies black copper sulfides with metal beneath.

PLATE 44 Polarized-light photomicrographs of a mounted sample of libethenite from the type site of Libethan, Hungary: A, viewed with plane polarized illumination; and B, viewed with crossed polars at 85° (magnification ×347).

43

44A

44B

45

46

PLATE 45 Copper-alloy nail excavated in 1985 from
the site of Kom Rabia at Memphis, Egypt. New Kingdom
(fourteenth to thirteenth century B.C.E.). The nail is
covered with a coat of sampleite, approx. 15 mm thick.

PLATE 46 Photomicrograph of sampleite from a copper-
alloy nail excavated from Memphis, Egypt. The particles
appear pale blue under plane polarized light and show
strong birefringence with bright blue and gray white
when viewed under crossed polars (melt-mount RI 1.662,
magnification ×217).

PLATE 47 Face Mask, Moche culture, Peru, second
century C.E. Copper with eyes of bone and pupils of an
iron mineral that could not be conclusively identified
but that may be a muscovite. H: 22.86 cm; W: 16.51 cm.
The sampleite corrosion on the surface is mixed with
malachite and cuprite. Santa Barbara Museum of Art,
Gift of Wright S. Ludington.

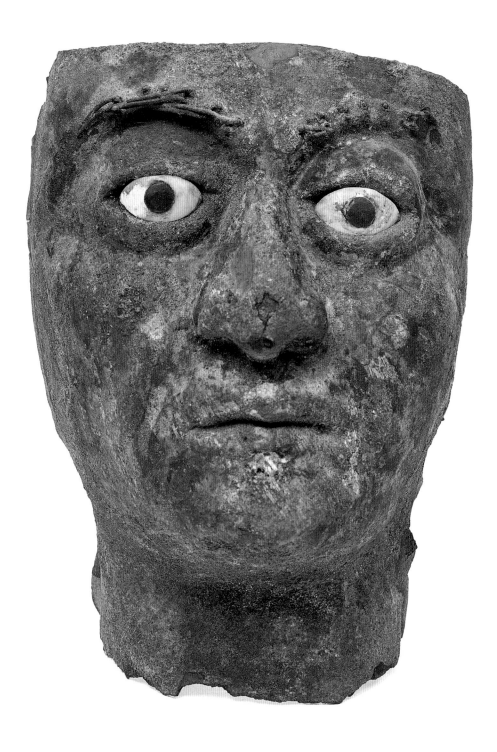

48

PLATE 48 Doors to the Dalziel family vaults, Highgate
Cemetery, London. Bronze. H: approx. 3 m. The doors,
which show rust-corrosion stains from ill-chosen iron
locks, are in close proximity to plant growth, which sug-
gests that fertilizer may have influenced the formation of
the basic copper nitrate salt, gerhardtite, found in the cor-
rosion crust.

49A

49B

49C

49D

PLATE 49 Photomicrographs of four samples of chryso-
colla, showing the variable appearance of the mineral
from different sources. Chrysocolla is often fibrous or has
a fine substructure within each particle. These crystals
show a green-blue birefringence when viewed under
crossed polars (all at magnification ×217).

PLATE 50 Photomicrograph of Egyptian blue pigment
used to decorate Ovoid Lekythos, the Canosa vase illus-
trated in FIGURE 8.2. The large glassy fragments show
internal detail of darker blue regions. Some pale blue
glassy fragments are also visible (magnification ×217).
Most samples of Egyptian blue appear blue in color when
viewed under the microscope, unlike some chrysocolla
samples that are so pale they appear only faintly green
or colorless. Malibu, J. Paul Getty Museum (76.AE.95).

50

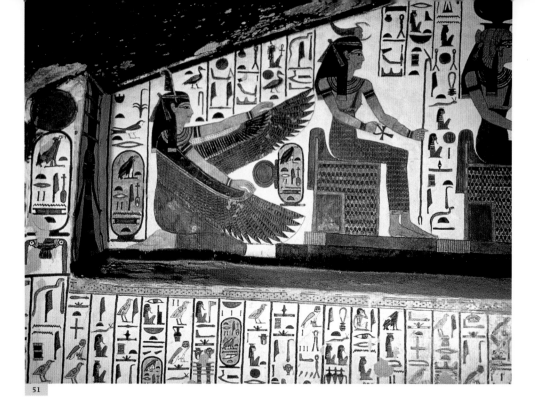

51

52

PLATE 51 Wall painting from the tomb of Queen Nefertari, Valley of the Queens, Egypt (ca. 1255 B.C.E.). Egyptian green was used to paint the wings of the attendant. This painting, located on the stair wall, east side of the upper tier of the tomb, is shown after final conservation treatment.

PLATE 52 Photomicrograph of a prepared sample of Han blue, showing intense blue particles under bright-field illumination (magnification ×325).

PLATE 53 Octagonal pigment stick of Han purple, Chinese. L: 3 cm.

PLATE 54 Photomicrograph of Han purple from a painted bronze vessel, Chinese, Han dynasty (206 B.C.E.–220 C.E.). The sample is viewed under partially crossed polars (magnification ×420).

PLATE 55 Polarized-light photomicrographs of two different verdigris samples: A, distilled verdigris; and B, basic verdigris (both at magnification ×325).

PLATE 56 Photomicrograph of basic verdigris, showing different crystalline phases. Upper portion of the image reveals very fine acicular pale crystals with some irregular larger clumps and long tabular crystals. The lower portion shows blue crystals of neutral verdigris with acicular, light green basic verdigris salts. Viewed under partially crossed polars (melt-mount RI 1.662, magnification ×325).

PLATE 57 Photomicrograph of basic verdigris under partially crossed polars (melt-mount RI 1.662, magnification ×325).

53

54

55A

55B

56

57

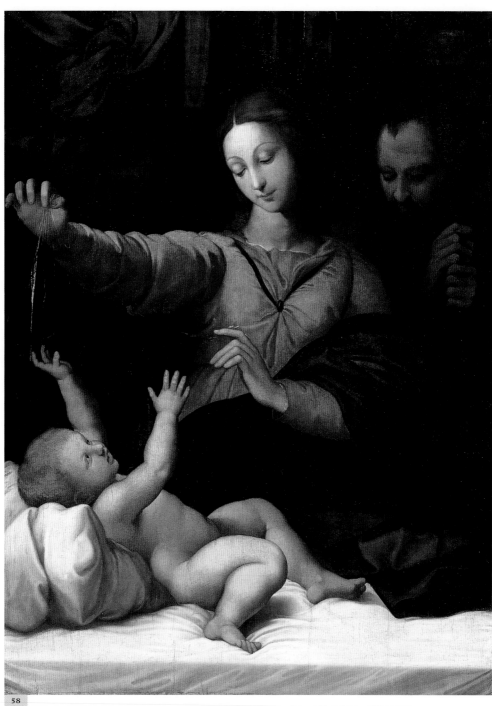

59

60A

60B

PLATE 58 Raphael (Raffaello Sanzio; Italian, 1483–1520), *The Holy Family* (The Madonna del Velo; Madonna di Loreto), mid-sixteenth century. Oil on panel. H: 120.5 cm; W: 91 cm. The green paint used for the drapery in the background is copper resinate, an organometallic compound commonly used during the Renaissance for a green pigment and as a green glaze. Los Angeles, J. Paul Getty Museum (71.PB.16).

PLATE 59 Cross section of copper resinate from *The Holy Family* shown in PLATE 58. The pigment is the very dark, opaque green layer in the photomicrograph (ultraviolet illumination, magnification ×270).

PLATE 60 Photomicrographs of a sample of Scheele's green from the Forbes pigment collection: A, viewed under plane polarized light; and B, viewed under crossed polars (both in melt-mount RI 1.662, magnification ×325).

PLATE 61 Photomicrograph of copper diarsenite in plane polarized light (melt-mount RI 1.662, magnification ×347).

61

62A

62B

PLATE 62 Two photomicrographs of copper ortho-arsenite: A, viewed under plane polarized light; and B, viewed under crossed polars (both in melt-mount RI 1.662, magnification ×347).

PLATE 63 James Ensor (Belgian, 1860–1949), *Christ's Entry into Brussels in 1889*, 1888. Oil on canvas. H: 252.5 cm; W: 430.5 cm. This seminal painting, which was not shown in public until 1924, made extensive use of Schweinfurt green (emerald green), among other vivid colors. Los Angeles, J. Paul Getty Museum (87.PA.96).

PLATE 64 Photomicrographs of sample of Schweinfurt green taken from *Christ's Entry into Brussels in 1889*: A, viewed in plane polarized light; and B, viewed under crossed polars. X-ray diffraction studies show that the synthetic pigment has suffered no degradation over the past one hundred years. The small spherical particles seen under crossed polars are typical for many synthetic copper pigments. Samples of this pigment often show circular or lobed rounded forms with a dark cross. Brushes of light can be seen to cross when the sample is rotated (both in melt-mount RI 1.662, magnification ×230).

63

64A

64B

65

66

PLATE 65 Scheele's green from the Forbes pigment collection. The sample shows light green birefringent particles of RI less than 1.662 (melt-mount RI 1.662, magnification ×325).

PLATE 66 Photomicrograph of phthalocyanine blue. The deep blue color of the pigment is easily visible even in a mounted preparation, and the intensely colored particles resemble Prussian blue (melt-mount RI 1.662, magnification ×347).

PLATE 67 Frans van Mieris the Elder (Dutch, 1635–81), *Pictura* (*An Allegory of Painting*), 1661. Oil on copper. H: 12.5 cm (arched top); W: 8.5 cm. In the painting, A, the allegorical figure is shown holding a palette with seven different colors. Scanning X-ray flourescence analysis revealed the following elements in various areas of the painting: B, copper and lead in the palette area; C, iron, manganese, calcium, and mercury in the face area; and D, calcium, iron, mercury, and tin in the palette. Maps for copper and lead in B reveal part of the copper sheet and the lead-white ground. The higher concentration of lead in a series of horizontal and vertical lines indicates where the copper surface was scored to improve adhesion of the ground to the metal. Los Angeles, J. Paul Getty Museum (82.PC.136).

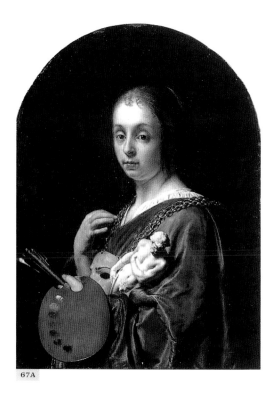

67A

COPPER LEAD

67B

IRON MANGANESE CALCIUM MERCURY

67C

CALCIUM IRON MERCURY TIN

67D

69

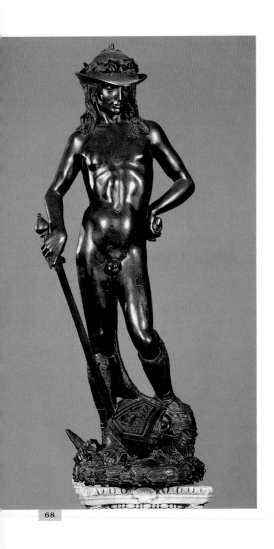

68

PLATE 68 Donatello (Italian, 1386–1466), *David*, ca. 1428–32. Bronze.
H: 158.12 cm. The dark patina of this famous sculpture disguises casting
flaws in the surface of the bronze. Erected in the 1430s, the work is
credited with being the first freestanding large bronze in the Western
world cast since Roman times. Originally in the Palazzo Medici, now in
the collections of the Museo Nazionale del Bargello, Florence.

PLATE 69 Giovanni Battista Foggini (Italian, 1652–1725), *Laocoön* (after
the antique), ca. 1720. Bronze. H: 55 cm; W: 44 cm; D: 22 cm. This hollow
bronze sculpture was cast with the lost-wax method over a core of plaster
with small amounts of clay, quartz, and calcite. The fine patina on the
surface was probably intended to preserve the aesthetics of a translucent
golden brown finish. Los Angeles, J. Paul Getty Museum (85.SB.413).

PLATE 70 Alessandro Vittoria (Italian, 1525–1608), *Mercury*, 1559–60.
Bronze. H: 65.4 cm; W: 22.2 cm; D: 22.2 cm. This bronze is probably
an indirect cast in a heavily leaded copper-tin-zinc alloy. Traces of oil
gilding can be seen under the microscope. The shiny steel-gray patina
has an unusually dark color that may be influenced by the lead content
of the alloy, although this cannot be ascertained without destructive
sampling. Los Angeles, J. Paul Getty Museum (85.SB.184).

71

72

PLATE 71 Statuette of Roma or Virtus, Roman, 40–68 C.E. Bronze. H: 33.1 cm. This anonymous Roman work is thought to be part of group comprising this figure, a relief fragment of two men (see PLATE 73), and Ceres or Juno, all at the J. Paul Getty Museum, and a winged Nike (see PLATE 74) at the Cleveland Museum of Art. The patina of the Roma is rich in tin oxides, compared with the composition of the metal, and has a matte luster with surface mottling, with enrichment in iron also evident. Malibu, J. Paul Getty Museum (84.AB.671).

PLATE 72 Detail from the reverse of the Roma shown in PLATE 71, revealing an unusual hexagonal network structure within the corrosion crust. There is no simple explanation for the presence of these hexagonal structures, which do not correspond to any obvious metallographic features in the bronze microstructure (magnification ×62).

PLATE 73 Relief Fragment of Two Men (the "Togati bronze"), Roman, 40–68 C.E. Bronze. H: 26 cm; W: 13.8 cm. This tin bronze, which may have originally belonged to a frieze, has an interesting iron-stained patina that is rich in tin oxides and also includes fibrous malachite, traces of terra-cotta tile, and pustules of corrosion. Malibu, J. Paul Getty Museum (85.AB.109).

PLATE 74 *Victory with Cornucopia* (winged Nike), Roman, 40–68 C.E. Bronze. H: 42 cm. The patina on this figure is similar to that of the two men shown in PLATE 73, with its matte surface, iron staining, enrichment in tin oxides, and the presence of fibrous malachite crystals. Cleveland Museum of Art, Leonard C. Hanna, Jr. Fund (1984.25).

PLATE 75 Low-power photomicrograph of surface corrosion on the two men shown in PLATE 73. Preservation of pseudomorphic remnants of the original dendritic structure can be seen in the dark green globular fragments, which contain substantial amounts of both copper and lead salts (magnification ×21).

PLATE 76 Photomicrograph of a sample from the bronze statuette of Roma shown in PLATE 71, illustrating cross section of one of the hexagonal features (see PLATE 72). The sample, taken from the interior surface of the figure, was lightly etched in alcoholic ferric chloride, revealing a microstructure with an equiaxed annealed cast morphology to the alpha+delta eutectoid phase and a fairly typical corrosion crust penetrating into the matrix (magnification ×352).

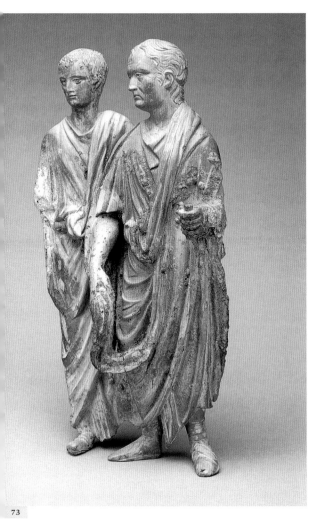

73

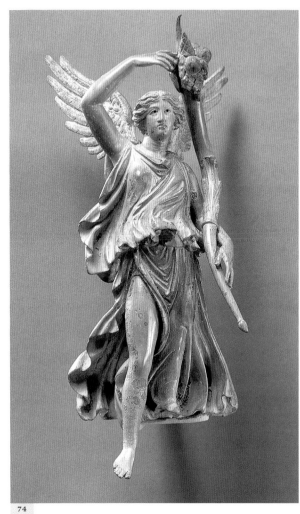

74

75

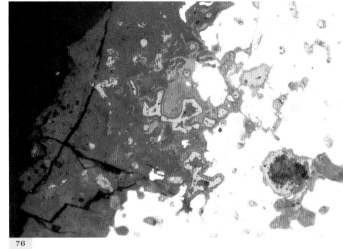

76

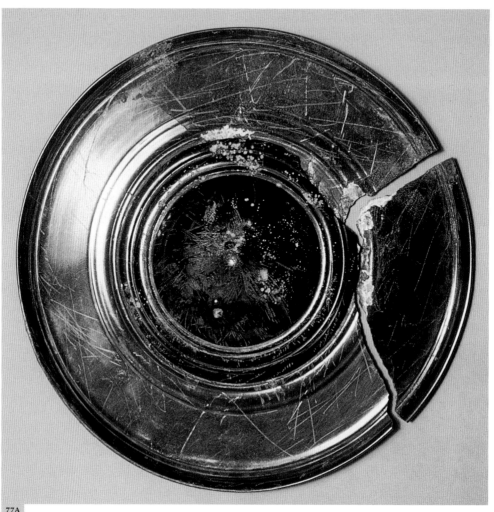

77A

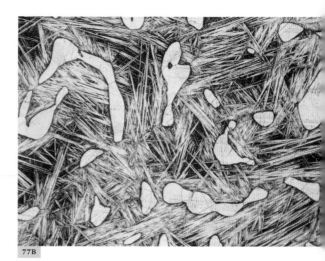

77B

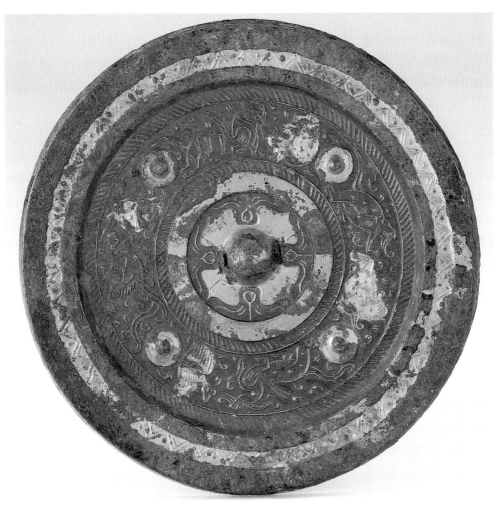

78

PLATE 77 Circular mirror, Java, ca. tenth century C.E. Bronze. DIAM: approx. 12 cm. The mirror, A, has a high tin content and was made using the beta bronze technology, as revealed in the photomicrograph, B, which shows typical microstructure for a cast, heated, and quenched beta bronze with about 20% tin content. Quenching from 650 °C to 550 °C results in the retention of the metastable beta phase, which is normally acicular, as seen here (magnification ×430). The alpha phase shows that the tin content is carefully controlled, as often these bronzes have about 20% of tin rather than the 21.4% of tin required to be completely beta on quenching. The alpha phase is often twinned (Scott 1991), as shown in B, due to hot-working of the bronze during shaping. Private collection.

PLATE 78 Bronze mirror, Eastern Han dynasty (25–220 C.E.), DIAM: 14 cm, showing typical, well-preserved green patina, principally of malachite and tin oxides. Here the tin content is about 19%, but the alloy is not quenched, and the eutectoid alpha+delta phase is seen instead of the beta phase. Freer Gallery of Art, Smithsonian Institution (F1909.275).

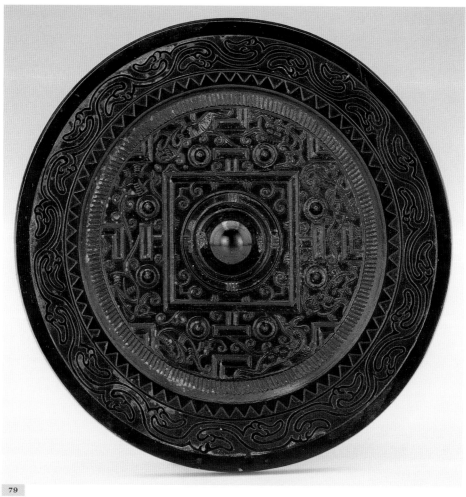

79

80A

80B

81

PLATE 79 Bronze mirror, Eastern Han dynasty (25–220 C.E.), DIAM: 14.3 cm. The back of this mirror shows typical black patina, consisting primarily of copper oxides and tin oxides. Here both the alpha+delta eutectoid phase and the alpha phase of the bronze have corroded. Freer Gallery of Art, Smithsonian Institution (F1937.30).

PLATE 80 Photomicrographs of cross sections of patina samples from two Chinese mirrors: A, a mirror from the Warring States period (475–221 B.C.E.), showing a green patina with preservation of the copper corrosion products and uncorroded alpha+delta eutectoid phase to the outer regions of the corrosion crust; and B, a mirror from the Han dynasty, with a black patina in which the alpha+delta eutectoid phase as well as the copper-rich phase have corroded (both at magnification ×488).

PLATE 81 Statuette of a Cat, Egyptian late period (700–300 B.C.E.). Bronze. H: 24.2 cm. This bronze casting was conserved by patina-removal techniques that were commonly in use from around 1890 to 1970. The entire patina has been stripped away by the chemical or electrolytic treatment. Most objects treated in this manner have oxidized metallic surfaces of a similarly raw appearance and are now usually confined to storage vaults. Ashmolean Museum, Oxford (1962.608).

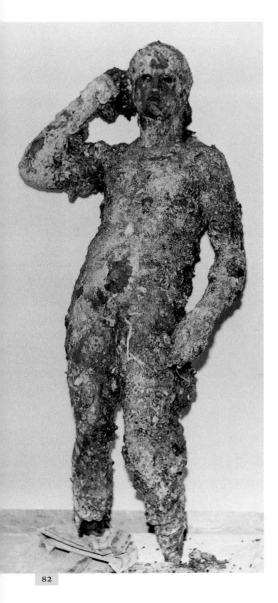

82

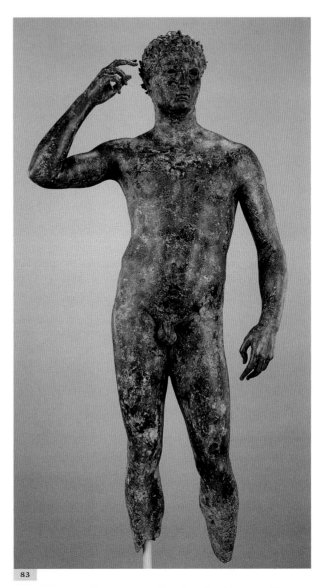

83

PLATE 82 Statue of a Victorious Youth (Getty bronze athlete), Greek, ca. 300 B.C.E. Hollow cast bronze with copper inlays, before mechanical cleaning and conservation. H: 151.5 cm. The statue is shown here shortly after it was found, heavily encrusted with corrosion, sediment, and marine organisms, a common result of marine burial. Malibu, J. Paul Getty Museum (77.AB.30).

PLATE 83 Statue shown in PLATE 82, after mechanical cleaning and conservation, revealing itself to be one of the finest bronze figures from the last decades of fourth-century B.C.E. Greece. The patina is cuprite overlaid with malachite and azurite and with occasional patches of clinoatacamite.

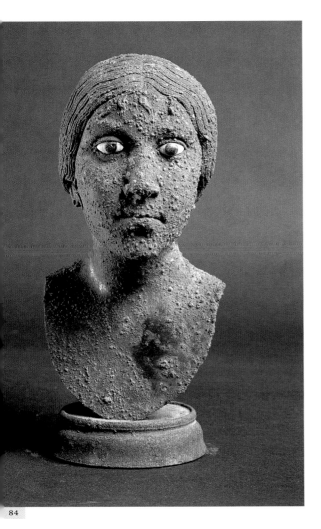

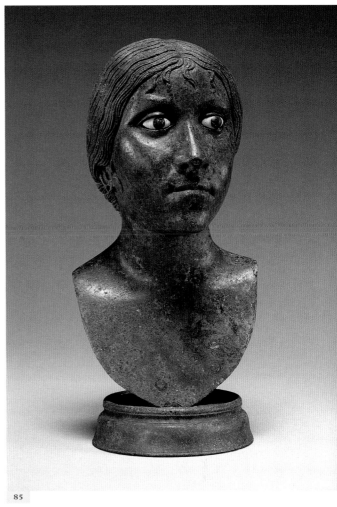

PLATE 84 Miniature Portrait Bust of a Woman, Roman, 25 B.C.E.–25 C.E.
Bronze with glass-paste inlays. H: 16.5 cm; DIAM (base): 6.7 cm. The bust is shown
here before conservation, illustrating pustular corrosion with pitting created
by bronze disease. Cuprous chloride is active within the pits after removal of the
cuprite and malachite crust that overlays the pustules. Malibu, J. Paul Getty
Museum (84.AB.59).

PLATE 85 Bust shown in PLATE 84, revealing smooth surface after mechanical
conservation cleaning. The bronze was treated several times with silver oxide
paste (Organ 1961), yet this did not completely stabilize the cuprous chloride,
which created conservation problems. The pustular corrosion interfered with the
details in the head, which had been carefully chased by the metalsmith after cast-
ing to articulate the braided and knotted hair that has remained remarkably well
preserved. The earlobes are drilled for earrings, now lost. This bronze probably
resided in a domestic shrine.

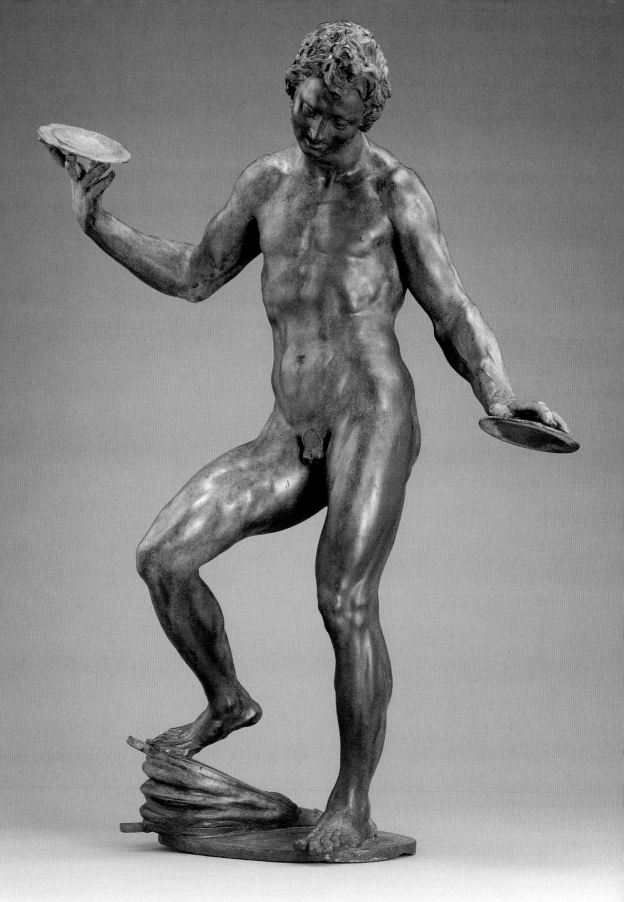

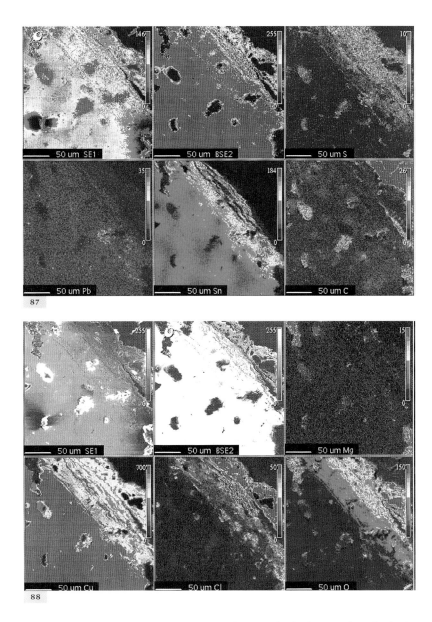

87

88

PLATE 86 Adriaen de Vries (Dutch, 1545–1626), *Juggling Figure,* ca. 1615. Bronze. H: 77 cm; W: 51.8 cm; D: 21.9 cm. This indoor bronze was found to have an "outdoor" patina, consisting principally of brochantite with small amounts of posnjakite over cuprite. The work was being used as a common piece of garden sculpture in England before being reattributed to de Vries. It is shown here after conservation treatment to disguise the visual impact of the streaked and corroded surface. Los Angeles, J. Paul Getty Museum (90.SB.44).

PLATE 87 Elemental distribution maps for sulfur, lead, tin, and carbon, together with secondary-electron (SE) and backscattered electron (BSE) images for the de Vries bronze shown in PLATE 86.

PLATE 88 Elemental distribution maps for magnesium, copper, chlorine, and oxygen, together with secondary-electron (SE) and backscattered electron (BSE) images for the same area of the de Vries bronze analyzed in PLATE 87. These electron microprobe maps show part of the detailed structure of the patina.

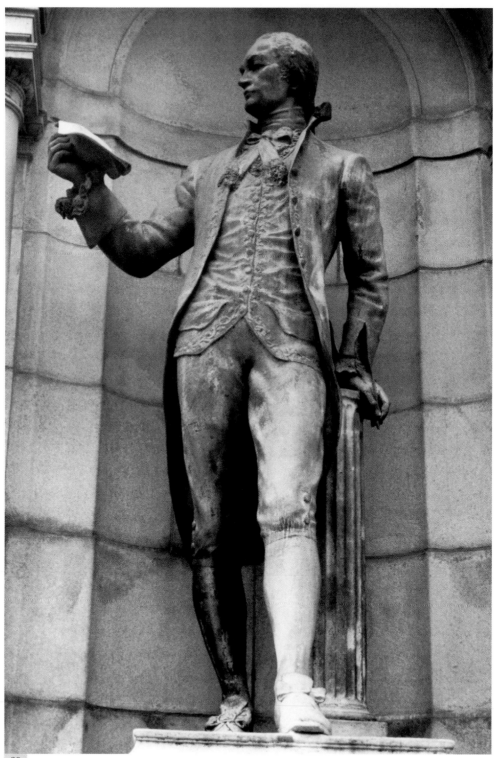

90A COPPER

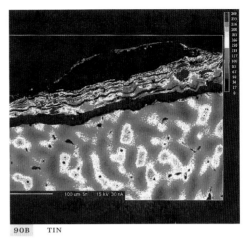

90B TIN

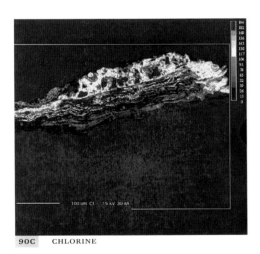

90C CHLORINE

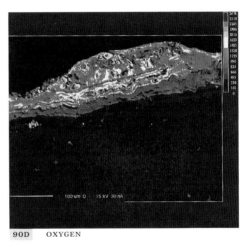

90D OXYGEN

90E ZINC

PLATE 89 W. O. Partridge (American, 1861–1930), statue of Alexander Hamilton, Hamilton Grange, New York, erected 1890. Bronze. The statue was treated and repatinated by Phoebe Dent Weil in 1978.

PLATE 90 Elemental distribution maps for the statue of Alexander Hamilton shown in PLATE 89: A, copper, B, tin, C, chlorine, D, oxygen, and E, zinc.

Copper Sulfides
CHAPTER 6

Take a thin leaf of Nepalese copper and embed it in powdered sulphur.
The substances are to be placed inside a saucer-shaped earthenware
vessel and covered with another. The rims are luted with sugar or
powdered rice-paste. The apparatus is heated in a sand-bath for three
hours. The copper thus prepared is powdered and administered with
other drugs.—CHAKRAPANI DUTTA[1]

The copper sulfides are a diverse and difficult group of compounds with dubious stoichiometry and crystallinity. Many new members have been identified in recent years. Sulfides are found in corrosion that varies from patinas formed in oxygen-deficient, aqueous environments to tarnish caused by undesirable museum pollutants. As inlay, copper sulfides were used to make the dense black substance, known as niello, that was used for decorating the surface of metals as long ago as the Bronze Age.

One interesting use of sulfides was medicinal, as alluded to by Chakrapani Dutta in his *Chakradatta* of 1050 (Ray 1956). Suspensions or ointments made from malachite, copper sulfides, verdigris, or small hammered flakes of elemental copper were used to treat pain in the muscles, spinal cord, or joints. In his *Natural History,* Pliny the Elder gives this prescription for a balm to "soften the member of" the knee:

Northern salt, gum ammoniac, ibex grease, honey, frankincense, celery, calamine (?), onion, hammering-flakes from copper, grease of sheep, cumin, oil and natron are ground and it is bandaged therewith.[2]

The small amount of copper ions needed for treatment could have been supplied by either copper or copper sulfides. In a recipe to remedy an injury to the eyes, Pliny states that "stibium, malachite, red ochre, sory and honey are applied to the eye-lids."[3] Sory has been identified by Knoll and colleagues (1985) as referring to the copper sulfides, although other authors regard it as probably a basic copper sulfate (see CHAPTER 4). Sugars and other organic ingredients in the honey probably produced copper salts in the mixture. One of the advantages of the copper sulfides in medicinal recipes is that their low solubility in aqueous solution allows control over the amount of copper delivered by the ointment or preparation.

The synthesis of copper sulfides for another medicinal was also recorded by Pliny in the following passage:

> Taken with honey it also acts as an emetic, but for this Cyprian copper with an equal weight of sulphur is roasted in pots of unbaked earthenware, the mouth of the vessels being stopped with oil; and then left in the furnace till the vessels themselves are completely baked.[4]

The *Mappae clavicula*, a medieval Latin manuscript containing recipes from the Classical world (Smith and Hawthorne 1974), includes a recipe by Dioscorides for the synthesis of a copper sulfide. The instructions given are similar to those in the Indian recipe from Dutta quoted earlier. Dioscorides' recipe 139 states that

> copper calcine is made in this way. Make leaves out of very clean copper and put these leaves in an unused pot with some ground natural sulphur; and spread out the leaves in a cooking-pot; then sprinkle sulphur on top, and again put leaves and sprinkle sulphur; do so repfeatedly until you have filled the pot. Then, place the pot in a glassworker's furnace, and cook for 3 days and when it has cooled, break it up very small. (Smith and Hawthorne 1974 : 12)

If the pot were well sealed, the product would certainly be a copper sulfide, or a mixture of copper sulfides, depending on the conditions of the reaction and the temperatures reached.

A number of historical records describe the action of sulfur on copper and the formation of sulfides, including observations by Geber[5] in his *Summa perfectionis magisterii* (The Sum of Perfection, or the Perfect Magistery), written in the fourteenth century (Mellor 1928), and those of the German philosopher and theologian Albertus Magnus (1200–1280), who studied the reaction of sulfur with a variety of metals. It took some time, however, before the diversity of these copper sulfides was fully appreciated.

The copper sulfides are generally opaque under bright-field microscopy and range in color from black to blue in reflected light. The refractive indices are all greater than 1.66. Chakrabarti and Laughlin (1983) give a provisional analysis of the copper-sulfur system that includes a detailed discussion of the copper-sulfur phase diagram. The major difficulty with this system is created by many phase regions, which can have variable composition, and relatively few sulfide compounds of fixed stoichiometry. A monoclinic low chalcocite, Cu_2S, has been identified that is stable at temperatures up to 103 °C; a hexagonal high chalcocite with the same formula is stable at temperatures above 103 °C. The face-centered cubic mineral digenite also comes in a high and low form: high digenite, $Cu_{7.2}S_4$, and low digenite (synthetic), Cu_9S_5. The ICDD files have another entry for digenite (synthetic), $Cu_{1.8}S$, which is the same formula as the previous entry divided by 5. Digenite is stable over a wider range of sulfur content than some of the other phases, and at room temperature, low digenite is thought to be stabilized by the presence of iron between 0.4 and 1.6 atomic%. Compounds with stoichiometry approximating chalcocite, Cu_2S, are stable between 435 °C and 1130 °C. The temperature stability of copper-deficient forms varies: at about 36.6% copper, they are stable up to 507 °C, and at 35.65% copper, down to 72 °C.

There is an orthorhombic djurleite of nominal composition, $Cu_{1.96}S$, stable to 72 °C, and another orthorhombic compound, anilite, $Cu_{1.75}S$, which is stable up to 75 °C. The hexagonal mineral covellite, CuS, is stable to 507 °C. Blaubleibender ("blue-remaining") covellite has a slightly different X-ray pattern than ordinary covellite and contains from 2 to 8 atomic% more copper. It can be formed by oxidation of digenite and chalcocite at room temperature. The ICDD files regard spionkopite, $Cu_{1.32}S$, as a component of blaubleibender covellite.

Some of these phases have a tendency to undergo thermomechanical alteration. This can make their identification difficult because the mineral phase can be altered by grinding during sample preparation, as exhibited, for example, by anilite, which can be altered to digenite by grinding.

The ICDD files recognize the eleven varieties of copper sulfides shown in TABLE 6.1. In addition, there is a diverse array of mixed metallic sulfides that includes copper-iron sulfides and copper-lead sulfides. These minerals—particularly chalcopyrite, $CuFeS_2$—have been used as ores of copper or other metallic elements since ancient times. Enargite, Cu_3AsS_4, and bornite, Cu_5FeS_4, were also of importance in the ancient smelting of copper (Rapp 1986).

TABLE 6.1 **CHARACTERISTICS OF SOME COPPER SULFIDE MINERALS**

MINERAL NAME	FORMULA	CRYSTAL SYSTEM	COLOR	MOHS HARDNESS
anilite	Cu_7S_4	orthorhombic	metallic bluish gray	3
chalcocite, low	Cu_2S	hexagonal	metallic blackish gray	2.5 – 3
chalcocite, high	Cu_2S	tetragonal	metallic black gray	?
chalcocite	Cu_2S	hexagonal	metallic blackish gray	2.5 – 3
covellite	CuS	hexagonal	submetallic blue	1.5 – 2
digenite, low	$Cu_{1.8}S$	rhombohedral	blue / black	2.5 – 3
djurleite	$Cu_{1.96}S$	monoclinic	metallic gray	2.5 – 3
geerite	$Cu_{1.6}S$	cubic	metallic bluish white	?
roxbyite	$Cu_{1.78}S$	monoclinic	metallic blue gray	2.5
spionkopite	$Cu_{1.32}S$	rhombohedral	metallic blue gray	2.5
yarrowite	$Cu_{1.2}S$	rhombohedral	metallic bluish gray	2.5

CORROSION ENVIRONMENTS AND COPPER SULFIDE PRODUCTION

Sulfide formation in reducing environments

On objects buried in seawater sediments, removed from oxygenated conditions, copper sulfides are a common corrosion product. In this environment, the whole range of compositions from covellite, CuS, to chalcocite, Cu_2S, is represented.

In burial conditions where reduction of sulfate by bacteria is possible, sulfide ions are produced essentially by the reaction

$$2SO_4{}^{2-} = S^o + S^{2+} + 4O_2 \qquad 6.1$$

The bacteria utilize the oxygen for oxidative enzymatic activity, and one of the end products in seawater or sediments is hydrogen sulfide,

$$2H^+ + S^{2-} = H_2S \qquad 6.2$$

which can form insoluble complexes with trace elements in oxygen-deficient sediments.

Removal of hydrogen from the cathodic areas results in depolarization of the cathode, allowing corrosion reactions to occur in the absence of oxygen. Cathodic areas may occur on bronze objects, but they may also represent contiguous materials that are functioning as cathodic regions. Hydrogen sulfide liberation accelerates the corrosion of copper alloys by

substitution of more oxidized, protective films. Because these films tend to be less well ordered, their protective properties can be less effective as a barrier to corrosion than surface patinas that are more oxidized. Additional bacterial growth may occur under concreted growths; this in turn may promote further corrosion. If the hydrogen sulfide presence on the copper surfaces is discontinuous, then pitting of the copper may occur above a potential of 150 mV. General corrosion rates of copper alloys can increase by up to five times in a hydrogen sulfide concentration of 4 ppm, with a concentration of 50 ppm being not uncommon in these types of deposits, accelerating corrosion even further (Florian 1987).

One of the earliest studies of the copper sulfides as a corrosion product was that of Daubree (1875), who examined the patina of some Roman coins and medals recovered many years earlier from French mineral springs. Daubree was able to identify chalcocite, Cu_2S; chalcopyrite, $CuFeS_2$; bornite, Cu_5FeS_4; tetrahedrite, $(Cu,Fe)_{12}Sb_4S_{13}$; and covellite, CuS, as present on the coins, medals, and other small finds. Daubree believed that the sulfide in the thermal springs originated from the reduction of soluble sulfates by the action of bacteria on vegetable matter. In 1879 Von Hochstetter, quoted by Daubree (1881), also gave an early report on the occurrence of covellite as a patina component of a Celtic bronze ax from excavations at Salzburg , Austria.

Examination of several fragments of a corroded gunpowder canister recovered from the wreck of the *Herminie*, the flagship of the French West Indies fleet that sank off the coast of Bermuda in 1838, showed that the copper had altered to a brittle blue-black mass identified by X-ray diffraction as covellite (Gettens 1964). Lacroix (1910) found covellite mixed with chalcocite on copper nails from a late Hellenistic shipwreck off Madia, Tunisia. In a related study, Lacroix (1909) described a black chalcocite, which was sectile and locally crystalline, on Roman bronze coins found at a thermal spring in Saone-et-Loire, France. Daubree (1881) noticed a black variety of chalcocite on copper coins from thermal springs as well, while Palache, Berman, and Frondel (1951) give the color as blackish lead-gray; obviously there is some color variation present. Gettens (1963a) notes that in 1961, Périnet identified chalcocite and digenite from the corrosion crust of a copper nail found in an ancient shipwreck in the Mediterranean sea off Grande Congloue, France.

MacLeod (1991) found a number of copper and silver sulfides on coins recovered from the 1811 wreck of the *Rapid* near the coast of Western Australia. The major copper sulfides found were chalcocite with small amounts of djurleite and digenite. Of interest are the mixed copper-silver sulfides, jalpaite, $Ag_{1.55}Cu_{0.45}S$, and stromeyerite, CuAgS. These mixed copper-silver sulfides were found on silver coins that had some copper content. Relatively few analyses of silver corrosion products are available, and the existence of these minerals is probably more common than present data would suggest. Many silver objects contain minor alloying additions of copper, so there is every reason to believe that more examples of jalpaite and stromeyerite will be found by future analytical studies. Typical working conditions for the recovery of these small

underwater finds from the work of MacLeod (1982, 1985) is illustrated in PLATE 39. PLATE 40 is a scanning electron photomicrograph of a leaded brass nail from the *Rapid* showing extensive corrosion producing covellite, chalcocite, and a variety of lead sulfides.

Nord, Lindahl, and Tronner (1993) described yet another sulfide found on a copper alloy compass ring salvaged from the wreck of the SS *Kronan*, which sank in the Baltic Sea in 1676. The object had an inner, grayish corrosion layer with occasional bluish tinges that was identified by X-ray diffraction as spionkopite, $Cu_{39}S_{28}$. This product was only characterized as a natural mineral in 1980 (Goble 1980). Covellite was also identified from this particular Baltic site. Less reducing sediments favor covellite formation over spionkopite, which has a stoichiometry that approximates to $Cu_{1.4}S$.

Corrosion during burial or in stagnant conditions, such as a hot spring , may deposit copper sulfides on other materials or react with contiguous objects to form mixed cation products, as the work of Daubree (1881) has shown. Another example is the Anglian helmet from the Coppergate burial site at York, England. The helmet is a crested Scandinavian type analogous to one found at Sutton Hoo,[6] Suffolk, England, and has a complex construction of iron plates reinforced and decorated with copper alloy bindings (Tweddle 1992). The helmet was well preserved because it was buried in an anaerobic deposit. This oxygen-deficient environment created unusual corrosive events resulting in siderite, $FeCO_3$, identified on the iron plates, and chalcopyrite, $CuFeS_2$, and bornite, Cu_5FeS_4, on the copper alloy components. All of the mineral identifications were determined by X-ray diffraction. Bornite was also reported by Organ (1981) as part of the encrustation on a Classical bronze horse in the collections of the Metropolitan Museum of Art.

In an extensive study, Duncan and Ganiaris (1987) described the corrosion products found on first-century C.E. Roman bronzes from waterfront sites along the Thames in London, where land reclaimed from the river produced areas of anaerobic activity, rich in sulfate-reducing bacteria. Medieval sites such as York, England, and Trondheim, Norway, may possess similar environmental conditions. The bronzes from the Thames were sometimes found to be covered with a dull, golden, sulfidic layer over a black corrosion crust, such as that exhibited by the fourteenth-century bronze trumpet shown in PLATE 41. Oddy and Meeks (1981) described a similar golden layer on a Roman brass bust in the British Museum as "pseudo-gilding ," but Duncan and Ganiaris, who studied the same object, determined that this layer was, in fact, a natural corrosion layer rather than a deliberately gilded surface. Analysis showed that these golden layers are composed of chalcopyrite, $CuFeS_2$, or pyrrhotite, $Fe_{(1-x)}S$, often in combination. PLATE 42 shows a partially cleaned Roman coin with a black sulfide layer under chalcopyrites; PLATE 43 illustrates a medieval key covered by botryoidal chalcopyrites and revealing some of the metallic core underneath. The minerals in the black crusts on sheet-copper objects from waterfront sites were identified as chalcocite, Cu_2S; covellite, CuS; and rare occurrences of geerite, $Cu_{1.6}S$.

X-ray diffraction studies also showed that some green-colored layers present on objects from the Thames sites consisted of antlerite, $Cu_3(SO_4)(OH)_4$, and the unusual sulfate mineral guildite, $CuFe(SO_4)_2(OH)\cdot 4H_2O$. No other occurrences of guildite have been reported. This mineral may form from a more common mixed copper-iron sulfide, such as chalcopyrite, that is transformed into the sulfate by oxidation after the object is removed from the burial environment. Until other examples of guildite are found, however, there is insufficient evidence to say exactly how it does form. The mechanism by which the chalcopyrite or pyrrhotite develop is also not known. The copper in the chalcopyrite may be a codeposit with iron when the elements are precipitated from solution, or the copper may have diffused from the object into the surface layers and substituted for iron in a defective film.

"LAKE" AND "LAND" PATINAS Schweizer (1994) described work on bronzes from human settlements around lakes near Neuchâtel, Switzerland, during the late Bronze Age (1050–870 B.C.E.) Compositional analyses showed that the objects were tin bronzes with about 8–9% tin, with an expected array of trace elements. Two primary patina types were identified: "lake patinas" (on objects excavated from lake sites), which had smooth, dense, brown-yellow surfaces; and "land patinas" (on objects from land sites), which had thick green-blue layers incorporating some quartz grains. The land patinas were identified as various mixtures of malachite, $Cu_2CO_3(OH)_2$; antlerite, $Cu_3SO_4(OH)_4$; and posnjakite, $Cu_4SO_4(OH)_6\cdot H_2O$. Posnjakite is normally associated with antlerite, brochantite, and atmospheric corrosion, and it is rarely mentioned in the context of excavated bronzes.

The identification of the true nature of the lake patina proved troublesome. In a preliminary publication, Schweizer concluded that sinnerite, $Cu_6As_4S_9$, was present, but later quantitative studies showed that this was erroneous; chalcopyrite was later confirmed as the phase actually present. On another bronze, a mixture of chalcocite, Cu_2S, and djurleite, $Cu_{1.96}S$, was identified. Schweizer postulated that the chalcopyrite formed because of the preferential dissolution of copper, leaving a tin-enriched interior zone. The copper ions, iron, and sulfur then combined and precipitated as a uniform layer of chalcopyrite.

Schweizer divides the objects from this site into three types of patina with the possible distribution into "lake" and "land" previously described: (1) objects with sulfide crusts, (2) objects with both sulfide and carbonate crusts, and (3) objects with carbonate and sulfate crusts. It is possible to make some inferences regarding these objects by examining the Pourbaix diagram for the copper–sulfate–water system, shown in FIGURE 6.1. The sulfides, which are the primary corrosion product, were formed under anaerobic conditions in a soil rich in organic matter and in the presence of sulfate-reducing bacteria. The sulfide crust is about 100 μm thick. The objects with a sulfide corrosion layer followed by a carbonate layer represent the transitional survivors from a reducing environment, where the sulfide layer is only partially oxidized to sulfates and carbonates. The carbonate and sulfate crust formed in an aerated soil in contact with air and grew from the oxidation of the primary sulfides.

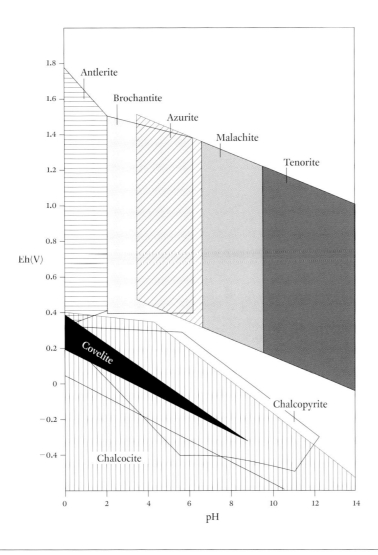

FIGURE 6.1 Pourbaix diagram for the Cu–S–H₂O system (Schweizer 1994).

Schweizer concluded that after the Bronze Age lake dwellers finished using these objects, the bronzes were discarded in damp, waterlogged soil or were thrown into the lake close to the shore and sank to the bottom. There they remained for a considerable period of time in anaerobic conditions. Later the water level in the lake dropped, exposing some of the objects to oxidizing conditions, and the sulfides transformed into basic carbonates and basic sulfates. The lake level rose around 750 B.C.E. and submerged all of the objects again, probably initiating further slow corrosion of the material.

Sulfide formation from atmospheric exposure	Copper sulfides are infrequently found as a component of exposed copper patinas produced by atmospheric corrosion because they will usually be oxidized to the basic copper

sulfates after they form. Sulfides are, however, sometimes found on exposed bronzes in urban environments. One of the earliest reports is that of Vernon and Whitby (1930), who found sulfides in a copper patina and thought that chalcocite might have later become oxidized to covellite. Franey and Davis (1987) observed that the artificial sulfide patina applied to a bronze statue began to transform into basic copper sulfates after the statue had been exposed outdoors for only a few months. Selwyn and colleagues (1996) found that on exposed bronzes in Ottawa, sulfides were present only as minor patina components: geerite, Cu_8S_5 or $Cu_{1.6}S$, was found seven times; chalcocite twice; and djurleite, $Cu_{31}S_{16}$ or $Cu_{1.96}S$, once.

Sulfide formation from pollution in the museum environment	The alarming appearance of what is called the "black fuzzies" or "brown fuzzies" on bronze or brass surfaces in the museum environment has generated much discussion and concern. These disfiguring excrescences of copper sulfides result from

exposure of metallic objects to indoor pollutants, primarily hydrogen sulfide emanating from inappropriate materials used for display, storage, or exhibition.

Madsen (1977) and Madsen and Hjelm-Hansen (1982) originally invoked microbiological activity as the origin of these black copper sulfide spots, after finding that a mold of the Cladosporium family grew in the presence of these copper sulfides. Hjelm-Hansen (1984) later recommended the use of 1-amido-1-cyanoethylene,2,2-disodium thiolate as the preferred cleaning reagent for the removal of these spots, which were identified as covellite, CuS. Other chemical reagents used to clean bronze may work as well. Oddy and Meeks (1982) published a paper expressing doubts about the microbiological theory of attack and suggested instead that all occurrences of black spots on a museum object could be accounted for by the presence of hydrogen sulfide, carbonyl sulfide, or similar pollutants in the air. This is now generally accepted as the correct explanation.

When copper is exposed to air with hydrogen sulfide contaminants, it rapidly develops a tarnish film that thickens, following a parabolic growth rate. An example of the growth of this sulfide film is shown in FIGURE 6.2. Laboratory experiments demonstrate that if copper is first exposed to an atmosphere containing small amounts of hydrogen sulfide and is then removed from it, the copper will continue to corrode at an accelerated rate. If, however, the copper is first exposed to pure air so that a thin film of cuprite forms, it will not tarnish if then exposed to air containing some hydrogen sulfide (Leidheiser 1979).

Identifying the sulfides in these spots is difficult because of the poor crystallinity of the compounds. Interpreting X-ray diffraction data also poses problems, even when a good array

FIGURE 6.2 Rate of tarnishing of copper in atmosphere with small amounts of sulfide. P indicates where parabolic growth begins (Leidheiser 1979).

of d-spacings can be measured, and some patterns remain unidentified. It is possible that not all dark brown or blackish excrescences on copper alloys are attributable to copper sulfides. This is shown, for example, by studies that were carried out on suspicious black spots on brass mounts, clocks, and other items in the Wallace Collection in London. Very small samples, less than 1 mg, were removed for study and examined by polarized-light microscopy, X-ray diffraction, and scanning electron microscopy with energy dispersive X-ray analysis. Corrosion on the brass objects was generally in the form of small, round, brown-black spots, scattered randomly over the surface; it was thought that the corrosion had developed many years prior to the study, which began in 1994. Light microscopy examination of a corrosion sample from a clock mount, illustrated in FIGURE 6.3, showed a very dark green transmittance in bright-field illumination and a refractive index greater than 1.66. The powder X-ray diffraction pattern, shown in APPENDIX D, TABLE 6, could not be matched with any known copper sulfide; scanning electron microscope studies were subsequently undertaken by Bezur and Scott (1996). The analysis showed the presence of copper, zinc, sulfur, and oxygen, with smaller amounts of chlorine and iron. With the discovery that the corrosion product contained zinc, a new search was performed, and a good match was found with the unusual mineral namuwite—which can be considered as a zinc substituted brochantite, $(Zn,Cu)_4SO_4(OH)_6 \cdot 4H_2O$—that was previously unreported as a corrosion product of art objects. Namuwite is a hexagonal mineral, a pearly sea-green when pure,

FIGURE 6.3 Gilded brass clock, French, ca. 1781, with a type of corrosion known as "brown fuzzies": A, full view, and B, detail, revealing the disfiguring brown-black spots. The clock, based on a design by the architect François-Joseph Bélanger (1744–1818), has a movement designed by Jean-Baptiste Lepaute (1727–1801). The corrosion excrescences were identified as nauwamite, a zinc-substituted basic copper sulfate hydrate. Wallace Collection, London (clock F269). Bequest of Lady Wallace.

A

with a low Mohs hardness of 2. It was first reported in 1982 from the type locality of Aberllyn mine, Llanrwst, Bettws-y-coed, Gwynedd, Wales (Nickel and Nichols 1991).

Seeley suggested a possible mechanism for the formation of this product on brass objects.[7] Atmospheric pollutants such as sulfur dioxide can cause local dezincification, leaving traces of zinc sulfite on the surface of an object, and these traces are rapidly oxidized to zinc sulfate. Zinc sulfate is highly deliquescent, therefore even slightly elevated relative humidity can cause localized spots of condensation. The zinc sulfate solution thus formed will dissolve more sulfur dioxide, which will be oxidized to sulfur trioxide, facilitated by the copper (II) ions also present on the surface. In the presence of the increasingly strong concentration of sulfuric acid in the droplets, together with atmospheric oxygen, more copper-zinc alloy will dissolve, resulting in the production of a mixed copper-zinc basic sulfate. This effect could be even greater in two-phase brasses or brasses with lead or other anodic inclusions present.

Seeley's explanation is perfectly reasonable, since one possibility for the presence of these corrosion spots on objects such as those in the Wallace Collection is that the corrosion originated in the 1950s when "pea-soup" smogs afflicted major cities such as London. The pollutants, such as sulfur dioxide, were capable of reaching levels of thousands of parts per billion and also significantly affected indoor air quality.

The general equation for copper sulfide formation is

$$Cu^{2+} + xH_2S = CuS_x + 2xH^+ \qquad 6.3$$

B

Assuming that metallic ions are precipitated from solution, the second mechanism that could produce sulfides is conversion of the surface oxide to a sulfide, as expressed in the following equation:

$$Cu_2O + xH_2S = 2CuS_x + \tfrac{1}{2}xH_2O$$

6.4

Duncan and Ganiaris (1987) exposed copper alloys with golden and black sulfide patinas to 80% RH, which is 20% higher than the level at which pyritic sulfides can become unstable. Color changes were observed within seven days; after thirty-five days, all the objects had changed color. This clearly demonstrates the inherent instability of these sulfide corrosion layers if appropriate conservation measures are not taken during the treatment, storage, or display of such material.

COPPER SULFIDES AND NIELLO

[O]n those that you want to niello, draw Greek foliage and engrave with a bold line; the grounds of these you engrave with thin circles and fine workmanship. Then make up the niello in this way.—THEOPHILUS[8]

Niello is a black metallic compound of mixed sulfides used to fill in decorative incised designs on metals, the term *niello* coming from the Latin *niger* for "black." The compound was prepared in antiquity from a mixture of copper and silver sulfides. By the time Theophilus was writing, in the twelfth century, lead had been added to the recipe as well, producing a mixture of copper,

silver, and lead sulfides. Niello has a long history of use as a decorative inlay and was often used as contrasting black areas of design with silver. It was usually used in champlevé style, as was common with enamels, where the object to be decorated was cut or engraved with a design, and the channels or lines were filled with niello. The object would be heated to fuse the niello into a compact mass and then finished by grinding and polishing. In his *De diversis artibus,* Theophilus (1961) provides detailed instructions on how to apply niello by filling goose quills with the fine particles and then tapping them into position on the engraved foliage before carefully heating the object in burning coals until the niello has melted into position.

Niello decoration was widely used on Bronze Age objects, often of gold; examples are known from many different cultures, including European, Islamic, and ancient Indian. Silver vessels inlaid with niello are known from the late Hellenistic and early Roman periods, with many examples from the third century and later. Some analyses show that pure silver sulfide was used to make Roman niello (Ogden 1982). Unlike the mixed sulfides of copper and silver, silver sulfide will decompose if heated, so it must have been burnished into position while being heated just enough to make the compound plastic. Eggert, Kutzke, and Wagner (1999), however, question whether these sulfides would really behave in a plastic fashion, like glass, below their melting point and wonder if some kind of flux might have been used. Ogden adds that on a later Roman ring there had been some diffusion of silver into the surrounding gold, suggesting the use of a mixed sulfide. Black copper sulfide inlays in some first-century C.E. Roman buckle plates that had been recovered from Hod Hill, Dorset, England, were not fused into position, however, and may have been inserted as precut inlays.

| *Niello recipes* | Pliny gives the following recipe for making the mixed copper-silver sulfides: |

The method adopted is as follows: with the silver is mixed one third its amount of the very fine Cyprus copper called chaplet-copper and the same amount of live sulphur as of silver, and then they are melted in an earthenware vessel having its lid stopped with potters clay; the heating goes on until the lids of the vessels open of their own accord.[9]

Niello began to be frequently used from the beginning of the Christian era. More recipes that may refer to the fabrication of niello are found in the Leyden Papyrus (Caley 1926), a medieval manuscript with content that may go back many centuries. Recipe 36 of the document refers to "black asem," which may mean niello. The recipe starts with copper, tin, lead, and sometimes mercury, which are placed in a crucible. To make black asem, two parts of "normal asem" (probably copper and silver) are mixed into the contents of the crucible along with four parts of lead; the mixture is then melted with three times as much sulfur.

Interestingly, another medieval niello recipe recorded by Theophilus (1961) calls for an elemental composition that is very similar to Pliny's mixture. Theophilus's recipe is complicated

but essentially calls for two-thirds silver, one-third copper, and a sixth part of lead. The partial recipe states:

> [W]hen you have melted the silver with the copper, stir it together with a piece of charcoal, and instantly pour onto it the lead and the sulphur from the copper crucible, and again stir vigorously with the charcoal. Rapidly pour this into the other cast crucible over the sulphur which you have put in it.[10]

Theophilus then goes on to describe how the niello is to be used in practice. He advises that the powdered niello be carefully applied to the moistened areas to be covered and that the object be carefully heated until the compound has melted into position.[11]

Many niello preparations were made using this mixture of copper and silver sulfides, which has great practical merit. Because pure silver sulfide decomposes below its melting point, it can be applied only as a solid, but if a mixture of metallic sulfides is used, a eutectic-type system is formed, and the melting point of the mixture is greatly reduced, allowing the niello to be applied in the molten state.

The medieval *Mappae clavicula* (Smith and Hawthorne 1974) contains six recipes (variously numbered) for the preparation of niello. Three of the recipes are for a niello that can be painted on the surface by grinding up the compound and mixing it with vinegar; the thin paste is then applied and the vessel heated. For gold surfaces, a mixture of silver, copper, and lead sulfides is recommended (recipe 56); for gilded surfaces, a mixture of copper and lead sulfides (recipe 206); and for silver surfaces, lead sulfide alone (recipe 89B). Recipe 56 provides the following instructions:

> [M]elt together equal parts of silver, red copper, and lead, and sprinkle native sulphur over it. When you have cast it, leave it to cool, put it in a mortar, grind it, add vinegar and make it the consistency of the ink with which writing is done. Write whatever you wish on gold and silver [vessels]. And when it has hardened, heat it and it will be [as if] inlaid. Melt it like this: carve charcoal and so put the silver and the copper in it and melt them (and while you are heating them add in the lead, then the sulphur). When you have mixed it, pour it out and do as was said above. (Smith and Hawthorne 1974 : 10)

The remaining three recipes are for making niello to be used for inlaying. The instructions state that for application to gold and silver, the niello must contain both copper and silver sulfides (recipes 195 and 196), but there should be a greater proportion of silver sulfide in the niello if it is used on gold. A pure silver sulfide is recommended for general use (recipe 58). These recipes suggest that niello prepared from mixtures of copper and silver sulfides was in use long before the eleventh century and that the use of the ternary mixture of lead, copper, and silver sulfides can be traced back to at least the eighth century and probably to the third century.

| *Artifacts decorated* | Giumlia-Mair and LaNiece (1998) identified niello on a par- |
| *with niello* | tially gilt silver rhyton in the Civici Musei di Arte e Storia in |

Trieste, Italy, that has been dated to the Hellenistic period. Two different niello compositions were found on this ancient Greek drinking vessel shaped in part like a bull's head: a silver sulfide niello was used to decorate the bull's eyes, nose, and mouth, while the nostrils were lined with a mixture of silver, copper, and lead sulfides. A second example of niello decoration is on a stag rhyton in the Ortiz collection in Geneva that is allegedly from the Black Sea, dating to the fourth century B.C.E. This is one of the earliest examples of niello reported in the literature, and it was identified by Giumlia-Mair (1998) as a silver sulfide. Some care must be taken when inferring that black residues in eyes and nostrils seen on partially cleaned silver objects are the deliberate use of niello because silver or silver-copper sulfide mixtures are quite common silver corrosion products. Thus it may be that evidence for the use of niello is equivocal in some cases.

QUESTIONABLE NIELLO IDENTIFICATION Oddy, Bimson, and LaNiece (1983) note that certain Bronze Age finds from the ancient Greek town of Mycenae that are often assumed to show the use of niello inlay have not been properly characterized. This was confirmed by Photos, Jones, and Papadopoulos (1994), who presented semiquantitative surface analytical data for a black inlay on a Mycenaean bronze dagger in the collections of the Archaeological Museum at Patras, Greece. They showed the inlay to be a copper-gold alloy with 5–10% gold, some silver, and perhaps a trace of tin. The inlay is therefore akin to the Japanese *shakudo* (discussed in CHAPTER 2) or to black-surfaced Corinthian bronze alloys; these inlays are not made of organic resin or niello. The ancient Egyptians were also assumed to have used niello, but again proof is lacking (Lucas 1962), and use of copper-gold alloys may be more likely (Craddock and Giumlia-Mair 1993).

| *Niello chemistry* | Oddy, Bimson, and LaNiece (1983) also surveyed objects with |
| | niello decoration dating from the first to the thirteenth century |

in the collections of the British Museum. Analysis of the niello on a first-century statuette of Nero from Ipswich showed the presence of cuprite and anilite, Cu_7S_4—the only case where anilite has been identified in this mixture. Other niello analyses revealed chalcocite, Cu_2S, as well as a mixture of djurleite, $Cu_{1.96}S$, and digenite, $Cu_{1.76}S$, which were identified by powder X-ray diffraction on a tin bronze from Hod Hill. Niello inlays were used, for example, on the famous Battersea shield, a gold object of master artisanship in the collections of the British Museum. The composition of the niello used on these inlaid bronze objects was found to be a mixed copper-silver sulfide, whereas that of other Roman silver objects was found to be silver sulfide with no copper addition. The composition of the niello used in the latter pieces was simply acanthite, Ag_2S, the same compound found on Byzantine silver objects from the sixth

and seventh centuries. On objects with gilt-silver surfaces, the niello was probably applied first, since it had to be heated to at least 600 °C to fuse it into position, whereas application of the gilding amalgam took place at temperatures no greater than 350 °C.

A gold buckle recovered from the Anglo-Saxon ship burial at Sutton Hoo was decorated with a monometallic silver sulfide niello, while a mixed silver-copper sulfide was used on a hanging bowl from the same site. The mixed silver-copper sulfide was identified as stromeyerite. The ICDD files assign the formula $Ag_{0.93}Cu_{1.07}S$ to this compound, but there is some latitude in the solid-solution composition between copper and silver, which probably results in fluctuations in composition and, therefore, in slightly varying d-spacings. Stromeyerite was also found on an Irish bell shrine from the eleventh century and on a crozier from Inisfallen, Ireland, which has a second, different inlay of niello consisting of acanthite. Only one object examined from the British Museum collections, a thirteenth-century Hugo crozier, was decorated with niello that contained lead. This niello is a mixture of stromeyerite with galena, PbS.

A problem with the X-ray diffraction data for niello is that one cannot be certain whether some of the minerals identified are the original components of the niello, the products of chemical alteration during burial, and/or the possible result of inappropriate conservation treatment. For example, chlorargyrite (silver chloride), $AgCl$, was identified as a surface alteration product on the silver sulfide niello applied to one of the Sutton Hoo finds. Chlorargyrite is not unexpected as a corrosion product derived from the original silver sulfide, since silver sulfide layers are easily disrupted during corrosion by chloride (or bromide) ions and converted into silver chloride or silver bromide, both of which are quite insoluble and relatively stable. These layers may be partially decomposed by light, producing localized alteration to metallic silver, although they are not washed away and so remain in situ. For this reason, care must be taken to ensure that any sample examined is representative of the niello as a whole and not just a surface scraping, which may provide ambiguous or erroneous information.

Notes

1 Chakrapani Dutta *Chakradatta* (Ray 1956:110).
2 Pliny the Elder *Natural History* 34.22 (Pliny 1979).
3 Pliny 34.23.
4 Ibid.
5 Geber is the pen name of an unknown author of several books that were among the most influential works on alchemy and metallurgy during the fourteenth and fifteenth centuries.
6 Sutton Hoo estate at Woodbridge, near the Deben River, Suffolk, England, is the site of a seventh-century grave or cenotaph of an Anglo-Saxon

king. Discovered in 1939, this Germanic burial site was one of the richest found in Europe, as it contained a ship fully equipped for the afterlife (but with no body).

7 Nigel J. Seeley, e-mail message to the author, 8 April 1997.
8 Presbyter Theophilus *De diversis artibus* 1.35.27 (Theophilus 1961).
9 Pliny 33.46.
10 Theophilus 1.35.28.
11 Theophilus 1.35.29.

Copper Phosphates and Copper Nitrates
CHAPTER 7

The copper phosphates are not generally found as corrosion products except in characteristic environments, primarily in association with buried bone and in arid climates. Only one copper phosphate, pseudomalachite, has any history as a pigment. The best known and most commonly occurring copper phosphate is turquoise, an ornamental stone of various blue and green hues whose exploitation as a mineral can be traced back eight millennia. Also discussed here are the relatively rare occurrences of copper nitrates.

THE COPPER PHOSPHATES

The most common copper phosphate found as a corrosion product is libethenite, $Cu_2(PO_4)(OH)$, a vitreous, light-to-dark olive-green mineral often associated with bronzes excavated from cremation sites. Photomicrographs of a sample of libethenite from the type site of Libethan, Hungary, is shown in PLATE 44. Cornetite, $Cu_3(PO_4)(OH)_3$, a vitreous or greenish

blue, has also been reported as a corrosion product, although rarely from the same contexts in which libethenite occurs.

Pseudomalachite, $Cu_5(PO_4)_2(OH)_4$, a vitreous green mineral, has been used as a pigment but has not been reported to date as a corrosion product on bronze objects. The mineral tagilite, $Cu_2PO_4(OH) \cdot H_2O$, named in 1844 from the type location of Nizhne Tagilsk in the Ural Mountains, is apparently identical to pseudomalachite.[1] In addition, ludjibaite, $Cu_5(PO_4)_2(OH)_4$, which was named for the city of Ludjiba, Zaire, in 1988, is an isomorphous variety of pseudomalachite. Like pseudomalachite, neither tagilite nor ludjibaite has been reported to date as a corrosion product.

Two complex copper phosphates have been identified as corrosion products. One is a pearly, light-blue, sodium-calcium-copper-phosphate chloride known as sampleite, $NaCaCu_5(PO_4)_4Cl \cdot 5H_2O$. The other is an aluminum-copper phosphate called zapatalite, $Cu_3Al_4(PO_4)_3(OH)_9 \cdot 4H_2O$, a translucent, pale blue mineral with a Mohs hardness of 1.5. The incorporation of aluminum in this formula is rather unexpected because ancient copper alloys do not contain aluminum; therefore, the element must have been introduced on the surface of the object by pollution. One report of a hydrated copper phosphate, $Cu_3(PO_4)_2 \cdot xH_2O$, has been published, although insufficient evidence is available to assign a precise formula to this phase (Mattsson et al. 1996).

Turquoise, $CuAl_6(PO_4)(OH)_8 \cdot 4H_2O$, is commonly a vitreous blue or blue green, with a Mohs hardness of 5–6 and a density of 2.84. Turquoise is isomorphous with chalcosiderite, $CuFe_6(PO_4)(OH)_8 \cdot 4H_2O$, which is a vitreous, light green mineral with a hardness of 4.5. Some of the copper content of turquoise can be replaced with zinc to form faustite, $(Zn,Cu)Al_6(PO_4)_4(OH)_8 \cdot 4H_2O$. This mineral, which has been identified to date only from New World contexts (ancient South America), is waxy with a dull, apple-green color.

Some of these minerals, particularly turquoise, are subject to blanching when weathered. Characteristics of the copper phosphate minerals discussed here are summarized in TABLE 7.1.

Copper phosphate chemistry | The stoichiometries of libethenite, pseudomalachite, and cornetite suggest that these minerals form in this order under conditions of increasing basicity. This is a general trend for the crystallization of these three phases. Pseudomalachite is the most common cupric phosphate in terms of natural occurrences (Magalhaes, Pedrosa de Jesus, and Williams 1986), which is anomalous in the sense that the mineral is also the rarest in terms of corrosion products. Cornetite is rare in most environments; the stability diagram in FIGURE 7.1 shows that cornetite is stable only under conditions of relatively high pH and high cupric ion activity. As previously discussed, however, high cupric ion activity is quite possible on bronzes in burial environments, which accounts for the existence of cornetite in this context.

TABLE 7.1 **CHARACTERISTICS OF SOME COPPER PHOSPHATE MINERALS**

MINERAL NAME	FORMULA	CRYSTAL SYSTEM	COLOR	MOHS HARDNESS
libethenite	$Cu_2(PO_4)(OH)$	orthorhombic	light-to-dark olive green	4
cornetite	$Cu_3(PO_4)(OH)_3$	orthorhombic	greenish blue	4.5
pseudomalachite	$Cu_5(PO_4)_2(OH)_4$	monoclinic	vitreous green	4.5–5
tagilite	$Cu_2PO_4(OH)\cdot H_2O$	monoclinic	vitreous green	4.5–5
ludjibaite	$Cu_5(PO_4)_2(OH)_4$	triclinic	vitreous blue green	?
sampleite	$NaCaCu_5(PO_4)_4Cl\cdot5H_2O$	orthorhombic	pearly light blue	4
zapatalite	$Cu_3Al_4(PO_4)_3(OH)_9\cdot4H_2O$	tetragonal	translucent pale blue	1.5
hydrated synthetic basic phosphate	$Cu_3(PO_4)_2\cdot xH_2O$	parameters not known		
turquoise	$CuAl_6(PO_4)(OH)_8\cdot4H_2O$	triclinic	vitreous blue green	5–6
chalcosiderite	$CuFe_6(PO_4)(OH_8\cdot4H_2O$	triclinic	vitreous light green	4.5
faustite	$(Zn,Cu)Al_6(PO_4)_4(OH)_8\cdot4H_2O$	triclinic	waxy, dull apple green	5.5

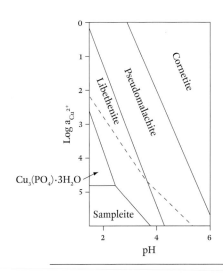

FIGURE 7.1 Stability diagram for cornetite, pseudomalachite, libethenite, and sampleite (after Pollard, Thomas, and Williams 1992b).

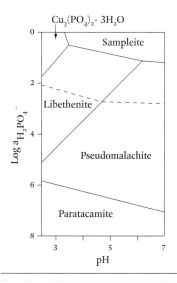

FIGURE 7.2 Stability diagram for pseudomalachite, libethenite, and sampleite (after Pollard, Thomas, and Williams 1992b).

Copper phosphate corrosion in different environments

BURIAL ENVIRONMENT Tomb burial of copper objects in association with decomposing bone, horn, or some other source of phosphorus, frequently produces copper (II) phosphates, either as a corrosion product on the objects or as a blue-green stain on the organic material. The occurrence of libethenite is probably quite common in both contexts, but its occurrence on bone is rarely reported in the literature, most likely because conservators may assume that the stained bone or other material is indurated with copper salts and that there is no particular reason to submit these samples for analysis.

Pioneering studies by Geilmann and Meisel (1942) identified libethenite as a blue-green corrosion on a bronze spiral from a Bronze Age tumulus in Germany. Mattsson and coworkers (1996) report the discovery of three copper phosphates from their extensive study of the corrosion of Swedish Bronze Age and Viking finds. In addition to cornetite, they identified a hydrated copper phosphate, $Cu_3(PO_4)_2 \cdot xH_2O$, and an unidentified copper phosphate mineral that contained copper, phosphorus, and oxygen as shown by scanning electron microscope–energy dispersive X-ray analysis (SEM-EDAX). This study also revealed that the occurrence of copper phosphates on bronze objects buried in cremation sites was deleterious to the preservation of the objects, because the copper phosphates formed under these conditions provided surprisingly poor protection of the bronze to further corrosive attack. It is interesting that cornetite was found in this study and that libethenite was not, since the general assumption has been that libethenite should be present in at least some of the analyzed material.

OUTDOOR ENVIRONMENT Selwyn and colleagues (1996) reported finding libethenite on Louis-Philippe Hébert's (1850–1917) outdoor statue of Sir John A. MacDonald that was unveiled in Ottawa in 1895. This mineral probably was formed by the interaction of bird droppings with other copper compounds in the corrosion crust. A second phosphate of copper, zapatalite, was also found on the same statue and marks the only known occurrence to date of this mineral in corrosion products.

Sampleite and the arid environment

The corrosion chemistry for the mineral sampleite indicates that this copper phosphate should occur on bronze objects in arid localities where groundwater has high concentrations of soluble salts. This association is supported by archaeological finds in Egypt and South America.

Pollard, Thomas, and Williams (1992b) found that the presence of mixed ions such as sodium, chloride, and phosphate in groundwater can produce sampleite. FIGURE 7.1 shows the relevant stability diagrams for the copper phosphate minerals where the log of the activity of the cupric ions is plotted against pH. Sampleite occupies the extreme left-hand corner at a log $a_{Cu^{2+}}$ of about 5 and between pH 2 and 4. The stability diagram for varying phosphate ion concentrations is shown in FIGURE 7.2. These equilibrium stability fields of sampleite strongly suggest

that the compound is expected to occur only on bronzes from environments where solutions of extreme ionic strength permit it to form, particularly in low pH environments. Such conditions are encountered in arid regions where periodic wetting followed by desiccation can create much higher concentrations of soluble salts than would generally occur in groundwater solutions.

In the early 1980s, during three seasons of excavation in the extremely arid environment of Memphis, Egypt, 350 copper alloy objects dating from the fifteenth to the twelfth century B.C.E. were recovered. Most of these objects possessed a remarkably thick, soft, light-green corrosion product that did not resemble any of the previously described copper corrosion products. After the first season of excavation, this product was identified by X-ray diffraction as sampleite, the complex copper phosphate first described as a naturally occurring mineral by Hurlbut (1942). The identification was confirmed by studies of mineral specimens of sampleite and by additional analytical studies of the corrosion product itself (Fabrizi et al. 1989). Found in association with sampleite on copper alloy objects from Egypt is the rare copper(II) chloride eriochalite, $CuCl_2 \cdot 2H_2O$, which shares the same region of stability as sampleite. Because eriochalite is water soluble, it occurs only in arid conditions and appears as wool-like aggregates or small crystals.

A striking feature of sampleite corrosion is the thickness of the crust that can be created by the mineral's formation; in many places, the corrosion product is thicker than the object itself. For example, thin rods only 2–3 mm in diameter can have a surrounding corrosion layer that is 10–15 mm thick. A typical example, shown in PLATE 45, is a copper-alloy nail with a very thick coating of sampleite that totally obscured the nature of the object underneath before partial mechanical cleaning. When first excavated and still moist, sampleite is blue green in color with a very soft, cream-cheese-like texture that can be easily pared away with a scalpel. When dried, the corrosion product is still soft and very fine, but it is a paler green, almost the color of bronze disease. A mounted preparation of sampleite from one of the Egyptian artifacts from Memphis is shown in PLATE 46. The particle size is small, 2–4 μm. When a sample is viewed under plane-polarized light in a melt-mount of refractive index 1.662, the crystals have very little relief because their refractive indices are all close to that of the medium; two of these indices are especially close. When viewed under crossed polars, the crystals show a gray-white birefringence. The wave plate shows clusters of tiny grains with differing orientations in the usual second-order, straw-yellow and sky-blue colors.

There is no question about sampleite undergoing changes in chemical composition following excavation; both hydrated and dried postexcavation material from Egypt revealed the presence of sampleite, and the corrosion products did not show any alteration. An X-ray diffraction study was carried out on the mineral, and the results are shown in APPENDIX D, TABLE 6. Column 1 of the table shows the ICDD data for sampleite (ICDD 11-349), which is compared with data from the type sample[2] in the British Museum (Natural History) and with data for corrosion product from objects excavated at Memphis, Egypt. The X-ray diffraction data uniquely identify the corrosion product as fairly pure sampleite.

FIGURE 7.3 Scanning electron photomicrograph showing the morphology of sampleite on a Moche-style spider nose ornament from ancient Peru (magnification ×1145). Collections of The Metropolitan Museum of Art, New York (1979.206.1230).

FIGURE 7.3 is a scanning electron photomicrograph of sampleite on an ancient Peruvian nose ornament of gilded copper from Loma Negra in the collections of the Metropolitan Museum of Art. The surface of the ornament had been disfigured by several types of corrosion that included a blue-green sampleite layer over gilded surfaces on a silver-copper alloy backplate. The sampleite was confirmed by SEM-EDAX, which determined the presence of copper, calcium, sodium, chlorine, and phosphorus. The photomicrograph, taken by Howe (1994), reveals a morphology of closed buds with multiple petal-like crystal components. This morphology is more often associated with synthetic copper minerals, such as the copper acetate-arsenite pigment emerald green.

Sampleite's association with arid environments has also been confirmed by the mineral's discovery on ancient Peruvian objects made of copper alloys. The burial environment of these artifacts is analogous to that of Egyptian bronzes; it is extremely arid and subject to periodic wetting, resulting in groundwater solutions of unusual composition. In addition to Howe's identification of sampleite on Peruvian objects, the author identified sampleite on a copper alloy mask from the Moche civilization of Peru that dated to around the second century C.E. and that can be assumed to be from an arid environment (Scott 1994b). Sampleite was also identified from a Moche face mask in the collections of the Santa Barbara Museum of Art (PLATE 47). The mask was inlaid with bone eyes and with pupils of an iron-rich mineral that, surprisingly, could not be identified. The sampleite is mixed with malachite and cuprite within the patina.

Some evidence suggests that sampleite may form from alteration of other copper minerals. Angelini and coworkers (1990) identified sampleite from a green pigment cake found in Egypt during the 1903–5 Italian Archaeological Mission excavations of Heliopolis. The exact date of these finds in not known but could possibly be from the Nineteeth to the Twenty-sixth Dynasty, which dates the material to between the eighth and the seventh centuries B.C.E.

COPPER PHOSPHATES AND COPPER NITRATES

The possibility that the excavated pigment cake could have been an alteration product from the burial environment was not considered by the authors. Since sampleite has been found in a number of different contexts as a corrosion product on copper alloy objects, however, the possibility must be considered that the formation of this compound could well represent the transformation of a more common pigment, such as malachite, to sampleite.

Bridge and colleagues (1978) examined the occurrence of sampleite from Jingemia cave in Western Australia and concluded that the mineral had formed from naturally occurring copper sulfides in contact with guano. In their discussion of the nature and origin of these copper phosphates, Bridge and coworkers suggest that the similarity in the X-ray diffraction data between sampleite and the synthetic copper phosphate $Cu_3(PO_4)_2 \cdot 3H_2O$ (ICDD file numbers 1-54 and 22-548), which was determined to be present as a corrosion product on ancient bronzes by Otto (1959, 1963), may be a misattribution because the ICDD file data for sampleite were not available at the time of Otto's writing. This suggestion is not necessarily correct because additional examples of the copper(II) phosphates were subsequently found, for example, from the Swedish corrosion work of Mattsson and coworkers (1996).

Pseudomalachite: A copper phosphate pigment

The basic copper phosphate known rather oddly as pseudomalachite (apparently, it does resemble malachite) is only rarely found, despite occupying a large region of the stability diagram (see FIGURE 7.1) and occurring in a more reasonable range of pH. In fact, pseudomalachite has been found thus far only as a painting pigment and not as a corrosion product. Banik (1990) identified the pigment in illuminated manuscripts of the sixteenth century. The only other report of pseudomalachite used as a pigment is from the frescoes in the Cathedral of the Nativity of the Virgin at the Ferapontov Monastery in Russia (Naumova, Pisareva, and Nechiporenko 1990). The pseudomalachite, identified in paint layers of the saints' clothing in the wall paintings and on the pillars of the monastery interior, was found as large dark-green masses with a fibrous and concentrically zoned structure similar to malachite. The pigment was finely ground, and the crystals had diverse shapes with sharp edges that are characteristic of the natural mineral. The extent to which this particular copper phosphate mineral was available for use as a pigment is still not known.

TURQUOISE

Turquoise is the only commonly occurring mineral phosphate of copper. It is a semiprecious stone, relatively easy to abrade and polish, and often of a blue-green or gray-green color, although the best quality stones are sky blue.[3] The mineral does not occur as a corrosion product, but it was commonly used as an ornamental stone for beads, inlays, and small carved stone amulets and other objects throughout the ancient world. Reference is often made to two versions of this

stone: oriental and occidental turquoise. The names are associated with either the source of the stone or its quality, according to Palache, Berman, and Frondel (1951).

The name *turquoise* is thought to be derived from the word *Turkish*, possibly because the stone was originally imported into Europe from Persia through Turkey. In antiquity, turquoise of very fine quality was obtained from the southern slopes of the Ali-Mirsa-Kuh Mountains, northwest of Maden in the Khorasan province of present-day Iran.[4] Minerals that are thought to refer to turquoise were called "chalchihuitl" by the Aztecs and "callais" and "callaina" by Pliny, who records the following observations on this semiprecious gem:

> Subsequently the stone is shaped by the drill, being in other respects an easy stone to deal with. The best stones have the colour of emerald (smaragdus), so that it is obvious, after all, that their attractiveness is not their own. They are enhanced by being set in gold, and no gem sets off gold so well. The finer specimens lose their colour if they are touched by oil, unguents or even undiluted wine, whereas the less valuable ones preserve it more steadfastly. No gemstone is more easily counterfeited by means of imitations in glass.[5]

The chemistry and mineralogy of turquoise	The turquoise group of minerals is actually quite complex and was recently reevaluated by Foord and Taggart (1998). The general formula for these minerals can be expressed as

$A_{0-1}B_6(PO_4)_{4-x}(PO_3OH)_x(OH)_8 \cdot 4H_2O$, where A and B are different cationic species and x ranges from 0 to 2. The group comprises six members: planerite, turquoise, faustite, aheylite, chalcosiderite, and an unnamed ferrous-ferric analogue. Planerite has the formula $X_1Al_6(PO_4)_2(PO_3OH)_2(OH)_2(OH)_8 \cdot 4H_2O$, where X may represent a variety of elements such as copper or iron. It was first described in 1862 and has been reaffirmed as a valid mineral species after more than a century of uncertainty. A complete solid solution is thought to exist between turquoise and planerite. Foord and Taggart state that many occurrences of turquoise described in earlier literature are, in fact, of planerite. There also appears to be a significant solid solution between turquoise, $CuAl_6(PO_4)(OH)_8 \cdot 4H_2O$, and chalcosiderite, $CuFe_6(PO_4)(OH)_8 \cdot 4H_2O$, and between turquoise and faustite, $(Zn,Cu)Al_6(PO_4)_4(OH)_8 \cdot 4H_2O$. The name "planerite" hardly has the romantic cachet of "turquoise," so redolent of a rare and precious material, and the name is unlikely to be changed any time in the near future. Nonetheless, the revision of this mineral group is potentially of considerable interest to future studies of ancient artifacts. Some members of the group, such as aheylite, $Fe^{2+}Al^6(PO_4)_4(OH)_8 \cdot 4H_2O$, do not contain any copper at all in their pure or uncorrupted forms, although the analyses listed by Foord and Taggart show that aheylite may contain some zinc.[6]

Minerals of the turquoise group are found in the ferruginous gossan of ore deposits. Turquoise usually has a massive habit, often with conchoidal fracture, and with a Mohs hardness of 5–6. The specific gravity is 2.6–2.8. The luster of turquoise may be vitreous or waxy; the

color, which can be altered by treatment with acids or ammonia, varies from greenish blue to apple green. The mineral is generally massive, but in certain localities crystalline turquoise may occasionally be found (Braithwaite 1981; Schaller 1912). More commonly, it is found as a surface mineral in small compact lumps, often associated with azurite or malachite, and sometimes as outcrops in veins of lead minerals. Turquoise is frequently found as a pseudomorph after ortho-clase, apatite, bone, and teeth (Palache, Berman, and Frondel 1951).

The history of turquoise	Turquoise appears at an early date in Iraq and was used for beads, examples of which were excavated from the sixth-

millennium B.C.E. site of Tepe Zagheh on the Iranian plateau and from the early site of Ali Kosh, Iran. The use of turquoise for beads, often in association with lapis lazuli, continued in this area throughout the prehistoric period. Afterward, the stone became rare in Mesopotamia, either because substitutes were available, as Pliny suggests in his observations quoted earlier, or because the supply of raw material became disrupted.

Areas where turquoise may have been mined include Iran; the Sinai Peninsula; the inner Kizil Kumy, southeast of the Aral Sea; and Afghanistan. Pliny writes in his *Natural History* of one source:

A far purer and finer stone is found in Carmania. In both localities, however, callaina [turquoise] occurs amidst inaccessible icy crags ... thus tribes accustomed to riding on horseback and too lazy to use their feet find it irksome to climb in search of stones.[7]

This region of Carmania, the area of Kerman province in Iran, is the same region noted by Marco Polo in the thirteenth century as "a source of the precious stones that we call turquoise."[8]

TURQUOISE ARTIFACTS FROM THE EASTERN HEMISPHERE
Turquoise is not a suitable stone for carving into seals, but there are a few finds of unusual type; for example, a small turquoise amulet in the form of a calf's head, now in the collections of the Musée du Louvre, which is inscribed for King Kadashman-Turgu of Babylon (ca. 1298–1297 B.C.E.).

Turquoise often occurs in jewelry of the Seleucid to Parthian periods (300 B.C.E.–100 C.E.) in Afghanistan (Moorey 1994). Numerous other locations where turquoise was found and worked are listed by Palache, Berman, and Frondel (1951). Turquoise has been used extensively for small beads and jewelry in both the Old and New Worlds[9] from prehistory to the present day, although there are many blue-green stones or beads described as turquoise that may actually be chrysocolla or another mineral. Vallat (1983) found a fragmentary text about King Darius I of Sumeria from excavations at Susa in southwestern Iran, which revealed that the Sumerians had a specific word for turquoise, *ashgiku,* in the Akkadian language.

Egyptian references to the mineral (Lucas 1962) tell of turquoise from Sinai and mention "new" turquoise. This designation refers to stone that has not decomposed with exposure to light and heat; the value of such "new," unsullied turquoise would certainly have been recognized. An example of turquoise that decomposed during burial is found on a chlorite schist vessel from Eastern Iran or Bactria, dating from the early to middle of the third millennium B.C.E. (Meyers 1996). Although the inlays have become whitish, X-ray diffraction analysis identified them as being originally turquoise in composition. Documented occurrences of turquoise for intaglio or cloisonné work are numerous, although it is not always clear how the identification of the mineral was confirmed. A circular belt ornament from the Western Han dynasty (206 B.C.E.–24 C.E.), now in the Shumei Family Collection, Japan, is decorated with hundreds of thin polygonal turquoise disks that are contrasted with red carnelian and a bronze patina. In the same collection are gold bracelets from the Achaemenid dynasty (525–404 B.C.E.) of ancient Persia that have winged caprid (goat-shaped) terminals inlaid with cloisonné work in lapis lazuli, carnelian, turquoise, and a vitreous paste (Shumei Foundation 1996).

TURQUOISE ARTIFACTS FROM THE NEW WORLD One of the precious objects presented to the Spanish conquistador Hernán Cortés when he arrived in Mexico in 1519 was a mask made of turquoise mosaic. In the New World, smaller objects, such as rings, beads, or pendants, were carved from solid turquoise, while larger objects were often made of wood covered with turquoise tesserae. Despite an extensive turquoise industry, there is an almost complete absence of sources for the mineral in ancient Mesoamerica. Turquoise mines were located in the desert regions of the American Southwest from California to New Mexico and in Chihuahua, Mexico. Harbottle and Weigard (1992) analyzed numerous turquoise samples from forty mines in the American Southwest and compared their elemental profiles with those of two thousand samples from twenty-eight sites in both the Southwest and Mesoamerica. The research showed that turquoise from the Southwest traveled not only to central Mexico but even to the Yucatan Peninsula. During the classic period in Mexico, around 700, the site of Alta Vista was an important turquoise workshop that used raw material from mines at Cerrillos in New Mexico. This Cerrillos turquoise has been identified in objects from the Mexican states of Sinaloa, Jalisco, and Nayarit (Lambert 1997).

Turquoise was worked closer to its southwestern sources during the Pueblo II period, around 1100, especially at Chaco Canyon in Arizona. By the mid-thirteenth century, numerous new mines had been located in various areas that supplied turquoise not only to craftspeople in the Southwest but also to the Aztecs by way of a Pacific coastal trade route as well as an inland route (Harbottle and Weigard 1992).

Some light-blue beads were examined from the first-century C.E. site of La Miña, not far from Sipan in the area of Peru occupied by the Moche (Scott 1994b). The X-ray diffraction data showed that the mineral used to make these small beads, originally thought to be turquoise, was,

in fact, faustite (see APPENDIX D, TABLE 7). The presence of both copper and zinc in the beads was confirmed by X-ray fluorescence. Faustite is a partially zinc-substituted turquoise mineral not mentioned in any Old World contexts. There does not seem to be any mention of chalcosiderite either, which raises some doubts about the exactitude of the identification of turquoise in the original texts. Foord and Taggart (1998) state that the number of known occurrences of faustite is quite small compared with occurrences of other members of the turquoise group. This adds to the significance of this mineral's discovery from Moche cultural contexts. Given the variations that may exist within the turquoise group of minerals, there is clearly a need for the publication of more detailed X-ray diffraction data and for trace elements to be examined as a possible distinguishing tool in the study of these minerals.

THE COPPER NITRATE MINERALS

Copper nitrates are relatively rare as minerals, pigments, or corrosion products, since the usual nitrate salts are all water soluble. The basic nitrates can occasionally be found, however, as pigments or as corrosion products. The most common copper nitrate mineral is the basic salt gerhardtite, $Cu_2(NO_3)(OH)_3$, which has been found as a secondary mineral associated with malachite and atacamite in massive cuprite deposits. Gerhardtite can occur as thick tabular crystals, dark green to emerald green in color (Palache, Berman, and Frondel 1951). The crystal structure was determined by Imhoff (1953), although the nitrate was characterized in 1885 and named after Gerhardt, who first synthesized the salt.

Other nitrate minerals include likasite, $Cu_3(NO_3)(OH)_5 \cdot 2H_2O$, and buttgenbachite, $Cu_{18}(NO_3)_2(OH)_{32}Cl_3 \cdot H_2O$, which has a complex and unusual stoichiometry. Neither mineral has yet been found as a corrosion product. Brief characteristics of the copper nitrate minerals are given in TABLE 7.2.

Copper nitrate corrosion products

The most common occurrence of gerhardtite is as a component of artificially patinated copper alloys. Many recipes for green patinas today contain ingredients such as nitric acid, potassium nitrate, sodium nitrite, or ammonium nitrate (Hughes and Rowe 1982), which would create a copper(II) nitrate salt.

Copper nitrates should be rare as a natural corrosion product since nitrate salts are usually the most water-soluble group of copper corrosion products and, if formed, would invariably be expected to be washed away from the surface. There are, however, some noted occurrences of copper nitrates in corrosion. Otto (1959) identified gerhardtite as a patina component on archaeological bronzes, and Riederer (1988) reported an occurrence of this basic nitrate on some ancient Mesopotamian bronzes in the collections of the Institut für Technologie der Malerei in Stuttgart.

TABLE 7.2 **CHARACTERISTICS OF SOME COPPER NITRATE MINERALS**

MINERAL NAME	FORMULA	CRYSTAL SYSTEM	COLOR	MOHS HARDNESS
gerhardtite	$Cu_2(NO_3)(OH)_3$	orthorhombic	transparent green	2
likasite	$Cu_3(NO_3)(OH)_5 \cdot 2H_2O$	orthorhombic	translucent blue	?
buttgenbachite	$Cu_{18}(NO_3)_2(OH)_{32} \cdot Cl_3H_2O$	hexagonal	vitreous blue	3

Aoyama (1960) identified another basic copper nitrate, $Cu(NO_3)_2Cu(OH)_2$, in green corrosion products on copper power lines in Japan, although the reported stoichiometry of this salt looks a little odd; perhaps gerhardtite was found. Gettens (1963b) mentions green crystalline corrosion on bronze vessels from a royal tomb at Gordion in Anatolia that was excavated by the University of Pennsylvania. Preliminary studies showed that these crystals have X-ray diffraction patterns identical with those of monoclinic, synthetic basic copper nitrates. Fiorentino and coworkers (1982) determined that basic copper nitrate is present on Ghiberti's *Gates of Paradise*, the gilded bronze doors of the Baptistery in Florence. Fabrizi and Scott (1987) found the same compound, identified as gerhardtite, on a set of doors to the marble-faced mausoleum of the Dalziel family in Highgate Cemetery, London; these doors, with iron-stained facade from ill-chosen iron locks, are shown in PLATE 48.

In a very unusual discovery, Banik (1989) identified gerhardtite as a green copper pigment in a study of medieval illuminated manuscripts, one of which dates to the fifteenth to sixteenth century. It is surprising that a basic copper nitrate should have been found at all on an illuminated manuscript. Because it is difficult to obtain a sufficient sample from these manuscripts, identification of the compound becomes even more intractable.

Notes

1 Because of some earlier confusion about the exact stoichiometry of these copper phosphates, the name "tagilite" had been used for some time before it became evident that taglite is actually pseudomalachite in most, if not all, instances.

2 The type sample is from Chuquicamata, Chile. Sampleite is thought to be isostructural with freirinite, which is a hydrated copper-sodium-calcium arsenate. A blue-green mineral from the department of Freirina, Chile, it is similar to lavendulan, $NaCaCu_5(AsO_4)_4Cl \cdot 5H_2O$.

3 Because turquoise is opaque with a waxy luster, it is cut *en cabochon* (in convex form but not faceted) for jewelry. The mineral tends to absorb oil or grease, which may discolor it, so it is often protected today with a plastic film. Some deeply colored stones lose their intensity in sunlight.

Their appearance can be improved by burying them in damp earth or by immersing them in a dilute ammonium hydroxide solution, which complexes with the copper ions and forms the colored cupra-ammonium ion complex.

4 For information concerning the history, ethnology, archaeology, and folklore of turquoise, see Pogue 1915.

5 Pliny the Elder *Natural History* 37.33 (Pliny 1979).

6 See Foord and Taggart 1998 for additional chemical analyses of these minerals.

7 Pliny 37.33

8 Marco Polo *The Most Noble and Famous Travels of Marco Polo* 1.14 (Polo [1579] 1937).

9 S. N. Campbell, personal communication, letter to the author 9.22.1997.

Copper Silicates

T he copper silicate minerals are highly insoluble and are found under widely disparate conditions. Only two of the copper silicates have relevance to the present discussion, however: chrysocolla and cuprorivaite. Chrysocolla, which is a commonly occurring mineral, is important primarily because of its use as a pigment. Cuprorivaite, which is rare, is the mineral analog of the important synthetic pigment Egyptian blue.

Dioptase, $CuSiO_3 \cdot H_2O$, (discussed later in this chapter) has been used occasionally as an inlay or overlay, no doubt, but there are very few reports of its occurrence. There are no reports of the use of two other copper silicate minerals: plancheite, $Cu_8(Si_4O_{11})_2(OH)_4 \cdot H_2O$, and shattuckite, $Cu_5(SiO_3)_4(OH)_2$.

Some characteristics of these minerals are presented in TABLE 8.1.

TABLE 8.1

CHARACTERISTICS OF SOME COPPER SILICATE MINERALS

MINERAL NAME	FORMULA	COLOR	MOHS HARDNESS
chrysocolla	$(Cu,Al)_2H_2Si_2O_5(OH)_4 \cdot xH_2O$	vitreous/earthy green	2–4
cuprorivaite	$CaCuSi_4O_{10}$	vitreous blue	5
dioptase	$CuSiO_3 \cdot H_2O$	vitreous green	5.5–6.5
plancheite	$Cu_8(Si_4O_{11})_2(OH)_4 \cdot H_2O$	translucent blue	5.5
shattuckite	$Cu_5(SiO_3)_4(OH)_2$	translucent dark blue	3.5

CHRYSOCOLLA

The chemical formula for the common copper silicate mineral chrysocolla was formerly expressed as $CuSiO_2 \cdot nH_2O$, but can be represented as $(Cu,Al)_2H_2Si_2O_5(OH)_4 \cdot xH_2O$ (Fleischer, Wilcox, and Matzko 1984). This is a monoclinic, fibrous or massive mineral of variable properties that commonly occurs in bands showing varying intensity of blue-green coloration (Garrels and Dreyer 1952). The bands may be associated with chalcedony, a cryptocrystalline variety of quartz. The color of chrysocolla in thin section ranges from black through blue green to only a slight greenish tinge; the birefringence increases with increasing color. Garrels and Dreyer reported the analyses of ten different chrysocolla samples, from green to black, and none of them had a composition that matched the shorter formula formerly used for this mineral. They suggest that chrysocolla may, in fact, be a solution of copper silicate in silica, which would help to explain the extraordinary variations in properties and composition of the chrysocolla samples studied.[1]

The mineral is sometimes described as being isotropic, but all specimens examined by the author in the laboratory have been anisotropic. These samples show a low refractive index, lower than 1.66, which is the refractive index of the mounting medium. Typical examples are illustrated in PLATE 49. When chrysocolla is ground to a fine powder, it can retain a good color, although when viewed under the microscope in transmitted bright-field illumination, the green color of the conchoidal fragments is often difficult to see, and the particles may appear almost colorless. Most of the mineral particles are birefringent, often with fibrous or undulose extinction. The pigment is stable in light and decomposes only in strongly acidic or strongly alkaline environments.

X-ray diffraction data for chrysocolla are often unsatisfactory and variable due to hydration and poor crystallinity of the sample. The ICDD files have two sets of X-ray diffraction entries for

chrysocolla: ICDD 27-188 and ICDD 11-322. There is also an entry in the mineral reference database by Nickel and Nichols (1991) that is similar to ICDD 11-322 but with some of the higher d-spacings absent. APPENDIX D, TABLE 9, compares X-ray diffraction data for a chrysocolla sample from the Old Dominion fault vein in Globe, Arizona, with the three reference data sets. Data for a second sample, a green pigment from a first-century rock-cut tomb painting at La Miña, Peru, are also given in TABLE 9. The data are similar to that for ICDD 11-322 (Scott 1997b). Superseded ICDD files should not be neglected when attempting to match diffraction data for poorly crystalline pigments such as chrysocolla.[2]

Theophrastus and Pliny wrote of the mineral chrysocolla, although there is always the possibility that they confused it with other copper minerals, such as malachite; it is not always clear which mineral is being referred to in most of the ancient texts. Chrysocolla achieved importance in antiquity as one of the copper compounds useful in the reaction soldering of gold.

The reaction soldering process is sometimes referred to as "colloidal hard soldering" or as the "Littledale" soldering process. The solder, used mainly for gold alloys, is made from a copper salt and glue. After careful heating with a blowpipe, the copper silicate or other salt decomposes to cuprite and then to tenorite. The glue reduces the tenorite to copper in situ as it carbonizes at about 600 – 800 °C. Finally, the copper metal diffuses into the gold, creating a very neat join without the need to flood the region to be joined with solder. This method is widely thought to have been used by the Etruscan and Greek civilizations and then rediscovered in the early twentieth century by Willoughby A. Littledale, an English jeweler.

Moorey (1994) explored the problem of identifying which so-called greenstones were actually used in ancient Mesopotamia by examining samples from the mesolithic Levant culture with its type site at Wadi an-Natüf in Israel. He reported that "greenstone" is a general term for minerals that include malachite, chrysocolla, rosasite, and turquoise. This suite of copper minerals is particularly associated with the copper-bearing rocks in the Wadi Feinan of Jordan, the Timna area of Israel, and in Turkey. Many Mesopotamian artifacts are mineralogically misidentified as jade; for example, a "jade" bead found at the important cave site of Shanidar in ancient Mesopotamia is actually chrysocolla (Moorey 1994).

Chrysocolla as a pigment | When chrysocolla was used as a pigment, the color selected varied from green to turquoise blue. Gettens and Stout (1966) identified the pigment on tenth-century wall paintings at Kizil in Chinese Turkestan, and Spurrell (1895) found it in wall paintings from Twelfth Dynasty tombs (1991–1783 B.C.E.) at El Bersha and at Kahun in Egypt.

The pigment was used sporadically, depending on availability, and by the sixteenth century, it was given the appellation of Ceder green (Harley 1970). During that time, Agricola ([1546] 1955) described a method for extracting chrysocolla for pigment use from deposits in mountainous areas by first grinding the mineral in place and then transporting it in a series of sluices. Chryso-

colla was valued by watercolor painters in the late sixteenth century. By the seventeenth century, however, it was already nearly forgotten (Harley 1970), and terre verte and synthetic copper pigments were becoming popular substitutes.

DIOPTASE

Dioptase, $CuSiO_3 \cdot H_2O$, a common silicate, is usually found as a massive vitreous green cluster, associated with other copper mineral deposits, although individual crystals may also sometimes be found. Dioptase can be a translucent, emerald-green color. The mineral is seldom used as a gemstone, but small crystals have been emerald cut (Newman 1987), and some clusters have been set in jewelry. The misnomer "copper emerald" is the name used for dioptase in the jewelry trade.

Dioptase was one of the pigments — along with ocher, carbon black, and lime white — identified on a cache of lime plaster statuettes, approximately eight thousand years old, from the pre-pottery Neolithic site of ʾAin Ghazal, Jordan (Tubb 1987). The dioptase was found in the eyeliner on the statuettes, and this appears to be the only recorded use of this mineral as a pigment in the ancient world, although there must be other examples that have not yet been reported in the literature.

COPPER SILICATES AND GLASSES

Glass colored with copper salts or cobalt or both are of great antiquity in Babylonia and Egypt. Partington (1935) mentions that glass-paste beads were found at Tell Mukayyar (ancient Ur), dating from 3500 to 3000 B.C.E., and bluish paste beads were found at Lagash (ancient Telloh) in Iraq. A fragment of blue glass from about 2400 B.C.E. that was found at Tell Abu Shahrain (ancient Eridu) in Iraq is now in the collections of the British Museum. (Some information concerning copper colorants is discussed in CHAPTER 2, under "Cuprite.")

Fine, dark blue Egyptian and Persian glazes were often imitated. In modern glass technology, this degree of color saturation can be achieved only with cobalt additions, and it was often assumed that the ancients also added cobalt to produce such an intense blue. This assumption, however, is erroneous, according to Weyl (1981). He points out that the use of cobalt ores in the Near and Far East is of later date and that the Egyptians produced their blue glazes with only copper and iron additions.[3] Neumann and Kotyga (1925) found copper as a colorant in Egyptian glasses from Tell el Amarna dating from 1400 B.C.E. All blue and green glasses of this period contain copper oxide as the colorant. Finds from Aswan (an island in the Nile) included some haematinon glasses (see CHAPTER 2) dating to around 1200 B.C.E. The outside of the glasses were turquoise in color, probably due to the oxidation of the copper during molding, which required repeated heating, according to Weyl. The behavior of copper in a silicate melt is not

straightforward: under oxidizing conditions, the cupric ion is formed, while under reducing conditions, cuprous ions—and even reduced copper—can form (see CHAPTER 2).

The use of copper compounds in glassmaking may have been influenced by the availability of copper-containing slags in the Bronze Age. This may also apply to red opaque glasses made in the early medieval period when slags produced during the refining of silver coinage debased with copper could have been put to practical use (Mass, Stone, and Wypyski 1997).

Copper was an important colorant for blue glazes applied to faience (as discussed later in this chapter) and steatite (soapstone) from the fourth millennium B.C.E. and later. It was used to make Egyptian blue pigment and pale turquoise frits (both discussed in the following section). From the Eighteenth Dynasty of Egypt onward (1550–1307 B.C.E.), the introduction of glass marked the beginning of the use of cobalt as a blue colorant (Tite et al. 1999). Used in a vitreous faience, the colorant corresponded to a product Lucas (1962) calls Lucas variant D.

Vandiver, Fenn, and Holland (1992) examined the glaze on a third-millennium B.C.E. quartz bead from Tell es-Sweyhat in Syria. Microprobe analysis and replicate melts showed that the composition was 60% quartz, 20% CuO, and 20% flux that was not precisely determined but was thought to be either soda or potassia. The presence of a flux had to be inferred in this study because it had weathered away; only with this amount of flux can a glass with such a high copper oxide content be molten at 800–1000 °C. Very few glass and glaze compositions are known from this time period, and none has such a high copper content as this glaze. Technologically innovative processes were being established during this time in the Near East. Since the successful smelting of copper had already been established by this time, it is natural that copper compounds were finding use in blue-green glazes or other colored products, such as the opaque-red glasses, which started around the second or first millennium B.C.E. and continued to the medieval period.

A

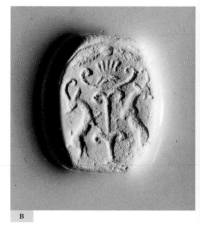
B

EGYPTIAN BLUE AND OTHER SYNTHETIC COPPER SILICATES

Methods of making blue were first discovered in Alexandria, and afterwards Vestorius set up the making of it at Puzzuoli [Pozzuoli]. *The method of obtaining it from the substances of which it has been found to consist, is strange enough. Sand and the flowers of natron are brayed together so finely that the product is like meal and copper is grated by means of coarse files over the mixture, like sawdust, to form a conglomerate. Then it is made into balls by rolling it in the hands and thus bound together for drying. The dry balls are put in an earthen jar, and the jars in an oven. As soon as the copper and the sand grow hot and unite under the intensity of the fire, they mutually receive each others sweat, relinquishing their peculiar properties through the intensity of the fire, they are reduced to a blue colour.*—VITRUVIUS [4]

The most important advance involving the copper silicates was the development of a synthetic analog known as Egyptian blue. This is a frit—a vitreous material made by fusing a mixture of quartz, lime, a copper compound, and an alkali flux to produce a distinctive blue color. Egyptian blue frit was used as a glaze or to make small solid objects, such as a Phoenician scarab and Egyptian seals (FIGURE 8.1) from the collections of the J. Paul Getty Museum. When powdered, the frit became the celebrated Egyptian blue pigment extensively used in wall paintings. With slight changes in ingredient proportions and processing of the initial mixture, the color of the resulting frit could be altered to create Egyptian green.

Egyptian blue first appeared in Egypt during the third millennium B.C.E. and was used extensively over the next three thousand years. Colored copper silicates were also developed in China but much later, during the Han dynasty (206 B.C.E.–220 C.E.), when Han blue and Han purple were used as pigments.

C

D

FIGURE 8.1 Small objects made of Egyptian blue frit: two views of a Phoenician scarab, late sixth to fifth century B.C.E. 16.5 by 12.8 by 8.5 mm, showing A, top, and B, impression; and an Egyptian seal from the early sixth century B.C.E. 15.2 by 14.0 by 8.8 mm, showing C, top, and D, impression. Malibu, J. Paul Getty Museum (83.AN.437.3; 85.AN.370.5).

Geographic distribution of Egyptian blue	This remarkable blue pigment first appears in wall paintings around the Egyptian Fifth Dynasty (2465–2323 B.C.E.). It continued to be used in Egypt through the Late Dynastic period

(1085–343 B.C.E.), becoming less common during the Greek (332–30 B.C.E.) and Roman periods (30 B.C.E.–395 C.E.) (Noll 1979, 1981). It was still in use until the construction of monuments during the reign of Caesar Tiberius (14–37 C.E.). Egyptian blue was used extensively in wall paintings at Pompeii, and the Etruscans also used the pigment frequently.

Less is known about the use of the pigment in ancient Mesopotamia and Persia, although it was undoubtedly available in such centers as Nimrud and Nineveh. Granger (1933) identified Egyptian blue from the Assyrian palace of Til Barsip, dating to about 1000–612 B.C.E., while Stodulski, Farrell, and Newman (1984) found Egyptian blue and azurite used in reliefs at the Persian sites of Persepolis and Pasargade, dating from the sixth to fifth century B.C.E.

The pigment has not been reported from India or from central or eastern Asia, where the earliest wall paintings date from around the first century B.C.E. (Riederer 1997). Only natural ultramarine, azurite, and indigo have been found as colorants in that part of the world, suggesting that those cultures may not have had a particular need to import Egyptian blue.

The most remarkable identification of Egyptian blue pigment is from the far north of Norway, within the arctic circle, where Rosenquist (1959) found it as blue pigment on a shield from graves of the Bo people of that region that date to about 250.

Lost and found secrets of Egyptian blue	By the fourth century the secrets of Egyptian blue manufacture were completely lost and remained a mystery for over fifteen hundred years until scientists of the early nineteenth century

began to unravel the story of the pigment's identity and methods of its fabrication. One of the first detailed investigations of that time was carried out by Sir Humphry Davy on blue pigments found in the baths of Titus and Livia in Rome, as well as in the ruins of Pompeii. Through chemical experiment, Davy deduced that Egyptian blue was a copper frit. He writes:

> A quantity of the colour was fused for half an hour with twice its weight of hydrate of potasse: the mass which was bluish-green was treated by muriatic acid in the manner usually employed for the analysis of siliceous stones, when it afforded a quantity of silica equal to more than ⅗ of its weight. The colouring matter readily dissolved in solution of ammonia, to which it gave a bright blue tint, and it proved to be oxide of copper. The residuum afforded a considerable quantity of alumine, and a small quantity of lime. (Davy 1815:99)

Davy was aware of the first-century B.C.E. writings of Vitruvius, who referred to Egyptian blue, which he called "caerulaeum," as the color commonly used in wall painting. Davy also knew that the pigment was made in Vitruvius's time at Pozzuoli, Italy, and that the method of

fabricating it was brought there from Egypt by the now-obscure historical figure Vestorius. In 1815 Davy succeeded in synthesizing a blue frit. He writes:

> [U]sing fifteen parts by weight of carbonate of soda, twenty parts of powdered opaque flints, and three parts of copper filings strongly heated together for two hours, gave a substance of exactly the same tint, and of nearly the same degree of fusibility, and which, when powdered, produced a fine deep sky blue. (Davy 1815:112)

Chaptal (1809) also carried out qualitative analyses of seven samples of the pigment from the shops of traders in ancient Pompeii. Chaptal determined that the pigment was a frit of the oxides of copper, calcium, and aluminum, which is not quite correct since alumina is usually only a minor component.

| *Chemical formulation of Egyptian blue* | Egyptian blue was identified as calcium copper tetrasilicate, $CaCuSi_4O_{10}$, as early as 1889 by Fougue. It is interesting that this synthetic pigment is, in fact, identical to a very rare natu- |

rally occurring mineral, cuprorivaite, identified by Minguzzi (1938) from deposits at Mount Vesuvius near Naples, Italy.

Egyptian blue is made by mixing quartz sand, calcium carbonate, and a copper compound with a small quantity of alkali and firing the mixture between 900 °C and 1000 °C for several hours. Both single and two-stage firing techniques were probably used; with the two-stage process, the first product formed was ground up and refired, resulting in a finer-grained pigment.

The major component of Egyptian blue corresponds to cuprorivaite, but it is usually accompanied by a copper-bearing compound that corresponds to wollastonite, $(Ca,Cu)SiO_3$, and a glass phase enriched in the alkali elements sodium and potassium. Egyptian blue samples from Old Kingdom sites, such as the tomb of Mereruka, Sixth Dynasty (2323–2150 B.C.E.), were found by El Goresy and colleagues (1986) to consist mostly of cuprorivaite particles up to 200 µm in size, with minor amounts of wollastonite, glass, and tenorite. In contrast, the amount of the glassy phase in pigments from the New Kingdom (ca. 1539–1075 B.C.E.) is much higher, and the texture is different. In these later pigments, cuprorivaite is idiomorphic to large subhedral crystals in a glassy matrix, with wollastonite as very small crystals in the interstices of the cuprorivaite. El Goresy's group also suggested that a repeated, multistage process of regrinding and sintering of the frit would be necessary to obtain such a high-grade pigment.

A typical sample of Egyptian blue pigment from a Canosa vase in the collections of the J. Paul Getty Museum was examined by Scott and Schilling (1991). This ceramic funerary vessel, shown in FIGURE 8.2, was produced in southwestern Italy during the fourth to third century B.C.E. and, like other vases of its type, was painted but not fired. The photomicrograph of the Egyptian blue (PLATE 50) used on this Canosa vase illustrates the glassy particles, conchoidal

FIGURE 8.2 Ovoid Lekythos, Canosa vase, South Italian, fourth to third century B.C.E. Terra-cotta and polychromy. H: 19 cm. These types of funerary vessels were painted and not fired. Burial in a tomb accounts for the survival of the Egyptian blue pigment. Malibu, J. Paul Getty Museum (76.AE.95).

fracture, and clear blue transmission of the pigment, which did not suffer any apparent degradation as a result of tomb burial.

The discovery of some pyrite particles in Egyptian blue pigment samples from the tomb of Akhet-hotep (Fifth Dynasty, 2465–2323 B.C.E.) and others suggest that the temperature of manufacture never exceeded 743 °C, at which point iron pyrites begin to decompose. This temperature maximum, however, does not accord with the research carried out by Tite (1984).

When scrap metal was the source of the copper used to make the pigment, small amounts (0.01–0.3%) of tin, arsenic, and lead, are usually present as well. Bronze scrap may have been used for some Egyptian blue manufacturing as suggested by the presence of tin compounds, such as cassiterite, in pigment samples from the time of Thutmose III (reigned 1479–1426 B.C.E.).

PIGMENT PROPERTIES Elemental studies of Egyptian blue show that the concentrations of the three principal components are 60–70% SiO_2, 7–15% CaO, and 10–20% CuO by weight. Most samples contain from 5% to 40% excess silica. Tite, Bimson, and Cowell (1987) deduced that the relative amounts of CuO and CaO are critical to controlling the nature of the frit produced. If the CuO content exceeds the CaO content, then Egyptian blue crystals are formed, and the frit has an intense blue color. If the CaO content exceeds the CuO content, however, Egyptian blue crystals do not occur; instead, excess lime is precipitated from the glass, often as wollastonite, and the copper oxide remains dissolved in the glass to produce a characteristic pale blue color. To determine the ancient methods used in fabricating Egyptian blue, Tite, Bimson, and Cowell (1987) conducted a series of studies on a wide variety of pigments with textures that varied from soft and friable to hard and semivitrified and with colors that ranged from light to dark blue. Their samples included material from the Late Old Kingdom of Egypt and from sites in Syro-Mesopotamia of the Late Bronze and Iron Ages. A ternary plot of some compositional data was made by Tite (1984), using CaO, SiO_2, and CuO as end members. This ternary diagram is useful for plotting the stoichiometric composition of cuprorivaite. Riederer (1997) used the same plot to illustrate the compositional clusters for Egyptian blue samples from Tell el Amarna, Egypt; Nimrud and Nineveh, Iraq; and from Roman-period sites in Egypt. Riederer found that the glassy phase, which is usually present in the pigment, provides long-range interconnection between the crystalline phases and that this causes the hardness of the frit to increase with increasing alkali content. The alkali content is a primary factor in controlling the microstructure of the pigment; it determines how "glassy" the tint or pigment will be.

Neo-Assyrian objects examined by Tite, Bimson, and Cowell (1987) often had a low alkali content, in the region of 0.5%, and were softer and more friable than earlier examples from Egypt, which had a higher alkali content, from 1% to 5%. On the basis of their laboratory work, the researchers decided that it was unnecessary to introduce the idea of multiple firings to explain the production of coarse-textured Egyptian blue. A single firing at 900 °C was sufficient for frits with a high alkali composition; a firing at 1000 °C was adequate for the low-alkali variety. This produces coarse-textured Egyptian blue, which is often quite dark with a hardness that depends on the amount of the interconnecting glassy phase. The coarse frit could subsequently be ground for use as a pigment with the range of color changed according to the degree of grinding; the pigment becomes progressively paler with finer grinding, as also happens with azurite and malachite.

Tite (1984) does suggest a two-stage firing cycle to produce small solid objects of fine-textured material. The frit is ground and molded to shape between the first and second firings, which produces Egyptian blue crystals uniformly interspersed among the unreacted quartz grains. This second firing process probably was carried out between 850 °C and 950 °C. The end

product is an undiluted, light blue color and soft if the alkali content is low; it is pale blue and hard if the alkali content is high. In another study of composition, firing atmospheres, and temperatures, Chase (1971) reached essentially the same conclusions as those arrived at by Tite.

Numerous small objects from the second half of the first millenium B.C.E. are made of fine-grained frit to facilitate molding; consequently, these objects are a paler blue. Kaczmarczyk and Hedges (1983) analyzed some Late Bronze Age fine-grained frits of Egyptian blue from Ras Shamra (ancient Ugarit), Syria, and showed that both copper and bronze scrap were used as starting materials for making the colorants. Moorey (1994) concluded that there is no distinction in composition between the Syrian and Egyptian material for these frits.

| PIGMENT DEGRADATION A study by Green (1995) essentially confirmed, once again, that Egyptian blue consists of cuprorivaite with copper wollastonite, silica, and a glass phase. Green analyzed a dark blue, almost black, sample of pigment on a papyrus that dated to 1300 B.C.E. and identified the pigment as Egyptian blue. Schiegel, Weiner, and El Goresy (1989) reported that Egyptian blue can degrade and become devitrified, resulting in a remnant phase of cuprorivaite that is a stronger blue than the original pigment. Mixtures of Egyptian blue and orpiment were found by Schiegel, Weiner, and El Goresy on a late Ptolemaic papyrus from the first century B.C.E. Polarizing light microscopy showed that many blue particles had become discolored and the edges were brown. This deterioration may result from the photochemical degradation of orpiment, which releases sulfur compounds. The group also found that on several papyri, Egyptian blue and some green pigments had acquired a black fringe, although the nature of the degradation was not reported in any further detail.

Green (1995) examined green pigments from two Egyptian coffins of the New Kingdom (1100 B.C.E.) and the Late Dynastic period (200–100 B.C.E.) that may have been derived from the deterioration of Egyptian blue. The pigments gave X-ray diffraction patterns consistent with copper (II) wollastonite, though several were found to be mixtures of Egyptian blue with atacamite. A pigment sample from a 1100 B.C.E. papyrus was identified as a mixture of Egyptian blue with a green that was similar but not identical to malachite. When found on papyri, atacamite appears to cause the material to become particularly fragile and brittle.

It may be difficult to correctly identify deteriorated samples of Egyptian blue pigment from other copper minerals on objects in a burial context. Tite (1987), for example, notes that severe weathering can leach out the bulk of the colorant as well as the alkali content, resulting in very pale or white-colored frits. A very pale blue piece from Arpachiyah in Mesopotamia that was thought to be an early example of deteriorated Egyptian blue frit proved on analysis to be a sample of azurite.

| Egyptian green | Egyptian green is not as well known as Egyptian blue, but the extent of its use as a pigment may be underrated. Schilling (1988), for example, identified Egyptian green in the wall paintings of the tomb of Queen Nefertari from about 1255 B.C.E. (PLATE 51). Schilling found that Egyptian green—rather than malachite, as one would suppose—was used throughout the tomb to produce all of the green-colored areas. Stulik, Porta, and Palet (1993) report microprobe data for Egyptian green that show the green frit is much higher in silica content than Egyptian blue. Schilling was able to synthesize the pigment under inert conditions by altering the ratio of starting components. According to Wiedemann and Bayer (1982), Egyptian green will form in preference to blue if the iron content of the silica (from impurities in sand) is in excess of 0.5%.

IDENTIFICATION AND MANUFACTURE Egyptian green was first identified by Noll and Hangst in 1975. Two distinct varieties were found: a glass-rich pigment with wollastonite as a minor phase and a wollastonite-rich pigment with glass and silica as minor phases. The earliest occurrence of both types was found in Thebes in the Sixth Dynasty tombs of Unas ankh (tomb no. 413) and of Khenti (tomb no. 405). El Goresy and coworkers (1986) note that the starting mixture for the green pigment must have had a higher lime and lower copper content than the mixture required to form Egyptian blue. Cassiterite was found in the glass matrix of the wollastonite-bearing green pigment, although not as frequently as in Egyptian blue samples; it was absent in all pigments from the Old and Middle Kingdoms. Cassiterite was first identified in Egyptian green from the tomb of Thutmose IV (reigned 1400–1390 B.C.E.) of the Eighteenth Dynasty, and its presence indicates that bronze filings or bronze scrap may have been employed as a starting material for the pigment.

Egyptian green was invented during the Sixth Dynasty (2323–2150 B.C.E.), and the color varies from olive green to blue green depending on the manufacturing technique (Ullrich 1987). The concentrations of silicon, calcium, copper, and sodium in Egyptian green are quite varied. The amount of copper oxide and calcium oxide, for example, can range from 2% to 10% by weight, but not in a molar ratio of 1:1, which would favor the formation of Egyptian blue. Occasionally, blue crystals are found within the green glassy pigment.

The manufacture of Egyptian green begins with making Egyptian blue, which, according to Ullrich, starts with a mixture of quartz (in the form of sand); lime (either as limestone or lime-containing sand); copper compounds (copper ores or bronze waste); and, as a flux, natural soda (natron) from Wadi Natrun in Lower Egypt. The ingredients are ground to a fine powder and mixed in the ratio by weight of 5 quartz : 2 lime : 2 copper : 1 soda. After the mixture is heated at 900–950 °C for 24–48 hours, a glassy blue mass develops with a high proportion of Egyptian blue. If this mass is ground and fired again, the proportion of Egyptian blue increases further. If the temperature exceeds 1000 °C or if a reducing atmosphere exists, then a green frit

is obtained. The green frit is also produced, according to Ullrich, if the ratio of CuO to CaO (lime) is not 1:1. This is not quite the same conclusion reached by Tite (1987), however, who found that if the CuO content exceeded that of the CaO, Egyptian blue would form and the frit would assume a deep blue color.

| *Terminology* | The terms used to discuss the interesting developments in the manufacture of blue-colored faience, glazed steatite, Egyptian |

blue, Egyptian green, and pale blue frits can be quite tangled. Tite (1987) makes the following distinctions among faience, glazed stones, and frits.

FAIENCE Faience, as found in ancient objects, is composed of a modeled core of relatively coarse quartz grains that are bonded together by varying amounts of glass (Tite and Bimson 1986). The core material, or "body," is usually covered by a glaze free of quartz, although the glaze may consist of quartz sand, lime, alkali, and a copper colorant that is applied to the quartz body.

The glaze can be applied by efflorescence, cementation, or direct application (Tite, Free-stone, and Bimson 1983; Vandiver 1982). In the efflorescence application, the glazing mixture — comprising an alkali, lime, and copper compound — is mixed with some of the moistened quartz material used to produce the body. As the form dries, components of the glaze are carried to the surface by efflorescence. When fired, these components react with the quartz to form the bright blue glaze that is characteristic of blue faience.

In the cementation process, the quartz body is buried in the glazing mixture — consisting of quartz, alkali, lime, and copper compound — which, when fired, reacts with the body to form a glaze. In the direct process, raw or partially fired glazing mixture is applied to the surface of the quartz body prior to firing (Tite et al. 1999). The efflorescence method is characterized by extensive interstitial glass and a thick interaction layer, while minimal interstitial glass is formed during the cementation reaction; the cores remain white and friable under their green blue glaze. The direct application technique is characterized by minimal interstitial glass and a thin interaction layer but with a thick glaze layer (Tite and Bimson 1986). The faience, of crushed quartz, often has natron (soda-rich ash) as the alkali. The lime used in the formulation is thought to be derived from plant ash. Further details about faience can be found in Tite (1983), Tite and Bimson (1986), and Tite and coworkers (1999).

Mao (1999) recently studied Egyptian faience artifacts from the Ptolemaic period (300–30 B.C.E.) in the collections of the Walters Art Gallery, Baltimore. Mao found a consider-able quantity of lead in the outer glazed layer. The lead ranged from 2.5 to 8.5 weight % PbO. Although lead glazes are known from earlier periods, the use of a lead-glaze coating on blue Ptolemaic faience figures is an interesting discovery because it suggests that samples of Egyptian blue from this period may also contain lead.

GLAZED STONES Another method of producing small objects was to carve soft stones into the desired shapes and then fire them, yielding so-called glazed stones. A soft rock, such as steatite, was often used as the core material. Steatite consists principally of talc, $Mg_3Si_4O_{10}(OH)_2$, and has a fine-textured microstructure. On firing, the talc is converted to enstatite, $Mg_2Si_2O_6$, and the body becomes harder. The glaze that results forms a practically continuous surface about 100 μm thick.

FRITS Frits of Egyptian blue are produced by firing a mixture of quartz, lime, alkali, and copper colorant. These differ from faience in having significantly higher percentages of lime (CaO content about 8–13%) and copper oxide (6–20%) throughout the body of the frit.

Pigment deterioration mystery A conundrum surrounds the origin of blue and green colors on wall paintings in Egyptian tombs from a range of dynasties. At first, the colors were thought to be original copper carbonate and copper silicate pigments, but then a peculiar deterioration process was proposed, involving Egyptian blue and Egyptian green pigments as the possible source of the colors. The mystery, however, has yet to be solved satisfactorily.

Lucas (1962) had reported that azurite, malachite, and chrysocolla were found in many tombs from different dynasties, but this was discounted by El Goresy and coworkers (1986), who found that basic copper chloride was the principal pigment used in tombs from the Fifth Dynasty in Saqqara to the Twelfth Dynasty tomb of Khnum-hotep in Beni Hassan. These researchers state, however, that some of these pigments consisted of granules of about 50 μm in diameter with a prominent concentric texture and cores composed of copper carbonate (malachite). The copper chlorides formed a thick, fluffy mantle with a diameter of 10–20 μm around this carbonate core. The occurrence of the copper chlorides as thin films over carbonates and also over silicates led them to state that "the copper chlorides are definitely synthetic products, perhaps the oldest ever manufactured in Egyptian history" (El Goresy et al. 1986:281).

Another much more probable explanation for the presence of these copper chlorides is that they are alteration products of the original malachite pigment that had come in contact with saline salt solutions percolating through the rock of the tombs. Even in a relatively dry tomb, such as that of Queen Nefertari, long prismatic crystals of sodium chloride are found, and these form slowly over many centuries. The ability of these salt solutions to create alteration crusts on malachite particles is well supported.

In a later study, Schiegel, Weiner, and El Goresy (1989) appear to have reversed the 1986 conclusion by El Goresy and coworkers that the basic copper chlorides were original pigments. The later study concludes that the copper chlorides were a form of cancer eating away at polychrome wall paintings and Egyptian faience. This article, however, does not use the same

terminology as defined by Tite (1987) for the description of faience. Apparently, what is being described is a frit—usually Egyptian blue or Egyptian green, composed of considerable amounts of glassy material—although glazed faience tiles are also discussed.

Evidence is presented in the 1986 study by El Goresy's group that the deterioration begins with the devitrification of the glass phase in Egyptian blue and green. Next, migrating chloride-containing solutions react with the copper and carbonate phases—calcite within the stucco layers underlying the pigment layer containing dissolved copper (II) species, for example—to form one of the basic copper trihydroxychlorides, usually atacamite or paratacamite. The same process of deterioration was also evident on green areas of tiles from the south tomb at Saqqara that dates to the Old Kingdom (2665–2155 B.C.E.). Where the surfaces were undeteriorated, the tiles were a smooth, shiny blue. The green zones were rough and dull, with evidence for the formation of atacamite or paratacamite on the surface. Several tiles had lost their glazed surface almost completely, and the white quartzite cores were exposed.

Schiegel, Weiner, and El Goresy (1989) found that most Old Kingdom blue pigments were severely attacked, with extensive alteration to green. The deterioration continued into the Middle Kingdom and gradually lessened by the New Kingdom and Ptolemaic period, when the extent of surface alteration was evaluated as being low medium.

These deteriorated surfaces indicative of copper chloride attack raise the possibility that the frits or faience, which were described in the earlier literature as green, may originally have been blue and are now discolored by chloride conversion. A 1989 inspection by Schiegel, Weiner, and El Goresy of objects in the Egyptian Museum in Cairo revealed that many objects—including painted stone reliefs, decorated wooden objects, and glazed ware—were showing symptoms of attack, with copper-containing silicate glasses or glazes also showing signs of deterioration. Further research on this issue is clearly needed to ascertain the nature and the extent of the problem.

HAN BLUE AND HAN PURPLE: SYNTHETIC PIGMENTS FROM CHINA

During the Han dynasty (206 B.C.E.–220 C.E.) in China, mixtures of blue and purple silicates were used as pigments for both ceramic and metallic objects. They were also formed into octagonal pigment sticks. The blue pigment, known as Han blue, was identified by Fitzhugh and Zycherman (1992) as a synthetic barium copper silicate, $BaCuSi_4O_{10}$, which is a barium analog of Egyptian blue ($CaCuSi_4O_{10}$). The synthetic preparation of Han blue by Wiedemann and Bayer (1997) shown in PLATE 52 illustrates the strongly colored crystalline particles in bright-field illumination. The crystal structure of both the barium copper silicate and the calcium copper silicate has been carefully studied by Pabst (1959), who showed that their structures are similar to the gillespite group, $BaFeSi_4O_{10}$.

Fitzhugh and Zycherman (1992) propose the name "Han purple" for the purple pigment, which was identified by X-ray diffraction as another barium copper silicate, $BaCuSi_2O_6$.

Remarkably, this pigment was only identified by modern science as a "new" and interesting silicate in 1989 (Finger, Hazen, and Hemley 1989).[5]

Examples of objects from the Han dynasty on which Han purple pigment have been found include a gilded bronze vessel with painted purple decoration on the inside cover; a bronze vessel; the top of a *hsien* (steamer) with painted decoration in red, light blue, and light purple; and many ceramic objects.

PLATE 53 illustrates an octagonal Han purple pigment stick from the collections of the Ostasiatiska Museet, Stockholm. PLATE 54 shows a mounted preparation of Han purple from a Chinese painted bronze vessel of the Han dynasty. The pigment is viewed under partially crossed polars, showing glassy particles with pink-purple birefringence (Fitzhugh and Zycherman 1992).

The Chinese synthesis of an artificial inorganic purple pigment represents a unique achievement: the only other purples of antiquity were obtained from organic colorants; reddish purple pigments were obtained from iron oxide earth, where available.

Analysis of a white coating on two octagonal pigment sticks of Han purple surprisingly identified the coating as cerrusite, $PbCO_3$, and a mixture of two different lead phosphates, $Pb_5(PO_4)_3OH$ and $Pb_9(PO_4)_6$, which are associated with the sticks' manufacture. Lead oxide was used as a flux in the preparation of these pigments. Brill, Tong, and Dohrenwend (1991) synthesized Han purple using several mixtures, including barium chloride, $BaCl_2$, copper carbonate, $CuCO_3$, silica, SiO_2, and a synthetic natron flux (a mixture of sodium sesquicarbonate, $Na_2CO_3NaHCO_3$, sodium sulfate, $Na_2SO_4 \cdot 10H_2O$, and sodium chloride, NaCl), which were heated between 870 °C and 1000 °C.

Notes

1 A most remarkable property was claimed for chrysocolla, according to Sir Richard Burton's 1886 translation of *The Perfumed Garden of Shaykh Nefzawi*, an Arabic text written by Shaykh Umar ibn Muhammed al-Nefzawi in the fourteenth to fifteenth century: "[P]rocure for yourself extraordinary erections by eating of chrysocolla the size of a mustard grain. The excitement resulting from the use of this nostrum is unparalleled and all your qualifications for coitus will be increased" (Burton [1886] 1974, ch. 13). This aphrodisiac effect is most improbable; any such effect must surely have been in the mind rather than in the chrysocolla.

2 The ICDD periodically issues revisions to the X-ray defraction data, which in most instances improves the quality of information available. For some more variable minerals such as chrysocolla, however, some of the earlier ICDD file entries may be better matches to the experimentally determined data for entries given as "superceded" in the more recently revised editions.

3 One of the difficulties in modern replication work is that these blue colors are stable only in very alkaline glazes, which tend to have high thermal coefficients of expansion so that they can be used only with ceramics or pastes with a high quartz content, which are not used, in any practical sense, today.

4 Vitruvius *De architectura* 7.11 (Vitruvius 1931).

5 The chemists did not realize that the "novel" compound they had made had already been synthesized, in fact, by Chinese alchemists many centuries earlier and was therefore not new to science, as they had thought.

The Organic Salts of Copper
CHAPTER 9

In his famous work *De materia medica*, the first-century Greek physician and pharmacologist Dioscorides records one of the earliest accounts of the preparation of *aerugo rasilis* (copper acetate) using vinegar and a brazen (copper) vessel from which the product is scraped off and put to use, most likely as a medicinal preparation:

> But Aerugo rasilis is thus prepared. Pouring it into an hogshead, or some such vessel, ye sharpest vinegar, turn upon it a brazen vessel: it is good if ye hollow look downward, if not, let it be plane. But let it be made clean and having no breathing space. Then after ten days take off ye cover and scrape off ye Aerugo that is come on it; or having made a plate of ye brass itself, hang it in the vessel, so as not to touch ye vinegar, and after ye like number of days, scrape it off.[1]

Copper forms a large number of salts with simple organic acids, such as formic, acetic, citric, and tartaric acid. Complex compounds may also be formed with plant materials, resins, and

proteins, but they are extremely difficult to characterize. The most important group of organic copper salts is the verdigris ensemble. These compounds are the result of many attempts at synthesizing copper greens that date from the early centuries B.C.E. through the late medieval period and—if copper phthalocyanins are included in this group—up to the modern era. From the eighteenth century onward, however, chemists began to produce synthetic compounds that gradually displaced the traditional pigments. The salts prepared by ancient and historic recipes often have subtle differences in their composition that can make positive identification difficult.

THE COPPER FORMATES

Since formic acid and formaldehyde can be omnipresent pollutants in museum display and storage environments, it is surprising how little mention the copper formates have received in the conservation literature to date. Evidence for the existence of copper formates as a patina component, in small concentrations, has come from the work of Graedel, McCrory-Joy, and Franey (1986) and from corrosion studies of the Statue of Liberty (see CHAPTER 5). In the corrosion of copper by wood, plywood, and laminates, there is a strong possibility that formate salts will be identified, although there are currently no entries for the basic copper formates in the ICDD files.

The defined formate salts are shown in TABLE 9.1 (Gmelin 1955; ICDD 1982). The neutral formate is freely soluble in water and is the usual product formed from direct reaction between copper and formic acid. The crystals are monoclinic and optically negative.

There are six entries in the ICDD files for variants of the neutral copper formates. These data, together with information derived from syntheses of the basic salts, provide the array of information given in APPENDIX D, TABLE 9.[2]

A paucity of recent information exists concerning the basic formates. The compound $Cu(HCOO)(OH)$ was studed by Mori, Kishita, and Inoue (1980); and the molecular and

TABLE 9.1 **CHARACTERISTICS OF SOME COPPER FORMATES**

CHEMICAL NAME	FORMULA	CRYSTAL SYSTEM
copper (I) formate	$Cu(HCOO)$	not stated in file
copper (II) formate	$Cu(HCOO)_2$	not stated in file
copper (II) formate	$Cu(HCOO)_2 \cdot 2H_2O$	monoclinic
basic copper (II) formate	$Cu(HCOO)(OH)$	monoclinic
basic copper (II) formate	$2Cu(HCOO)_2 \cdot Cu(OH)_2 \cdot 2H_2O$	triclinic
basic copper (II) formate	$Cu(HCOO)_2 \cdot Cu(OH)_2$	not known
basic copper (II) formate	$Cu(HCOO)_2 \cdot 2Cu(OH)_2$	not known

crystal structure was determined by Tamura and coworkers (1981). The structure consists of infinite zigzag chains with HCOO and OH groups bridging neighboring copper ions. The structure is of interest since many other formate salts adopt a dimeric structure rather than an infinite chain structure.

In one of the first studies of the basic formates, Fowles (1915) found that when solutions of the neutral copper (II) formate were boiled, $2Cu(HCOO)_2 \cdot Cu(OH)_2 \cdot 2H_2O$, an insoluble basic salt, was formed. Fowles observed that copper (II) hydroxide readily combined when shaken with a cold solution of copper formate to form the salt $Cu(HCOO)_2 \cdot 3Cu(OH)_2$ that tended to revert to $Cu(HCOO)_2 \cdot 2Cu(OH)_2$. If the salt, $Cu(HCOO)_2 \cdot 3Cu(OH)_2$, freshly prepared, is added to a dilute solution of the neutral formate, it will change into a heavy, green crystalline powder after ten weeks. If an excess of a saturated solution of the neutral salt is used, complete conversion requires seventeen days. The compound obtained, $Cu(HCOO)_2 \cdot Cu(OH)_2$, is a fine, emerald green color.

If copper strips are kept in an atmosphere of 80% RH with 200 ppm of formic acid, dark green corrosion spots form on the copper surface. Powder X-ray diffraction analysis shows data very similar to that for the laboratory synthesis of $2Cu(HCOO)_2 \cdot Cu(OH)_2 \cdot 2H_2O$. This illustrates the potential importance of the new data; if only the ICDD (JCPDS) files were relied on for reference information, the corrosion formed on the copper strips would remain unidentified. Two refractive indices could be determined from the mounted crystals in Cargille liquids, one at $\mu = 1.620$ and the other at about 1.652.

Pey (1998) makes an unusual mention of the formate anion in reference to the characterization of some green pigments found in the Hafkenscheid collection, a historical collection of Dutch pigments that dates from the early decades of the nineteenth century. Pey describes one pigment, papegaaigroen (parrot green), as "possibly a formo-arsenite," which would make parrot green an analog of Schweinfurt green;[3] no further analytical data are provided, however.

THE COPPER ACETATES

The chemistry of verdigris | The preeminent organic salt of copper is verdigris, essentially a copper acetate, of which there are a bewildering number of possible varieties or mixtures. The name, however, is not always specific to copper acetate. Some compounds called verdigris may actually be a mixture of carboxylate salts, or they could be basic copper chlorides, carbonates, or other more exotic compounds.

Verdigris, which ranges in color from pale blue through turquoise to green, was made for use as a synthetic pigment or as a medicinal preparation. It is also an undesirable and disfiguring corrosion product on copper or bronze alloys. Verdigris has been known from at least Greek and Roman times and is mentioned by Theophrastus and Dioscorides. The origin of the word *aeruginous,* often used to describe "copper rust" (verdigris) goes back to Pliny.

TABLE 9.2 CHARACTERISTICS OF SOME BASIC COPPER ACETATES

CHEMICAL NAME[a]	FORMULA	COLOR
basic copper(II) acetate (A)	$[Cu(CH_3COO)_2]_2 \cdot Cu(OH)_2 \cdot 5H_2O$	blue
basic copper(II) acetate (B)	$[Cu(CH_3COO)_2]Cu(OH)_2 \cdot 5H_2O$	pale blue
basic copper(II) acetate (C)	$Cu(CH_3COO)_2[Cu(OH_2)]_2$	blue
basic copper(II) acetate (D)	$Cu(CH_3COO)_2[Cu(OH)_2]_3 \cdot 2H_2O$	green
basic copper(II) acetate (H)	$Cu(CH_3COO)_2[Cu(OH)_2]_4 \cdot 3H_2O$	blue green

[a]Letters in parentheses refer to in-text citations of individual compounds.

The compound was obviously made to be used as a pigment at an early date, though most of the published evidence derived from scientific examination of paintings places the predominant period of use from the thirteenth to the nineteenth century. The pigment continued to be made up to the advent of World War I, although it was already becoming less common, even at the beginning of the nineteenth century. These verdigris pigments were sometimes complicated mixtures of compounds, which was recognized in practice by statements noting the suitability of use for a particular pigment. Historical texts sometimes state that the verdigris in question is nearly insoluble in water, or highly soluble in water, or unsuitable for use in manuscript illumination, or recommended as a pigment for general use but not suitable for works of fine art. These wide-ranging properties were a natural consequence of the pigment's mode of production, which was primarily by deliberate corrosion of copper or copper alloys using a variety of organic materials, such as the lees of wine, stale vinegar, curdled milk, urine, and other substances. These mixed or impure products all went under the generic name of verdigris.

As alchemical knowledge grew more sophisticated, new compounds were prepared by recrystallization of the initial reaction products or by starting a recipe with known copper compounds rather than with copper sheets or filings.

| BASIC AND NEUTRAL VERDIGRIS The copper acetates are divided into two groups: the basic copper(II) acetates and the neutral copper(II) or copper(I) acetates. The basic copper acetates are the more important group, since the difficulties of characterizing most of the verdigris salts depend on these basic compounds. Most of the work on the basic copper acetates reported in the chemical literature can be traced back to an unpublished doctoral thesis by Gauthier (1958). This has only recently been revised by Rahn-Koltermann and coworkers (1991). The compounds, which are identified in the following discussion by capital letters, are listed in TABLE 9.2.

A number of subtleties in the assemblage of basic copper (II) acetates are listed in TABLE 9.2. Rahn-Koltermann and colleagues could not produce $[Cu(CH_3COO)_2]Cu(OH)_2 \cdot 5H_2O$ (compound B), for example, during their research and therefore concluded that it does not exist. Gauthier found that manufactured verdigris could be any one of the compounds on the list or mixtures of A and B, or B and D. The basic salt $Cu(CH_3COO)_2[Cu(OH_2)]_2$ (compound C) can occur only as a single species on the basis of the equilibrium diagram, according to Gauthier.

Rahn-Koltermann's group utilized both powder X-ray diffraction and infrared spectroscopy in determining data for compounds A, C, and D. They also found evidence for the existence of a new phase not previously reported in the literature that has been assigned the formula $Cu(CH_3COO)_2[Cu(OH)_2]_4 \cdot 3H_2O$, which is analogous to compound D. This new substance is labeled compound H. The existence of a new basic salt complicates the discussion of these compounds. In fact, there may be a continuum of these basic copper (II) acetates comprising a number of salts with the following stoichiometry:

$$[Cu(CH_3COO)_2]_x[Cu(OH)_2]_y \cdot zH_2O \qquad\qquad 9.1$$

where typical values are $x = 1, y = 3$, and $z = 2$. This would equate to compound D, as found by Gauthier, although compounds A, B, C, and H can all be considered possible variants on this general formula.

The only relevant neutral salt that has been well characterized, based on the most recent ICDD files, is the neutral copper (II) acetate monohydrate (compound F). This salt, $Cu(CH_3COO)_2 \cdot H_2O$, has a distinctive blue-green color. As shown in TABLE 9.3, there are two other neutral salts in the ICDD files with more limited relevance: the anhydrous copper (II) acetate (compound E) and the anhydrous copper (I) acetate (compound G).

Compound F is the product most easily made with modern, chemically pure ingredients. In the past, this neutral acetate often had to be prepared by dissolving crude verdigris in vinegar and collecting the neutral verdigris crystals as grapelike clusters grown from the evaporation

TABLE 9.3 **CHARACTERISTICS OF SOME COPPER ACETATES**

CHEMICAL NAME[a]	FORMULA	X-RAY LISTING	CRYSTAL SYSTEM
copper (II) acetate (E)	$Cu(CH_3COO)_2$	ICDD 27–1126	tetragonal
copper (II) acetate hydrate (F)	$Cu(CH_3COO)_2 \cdot H_2O$	ICDD 27–145	monoclinic
copper (I) acetate (G)	$Cu(CH_3COO)$	ICDD 28–0392	not known

[a] Letters in parentheses refer to in-text citations of individual compounds.

of the solution on small wooden sticks. This neutral monohydrate is the best-known salt, but even here there are possibilities for some variation in properties. Laboratory research at the Getty Conservation Institute showed that samples could be prepared that were either monoclinic or triclinic in crystal habit.[4] APPENDIX D, TABLE 10, shows the results of a typical experiment to make a basic verdigris by the reaction of vinegar with copper foil; it only succeeded in producing another example of the neutral salt corresponding to ICDD 27-145. In 1998 Roy provided the GCI Museum Research Laboratory with specimens of five different verdigris salts from the collections of the National Gallery of Art, London.[5] Two of these corresponded to the same salt produced in the previous experiment. Results of the Debye-Scherrer powder X-ray diffraction study of these samples are shown in APPENDIX D, TABLE 11.

NEW VERDIGRIS SYNTHESES The previously published X-ray diffraction data for the basic copper(II) acetates are sometimes contradictory and difficult to understand. To rectify this situation, a number of new syntheses were carried out at the GCI Museum Research Laboratory using recipes designed there, as well as recipes from Gauthier (1958); Schweizer and Mühlethaler (1968); and Rahn-Koltermann and colleagues (1991). Historical pigment recipes were also replicated.

Compound A, $[Cu(CH_3COO)_2]_2 \cdot Cu(OH)_2 \cdot 5H_2O$, was synthesized using a recipe from Gauthier (quoted in Schweizer and Mühlethaler 1968) and by Rahn-Koltermann and coworkers. Two syntheses for compound A are described in APPENDIX B, RECIPE 8. Schweizer and Mühlethaler's synthesis of compound B is given in APPENDIX B, RECIPE 9. Two syntheses of compound C are given in APPENDIX B, RECIPE 10. Data for additional syntheses of compounds A, B, and C are given in APPENDIX D, TABLE 12. The synthesis of compound D, as well as original recipes with samples provided by Roy, is described in APPENDIX B, RECIPE 11.

Rahn-Koltermann's group could not synthesize compound B. The author was successful, however, in producing five different solid products that were removed at different stages of the reaction. APPENDIX D, TABLE 13, presents the following seven data sets: the author's five products (labeled B1 through B5) from the synthesis of compound B; new data for the Schweizer and Mühlethaler version of compound B; and data for a laboratory synthesis of compound A. Judging by the X-ray diffraction data, most of these syntheses of $Cu(CH_3COO)_2 \cdot Cu(OH)_2 \cdot 5H_2O$ produced quite similar results.

The National Gallery's sample of compound D, $Cu(CH_3COO)_2[Cu(OH)_2]_3 \cdot 2H_2O$, was confirmed as being the same salt as the one derived from Schweizer and Mühlethaler's recipe. APPENDIX D, TABLE 14, compares data for this sample with data for two syntheses (labeled ytD and Ayt2) from the GCI Museum Research Laboratory. APPENDIX D, TABLE 15, shows the value of this newly revised and expanded set of data: it was used to show that a light green verdigris pigment sample from a manuscript had an X-ray diffraction pattern that was an excellent match to the author's synthesis of compound B (sample B4). The verdigris pigment is from *Barlaam und*

Josaphat, a German illuminated manuscript in the collections of the J. Paul Getty Museum (83.MR.179). The manuscript, which dates to 1469, is by Rudolf von Ems (ca. 1200–1254), with illustrations by the Diebold Lauber atelier. No previously published X-ray diffraction data provide a match with this German verdigris sample.

Another example of the application of this data is shown in APPENDIX D, TABLE 16. Data for a verdigris synthesis from a recipe in the *Mappae clavicula* (Smith and Hawthorne 1974: sec. 6) that uses copper foil, soap, and vinegar are compared with data from the Schweizer and Mühlethaler version of compound B and from the author's synthesis of compound A. Also shown in this table are data from the synthesis of a basic verdigris by Mactaggart.[6] The comparison shows that, apart from matching a few lines of some compound A and B data, the Mactaggart sample is principally the neutral verdigris salt, compound F.

| OPTICAL PROPERTIES OF VERDIGRIS Verdigris produced from the exposure of copper foil to vinegar is in the form of clear, light blue-green tabular crystals with a refractive index of less than 1.66. When the crystals are mounted in a melt-mount of index 1.539, they have a slightly higher index than the medium, suggesting that they have an index of about 1.55. The crystals reveal a second-order blue parallel to the slow direction of the quartz wave plate, indicative of a positive sign of elongation. Not all verdigris samples have clear extinction; some, such as the sample of distilled verdigris from Mactaggart illustrated in PLATE 55, showed undulose extinction and mixed blue-straw colors with the quartz wave plate. Some basic verdigris crystals show a long fibrous aggregation of curved crystals.

Optically, the copper acetates are usually blue green and of variable crystalline size and shape. The crystals are, in general, anisotropic with pale blue birefringence and refractive indices of less than 1.66. Some typical polarized-light microscope preparations are shown in PLATES 55–57.

The most common salt, neutral verdigris (compound F), is a deep blue green; under the microscope, it is characterized by crystalline fragments that often show conchoidal fracture and clear relief when mounted in a melt-mount of RI 1.662. The particles tend to show a uniform light blue color without visible defects within the crystalline fragments, which have a refractive index of about 1.55. When viewed under crossed polars, the neutral salt reveals muted brown, yellow, and dark blue colors, none of them very intense, and often with clear extinction.

Basic verdigris compound A is a pale blue or blue-green color and under the microscope appears as turquoise-colored fibrous crystals. The brushlike crystal aggregates show intense green, yellow, and blue birefringence under crossed polars with some crystals appearing almost white. The size of the individual fibrous crystals is very small.

Basic verdigris compound B is a deep blue-green color that appears dark green to deep blue green under the microscope and may be composed of at least two different crystal forms. Most of the particles appear to be composed of bundles of fine fibers of varying orientation, some

curved. The relief varies on rotation, showing differences in refractive index, the principal RI determined was $\mu = 1.548$, the other closer to 1.53. The particles tend to have undulose or no clear extinction under crossed polars. They show an intense birefringence, the greener particles retaining a finely variegated light green color under crossed polars, while the lighter blue-green fibrous particles appear strongly colored with intense blue and light yellow color. Individual fibers that can be seen show a positive sign of elongation. In preparations at the GCI Museum Research Laboratory, some of these B group compounds also occurred as irregular crystalline fragments of pale blue-green color rather than as fibrous particles. Kuhn (1993) quotes the RI of basic verdigris as 1.56 and 1.53. These are similar values to those found here for compound B, but some of the other basic salts have refractive indexes higher than these two values.

Basic verdigris compound C, visually a pale turquoise color, is quite distinctive since it consists of a mass of well-formed, acicular crystals, some perfectly rectangular and prismatic in shape. Under plane polarized light, the acicular clumps look light green in color, some of the crystals curved and fibrous, but the majority appearing as long prismatic needles that have parallel extinction under crossed polars. Under plane polarized light, in Cargille liquid of 1.580, the needles almost disappear on rotation, showing that one RI is very close to 1.580 parallel to the long axis of the crystal. The RI is lowest at 45° to the long axis and about 1.560. The needles appear blue parallel to the wave plate, indicating that they have a positive sign of elongation.

Basic verdigris compound D macroscopically appears a light green-blue color and microscopically is composed of pale light green to transparent crystalline fragments often tinged with light blue green. These particles show only low to moderate relief in a melt-mount of RI 1.662 without any noticeable change in relief on rotation under plane polarized light. Under crossed polars, the particles appear intensely colored with light straw and strong light blue colors. Some particles appear veined with microcracks or fissures and twinkle on rotation under crossed polars with no clear extinction. According to Yamanaka (1996), compound D has a layered structure of the botallackite type. The acetate ions are located between the positively charged copper hydroxide layers and can be exchanged with various other anions. This may partially explain why some of these verdigris samples may be difficult to fully characterize, because the presence of other anions—such as chloride, sulfate, or nitrate—may produce slight variants of the parent compound by substitution of some of the copper hydroxide layers. This substitution may also help to explain the considerable variation in the analytical data for these verdigris compounds, particularly the powder X-ray diffraction data.

Reexamination of the melt-mount preparations after two years in storage showed that some of them had already undergone a reaction with the mounting medium; the resin was slightly discolored and the particles partially dissolved. Preparations in melt-mount should therefore be examined and photographed when freshly made.

| DECOMPOSITION STUDIES Several recent studies have derived thermal decomposition data for neutral copper acetate. Mansour (1996) found that dehydration occurred at 190 °C and that there was only partial decomposition to cuprite and tenorite at 220 °C. Maiti and Ghosh (1983) state that the decomposition products at 300 °C comprise cuprite, tenorite, and copper, with the final product of the thermal decomposition being the copper oxide tenorite.

The history of verdigris | An interesting historical account of the preparation of verdigris in France from the twelfth through the nineteenth century was given by Benhamou (1984). During this time, verdigris was used as an ingredient in oil-based paints to embellish the exteriors of French country houses and Dutch homes; it also gave an attractive green to sedan chairs. Verdigris was mixed with oil or distemper to illustrate postage stamps and to tint paper, as well as to color woods for marquetry. In metallurgical processes it was used in the soldering and coloring of gold jewelry. The tints and colors based on verdigris were usually green, but the compound could also be used to produce black on both wood and cloth, perhaps from tenorite formation within the fibers. Montet writes, "I am told that another common use of verdigris is to dye hats black; and a famous dyer of this city told me that he used only verdigris to dye woolen cloth black" (Montet 1757:27).

Benhamou's historical account notes that the production and trade of this important pigment was, interestingly, controlled by a monopoly of women for eight hundred years. Any man who attempted to turn his hand to the task was ridiculed, a social technique that was apparently effective in protecting this occupation from masculine encroachment. During this period, the synthesis of verdigris started with 53.34 cm (21 in.) copper disks that were specially imported from Sweden. These were cut into twenty-eight strips and hammered smooth before being buried for three to four days in old verdigris to season them. The copper strips, which could be used through a number of production cycles, were then placed in partially fired earthenware pots, each holding about one hundred strips.

New jars were moisture proofed by soaking for about ten days in *vinasse* (wine vinegar), distilled from a strong red wine. The jars were then scrubbed in the same liquid to cleanse them of tartarous deposits. Grapes were used for chemical transformation of the copper. The grapes were squeezed from their skins, sun dried, and pressed before being soaked in vinasse until they doubled in size. The plumped grapes were then formed into large balls, sealed in the earthenware jars with three pots of wine, and left to ferment for up to twenty days. At just the right moment during fermentation, the liquid was drained from the jars, the grapes were layered with heated copper strips, then left for three to four days until the strips developed white crystals. The crystal-covered strips were then placed on a rack and wetted occasionally with wine or vinasse, a process that continued for about a month, or until the strips developed the desired green and spongy growth.[7]

The moist verdigris was scraped from the copper strips and prepared in semidarkness to protect the crop from strong light. Since it is known that many copper reactions are influenced by light, it is intriguing that the new crop of verdigris should have been protected from it, since the action of light in altering the path or sequence of reactions in this system had not yet been elucidated by modern chemistry.

Once dried, the verdigris was pulverized and then taken to an assessor to be certified. Product of an acceptable quality was sold to merchants who exported most of it, primarily to Holland where it was used principally as a painting pigment. There are many examples of verdigris being used as a pigment from the thirteenth to the nineteenth century, ranging, for example, from a thirteenth-century German altarpiece to an 1877 painting by the Russian artist Ernst von Liphart (1847–1934) (Kühn 1993).

Laurie (1914) was not able to identify verdigris with certainty on any manuscript before 1400, while manuscripts from 1419 onward showed brilliant greens that were found to reveal the crystalline structure of verdigris. For example, on a manuscript from the Burgundy Breviary,[8] Laurie identified finely crystalline verdigris that he considers characteristic of fifteenth-century continental manuscripts. He describes these greens as partially composed of doubly refracting crystals with a refractive index below that of oil of Cassia (RI = 1.602). They are a pale emerald green, not matched by the blue green usually associated with verdigris. Laurie proposed the following explanation for the color difference: Because verdigris is partially soluble in water, its direct use on manuscripts was objectionable. Instead, the crude product of basic verdigris, first leached with water, could have been employed for manuscript illumination. This preparation would have greater stability in gum arabic solutions. The author's studies of a pale green verdigris on *Barlaam und Josaphat,* the German illuminated manuscript described earlier, confirmed that the verdigris was composed of pale emerald green crystals matching verdigris sample B4 in the X-ray diffraction data shown in APPENDIX D, TABLE 15. This particular basic verdigris salt is completely soluble in water, however, so it is unlikely that Laurie's suggestion can be correct here.

From the *Coram Rege Rolls* (folio 1013) dated 1500–1700, Laurie identified a verdigris green, but it was mixed with particles of azurite. This suggests that the verdigris was not prepared by the corrosion of copper but by the dissolution of azurite in vinegar. Laurie also found blue particles in some of the copper resinate greens from manuscripts, and this may also support his theory. In this case, however, a more likely explanation may be the presence of undissolved crystals of verdigris used in making the copper resinate green.

ANCIENT MEDICINAL USES Verdigris and other copper compounds were appreciated at a very early period for their medicinal qualities (see CHAPTER 6). The biochemical basis for the use of copper salts in medicine is discussed by Weser (1987), who draws attention to a Middle Kingdom Egyptian papyrus from about 1536 B.C.E. This document,

published by Ebers in 1875 and known as the *Papyrus Ebers* (Ebbell 1937), mentions various preparations using copper compounds in both medicinal and cosmetic contexts. One of these preparations, a mascara analyzed at the British Museum, proved to be of resin and verdigris (Stetter 1993).

Weser notes that more than twenty copper proteins are known that have specific biochemical reactivity, and the efficacy of copper compounds in many biochemical systems has been confirmed by medical research. Copper has excellent chelating ability that enables it to interfere with the reproduction of many microorganisms, and the protein known as copper-zinc superoxide dismutase has one of the fastest reaction rates measured in biochemical systems. In laboratory studies, Weser demonstrated that copper chelates of some simple amino acids display enzymatic activity similar to the natural dismutase. There is, therefore, a good biochemical basis for ancient recipes that use copper for the treatment of skin infections and muscular pain. Pliny records the following medicinal treatments using verdigris:

> [V]erdigris in a crude state is used as an ingredient in plasters for wounds also. In combination with oil it is a marvelous cure for ulcerations of the mouth and gums and for sore lips, and if wax is also added to the mixture it cleans them and makes them form a cicatrix. Verdigris also eats away the callosity of fistulas and of sores around the anus either applied by itself or with gum of Hammon.[9]

The use of verdigris as a medicinal compound lasted until the beginning of the nineteenth century. According to Ebers (1875), Buchner wrote in 1816 of the preparation of "Das Kupfersauerhonig" (*Unguentum Aegyptiacum*), or Egyptian unguent. Chambers (1738) gives a formula for Aegyptiacum, "improperly called an unguent," which may have been used to treat canker sores in children. In 1895 Kobert reviewed the medicinal copper salts used by Swiss-born alchemist and physician Paracelsus (1493–1541) and confirmed that they had a beneficial reactivity. In the eighteenth century, verdigris—called "verdegrease" at the time—was used in pharmaceutical preparations (Benhamou 1984). Surgeons used these preparations to cleanse old ulcers and to treat fungal infections; this is very reminiscent of the use of verdigris in Pliny's time, eighteen centuries earlier.

Although supposedly controlled in pharmaceutical preparations, verdigris had a well-deserved reputation as a poison. Benhamou notes that an eighteenth-century periodical blamed the verdigris that formed in untinned copper boilers used for Parisian beer production for making that beverage unwholesome and that some deaths were attributed to eating bread baked in an oven fueled by green-painted wood.

EARLY VERDIGRIS RECIPES

Recipes from
Pliny the Elder

Pliny records several recipes for verdigris, showing that there was probably a long tradition of making the pigment by the first century, although some of the compounds were simply corrosion products of copper rather than specific recipes for the preparation of copper acetate. The following are two of Pliny's recipes for making verdigris:

[I]t is scraped off the stone from which copper is smelted or by drilling holes in white copper and hanging it up in casks of strong vinegar which is stopped with a lid; the verdigris is of much better quality if the same process is performed with scales of copper. Some people put the actual vessels, made of white copper, into vinegar in earthenware jars, and nine days later scrape them. Others cover the vessels with grape-skins and scrape them after the same interval, others sprinkle copper filings with vinegar and several times a day turn them over with spattles until the copper is completely dissolved. Others prefer to grind copper filings mixed with vinegar in copper mortars. But the quickest result is obtained by adding to the vinegar shavings of coronet copper.[10]

There is also another kind of verdigris called from the Greek worm-like verdigris, made by grinding up in a mortar of true cyprian copper with a pestle of the same metal equal weights of alum and salt or soda with the very strongest white vinegar. This preparation is only made on the very hottest days of the year, about the rising of the Dogstar. The mixture is ground up until it becomes of a green colour and shrivels into what looks like a cluster of small worms, whence its name. To remedy any that is blemished, the urine of a young boy to twice the quantity of vinegar that was used is added to the mixture.[11]

Attempts by researchers at the GCI and elsewhere to duplicate some of these recipes mostly resulted in the production of neutral verdigris, or a mixture of neutral and basic forms. These are essentially similar to the recipes discussed in the following paragraphs.

REPLICATION EXPERIMENTS The first of Pliny's recipes given here results in the manufacture of various copper acetates. It is not apparent what range of compounds would result from the second recipe, however, which is a precis of an earlier account taken from Dioscorides.[12] To investigate this more closely, a replication experiment was conducted at the GCI Museum Research Laboratory using a mortar and pestle made from pure copper, which is what Pliny implies by specifying "cyprian copper" (copper from Cyprus, known to be a supplier of relatively pure copper metal in Roman times). The alum used in the replication experiment, which is given in APPENDIX B, RECIPE 12, was potassium aluminium sulfate, and the salt was sodium chloride. The product formed using this mixture was the chloride atacamite; when soda was substituted for the sodium chloride, the principal product was the carbonate chalconatronite. Although the formation of chalconatronite is slightly surprising,

THE ORGANIC SALTS OF COPPER

279

all the essential ingredients for its formation are found in the recipe: the copper ions from the mortar and pestle, the sodium from the soda, and the carbonate from the soda.

Urine, which is called for in Pliny's recipe, is often mentioned in connection with several pigment recipes and may play a complex role in the formation of a range of products. The principal components of urine (in mg/100 ml) are 1820 mg of urea, H_2NCONH_2; 53 mg of uric acid; a nitrogen heterocyclic compound of empirical formula $N_4C_5O_3H_4$ with three carbonyl groups and four nitrogen atoms linked to hydrogen atoms; 196 mg of creatinine, a single-ring nitrogen heterocycle with empirical formula $N_3C_4H_7O$; and small amounts of sodium, potassium, calcium, magnesium, chloride, bicarbonate, sulfate, and phosphate ions (Shier, Butler, and Lewis 1996). This complex mixture is capable of dissolving verdigris and corroding copper to some extent. It is much more active as an ingredient than water alone, which results in a very complex mixture of organic and inorganic salts.

TESTING FOR IMPURITIES Even in Roman times, verdigris was not cheap to produce, and the pigment was sometimes adulterated with powdered marble, pumice, gum, and even shoemaker's black. To test for powdered mineral additives, Dioscorides recommended the following procedure based on knowledge of the relative solubility of verdigris:

> [F]or some do mix it with ye pumice stone, some with marble, but others with Calcanthum. But we shall find out the Pumice stone, and ye marble, by wetting the thumb of ye left hand, and by rubbing some part of ye rust with the other. For it happens that ye rust of it runs abroad, but ye parts of ye Pumice stone and ye marble remain undissolved and at last it grows white with ye long rubbing and with ye mixture of ye moisture. And not only so, but by the crushing of ye teeth, for the unmixed falls down smooth and not rough.[13]

The problem of detecting adulteration with shoemaker's black was nicely dispatched by a test described by Pliny that was based on knowing that the Roman shoeblack contained iron sulfates: "It is also detected by means of papyrus previously steeped in an infusion of plantgall, as this when smeared with genuine verdigris at once turns black."[14] This is perhaps the first recorded chemical spot-test, and it is quite accurate because the gallnut extract forms a strong black colorant with iron salts; this mixture was long used as an iron gall ink.

Less accurate is the statement by Pliny that the presence of verdigris can also be detected by heating the substance in question on a hot fire-shovel to see if the compound remains unchanged. The idea that verdigris will remain unchanged also exists in an earlier text by Dioscorides. Tests show, however, that after heating verdigris on an iron shovel, the copper salt first turns red and possibly black under strong heat, first forming cuprite and gradually transforming to tenorite. What might have been meant, and was perhaps misconstrued from some lost original source, is that the presence of verdigris as a copper compound could be determined by heating to see if the characteristic red of cuprite and the black of tenorite would form.

One of the more accurate descriptions for verdigris preparation from the Middle Ages comes from Theophilus, whose twelfth-century work, *De diversis artibus*, records recipes for two variants of verdigris: *viride salsum* and *viride hispanicum*. His *viride salsum* was made as follows:

> If you wish to make a green colour take a piece of oak of whatever length and width you like, and hollow it out in the form of a box. Then take some copper and have it beaten into thin sheets, as wide as you like but long enough to go over the width of the hollow box. After this, take a dish full of salt and, firmly compressing it, put it in the fire and cover it with coal overnight. The next day, very carefully grind it on a dry stone. Next, gather some small twigs, place then in the above-mentioned hollow box so that two parts of the cavity are below and a third above, coat the copper sheets on each side with pure honey over which you sprinkle pounded salt, place them together over the twigs and carefully cover them with another piece of wood, prepared for the purpose, so that no vapour can escape. Next, have an opening bored in a corner of this piece of wood through which you can pour warm vinegar or hot urine until a third part of it is filled, and then stop up the opening. You should put this wooden container in a place where you can cover it on every side with dung. After four weeks take off the cover and whatever you find on the copper scrape off and keep. Replace it again and cover it as above.[15]

Banik (1989) researched this recipe and concluded that the resulting products were often mixtures of copper salts, including basic and neutral copper acetates, with some malachite and additional phases that could not be characterized. If the salt predominates in this kind of mixture, then the principal product will be atacamite, as found in the GCI Museum Research Laboratory's work. However, the interaction of the honey with the other ingredients in this recipe is of interest. Some nantokite, $CuCl$, was found in areas associated with the honey, which suggests that the reducing sugars in the honey had a significant effect on the corrosion of the copper in this case. How the nantokite would eventually transform to other products is difficult to resolve at present, but further interaction between the nantokite and copper under humid conditions could be expected to produce atacamite, an assumption confirmed by X-ray diffraction studies at the GCI Museum Research Laboratory. Other phases were present in the material produced by this recipe, as well, including a dark green substance that may be a copper chelate complex. Maekawa and Mori (1965) suggest that this dark green complex may form in high humidity and in the absence of light, which the recipe requires. The discovery that many so-called verdigris pigments in illuminated manuscripts are actually basic chlorides that could easily have been made by Theophilus's *viride salsum* technique attests to the historical veracity of these recipes. The replication experiment for this recipe is given in APPENDIX B, RECIPE 13.

Theophilus's *viride hispanicum* (Spanish green) is as follows:

> If you want to make Spanish Green, take some plates of copper that have been beaten thin, carefully scrape them on each side, pour over them pure, warm vinegar, without honey and salt, and put them in a small hollowed out piece of wood in the above way. After two weeks, inspect and scrape them and do this until you have enough colour.[16]

It is interesting that sodium chloride is specifically excluded in this recipe, which suggests that many other recipes did use honey and salt. Banik replicated this recipe and found the product to be a complex mixture of basic copper salts: besides copper acetates and carbonates, some basic copper chlorides were also formed.

The *Mappae clavicula*, representing a varied body of knowledge compiled from the eighth to the twelfth century (Smith and Hawthorne 1974), mentions seven different recipes for the preparation of various copper corrosion products, not all of which would produce common verdigris. Some examples of these recipes from the *Mappae clavicula*, together with relevant passages from other medieval texts, are given in the following paragraphs.

> [recipe iii] If you wish to make a different azure, take a flask of the purest copper and put lime into it, half way up and then fill it with very strong vinegar. Cover it and seal it. Then put the flask in a warm place for one month. Not as good as [recipe] ii but it is suitable for wood and plaster. (Smith and Hawthorne 1974 : 26)

Orna (1996) replicated this recipe, utilizing copper plates in a glass container. After one month, mixed green, blue, and colorless crystals were found, as well as a blue reaction product and unreacted starting materials. Elemental analysis of the crystalline product suggested an empirical formula of $Cu(CH_3COO)_2 \cdot Ca(CH_3COO)_2 \cdot 6H_2O$, calcium copper acetate hexahydrate, which is a water-soluble, deep blue crystalline solid that becomes very pale blue when ground to a powder. This identification was confirmed by X-ray diffraction studies, the data for which are shown in APPENDIX D, TABLE 17. The synthesis is described in APPENDIX B, RECIPE 14.

Langs and Hare (1967) reported that calcium copper acetate hexahydrate can be prepared by the slow evaporation of an equimolar solution of calcium acetate and cupric acetate. After the initial pale green deposit was filtered, large deep-blue tetragonal prisms crystallized out of the solution. Orna showed that these crystals had the same X-ray diffraction data as the product from recipe iii of the *Mappae clavicula*. Calcium copper acetate hexahydrate may have been useful as a pigment on wood or plaster but was probably not used for fine painting, and indeed the *Mappae clavicula* text notes that it is not as good a pigment as that produced from recipe ii (discussed later in this chapter).

Despite the observation by Wallert (1995) that the fifteenth-century manuscript *Libro Secondo de Diversi Colorie Sise da Mettere a Oro*, known as the Simone manuscript, is not par-

ticularly related to the *Mappae clavicula* tradition, it does contain the following closely related recipe for a blue pigment:

> [39] *To make a beautiful blue at little cost.* Take quicklime and green and ground verdigris and sal ammoniac, as much of one as of the other. Grind these all together with urine and you will see a beautiful blue. Temper it with the previously described glair [egg white], when you want to work with it. (Wallert 1995 : 43)

The "green" referred to here is an organic sap green. As seen with recipe iii of the *Mappae clavicula*, reactions with lime, or in this case with quicklime (calcium oxide), are likely to produce complex or unusual salts, such as calcium copper acetate hexahydrate. Here the addition of sal ammoniac (ammonium chloride) suggests that mixtures of the calcium copper acetates and copper trihydroxychlorides are quite possible, since adding ammonium chloride tends to result in the replacement of the acetate groups with basic chlorides. Combining copper (verdigris), organic plant substances (green), and urine components adds to the probable complexity of the products of this particular recipe. This, in fact, proved to be the case: a laboratory synthesis of the recipe from the Simone manuscript for a blue pigment produced soft turquoise particles that did not give an identifiable powder X-ray diffraction pattern.

The following recipe from the *Mappae clavicula* is for "Byzantine Green":

> [recipe 5] If you want to make Byzantine Green, take a new pot and put sheets of copper in it then fill with very strong vinegar, cover and seal, leave for six months. The product can be dried in the sun. (Smith and Hawthorne 1974 : 27)

Another set of instructions from the *Mappae clavicula* (recipe 10) mentions that Byzantine green can be tempered with vinegar, which would convert the basic verdigris salts into neutral verdigris (Smith and Hawthorne 1974 : 27). This would help produce a purer product on recrystallization.

The *Mappae clavicula* also gives instructions for making "Rouen Green":

> [recipe 6] Rouen Green. Take sheets of copper, smear with soap. Put the sheets into a pot, fill with vinegar, cover, seal and place in a warm place for fifteen days. (Smith and Hawthorne 1974 : 27)

APPENDIX B, RECIPE 15, describes the replication experiment for this recipe, which produced a light blue material that is probably basic verdigris.

The following process from the *Mappae clavicula* calls for the use of copper strips:

> [recipe 221-D] Take copper strips and scrape them down well and hang them over vinegar. Scrape off and gather the stuff that collects on it. (Smith and Hawthorne 1974 : 61)

The sets of three experiments given in APPENDIX B, RECIPE 16, are broadly similar to this one, taking strips of copper and exposing them over warm vinegar. The experiments were carried out in the laboratory using strips of pure copper, bronze, and brass exposed to a variety of modern vinegar types. In virtually all of this experimental work, X-ray diffraction analysis showed that the green product made was neutral verdigris; in one case, a mixture of two basic acetates was produced.

Another *Mappae clavicula* recipe exposes copper to urine:

> [recipe 96] Coat copper, beaten out into sheets with honey and put beneath it in a pot broad laths of wood and pour over it a man's urine. Let it stand, covered for fourteen days. (Smith and Hawthorne 1974 : 41)

This recipe was replicated using oak wood chunks and a pure copper sheet covered with urine in a jar for fourteen days. A darkish green product formed only in small patches over the copper sheet. It was poorly crystalline, giving no powder X-ray diffraction pattern. Examination of the same product with Fourier transform infrared (FTIR) spectroscopy showed significant peaks in the spectrum, associated with nitrogen bonds, indicating that one of the major products must be a compound between copper (II) and one of the nitrogenous compounds of urine, such as urea, uric acid, or creatinine. This is not unexpected, given the reactivity of copper ions with both oxygen and nitrogen groups. The identity of the compound is currently being investigated.

The following *Mappae clavicula* recipe uses copper filings:

> [recipe 80] Changing copper—take six minas [unit of weight] of salt and four minas of filings or scrapings of copper. Mix the filings in a pot with ground salt, sprinkling vinegar over them and leave for three days and you will find it has turned green. (Smith and Hawthorne 1974 : 38)

The replication experiment found that the copper filings did indeed turn green, with the principal product identified as atacamite, as described in APPENDIX B, RECIPE 17.

Many historic recipes call for the preparation of verdigris using copper sheets or strips that are smeared with honey to which salt is added; the sheets or strips are then hung over vinegar. These recipes invariably produced atacamite. The resulting product was a mixture of light green and darker green mottled crystals over the honey-smeared copper surface. Copper compounds enveloped the sodium chloride, and concentric or globular crystals formed over the copper. X-ray diffraction analysis of the resulting products showed them to be atacamite.

Orna, Low, and Baer (1980) provide some important information on manuscripts from the ninth to the sixteenth century. In addition, an eighth-century Latin manuscript from Lucca, Italy, known as *Codex Lucensis 490* or *Compositiones variae*[17] (Burnham 1920), contains a recipe that tells how to make a product called "flowers of copper," identified as "iarin," which appears to be verdigris:

Take pure copper plates and hang them over strong vinegar. Place them in the sun without touching them. After two weeks, open the container and take out the plates. Collect the efflorescence and you will have very pure iarin. (Burnham 1920:13)

There are many variants to preparing verdigris with just copper and vinegar. For example, Mactaggart prepared basic verdigris using malt vinegar and copper foil, as described in APPENDIX B, RECIPE 18.[18] A verdigris sample prepared by the same method at the GCI produced an X-ray diffraction pattern very different from that of Mactaggart's verdigris. A second attempt was made using the same ingredients but with burial of the copper foil wrapped in a vinegar-soaked cloth. This successfully produced crystals of both neutral verdigris and the lighter-blue basic verdigris salts, which were characterized as being similar to compound B.

| LATE-MEDIEVAL PIGMENT RECIPES Manuscripts from the fourteenth to the sixteenth century reveal a more detailed knowledge concerning the preparation of blue copper-based pigments. Most of these manuscripts prescribe verdigris rather than copper metal as the starting material. A fifteenth-century manuscript, MS 1243 in the Biblioteca Riccardiana, Padua, Italy (Merrifield 1849), gives this typical recipe for a durable azure:

[M]ix well one part of sal ammoniac and three parts of verdigris with oil of tartar until it is soft and paste-like, or even softer. Then place it in a glass vessel under hot dung for a day; afterwards, you will find that the green has turned to best blue. Another way of making the best blue. R[ecipe]: mix together three parts of sal ammoniac and six parts of verdigris with oil of tartar until soft and paste-like or even softer. Then place the paste into a glass ampoule, and when it is well-stoppered and sealed, place it in a hot oven and let it stand for some days; afterwards, take it out and you will find it turned into the best azure. (Merrifield 1849:226)

Crosland (1962) identifies "oil of tartar" as a saturated solution of potassium carbonate. Both methods mentioned in this recipe produce bright blue needles or cylinders mixed with colorless crystals of varying morphology. Orna (1996) found that these blue crystals gave an X-ray diffraction pattern that did not match any published data, and the product could not be characterized. The same synthesis was attempted at the GCI Museum Research Laboratory using the sal ammoniac, verdigris, and a variant of oil of tartar. APPENDIX B, RECIPE 19, describes these results.

The synthesis appears to produce a mixture of products. One bright blue clump of crystals was ground and analyzed by X-ray diffraction, which showed possible matches to potassium copper acetate, $2K(CH_3COO) \cdot Cu(CH_3COO)_2$, ammonium chloride, and/or ammonium copper acetate acetic acid, $C_{14}H_{50}CuN_4O_{20}$, as shown in APPENDIX D, TABLE 18. Clearly, this medieval recipe produces a blue product of a somewhat intractable nature. The range of

chemical species made by this recipe is an interesting problem, which future research will probably resolve, although the utility of the blue pigment produced remains doubtful.

Orna, Low, and Julian (1985) carefully examined the recipes for blue pigments requiring silver as a starting material. They conclusively showed that medieval silver contained some copper and that this copper content was responsible for the formation of the required substances. In describing how to make the best azure, the *Mappae clavicula* instructs:

> [recipe ii] [T]ake a new pot that has never been used for any work and set in it sheets of the purest silver, as many as you want, and then cover the pot and seal it. Set the pot in the must that is discarded from a wine press, and there cover it well with the must and keep it well for fifteen days. Then uncover the pot and shake the efflorescence that surrounds the sheets of silver into a bowl. (Smith and Hawthorne 1974:26)

Pure silver strips did not react during laboratory trials of this recipe using 5 M acetic acid, while silver alloys with some copper produced cupric acetate monohydrate, neutral verdigris. Alloy samples treated with acetic acid and horse dung also produced cupric acetate but apparently of a different structure—larger and more perfectly formed—than the product formed with acetic acid alone. Single crystal X-ray crystallography work showed that the structure of this cupric acetate was identical with $Cu_2(CH_3COO)_4 \cdot 2H_2O$, tetra-μ-acetato-bisdiaquocopper(II), a dinuclear species. Orna (1996) states that this compound may form because of the slower reaction rate for the silver-copper strip exposed to the acetic acid and horse dung compared with exposure to acetic acid alone. This is a little perplexing, since many copper compounds, such as copper acetates, are actually dimeric in structure. The formula shown here for the dinuclear species is, in fact, simply neutral copper acetate monohydrate stated in a more complicated way; there is really no significant difference (de Meester, Fletcher, and Skspski 1973).

Merrifield (1849) records a great deal of relevant information about pigments from another Paduan manuscript, *Ricitte per Far Ogni Sorte di Colori*, MS 992 in the Library of the University of Padua. This manuscript apparently originated in Venice and probably dates to the middle or late seventeenth century. By this time, the chemical procedures had become quite complex and are sometimes difficult to interpret, as shown by the following recipes:

> [recipe 16] To make a good green of verderame—Take 10 parts of verdigris, 2 of corrosive sublimate, ½ a part of saffron, ¼ of galls of Istria, and ½ of sal ammoniac, grind them up with very strong vinegar (distilled vinegar is the best), put them into a glass vase, and when the vinegar is clear and coloured, let it be decanted and evaporated in a glazed vase. Then pour fresh vinegar on the remainder, mix again and do as before, until the part which settles ceases to colour the vinegar, and if you pour the coloured vinegar into shallow open vases, it will dry much quicker either in the sun or in the shade. When dry remove the colour

gently by dipping the brush in the vinegar, and afterwards grind up the colour with a little roch alum and a little gum arabic, so as to make it into a cake. (Merrifield 1849 : 658, 660).

Since corrosive sublimate is mercuric chloride, this recipe may have been corrupted by incorrect copying of the original source. Consequently, the synthesis was not attempted in the laboratory. It is interesting, however, to see how alum and ammonium chloride commonly appear in recipes for these synthetic greens and blues.

This recipe in MS 992 calls for "tartar of Bologna," which is approximated by the modern cooking aid "cream of tartar" (sodium potassium tartrate):

[recipe 17] To make another brilliant green—Take oz. vi of the best verdigris, oz. ij of tartar of Bologna, and dr. j ss. [weight units] of roch alum.; pulverize the whole, and grind each article separately, then grind them together rather stiffly with distilled vinegar, put the powder into a glass vase with a little saffron, and expose it to the sun. Then pour on it a bocale [jug] of distilled vinegar, and the longer it is exposed to the sun the more beautiful will be the colour. (Merrifield 1849 : 660).

"Roch alum" is potassium aluminium sulfate. A recent laboratory synthesis of this recipe is given in APPENDIX B, RECIPE 20.

The same manuscript contains a recipe for refining verdigris:

[recipe 32] How to refine verdigris—Take the verdigris, grind it well, steep it in the best vinegar for 3 or 4 days, strain it, then pour the strained liquid on other well-ground verdigris; let it settle for 2 days more, strain it again gently, leaving the lees of the verdigris at the bottom of the vase; put the liquid which has been strained in a glass vessel with a little saffron, and keep it well covered. (Merrifield 1849 : 664).

This recipe is fairly straightforward: crude basic verdigris is dissolved in good quality vinegar. The residue is decanted from the solution, which is then left to slowly evaporate in a covered vessel. This will produce a crystalline deposit of refined, neutral verdigris.

Another recipe from MS 992 for green verdigris is as follows:

[recipe 33] A most beautiful green colour—Take the powdered verdigris, dissolve it with lemon juice, and let it settle for 24 hours; then strain the most fluid portion very carefully, leaving the lees at the bottom of the vase. Put the strained liquid into a glass vase, and add to it a little of the above-mentioned pasta verde, let it dry, and when you use it, add to it some more lemon juice, and the more you add the more beautiful the colour will be, so that it will be like an emerald; take care, however, that you do not permit the brush to touch water. (Merrifield 1849 : 664).

This recipe was replicated in the laboratory using distilled verdigris (ordinary verdigris dissolved in acetic acid and crystallized out) and freshly squeezed lemon juice. After mixing, the solution was allowed to stand for twenty-four hours; it was then decanted into a dish to remove the lemon-juice sediment. After a few hours, a light green crust began to crystallize out on the surface of the dish, and this deposit was removed for analysis. Eventually, the remainder of the solution solidified into a sticky green mass. Debye-Scherrer powder X-ray diffraction identified the light green crust from the dish surface as cupric citrate pentahydrate (ICDD 1-091), $Cu_4[HOC(CH_2COO)_2(COO)]_2$. Citric acid, 2-hydroxy-1,2,3-propane tricarboxylic acid, is one of the major components of lemon juice, and the transformation of distilled verdigris to cupric citrate in this recipe is not unexpected. The powder X-ray diffraction data for this recipe are given in APPENDIX D, TABLE 19.

Color measurements were made of samples of the distilled verdigris and of the cupric citrate, both ground in gum arabic as pigment preparations. The color shift of the cupric citrate toward green compared with that of distilled verdigris is seen in FIGURES 9.1 and 9.2. Verdigris has different CIEL*a*b* coordinates; the peak maxima of copper citrate is around 520 nm while neutral verdigris is at 495 nm, which is significantly more into the blue range of the spectrum. The formula is therefore a workable recipe for preparing a green pigment from verdigris. To the author's knowledge, no identifications of copper citrate used as a manuscript or painting pigment have been reported. Positive identification of this pigment, however, would require removal of a small sample, and this is rarely possible in manuscript studies, especially since the identification of a copper citrate green from a very small sample could prove problematic.

These citrate and tartrate salts of copper have dubious stability. The GCI Museum Research Laboratory's preparation of the copper (II) citrate appeared to be stable and granular for several months, kept in a polyethylene bag exposed to ambient light levels in the laboratory. After about a year, however, the larger mass of crystals began to turn much darker in color, and the outer surfaces of the citrate developed into a viscous, dark green mass. Further study of these compounds is required to evaluate their stability in glair or gum arabic. The *pasta verde* (green paste) referred to in the MS 992 recipe is actually a sap green added to the preparation to produce an even brighter green color. The sap green may have other properties in terms of complexation of copper ions and so could potentially act as a stabilizer of the prepared pigment.

Turner (1998) draws attention to the recipe collection of Johannes Alcherius, whose treatise dates from around 1411. Alcherius gives a recipe not only for a copper citrate but also for copper tartrates and for various combinations of copper greens mixed with organic dyestuffs (Merrifield 1849 : 3–9, 45, 90, 95). The recipes compiled by Alcherius and used by illuminator Antoine de Compeigne are of interest for their observations on the corrosive nature of these green pigments. In fact, de Compeigne suggested neutralizing this property by adding gladiolus juice (Merrifield 1849 : 284, 286, 288), which may have acted as a stabilizer similar to the sap green discussed earlier.

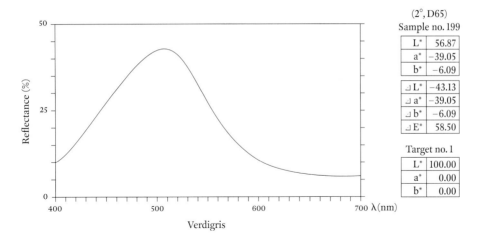

(2°, D65)	
Sample no. 199	
L*	56.87
a*	−39.05
b*	−6.09
⌐L*	−43.13
⌐a*	−39.05
⌐b*	−6.09
⌐E*	58.50

Target no. 1	
L*	100.00
a*	0.00
b*	0.00

FIGURE 9.1 Visible spectra for verdigris.

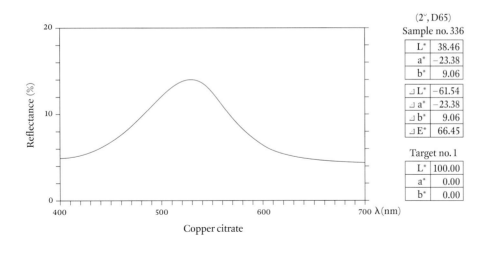

(2°, D65)	
Sample no. 336	
L*	38.46
a*	−23.38
b*	9.06
⌐L*	−61.54
⌐a*	−23.38
⌐b*	9.06
⌐E*	66.45

Target no. 1	
L*	100.00
a*	0.00
b*	0.00

FIGURE 9.2 Visible spectra for copper citrate.

MS 992 gives the following recipe for the manufacture of an ink:

[recipe 69] To write green letters—Take strong vinegar, powdered gum arabic, verdigris, and roch alum, all at discretion, mixed with the juice of rue, and made so liquid that the mixture will flow like ink. (Merrifield 1849 : 678).

Distilled verdigris was used to duplicate this recipe, along with white wine vinegar, powdered alum,[19] and a solution of gum arabic. The mixture produced a green liquid that could be painted on card, and it clearly produced a brighter green color than verdigris alone. Juice of rue[20] would add to the solubilization of the mixture because the porphyrin ring structure of the chlorophyll in the plant juice could replace copper for magnesium in the complex. This would help to make a brighter green ink for manuscript lettering. Because the product is so complex, it is very difficult to determine if the concoction had been used for green lettering on manuscripts.

The following recipe was not reproduced during the author's investigations. The rationale behind the formula is difficult to understand, and the presence of quicksilver and of the need to grind it with other ingredients makes it potentially hazardous:

[recipe 74] A most beautiful green for miniature painting—Take equal quantities of verdigris, litharge of gold, and quicksilver, grind them all to a fine powder with urine, and put them into a bottle, which you must bury in horse dung for 20 days; then take it out, grind the verdigris again, and you will have a most noble green for miniatures, writing, and painting. (Merrifield 1849 : 680).

In the recipe that follows, the verdigris starting material, which was probably impure, is first converted to the neutral salt by dissolution in vinegar:

[recipe 82] To make a green for miniatures and painting—Take verdigris, dissolve it in vinegar, and when it is well dissolved strain it through a fine cloth; then grind it up well on the porphyry slab with clear water, adding honey during the grinding. Let it dry, and again grind it up with gum water, and it will be done. (Merrifield 1849 : 682)

Grinding the mixture with honey produces a complex product of copper salts of sugars. This was probably mixed with some neutral verdigris, depending on the quantities of the ingredients used.

The following recipe from MS 992 is for verdigris. A replication experiment for this account is described in APPENDIX B, RECIPE 21.

[recipe 130] To make verdigris—Take pieces of copper anointed with purified honey, and fasten them to the cover of a well glazed pot, which must be full of hot vinegar made with strong wine; then cover it and place it in a warm situation for 4 or 5 weeks, and when you uncover it, remove the colour which you find on the pieces of copper, and it will be most beautiful. (Merrifield 1849 : 706)

In China, verdigris was prepared as both a pigment and a medicinal by at least the early centuries B.C.E. (Needham 1974), using the familiar technique of exposing copper to the fumes of warm vinegar. Verdigris solutions were also applied to the surfaces of wooden objects as a stain and to prevent biodeterioration of the wood.

The following is a recipe for a synthetic blue pigment:

> To get a blue pigment from copper one must mix three tean [tenths of an ounce] of the rust of copper with seventeen tean of sal ammoniac and boil this mixture with pure water. Hhienepann who lived in the Han Dynasty was the inventor of this pigment. (Needham 1974 : 244)

Assuming that the rust of copper is copper (I) oxide, cuprite, this recipe was followed using 1.5 g of cuprite and 8.5 g of ammonium chloride. The light blue-green precipitate that formed was identified by X-ray diffraction as pure atacamite. Details of this replication experiment are found in APPENDIX B, RECIPE 22.

Needham mentions an ancient text by Sun Ssu-Mo, who refers to coloring verdigris with indigo to give it a bluer color. Needham calls the mineral discussed "malachite," since malachite is green, but this may not be correct. Perhaps azurite is really implied by Sun's text. The blue pigment described would have been useful in both fresco and scroll painting, according to Needham (1974: 136).

A Chinese text originally translated by Klaproth and discussed by Needham gives the following instructions for making green pigment. As mentioned in CHAPTER 3, this recipe can actually produce chalconatronite, $Na_2Cu(CO_3)_2 \cdot 3H_2O$:

> To get a fine green pigment from copper one must calcine the rust [to make a copper oxide] and then boil it with white alum in a sufficient amount of water. After it has cooled it will be green, and one must add some natron solution [a naturally occurring mixture of sodium carbonate, sulfate, and chloride] which will precipitate the green colour called *hsiao lu se*. This is used in painting for the colour of plant and bamboo leaves. (Needham 1974 : 32)

Bukhari (1963) discusses an Indian manuscript describing pigment recipes prepared during the reign of Aurangzeb (1618–1707), the last of the great Mughal emperors of India. The manuscript, known as the *Asrarul Khat*, was written by Fadlu'llah Ansari wal Faruqi in 1690. Recipe 4 of this manuscript describes the production of a good quality of "zangar" (verdigris):

> [recipe 4] [T]ake one rati [weight unit] of naushagar [sal ammoniac] and half rati of copper scraps, put them in a pot and pour grape vinegar drop by drop into the vessel and with the help of a stick, whose top should be flat, grind the admixture in the pot till it becomes zangar. (Bukhari 1963 : iii)

THE ORGANIC SALTS OF COPPER

This recipe will produce a mixture of the basic copper chlorides, principally atacamite, with copper acetates, depending on the extent to which the "naushagar" (sal ammoniac) has acted to convert the copper scraps to the chloride before the grape vinegar is added. Almost certainly the final product will be a complex mixture of salts. A laboratory replication, described in APPENDIX B, RECIPE 23, produced neutral verdigris, rather than atacamite, with a little residual ammonium chloride.

Ancient Indian texts apparently do not mention recipes for verdigris because the pigment was obtained from Persia during the early centuries C.E., according to Agrawal.[21]

The *Asrarul Khat* gives another recipe for the preparation of ordinary verdigris: "Put the specks of copper in a copper pot, crush them with curd and let the mixture be dried up for three days and nights. The zangar will be ready for use" (Bukhari 1963 : iii).

Banik (1989) states that the use of sour milk, instead of vinegar, was also common in Russia and cites Radosavljcvic (1972), who noted that the use of sour milk or curd for preparing pigment was quite common in some regions.

Purinton and Watters (1991) briefly review some information on Persian green pigments from the medieval period, although the data are somewhat incomplete. The most common green was described as verdigris. Dickson and Welch (1981) translate the canons of painting by the medieval writer Sadiqi Bek, whose recipe for the preparation of verdigris calls for digging a pit 2 m deep and burying in it for a month copper plates that have been immersed in wine vinegar.

Rather than completely converting copper surfaces to verdigris, corrosion by plant or animal materials—such as garlic or curd—could also be employed to alter the copper surface. For example, the deliberate corrosive etching of copper plates used for oil painting was done to make the imprimatura adhere thoroughly to the copper substrate. Palomino de Castro y Velasco ([1715–23] 1944) recommends that the flat surface of the copper should be prepared by rubbing it with garlic juice, which would dissolve the oxide layer and produce a scoured surface for painting.

In a number of instances, the corrosion of copper to produce verdigris actually produces one of the copper trihydroxychlorides (discussed in greater detail in CHAPTER 4). For example, Naumova and Pisareva (1994) report a diversity of copper compounds used as pigments in Russian frescoes from the early sixteenth century. They conclude that most historical recipes do indeed refer to the production of copper acetates, with a smaller number producing atacamite. This was confirmed by Banik (1989), who reported paratacamite and other basic copper chlorides as pigments from fifteenth- and sixteenth-century illuminated manuscripts. These basic chlorides were mostly sampled from undeteriorated areas of the manuscripts. This is of particular interest because a common decomposition product of verdigris salts on interaction with chlorides is one of the copper trihydroxychlorides. The fact that the chloride salts were found in undeteriorated areas suggests that this is not the etiology in this case.

Examination of small samples of verdigris from illuminated manuscripts always presents the problem of how to obtain a sample without obvious damage to the manuscript. Banik (1989) devised a sampling technique that avoided this difficulty. It used a polished resin block, equipped with a fine copper grid, that was simply pressed against the surface being sampled. He found that a sufficient number of pigment particles adhered to the resin without the use of any additional adhesive. The adhesion was strong enough to prevent migration or dislocation of the particles during analysis. The block loaded with the sample was viewed under a light microscope; the copper grid ensured a convenient coordinate system for electron microscopy and for quantitative analysis of the copper compound. Analytical studies showed that with increasing degrees of surface damage, a corresponding decrease in the copper content of the remaining pigment particles occurred, as low as 8–10% by weight, making it impossible to identify the original pigment that was present.

Banik (1989) also discovered that a recipe for making verdigris, dating to the eighteenth century, actually produced posnjakite, $Cu_4SO_4(OH)_6 \cdot H_2O$, rather than a carbonate or an acetate.

Problems with verdigris	Copper acetates slowly change color in binding media: with resins, they form copper resinates; with oils, copper oleates; and

with proteins, copper-protein compounds. The reaction of copper with oleic acid was reported by Gates (1911), who found that when clean pieces of copper were placed in oleic acid, the solution gradually became a deep green color. Loss in weight of the chemical reaction in this case probably resulted from the liberation of hydrogen, as described by the following:

$$Cu + 2C_{17}H_{33}COOH = (C_{17}H_{33}COO)_2Cu + H_2 \qquad 9.2$$

Both stearic and palmitic acids, when melted onto copper foil and fused for a minute, produced green-colored pastes, showing that reaction had occurred between copper ions and the contiguous fused solid, resulting in the formation of copper (II) stearate and copper (II) palmitate.

The possibility of verdigris causing problems because of its solubility was well known for centuries. Leonardo da Vinci (1452–1519), for example, remarks that verdigris ground in oil can last only when varnished immediately after it has dried, otherwise "it not only fades, but may be removed by a wet sponge, especially in humid weather. This is because of its saline nature; it becomes deliquescent in a moist atmosphere" (Eastlake 1847: 458).

This behavior would be particularly true with distilled verdigris, whereas some of the basic salts or other products masquerading as verdigris would not necessarily be affected by very humid weather.

Eastlake comments on Leonardo's observations on humid conditions by adding that "the mode of 'locking up' verdigris may exemplify the means by which all colours liable to be affected by damp, can be rendered durable. The colour was mixed either with a strong oleo-resinous vehicle…or with varnish only" (Eastlake 1847: 459).

Thompson (1932) notes that the Italian painter and author Cennino Cennini (ca. 1370–ca. 1440) used both lead white and verdigris to assist in the drying and consolidation of cements. Eastlake (1847) also reports that Cennini was well aware of the siccative power of verdigris. As the artist states:

> If you wish this mordant to last [that is, to remain adhesive] for a week before gilding, put no verdigris; if you wish it to last four days, put a little verdigris; if you wish the mordant to be good for a day only, put much verdigris. (Eastlake 1847:136)

Additional effects of the copper acetates include activity as an antioxidant in linseed oil, a protector of nonsaponifiable fractions of drying oils, and a drying promoter. There are many examples of Indian miniatures, for example, that have partially deteriorated, especially in areas where verdigris is present.

THE COPPER RESINATES

The dissolution of verdigris in a resin produces the so-called copper resinate pigment group. This was a way of treating verdigris to create a good-quality green pigment. Eastlake (1847), quoting Samuel van Hoogstraten (1627–78), remarks that satisfactory green pigments were not as easily obtained as other pigments and that terre verte is too weak, verdigris (basic copper acetate) too crude, and green bice (malachite)[22] not durable.

When copper resinate pigments were first made is not precisely known, although they may have been used in manuscript illumination as early as the tenth century, but this needs to be confirmed. Copper resinates were primarily used from the fourteenth to the sixteenth century; they are not common after the end of the sixteenth century.

In his *De Mayerne Manuscript* of 1620, the English court physician Théodore Turquet de Mayerne (1573–1655) records the following recipe for treating verdigris to produce a good green pigment:

> Bouffault, a very excellent workman, gave me these secrets on his deathbed. A beautiful green. Take of Venice turpentine two ounces, spirit of turpentine an ounce and a half, mix them, add two ounces of verdigris, reduced to small fragments. Place these ingredients on hot ashes, and let them gently dissolve. Try the colour on glass. Pass it through linen. (Eastlake 1847:142)

Grinding verdigris with oil will also produce a kind of copper resinate. Eastlake provides the following instructions for one from *Liber de coloribus illuminatorum sive pictorum*, a manuscript in the British Museum (Sloane MS 1754) that probably dates from the fourteenth century:

Grind white [lead] with wine for parchment, but with oil for wood and for walls. In like manner grind and temper green [verdigris] with oil for wood and with wine for walls, or, if you prefer it, with oil.... but for books do not grind it, but suffer it to dissolve in good and very clear white wine. (Eastlake 1847: 146)

Woudhuysen-Keller and Woudhuysen (1998) replicated the de Mayerne recipe. They make a distinction between verdigris dissolved in pine resin, which they call "copper resinate I," and verdigris dissolved in a hot oil and pine resin mixture, which they call "copper resinate II," although any clear-cut distinction may be difficult to establish in works of art. They note that the terminology for oils was not clear at the time de Mayerne was writing, about 1620–40 (Graaf 1958). Thus the Venice turpentine called for in the recipe may not have been the equivalent of modern Venice turpentine, which is the balsam of the larch tree. It was found to be ineffective in dissolving verdigris. The same problem was found with Strasburg turpentine, which is an exudation from the fir tree (genus *Abies*).

In their replication of de Mayerne's recipe, Woudhuysen-Keller and Woudhuysen found it simplest to omit the spirit of turpentine and to use only a pine balsam, such as Bordeaux balsam, as the solvent instead of the Venice turpentine. As the verdigris dissolved, a large quantity of colophony (rosin) was added until the solution turned clear. When the solution was heated carefully for two hours at a temperature not exceeding 150 °C, a mossy green, glassy mass of resinate formed. It consisted of green isotropic particles with conchoidal fracture and a refractive index lower than 1.66. If insufficient colophony is used, undissolved verdigris particles are seen in cross section. The copper resinate can then be ground and mixed with linseed oil, varnish, or spirit of turpentine.

De Mayerne also mentioned making the resinate by grinding verdigris with linseed oil and then adding common varnish, stirring well, and decanting the clear liquid from settled impurities. Woudhuysen-Keller and Woudhuysen mixed one part of verdigris with four parts of linseed oil and heated the mixture slowly to 80 °C. Eight parts of colophony were then added in small lumps,[23] and the temperature was raised to 120 °C. This method produces a deep green solution that, when used cold, draws threads and is difficult to spread with a brush, although it makes a softly rounded impasto.

Laurie (1914) used the ferrocyanide test to show that the transparent greens used in the manuscripts he studied were copper-based rather than vegetable-based greens. On one manuscript, Laurie observed some crystalline particles that were only partially dissolved in the green, and he determined them to be azurite. Since azurite is not readily soluble, he supposed that it had been treated with vinegar, evaporated, and then dissolved in pine balsam, with a few particles escaping decomposition.

The first use of copper resinates in paintings is found in early Netherlandish and Italian works. These paintings often show a brown discoloration at the surface due to deterioration,

and this may be caused by Venice turpentine being used to make the copper resinate pigment. Mills and White (1977) note that although Venice turpentine is often mentioned in early copper resinate recipes, it is not entirely satisfactory for this purpose because it dries to a yellowy, brittle film. Venice turpentine contains a high proportion of neutral components; consequently, there are fewer acid groups to react with the copper compounds to form a resinate pigment. Pine resin, as used in a painting by Raphael (1483–1520) cited by Mills and White as a salient example, consists almost entirely of resin acids and is much more suitable than Venice turpentine as the pigment medium.

The usual medium for copper resinate, however, is one of the drying oils. In fact, Cennini mentions that verdigris should be used ground in a drying oil even when the rest of the painting may be in tempera, as with the Raphael work mentioned by Mills and White.

There are many historical sources that draw attention to the use of glazes over the copper resinate layer to change the color, but these glazes themselves may discolor, creating difficulties for conservation practice and for the identification of the materials in these organic glazes (Woudhuysen-Keller 1995).

Italian painter and author Giovan Battista Armenini (1530–1609), writing around 1580, also refers to verdigris and mentions an interesting mixture with soot and oil to form a dark varnish. He writes that soot of rosin is incorporated

> most beautifully with verdigris, well ground with oil. One third part of verdigris is used to two thirds of soot, and they are mixed together on the stone with some oil and a little common varnish. This varnish is of such quality that it gives strength to all colours that suffer upon drying. (Armenini 1977:66)

Kockaert (1979) noted that dark greens and some gray or whitish tones on fourteenth- to sixteenth-century paintings from the Netherlands often appear brownish, adding that these transparent browns cannot be confused with general varnishes because they are limited to particular areas with a definite pictorial imagery. The most probable explanation for the presence of these layers, according to Kockaert, is that the artist altered the color balance of the resinate layer by the addition of other oil-based pigments, for example, that could have influenced the degree of deterioration of the resinate layer. Kockaert also examined more than one hundred cross sections, including thirty-three thin sections, from fifteenth- and sixteenth-century paintings. In some paintings, the copper resinate was still perfectly green; in others, it exhibited extensive brown discoloration, mainly at the surface, to a depth of 1 μm or more.

For example, a sample of resinate from Jan van Eyck's (1390–1441) *Mystic Lamb* in St. Bavon Cathedral, Belgium, appeared different from samples of resinate in other paintings by a certain heterogeneity due to darker grains and by its retention of a good green color. Kockaert demonstrated that if a copper resinate has been protected from light, it will survive in much better con-

dition than if exposed to ambient light. The discoloration of the transparent greens in the van Eyck painting was not linked to the presence of remnant blue-green grains, which did not show any sign of attack by the medium. Therefore, it appears that photochemical activity was an important aspect of the deterioration of these copper resinate layers. This brown discoloration differed from the brown glaze over the resinate layers by its continuity with the green and by its characteristic hue, often a light orange brown in transmitted light. Leonardo mentions the use of aloe for the purpose of conferring additional stability on the copper greens: "If you have finished a work with simple green [a copper green] and you glaze it thinly with aloe dissolved in water, then the work has a very beautiful colour" (Leonardo [1651] 1956:88).

Alternatively, a protective layer or varnish could have been applied on surfaces painted with verdigris pigment, as suggested by Merrifield (1849).

| *The chemistry of copper resinates* | A series of experiments were conducted by Kühn (1970) in which prepared samples of copper resinate were exposed at 20 °C and 55% RH to high-intensity shortwave ultraviolet radia- |

tion and to light from xenon lamps, fluorescent tubes, and daylight, with the exposure equivalent to 120, 60, and 5 years. A brown discoloration was noticed in the samples exposed to the high-intensity shortwave ultraviolet radiation. This was also noticed in tests carried out at the National Gallery of Art, London.

As with the verdigris pigments, some of the recipes for copper resinates call for chemical additions that may produce a series of complex reactions with the original verdigris component. Birelli (1601), for example, mentions that the preparation of a "green like the emerald" starts with linseed oil, rock alum, and good quality verdigris, with the subsequent addition of pine resin. In recipes such as this, the addition of potassium aluminium sulfate is commonly used as a reagent with copper salts (see CHAPTER 5 for further uses of sulfates).

A variety of resinous mixtures could have been mixed with verdigris to create copper resinate pigments. One recipe recounted by Kühn (1993) calls for purified neutral verdigris to be well ground with one part walnut oil, two parts turpentine distillate, and one part pine resin. If resins from conifers are used, the principal copper salts expected to form are those of abietic acid, $C_{19}H_{29}COOH$; the major components of colophony, which is the primary residue from the distillation of turpentine, are abietic, dehydroabietic, pimaric, isopimaric, and sandaracopimaric acids.

Detailed chemical studies of copper resinates used in works of art demand sophisticated organic analysis techniques. Mills and White (1987) used such techniques when they examined Raphael's *Saint John the Baptist Preaching* in the collections of the National Gallery of Art, London. The paint medium was oil, but the green paint, after saponification and methylation, showed a gas chromatogram that revealed the presence of methyl dehydroabietate and methyl

7-oxydehydroabietate as well as copper. Mass spectrographic analysis also gave results consistent with the inference that the original organic component had been pine resin and that the oxidation of the abietadiene acids in the resin had produced dehydroabietic acid and 7-oxydehydroabietic acid.

The most reliable method to detect the presence of copper resinate is gas chromatography–mass spectrometry of the relatively stable dehydroabietate component of the resinate films, according to Mills and White (1987). That copper resinate greens can be made from verdigris, prepared, in turn, from bronze or bronze scrap was shown by analysis of Raphael's *The Holy Family* in the collections of the J. Paul Getty Museum. Nondestructive microscanning X-ray fluorescence spectroscopy revealed some tin content in the copper resinate used in the painting.[24] *The Holy Family* is shown in PLATE 58, and a cross section of the copper resinate used in this painting is shown in PLATE 59.

Copper salts of higher acids	Apart from their occurrence as corrosion products (discussed later in this chapter), copper salts of higher acids, such as cupric oleates, maleates, and stearates, may also be found as pigments.

Using Fourier transform infrared (FTIR) spectroscopy, Moffett, Sirois, and Miller (1997) report the probable identification of a mixture of the fatty acids copper palmitate and copper stearate on two late-eighteenth-century Naskapi Indian artifacts, a coat and a pair of leggings. The Naskapi were an Algonquian-speaking people who inhabited the Quebec-Labrador Peninsula; museum collections of this tribal group are widely dispersed. The green pigments on the artifacts gave no X-ray diffraction pattern, indicating that they are poorly crystalline or X-ray amorphous. The use of green colorants is not common in Naspaki objects, and the copper salts of these fatty acids may have been prepared locally rather than imported as prepared pigments.

Copper proteinates	A neglected topic in connection with the resinates is that of the copper proteinates. Verdigris pigments and other copper salts

can react with proteinaceous media to form copper-protein complexes that can be used as pigment preparations in much the same way as a copper resinate. This subject has not received a great deal of attention in tems of artist's materials, although the chemical reactions between copper ions and proteins has been the subject of a considerable body of research. Copper proteinate pigments can be made from ingredients such as sturgeon glue, gelatin derived from vellum, or perhaps the lees of wine, which are mentioned in some historical texts. Cennino d'Andrea Cennini (ca. 1370–1440), author of *Il libro dell'arte* (The craftsman's handbook) of 1437, mentions that verdigris is a useful color on paper when mixed with egg yolk. He writes, "Work it [the verdigris] up with vinegar, which it retains in accordance with its nature … and it is especially good on paper or parchment, tempered with yolk of egg."[25]

There are some published reports of copper-protein compounds being used in illuminated manuscripts. Laurie (1914), for example, reports a grass-green, transparent, copper-containing pigment in illuminated manuscripts from the eighth to the fourteenth century, and Flieder (1968) mentions the same occurrence in illuminated manuscripts from the tenth to the fifteenth century. These pigments were identified as copper proteinates. The GCI Museum Research Laboratory was also able to identify a copper proteinate used as a dark green pigment, applied in selective areas of design over verdigris, in the von Ems illuminated manuscript *Barlaam und Josaphat*, which is discussed earlier. Evidence for the copper proteinate was derived from scanning X-ray fluorescence microanalysis (Scott et al. 2001), which showed enhanced concentration of copper in the dark green areas, and from the determination of the presence of protein by FTIR microscopy.[26] Analytical studies by gas chromatography–mass spectrometry confirmed that the amino acid composition of this copper proteinate matched that of egg, validating the comments by Cennini concerning the use of egg mixtures with verdigris as a stable manuscript pigment.

Roosen-Runge (1967) reports a glassy green paint that showed discrete particles of what was assumed to be verdigris on manuscripts from the Middle Ages. More work is required to confirm the extent to which copper resinates or copper proteinates were actually used for illuminating manuscripts.

ORGANIC SALTS OF COPPER AND BRONZE CORROSION

Copper acetates can occur on bronze antiquities either as components of deliberate patinas produced by modern chemical techniques (Hughes and Rowe 1982) or as undesirable alteration products due to poor storage conditions (Oddy 1975; Tennent and Baird 1992; Tennent et al. 1993). Some of the first cogent observations that display or storage can cause corrosion of bronze objects was from work done at the British Museum (Werner 1972).

Corrosion problems in the museum environment | In the past, oak and mahogany were often used for the construction of museum display or storage cabinets in England. Starting in the early 1970s, however, the increasing price of timber resulted in a host of new laminated plywoods and chipboard being used by museums. These plywoods can release large amounts of acetic acid, formic acid, formaldehyde, and sulfides. Fresh oak, in particular, produces unacceptable emanations of acetic acid, with concentrations reaching as high as 50–200 ppm in a confined space. These new materials create a large number of problems for both conservators and curators, more so than old polished woods, many of which are of the Victorian period, that are probably now dormant with little or no outgassing of pollutants.

Emanations harmful to copper are not always from the wood but may come from associated materials such as flame retardants and preservatives. For example, African mahogany tested many years ago at the British Museum Research Laboratory (Oddy 1974a) was approved for use in display cases, but copper alloys placed in the cases tarnished. The problem was traced to the wood preservative, probably a phosphate derivative used to treat that particular batch of mahogany before it left Africa.

Concentrations of formaldehyde, acetic acid, or formic acid in the tens or hundreds of parts per million range are not acceptable in the museum context; the levels of these pollutants should probably be in the low parts per billion range for overall safety of the collections. This general recommendation is based on numerous museum surveys conducted for the Getty Conservation Institute by Grzywacz (1993) and by Grzywacz and Tennent (1994). Thickett, Bradley, and Lee (1998) attempted to provide a wider perspective to the problem. Their experimental work showed that at 100% RH, acetic acid created severe corrosion of lead coupons; formic acid was less corrosive, and formaldehyde the least. At 50% RH, the acetic and formic acids were less corrosive, and no corrosion was observed with formaldehyde, although the concentrations used in the experimental work were not stated in the publication.

Thickett, Bradley, and Lee monitored the internal environment of a display case containing leaded bronzes and found 175 ppb of acetic acid but no corrosion. Their examination of Egyptian bronzes that had been stored in wooden drawers inside wood cupboards since the 1930s, however, showed an unusual blue corrosion product. The relative humidity reached a maximum level of 45% inside the cupboards; the acetic acid level was about 500 ppb in one example and greater than 2500 ppb in another.

A direct relationship was found between the levels of acetic acid and the percentage of objects that had been damaged by the formation of the blue corrosion product. There was no evidence that corrosion was ongoing, however; lead coupons placed in the cupboards were uncorroded after two years of exposure. One possible explanation is that since the 1930s museum heating has improved, the cupboards have become seasoned, and consequently the relative humidity has fallen to levels at which bronze corrosion cannot readily proceed. If this is the case, it suggests that controlling relative humidity is crucial in cases where high levels of these pollutants are present.

Another example of corrosion on displayed bronzes is an Egyptian torque (a necklace of twisted bronze) from the Burrell Collection in Glasgow, Scotland, that was exposed for ten years in a wooden cabinet that contained high levels of acetic acid. The bronze had developed patches of light blue corrosion products.

It is very difficult to determine the exact constituents of the corrosion products formed on artifacts in storage or on display and whether some products, in fact, represent new compounds occurring as corrosion products, not previously described. For example, corrosion from copper

foil that had been exposed to acetic acid vapor and corrosion from an Egyptian bronze in the collections of Marischal College, University of Aberdeen, Aberdeen, Scotland, gave powder X-ray diffraction patterns that could not be identified (Tennent et al. 1993), but as the data now available are more detailed, it should be possible to at least identify the product from the exposure of the copper foil to acetic acid. Ion chromatography was only partially helpful in identifying the material; the corrosion on the foil was probably a basic copper acetate, but minimal acetate or formate content was found in the light blue corrosion on the Marischal bronze.

X-ray diffraction data were collected for representative examples of light blue corrosion products on bronze objects as part of a collaborative study at the GCI Museum Research Laboratory, with samples provided by Tennent. The light blue to blue-green samples of corrosion were from Egyptian bronzes in the collections of the Museum of Fine Arts, Boston; the Fitzwilliam Museum, Cambridge, England; Glasgow Art Gallery and Museum, Kelvingrove, Scotland; and the Burrell Collection.

Appendix D, table 20, presents data from the head of an Egyptian bronze of Min-Amun in the collections of the Fitzwilliam Museum. The data reveal that some of these corrosion products are of chalconatronite, or of compounds related to chalconatronite that may have formed during storage and contain sodium, copper, carbon, oxygen and hydrogen, but whose structure remains to be elucidated. Other entries show that at least some of the identified compounds are, in fact, malachite, calcite, and connellite (the connellite found on this bronze is discussed in chapter 6). Chalconatronite is not uncommon as a corrosion product on Egyptian bronzes, although in the absence of detailed treatment records, it is possible that the chalconatronite could have been produced as a result of patina alterations when the object was soaked in sodium sesquicarbonate solutions, resulting in the slow crystallization of chalconatronite during long periods of storage.

Another group of objects of interest are from Kelvingrove, which provide further examples of the formation of unusual corrosion products as a result of alterations occurring during storage or display in polluted showcases. A bright blue crystalline deposit from one object in Kelvingrove gave the X-ray diffraction pattern shown in appendix D, table 21 (GCI XRD no. 612). The data suggest that the compound is closely related to potassium copper carbonate hydroxide hydrate. Environmental scanning electron microscopy (ESEM) data for this salt also revealed the presence of potassium, copper, carbon, oxygen, and a very small peak for sulfur. A number of lines should be present according to the ICDD files that are absent in the sample. Although the elemental analysis corroboration provided by the ESEM data appears reasonable, the identity of the compound cannot be determined with complete certainty. The GCI Museum Research Laboratory was able to isolate some crystalline particles from the sample and, in collaboration with Hardcastle from California State University, Northridge,[27] single crystal diffraction data were obtained; the cell dimensions of the crystal lattice are currently under study.

The match of this Kelvingrove sample to ICDD 28-746, potassium copper carbonate hydroxide hydrate, $K[Cu_2(CO_3)_2(OH)] \cdot 4H_2O$, is far from perfect, which is a good illustration of the problems encountered in these studies where single-crystal data may be hard to determine. Two other corrosion samples from the Burrell Collection have very similar spectra; the data for one of them are shown in APPENDIX D, TABLE 22, along with data for the newly characterized sodium copper carbonate acetate (hydrate) that has been identified by Thickett and Odlyha (2000), who investigated a pale blue corrosion product found on 184 ancient Egyptian bronzes during a survey of 2,840 Egyptian artifacts in the British Museum. The storage cupboards in which these objects were kept contained significant amounts of acetic acid pollutant, between 1071 and 2880 $\mu g/m^3$, and very low levels of other carbonyl compounds. In two cases, the pale blue corrosion matched ICDD 31-453, copper chloride acetate, $C_2H_2ClCuO_2$.[28] By titration, ion chromatography, and thermogravimetric analysis (TGA), it was determined that the unknown pale blue corrosion product had a stoichiometry of 1 : 1 : 1 : 1 in terms of sodium, copper, carbonate, and acetate groups. TGA also indicated the presence of some water of crystallization, and most likely oxide or hydroxide groups are present as well since these are very common components of such compounds. Because the chemical valences can be balanced by assuming a formula of $CH_3COONa \cdot CuCO_3$, it is possible that this new compound is an acetate analog of chalconatronite, the sodium copper carbonate, whose formula can be written as $Na_2CO_3 \cdot CuCO_3$. The logical conclusion is that this new corrosion product formed by reaction of the bronze object with airborne acetic acid, sodium ions present on the surface of the object (either from prior conservation treatments using sodium hydroxide or from naturally occurring halite from the Egyptian soil), and carbonate corrosion products such as malachite. The combination of these four ions as a prerequisite limits the occurrence of this sodium copper carbonate acetate (hydrate) to very localized instances on these Egyptian bronzes from the British Museum. The X-ray diffraction data determined by Thickett and Odlyha are shown in APPENDIX D, TABLE 23.

The two Burrell samples are probably more examples of this new compound. It is not yet proved that these salts are actually a hydrate, but by analogy to other known salts of a similar type that are all hydrated, it is a fairly safe assumption for these samples as well. Scanning electron microscopy – energy dispersive X-ray analysis determined that both unidentified salt samples contained copper and sodium, with substantial peaks for carbon and oxygen and a trace of sulfur. The occurrence of this pale blue corrosion product, a sodium copper carbonate acetate, is probably more common as an alteration product than previously realized, now that reference data have been obtained by Thickett and Odlyha. There are undoubtedly other crystalline deposits from the corrosion of bronze objects on display that await complete characterization.

Tennent and Baird (1992) investigated a white, acicular, crystalline efflorescence on an Egyptian bronze tripod vessel from the Burrell Collection. The salt, which was associated with

the light blue corrosion products mentioned earlier, was characterized as sodium acetate trihydrate, $CH_3COONa \cdot 3H_2O$. The source of the acetic acid was clearly from the display and storage materials being used in the Burrell Collection. The source of the sodium is more problematic. Sodium acetate trihydrate crystals were previously observed on the interior surface of wooden drawers covered with glass. The presence of sodium in conjunction with bronzes may be associated with previous conservation treatments or with sodium-containing corrosion products, either of which is quite possible, especially with ancient Egyptian bronzes. A similar Egyptian tripod vessel, conserved at the Institute of Archaeology, London, in 1982–83, was found to have light blue corrosion patches that were identified as chalconatronite by X-ray diffraction. The data obtained were so detailed that more lines were determined than reported in the ICDD file 22-1458. This tripod had been conserved before 1982 with the sodium sesquicarbonate method. This appears to be another example of chalconatronite occurrence as a consequence of conservation that was first mentioned by Horie and Vint in 1982.

CONSERVATION TREATMENTS

In 1948 a virulent outbreak of corrosion attacked bronzes from the Fitzwilliam Museum in Cambridge, England. These bronzes had been in long-term storage, packed in (probably moist) wood shavings, in caves in Wales during World War II. Evans (1951) studied these bronzes and was convinced that acetic acid released from the wood shavings had corroded them by a mechanism analogous to basic lead carbonate formation on lead objects exposed to acetic acid; this turned out to be an astute observation. A detailed account of the Evans study is given in Dawson (1988).

Evans devised a localized electrochemical treatment procedure for the objects: an inconspicuous area of bare metal was exposed by scraping and was attached by a wire to the positive terminal of a milliammeter. A zinc nib, cut from sheet, was attached to the negative terminal. The nib was dipped in a dilute hydrochloric acid solution ($1\ HCl : 3\ H_2O$) and applied to the corrosion spot. This created a circuit, and the milliammeter registered a current rise as the corrosion was dissolved. When no further increase was recorded, excess acid was blotted away, and the procedure was repeated with the nib dipped next in syrupy phosphoric acid and finally in a 20% (w/v) aqueous solution of sodium carbonate. No external source of electric current was used for this treatment. The Evans technique forms a circuit drawing chloride ions away from the object, and the chloride ions are dissolved by the hydrochloric acid. Next, the phosphoric acid precipitates relatively insoluble copper phosphates, and the sodium carbonate neutralizes any remaining acid on the object.

Although relatively successful, the Evans method was never used outside of Cambridge. It was certainly preferable to total electrolytic reduction, which was still extensively in vogue in Europe at the time. This treatment reduced many important bronzes to shapeless lumps of bare

metal or left them honeycombed like a sponge. The majority of these objects are now kept in museum storage vaults as embarrassing reminders of excessively interventionist treatment. The work by Evans foreshadowed many other developments, notably the use of local reduction methods (Aldaz et al. 1986) and the use of sodium carbonate treatments (Weisser 1987), although these treatments do not seem to be particularly recommended.[29]

Treatment residues and the formation of copper salts	Schrenk (1991) carried out a detailed examination of so-called Benin bronzes from the Republic of Benin in West Africa that revealed the presence of organometallic copper salts on the sur-

faces caused by ill-advised conservation treatments in the past. These Benin bronzes are, in fact, made of copper-zinc alloys and should therefore be referred to as Benin brasses. Some of these objects reached Europe after 1897, when they were appropriated by British forces. Several Benin brasses now in the collection of the Pitt-Rivers Museum, Oxford, were apparently treated many decades ago with neat's-foot oil, although there is no evidence for the use of this substance. FTIR spectroscopy suggests that gum tragacanth, a substance similar to neat's-foot oil, was used instead (Moffett 1996). These same objects, which are now in the collections of the National Museum of African Art, Washington, D.C., exhibited a dark olive-green coating with tarry black deposits in interstices after conservation treatment. The original aesthetic of the Benin art had been drastically altered by the treatment.

Turquoise-colored corrosion was observed on the surfaces of Benin objects from at least three other European collections, although there were individual differences. FTIR spectroscopy revealed maxima that were characteristic of fatty acids. The spectra of the bright turquoise-colored corrosion matched those of copper fatty acid salts and occasionally zinc fatty acid salts, and the probable presence of copper oleate and copper stearate was deduced from X-ray diffraction studies. Brick-red inclusions within the turquoise-colored samples were shown by X-ray diffraction to be cuprite, but there is still the possibility that this cuprite may be part of the original patina that is now detached from the surface by growth of the copper organometallic salts. Moffett (1996) carried out another study on the same cultural material. One Benin bronze from the National Museum of African Art had developed a white surface haze, and Moffett reported that it was difficult to remove the Incralac (see CHAPTER 12) and the polyethylene and microcrystalline waxes from the treated surface. Toluene was tried first, but it left a brittle translucent white residue. Only hot xylene was able to remove this component of the wax. A yellow material was also removed from the surface, and this was identified by FTIR spectroscopy as a copper carboxylic acid, probably a residue from a previous coating removed during treatment in 1984.

The growth of copper salts in the patina of exposed bronzes was reported by Burmester and Koller (1987). They examined the state of preservation of the bronze doors on the Cathedral of Augsburg in Augsburg, Germany, which dates to the second half of the eleventh century, as well as the St. Georgsbrunnen, also in Augsburg. A complex array of corrosion products was found, including a rare form of hydrated brochantite, $CuSO_4Cu(OH)_2 \cdot 2H_2O$.[30] Brochantite was the most stable and usual corrosion product, but some of the other compounds present in the patina included a variety of copper salts and lead salts of organic acids. These organometallics resulted from the application of unsuitable protective coatings based on beeswax, paraffin waxes, or linseed oil during previous conservation treatments of the bronze surfaces. These coatings can liberate free fatty acids or dicarboxylic acids, which will combine with copper or lead ions to form metal soaps.

Copper soaps are especially chemically unstable and promote further corrosion of the bronze. The influence of copper ions, oxygen, humidity, light, and heat causes oxidation of double bonds in unsaturated fatty acids, as well as in alkenes, esters, alcohols, and ketones, resulting in low-molecular-weight fatty acids and dicarboxylic acids, which are more aggressive than the original products. These surface corrosion processes negate the purpose of using these coatings as conservation treatments.

The interaction of bird droppings or other sources of phosphates and oxalates presents a common problem for exposed bronze surfaces, since copper phosphates or copper oxalates will form, resulting in disfiguring corrosion of the patina. Alunno-Rossetti and Marabelli (1976) identified copper oxalates in two studies of bronze statuary in Venice; one occurrence was on the famous gilded bronze horses of St. Mark's Basilica. The same mineral type was also identified on the Marcus Aurelius equestrian statue in Rome (Marabelli 1987), on two statues in Florence (Bernardini et al. 1992), and on the bronze doors of the central portico at Loreto (Mazzeo, Chiavari, and Morigi 1989). Bernardini and coworkers were unsuccessful in determining the exact crystal structure of the mineral. Nevertheless, the authors assigned it a formula of $Cu(COO)_2 \cdot nH_2O$, which is identical to that usually given for moolooite.

Selwyn and colleagues (1996) identified moolooite in two samples from sheltered areas on outdoor bronzes in Ottawa, Canada, and oxalate anions were found as a minor component in the Statue of Liberty patina. Scott and Taniguchi (1999) identified moolooite as a major component of some gray, discolored patches on Italian reproduction bronze sculptures of Roman philosophers and statesmen. These were situated in a sheltered outdoor location along the colonnade of the outer peristyle garden of the J. Paul Getty Museum in Malibu, California, from 1973 to 2000.[31] For nearly twenty-seven years, birds had been using the heads of these statues as convenient resting spots and leaving their droppings on the bronze surfaces, which resulted in corrosion of the bronze and the formation of moolooite.

COPPER SALTS AS PIGMENTS

Green copper pigments　There are many different green pigments, some of which have been described as "verdigris" but which are actually other types of copper salts. The copper-arsenic pigments also have a place in this discussion.

BRUNSWICK GREEN　The pigment known as Brunswick green, whose use goes back to antiquity, was considered a verdigris because it was prepared from copper corroded in the presence of sodium chloride. This is a misnomer, however, since Brunswick green is an example of one of the basic copper chlorides.

Riffault, Vergnand, and Toussaint explain that malachite was too expensive to be generally used in painting in the late 1800s and add that "it has been advantageously replaced, first, by the greens of Brunswick and of Bremen, and afterwards, by that of Schweinfurt and by Mittis green, which are more durable than the two former" (Riffault, Vergnand, and Toussaint 1874 : 227).

Brunswick green was made by the action of hydrochloric acid on copper ores, which produced a variety of copper trihydroxychlorides. Brunswick green, which began to be made around 1795, was named after the town of Brunswick, Germany, where it was prepared by the brothers Gravenhorst. They made the pigment by covering copper filings with a solution of ammonium chloride and leaving the mixture in a closed container. The solid that formed was then washed and dried. It was probably primarily atacamite or possibly an ammonium copper chloride salt. This recipe was replicated in the laboratory using pure copper filings that were kept partially covered with ammonium chloride for four days, as described in APPENDIX B, RECIPE 24. The product that formed was analyzed by powder X-ray diffraction and matched the reference data for atacamite, $Cu_2(OH)_3Cl$. APPENDIX D, TABLE 24, shows the data for this preparation.

Brunswick green was used both for oil painting and for printing, but the extent of its use remains obscure. By the 1920s, the name Brunswick green no longer referred to one of the copper trihydroxychlorides but to a green prepared from a mixture of chrome yellow and Prussian blue (ferric ferrocyanide) that included varying amounts of barytes, depending on the grade of the pigment (Bearn 1923). This mix of Prussian blue and chrome yellow was a very common pigment at that time. Bremen green and Bremen blue were alternative names for green verditer and blue verditer, respectively. Roy (1993) confirmed these descriptions, noting that many old samples in the collections of the National Gallery of Art that are labeled "Brunswick green" are really mixtures of Prussian blue with various yellow, brown, and black pigments, some of which contain chrome yellow.

Other unusual copper pigments, related by name or tradition to these synthetic pigments, were also produced during the nineteenth century. Riffault, Vergnand, and Toussaint (1874) describe an interesting example of a copper blue derived from Bremen blue that used both copper and zinc salts. The synthesis began with a solution of copper nitrate, which was heated and

then decomposed with a clear solution of potassium carbonate. As soon as the resulting effervescence slowed down, additional potassium carbonate solution was added in small amounts. The precipitated green copper carbonate was then added to a new solution of copper nitrate to which a potassium zincate solution was also added. This solution was made by dissolving clippings of metallic zinc in a solution of potassium hydroxide. When the solution cleared, it was added to the solution of copper carbonate in copper nitrate. This precipitated a light blue synthetic pigment that is sometimes called light Bremen blue.

SCHEELE'S GREEN Scheele's green is copper arsenite, $CuHAsO_3$, a pigment discovered by the Swedish chemist Carl Wilhelm Scheele (1742–86)[32] in 1775 while working on arsenic compounds. Scheele was well aware of its poisonous properties and warned others of the danger in using the compound as a pigment. The formula for Scheele's green is variable, depending on the preparation conditions. A synthesis by Schweizer and Mühlethaler (1968) suggests that copper diarsenite, $2CuO \cdot As_2O_3 \cdot 2H_2O$, forms in the cold; copper orthoarsenite, $3CuO \cdot As_2O_3 \cdot 2H_2O$, forms in hot solutions; and copper metaarsenite, $CuO \cdot As_2O_3$, forms when the arsenic content is increased.

These arsenic-containing pigments were often referred to as "arsenates" in older literature, but this is not correct. The arsenates are based on $AsO_4{}^{3-}$, and these pigments are based on $AsO_3{}^{3-}$, which makes them arsenites. Some of the arsenites may be polymeric; for example, the metaarsenites are composed of extended anionic chains formed by oxygen-bridged, pyramidal AsO_3 units (King 1996). This helps to explain some of the difficulties with identification sometimes encountered with this group of pigments. Work by Stavenhagen (1895) suggested that the composition of a particular copper arsenite depended on the method of synthesis. Both copper diarsenite and orthoarsenite are a lighter shade of green than the color usually associated with Scheele's green. All of these factors make it difficult to identify the pigment from the usual microsample.

Scheele's green has a deep green color and reasonable covering power as a pigment, although the extent of its use as a pigment is not entirely clear. A process for its production was patented in England in 1812, and the pigment was then sold as "patent green." The original preparation mixed potash and a pulverized material called "white arsenic" (apparently arsenic sulfide, As_2S_3, rather than arsenious acid, As_2O_3) in water. The solution was heated and slowly added to a warm solution of copper sulfate. It then was allowed to stand until a green precipitate formed that was then washed and dried.

A preparation by Liebig (1823) began with dissolving verdigris in warm vinegar, then adding an aqueous solution of arsenic sulfide to obtain a dark green precipitate. Additional vinegar was added to redissolve the precipitate, and the solution was then boiled and cooled to produce the brighter green of the copper arsenite.

Riffault, Vergnand, and Toussaint (1874) provide the following commentary on making Scheele's green:

> Oxide of copper, combined with various substances, produces quite a number of green colours, which, unhappily, are highly poisonous, but possess great brightness. The oldest of these colours is a neutral arsenite of copper, discovered in 1778 by Scheele. Dissolve in a copper kettle 1 kilogramme of pure sulphate of copper in 20 litres of water. In another vessel prepare an arsenite of potassa by boiling 1 kilogramme of carbonate of potassa and 325 grammes of arsenious acid in 6 litres of water. These two solutions are filtered, and while they are still hot the arsenite of potassa is slowly poured into the solution of sulphate of copper, which is stirred all the while. The precipitate of arsenite of copper settles in the liquor which has become a solution of sulphate of potassa. This is decanted, and the precipitate is carefully washed with hot water, drained upon a cloth and dried at a low temperature. (Riffault, Vergnand, and Toussaint 1874 : 234)

This recipe was replicated in the laboratory and produced a dark green precipitate of very fine particle size. After the precipitate was washed in distilled water and allowed to air-dry for four days, it was ground and analyzed using the Siemens D5005 X-ray spectrometer with Gobel mirrors attached. A reasonable X-ray diffraction pattern was obtained from this preparation. These X-ray diffraction patterns reveal considerable discrepancies among preparations, confirming that different pigments were made depending on the route employed to produce them.

Two of the distinct copper arsenites mentioned earlier were prepared in the GCI Museum Research Laboratory following recipes from Gmelin (1965): the synthesis of copper orthoarsenite, $3CuO \cdot As_2O_3 \cdot 2H_2O$, is described in APPENDIX B, RECIPE 25, and that of copper diarsenate I, $2CuO \cdot As_2O_3 \cdot 2H_2O$, in RECIPE 26. The pigment was also synthesized using Scheele's method: 10.5 g of sodium carbonate was dissolved in 60 ml of water, and the solution was heated on a hot plate to about 90 °C. Next, 3.25 g of arsenious oxide was slowly stirred into the solution until completely dissolved. Separately, 10 g of cupric sulfate was dissolved in 200 ml of water, then heated to the same temperature. The sodium arsenite solution was then added slowly, with stirring, to the cupric sulfate solution; the resulting precipitate of copper arsenite was washed in hot water and then dried at 45 °C.

Interestingly, powder X-ray diffraction studies of the product made with Scheele's method showed that it is essentially amorphous: no pattern whatever was obtained from this solid precipitate. The recipe from Riffault, Vergnand, and Toussaint, however, did produce a crystalline solid.

A variety of chemical syntheses can be used for the preparation of this pigment, and this complicates the diagnostic data for Scheele's green (Fiedler and Bayard 1997). In fact, the entire subject requires further research to unravel the subtleties of these copper arsenites. For

example, the following syntheses can produce different products, all of which might go by the name of Scheele's green: In a method used by Payen (1835), arsenious oxide was dissolved in boiling water, and copper (II) sulfate solution was added until an aliquot gave a good color when precipitated with potassium carbonate. In another process, Gentele (1906) used a solution of potassium carbonate and potassium hydroxide that was added to a solution of copper sulfate. A solution of arsenic trioxide and potassium carbonate was then added to this alkaline mix after it had cooled to produce a copper diarsenite. (This process calls for the alkali to be dissolved with the arsenic trioxide rather than with the copper sulfate.) A lighter shade of pigment was produced by stirring boiling copper sulfate into the basic arsenite solution, which may, with some difficulty, form copper metaarsenite. In a subsequent process, Church (1915) recounts that hot solutions of arsenious oxide and copper sulfate were mixed together and precipitated with small additions of potassium carbonate until the color of the desired shade was obtained.

PLATE 60 shows two photomicrographs of a sample of Scheele's green from the Forbes pigment collection. The sample was mounted in two ways: in melt-mount (RI 1.662) for polarized-light microscopy, and for X-ray diffraction studies. The pigment was found to be composed of clusters of small rounded particles with an anomalous blue-white birefringence. The particles appear only faintly green or colorless under plane-polarized light as seen in PLATE 60A. The same sample is shown viewed under crossed polars in PLATE 60B.

A photomicrograph of copper diarsenite is shown in PLATE 61, and two views of copper orthoarsenite are shown in PLATE 62. A number of copper arsenite mineral species are listed in the ICDD files. Some of them may be germane to a discussion of Scheele's green, given that many different routes were used historically to prepare the pigment. This group includes trippkeite, $CuAs_2O_4$; lammerite, $Cu_3(AsO_4)_2$; mixite, $Cu_3(AsO_4)_2 \cdot 6H_2O$; lindackerite, $Cu_5As_4O_{15} \cdot 9H_2O$; cornubite, $Cu_5(AsO_4)_2(OH)_4$; clinoclase, $Cu_3(AsO_4)(OH)_3$; and olivenite, $Cu_2(AsO_4)(OH)$, although, insofar as it is known, the only possible comparison is with trippkeite.

A comparison of the X-ray diffraction data for trippkeite with the data for two samples of Scheele's green from the Forbes collection reveals significant differences between the data sets, as shown in APPENDIX D, TABLE 25. Both of the Forbes samples have peaks at 3.11, while trippkeite has a major peak at 3.16. However, the relative intensities for the d-spacings are not at all consistent, and further research into the chemical relationships of the copper arsenites in general is required to clarify the situation.

A sample of trippkeite from Copiapo, Atacama, Chile, from the collections of the Smithsonian Institution, appears very pale green under plane-polarized light and bright yellow green under crossed polars with almost parallel extinction; some particles are rather undulose. The most impressive characteristic is that the crystals are composed of numerous fiberlike particles that flake easily in melt-mount to fine acicular crystals. Examination with the standard quartz wave plate showed that the individual crystals have second-order blue color parallel to the slow

direction, and second-order straw color perpendicular to the slow direction, which indicates a positive sign of elongation. The highly pronounced fibrous structure of trippkeite is very different from the structure of Scheele's green preparations. In addition, the color of the trippkeite crystals is a pellucid turquoise when viewed macroscopically, whereas Scheele's green is an entirely different color. Color-reflectance data for Scheele's green are shown in FIGURE 9.3A. There is, therefore, no similarity whatever between these two substances, despite suggestions that they might be closely related.

The commercial preparation of Scheele's green appears to have included a number of variants, such as the various greens known as Braunschweig green, Kaiser green, mountain green, and Berg green. Some have various arsenic-to-copper ratios, depending on their method of manufacture. In some cases, the pigment may actually constitute a copper acetoarsenite containing calcium or barium sulfate (Mierzinski 1881).

Scheele's green may be used with water or oil, but the extent to which the pigment was used in painting is obscure. By the 1870s, Scheele's green was becoming replaced by Schweinfurt green (also known as emerald green), which had better durability. Bomford and colleagues (1990) mention the discovery of both Scheele's green and Schweinfurt green together with a yellow lake in the painting *Music in the Tuileries Gardens* by Edouard Manet (1832–83). Roy (1993) found it in the 1866 painting *Queen Victoria at Osborne* by Sir Edwin Henry Landseer (1802–73). Scheele's green was also used as a colorant for wallpaper and fabrics, and in calico printing after fixation with albumen. Parker (1812) even claimed that his preparation of the pigment could be used to decorate coaches and building facades as well as to paint houses and ships.

| EMERALD GREEN Emerald green is a mixed copper acetate–copper arsenite salt, $Cu(CH_3COO)_2 \cdot 3Cu(AsO_2)_2$, that was originally produced as a pigment in Schweinfurt, Germany, in about 1814; hence its alternate name, Schweinfurt green. This pigment was synthesized by Liebig (1823) and by industrialist Wilhelm Sattler, who, according to Ultsch (1987), kept the process secret and built a lucrative business on the discovery from around 1814 to 1822. Liebig's preparation is as follows:

> [O]ne part of verdigris is heated in a copper kettle with sufficient distilled vinegar to be dissolved, then one part of arsenious acid, dissolved in water, is added. The mixture of these substances produces a dirty green precipitate, which is dissolved in a new quantity of vinegar. After boiling for some time, a new precipitate appears which is granular, crystalline, and of a magnificent green. It is separated from the liquor, carefully washed and drained. (Ultsch 1987: 32)

There are essentially two routes for making the synthetic pigment—the acetate route and the sulfate route—both of which demand considerable skill and knowledge to produce the best quality product.

In the acetate reactions, the following sequence may occur:

$$6NaAsO_2 + 4Cu(CH_3COO)_2 = 3Cu(AsO_2)_2 \cdot Cu(CH_3COO)_2 + 6CH_3COONa \qquad 9.3$$

With the sulfate method, the reactions are:

$$4CuSO_4 + 6NaAsO_2 + 2CH_3COOH + Na_2CO_3 = \qquad 9.4$$
$$3Cu(AsO_2)_2 \cdot Cu(CH_3COO)_2 + 4Na_2SO_4 + H_2O + CO_2$$

The recipe given by Bearn (1923) uses the acetate method and calls for 100 parts of soda ash (sodium carbonate), 200 parts of white arsenic (arsenious oxide, As_2O_3), 150 parts of soda acetate (sodium acetate), and 250 parts of copper sulfate. The sodium carbonate is dissolved in water, and half the required amount of white arsenic is added. Steam is then passed through the solution until all the arsenic oxide is dissolved. The rest of the arsenic oxide is then added, and the mixture is boiled until the arsenic oxide is completely dissolved, which can take more than six hours. The resulting solution of sodium arsenite has a syrupy consistency and must be diluted and allowed to settle. The copper sulfate is then dissolved to make a fairly concentrated solution (1:25), aided by heating and constant stirring. When all the copper sulfate has dissolved and the temperature of the solution is about 90 °C, then the clear liquor of the prepared sodium arsenite solution, after being filtered to remove any undissolved particles, is added at its boiling point, with continuous stirring. The requisite amount of a dilute solution of acetic acid or sodium acetate is then stirred into this mixture until the characteristic green color develops.

Care must be taken at this stage not to stir too much: to be properly formed, the pigment must have a coarsely developed crystal structure to produce the brilliant green color. Likewise, Bearn urges great care in regulating the temperature of the reacting solutions, otherwise the shade of the pigment will vary enormously; he discovered empirically that the best shades are produced only at about 90 °C. The product is filtered and washed well to remove all soluble salts and then dried at a low temperature. APPENDIX B, RECIPE 27, describes the author's laboratory synthesis of emerald green using this recipe.

Two other, completely different synthetic preparations of emerald green were made using recipes derived from Gmelin (1965). The syntheses are described in APPENDIX B, RECIPES 28 and 29.

In addition to synthesizing emerald green using various recipes, two samples labeled emerald green from the Forbes historical pigment collection were also examined during this study. Powder X-ray diffraction patterns were taken for the these two historical pigments and for the two different synthetic preparations made in the laboratory. The results are shown in APPENDIX D, TABLE 26. Schweinfurt green has a characteristic array of d-spacings with an unusually large number of strong reflections that span a large range of angstroms. The 1938 ICDD files contain one minimal entry for emerald green (ICDD 1-51),[33] which is shown with the data derived

from laboratory work (see APPENDIX D, TABLE 26); this is sufficient for identification. There is, however, a finely detailed and more recent entry for copper acetate-arsenite (ICDD 31-448), which renders the earlier entry obsolete. Fiedler and Bayard (1997) illustrate X-ray diffraction data for emerald green pigment samples taken from *Rocks at Belle Isle* by Claude Monet (1840–1926) and from *Follow the Arrow* by Fernand Léger (1881–1955), both of which are in the collections of the Art Institute of Chicago. In APPENDIX D, TABLE 27, these data are compared with data for copper acetate-arsenite. Curiously, neither of the pigment samples from the paintings appears to have a major line at 9.71, but some examples of this pigment do. APPENDIX D, TABLE 28, illustrates X-ray diffraction data from an emerald green (Schweinfurt green) pigment taken from James Ensor's (1860–1949) seminal painting *Christ's Entry into Brussels in 1889*. Painted in 1888, this work in the collections of the J. Paul Getty Museum is shown in PLATE 63. The data for the pigment from the painting are a good match to the standard ICDD data for copper acetate-arsenite (see APPENDIX D, TABLE 28) and also show that the pigment can retain good stability over a one-hundred-year period.

Emerald green is a bright blue-green pigment, but the color varies depending on the method of manufacture. This was evident from the laboratory syntheses: the pigment made from the recipe derived from Bearn (see APPENDIX B, RECIPE 27) was a brighter green than that made using Gmelin's recipes (see APPENDIX B, RECIPES 28 and 29). The color-reflectance spectrum for emerald green in gum arabic is shown in FIGURE 9.3B and is compared with that of Scheele's green (see FIGURE 9.3A) and of copper orthoarsenite, also in gum arabic, shown in FIGURE 9.3C. Emerald green is lighter than Scheele's green, which is darker and duller, as seen from the color coordinates in FIGURE 9.3A. Particles of copper orthoarsenite are often microscopically characteristic—consisting of small, rounded grains that are uniform in size—exhibit a radial structure, and are strongly birefringent. Some may have a pit or dark spot in the center (Gettens and Stout 1966). PLATE 64 shows two photomicrographs of Schweinfurt green (emerald green) from Ensor's painting; PLATE 65 shows a photomicrograph of Scheele's green.

Judging by the occurrences of emerald green listed by Fiedler and Bayard (1997), emerald green was used primarily from the 1830s to the early 1900s, with many examples from the Impressionist school. The pigment was identified by Townsend (1993) in *Going to School*, a watercolor on paper from around 1832 by Joseph Mallord William Turner (1775–1851) in the Tate Gallery, London, and in Léger's 1919 painting *Follow the Arrow*. An interesting occurrence of both emerald green and Scheele's green on Tibetan *thang-ka* paintings is mentioned by Mehra (1970), although exactly how the pigments were identified is not mentioned in the text. Thang-ka is a popular form of religious painting on cloth done in the Himalayan regions of Tibet, Nepal, Bhutan, and Sikkim. The need for these copper arsenate pigments in such areas is surprising because the traditional green pigments used for thang-ka paintings have been verdigris and malachite.

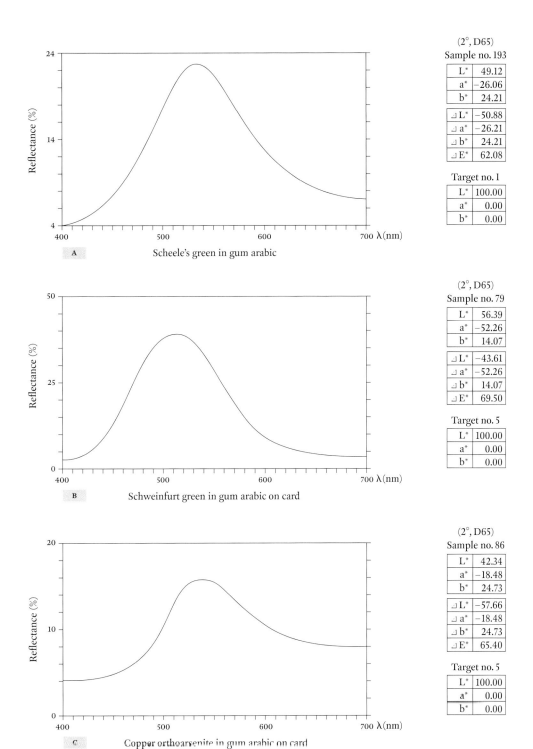

(2°, D65)	
Sample no. 193	
L*	49.12
a*	−26.06
b*	24.21
⌐L*	−50.88
⌐a*	−26.21
⌐b*	24.21
⌐E*	62.08

Target no. 1	
L*	100.00
a*	0.00
b*	0.00

A Scheele's green in gum arabic

(2°, D65)	
Sample no. 79	
L*	56.39
a*	−52.26
b*	14.07
⌐L*	−43.61
⌐a*	−52.26
⌐b*	14.07
⌐E*	69.50

Target no. 5	
L*	100.00
a*	0.00
b*	0.00

B Schweinfurt green in gum arabic on card

(2°, D65)	
Sample no. 86	
L*	42.34
a*	−18.48
b*	24.73
⌐L*	−57.66
⌐a*	−18.48
⌐b*	24.73
⌐E*	65.40

Target no. 5	
L*	100.00
a*	0.00
b*	0.00

C Copper orthoarsenite in gum arabic on card

FIGURE 9.3 Color reflectance data for A, Scheele's green in gum arabic; B, Schweinfurt green in gum arabic; and C, copper orthoarsenite in gum arabic.

Emerald green was found on two works of art from the Vever Collection of the Freer Gallery of Art: an Indian painting dating to about 1900 (Fitzhugh 1988) and a Japanese Ukiyo-e painting by Hiroshige (1797–1858) (Fitzhugh 1979). Paul Gauguin (1848–1903) apparently used emerald green in his work; his correspondence with the dealer Ambroise Vollard in 1902 shows his requesting that tubes of "vert veronese" (emerald green) be sent to him in Tahiti (Christensen 1993).

For a time, emerald green, under its alternate name of Paris green, was the favorite of fakers and restorers of Chinese bronzes, and it was often employed to imitate the green corrosion crusts of ancient bronzes (Gettens 1969). Paris green was also used extensively as an insecticide, and by the time Bearn was writing in 1923, its use as a pigment had been almost completely abandoned. Large quantities of Paris green were still being exported from England for use as a fungicide and for making antifouling paints for ships from the end of World War I until the 1920s, but the pigment had to be handled with care because it was highly poisonous. The so-called Tanalith process for treating materials against biological attack used Paris green for this purpose.

Emerald green never attained great popularity as a pigment because of two shortcomings: it is blackened by sulfurous pollutants in the atmosphere, and mixtures of this pigment with cadmium yellow darkened rapidly due to sulfide formation (Fiedler and Bayard 1986). The British painter William Holman Hunt (1827–1910) refers to this kind of mixture as "a well-known misalliance…when put on, the tint was brighter than this at the side. It is now as it was within two weeks of its first application—nearly black" (Hunt 1880 : 491).

Fiedler and Bayard (1997) found that emerald green mixed with a cadmium yellow that had a small sulfur content reacted immediately to form a dark brown substance when heated slightly. The nominal reaction is:

$$4CdS + Cu(CH_3COO)_2 \cdot 3Cu(AsO_2)_2 = 4CuS + Cd(CH_3COO)_2 + 3Cd(AsO_2)_2 \qquad 9.5$$

| OTHER GREEN PIGMENTS An unusual group of green pigments known as green stannate of copper (Riffault, Vergnand, and Toussaint 1874) was considered the equal of the better-known arsenic greens, according to Gentele (1906). There are many recipes for the preparation of this pigment group. One of them calls for a solution of 125 parts of copper sulfate in water added to a solution of 59 parts of tin in nitric acid. The mixture is precipitated by adding sodium hydroxide, and the green product is washed and dried.

Other ingenious methods were devised for stabilizing a precipitated copper salt as a pigment. For example, a pigment known as Elsner green was made in Germany, according to Riffault, Vergnand, and Toussaint; although not as bright as Schweinfurt green, it provided a serviceable color. Elsner green was made by pouring a decoction of yellow wood that had been clarified with gelatin into a solution of copper sulfate, then adding from 10% to 12% tin dichloride. The mixture was then precipitated by adding an excess of potassium hydroxide, and the

deposit was thoroughly washed when the green color acquired a bluish tinge. A more yellowish hue was apparently obtained by increasing the proportion of yellow wood.

| *Brown copper pigments* | A number of rather obscure mixtures for brown pigment have also been produced with copper compounds. Osborn (1854) and |

Field (1835) mention a brown made with "hydrocyanate of copper" (hydrocyanic or prussic acid and copper), which had been recommended "for beauty and intensity by an English chemist of the name Hatchett" (Field 1835 : 31). There are two copper cyanides, $Cu(I)CN$ and $Cu(II)(CN)_2$; it is the latter cupric form that would have been produced. As this is a very poisonous pigment, the extent to which it was put to practical use remains unknown.

Standage (1887) records a pigment known as "copper brown," which is described as being a "ferrocyanide of copper." This is, in fact, a copper analog of Prussian blue, with the iron replaced by copper. Copper (II) hexakis-cyanoferrate, otherwise known as cupric ferrocyanide, $Cu_2Fe(CN)_6$, is a good brown color but is awaiting identification as a pigment, as is copper borate, $Cu_xB(OH)_3$, a pale green mentioned by Salter (1869). Richter (1988) describes the identification of a potassium copper chloride, $KCuCl$, that is also very obscure.

| *Copper phthalocyanine* | Copper phthalocyanine, $CuN_8C_{32}H_{16}$, was discovered by Arthur Gilbert Dandridge and others in 1928 and was first intro- |

duced as a pigment under the trade name Monastral blue at an exhibition in London in 1935.[34] Copper phthalocyanine is a tetraazatetrabenzo derivative of porphyrin; it is made from the condensation reaction between four molecules of phthalonitrile, which reacts at 200 °C with one atom of copper to form the phthalocyanine salt (Roberts and Caserio 1964). It is a bright blue microcrystalline solid with a purple luster that is practically insoluble in water, ethanol, and hydrocarbons. Many of the phthalocyanine group of pigments have exceptionally good light-fastness. Dahlen (1939) describes the crystalline salt as a deep blue with a strong bronze reflection, but the dry dispersed pigment is bright blue with little or no bronze reflection. The dispersed pigment is very close to an ideal pure blue, absorbing light almost completely in the red and yellow, and reflecting only green and blue. The tinting strength is very strong, about twice the strength of Prussian blue and twenty to forty times that of ultramarine. A microscope preparation of the pigment is shown in PLATE 66.

Other varieties of the phthalocyanine group include a chlorinated copper phthalocyanine, which produces a green dye, as well as a pigment with properties similar to those of the blue variety (Gettens and Stout 1966). Copper phthalocyanine has been extensively used as a pigment for inks and paints, although it is not as popular as it once was and has declined in use in recent years. The solid can exist in two forms: the thermodynamically less stable, redder alpha form is a better pigment than the more stable, greener, beta form (*Merck Index* 1983). In the presence of aromatic solvents, heat, or high shear stress, the alpha form may convert to the beta variety.

1 Pedanius Dioscorides *De materia medica* 5.91 (Dioscorides [1933] 1968).

2 Since there are no entries in the ICDD files for the basic copper(II) formates, some additional X-ray diffraction data were determined at the GCI Museum Research Laboratory to produce the set of data shown in APPENDIX D, TABLE 9.

3 Schweinfurt green is the alternate name for emerald green, a mixed copper acetate–copper arsenite salt discussed later in this chapter.

4 Observations by the author and Kenneth Hardcastle, Los Angeles, June 1999.

5 Ashok Roy, letter to the author, 12 April 1998.

6 Peter Mactaggart, letter to the author, with samples, 6 July 1997.

7 The use of grapes in the production of verdigris was mentioned by Dioscorides in his *De materia medica* as early as the first century. He writes that "hiding one mass or plate [of copper] or else more amongst the huskes of grapes, not pressed of late, but growing sour, invert it in like sort" (Dioscorides 5.91).

8 Harley 2897, Department of Printed Books and Manuscripts, the British Museum, London.

9 Pliny the Elder *Natural History* 34.27 (Pliny 1979).

10 Pliny 34.26.

11 Pliny 34.28.

12 Dioscorides 5.91, s.v. "verdigris."

13 Dioscorides 5.91.

14 Pliny 34.26.

15 Presbyter Theophilus *De diversis artibus,* recipe 35 (Theophilus 1961).

16 Theophilus, recipe 36.

17 This manuscript is discussed in CHAPTER 1 in connection with the plating of iron.

18 Peter Mactaggart, letter to the author, 22 September 1996.

19 Alum (potassium aluminium sulfate) was also known as *alume di Roccha,* which the Italian metallurgist Vannoccio Biringuccio (1480–ca. 1539) notes is probably derived from "al-Ruha," the Arabic name for Edessa (now Urfa, Turkey) (Partington 1961). Arie Wallert, however, in a conversation with the author, July 1997, doubted that this was correct and stated that the "roch alum" referred to in the recipe probably derives from the use of rock or mineral alum, the crude initial deposit as opposed to a purer variety, and has nothing to do with Edessa.

20 A perennial evergreen shrub with bitter, strongly scented leaves, used for thousands of years in medicinal preparations.

21 O. P. Agrawal, conversation with the author, Lucknow, India, April 1996.

22 Green bice (malachite) was often used from the sixteenth to the eighteenth century in synthetic as well as natural form.

23 If too much colophony is added, the color of the mixture becomes less intense.

24 Analysis by Narayan Khandekar, GCI Museum Research Laboratory, Los Angeles, September 1997.

25 Cennino d'Andrea Cennini *The Craftsman's Handbook* 56.33 (Cennini [1437] 1960).

26 Herant Khanjian, letter to the author, 22 September 1998.

27 Kenneth Hardcastle, conversation with the author, March 1997.

28 Although this formula is given in the ICDD files, it seems a rather strange empirical formula, and one wonders if it should not be $ClCu(CH_3COO)$.

29 John Twilley, conversation with the author, 6 April 1999.

30 Since this formula is very similar to that of posnjakite, $Cu_4SO_4(OH)_6 \cdot H_2O$, there is a possibility that posnjakite is actually present. Alternatively, it could be the new compound identified by Strandberg (see CHAPTER 5).

31 The J. Paul Getty Museum's villa site in Malibu was closed to the public in 1998, and the sculptures were removed in 2000 for renovation of the villa.

32 Scheele anticipated Joseph Priestley's discovery of oxygen and made many other important discoveries.

33 This is the first volume issued by the ICDD, and it is surprising that a material now as obscure as emerald green would have been listed so early in these files.

34 Arthur Gilbert Dandridge, Hugh Albert Edward Drescher, John Thomas, and Scottish Dyes Limited are named as inventors in British patent 322169.

Copper as a Substrate for Paintings
CHAPTER 10

Although copper as a support for painting was not really used much before the sixteenth century, at least in European art, there are earlier references to this unusual art form: In the twelfth century, Theophilus mentions oil painting on copper leaf; during the early fifteenth century, the Florentine painter Cennino Cennini used it for works in tempera. When oil painting on copper was in vogue, many works of art on such supports were made, although it is not always clear if copper, brass, or bronze was used. By the eighteenth century, however, this curious use of copper was already in decline. Bowron (1999) provides a useful historical critique of the subject.

EARLY COATINGS AND FABRICATION METHODS

In some cases, a copper support was itself coated with tin, silver, lead, or even zinc once that metal had become available in Europe after the fifteenth century. *Coronation of the Virgin*, a

painting by Guido Reni (1575–1642) in the collections of the National Gallery, London, was shown by electron probe microanalysis to be on tin-coated copper.

One possible advantage of coating copper was to prevent chemical reactions between substrate and media, as well as to help prevent corrosion of the copper itself.[1] There are cases of uncoated copper supports corroding; when this has occurred, small, usually randomly distributed dark stains or excrescences that are visually disturbing appeared on the front of the painting. This kind of random pitting corrosion is quite common in coated metal objects where small anodic pits and large cathodic surfaces are a common problem.

A vivid green layer, undoubtedly due to the formation of copper organometallics, can sometimes be seen between a painting's copper support and ground, according to Horovitz (1986). Experiments by Horovitz with copper strips coated with linseed, poppy, and nut oils showed that after periods ranging from twenty-four hours to ten days, all samples developed a greenish tinge. Graaf (1972) has suggested that this corrosion might even aid retention of the paint layers.

Copper supports were fabricated primarily by casting the metal into an inclined bed of sand and finishing it by cold-working with a hammer or roller or possibly both, according to Horovitz. Since it becomes progressively more difficult to hammer thin sheets of relatively pure copper from cast blocks, the metal was probably annealed at various stages, although Horovitz (1999) does not mention annealing in his review of European paintings on copper supports. The earliest known rolling machines are depicted in Leonardo da Vinci's notebooks, although even as late as the eighteenth century, the most accessible technology was to hammer and anneal the copper into shape.

Horovitz uses *Rest on the Flight into Egypt* by the Bolognese artist Domenichino (Domenico Zampieri, 1581–1641) as an example of a painting in which both rolling and hammering may have been used to create the copper support. Hammering tends to form an uneven surface, which sometimes takes the form of concentric rings that are visible when viewed in raking light. In contrast, early rolling machines produced a rippling effect, characterized by a series of parallel undulations due to uneven deformation of the copper during cold-working. Roughly parallel striae in another painting by Domenichino suggested to Buck (1970) that a rolling process had been used to shape the support. X-ray radiography may reveal details that are important in deciding if a support has been hammered and then rolled, or cast and rolled, or simply hammered. These copper sheets are usually small, typically no more than 20 by 30 cm, though occasionally large single sheets of copper, often rolled, were used as supports. For example, *The Archduke Leopold Willen in His Painting Gallery in Brussels* by the Flemish painter David Teniers II (1610–90) measures 106 by 129 cm. Rare examples of large-scale altarpieces made from several sheets of copper joined by riveting and soldering are known. One of them is Domenichino's altarpiece for the Cappella del Tesoro of San Gennaro in Naples, Italy (Horovitz 1999). The copper plates were finished by tinning, but despite this protected surface, there are

adhesion problems between the paint film and the substrate. The potential corrosion of the copper, especially in humid environments, may have influenced artists to employ tinned copper panels, but this is not necessarily the only reason, since tinning would also have given a quality of luminosity with thin paint films.

Some artists may have chosen copper supports because they appreciated the metal's dimensional stability against changes in relative humidity and temperature; this is especially important for small, delicate paintings. Craquelure is reduced with copper, which has a linear coefficient of expansion of 14×10^{-6}, whereas wood may reach 35×10^{-6}.

The surface of the copper plate would often be mechanically roughened for better adherence of the paint film. Garlic is sometimes mentioned as an additional means of surface preparation (Horovitz 1999); it would be applied either as a cut clove rubbed over the surface or as strained garlic juice. This treatment probably helps to wet the surface and provide a sticky, slightly grainy base over which the paint can be applied. Some copper organometallic salts are probably formed during this process, and they may also help to adhere the paint film.

Most paintings on copper have a conventional ground of lead white, although occasionally this is absent, allowing hues from the underlying copper metal to enhance the visual effects of the painting.

Analytical techniques | Bridgman, Michaels, and Sherwood (1965) successfully carried out electron-emission radiography of a painting on copper; conventional radiography was completely ineffective, however, because the copper masked any radiographic contrast of the pigments used in the painting. They examined *Susanna Van Collen*, a small oval portrait in oil, attributed to the Dutch artist Cornelis van Poelenburgh (1586–1667). The portrait had an underdrawing, which was successfully revealed by electron-emission radiography. This technique requires that the surface to be radiographed be in very close contact with the film to minimize image distortion. Because this copper support had a slight concavity, the painting was not mounted in a vacuum holder; instead, a thin foam-rubber lining was used to gently but firmly maintain the film in close contact with the paint surface. The painting was placed face up with a sheet of Kodak type M industrial single-emulsion film with emulsion side contiguous with the painting. The X-ray tube was positioned 1 m above the film cassette. A hard X-ray beam is required to minimize the effects of the direct exposure and to provide a good yield of energetic electrons to penetrate the outer layers of paint. To accomplish this, an 8 mil thick copper filtration plate was used to remove softer X rays that would have fogged the film. An exposure of 220 kV at 10 mA was made for three minutes. This technique created a satisfactory image of the painting and revealed its underpainting.

Poelenburgh created many paintings on copper sheet. *Landscape with Bathing Nudes* in the collections of the J. Paul Getty Museum was imaged with X-ray radiography to examine the copper substrate, but the painting's lead white ground made it difficult for the beam to penetrate

through the copper sheet. A new imaging attempt was made with an exposure of 190 kV at 5 mA for two minutes with a tube distance of 1.3 m. The resulting radiograph revealed mottling, which showed that the copper sheet had been hammered into shape rather than rolled. Electron-emission radiography using the method of Bridgman was also tried with this painting, but it did not reveal any detail of an underdrawing.

An alternative approach to examining paintings on copper supports is scanning X-ray fluorescence analysis. This is more strongly penetrating than scanning electron microscopy – energy dispersive X-ray analysis and provides more information about paint layers than conventional X-ray radiography; in addition, it can reveal the composition of the copper substrate below the paint layers. This technique was used to examine *Pictura* (*An Allegory of Painting*), a work by Dutch artist Frans van Mieris the Elder (1635–81) that is in the collections of the J. Paul Getty Museum. This small painting, 12 by 9 cm, on copper sheet is shown in PLATE 67A.[2]

PLATE 67B clearly shows roughening of the surface of the copper sheet under X-ray fluorescence. This is evident in the elevated concentrations of lead white (revealed in the lead map), which was used as the ground; the lead white is thickened in the grooves that were cut into the sheet to give the surface better adhesion.

Elemental scans of the face, shown in PLATE 67C, reveal the presence of iron, manganese, calcium, and mercury in the painted image. For example, two small white dots can be seen in the center of the calcium map; these correspond to the bone black used for the pupils. The higher concentration on the left side of the calcium map shows that bone black was also used for the background. The iron map shows that earth colors were used for the shadows in the flesh tones; there is a faint echo of this pattern in the manganese map, which shows that some umber was used. The mercury map highlights the red blush on cheeks and lips, indicating that cinnabar was used for these parts of the face. The small area of tin barely visible on the far right side of the scan for tin shows that van Mieris made use of lead-tin yellow in the painting.

The elemental distribution maps for calcium, iron, mercury, and tin in the palette are illustrated in PLATE 67D. The calcium content of the black pigment is strongly indicative of ivory or bone black, which contains calcium hydroxyapatite, $Ca_5(OH)(PO_4)_3$. Many areas of the painting show both iron and a small amount of manganese, attesting to the presence of umbers. Since the only common red pigment containing mercury is cinnabar, the presence of this pigment can be inferred from the elemental maps.

Not only do the maps illustrate the presence of clearly different pigment areas, they also reveal that van Mieris slightly shifted the position of the painted palette from its original outline, as indicated by red arrows on the elemental scans in PLATE 67D; this shift is especially visible in the maps for iron and mercury. The discovery of these pentimenti by scanning X-ray fluorescence analysis indicates the potential of the technique.

ENAMEL ON COPPER

Copper has long been used as a substrate for the application of enamels. Maryon (1959) notes that the copper sheet or plaque is prepared for the enamel by being domed up slightly in the center, forming a small lip around the edge to hold the enamel in place. If the plaque is to be covered with enamels of different colors, the design is first scratched into the copper plaque with a steel point. The copper is traditionally cleaned of any oxide scale by being boiled in 5% sulfuric acid, then scrubbed thoroughly with pumice powder and water. By coating the copper plaque with a clear flux before the enamels are applied, the colors show much greater depth than if they were applied to the copper directly.

Smith, Carlson, and Newman (1987) report on the preparation layers that were traditionally used on copper for fine enamels, such as those made in Limoges, France, from 1470 to 1530. The copper plate was either flat or slightly convex and from 0.5 to 1.0 mm thick. The copper surface was roughened to provide a key for better adhesion of the enamel ground or preparation layer. A thin white layer of opaque white enamel was fused to the front of the plate. A counter-enamel, made from scraps of waste glass, was applied to the reverse of the plate and fired together with the white enamel ground. The counter-enamel helps to prevent differential expansion and contraction of the enamel decoration on the front during firing. The different colors of the enamel design were then fired over the white enamel ground. Deterioration of these enamel layers is much more common than corrosion of the copper substrate, which is usually well protected by the glassy coatings.

Notes

1 Reactions between substrate and media are somewhat different from the corrosion of copper itself. In the first situation, copper ions might diffuse into an organic medium and produce chemical changes to it that could be deleterious. In the second case, corrosion of the copper might occur directly if, for example, the medium were very acidic.

2 The painting, which is signed "F. v. Mieris/Ao 1661" to the right of the woman's shoulder, has an extraordinarily complex provenance stretching back to around 1690. In 1849 the painting was in the possession of William Williams Hope of Rushton Hall, Northamptonshire, before passing to the first Baron Revelstoke, London, by 1875.

Some Aspects of Bronze Patinas

CHAPTER 11

Patinas have been an object of fascination for thousands of years and have given rise to most of the compounds discussed in this book. In this chapter, various aspects of patina are considered in the context of bronze corrosion and with reference to some of the compounds discussed in earlier chapters.

As Smith rather cryptically remarks, corrosion can be broadly considered as "the movement of interphase interfaces," and its chemistry is that of heterogeneous systems in general (Smith 1977:143). By "interphase interfaces," he is referring to the phase boundary region between events. Events that occur during corrosion can be thought of as a boundary system in which the solid metal substrate is attacked by or interacts with liquid or gaseous substances that impinge on it. The movement of the interface is, therefore, the corrosion event itself, and interphase interfaces are what make up the corrosion crust—or patina—of copper alloys.

One of the principal problems inherent in any discussion of patina with respect to bronzes is understanding the nature of the changes to the object's surface over time, whether during bur-

ial or exposure, and the concomitant difficulty of sorting out which corrosive event is due to which period in the object's life. This complexity of events adds interest to the discussion of patina since in some cases it is impossible to know what an object's original appearance was intended to be. Recent research has added fresh insights into this difficult subject.

Patinas can be naturally occurring, such as the smooth, attractive surface that develops on bronzes over time, or they can be artificially created by the deliberate treatment of an object's surface to create a colored layer, a copper compound, or an intentional corrosion product that may be formed before burial.

The attractive nature of colored copper surfaces was already well appreciated in antiquity. Plutarch, for example, writes in his *Moralia:*

> [A] number of visitors to the sanctuary of Apollo at Delphi are made to discuss the question whether the patina on the bronze group in front of which they are standing is natural or artificial. One of them is admiring the beautiful surface of the bronze, which resembles neither dirt nor rust, but looks as if it had been dipped in a bath of brilliant blue colour. I wonder whether the ancient masters used a certain mixture or preparation on their bronzes?[1]

CHANGING VIEWS OF BRONZE PATINAS

One still unresolved question is whether the ancients artificially patinated their bronzes or kept them bright and polished. In 1915 Richter evaluated the available evidence and concluded that the majority of bronzes must have been kept polished and golden in color.[2] Indeed, the golden color of bronze, as opposed to the reddish hues of copper, must surely have been appreciated in the endless search for gold and golden-colored surfaces that played such a prominent role in the technology of both the Old and New Worlds. As Richter observes:

> It is a curious anomaly that nowadays we cover many of our bronzes with an artificial darkish tone, and thus obtain artificially a patina similar in appearance to that produced by nature on ancient specimens. For the Greeks and Romans themselves, to judge by what evidence we have, kept their bronzes in their original color, and thereby had the double advantage of a rich golden tone and a beautiful play of reflected lights on the surface. (Richter 1915 : xxvii–xxviii)

To support her thesis, Richter notes that a number of utensils and implements, which could only have served their purpose if kept bright and clean, are now covered in exactly the same patina as statuettes and other decorative objects. Some bronzes are decorated with niello, silver, copper, or paint; and the aesthetic effect of this decoration would have depended on these areas being contrasted with shiny bronze metal.

Richter also makes the observation that bronzes from the same locality are usually covered with the same kind of patina. Although this is not always the case, it is a useful general principle. Some bronzes in the British Museum, for example, may be distinguished by the color of their patinas: some Roman bronzes from Campania have a bright apple-green color; the Etruscan bronzes from the Lake of Falterona are covered with a brownish green patina; bronzes from the site of Falerii, Italy, are apt to show a smooth turquoise blue; the Boscoreale bronzes (from Bosco, Italy) have a rough green patina with dark blue patches; and the bronzes of Dodona are almost invariably distinguished by a patina of great beauty and finish.

A freshly polished bronze or even brass surface might have been used to counterfeit gold, which was always so much more expensive and unattainable. In fact, the aesthetics of a polished surface may have applied to the majority of ancient bronzes, but variations in surface finish had not been identified by 1915, when Richter was writing, and her assertions in this regard have since been modified. For example, recent scientific studies have verified the existence of bronzes whose surfaces were deliberately given a black patina. Pliny refers to them as Corinthian bronzes, recalling the account by Plutarch (see CHAPTER 2, on cuprite patinas), who recorded that when Corinth was destroyed by the Roman army under Lucias Mummius in 146 B.C.E. and many metal objects were subjected to fire, the melting of copper with some gold and silver produced an alloy whose oxidized patina was an attractive blue black. The existence of black-patinated Egyptian bronzes, known as *hsmn-km*, from the first millenium B.C.E. indicates that this kind of patina originated well before the destruction of Corinth (Cooney 1966) and reveals that Pliny's account is apocryphal.

Penny (1993) suggests that in color and finish these black-surfaced bronzes would have resembled polished hard stones, such as basanite and basalt, that were used so extensively for ancient Egyptian and Greek sculpture. Craddock and Giumlia-Mair (1993), who analyzed black-surfaced bronzes in the collections of the British Museum, showed that some of these bronzes have a composition of about 94% copper, 4% gold, 1% arsenic, and 1% silver. This is very similar to the later Roman Corinthian bronzes, which contain a characteristic small percentage of gold. Plutarch claims that Silanion of Athens, working around 325 B.C.E., used a small amount of silver in the alloy for the head of his sculpture of the dying Jocasta to impart a pallid appearance. This may be so, since silver-copper alloys were well known at the time. The silver-copper alloys generally contained only 1–5% copper to harden the silver, but the progressive dilution of the rose-pink color of copper with a small percentage of silver would also have been known; alloys with 10% silver are already noticeably lighter in color. The microstructure of an alloy with this kind of composition would consist of an alpha-phase, copper-rich dendritic matrix with an infill of the alpha+beta eutectic. Since these alloys are so heavily segregated, however, the eutectic may also be represented by silver-rich beta-phase particles in a cored dendritic matrix (Scott 1991).

Concerning the use of metal alloys, in this case copper and iron, for their aesthetic attributes, Pliny writes of the artist Aristonidas who sought to capture in a sculpture the madness of Athamas after he had hurled his son Learchus from a rock:

> [H]e made a blend of copper and iron, in order that the blush of shame should be represented by rust of the iron shining through the brilliant surface of the copper; this statue is still standing at Rhodes.[3]

Iron is insoluble in copper at room temperature; if present in the alloy, it will occur as small dendrites or globules mixed with the copper grains. The equilibrium diagram is discussed by Cooke and Aschenbrenner (1975) and by Scott (1991). It is quite possible that iron was added to the bronze used to cast the head of Aristonidas's sculpture. The iron would have remained unalloyed, or it would have been incorporated as dendritic zones; in either case, subsequent corrosion could produce a superficial bloom of rust on the surface of the alloy. Since small additions of elements such as arsenic, lead, iron, and gold are closely associated with Corinthian bronzes and are also linked with deliberate patination to produce black-colored surfaces, it is quite possible that Pliny's allusion to "a blend of copper and iron" refers to these types of bronzes (discussed in greater detail in CHAPTER 2).

Alloys of different composition were certainly recognized early as conferring a particular color or producing a certain kind of patina. In Southeast Asia, for example, brass was known as *tombac;* an alloy with a very high copper content was called *hong deng;* and copper alloys with precious metals was known as *samrit* (Coedes 1923). The existence of a specific nomenclature suggests that surface coloration of these alloys was known and employed in these regions. Within the Greek and Roman context, Pliny writes that so-called Delian bronzes (from the Greek Island of Delos) were the first to become famous, then those from the island of Aegina, and still later the Corinthian bronzes. These examples suffice to show that surface color and patina were certainly important aspects of the appearance of bronze sculpture, even if the majority of bronzes were kept bright and polished, as Richter held.

In the *Moralia* Plutarch's characters muse on the different possibilities for the nature of patina on old bronzes, wondering if the ancient masters used a certain mixture or preparation to achieve a particular effect. Various suggestions, some of them rather poetic, are made to account for the presence of the patina through physical conditions: that it is due to the atmosphere entering the bronze and forcing out the rust, for example, or that when the bronze gets old it "exhales" the rust.

A Greek bronze of a type that could well have been discussed by Plutarch is the Herm mentioned earlier (see PLATE 2), which dates to 100–50 B.C.E. Plutarch was probably surprised at the patinated appearance of old Greek bronzes such as this one; in his own time, such objects would have retained a bronze-colored metallic sheen. Evidence in support of this includes an Egyptian inscription from the ancient town of Chios[4] that dates to the fourth century B.C.E. and

records instructions for the restoration of a bronze statue of a tyrannicide (Pernice 1910). The clerks of the market are told to ensure that the statue is kept free of rust and that it is provided with a garland and kept bright.

Also of interest are some papyri recording the accounts of the Roman temple of Jupiter Capitolinus in the ancient Egyptian settlement of Arsinoe for the year 215 C.E. Three of the accounts record the treatment of some bronze statues and utensils. The treatment is referred to as an "anointment" and was entrusted to a worker specially trained for this vocation. Here again, special steps were taken to ensure that the bronze surface was maintained and not allowed to develop an unsightly patina. Pliny notes that "in early days people used to stain statues with bitumen."[5] In a subsequent passage, he remarks that burnt bitumen, "among other uses," is applied as a coating to copper and bronze vessels to make them fireproof and that "it used to be the practice to employ it [bitumen] for staining copper and bronze and coating statues."[6] Here Pliny appears to be referring to the practice, in vogue in his own time, of gilding statues rather than giving them a protective lacquer with bitumen, as was apparently done before his time; this could explain his use of the past tense. Clearly the application of a thick or burnt bitumen coating would provide good protection for bronzes designed to be used as cauldrons and other utensils. For statues, however, Pliny implies that a shiny bronze surface was maintained by the use of a protective lacquer of bitumen rather than an opaque finish.

Pernice attempted to replicate an opaque finish on a bronze by applying a solution of bitumen in turpentine, which enhanced the color of the bronze and gave it a slightly yellowed tint. Not only may this finish have been more attractive than an opaque one, but it also provided some corrosion protection to the bare metallic surface. The Renaissance practice of applying a translucent, reflective coating to enhance the beauty of a finished bronze or brass surface of a sculpture served a similar purpose.

During the medieval period, the treatment know as *émail brun* was used to patinate copper alloys and to impart a rich, dark brown color. The practice is discussed by Theophilus in *De diversis artibus* of 1110–40. According to the translator's commentary (Dodwell 1961), this technique of coloring copper was known in the eleventh century but used only sporadically until the twelfth century, when it became established practice. Theophilus's text instructs the metalsmith to first engrave the copper object with the desired design and then to coat it with linseed oil using a goose feather. The copper object is then heated over red-hot embers. When the oil has melted, another coat is applied and the heating repeated. When the coating is evenly dried, the copper object is placed on a strong fire and left until all fumes have dissipated and the *émail brun* has reached the desired shade. Theophilus continues: "When it has been cooled—not in water but by itself—carefully scrape the small flowers with very sharp scraping tools, but leaving the backgrounds dark."[7] The use of organic lacquers or finishes—as, for example, bitumen dissolved in a suitable solvent such as turpentine or linseed oil—to color copper can therefore be traced from ancient Roman times to the medieval period.

SOME PATINA VARIATIONS

Arsenic coating as a patina

In the early 1970s an arsenic-rich coating found on the surface of an Anatolian bronze bull dating from about 2100 B.C.E. raised the question of whether such a coating was a feature of the original casting or if it was applied separately over part of the surface (Smith 1973). The figure is from the northeastern Anatolian site of Horoztepe, now in Turkey. Smith thought the bronze contained no arsenic and that it must have been added as a separate coating or patination. It was difficult, however, to reconstruct how the remarkable technology of making an arsenic patina might have been developed four thousand years ago in Anatolia. Smith found it unlikely that the copper-arsenic alloy could have been applied in the molten state; the microstructure revealed no sign of a eutectic alpha+domeykite (Cu_3As) phase, which makes application in the molten state improbable.

More recently, Beale has offered a different approach, showing that such bronze bulls were cast in four or five pieces.[8] An arsenic-rich surface, therefore, could be related to arsenic in the alloy used in the casting. Beale found that the hindquarters of one such bull is cast in an arsenical copper while the front legs are made of leaded tin bronze. X-ray diffraction analysis of the panels to each flank and the hindquarters of the bull showed the presence of the copper-arsenic phases whitneyite and domeykite, suggesting that surface segregation of arsenic is an explanation for the presence of the domeykite phase. Inverse segregation on casting is probably responsible for the coating in this case, since during the casting process some of the lower melting point constituents, such as arsenic-rich phase, could be carried to the outer surface of the mold.

At the time that Smith was writing, it was thought that the coating must have been applied by a cementation process. If this were the case, areas of the surface that were to have been left bronze in color would have been coated with an impermeable stop-off material. Although arsenic oxide sublimes at 193 °C, the potash and soda that would be necessary to make these alkalies would be available from plant ash, which are easily reduced with charcoal at moderate temperatures. Smith's laboratory replication was only partially successful in producing a domeykite coating on a bronze replica trial piece. It used 4 parts arsenic oxide (As_2O_3), 1 part dry potassium carbonate, and 0.3 parts carbon black, all finely powdered and heated with the copper object for one hour at 450 °C. The paucity of scientific data for Hittite bronze and bronze technology means that we have no idea how prevalent such coatings, or segregations, may have been in ancient Anatolia. Arsenic coatings are also found on some Egyptian bronzes (Fink and Polushkin 1936), but no metallographic evidence has been published so far. Until that work is available, the Egyptian technology cannot be considered properly characterized; the coatings may simply be due, again, to surface segregation of arsenic during casting.

Lead and patinas | Some bronze and brass alloys contain lead, which may influence the patina and the kinds of corrosion products that can be formed. Dews (1930) concluded that lead has no great effect on the color of new bronze but it does increase the rate of tarnishing. A lead-free bronze with 8–10% tin content will remain fairly bright in dry air for a long time, but a leaded bronze will tarnish quickly and become darker than an unleaded one; for this reason ornamental bronzes that are required to develop a deep patina usually contain 10–18% lead.

These conclusions about new bronze, however, do not necessarily apply to ancient bronzes containing lead; here the situation is much more complex than that outlined by Dews. For example, during casting it is possible to get some segregation of the lead to the outer surface of the mold, with the result that there may be a prevalence of lead-containing corrosion products, such as the commonly encountered hydrocerrusite, in the patina. Similar segregation events may occur when the bronze contains discrete globules of lead. Because of lead's particular susceptibility to corrosion in the presence of organic acids, patches of white lead acetates and basic carbonates, in particular, can result from storing lead-containing bronze objects in unsuitable wooden drawers or displaying them where organic-acid components may be emanating from fiber composites, glues, rubbers, and so on. The lead may also be slowly corroded along with other bronze components during burial and be replaced with lead corrosion products or leached away and replaced with cuprite. The leached lead salts are often relatively insoluble and may form part of the overall patina of the bronze.

Black patina in the *aqueous environment* | Zenghelis (1930) studied the ephebe of Marathon[9] and the beard from a statue of Zeus that was found in the sea at Cape Artemision.[10] Zenghelis reported that both bronzes were covered with the same black patina, which was considered to be original in both cases. Analysis of the hoof of a horse from the Marathon sculpture showed a composition of about 64.8% copper, 1.1% iron, 13.7% sulfur, and 18% oxygen, with 2.4% insoluble matter. It is possible, but not proved, that these patinas are original and not formed by sea burial. This cannot be assumed, however, since the production of sulfidic patinas is expected as the principal corrosion event in oxygen-deficient waters because of the prevalence of sulfate-reducing bacteria.

X-ray diffraction analysis of the outer part of the concretion covering the Riace bronzes,[11] which were submerged for many centuries at a depth of 8 m at the bottom of the Ionian Sea, showed the presence of alpha quartz, atacamite, cuprite, and chalconatronite. The blackish surface below the sandy encrustation layer consists of cuprite, atacamite, tenorite, and chalcocite. Formigli (1991) maintains that this layer is not to be confused with the original patina, which is also black. Energy dispersive analysis of a sample of the patina about 70 μm thick showed a

composition of 35% Sn, 7% Cu, 7% Mg , 7% Fe, 2% Mn, 2% Si, and 0.2% Pb; while X-ray diffraction analysis showed the presence of $MgSn(OH)_6$ and $FeSn(OH)_6$—magnesium and iron hexahydroxystannate, respectively. From the published data it is not possible to conclude that the Riace bronzes actually had a black patina before they were lost at sea. In oxygen-depleted seawater, the initial cuprite crust could easily be converted to copper sulfides by natural corrosion processes under the smoothly deposited sandy concretion. Since the cuprite or original surface would preserve the original outline of the object, there is no reason why the conversion of the cuprite to a black sulfide would not result in a smoothly preserved sulfidic patina; fine black patinas have been noticed on less-impressive objects that were buried at sea.

PATINAS IN THE RENAISSANCE

The renewed interest in everything antique brought the subject of the patination of bronzes under close scrutiny during the Renaissance. Weil (1996) searched for the earliest use of the word "patina" and found a likely candidate in an art dictionary published by Filippo Baldinucci in 1681. The word is defined there as "the general dark tone that time causes to appear on paintings, that can occasionally be flattering to them" (Weil 1996 : 398 – 99)

Yet the use of the term appears to go back even further than the seventeenth-century. For example, Jaffé (1989) discusses the depiction of a bronze Etruscan mirror fragment in a drawing by Nicolas Poussin (ca. 1593–1665), titled *Studies of Antiquities*.[12] Jaffé also notes that a commentary by Peiresc published in Rome in 1590 concerning the distinguished antiquarian Pietrus Ciacconius (Pedro Chacon, 1527– 81) included a reference to patina.

Many Renaissance bronzes were finished with a reddish translucent patina that was partially formed by cuprite and overlaid with resinous finishes. The Italian artist Giorgio Vasari (1511 – 54) observed that bronzes will naturally darken with time (Vasari [1907] 1960). Both he and the sculptor Pomponius Gauricus (ca. 1481–1528), writing in 1504, prescribed the use of vinegar to turn the surface green and the use of oil or varnish to produce a black finish (Gaurico 1969). Green verdigris-like coatings may have been useful for some purposes and may have been a historical reference to earlier, antique bronzes. Such bright green patinas, however, are not particularly attractive on fine Renaissance sculpture and did not really come into vogue in Europe until the nineteenth century. Vasari writes:

> [T]his bronze, which is red when it is worked assumes through time by a natural change colour that draws towards black. Some turn it black with oil, others with vinegar make it green, and others with varnish give it the colour of black, so that every one makes it come as he likes best. (Vasari [1907] 1960 : 165 – 66)

Some artists, like Leone Leoni (1509–90), used a green varnish to imitate natural patination, and there is a suspicion that some bronze workers used a thick greenish varnish in an

attempt to conceal poor quality workmanship (Hughes and Rowe 1982). The available evidence, however, suggests that this approach to surface color was less common than that of applying reddish or pellucid patina finishes.

Other coatings on
Renaissance bronzes

It is difficult to determine the original surface appearance of most Renaissance bronzes since they have often been recoated several times over the life of the object. Some sculptures from this period may have been originally colored red, brown, opaque gray, or black. This range of color was used skillfully by such artists as Andrea Briosco (Riccio) (1470–1532), Jacopo Sansovino (1486–1570), and Baccio Bandinelli (1493–1560). Giovanni Fonduli (ca. 1430–ca. 1485–97), Francesco Susini (act. 1635–46), and Antico (Pier Jacopo Alari Bonacolsi) (ca. 1460–1528) all used translucent red, which was greatly admired. There is a considerable variety of possible appearance for these kinds of translucent, principally organic resins or varnishes, which are applied to a surface for reflectivity and to augment the color of the patina. Bewer (1996) reports that most of the bronzes in the Museo e Gallerie di Capodimonte in Naples were coated with an opaque black layer many years ago. Bewer also provides evidence that the surfaces of the bronzes in the *studiolo*[13] of Francesco I de' Medici (1541–87) in the Palazzo Vecchio in Florence were recoated only a few decades after the sculptures were installed.

Recent analyses of surface coatings on a small selection of fifteenth- and sixteenth-century bronzes were made by Stone, White, and Indictor (1990). Some drying oils and turpentine could be identified, but there were other coatings with polymeric copper-containing substances that could not be readily identified by Fourier transform infrared spectroscopy, gas chromatography–mass spectrometry, or pyrolysis-gas chromatography–mass spectrometry. This is a common problem once copper cations start to interact with organic polymers—crosslinking and degradation, chain-scission, and complexation make it difficult to identify autochthonous components.

More humble techniques, such as long- and shortwave ultraviolet illumination, can be of assistance in examining more recent restorations of patina involving wax or other coatings of resin or varnish. The majority of Renaissance bronzes were waxed to seal and finish the patina and are routinely rewaxed as part of their normal maintenance. Beeswax was commonly used for this purpose, as well as linseed oil and lavender oil (Hughes and Rowe 1982). This tradition is still extant; during a visit to a church in Venice, Bewer (1996) found a sixteenth-century sculpture being literally immersed in linseed oil. When examined under ultraviolet light, most sculptures manifest only a bluish glow from thick accumulations of wax. In one case, however, Bewer found that *Saturn Devouring a Child*, a bronze attributed to Simon Hurtrelle (1648–1724) in the collections of the J. Paul Getty Museum, gave a distinctive orange glow from the presence of shellac on the wings and drape of the sculpture.

Weil (1996) notes that the famous statue of *David* by Donatello (1386–1466),[14] which was cast during the 1430s, was covered with a dark lacquer. This helped to conceal small casting flaws and repairs, which are reputedly a common feature of fifteenth-century Florentine bronzes. Donatello's sculpture, shown in PLATE 68, is now in the Museo Nazionale del Bargello in Florence and once stood in the courtyard of the Medici Palace.

A similar use of dark lacquer to conceal flaws was discovered when the lacquer and corrosion products were cleaned from the bronze doors cast in 1433–45 by Antonio Averlino (Filarete) (1400–1469) for St. Peter's Basilica in Rome. The doors contained numerous repairs and were made in different alloy components; patination was used to disguise the uneven surface appearance. In contrast, the bronze doors on the Church of San Michele at Monte Sant'Angelo, Italy, were probably finely cast, since they have an inscription from the sponsor, Pantaleone d'Amalfi, to the effect that the doors need to be cleaned once a year to retain their bright and shiny appearance (Federici 1969).

Gauricus (Gaurico 1969) mentions that polished bronze or brass will turn yellow by placing it on an incandescent plate and that the surface of a bronze can be blackened by holding it over the smoke of damp or wet-burning hay. Sometimes drying oils, colored lacquers, or varnishes were applied directly to the polished metal surface to give it a warm glow or to darken it. Vasari describes the use of oil or varnish to turn the surface black, and Gauricus suggests coating it with pitch. In archival material concerning a bronze mythological group by Massimiliano Soldani (1656–1740), Avery (1996) discovered an interesting reference to patination after repairs had been made. An English dealer identified as Zamboni had written to Soldani asking for his advice on how to repair the bronzes damaged during shipment. The sculptures had been mended by soldering but this had ruined the patination. In his reply, dated 28 April 1725, Soldani advised never to solder the parts but rather to fix them together with molten bronze of the same alloy as that of the cast so it will have the same color. To restore the damaged patina, Soldani continued, it is necessary to remove the old one first by bathing the bronze in lye and using a bristle brush to remove the varnish. Then the surface is to be cleaned with pungent lemon juice that is rubbed on the metal with smooth white sand and a wooden stick. Finally, the sand and juice are removed with water, and the metal is dried with a cloth and by warming. Soldani's new patina was made by first applying clear walnut or linseed oil with a bristle brush, then following this with a coating of finely ground hematite or lapis rouge. Soldani cautioned against applying too much hematite on the rough areas to prevent the material from lodging in recesses and causing them to appear dark and subfusc. This patina is essentially oil with a glazing of hematite that is left to dry.

A fine translucent tawny patina on a Renaissance bronze is shown in PLATE 69. This *Laocoön*, by Giovanni Battista Foggini (1652–1725) and dating from about 1720, is in the collections of the J. Paul Getty Museum. *Mercury*, a bronze cast around 1559–60 by Alessandro Vittoria

(1525–1608), exhibits a darker patinated finish. This sculpture, also at the J. Paul Getty Museum, is shown in PLATE 70. For most of these Renaissance sculptures, a green patina would be unnecessarily crude since it would usually be opaque, hiding the nuances of the surface metal.

<table>
<tr><td>Unraveling an object's patination history</td><td>The intricacies surrounding the issue of surface appearance are exemplified by Nessus and Dejanira, a Renaissance bronze attributed to Giambologna (act. ca. 1690) in the collections of the</td></tr>
</table>

Huntington Library and Art Galleries in San Marino, California. There are three known signed versions of this bronze group; the other two are in the collections of the Louvre in Paris and in the Skulpturensammlung in Dresden (Bewer 1996). The surface patina of the bronze is very uneven, and some parts appear to have been repatinated. The surface scratches may have a number of different causes. In some areas, friable white deposits suggest that a plaster piece-mold may have been taken from the bronze at some stage. In addition a series of deep, straight, darkened scratches run in one line from the figure's right shoulder, across the body, and down the left side, resembling the marks often made during the process of *surmoulage* (taking a plaster mold directly from a finished bronze). The marks from a plaster piece-mold should be positive, so perhaps the surface scratches in the metal are a result of taking a gelatin mold from the sculpture.[15]

A bronze pin had been used to repair a break in a leg, and solder had been used to secure the repair. This was replaced in the modern restoration of the piece with a stainless-steel pin and epoxy resin. The bronze has been finished with a fine scratch-brushed surface that shines through the primary translucent layer.

An interesting attempt to discover more about the way Giambologna finished his bronze surfaces was investigated by Stone, White, and Indictor (1990). They found that various oils, pitches, and resins had been used to coat the surfaces of the sculptor's bronzes in the collections of the Metropolitan Museum of Art. In recessed areas, the reddish brown coating has darkened and become opaque; in some exposed areas, the coating is worn away and the metallic surface appears gray. Another coating of a different material covers selected areas of the lacquered figures. In *Nessus and Dejanira*, for example, Nessus's face is covered by a fine layer of darker opaque, grayish green, brittle material with granular inclusions; this appears to be a hard waxy solid. A deeper red, lacquerlike coating covers most of Dejanira and has flaked off in some spots, revealing the wire-brushed metal surface below. Under ultraviolet illumination, the thicker deposits show a bright yellow-green fluorescence, which is suggestive of shellac. The surface patina of this bronze therefore reflects a complex pastiche of events that could have occurred at any stage from the sixteenth to the nineteenth century. It is difficult to be sure of the nature of the original finish applied to such Renaissance bronzes, although in this case it can be inferred that the wire-brushed finish was specifically employed to enable the subtle surface reflections to show through a translucent reddish brown surface coating.

Weil (1996) has produced an interesting essay about attitudes toward the subject of patination in different periods; it should be read for its humanistic approach to the topic. Weil's discussion of the nature and attitudes toward patina has a bearing on arguments that are sometimes made to show that ancient bronze objects were often polychrome in their surface finish as a result of different patinas being applied or created on the bronze surface (Born 1993). Born gives as an example the statue of Dionysis in the Museo Nazionale (Terme Museum) in Rome. This bronze was found in the Tiber River with a fine brown-black patina. The hair region of the statue is a deep black that contrasts with the patina on the skin. The statue has been conserved, however, and there may originally have been a dark surface coating over the entire statue. Another possibility is that the hair region may have entrapped corrosive solutions more effectively and thus become darker than the rest of the figure.

PATINATION DURING THE NINETEENTH CENTURY

During the nineteenth century there was a revival of interest in the patination of bronze and brass. Hughes and Rowe (1982) note that a manual of workshop receipts by Lacome (1910) reveals that patina began to be of special interest around 1828 when a patina called Florentine tint was popularized by the work of a metal founder by the name of Lafleur. Lafleur's patina involved coating an object with copper and then applying a thin paste of sanguine (principally hematite, or a red earth) and plumbago (graphite) dissolved in an alcohol or spirit-based solution; this is not unlike Soldani's rouge technique described earlier.

Later an entirely different patination technique, based on smoking the bronze using a special smoking oven, became popular and was used extensively throughout the nineteenth century. The smoking method was varied by employing yellow and red pigments to highlight both green- and brown-colored patinas, marking a transition from the use of pigments within the patina to painterly patinas, in which variations were sometimes made with the addition of bronze powders to create a variety of surface effects. These typically greenish bronze powders were lightly scattered over parts of the surface to create a variegated appearance, known colloquially as "pigeon's neck" (Hughes and Rowe 1982; Hughes 1993). Some artists, such as A. L. Barye (1796–1875), sought to retain control of the bronze's finish rather than leave this aspect of the work to the foundry, which was the normal practice. Consequently, these artists developed considerable skill in the application of appropriately colored patinas.

One rather amusing set of instructions for producing a malachite patina to simulate antiquity comes from a twentieth-century craft handbook (Taubes 1976). It calls for the procurement of a large fish that is slit open and the copper object to be patinated slipped inside. The stuffed fish is then buried in the ground for several months. After the fish is dug up, the object is removed and transferred to a Vienna wine cellar for several weeks for carbonation of the surface. Following this treatment, the object is boiled in mud and cleaned; according to the handbook, it now has a "natural" patina.

Roman bronzes | The author made a detailed study of the natural patinas of four bronzes that came on the art market in 1984, finding evidence that could be used to support the archaeological association of these sculptures (Scott 1994a). This group consists of three objects in the collections of the J. Paul Getty Museum—a Roman bronze identified as a statuette of Roma (Rome) or Virtus (valor), a relief fragment of two men (the "Togati bronze"),[16] and a statuette of Ceres (the Greek Demeter) or Juno (the Greek Hera)—and a fourth piece, *Victory with Cornucopia* (winged Nike), at the Cleveland Museum of Art. All four sculptures are assigned a date between 40 and 68 C.E., and all are made by the lost-wax process in leaded tin bronze with cast-on additions. Further details of their X-radiography and casting are reported by Scott and Podany (1990).

The statuette of Roma, or Virtus, is shown in PLATE 71. This bronze statuette, which may originally have been a chariot attachment, is shown wearing a short tunic unfastened on the right shoulder and an Attic helmet with a visor and crest. Roma is shown standing in this dress on coinage from the time of the Roman Emperor Galba (reigned 68–69 C.E.) (Herrmann 1988). An unusual hexagonal network in the detail on the reverse surface of the figure, near a large opening in the back, is shown in PLATE 72. Each hexagon is about 1 mm across, and the network is clearly visible in many areas of this surface. This hexagonal structure is rarely seen in corrosion layers, and no satisfactory explanation has yet been offered for its presence.

In the Togati bronze, shown in PLATE 73, the figures are dressed for a patrician ceremony. The details of their dress and clothing suggest first-century comparisons, as does the hair on the older-looking figure; it is brushed forward on the neck, as in portraits of Caligula, Nero, and their contemporaries (Herrmann 1988). The two figures were cast in one piece, with heads inverted in the mold so that more gaseous regions toward the top of the casting are in the areas of the feet, as evidenced by the sculpture being more porous in that region (Podany 1988).

The third piece in the group, not pictured here, is a bronze figure of Ceres or Juno, clad in a long tunic and mantle. The position of the figure's arms and hands suggests that she once held an offering dish in her right hand and a scepter in her left. A large, square hole in the back of the statuette indicates that it was once fastened to another object, perhaps a chariot or a piece of furniture.

The *Victory with Cornucopia*, or winged Nike, is shown in PLATE 74. Christman (1989) notes that the left arm, right leg, and wings were cast separately from the body, which is hollow. This is very similar to the mode of manufacture of the Roma and Ceres. In an ancient restoration of the Nike, the wings were repositioned farther apart and lower.

The patina on all four of these bronzes contains the same fibrous malachite that is discussed in CHAPTER 3 (see PLATES 20 and 21). PLATE 75 is a low-power photomicrograph, revealing some of the features of the surface corrosion of the Togati. In areas where the surface has been

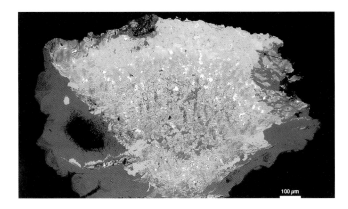

FIGURE 11.1 Cross section of a corrosion pustule on the Togati bronze (see PLATES 73 and 75), showing the complex structure of the corrosion products. The lighter gray phase is cuprite; the darker gray is malachite; the light, solid particles are lead carbonates; and the light particles are alpha+delta eutectoid. The area of the pustule that is in contact with the metal surface is toward the bottom of the picture. Viewed under the electron microprobe in backscattered mode. Scale bar represents 100 μm.

FIGURE 11.2 Backscattered electron image of part of the pustule shown in FIGURE 11.1. Attachment of the pustule to the mineralized surface zone, which includes tin oxides, is visible at the bottom of the image. The lighter gray fragments just above the attachment are euhedral crystals of cuprite. Above this are more massive cuprite layers. Lighter gray particles are alpha+delta eutectoid; the very light particles are basic lead carbonates (magnification ×320).

cleaned, the figures have a smooth, sometimes mottled patina. Overlying this layer are disseminated fragments of a copper- and lead-rich phase whose globular shape is oriented in a pattern suggesting interdendritic regions. These globular particles can be easily cleaved from the patina with a scalpel, using a gentle cutting motion parallel to the patinated surface. The surface continuity is periodically interrupted by pustules of corrosion, as illustrated in FIGURE 11.1. These pustules have an apparently layered structure; beneath each pustule, the smooth patina is interrupted by a zone of cuprite. An overall backscattered electron image of one such pustule is shown in FIGURE 11.2.

| SAMPLE DETAILS A core sample was taken through the hexagonal network structure on the surface of the Roma bronze to examine the microstructure in this area. PLATE 76 shows a cross section of this sample, taken through one of these hexagonal surface features at ×130 magnification. Toward the top of the photomicrograph, an area of eutectoid (the part of the structure examined through the hexagonal surface feature) is seen isolated within the corrosion layer, showing that the copper-rich alpha phase of the bronze is preferentially corroded with preservation of eutectoid relicts. This microstructural study reveals that the tin-enriched surface of the Roma bronze has not been formed by the corrosion of a deliberately tinned surface layer. The part of the structure examined is not obviously dendritic; it has the appearance of an annealed casting and could have been caused by the casting-on of the legs and feet. The original dendritic and cored microstructure of the object could have been altered by heating during the casting-on process to produce a microstructure more typical of annealed bronzes. Changes in structure of this type have been seen in other works where casting-on has been employed; an example is a dagger handle from Luristan, Iran (Scott 1991:94).

The corrosion pustule from the Togati bronze, (see FIGURES 11.1, 11.2), has a complex microstructure. Part of the structure toward the left side of FIGURE 11.1 contains a vacuole surrounded by malachite crystals. The bottom of the photomicrograph in FIGURE 11.2 represents the surface adjacent to the tin-rich patina; the right side is the outer surface of the pustule. One surprising observation was the existence of metallic remnants of alpha+delta phase eutectoid at the outer extremity of the pustule; this is a considerable distance from the metallic core of the figures and 1 mm above the tin-oxide patina. The very light-colored particles seen in FIGURE 11.2 are basic lead carbonates, while the gray middle tones or lighter gray regions are mostly cuprite, and the darker surrounding area mostly malachite.

Toward the center of the same pustule (see FIGURE 11.1), thousands of tiny malachite crystals can be seen projecting inward while toward the outer surface the curved crystal growth of the malachite predominates. The lighter regions are cuprite that has floated away from the main cuprite mass and become incorporated into the malachite area. The central part of the pustule consists of interconnected ribbons of massive and euhedral cuprite passing upward, away from the patinated surface. Interspersed in this cuprite are isolated patches of hydrocerrusite, islands of alpha+delta eutectoid, and malachite. The malachite becomes more prevalent toward the outer surface of the pustule. It is significant that there are no chlorides within the pustule, nor are there any chloride-containing species within the patina layer.[17]

| CLASSIFICATION OF STRUCTURES Structures of corrosion crusts may be classified on the basis of their morphological or descriptive characteristics or their presumed mode of origin. Both of these approaches involve some compromise. Descriptive classifications, such as those used by Fink and Polushkin (1936), provide little information about the genesis of structures. Genetic classifications may be misleading, however, and some struc-

tures could easily form by more than one process or by a mixture of processes that would be genetically distinct. Keeping these difficulties in mind, a general conclusion can be made based on recent studies that there are at least two distinct forms of pustular, or "warty," corrosion:

1. pustules of corrosion that are associated with cuprous chloride or with the copper tri-hydroxychlorides that result from the subsequent transformation of the cuprous chloride; this cuprous chloride is often at the interface between the patina layer and the base of the pustule (Tennent and Antonio 1981; Scott 1990); and

2. pustules of corrosion with cuprite and malachite but no chloride ion content; these pustules may be associated with tin-oxide-enriched patinas in which the corrosion process has proceeded in soils that do not contain significant amounts of chloride ions; the preservation of metallic components, such as alpha+delta eutectoid phase, may also be seen.

In the case of the Togati bronze, the corrosion pustules appear to originate by the formation of cuprite septa, filaments of cuprite that pass through the malachite and cuprite mass of the pustule. These cuprite septa pass across the tin-oxide patina, allowing the diffusion of copper to occur at particular locations. The tin-oxide layer that develops is probably hydrated, and at varying times during burial it may be liable to dehydrate to some extent. Cracking of this layer, which would accompany partial dehydration, could cause further loss of copper as cuprite septa move through the tin-oxide patina and relay copper ions to the exterior.

Expansion of the corroded matrix of the original bronze metal is shown by the presence of lead carbonates, which would have created a greatly expanded volume compared with that of the original lead globules present in the metal, and particularly by the relict fragments of alpha+delta eutectoid phase toward the outer surface of the pustule. The lead—which is present in the alloy as discrete, small globules—is carried outward into the pustule where it becomes carbonated and converted into cerrusite with considerable expansion in volume. This accounts for the relatively large size of these lead-rich zones in the corrosion; they can range from about 10 to 35 µm across. The tin-rich region of the eutectoid is preferentially preserved while the copper-rich region is converted primarily into cuprite. FIGURE 11.3 is a schematic diagram comparing the first type of warty corrosion described earlier with the second type, which is found in the corrosion pustules on the Togati bronze.

| CONCLUSIONS A hypothesis explaining the origin of the type of corrosion seen on the Roman bronzes can be formulated based on research by Geilmann (1956) and on the observed morphological characteristics: the tin-oxide enrichment in the patina, the presence of mottled areas containing enhanced levels of iron, and the pseudomorphosis of structural details. According to this hypothesis, one possible environment for the corrosion observed on these bronzes is burial in a porous soil that had both oxygen and carbon

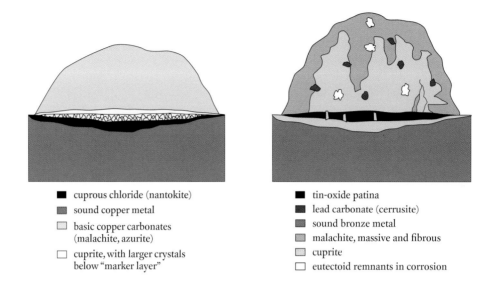

cuprous chloride (nantokite)
■ sound copper metal
basic copper carbonates
(malachite, azurite)
cuprite, with larger crystals
below "marker layer"

tin-oxide patina
■ lead carbonate (cerrusite)
■ sound bronze metal
malachite, massive and fibrous
cuprite
eutectoid remnants in corrosion

FIGURE 11.3 Schematic diagram comparing the conventional type of corrosion pustule containing chloride corrosion with the pustule observed on the Togati bronze shown in FIGURES 11.1 and 11.2.

dioxide readily available but had no corrosion due to chloride ions. In this scenario, the corrosion products and pustules should show no evidence of chloride corrosion, nor should the pustules be associated with cuprous chloride. This hypothesis was, in fact, confirmed by Geilmann's analytical and microstructural studies. This corrosion environment was not deficient in carbon dioxide, as seen from the extensive malachite deposits on the surface of the bronzes, the conversion of the lead globules in the alloy to lead carbonates, and the presence of azurite crystals on the Nike and the Ceres bronzes. In the case of the Ceres, azurite can be seen growing on individual malachite fibers as tiny deep blue compact crystals. The outer surfaces of the corrosion pustule on the Togati are also malachite rather than basic copper chlorides. This kind of warty corrosion on all four of the bronzes studied is a strong argument that all of them were buried in the same environment. Unlike warty corrosion associated with chloride ions, the kind seen on the surface of these four Roman bronzes is chemically stable under storage or exhibition conditions. Such objects do not require especially strict humidity control. The Roman bronzes had been kept in a special case with the humidity regulated to below 40%, but since there is no chloride instability in the corrosion, such measures were unnecessary. During conservation treatment, there is no need to remove warty corrosion unless it is justified for aesthetic reasons.

Chinese bronze mirrors Some of the most puzzling and difficult quandaries to unravel in regard to patinas are those found on excavated Chinese bronze mirrors. These mirrors exhibit a wide range of surface preservation and include smooth, shiny, silver-colored patinas; lustrous black patinas; smooth green patinas with a translucent aspect; and the more common patinas, such as those found on any buried bronze, with pustules of corrosion, eruptions of cuprite or nantokite, or partially disrupted surface layers with loss of detail.

From about the tenth century, an important trading center was established at Kota Cina, Sumatra, and fragments of bronze mirrors made by the sophisticated beta bronze technology occur in related areas, such as Java. One such example, a beta-quenched[18] Javanese bronze mirror with a reflective green-black surface, is shown in PLATE 77A. The microstructure of this object is illustrated in PLATE 77B, which reveals a well-developed beta-phase morphology in which the islands of alpha are twinned, revealing that some hot-working of the alloy must have occurred during the fabrication process. Working these kinds of alloys at high temperature demands great skill.

Two examples of representative patinas on Chinese mirrors from the Freer Gallery of Art in Washington, D.C., are shown in PLATES 78 and 79. Characteristic microstructures of the alloys and patinas for these types of bronzes are shown in PLATE 80. The earliest Chinese bronze mirror was excavated from Guinan county, Qinghai province, and dates to the Xia dynasty (2100–1600 B.C.E.), according to Zhu and He (1993). These mirrors were prized for more than two thousand years, starting in the Warring States Period (475–221 B.C.E.) of the Eastern Zhou dynasty and continuing into the period of the Qing dynasty (1644–1911).

COMPOSITION Some evidence suggests that Chinese metalsmiths employed many fire-refinings[19] of the copper used to make high-quality mirrors before alloying with lead and tin. From the Warring States Period to the Tang dynasty (618–907 C.E.), these mirrors had a composition of about 69–72% copper, 22–25% tin, and 4–6% lead. Mirrors made after the Song dynasty (960–1279) tended to have more variable composition and less tin content. Most fine-quality mirrors that have been excavated have either a silver-colored surface under a corrosion layer or a black-colored surface, which may itself represent a corrosion layer. Both kinds of surfaces have given rise to extensive speculation about their origins. Were they created artificially, or naturally in a burial environment over long periods of time? The corrosion that occurs on the silver-colored surface could have formed by the diffusion of copper ions through the surface layer; therefore, it is not clear how such a surface is either preserved or formed as a possible result of corrosion. The same kind of speculation occurs in regard to the black layer. The first scientific paper on Chinese and Japanese bronzes appears to be that of Morin (1874). The most cogent investigations on the subject are those reported by Meeks (1988a,b; 1993a,b).

Chinese mirrors were usually made in a high-tin alloy to produce a highly reflective, silver-colored surface. Many Chinese textual descriptions of these mirrors imply that they were purposely manufactured to be bright and shiny. Some excavated mirrors retain vestiges of this silver-colored surface, which is simply the color of the polished metal. During corrosion, the alpha-phase solid solution and the alpha component of the eutectoid present the common mode of attack, frequently engulfing the lead globules in the metal, to a depth that varies from 25 to 200 μm. The delta phase remains uncorroded and retains or imparts a silver-colored surface appearance. The black-surfaced mirrors show the same kind of corroded surface with the important difference that the delta phase of the eutectoid is also corroded, often to a depth of only a few micrometers, but this is sufficient to produce a black coloration. It is interesting to note that very little cuprite is seen in the corrosion crusts of these mirrors. Soil minerals are absorbed into the corroded surface layer, which, in addition to some cassiterite or stannous oxides, may include silicon, aluminum, iron, and sulfur.

All three major alloying elements suffer mineralization in the surface layers of these mirrors; there is a severe depletion of copper, which is mostly leached away into the surrounding soil. The tin and lead are converted to oxides or, in the case of lead, possibly to carbonates. Low concentrations of silicon, aluminum, iron, phosphorus, chlorine, potassium, and calcium ions are also found, readily explained by exchange with the surrounding soil minerals. Hydrous tin oxides, which may form part of the patina, are essentially gel-like on initial formation and act as efficient ion-exchange media for ions from the immediate burial environment.[20]

| BURIAL ENVIRONMENT AND PATINA Collins (1934) found a Han dynasty mirror that was only partially buried in the typical Chinese loess soil. The buried part had a blue-black patina while the exposed part remained silver colored, suggesting that in most circumstances the burial environment is the critical factor in determining the nature of the surviving patina. Sun and colleagues (1992) showed that humic acids can have an important influence over the corrosion process in helping the formation of the black surface. No reference is made in this discussion, however, to the important early work published by Geilmann (1956), whose results are directly applicable to the Chinese bronze mirrors considered here. Geilmann carried out a detailed examination of the corrosion of bronzes buried in the sandy soils of German Bronze Age tumuli, employing wet chemical analysis to investigate the elemental or element-oxide concentrations of twelve bronzes, many of which were reduced to a residue of stannic oxide. Geilmann analyzed objects that were completely corroded, samples in an advanced state of deterioration, and samples of patina. He also studied the dissolution of copper from the patina, the fixation of metallic constituents that had been dissolved from the patina or bronze, and the process of corrosion of bronzes in the absence of chloride ions. In an examination of objects in an advanced state of corrosion, Geilmann included a sword blade from the

Middle Bronze Age, dating to about 1000 B.C.E., and an urn from a grave site dating to the Early Iron Age, around the second to third century C.E. Some of these objects, which had been entirely leached of copper, had such an osseous appearance that they were originally mistaken for stained or indurated bone.

The sword blade retained a marker layer, or original surface, even when only hydrated tin oxide remained. The urn, however, had a thin, dark green patina and an almost white tin-oxide layer underneath this green surface, which retained the shape of the object. A representative set of Geilmann's analyses are given in TABLES 11.1 and 11.2. Geilmann deduced that the absolute tin content of these bronzes was unchanged during corrosion and that no arsenic or antimony was lost. Iron and aluminum levels were increased in the patina layer from interactions with soil minerals. Geilmann's data show that some objects retain a copper-rich patina, but the study also revealed that other objects have copper leached from the surface zone until only hydrated tin oxide remains. This hydrated tin-oxide layer is then quite stable and resistant to further attack by soil groundwater. Geilmann writes:

> [T]he formation of these patina in burial is ascribed to oxygen and carbon dioxide carried by groundwaters. The salts present in soil solutions can influence the formation of the patina and the nature of the corrosion, but on the whole are of minor importance. The dissolution of copper and other divalent ions is solely due to the free carbon dioxide in the water and the progress of this dissolution is dependent on the concentration of carbon dioxide in solution. If this concentration is high, as for example in humus or porous sandy soils, then the patina is formed rapidly and the continuing dissolution of copper results in an end product of pure tin oxide, whereas in other soils, such as clay, bronzes of the same age may only be covered in a thin patina. In humus-rich sandy soils with a low lime content, there is no inhibiting effect on the decomposition of the patina to create a tin-oxide surface, while in lime containing soils, where the soil solutions may contain calcium bicarbonate, this decomposition is inhibited. (Geilmann 1956:208)

Geilmann's experimental dissolution studies showed that copper would be lost from a laboratory mixture of copper carbonate and tin oxide. In addition, salts of trivalent iron and aluminum may contribute to tin-oxide enrichment if they are present in the burial environment. The copper carbonates are preferentially dissolved while iron or aluminum hydroxide is precipitated; this accounts for the increase in these metallic ions in the patina. Analyses of soil samples taken from the earth surrounding the buried object in this study showed the fixation of most metals from the bronze with the exception of arsenic, antimony, and tin. Geilmann proposed that cuprite is the first corrosion product to form, along with the corrosion of both the copper and the tin content, followed by the dissolution of copper in the oxidation zone of burial. Geilmann explains this as follows:

[I]f this proceeds, the copper is dissolved by carbon dioxide containing waters, so that finally pure tin oxide remains which combines with various compounds from the soil.... [T]he degree of this decomposition depends on the ratio of oxygen and aggressive carbon dioxide in the groundwaters. If oxygen is missing the decomposition will be slow, even in the presence of high amounts of carbon dioxide.... [I]f there is a lot of oxygen, but little carbon dioxide, then the metal is often oxidized and covered with a carbonate patina. (Geilmann 1956 : 210)

TABLE 11.1 **COMPOSITIONAL ANALYSIS OF A BURIED BRONZE URN DATING TO THE EARLY IRON AGE**

METAL (wt %)		COMPOUNDS	PATINA	TIN OXIDE ANALYSIS NO. 1	TIN OXIDE ANALYSIS NO. 2
Cu	83.70	CuO	54.84	9.30	0.78
Sn	11.85	SnO_2	28.31	56.07	63.20
Sb	0.53	Sb_2O_5	1.91	2.35	2.80
As	0.14	As_2O_5	0.40	0.78	0.90
Pb	2.98	PbO	0.27	0.20	0.01
Fe	0.96	Fe_2O_3	1.90	2.42	2.67
		NiO	—	—	—
TOTAL	**100.16**	CoO	—	—	—
		Al_2O_3	0.05	2.24	2.75
		MnO_2	—	0.09	0.15
		CaO	0.05	0.10	0.03
		P_2O_5	0.76	2.39	2.69
		SO_3	0.10	0.05	0.02
		SiO_2	0.37	3.17	3.20
		CO_2	6.45	1.58	0.05
		Loss[a]	6.32	19.31	21.30
		TOTAL	**99.83**	**100.05**	**100.25**
		Humus	trace	trace	0.08
		NH_4	—	—	—
		Cl	0.05	0.08	0.03

After Geilmann (1956).

[a] Loss of weight on ignition.

These corrosion processes, Geilmann argues, occur in the absence of chloride ions, and his analytical results tend to support this interpretation. The presence of humic acids in the soil—along with enhanced levels of soil minerals such as iron, silicon, and aluminum—was also shown to be an important factor in the corrosion of the bronze objects from these sites.

Several papers have confirmed the essential fact of humic acid's role in the corrosion of buried copper-alloy objects. Taube, King, and Chase (1997), for example, found that Chinese bronze mirrors with a typical composition of 70Cu25Sn5Pb might have a 100 μm thick patina

TABLE 11.2 **COMPOSITIONAL ANALYSIS OF A BURIED SWORD BLADE DATING TO THE MIDDLE BRONZE AGE**

METAL (wt %)		COMPOUNDS	OXIDE PATINA[a]	OUTER REGION OF BLADE	CENTER REGION OF BLADE	POINT OF BLADE
Cu	90.26	CuO	72.02	22.55	8.72	5.60
Sn	8.70	SnO_2	28.53	55.07	68.59	68.15
Sb	0.20	Sb_2O_5	0.75	1.34	1.46	1.74
As	0.05	As_2O_5	0.42	1.09	0.93	0.91
Pb	0.18	PbO	0.01	0.05	0.05	0.05
Fe	0.15	Fe_2O_3	0.12	0.72	0.91	1.64
Ni	0.24	NiO	0.07	0.15	—	—
Co	0.10	CoO	0.06	0.09	—	—
TOTAL	**99.88**	Al_2O_3	0.01	0.15	0.25	0.52
		MnO_2	—	—	0.05	0.12
		CaO	—	0.05	0.10	0.09
		P_2O_5	0.12	1.01	1.07	1.05
		SO_3	—	—	0.12	0.05
		SiO_2	0.02	0.06	0.08	0.05
		CO_2	0.22	2.40	0.64	0.42
		Loss[b]	nil	15.41	17.28	19.83
		TOTAL	**102.35**	**100.14**	**100.20**	**100.19**
		Humus	—	0.16	0.15	0.49
		NH_4	—	0.03	0.06	0.08

After Geilmann (1956).

[a] Composition of layer isolated from what appears to be a cuprite zone.

[b] Loss of weight on ignition.

in which corrosion had selectively replaced the copper-rich alpha phase, leaving the tin-rich delta phase intact. X-ray diffraction data by these authors show that the alpha-phase replacement product was poorly crystallized or nanocrystalline cassiterite. It can be very difficult to completely characterize fine, dark patinas of this type. Transmission electron microscopy suggests that this alpha-phase replacement has a composition of $Sn_{1-x}(Cu,Fe,Pb,Si)_xO_2$.

Another example of subtle identification problems concerns the very dark green patinas examined on a number of bronzes from the sixth century B.C.E. that were excavated from the religious sanctuary site of Francavilla Marittima in southern Italy (Scott and Taniguchi 1999). The greenish black patina suggested that a copper sulfide might be present, but detailed studies by X-ray diffraction found that the only possible analogies were to chvilevaite, $Na(Cu,Fe,Zn)_2S_2$, or frerbergite, $(Cu,Ag,Fe)_{12}Sb_{4.4}S_{12.6}$ (ICDD 27-190). Partially substituted lattices, in which copper can be replaced with other metallic ions, may explain why these oxide or sulfide patinas can be so analytically intractable. This consideration of the corrosion of Chinese bronze mirrors leads to a wider discussion concerning various attempts at imitating or replicating patinas, a subject of considerable interest from ancient times.

HISTORICAL ATTEMPTS AT REPLICATING PATINAS In seventeenth-century Europe, Etruscan mirrors were eagerly collected objects, as were other Greek and Etruscan bronzes, in parallel to the revival of interest in everything antique. Several centuries earlier in the Far East, Chinese connoisseurs were fascinated by the appearance of excavated bronzes with their varied colors and surface finishes. During the Southern Song dynasty (1127–79) and Ming dynasty (1368–1644), many attempts were made to imitate both the style and patination of these treasured artifacts, which often displayed black, tin-enriched patinas or smooth and subtle light greenish blue surfaces, incorporating a substantial proportion of tin compounds along with copper corrosion products. Many techniques were developed to try to replicate these finishes; they ranged from the simple adhesion of ground-up malachite with glue binder to the thinly patinated surface, often with a cuprite crust a few micrometers thick,[21] to highly complex chemical treatments. Kerr (1990) suggests that the deliberate forging of Chinese bronzes was already prevalent by the time of the Song dynasty.

Several recipes have survived for producing the greens and reds of the patinas that were much admired. Gao Lian, a collector living during the Ming period, records a complex treatment to produce an artificial patina that begins with applying a mixture of sal ammoniac, alum, borax, and sulfuric acid to the surface of a bronze object and baking it. Next the object is placed in a pit lined with red-hot charcoal that has been splashed with vinegar. A variety of substances are added to the surface of the object to encourage salt efflorescence, such as pigment, piles of salt placed on certain areas of the bronze surface, metal filings, or cinnabar. The treatment ends with burial of the bronze in acidic soil for an extended period of time. The initial mixture

applied to the bronze object will not produce a malachite patina; the mixture's primary corrosive agents are chloride and sulfate anions, which would result in a mixed atacamite-brochantite patina at best. If the charcoal is able to burn off this crust to make a cuprite-tenorite layer, however, this may be partially converted to a copper acetate patina. Burial could perhaps then partially convert this new patina to a paratacamite-malachite crust, depending on the soil's acidity and other parameters.

Barnard (1961) provides examples of other historical recipes for the alteration of surface appearance, including the following one from the *Tung-t'ien ch'ing-lu*, a tenth-century scroll from the Song dynasty:

> The method of faking archaic bronzes is achieved by an application of quicksilver and tin-powder—the chemical mixture now used to coat mirrors. This is firstly applied uniformly onto the surface of the new bronze vessel, afterwards a mixture of strong vinegar and fine sand powder is applied evenly by brush; it is left until the surface colour is like that of dried tea, then it is immediately immersed into fresh water and fully soaked. It thereby becomes permanently the colour of dried tea; if it is left until it turns a lacquer-like colour and immediately immersed into fresh water and soaked, it thereby becomes permanently the colour of lacquer. If the soaking is delayed the colour will change. If it is not immersed in water it will then turn into a pure kingfisher-green colour. In each of these three cases the vessel is rubbed with a new cloth to give it lustre. Its bronze malodour is covered by the quicksilver and never appears; however, the sound of old bronze is dainty and clear, whilst the sound of new bronze is turbid and clamorous—this cannot escape the observation of the connoisseur. (Barnard 1961 : 214)

Use of the mercury-tin amalgam described here may have been an attempt to imitate the lustrous, shiny, silver-colored surfaces that are sometimes found on old mirrors and that may appear to be corroded to some extent by the application of corrosive agents to artificially pit and mar the surface. Such attempts at patina replication, however, would not be expected to deceive the connoisseur.

Analytical studies rarely show the presence of mercury in the patina of ancient Chinese mirrors, despite the fact that mercury and tin are frequently mentioned in association with their finish. Part of the explanation can be found in an ancient recipe for a polishing compound known as *xuan xi*, which was essentially a mercury-tin amalgam (Zhu and He 1993). Investigations by Meeks (1988a,b; 1993a,b) have helped to clarify the issue. When mercury and tin are mixed together, a very sluggish reaction occurs at room temperature, and the mixture must be heated to form a mercury-tin amalgam; heating at 200–250 °C produces a pasty gamma-phase $HgSn_6$. The gamma phase decomposes at 214 °C, and mercury can be driven off by heating

above 357 °C with tin diffusion into the copper substrate. A thin layer of nu intermetallic compound develops at the outer surface over a thick layer of epsilon intermetallic compound; if the surface of the object is heated above 520 °C, a layer of alpha+delta eutectoid phase develops under this layer and is contiguous with the copper substrate.

Very little evidence exists to support the use of tinned surfaces made by applying a mercury-tin amalgam to ancient Chinese mirrors. These mirrors were usually made in leaded bronze with a high tin content, and there would be no need to create extra tin-rich copper phases by chemically treating the surface. Meeks (1993a) discovered, however, that a cold, mechanical application of a mercury-tin amalgam to the polished surface of a 25% tin bronze did produce a subtle surface effect. The treatment involved rubbing the polished bronze surface with a small crushed pellet of the amalgam. After two minutes, the treated surface appeared more noticeably silver colored. Optical microscopy revealed that a silver-colored film obscured all but a faint trace of the morphology of the underlying eutectoid microstructure. Examination of the surface with a scanning electron microscope confirmed that this layer is very thin, perhaps 10–100 nm, and appears to consist of tin with some mercury. Meeks thinks that this extremely thin coating may result from localized heating of the amalgam when it is rubbed on the surface; the heating breaks down the gamma compound into its constituent parts, allowing the tin to bond to the surface. Thus, *xuan xi* could have been used to enhance the silvery finish of the mirror.

It is interesting that this Song dynasty recipe is not designed to produce genuine corrosion products of any depth on the surface of the bronze. Instead, it relies on a purely superficial deception. The same is also partially true of the recipe given below from the Ming dynasty manuscript called the *Hsin-ju wei-tso*. It invokes a concoction of truly alchemical proportions for faking a patina, as follows:

[A]fter [the bronze vessels] are cast they are scraped and polished until they are clean and shining; where the decor has not been cast clearly, it is engraved with tools. Then the vessel is soaked for a time in a mixture of morning-fresh well-water, clay and alumina, it is taken out and baked, again immersed, and again baked. This is done three times and is termed "making the basic colour." When the vessel is dry, a solution of ammonium chloride, copper sulphate, sodium chloride and "gold-thread alumina" is applied in green brine using a clean brush two or three times and after one or two days is washed away; again dried and again washed. The whole process is in adjusting the surface colour and the amount of washing may have to be done three or five times before it is settled. Next an oven is dug into the earth, red-hot charcoal is heaped in it and strong vinegar is sprinkled onto it; the bronze vessels are placed inside and still more vinegar is thrown over them and they are completely covered with earth and left buried for three days. When taken out and examined they are all found to have grown the colours of ancient patina mould; wax is rubbed

over them. When the colour is required to be deepened, they are smoked in burning bamboo leaves. There are two ways, by heat or by cold, in which other colour details are added to the surface colour; both employ clear gum resin which has exhausted its extremely astringent taste, compounded with melted white wax. For blue-green colour, azurite is put in the wax, for green malachite is used, for red cinnabar is used. Wax is used most in the heat method; for the cold method equal quantities of wax and gum resin are used; with these blended as required they make the added colour details. For coloured protrusions from the surface they make small amounts of salt, metal filings, and cinnabar. The mercury colour is made by an application of mercury and tin onto the sides and edges of the vessels, when covered with wax the colour is hidden and dulled a little in order to dupe the collector. When rubbed in the hands a stench arizes which cannot be got rid of even by washing. Sometimes after this process is completed they bury the vessel in the ground for a year or two; it seems then to have archaic characteristics. (Barnard 1961: 216)

Even though the superficial appearance of the treated bronze may have been quite convincing, a connoisseur would certainly have been able to detect it, especially since the craftsman resorted to attaching artificial bronze corrosion products with wax and resin, which could easily be discovered by scraping or probing the object's surface. The use of copper sulfate, ammonium chloride, and salt during the initial phases of treatment is reminiscent of modern attempts to patinate brass and bronze objects, as described in the numerous recipes collected in Hughes and Rowe 1982.

More insight into patina during the Ming dynasty is offered by the following commentary from the *Hsuan-lu po-lun* manuscript:

[W]ith the exception of vessels maintaining the original colour of the metal, the Hsuan period vessels contained a class with an imitation of ancient patina. They are not like the forged products of Honan, Chin-ling, Ku-su and such places made by baking and burying. An old bronze founder told me that the imitation of the archaic green colours on the Hsuan bronzes was achieved by obtaining from the Royal stores broken and incomplete ancient vessels. They selected those with the blue-green and jade-green colourings and pounded them into a powder and dissolving this in quicksilver, threw it into the molten bronze and melted it together. When the vessel was completed, they next applied the colours of green patina and red cinnabar using a mixture of quicksilver and finest sand, blended with the colours, dabbing this on to the vessel body and allowing it to soak in. The vessel was then roasted and cooled alternately over a fierce fire up to five times and thus the green patina colour entered deeply into the interior of the metal. Then the vessel was boiled thoroughly in molten white wax, brushed with a coir palm-leaf brush, rubbed with cotton cloth, then within and without, the green and red colourings stood out, and even when scraped with a knife they did not break away. (Barnard 1961: 217)

It is difficult to fully understand this recipe as recorded in this translation. Cuprite and tenorite would be expected to form during the melting down of the old bronze vessels; the roasting stage mentioned later in the recipe would have had the same effect. The reliance on mercury in several of these recipes is interesting, and additional associations are made between the color of cinnabar and the color of the cuprite corrosion of the bronzes. This indicates that ancient connoisseurs clearly recognized that the desirable red color of cuprite corrosion could be imitated by the more readily available cinnabar.

Chase (1994) reports an archaeologically interesting group of bronzes from the Western Han dynasty tombs of Lui Sheng and Duo Win in Man-cheng, northwest of Beijing. These tombs, which date to around 175 B.C.E., were cut in solid rock, and cast iron was poured into the prepared cavity to seal them. The chambers were never filled with earth. The bronzes preserved in these tombs present a variety of patinas. A sword, for example, has what looks like a transparent shiny patina over deep yellow, bronze-colored metal. Another appears to have silvery edges and a black center. A *ge* dagger-ax has a surface pattern of black dots on a bronze-colored background. Mirrors of three different colors were found. Most of the bronzes were dark and shiny, but the famous *boshanlu* censer from these tombs is a matte black that contrasts well with the gold inlay. Chase hypothesizes that these bronzes already had a variety of different patinas when they were placed in the rock-cut tombs.

AN INDIAN PATINA A blackened surface used for decorative metalwork in India is found on the well-known *bidri* ware, which is made of zinc-copper alloy often inlaid with silver or brass wires. The earliest surviving examples of Indian *bidri* ware date from the sixteenth to the seventeenth century. Most of the *bidri* alloys contain zinc, copper, lead, and tin; typically the composition falls in the range of 80–95% zinc, 3–10% copper, 2–8% lead, and 1–2% tin with a trace of iron (Stronge 1993). After manufacture, this high-zinc brass is patinated with a mixture of mud or clay paste containing one part ammonium chloride mixed with one-quarter part unrefined potassium nitrate and the same amount of salt. If the mixture is hot, the patina develops within a few seconds. The object can be either immersed in boiling slurry or first heated and then coated with the patinating mixture. To date the analytical characterization of the *bidri* ware patina has met with only partial success. It is assumed that mixed oxides of both copper and zinc are involved since the potassium nitrate will ensure a highly oxidizing environment at the metal surface; copper or zinc chlorides are discounted since they are not black. A study by LaNiece and Martin (1987) found that pure zinc treated in the *bidri* patinating solution developed only a pale gray patina of zinc oxide and chloride.

Analyses of *bidri* ware in the Victoria and Albert Museum showed the typical composition range quoted earlier. Black patina samples from twelve objects were analyzed by X-ray diffraction. In all cases, simonkolleite; zinc-hydroxide-chloride hydrate, $Zn_5(OH)_8Cl_2 \cdot H_2O$ (ICDD 7-155); and zinc oxide, ZnO (ICDD 5-664), were present in the patina. In some cases, cuprite was found as well. The proportions of zinc and copper in the alloy appear to be a critical factor for

the formation of the black patina. Brasses of composition 60Cu40Zn and 50Cu50Zn do not form a patina in the solution, confirming claims in the literature that the blackening process does not affect the brass wire inlays. All available *bidri* analytical data show a copper content of less than 12%, and the alloy therefore falls into the epsilon+nu phase field of the binary copper-zinc diagram. Up to about 1% copper in the zinc forms the terminal solid solution, nu; at greater than 1% copper, the epsilon phase precipitates at the grain boundaries. Apart from the work by LaNiece and Martin, there has been surprisingly little interest in the analytical conundrum of identifying this black coating, compared with the prolific number of papers that address the subject of black-patinated Chinese bronzes.

SOME FINISHES AND PRESERVED STRUCTURES

Traditional finishes on scientific instruments

Birnie (1993) reviewed some of the traditional finishes used on scientific instruments made of brass. Aesthetic appearance, corrosion resistance, and alteration of surface reflectivity are potentially important aspects of the final color; brown, blue, black, gray, and green finishes are used for particular purposes. Most instruments studied were not given a mirror finish; more frequently a satin or machined finish was preferable.[22] For patination, dark gray or browns were achieved using either platinum, arsenic, or mercury solutions (briefly discussed in CHAPTER 1 in relation to galvanic effects). Lacquer used to be a very important surface finish on scientific instruments. The old lacquers were based on resinous concoctions used with methanol, ethanol, turpentine, or white spirit. Many recipes used additives that included saffron, turmeric, sandalwood extract, and other dyes to give a colored surface finish. The technique used for applying this lacquer coat over polished brass required great skill. A flat camel's-hair brush was used to apply the lacquer in single long strokes on the metalwork, which had been heated to about 76 °C. Fingerprints can be very damaging to the surface finish of these instruments. Perspiration contains 2.17 g/l of lactic acid and 2.5 g/l of sodium chloride, in addition to amino acids and fatty acids. For this reason it is essential that gloves are worn when handling instruments finished with this kind of surface.

Tool marks preserved in patinas

Not only may recent patinas preserve inadvertent damage, such as fingerprints, that has etched into the metal surface, but ancient patinas may also preserve the impression of tool marks or other clues to how the surface was finished in antiquity. In waterlogged deposits, the absence of a normal patina may allow selective etching of the metal surface, revealing details concerning metallic structure that would normally be visible only after metallographic examination of a cross section of the object concerned.

Both Larsen (1987) and Goodburn-Brown (1996, 1997) have made significant contributions to the study of tool marks and structural detail preserved in surface patina or corrosion. Careful binocular examination under oblique or raking illumination may reveal details of tool marks in a bronze patina. In particular, artifacts from freshwater anoxic sites may be covered in a crust of copper (II) sulfides that adheres poorly to the surface. This crust can be readily removed during surface cleaning to reveal a characteristically etched and shiny metal surface. Selective natural etching at grain boundaries, twin lines, and nonmetallic inclusions or secondary phases may reveal an extraordinary corpus of detail concerning the manufacture of the objects. Because of topotaxic transformations that may occur, iron objects are generally too corroded for the observation of microstructural detail. Copper alloys, however, are often remarkably preserved. Uncoated small objects can be examined directly with a scanning electron microscope. If an object is too large to fit in the chamber, its surface can be replicated with silicon rubber; these small rubber impressions can be coated with a gold-palladium deposition for study in the microscope. An illustration in Goodburn-Brown (1997) shows how microstructural detail—such as grain boundaries, inclusions, and twin planes—can be clearly seen by this kind of surface examination. The object in the illustration is a third-century Roman Radiate coin recovered by the Museum of London during excavations along the river Thames. Another example shows distorted twin planes on the surface of a second Roman coin, indicating that it was either cold-worked in the final stage of fabrication or hot-struck at a temperature below that of the recrystallization of the alloy.

There is considerable potential for the surface examination of bronze patinas from other freshwater anoxic sites that have been excavated over the last several years. These sites include Trondheim, Norway; Coppergate, York, England (Ottaway 1992); the Araisi Lake fortress in Latvia (Apals and Apals 1998); and sites in Denmark (Rieck and Crumlin-Pederson 1988). Not all of this material is necessarily preserved in the same way as the waterfront material from the Thames excavations in London, and much of it may not be capable of preserving detail. For example, some bronzes from Trondheim have a heavy sulfidic corrosion that was created by rotting organic materials, such as leather and wood; this preserves no surface detail whatsoever. Other bronzes are reduced to a green-colored shell of corrosion with an internal core of black powdery copper sulfides (Scott 1977). The corrosion on objects from such environments is likely to undergo postexcavation alterations because of oxidation of the sulfides to sulfates such as brochantite, antlerite, and posnjakite.

Notes

1. Plutarch *Moralia, the Oracles at Delphi no longer given in verse* 5.264–65 (Plutarch 1984).

2. This conclusion does not necessarily pertain to the golden surfaces of New World arsenical copper or tin bronze objects, which may have been painted or altered before burial. Following excavation, careful examination might need to be made to determine if the surface was altered before or after burial.

3. Pliny the Elder *Natural History* 34.40 (Pliny 1979).

4. Chios was on the island of Nisos, which is reputed to have been the home of Homer.

5. Pliny 34.9.

6. Pliny 35.51.

7. Presbyter Theophilus *De diversis artibus* 3.71 (Theophilus 1961).

8. Arthur Beale, letter to the author, 22 January 1998.

9. The ephebe of Marathon is a bronze statue of a young boy by Praxiteles or one of his students, ca. 330 B.C.E. The sculpture was recovered from the sea in the bay of Marathon, Greece, in 1926, and is widely considered to be one of the masterworks of ancient Greece.

10. The Zeus (or Poseidon) was found in 1928 off Cape Artemision, Greece, in the wreckage of a ship. It is one of the few surviving masterpieces of Classical sculpture.

11. The Riace bronzes, dating from the fifth century B.C.E. and recovered from the sea off Calabria, Italy, must have been in transit from Greece or Magna Graecia by a boat that sank near Riace, taking these two bronze masterpieces to the deep for 2,500 years.

12. Formerly in the collection of Sir Anthony Blunt, now in the J. Paul Getty Museum.

13. A Renaissance nobleman's "cabinet of wonders," containing art objects and curiosities from the natural world.

14. Donatello's *David* remains a masterpiece of freestanding bronze art, the first in Europe since the fall of the Roman Empire. Vasari accused the artist of having cast the figure from life, but this is completely unfounded. Rodin was similarly accused when he made *The Age of Bronze,* which was first exhibited in 1878.

15. The surface appearance of a work of art may change with ownership and personal tastes. Some details of the provenance of this bronze are known: by 1581 the object passed from the Niccolo Gaddi collection to a London Gaddi sale of March 1764; by 1822 it is thought to have been sold to an Alderman Beckford and William Beckford of Fonthill; by 1844 the bronze passed by inheritance to Alexander, tenth Duke of Hamilton; in July 1882 it was bought by F. Davis in a Hamilton Place sale; in 1917 the work was purchased by J. Pierpont Morgan, then by Henry E. Huntington, thereby reaching the collections of the Huntington Library and Art Galleries in San Marino, where this bronze resides today.

16. Because of the togas worn by the figures, this relief fragment is often informally referred to as the "Togati bronze."

17. The microstructures of the pustule are discussed in greater detail in Scott (1994a).

18. The beta phase of the copper–tin system, which occurs in bronzes of 21–24% tin, can be retained by heating to 650–700 °C, followed by quenching in water. The metastable beta phase, usually acicular, is therefore retained by the quenching process. The advantage of retaining the beta phase is that the alloy is hard but not brittle, since the equilibrium alternative is delta phase with alpha infill, which is extremely brittle. The beta-phase quenched alloys are particularly suitable for polished mirror surfaces. Some of the especially fine and lustrous patinas on objects of this type are related to the kind of alloy employed and the very careful polishing they underwent.

19. Fire-refining is the process of heating a metal or alloy, usually in a crucible, and removing the dross that forms on the surface. The alloy can be poured into another crucible or simply heated again in the original crucible and the dross removed again. Repeating this process results in the gradual removal of many of the impurities associated with copper, such as iron, arsenic, antimony, and zinc.

20. Cf. Stambolov 1985: sec. 4.6.

21. Because artificial patinas generally have no ability to create a cuprite patina in depth, artificial patinas usually manifest a cuprite crust only a few microns in depth, if at all. The malachite patina was applied to this cuprite surface to attempt to build up a convincing depth of corrosion, in the right sequence, that would have taken many hundreds of years to develop on a buried bronze.

22. These finishes were achieved with a variety of polishing techniques demanding considerable skill in execution. After the instrument was filed, Water of Ayr stone would be used to matte the surface, which was finished by rubbing on soft gray slate stone. The Washemery and Fesh brands of polishing papers were used where a bright finish was needed. The heads of screws and small turned parts would be finished with a burnisher on a lathe.

Conservation Treatments for Bronze Objects

CHAPTER 12

Many relics from past conservation campaigns, it is sad to note, are now consigned to museum storerooms and basements. A knowledge of the chemical history of treated bronzes is important to an understanding of why certain bronzes look the way they do, and why some earlier conservation treatments may have been damaging to the objects they were trying to preserve. This chapter discusses the history of conservation treatments employed for bronze objects and the effects these treatments may have had on their appearance, or the preservation of scientific information concerning their environmental milieu. This history includes events that may have occurred during burial and also since the bronzes were excavated.

UNDERSTANDING TREATMENT HISTORIES

The lack of documentation has made it difficult to reconstruct exactly what was done to objects in the past. Different treatment approaches were, of course, used for outdoor patinated bronze, indoor patinated bronze, architectural bronze, ornamental brass, gilded bronze, archaeological bronzes, and so on, but it is difficult to discuss these historical treatments in a systematic manner due to the paucity of information. This lack of information is especially apparent when it comes to a discussion of treatments used to conserve outdoor bronze monuments. Generally, outdoor bronzes, if they were maintained at all in the late nineteenth and early twentieth centuries, came under the aegis of town councils or local authorities, just as outdoor bronzes in the city of London, for example, still do. In the United States, the National Park Service now cares for many bronzes erected on federal property. Treatments traditionally have evolved from washing and scrubbing the bronzes to including the use of protective waxes or natural oils and resins. Patina was not normally removed during these treatments, and the need for routine maintenance and regular oiling or waxing was generally appreciated.

The typical treatment for archaeological bronzes from 1880 to 1970 was the chemical or electrolytic removal of corrosion products. The treatment could be applied locally or, more commonly, by complete immersion of the bronze. The superficial cleaning of dirt from objects has had some benefit, but museum curators were often dismayed at the appearance of bronzes that were returned from the conservation laboratory with their green patinas stripped away. The rationale for this kind of treatment, which frequently altered the appearance of the object quite drastically, was to remove dangerous compounds within the corrosion crust, although the historical and aesthetic issues were never properly debated within the conservation profession at that time. Some bronzes, mostly archaeological objects, did require some form of treatment to avoid the risk of bronze disease, which could reduce them to a heap of green powder, but there appeared to be little testing of the bronzes to ascertain if, indeed, treatment was really necessary. Objects not at risk were relegated to the same treatment for the disease as those with chronic cases, with the result that healthy bronzes were needlessly stripped of their patinas.

SOME PAST CONSERVATION TREATMENTS

Patina-stripping techniques | Many approaches to the conservation of bronzes during the nineteenth or first half of the twentieth century employed chemical or electrochemical treatments that resulted in wholesale patina removal, with the result that bronzes might be stripped back to an oxidized-looking brown or variegated golden metallic surface, which often represented substantial loss of original surface or associated material. An example of this treatment approach is that of the Egyptian cat shown in PLATE 81. The surface was left in a raw and unappealing state following the chemical cleaning procedure.

Norman (1988) recounts that in the 1920s the Fitzwilliam Museum in Cambridge, England, was sending its bronzes to the Ashmolean Museum in Oxford for conservation. The Honorary Keeper of Antiquities at the Fitzwilliam was so horrified, however, when the objects came back with their surfaces a chocolate-brown cuprite or coppery metal that the museum devised its own conservation methods. Norman infers that the damaging treatment used in Oxford was the zinc granule and sodium hydroxide method that had been published first by Rathgen (1905) and later by Scott (1926). Rathgen notes that the treatment, known as "Krefting's Method," had been in use in Denmark since at least 1887 (Krefting 1892a,b). With this treatment, the object is immersed in a 10% (w/v) solution of sodium hydroxide, usually warmed on a hot plate, to which zinc granules are added. This reaction, given in equation 12.1, has long been used in the laboratory to produce hydrogen.

$$Zn + 2NaOH = Na_2ZnO_2 + H_2 \qquad\qquad 12.1$$

This reaction electrochemically reduced the corrosion products on the immersed object, and these products would fall away as a precipitate in the sodium zincate solution. Because of the electrochemical potential between copper and zinc, the end result might be a surface leached of alloying elements over which zinc metal precipitated from solution; or the partial elimination of a cuprite patina might produce the undesirable subfusc surfaces that elicited such horror from the Fitzwilliam Museum curator.

The treated bronzes at the Fitzwilliam Museum were sometimes polished after electrochemical reduction, but they were never lacquered. Further deterioration may occur as a result of these chemical-stripping techniques, as in the example cited by Norman, in which a leaded bronze treated with this technique now has a thin gray-to-white deposit over most of its surface. The corrosion of the lead component of this bronze was probably exacerbated by the use of the patina-stripping techniques, which would have exposed the bare metallic surface to more immediate deterioration as a result of organic acid pollutants within the display case.

Jaeschke and Jaeschke (1988) reviewed the treatment records of some Egyptian bronzes in the Petrie Museum of University College, London. During the 1950s and 1960s, many of these bronzes were treated using the sodium sesquicarbonate method, in which bronzes are immersed for long periods of time in a 10% solution of sodium sesquicarbonate in distilled water, and the release of chloride ions is monitored during the treatment. During the re-treatment of one such object in 1982, small yellow metallic flakes occurred on the surface, which were probably particles of redeposited copper produced as a consequence of the earlier conservation treatment with sodium sesquicarbonate. The change in appearance of the copper particles may have been due to the highly alkaline environment of the treated surface of the bronze, which may have resulted in the alteration of the redeposited copper to cuprite and partially to tenorite. This could also explain why the conservators observed this surface feature changing color, from yellow to red to purple, within a few months of the re-treatment.

Although sodium sesquicarbonate treatment was often used in the past, more drastic chemical methods were also commonplace. For example, a bronze might first be immersed in a solution of Calgon (sodium polyphosphate),[1] then boiled in alkaline Rochelle salt (sodium potassium tartrate and sodium hydroxide), then boiled in dilute sulfuric acid, and finally returned to the Calgon solution. Immersion in Calgon and boiling in 10% sulfuric acid were often used as pretreatments before electrolytic reduction. Jaeschke and Jaeschke found several variations of different chemical applications recorded in the treatment files at the Petrie Museum.

Dramatic examples of the damage done by overzealous chemical or electrolytic cleaning are found in the storerooms of the British Museum located in Islington, London. Housed there are ancient Peruvian mace heads of arsenical copper or tin bronze that are now so honeycombed that they bear more resemblance to brown sponges than to ancient bronzes. Treatment in the 1930s left a lustrous metallic sheen of freshly stripped metal that has slowly tarnished during their sixty years of storage to a sad, tawny brown. These objects are now devoid of any aesthetic value, if not of prurient scientific interest for the historical chronicle they represent. Fortunately, many bronzes that were collected by museums before and during the 1950s and 1960s were never "conserved" at all and have survived in relatively good condition. Some museums had no conservation staff to carry out treatment until relatively recently. Ironically, some bronzes in these collections may have survived unscathed, though neglect may have reduced other more fragile pieces to a heap of unrecognizable fragments.

Early practitioners of conservation were concerned about the adverse consequences of such drastic treatments and sought to minimize them. Gettens (1933), for example, began taking X-ray radiographs of bronze objects before attempting electrolytic reduction to ensure that a sound metallic core remained; otherwise unsuitable artifacts might be converted to green sludge by the treatment. Beale (1996) notes that by 1956, when Plenderleith was writing his now classic textbook, *The Conservation of Antiquities and Works of Art: Treatment, Repair, and Restoration*, advice about reductive methods had progressed to a warning about employing them only when a substantial metallic core remained and when the mechanical strength of the object was beyond doubt.[2]

Drying and sealing methods | Another early and insightful example of how the conservation of bronzes was regarded at the turn of the twentieth century, this time from the perspective of a museum director, is contained in correspondence from Edward Robinson, former director of the Metropolitan Museum of Art in New York. In 1910 Robinson received a letter from the noted collector Henry Walters,[3] asking for advice about the conservation of some bronzes. Robinson's response, in correspondence documented by Drayman-Weisser (1994), was surprisingly sound. He advised keeping the bronzes dry in sealed cases containing a desiccating agent, such as hydrate of potassia (potassium hydroxide). He also

recommended a treatment developed by the French restorer Alfred André that began with thoroughly drying the bronze, excavating the actively corroding region with a needle, and then sealing the canker with a drop of Palestine bitumen. Either of these treatments would have been efficacious if conscientiously employed. Potassium hydroxide pellets are an effective desiccant in wide laboratory use over the past one hundred years. The drying, excavating, and sealing of actively corroding areas are not very different from a number of more recent conservation treatments.

Lack of intervention has not been particularly harmful to the average bronze artifact. The collections of the National Museum of the American Indian [4] are a case in point. Very few of the bronzes in this collection, which date from around 1900, have been treated at all. Those few artifacts that were treated at some unknown time in the past were stripped, resulting in the usual loss of surface information. Those treated only to benign neglect retain the dusty ambience of bronzes that have remained undisturbed by storage in an essentially uncontrolled environment for nearly one hundred years, with their original patinas intact.

Other early treatment methods	Various approaches to chemical or mechanical cleaning have been tried on a wide array of bronzes from different contexts. An interesting and quite laudable early approach to the cleaning

of marine finds is that of Zenghelis (1930), who treated such important large bronze sculptures as the Ephebe of Marathon and a Zeus recovered from Cape Artemision, Greece. Zenghelis first soaked these bronzes for several months in frequent changes of distilled water to remove salts, then softened the remaining deposits with superheated steam before removing them with local mechanical cleaning. None of these treatments would have necessarily entailed drastic alteration to the patina or the appearance of the bronze.

The methods used by commercial dealers to clean and patinate bronzes today often have their roots in traditional practice, involving a number of esoteric or mundane substances that range from secret concoctions to materials as prosaic as oven cleaner or lemon juice. Both strong lye and citric acid are traditional methods with long pedigrees. One dealer surveyed in Los Angeles usually begins treatment by spraying the entire bronze with an aerosol can of oven cleaner, followed by a thorough washing in water. The bronze is next heated with a blowtorch until hot to the touch and then sprayed with a commercial wax, such as Pledge, followed by buffing and polishing. Although this treatment is not as harmful as those that rely on soaking in acids or on reducing the corrosion products electrolytically, the oven cleaner usually contains sodium hydroxide that will remove or alter patina constituents along with any attendant dirt or encrustations. The local application of heat to a small bronze object can also be damaging and, in some cases, very destructive.

Preservation
without treatment

Some curators never allowed the bronzes in their care to be conserved. This is often the case with many collections of Chinese art, where the aesthetically pleasing patinas of Chinese bronzes are highly prized and preserved without treatment. This is exemplified by the *fang lei* mentioned in CHAPTER 3 (see PLATE 19). This wine vessel, dating to the fifth to the fourth century B.C.E. of the Eastern Zhou dynasty, is elaborately and skillfully inlaid with malachite that is set in intaglio within the borders of the copper strips with a white cement. Subtle banding in the malachite inlays is still visible. The copper strips have corroded to a light green, while the bronze vessel itself is generally a darker green, both colors contrasting subtly with the green of the malachite. Originally, the copper strips would have been reddish, complementing the golden surface of the bronze and the green of the malachite.

This *fang lei* presents a surface patina of extraordinary interest. One of the problems with treating such surfaces is the danger of altering their aesthetics. Benzotriazole, for example, may darken some patinas through interactions with copper minerals, such as chlorides. The use of this corrosion inhibitor may be inadvisable on surfaces as complex as the *fang lei* discussed here.

MECHANICAL CLEANING

Preserving evidence
of the past

Although thermodynamically less damaging than chemical cleaning, mechanical cleaning may remove evidence of materials, such as burial conditions and corrosion chemistry, adhering to the surface of an object. This evidence is lost forever when these products are removed. In a paper dealing with the mechanical cleaning of some Egyptian bronzes, Jedrzejewska (1976) made a clear case for leaving some bronzes uncleaned to serve as archaeological records in their own right. For those bronzes that are cleaned, she advocated that a small area of the surface be left untreated, if at all possible, to serve as a record of the true state of the original patina. Over the last twenty years this wise advice all too often has not been heeded by conservators; consequently, a considerable amount of information has been lost because of conservation carried out without regard to the scientific principles of preservation of evidence.

There is a clear need to support and encourage the principle of evidence preservation, especially among conservators working in private practice who may not have the time or resources to conduct proper documentation. Awareness has gradually spread through the profession, and there is now much less invasive mechanical cleaning; the point still needs to be stressed, however, that many bronzes are visually attractive and stable when left covered in their original aeruginous coat. Such an object can also testify to its own burial and authenticity, which a cleaned bronze may no longer have the power to do. The British art critic and author John Ruskin (1819–1900) would surely have appreciated this approach of benign neglect, although it might not always be justified by the particular needs or circumstances of an object.

The interplay between these two approaches of cleaning deposits from a bronze and preserving evidence is constantly changing. Most conservation professionals would now take issue with the eminent French conservator Albert France-Lanord (1915–93), who in 1965 wrote a short article about knowing the object before conserving it. The article ends with two examples: the restoration of a Hallstatt urn,[5] which had textile remains on its surface; and the conservation of the famous Vix krater (mixing bowl),[6] which had traces of leather covering part of its surface. In the case of the Hallstatt urn, the fibers were retained during conservation treatment, which certainly was not always the situation at that time. As for the Vix krater, however, the leather fragments were removed during treatment "because they harmed the beauty of the object" (France-Lanord 1965 : 13).

France-Lanord considers these two cases as examples of how the choice of treatment method was determined by essentially human (aesthetic) considerations. The conservation community has since come to appreciate that removal of the leather fragments preserved on the Vix krater is a considerable loss. Much could have been learned about the type of leather, its position in the burial relative to the krater, whether it partially covered the krater because of religious or shamanistic reasons associated with the burial, and so on.

Today there is a better appreciation of the fact that the "beauty of the object" is not necessarily compromised when associated materials are left in situ. In addition, an ancient object is not of value for aesthetic reasons alone; it is also a repository of potentially important cultural and anthropological as well as scientific information. Today the leather remnants would be retained, and perhaps a discussion of their association with the bowl would become part of a museum display, adding to the general appreciation of the object.

Many beautiful, cleaned bronzes already exist in museum collections; therefore, newly acquired pieces should not need to be cleaned to the same level throughout without leaving some untreated for future scientific inquiry. If mechanical cleaning is unavoidable, then the removed corrosion products and soil should be stored in small marked vials together with the conservation records to facilitate future research into the surface corrosion, the nature of the burial soil, the possible entrapment of organic materials within the outer corrosion crust, and the reaction interface between the soil and metal corrosion products.

Mechanical cleaning techniques today

Because of the difficulties in controlling reactions during chemical treatment, which may compromise the shape of an object—including details of design, tool marks, or surface finishes retained within the corrosion—mechanical cleaning remains the preferred option in these cases.

In its crudest form, mechanical cleaning involves the use of chisels and hammers to break off concretions or to remove unsightly corrosion from the surface of an object. Such mechanical cleaning methods were already in use by Rathgen and others before the turn of the nineteenth century. In modern practice, most mechanical cleaning operations on a bronze surface

are carried out under binocular magnification of ×10 to ×40. The object is usually illuminated by a fiber-optic light source to avoid undue heating of the object during cleaning. Prior to treatment, ethanol or water is sometimes applied to the surface to moisten the soil or corrosion to facilitate removal. Some of the fine tools used during cleaning include glass-fiber brushes, painting brushes, dental picks, a pin held in a pin vice, wooden carving tools or sticks, and small camera bellows to blow away dust.

Before attempting overall mechanical cleaning of an object, it is essential that some exploratory cleaning be done to evaluate the extent to which a desirable result can be achieved for display purposes. This work may also be necessary to assess the mechanical stability of the object, whether it is totally mineralized or whether some metallic core remains. The surface is investigated at this stage to ascertain the presence of any unusual corrosion features, surface finishes, or mineralized remains.

During the actual cleaning, no special problems are usually encountered when removing soil or earthy minerals to reveal the outermost layers of the bronze patina. The real problems begin when attempting to expose the object's original surface, which may be preserved in a cuprite layer below outer, sometimes swollen, covering layers of basic copper carbonates and basic chlorides. These layers are often quite hard, and the cuprite layer itself may be either very compact or sugary, which cannot be gauged without prior exploratory cleaning.

A dramatic example of a bronze before and after mechanical cleaning is the victorious youth, also known as the "Getty bronze athlete," in the collections of the J. Paul Getty Museum. PLATE 82 shows the statue with heavy encrustation from marine burial, before mechanical cleaning and conservation; PLATE 83 shows the same statue after treatment. Another example is a small bronze bust of a Roman lady in the collections of the J. Paul Getty Museum. PLATE 84 shows the surface of the bronze extensively attacked by erupted pustules of bronze disease; PLATE 85 shows the bust after mechanical cleaning.

PROBLEMS WITH MECHANICAL CLEANING In deciding on a cleaning method, it is difficult to generalize from experience gained with bronzes from one part of the world and apply it to those from other regions; in some cases no comparison is possible. For example, ancient South American bronzes are likely to be made of copper-arsenic alloys that have a good cuprite layer but no developed passive-tin-oxide layer that could serve as a surface to clean. Some of the finely preserved patinas in tin bronzes from the Old World are due to the retention of tin oxides within the patina, whereas with many South American copper alloys, the alloying with arsenic and the different burial conditions may produce an entirely different surface, making the cuprite layer difficult to follow. Even if this layer is followed skillfully by the conservator, signs of surface scraping with the scalpel will be invariably evident under the binocular microscope. In some cases, this surface layer is so close to the bare metal that it would not be advisable to reveal the cuprite layer at all. More in keeping with the integrity of these

objects, it is generally best to clean only what is absolutely necessary and to leave the cutaneous layer of green-colored corrosion products intact.

Other problems may be encountered during the mechanical cleaning process itself. For example, many ancient Peruvian copper alloys may have been gilded or silvered by the electro-chemical replacement plating technology described in CHAPTER 1 (Lechtman 1979; Lechtman, Erlij, and Barry 1982). Because this subtle gilded layer, often no more than 2 μm thick, is frequently disrupted and discontinuous, it can easily be completely lost during cleaning.

Another frequent problem is the presence of textile fibers. Textiles play a crucial role in many ancient Andean societies, for example; bronzes within tombs or burials are often placed on the body, or next to it, in association with clothing, textiles, feathers, bone objects, and so on. Fiber remnants are, therefore, commonly encountered during the cleaning of bronze objects from such sites, and the associated organic residues or preserved fibers may be very significant from an archaeological standpoint. Mechanical cleaning through hard layers containing these textile fibers is possible, but the delicate strands may be destroyed in the process.

The patina or corrosion on outdoor bronzes, as opposed to those displayed or stored indoors, presents an altogether different problem in terms of mechanical cleaning. Streaks of light-green corrosion products and the presence of unsightly deposits destroy not only the stability of the patina but also the aesthetics of the bronze, creating a variety of problems for the conservator. Such bronzes frequently require cleaning. The aim should be to remove as little material as possible and compatible with the aesthetic aims of the proposed treatment and, where possible, to analyze the corrosion products and record a history of the object and of the corrosive events that shaped its condition up to the time of cleaning.

| GLASS-BEAD PEENING AND OTHER ABRASIVE TECHNIQUES
Weil (1976, 1980, 1983) made the controversial proposal that the patina that develops on a bronze over time from outdoor exposure is actually aggressive to the bronze metal and should be removed. For this purpose, Weil often used glass-bead peening,[7] followed by an application of Incralac (discussed under "Coatings for Copper Alloys") and a sacrificial outer wax coating.[8] This treatment regimen was used quite frequently in the United States during the 1970s. Many metal conservators were troubled by the removal of patina and by the claim made by other conservators that glass-bead-peened bronze surfaces showed enhanced corrosion resistance compared with the patinated metal. Veloz, Ruff, and Chase (1987) reviewed some aspects of this approach. They noted that glass-bead microspheres, about 100 μm in diameter and applied at a pressure of 40–80 psig, had been used to clean bronze sculpture since the middle of the 1970s. The glass spheres can damage the metal surface once the patina has been removed, and Veloz, Ruff, and Chase suggested the use of a much softer abrasive, namely crushed walnut shells. These had already been used in 1979 to clean, without complete patina removal, a bronze statue of Admiral Richard Evelyn Byrd by Felix de Weldon (b. 1907) that was located in Arlington, Virginia.[9]

Veloz, Ruff, and Chase (1987) performed tests to evaluate the effectiveness of walnut shells and glass-bead peening to clean both cast and polished surfaces. The glass beads, as well as other hard abrasives, severely deformed the surface on a microscopic level. This finding was confirmed by Barbour and Lie (1987), who evaluated the effectiveness of three different plastic blasting media compared with walnut shells, powdered sodium bicarbonate, and glass beads. They found that using glass beads at both 25 psig and 80 psig left substantial imprints, cratering, and deformation on polished, work-hardened bronze coupons and on corroded copper sheeting. No alteration was found with two of the three plastic media or with walnut shells. Ground walnut shells and sodium bicarbonate had no effect on the surface finish of the bronze, and the mixture removed virtually all accumulated dirt, grime, and loosely attached corrosion products. A weight loss of 2 mg/cm^2 occurred following a moderate use of glass-bead peening, but no discernible weight loss or surface change followed the use of walnut-shell peening. Although Weil and colleagues claimed that glass-bead peening reduced the corrosion rate of outdoor bronze sculpture (Weil et al. 1982), laboratory evaluation by Barbour and Lie indicated that the rate of atmospheric corrosion may actually be increased after this treatment.

Barbour and Lie also found that a number of variables control the effectiveness of cleaning corroded bronzes with crushed walnut shells. For example, smaller particles were more efficient than larger particles—60/200 mesh walnut shells gave good results—and the ratio of total mass of air to abrasive is very significant. In practical application, the effectiveness of the cleaning was improved by using a larger nozzle with decreased pressure. Veloz, Ruff, and Chase (1987) used a 0.8 cm (5/16 in.) nozzle at 20 psi in contrast to a 0.4 (5/32 in.) nozzle at 40 psi. The most effective angle of impact was within 20 degrees of perpendicular to the surface being cleaned, and the results obtained were judged to be quite satisfactory.

WATER BLASTING Another recent development in mechanical cleaning, especially for outdoor bronzes, zinc sculpture, and marine finds, is water blasting, using either medium-high-pressure (MPH) water at about 1000–7000 psi or ultra-high-pressure (UHP) water at around 30,000 psi. The UHP method was used by Lins (1992) in 1987 for the conservation treatment of the 10.67 m (35 ft.) tall bronze sculpture of William Penn by Alexander Milne Calder that is on the top of City Hall Tower in Philadelphia. The equipment for UHP spraying is capable of directing rotating jets of water through a series of nozzles about 0.5 mm in diameter at velocities of up to 670.56 m (2,220 ft.) per second, more than twice the speed of sound. The apparatus used to clean the Penn monument could produce a water pressure of 32,000 psi, but because of the height of the sculpture, a pressure of about 29,000 psi was more practical. Lins (1992) concluded that this water-blasting method was more effective in removing corrosion products from a pitted surface than other methods, and it did so without any significant damage to the metallic bronze substrate. Considerable safety precautions must be taken when using the UHP procedure because of the very high water velocities used. As with any mechanical cleaning method, the skill and experience of the operator is of paramount

importance. Linda Merk-Gould used the MHP method at a pressure of 1000–4000 psi for cleaning prior to repatination (Harris 1994). She used this method several times to clean outdoor bronze sculpture and obtained good results without undue damage to the surfaces.

LASER CLEANING Laser cleaning of metals is a recent development. A neodymium (Nd) laser has been successfully used to clean surface concretions from stone objects. The use of a controlled burst of high-energy photons produced by a laser can also be used to clean metallic surfaces. With this method, the minerals are ablated, or vaporized, from the surface, removing the corrosion without the need for chemical reagents. The principal problem with this technique is controllability of the results.

A number of different approaches to the use of lasers for the cleaning of metallic surfaces have been published. For example, Asmus (1987) suggests the use of carbon dioxide lasers for metal cleaning, while Watkins (1997) reviews the application of Nd : Yag lasers to the cleaning of bronzes. Removal of tarnish from the surface of silver-coated copper daguerreotypes with an excimer laser has been investigated by Turovets, Maggen, and Lewis (1998).

Cottam and coworkers (1997) discuss cleaning metallic surfaces using a TEA-CO_2 laser-ablation technique at 10.6 μm in the far infrared. Copper and bronze with both naturally and artificially grown corrosion layers were treated. The inorganic minerals comprising the corrosion crust showed a varied response to the laser radiation. In general, it was found that the more complex copper-corrosion products such as brochantite were more susceptible to ablation than simple compounds such as cuprite.

Unanswered questions Difficult aesthetic and scientific questions remain unanswered regarding the cleaning of outdoor sculpture, especially since many objects will require re-treatment in years to come, and some may have to be repatinated or recoated yet again. All outdoor sculpture requires maintenance, such as washing and rewaxing every two years or so, and this is frequently overlooked in treatment proposals. Naude and Wharton (1995) have prepared a useful handbook, *Guide to the Maintenance of Outdoor Sculpture*, that discusses the issues involved in establishing a maintenance program for such works.

CHEMICAL CLEANING TREATMENTS

Chemical methods of cleaning have a long history and traditionally include the use of domestic materials, such as lemon juice, with which corroded objects could be scrubbed. Chemical cleaning seeks to remove some or all of the patina, or corrosion, on the surface of the object. In conservation practice, chemical cleaning usually attempts selective removal of certain types of corrosion layers or chemical substances, leaving others unaffected. For example, in the cleaning of bronzes it is common to leave the cuprite layer adjacent to the metal intact, since removal of this layer usually reveals bare metal, which amounts to complete stripping of the surface, which, in most cases, is undesirable.

ELECTROLYTIC REDUCTION At the end of the nineteenth century, electrolytic reduction represented a state-of-the-art application of science, perhaps similar to the recent fascination with plasma reduction or the laser cleaning of artifacts. In 1905 Rathgen employed electrolytic reduction, using a 2% potassium cyanide solution in water as electrolyte and platinum anodes, to eradicate unstable cuprous chloride from objects. Later, less dangerous electrolytes and less expensive anodes came into use for museum treatments.

If used with skill and care, electrolytic reduction is capable of surprisingly good results. Fink (1948), for example, illustrated the results of electrolytic reduction on an inlaid Egyptian bronze in the collections of the Metropolitan Museum of Art in New York. Fink's photographs of the bronze before and after treatment showed that no grossly deleterious effects had been caused by this cleaning method. This, however, is the exception rather than the rule.

Plenderleith (1956) recommended using sodium hydroxide as the electrolyte and stainless steel for the anodes.[10] This treatment regimen continued into the 1970s in the United Kingdom where molybdenum-stabilized stainless steel anodes were used with the sodium hydroxide solution. On anything but very thin patinas over sound metal, this technique essentially strips away both the patina and deeper zones of metallic corrosion. Stripping the metal bare in this way may result in severe loss of the surface and possibly the original shape of the object.

CHEMICAL ALTERATION IN THE LABORATORY Laboratory-induced chemical alteration of one copper mineral to another often forms the basis for conservation treatment. Thus cuprous chloride may be completely eliminated by electrolytic reduction, or it can be altered to a mineral phase that is more stable by immersing the object in a variety of chemical reagents. Scott (1921), for example, recommended the use of a 5% solution of sodium sesquicarbonate, $NaHCO_3 \cdot Na_2CO_3$, as an immersion solution for chloride removal from both iron and bronze artifacts. The sesquicarbonate solution has a pH of about 10; at this alkalinity level, cuprous chloride is unstable and can be converted to cuprite. The hydrochloric acid released is then neutralized by the carbonate, forming sodium chloride.

Oddy and Hughes (1970) reassessed this method in greater detail and recommended extended periods of immersion, sometimes longer than a year, for bronze objects. This long-term treatment did succeed in washing chloride ions out of corroded bronze surfaces, but it was also found to cause mineralogical changes to the patina, sometimes drastically altering the appearance of the bronze. A secondary layer of malachite also sometimes formed as a precipitate on the object, even though the ion $[Cu(CO_3)_2]^{2-}$ is supposed to be stable in the presence of bicarbonate ion. Conservators were advised to change the solution if this precipitation occurred, but it was often difficult to adequately monitor the solution over long periods.

The chemical basis for this treatment is that when cuprous chloride is allowed to react with water, there is a steady increase in chloride ion concentration in solution as a function of time,

although the reaction is slow. The solid products, confirmed by X-ray diffraction, are cuprite and paratacamite (clinoatacamite). With sodium sesquicarbonate, the OH$^-$ ion concentration is higher than in water alone, and the following reaction occurs:

$$2CuCl + OH^- = Cu_2O + 2Cl^- + H^+ \qquad 12.2$$

As a result, there may be some cuprite formation as well as dissolution of cuprous chloride.

Treating bronzes with carbonate solutions has resulted in some interesting chemical problems. Horie and Vint (1982) drew attention to the formation of chalconatronite as an alteration product resulting from treatment. They had found chalconatronite crystals on Roman copper and iron armor from an excavated site in Chester, England, and attributed its formation to the conservation work done many years earlier when the metalwork had been treated with sodium sesquicarbonate. The researchers noted that in the laboratory, sodium copper carbonate (chalconatronite) can be prepared by precipitating the crystals from a concentrated solution of sodium carbonate containing bicarbonate and copper ions.

Earlier, chalconatronite had been reported as a bluish green, chalky crust within the hollow interior of an Egyptian bronze figurine of the deity Sekmet in the Fogg Museum of Art; on an Egyptian bronze group of a cat and kittens in the Gulbenkian Collection, Lisbon; and on a Coptic censer in the Freer Gallery of Art (Gettens and Frondel 1955). Chalconatronite was subsequently identified on a copper pin from St. Mark's Basilica in Venice (Staffeldt and Paleni 1978).

Localized	In the treatment of some bronzes, localized cleaning of parts of
chemical treatments	a surface may be necessary. Often this is directed at the removal
	of chlorides in an attempt to improve the stability of the bronze.

For example, Organ (1961) quotes Nichols, who attempted the local stabilization of copper chlorides in pitting corrosion at the British Museum in 1924. Nichols had used a dilute solution of silver nitrate to immobilize the chlorides as silver salts. Organ improved on this method by rubbing a paste of silver oxide and ethanol into the corrosion pit and allowing the silver chloride that formed to plug it. Sharma, Shankar Lal, and Nair (1995), however, reported several failures with the silver oxide paste on bronzes with severe chloride corrosion. They suggested that a possible detrimental aspect of the silver chloride paste is that this compound acts as both an electronic and an electrolytic conductor, resulting in the seal being only partially protective. These investigators then studied the efficacy of using zinc dust instead of silver oxide. After removing the copper trihydroxychloride eruptions, they applied zinc dust moistened with aqueous ethanol (1 : 10 v/v) to the excavated pits with a small artist's brush. To ensure good contact with the nantokite (CuCl) and the excavated edges, the moist zinc dust was depressed with the tip of a scalpel. The treated spots were then moistened with aqueous ethanol at one-hour intervals ten to twelve times per day for the next three days. A relatively tough seal of gray zinc reaction

products formed. The gray spots could later be color-matched to the patina if desired (see PLATES 84 and 85 for an example of pitting corrosion before and after cleaning, respectively).[11]

The chemical reactions that result in this seal start with hydrolysis of the CuCl in contact with the moist zinc dust. This results in cuprite formation and the generation of a slightly acidic solution that favors the production of more zinc ions. These zinc ions then react to form basic zinc hydroxide chloride, which provides a more effective treatment than conservation with silver oxide paste. At least two basic zinc hydroxide chlorides—$6Zn(OH)_2 \cdot ZnCl_2$ and $4Zn(OH)_2ZnCl_2$—form in the presence of chlorides and zinc ions at a concentration greater than 0.01 M and at a pH less than 7; crystalline zinc hydroxide, $Zn(OH)_2$, also forms. The layered structure of $4Zn(OH)_2ZnCl_2$ is beneficial to the anticorrosion behavior of zinc coatings in general.

There are two drawbacks to the zinc-dust treatment as published. One is the amount of repetitive work needed to moisten the pits ten to twelve times per day; it may be that this can be substantially reduced without affecting the efficacy of the treatment. The second drawback is the need to cosmetically color-match the filled pits either with copper carbonates as a paint, as suggested by Sharma, Shankar Lal, and Nair (1995), or with acrylics in a suitable medium, such as acrylic emulsion or polyvinyl acetate emulsion. If there are many pits to be treated on an object, the work may become highly labor intensive, and some conservators may still prefer the silver-oxide paste treatment,[12] especially since the dark brown-black color of the silver oxide paste blends well with most patinas.

Another approach to localized treatment was taken by Aldaz and coworkers (1986), who developed a simple electrolytic tool for corrosion removal. With their apparatus, the object being treated is used as the cathode in an electrolytic cell; the anode is made of carbon or stainless steel; and the electrolyte is a solution of sodium hydroxide. The anode rod and electrolyte are housed in a plastic cylinder that ends in a porous tip, such as sintered glass. A drop of the solution is placed on the area to be treated, and the tip of the cylinder is applied to it; the surrounding metallic area becomes the anode, and the two areas are connected by a copper wire to a battery, forming a circuit. The authors claim good results using this method on Roman bronze coins from Santa Pola, Alicante, Spain. There are problems with this method, however, such as the application of the electrolyte to the object's surface, since chemical changes to the surface corrosion products may result, and it may be difficult to make a circuit function properly on heavily corroded bronzes. It may also be difficult to limit the electrolytic action precisely to the spot under treatment; there is always a danger that the solution will affect the region immediately surrounding the area under treatment, causing it to darken or undergo other alteration. As a treatment method, this technique does not appear to be worse than some others, but it has not been mentioned in the literature again since it was published in 1986, which limits the evaluation of its efficacy.

Cleaning reagents A wide range of chemical cleaning reagents have been traditionally used on bronze objects. Over the past fifty years or so of practice, the most common ones have been alkaline glycerol, alkaline Rochelle salt, Calgon, citric acid, buffered citric acid, formic acid, ammonium hydroxide, ammonium tricitrate, disodium or tetrasodium ethylene diamine tetra-acetic acid (EDTA), dilute sodium hydroxide, and dilute sulfuric acid. Commonly available reagents used today for surface cleaning include alkaline Rochelle salt (50 g/l of sodium hydroxide and 150 g/l of sodium potassium tartrate); alkaline glycerol (150 g/l of sodium hydroxide and 40 ml/l of glycerol); Calgon (used as 150 g/l); citric acid (as 40 g/l); and citric acid buffered with ammonium hydroxide (25 g/l citric acid and 14 ml/l ammonium hydroxide). All of these reagents are capable of etching the metallic surface of a typical tin bronze (Merk 1978). Alkaline glycerol and alkaline Rochelle salt will attack cupric salts preferentially and cuprite only slowly, whereas Calgon and citric acid both attack the cuprite layer rather severely. With reagents such as citric acid and some others there is always the danger of dissolved copper salts precipitating as redeposited copper on the surface of the object. This vitiates the purpose of the cleaning, and severe chemical or mechanical methods may be needed to remove the redeposited copper from the pores of the object.

In alloys with a higher percentage of anodic metal, Merk found, for example, that leaded tin bronzes were etched more rapidly. Buffered citric acid solution showed the least severe etching of the bronze metal, but as mentioned previously, citric acid tends to be a harsh cleaner because it readily dissolves cuprite. In a related study, Merk (1981) found that the addition of a 1% (w/v) solution of benzotriazole to the stripping solutions resulted in substantially less corrosion of the bronze surface. Citric acid, however, was the only reagent that still showed substantial attack on the bronze substrate even with the added benefit of benzotriazole.

Cleaning reagents for outdoor bronzes are similar to those used on indoor bronzes, although some of the reagent concentrations are much stronger. For example, Jack (1951) sometimes used 0.88 SG ammonia,[13] diluted to half this strength with water, to clean grime-encrusted London statues. The solution was rubbed into the surface with a wire brush or natural pumice stone. Jack made a paste to clean badly corroded outdoor bronze surfaces with a mixture by volume of one part powdered soda, two parts slaked lime, and two parts sawdust. The high pH of the slaked lime would be a cause for concern today because of the likelihood of patina alterations. Matteini and Moles, as recently as 1981, repeated the old alkaline, Rochelle-salt method to remove corrosion, and apparently carried out treatment without attacking the substrate metal. Ternbach[14] (1972) used a dilute solution of ammonia, while rubbing the surface with bronze wool, to reduce the amount of loose corrosion products on bronzes under treatment prior to repatination. This is a similar approach to Jack's, in that the old patina was attacked and abraded prior to repatination, but it probably did not have as severe an effect.

In general cleaning operations, sodium tripolyphosphate, which is an effective chelating agent particularly for calcium ions, has been recommended by Sharma and Kharbade (1994) for cleaning bronze surfaces. They found that sodium polyphosphate drastically altered the infrared spectra of malachite, indicating that the hydroxyl stretch bands disappeared as the compound was complexed. On the other hand, no change was noted when sodium tripolyphosphate was used, indicating that the tripolyphosphate may be a safe complexing reagent for the removal of calcareous accretions without disturbing the copper patina minerals. The authors had safely cleaned an eleventh-century bronze from Thanjavur, in southern India, that had been covered with a tough whitish concretion. They used a carboxymethyl cellulose gel containing a 0.5%–2% solution of sodium tripolyphosphate. No further evaluations of this cleaning agent have been published to date.

MacLeod (1987a) examined the efficacy of chloride extraction from bronzes using a variety of solutions, including sodium sesquicarbonate, benzotriazole, acetonitrile, citric acid, and alkaline sodium dithionite. The rate of chloride ion extraction was fastest with the alkaline dithionite; thiourea-inhibited citric acid also showed good extraction rates, but both solutions created substantial patina alteration. With alkaline dithionite, the patina changed within a few minutes from a blue-green copper (II) hydroxychloride, through a yellow-orange transient copper (I) hydroxide, to a chocolate-brown patina containing finely divided metallic copper (a reaction discussed later in this chapter under "Cleaning Marine Finds"). After two hours, the thiourea-inhibited citric acid had altered the patina color to a dull brown attributed to a mixture of cuprite and the adsorption of thiourea on the corrosion interface. If there were any carbonates or hydroxychlorides in the patina, they would have been dissolved by the highly acidic conditions (pH 0.95) and the complexing ability of the citric acid.

Weisser (1987) suggested the localized application of sodium carbonate solution as a treatment for bronze disease. One disadvantage of the treatment noted by Weisser was the occasional formation of black spots on the surface (see CHAPTER 2). This method is only one of many different treatment options for bronze disease that have been published over the last hundred years.

In 1917 Rosenberg published the results of his research into the problem of bronze disease and recommended the use of an electrochemical reduction method. In one of the several variants to this technique, the object to be treated is wrapped in aluminium foil and exposed to high humidity, typically higher than 90% RH. To effect an electrical connection between the bronze surface and the foil, Rosenberg used a poultice of 6 parts agar-agar, 80 parts water and 6 parts glycerol. The object was coated with the jelly, wrapped in foil, and exposed for two to four days in the humid atmosphere. After completion of the reduction, the poultice was removed by washing in hot water. With this method, any active chlorides in the object will react with the aluminium foil, forming localized corrosion of aluminium chloride spots on the foil and reducing the copper chlorides to cuprite or tenorite. If exposure of the treated object to high humidity

results in further formation of basic copper chlorides, the treatment can be repeated. In the same study, Rosenberg employed a local treatment consisting of 200 parts tin or zinc, or 150 parts aluminium powder, mixed with 8 parts of animal glue and 4 parts of glycerol dissolved in 10 parts of hot water.

In an approach similar to Rosenberg's, zinc granules are added to a solution of sodium hydroxide in which the object is then placed. Electrochemical reduction can then occur on the surface of the object. Many student attempts to use this electrochemical reduction method resulted either in irreparable damage to the patina, which was essentially stripped away from the metallic substrate, or in the plating of zinc on the surface; the zinc then had to be removed by further chemical treatment, such as boiling in sodium hydroxide solution.

Such treatments, making use of either overall or localized chemical reduction techniques, were commonplace from 1920 to 1970 and highly damaging to the aesthetic and scientific interests of the object. Rosenberg's electrochemical reduction method, however, does not necessarily imply that the patina as a whole will be stripped away. In fact, Madsen[15] found that a problematic bronze object in Denmark that had been previously treated with 3% benzotriazole in ethanol continued to show evidence of bronze disease until Rosenberg's electrochemical reduction method was tried. Following the use of this treatment, outbreaks of the disease were halted.

Another approach to the treatment of bronze disease that did not involve stripping away the patina was investigated by France-Lanord (1952). With this electrolytic method, the object was immersed in distilled water and became the cathode. It was connected by a wire to a milliammeter and an anode of platinum or gold. The very low current passing between the electrodes, due to chloride dissolution, was measured and plotted with time. When current flow reached a plateau, the water was changed and the procedure repeated until no more current was registered, indicating the washing out of most of the chlorides.

Although the methods proposed by Rosenberg and France-Lanord have much to commend them compared with the more usual electrolytic stripping techniques, no recent appraisal of the benefits of either method has been made. This is largely because of the danger of lack of control over processes that involve immersing objects in gels or water followed by electrochemical reduction, even if only affected parts of the object are treated; electrolytic desalination[16] poses the same problem. At least in the United Kingdom and the United States, these methods appear to have been largely overlooked in the past or ignored in preference to complete patina removal. This is regrettable because much of the damage that occurred to bronzes in major museum collections from 1900 to 1960 could have been mitigated by using gentler techniques, such as those of Rosenberg and France-Lanord, that were more sympathetic to the integrity of the object and patina.

Twenty-five years after France-Lanord's work was originally described, Bertholon and coworkers (1997) have, in effect, revived it by using electrolysis to remove chloride ions from copper alloys. They chose, however, a 1% solution of sodium sesquicarbonate as the electrolyte

because it removed chloride more effectively than water alone, although, as described earlier, there would be the danger of patina alteration with this solution. The criticisms voiced about total immersion methods were not addressed by Bertholon and coworkers; therefore, their approach will probably not find many conservators using it as a practical treatment. The idea of immersion and electrolytic treatment in pure water as published by France-Lanord in 1952 still seems a more gentle approach to the dangers inherent in electrolytic treatment than this more recent work, if immersion is going to be used at all.

Goodburn-Brown (1996) tested different cleaning treatments on forty-five bronze Roman coins to evaluate the degree of damage to microstructural detail preserved on their surface. These bronze artifacts are from freshwater anoxic burial sites near the river Thames in London, where many objects show remarkable surface preservation under copper sulfide crusts (Goodburn Brown 1997). This is not by any means a common occurrence in ancient buried bronzes. Fifteen coins were cleaned using glass-fiber brushes. Encrustations were removed from another fifteen coins cleaned electrolytically in a 5% sodium carbonate solution. A steel anode was used, and the current adjusted until a gentle stream of bubbles evolved from the coins. Each coin was examined after 10 minutes, and none were cleaned for longer than 40 minutes. The remaining fifteen coins were cleaned in a solution of 5% sodium diethylene triaminepentaacetic acid (DTPA) with 0.5% Triton X-100, which is reputedly a biodegradable nonionic surfactant (iso-octylphenoxypolyethoxyethanol).[17] The most deleterious treatment was determined to be caused by cleaning with glass-fiber brushes, which left surface striations across the cleaned surface. Neither the electrolytic nor the DTPA treatment destroyed microstructural detail; both of them left a slight etching on the surface, but the end results were surprisingly acceptable. The DTPA treatment is currently being used for surface cleaning of horological instruments at the National Maritime Museum in Greenwich, England.

CLEANING MARINE FINDS

Bronzes recovered from marine environments may be so thoroughly covered with concretions that the entire surface is obscured. Marine finds can also be heavily contaminated with chloride ions, and this contamination will have to be treated if the bronzes are to be stabilized against continuing corrosion. Therefore, removing marine concretions to reveal the object underneath may require elaborate mechanical cleaning as well as chemical stabilization treatments. In some cases, this may also involve removal of the patina of the bronze or dissolution of corrosion products. The aesthetic arguments in favor of nonstripping techniques have to be weighed against the practicalities of dealing with marine finds.

The so-called Getty bronze athlete, which was extensively covered with concretions (see PLATE 82), is an example of a famous marine find that was successfully treated. Although the cleaning and the removal of core material[18] by the private conservator was somewhat crude and

involved repairs that would today be carried out much less intrusively, the bronze patina retained the shape of the original cast figure quite well, as seen in PLATE 83.

The Riace bronzes (see CHAPTER 11), recovered from sea burial with a dark sulfidic patina, were conserved after careful mechanical cleaning by immersion in deionized water until the chloride ion release (from the iron and the bronze components) abated after sixty days. This was followed by an unconventional conservation treatment called the "B70 method" (Formigli 1991) for which a covered tank was made to the specific measurements of the bronze being treated. A controlled relative humidity chamber was also built to subject the treated bronzes to higher levels of RH, allowing an assessment of stability after treatment. One of the Riace bronzes was then placed in the tank and covered with a solution of ammonia in methanol. After two hours in this solution, it was immersed for another two hours in a second bath of hydrogen peroxide in methanol. Following this treatment, the bronze was placed in a humidity chamber; after twenty hours, a bloom of paratacamite had formed on parts of the statue.

This conservation procedure appears inadvisable in view of the fact that the casting core had not yet been removed and remained salt-laden, which surely counteracts the purpose of the humidity treatment. The core was subsequently removed after cutting away lead fills on the base of the feet. Treatment with ammonia in methanol and hydrogen peroxide in methanol was then employed on the inside of the bronze by temporarily plugging the opening in the feet. After drying, the humidity-chamber test was again applied. Eventually, after further air-abrasive cleaning and RH testing, the bronze was locally treated with benzotriazole in ethanol. Only three areas were lacquered, and the cleaned surface was left otherwise uncoated. This particular strategy remains questionable, however, since electrochemical effects may result in anode and cathode areas becoming active on the untreated surface.

| *Stabilization problems and techniques* | MacLeod (1981, 1982, 1987b) has addressed some of the difficulties of stabilizing marine copper alloys, based on experience dealing with the conservation of over twelve thousand copper- |

based artifacts. Most of the objects studied were from ten shipwreck sites off the West Australian coast. The ages of the sites range from the wreck of the *Batavia* in 1629 to that of the *Macedon* in 1883. After excavation and treatment with a variety of conservation methods over several weeks, most of the objects, which had been stored at 20 °C and 55% RH, still showed signs of instability. This indicated that a few weeks of treatment were insufficient to stabilize heavily corroded copper alloys, and extended washing regimes were then employed to extract as much chloride ion as possible from the objects.

The treatments were based on solutions made with distilled water or sodium sesquicarbonate, since these were the least damaging to the patina. Some pieces of bronze were removed from the *Batavia* and used as test strips. These were first cleaned in 10% citric acid inhibited with 2% thiourea for two weeks.[19] The strips were then treated in a 2% sodium sesquicarbonate solution

for forty weeks, during which time the chloride-ion release rates were on the order of 3.7 and 2.5 ppm per hour. The study showed that the extraction of chlorides from these bronzes is largely diffusion controlled. MacLeod also found that there were notable differences in extraction rates, depending on the type of alloy involved. The concentration of chloride ions in these marine objects was greatest in aerobically corroded bronzes, somewhat less in brasses, and the least for copper. This is due to the selective corrosion of bronze objects with correspondingly greater absorption of chloride ions below the surface. The same principles apply to brasses, although these are usually cored, dendritic, single-phase structures, since the zinc content is usually insufficient to produce alpha-beta phase structures. If the brasses had possessed duplex structures, then the corrosion would have been much greater.

One particular stabilization technique investigated by MacLeod (1987a) to clean marine finds is the alkaline dithionite method, originally devised by MacLeod and North in 1979 for the conservation of corroded silver. It is based on a treatment solution of 40 g/l of sodium hydroxide with 50 g/l of sodium dithionite, $Na_2S_2O_4$. The objects to be treated are added quickly to this solution, and the container is sealed to eliminate atmospheric oxygen to the extent that this is possible. When placed in alkaline dithionite, bronze objects change color from the blue green of copper trihydroxychlorides, through a yellow orange of transient copper(I) hydroxide, to a chocolate brown of finely divided metallic copper; all of this occurs within a few minutes of immersion. The overall reaction is complex, but MacLeod resolves it into the following stepwise process:

$$3Cu_2(OH)_3Cl + S_2O_4{}^{2-} + OH^- = 6[Cu(OH)] + 3Cl^- + 2SO_4{}^{2-} + 4H^+ \qquad 12.3$$

$$6Cu(OH) + S_2O_4{}^{2-} = 6Cu + 2SO_4{}^{2-} + 2H_2O + 2H^+ \qquad 12.4$$

$$3Cu_2O + S_2O_4{}^{2-} + OH^- = 6Cu + 2SO_4{}^{2-} + H^+ \qquad 12.5$$

The use of alkaline dithionite, which is a powerful reducing agent, will necessarily entail patina alteration, so its use will depend on the aesthetic issues in question for the object. MacLeod used this reagent to conserve several sets of Greco-Roman coins so badly corroded that there was no discernible inscription. After treatment, the pustular corrosion was reduced to a loosely adherent copper powder that could be brushed away, revealing the original inscription. After treatment, the coins were washed for up to forty-eight hours in deionized water to remove any residual chemicals. Monitoring the concentration of chloride, lead, tin, and zinc in the cleaning solution showed that significant amounts of tin were present; this originated from the corrosion crust rather than from the alloy itself.

MacLeod found that alkaline dithionite treatment can consolidate heavily corroded bronzes and may be able to reconsolidate the original surface, although the method must be used with care; some fragile archaeological bronzes may simply disintegrate if immersed in alkaline dithionite. Fox (1995) successfully employed the method to treat several bronze coins from

Tel Nami, Israel. The objects were affected with cuprous chloride corrosion, and Fox found that their surfaces were consolidated to some extent after treatment. One of the practical problems associated with the use of alkaline dithionite is cost: the high-grade chemical is relatively expensive, and the commercial-grade reagent tends to contain pungent-smelling impurities. Another difficulty concerns the disposal of large volumes of partially spent solution. Apart from disposal restrictions in different countries, the chemical will upset the microbiological balance of sewage systems if poured down the drain.

MacLeod (1987a) found that for chloride ion removal, alkaline dithionite was the most effective compared with inhibited citric acid, benzotriazole, sodium sesquicarbonate, or aqueous acetonitrile. As mentioned earlier, however, this does not necessarily imply that dithionite solutions are the preferred treatment choice.

In another treatment of marine finds, aqueous acetonitrile, CH_3CN, proved to be a highly effective complexing reagent for copper(I) corrosion products, removing cuprous chloride from objects with active bronze disease when used as a 50% (v/v) acetonitrile-water solution. Analysis of the colorless treatment solution (MacLeod 1987a) showed that the molar ratio of chloride to copper ions was 1:1, which suggests that the following reaction is taking place:

$$CuCl + 4CH_3CN = Cu(CH_3CN)_4^+ Cl^-$$ 12.6

Washing regimes longer than six weeks, however, may result in discoloration of the patina. Because of the greater solubility of molecular oxygen in the mixed solvent system, there is a tendency for the resulting cuprite to be further oxidized to tenorite, which had developed on some objects during a lengthy treatment. Because acetonitrile vapor is moderately toxic, care must be taken to use the solution under a fume hood in a well-ventilated area, or to seal the containers.

In another evaluation along the same lines, Uminski and Guidetti (1995) used artificially corroded bronze sheets to compare the effectiveness of acetonitrile with that of water and with solutions of benzotriazole, AMT (5-amino-2-mercapto-1,3,4-thiadiazole), sodium carbonate, or sodium bicarbonate. The acetonitrile was the most effective reagent for the removal of the artificial cuprous chloride (nantokite) corrosion. Acetonitrile can complex with other copper(I) species, so there may be the danger of disrupting cuprite layers, especially if they are interlayered with nantokite. This study needs to be evaluated on actual artifacts. Treating bronze plates containing only nantokite corrosion cannot replicate the difficulties associated with chloride-ion removal from antiquities, in which the chlorides may be deep-seated and not exposed to the surface.

Treatment recommendations based on comparative evaluations depend on the objects studied and the methods employed for cleaning. For example, Thickett and Enderly (1997) examined the range of chemical treatments discussed here to clean coin hoards, which can contain several hundred coins corroded together as a mass. Surprisingly, the use of alkaline Rochelle salt caused the least damage to the coins,[20] and alkaline dithionite was the most aggressive, although in all

cases, the effects were not great. Alkaline glycerol and formic acid treatments adversely affected coins containing lead.

Another use of Rochelle salt for cleaning an important, exposed bronze surface is worth noting here. Around 1990 Ghiberti's famous bronze doors on the Baptistry in Florence, Italy, were taken indoors and replaced by replicas, while the conservation studios of the Opificio delle Pietre Dure in Florence undertook conservation work on their gypsum-encrusted surfaces.[21] Rochelle salt was shown to be the most effective treatment for this large bronze relief. The salt was used in neutral aqueous solution, however, without any alkali additions, at a concentration of about 30% (w/v). This solution effectively treated some of the individual gilded door panels without disrupting the cuprite surface immediately under the gold. In other areas of the surface, however, brochantite and antlerite existed within small pits under the amalgam gilding, resulting in the gold surface being blistered with numerous small mounds. Some of these blistered gilded areas burst open to reveal copper sulfates; beneath these sulfates some copper chlorides — such as clinoatacamite and paratacamite, or even nantokite — may exist. These open blisters could not be fully treated.

After treatment of the door panels, distilled water was used to wash away residues of the Rochelle salt. The panels were then dewatered with acetone and finally heated slightly to dry. The doors are now on exhibit in nitrogen-filled display cases in Florence.

Immersing objects in large tanks of aqueous solutions is difficult and can create practical problems. Aqueous gels based on cleaning reagents that incorporate polyacrylamides such as buffered citric acid or tartrates with BTA additions may eventually prove useful for cleaning bronze objects.[22]

Washing marine finds in distilled water has also been attempted, but, although this may wash out chlorides by hydrolysis of cuprous chloride, the process is very slow. MacLeod (1987a) estimates that effective stabilization can be attained only if the washing period is from two to four years, which is generally impractical. During such long periods of immersion, reactions with other corrosion products might occur, and these would not be controllable. For these reasons, this method cannot be recommended.

Another approach to the washing process for bronze objects is immersion in sodium sesquicarbonate solutions, subject to the patina alteration problems previously discussed. Sodium sesquicarbonate does remove more chloride ions than distilled water, although at 5% (w/v) in water this solution also slowly removes copper from the sound metallic regions of an object as well as from the corrosion crust.

MacLeod (1987a) also noted that a solution of 1% (w/v) of aqueous benzotriazole with 5% (v/v) of ethanol is capable of displacing a large proportion of chloride-containing corrosion products. Some of these treatments have not been successful, however, possibly due to insufficient impregnation time. Immersion in this solution for a few months, rather than a few days, may lead to better corrosion resistance of the treated artifacts.

REPATINATION OF CLEANED SURFACES

The repatination of cleaned surfaces is a reintegration technique that is often necessary with corroded bronzes in the outdoor environment. Repatination may be limited to damaged areas of the remaining patina, or it may be applied to the entire bronze sculpture, creating a new surface that hopefully will be maintained for the future. Repatination of an original bronze surface, even if badly corroded and disfigured, is still a contentious issue because there is no certainty that the treatment will improve the preservation of the bronze in the long term unless continued maintenance is provided.

Outdoor bronzes

Weil and coworkers maintained that most outdoor bronze sculpture was intended to be bronze in color and polished (Weil et al. 1982; Weil 1985b) and that patinated or at least severely corroded bronze sculpture was best restored to its original appearance. This point of view was exemplified by Weil's work on a group of thirteen bronzes on the Washington monument by Thomas Crawford (1814–57) and Randolph Rogers (1825–92) erected from 1844 to 1869 on the grounds of the state capitol in Richmond, Virginia. Weil used a variety of repatination treatments to restore the sculptures to the appearance they had when dedicated and first placed outdoors. Each bronze figure was first heated, area by area, with a large blowtorch until any water present on the statue vaporized. The patination mixture employed was the commonly used dilute solution of copper nitrate, ferric nitrate, and potassium sulfide. This was applied in successive applications by brush or spray. The surface was washed frequently to remove excess unreacted chemicals.

Weil also used the cold application of a patination solution called "French green," based on ammonium chloride, creating a principally atacamite patina. This was followed by an application of dark pigmented wax whose surface appearance was modified by partial buffing to better integrate the surface color and texture of the treated regions with the untreated surface. A coating of Incralac (discussed under "Coatings for Copper Alloys") applied by spray could also be used over this "French green" patina. This repatination solution was commonly used on later French bronzes from the foundries of Barbedienne and Rudier, according to Weil (1985a).

In another example, the Museum of Art in Philadelphia cleaned the disfiguring surface layers on a version of Rodin's *The Thinker* in 1992 using a poultice of disodium ethylene diamine tetra-acetic acid (EDTA) mixed with cellulose powder. This complexing reagent is particularly efficient, as are most chemical reagents, in removing cupric salts, but it attacks the cuprite layer very slowly. Consequently, the outer corrosion layers on this sculpture were removed down to a compact cuprite layer, which was then used as the base for chemical repatination using a solution of ammonium chloride and potassium polysulfide. This was followed by hot waxing to protect the new patina.

At the Fogg Museum of Art in 1985, Crane is reported to have used partial repatination with ferric nitrate and potassium permanganate to blend a new, cleaned bronze surface with the existing patinated areas.[23]

Another more complicated cleaning and repatination treatment was carried out by Puhringer and Johnsson (1990), who first cleaned an outdoor bronze sculpture with a poultice of Calgon (sodium polyphosphate) mixed with clay. The surface color was then modified by application of another poultice made from clay mixed with "K-Fe cyanide" solution; it is not clear whether this was potassium ferricyanide or potassium ferrocyanide. Next, concentrates of alkyltrialkoxysilanes with catalysts of metallic acid esters were applied to the surface as part of a protective coating. The authors claim that the polymerized siloxanes can be removed by the application of packs of monomeric alkylalkoxysilanes in silica or clay.[24] This treatment requires further evaluation as to its long-term efficacy. Calgon can be a harsh cleaning reagent, and it can slowly attack cuprite layers. The nature of the artificial patination also needs to be more fully characterized in terms of the longevity of the silane coating.

| An "indoor" bronze outdoors | Bronzes intended for display indoors may sometimes have an "outdoor" patina if exposed to the elements, as illustrated by *Juggling Figure*, shown in PLATE 86, executed in about 1610–15 |

by the Dutch artist Adriaen de Vries (1546–1626) and now on display at the J. Paul Getty Museum. In this instance, the outdoor patina resulted from the bronze having been mistaken earlier for a piece of garden sculpture.[25]

The patina of the bronze revealed a corrosion layer that was 20–100 μm thick and had remnant areas of eutectoid phase of the copper-tin system immersed in a striated corrosion crust incorporating copper oxides, chlorides, and sulfates. Only brochantite, however, was identified by powder X-ray diffraction (see APPENDIX D, TABLE 29). The corrosion contains a variety of components as revealed by PLATES 87 and 88, which show X-ray fluorescence elemental distribution maps (each identified by the element symbol) along with secondary-electron and backscattered-electron images. The maps in PLATE 87 show the presence of sulfur, tin, and lead in the patina. The map for carbon, which includes the edge of the resin used to mount the cross section of the sample for polishing visible in the upper right corner, shows that carbonate is not prevalent in the patina. PLATE 88 reveals, most significantly, the distribution of copper, chlorine, and oxygen. These illustrations show that tin compounds are present in the lower layers of the patina, closer to the metal, while chlorides occur toward the outer layers. This contrasts with the more common occurrence of chlorides contiguous with the metallic surface.

The aesthetic appearance of *Juggling Figure* was quite problematic in terms of returning it to a more appropriate hue for museum display and disguising the blackish and contrasting green areas of the principally brochantite surface. A cosmetic treatment was recommended by Stone,[26] who believed that treatment with a pigmented wax mixture would wear off in the long

run and that, in any case, the sheen of the waxed surface that is commonly used as a protective coating on bronzes of this kind would not be desirable in this particular case. Instead, he recommended the use of a tinted shellac applied to the green areas to reduce the contrast between the green and the black coloration. During the first conservation treatment, the sculpture was given a diluted coating of Incralac. The appearance was not greatly improved, however, and the bronze was retreated in 1992 with Arkon P-90,[27] a fully saturated alicyclic hydrocarbon soluble in petroleum naphtha, used as a 15% solution. During the four years that the treated sculpture was on exhibit, this coating became more plastic-looking and developed a slight milkiness. The decision was made to re-treat the surface to try to achieve better reintegration. The Arkon P-90 was removed with Shellsol 71,[28] which was followed by cleaning with naphtha, but this failed to remove all of the coating. Xylene applied with cotton swabs finally succeeded in removing the remaining coating.

A new treatment using Laropal aldehyde resin[29] in mineral spirits was tried with good results, but it left too much surface gloss that would have necessitated matting out areas with powder pigments. Most acrylic resins that were tried were also too glossy. Finally, tinted super-blonde shellac was applied. This varied the opacity and finish of the resin to suit different areas of the variegated surface (Bassett 1996); this is the finish that the sculpture now has.

In all these examples, any earlier patina still on the bronze after cleaning was allowed to remain there when the sculpture was repatinated. There are, of course, conservation approaches that involve totally stripping away an existing patina, using both chemical and mechanical techniques, before a new one is applied. This may be justified in particular cases, since every bronze must be considered as an individual object with specific conservation requirements. There is no universal panacea.

THE USE OF CORROSION INHIBITORS

A number of different organic compounds that complex with copper have been proposed as corrosion inhibitors for ancient copper alloys or exposed bronze statuary. Corrosion inhibitors act to retard the corrosion of metals by forming a stable surface complex that interferes with the anodic reaction, the cathodic reaction, or both. In the case of copper alloys, complexes can also be formed between benzotriazole and copper-corrosion products. The most well known compound is benzotriazole, which is reviewed here first and is followed by a brief account of other corrosion inhibitors.

| *Benzotriazole* | In 1967 Madsen introduced the use of the corrosion inhibitor benzotriazole (BTA) to conservation practice. In fact, benzotri- |

azole had been the subject of a British patent for use as a corrosion inhibitor in 1947 (Cotton and Scholes 1967), and it had been used in commercial applications[30] for twenty years before the conservation community became aware of its benefits for the stabilization of ancient bronzes.

The use of a stabilization treatment was beneficial in creating a revised approach toward the concepts of patina retention and humidity control as viable alternatives to the conservation of ancient bronzes, which traditionally involved either patina removal or drastic alteration to the existing patina. The precise mode of benzotriazole's action as a copper inhibitor has been under discussion for several years. Since all copper surfaces have a thin film of copper (I) oxide present, the polymer layer that is formed over the cuprite layer is thought to provide the major anchoring sites for the benzotriazole multilayered complex. Hollander and May (1985) concluded from numerous prior studies that benzotriazole forms a protective film of predominantly Cu(I) benzotriazole over the metal surface. This chemisorbed complex may form a polymeric film up to thirty molecular layers thick that acts primarily to retard the cathodic reduction of oxygen, although some studies also suggest mixed or anodic control. Detailed electron spectroscopy for chemical analysis (ESCA) and infrared work has shown that the protective film is a 1.1 complex of Cu(I) and benzotriazole, probably polymeric, with benzotriazole bridging two copper atoms via the N_1 and N_3, with the aromatic ring aligned parallel to the metal surface.

This Cu(I) BTA complex is extremely insoluble, which is additional evidence for its polymeric nature. The conditions under which the metal is pretreated affects the nature of the resulting BTA film. Pretreatment conditions include the nature of the patina, the degree of corrosion, the presence of active chloride corrosion in pits, the composition of the patina, and how it is cleaned prior to treatment. At low pH conditions, such as may be encountered with bronze disease, BTA can form very thick films, but these are apparently caused by the partial precipitation of benzotriazole from solution, since it becomes increasingly insoluble as the pH falls. Increasing the temperature used during treatment produces a more effective BTA deposition.

BTA may also form a series of cupric complexes whose structures are currently unknown. Using Fourier transform infrared spectroscopy, Brostoff (1997) found that the main triazo stretching band in Cu(II) BTA derivatives showed more variability in position and shape than in the Cu(I) derivatives, suggesting that the divalent complexes are more variable and irregular than the monovalent complexes. A series of studies were conducted by Brostoff on the interaction between BTA and a variety of copper compounds, and the results are shown in TABLE 12.1. Not unexpectedly, Cu(I) BTA predominates in reactions with cuprite and with copper powder. Cu(II) BTA derivatives were identified from reactions with nantokite. These studies showed that copper chloride salts strongly influence the copper-BTA reactions and that intermediates such as $CuCl_2$ and unstable cuprous chloride-BTA derivatives may be involved in the CuCl-BTA reaction mechanism.

When BTA reacts with cupric chloride, a cupric-BTA derivative precipitates from solution; this has been assigned the formula Cu(BTA)Cl. Under certain circumstances, there may be problems with the stability of an artifact being treated if large amounts of cuprous chloride are present. For example, when workers at the Conservation Laboratory of the Museum of London applied BTA to a particular object, a plume of reactants emerged from a chloride-containing corrosion pit.[31]

TABLE 12.1 **COPPER MINERAL–BTA POWDER REACTION PRODUCTS**

REACTANTS: BTA + (BTA : Cu molar ratio)	SOLVENT/SOLUBILITY	PRODUCT DESCRIPTION	PRODUCT IDENTITY
1. Cu powder (3:1)	reagent alcohol/insoluble	copper color	Cu
2. Cu powder (3:1)	dil. HCl, pH 1.0/insoluble	green brown; fine particles	Cu_2O; Cu(I) BTA; Cu; $Cu_2(OH)_3Cl$; CuCl
3. Cu_2O (1.5:1)	reagent alcohol/insoluble	dark green, dried to light dull green; large particles	CuCl; Cu(II) BTA
4. Cu_2O (1.5:1)	dil. HCl, pH 1.0/soluble	pale gray green; fine particles	Cu_2O; Cu(I) BTA; $Cu_2(OH)_3Cl$;
5. CuCl (1.5:1)	reagent alcohol/insoluble	dark green; very fine precipitate formed slowly	CuCl; Cu(II) BTA
6. CuCl (1.5:1)	dil. HCl, pH 1.0/ slightly soluble	yellow green, dried to light dull green; large particles	$Cu_2(OH)_3Cl$; Cu_2O; Cu(II) BTA; Cu(I) BTA
7. $CuCl_2$ (4:1–0.5:1)	reagent alcohol/soluble	lime blue green; med. particles	Cu(II) BTA
8. $CuCl_2$ (3:1, 1:1)	hot acetone (40 °C)/ sparingly soluble	lime green, fluffy; med. particles	Cu(II) BTA + ?
9. $CuCl_2$ (1:1)	$CuCl_2$/alcohol/ BTA/acetone soluble	lime green solution	Cu(II) BTA
10. $CuCl_2$ (2:1)	dil. HCl, pH 1.0/soluble	pale mint green; med. particles, formed slowly	Cu(II) BTA
11. $CuCl_2$ (1:1)	dil. HCl, pH 2.0/soluble	med. bluish green; very fine particles	Cu(II) BTA
12. $CuCl_2$ (2:1)	dil. HCl, pH 4.5/soluble	med. bluish green; very fine particles	Cu(II) BTA
13. $CuCl_2$ (2:1)	H_2O, pH 10.0/soluble	dull bluish green; very fine particles	Cu(II) BTA
14. $CuCl_2$ (2:1)	dil. CaOH, pH 10.0/soluble	med. bluish green; very fine particles	Cu(II) BTA
15. paratacamite (3:1)	reagent alcohol/insoluble	pale green; med. particles	paratacamite
16. paratacamite (3:1)	dil. HCl, pH <1.0/soluble	no precipitate	—
17. paratacamite (3:1)	dil. HCl, pH 1.0/ soluble (blue), soluble to pH 1.5	lime green; med. particles, very high yield	Cu(II) BTA

18. paratacamite (3:1)	dil. HCl, pH 2.0/ soluble to pH 4	dark green; med. particles, formed quickly	Cu(II) BTA
19. paratacamite (3:1)	dil. HCl, pH 3.5/soluble	med. green; fine particles	Cu(II) BTA; paratacamite; Cu_2O
20. paratacamite (3:1)	H_2O, pH 6.0/insoluble	pale green; fine particles	paratacamite; Cu(II) BTA
21. paratacamite (3:1)	dil. CaOH, pH 9.5/insoluble	pale green; fine particles	paratacamite; Cu(II) BTA
22. $Cu_2(OH)_2CO_3$ (3:1)	reagent alcohol/insoluble	med. green; med. particles	$Cu_2(OH)_2CO_3$

In some cases, treatment with BTA fails to stabilize the object (Plenderleith and Werner 1971; Madsen 1985; Weisser 1987). Research by Faltermeier (1995) suggests that the reason for this failure is the low pH (around pH 2) generated by the reaction between CuCl and BTA. Fang, Olson, and Lynch (1986) found that the formation of the BTA–copper polymer was influenced by the pH of the BTA solution. Brusic and coworkers (1991) discovered that copper-BTA films grown at a pH of 3 acted as cathodic inhibitors for hydrogen evolution but that they failed to inhibit the oxygen-reduction reaction. Similar results were obtained by Musiani and colleagues (1987), suggesting that these low pH environments are not suitable for the inhibitor to lay down a protective film.

Faltermeier (1995) recommended that troublesome bronzes should be only briefly immersed in 3% BTA ethanoic solutions, and, where possible, this should be carried out in vacuo to minimize moisture uptake by the inhibitor solution. This was, in fact, the standard way to treat such bronzes during the 1970s in the laboratories of the Department of Conservation and Materials Science at the Institute of Archaeology, London. Large canister vacuum vessels with thick glass viewing ports were more in vogue at that time. If a difficult artifact cannot be stabilized by two such treatments, Faltermeier recommends moving to other techniques, such as environmental control or silver oxide paste.

Benzotriazole can also react with other corrosion products, for example, paratacamite. X-ray photoelectron spectroscopy by Brostoff (1997) suggested a composition of $Cu(II)(BTA)_x(Cl)_y(OH)$ for the reaction product, where the ratio of BTA to copper is greater than 1, and $x + y = 2$. This suggests either a six-coordinate, octahedral, polymeric network complex

with coplanar BTA and chloride ligands or a fairly low degree of polymerization. The adhesion of these films, however, even if they formed as oligomers, should be beneficial to the preservation of the treated bronzes, because these films will insulate the active corrosion products from the external environment. Stock[32] notes that neither conventional benzotriazole treatment nor control of the relative humidity effectively conserved bronzes with extensive chalconatronite corrosion in the collections of the Royal Ontario Museum; after treatment, bright blue powder continued to be produced from the affected objects. Further research in this area is needed, although it is often not possible to confirm or reproduce some of the difficulties reported by conservators during their treatment of particular objects.

The overall process of benzotriazole interaction with objects affected by bronze disease is complex. Significant amounts of chloride ions may accumulate from soluble salts, from corrosion reactions, and from Cu(II) BTA reaction products. MacLeod (1987b) demonstrated that Cu(II) BTA reaction products accumulated when bronze objects were immersed for two hours in a 1% (w/v) aqueous BTA solution. The results of this study showed that oxygen and water may be present in sufficient quantities, even in alcohol, to activate corrosion reactions, and this has a direct bearing on the observations by Faltermeier described above.

Tennent and Antonio (1981) have established that the complex formed between BTA and cuprous chloride may not be stabilized against further reaction and that its conversion to a BTA-atacamite complex occurred after seventy-two hours of reaction with water. There is some evidence that the cuprous chloride–BTA complex is stable to a higher relative humidity than cuprous chloride alone, which tends to transform to one of the copper trihydroxychlorides at over 45% relative humidity (Scott and O'Hanlon 1987; Tennent and Antonio 1981).

STANDARD PRACTICE AND RECOMMENDATIONS It is now standard practice for conservation treatment to immerse bronzes in a 3% (w/v) benzotriazole solution in ethanol at room temperature, often under vacuum, for up to twenty-four hours.[33] The object is then removed from the solution, excess BTA crystals are rinsed from the object with clean ethanol, and the object is dried. The BTA film that remains on the object is often given a protective coating, either with a 5% solution of Paraloid B72 (Acryloid B72 in the U.S.) in ethanol or with a solution of Incralac lacquer diluted in ethanol or toluene (see the following section, "Coatings for Copper Alloys"). Often aerogel silica is added to the Incralac mixture as a matting agent to prevent the surface from appearing too plastic; the aerogel silica particles reduce surface gloss substantially. More than one coat of the Paraloid B72 polymer film is usually applied to increase its protective capacity.

The results of the studies discussed in this section suggest that pretreatment regimes, such as rinsing and exposure to buffering agents to remove soluble chlorides and neutralize acidity, may be beneficial before using BTA solutions. Relatively short immersion times and the use of fresh BTA solutions are advisable. The latter advice is particularly noteworthy, since most conservation laboratories using benzotriazole as a 3% w/v solution in ethanol tend to reuse the

solution to avoid the necessity of making fresh solutions and disposing of the old ones, and the solution eventually becomes pale green in color. Benzotriazole is potentially carcinogenic and must be handled with care, which is an additional disadvantage to repeatedly making fresh BTA solutions, yet the current research clearly shows that this is the most effective method.

| SAFETY ISSUES The hazards associated with benzotriazole use are discussed by Oddy (1972, 1974b) and by Sease (1978), who point out that according to Sax (1976), BTA has manifested only moderate toxicity in animal trials. Other references to the same animal tests report the results to be "equivocal," although the material safety data sheets of the international German chemical company ICN state that benzotriazole is not a carcinogen.[34]

Oddy (1972) recommends the following precautions for using BTA in the museum laboratory:

- Do not inhale any powder.
- Do not allow alcoholic solutions of BTA to come in contact with the skin.
- Do not allow alcoholic solutions of BTA to evaporate to dryness.
- Wear rubber or polyethylene gloves when handling treated objects.
- Clean all glassware after use.
- Never heat BTA solutions (the solid sublimes at 98 °C).
- Wear a face mask when spraying any lacquers containing BTA, such as Incralac.

One of the most difficult recommendations to follow in practice concerns the evaporation of alcoholic BTA solutions. The solutions are very prone to crystallize thin films of BTA crystals around beakers and containers, very quickly forming dry deposits that might present a hazard in the laboratory if extensively used outside of a fume hood. Excess benzotriazole crystals may also precipitate on the treated object and would need to be brushed away from the surface.

AMT as a corrosion inhibitor
Ganorkar and colleagues (1988) describe another corrosion inhibition system that is claimed to remove bronze disease at the same time. The method uses 5-amino-2-mercapto-1,3,4-thiadiazole, known as AMT, which is a heterocyclic ring compound with the formula $(NH_2)CNNC(SH)S$. It is a pale yellow solid that is soluble in hot water and ethanol. The reagent was tested on fifteen corroded bronze coins dating to the Islamic period, around the fifteenth century, from the Birla Archaeological Institute, Hyderabad, India. The coins were first washed in distilled water, then immersed in 150 ml of 0.01 M aqueous solution of AMT. A pale yellowish green, curdy precipitate formed on the cuprous chloride areas; after an hour, the coins were removed and washed. This procedure was repeated under vacuum until no further reaction took place. The AMT appears to form a complex species with the cuprous chloride; in addition, the formation of a polymeric layer on the bronze, confirmed by infrared studies, confers some overall surface protection.

Three recent reappraisals of the efficacy of AMT have been undertaken. Brunner (1993) found that during treatment of a group of ancient bronze coins, only partial stabilization was achieved. Hawley (1996) employed AMT in the conservation of a large group of Celtic finds from Basel, Switzerland, and judged it to be quite effective at extracting chloride ions. It was difficult, however, to remove the resulting sludge from the pores and crevices of the treated objects. Li and coworkers (1998) carried out comparative studies of corrosion resistance that showed a protective film was indeed deposited on the surface of objects. The researchers found that the reagent complexed effectively with chloride ions in the treatment of a Chinese bronze bell and that AMT has excellent inhibitory effects in acidic media. They reported that a combination of 5% citric acid and AMT efficiently cleaned surface deposits and that the use of this reagent mixture avoided the development of light yellow precipitates within the surface patina of the cleaned object. Judging from the black-and-white photographic illustrations published with this article, however, it appears that the Chinese bell has been cleaned down to a cuprite patina by this mixture. This level of cleaning may not always be necessary and may remove too much of the original patina to be aesthetically desirable; in many cases, retention of the malachite patina is preferable. Judgment of the merits of using this inhibitor must await further research. If, indeed, it dissolves cuprous chloride selectively, then it may have some wider application. The Ganorkar publication did not discuss one of the important issues of using organic inhibitors in the conservation laboratory, namely, safety. How safe is it to use, and is the compound a potential carcinogen?

COATINGS FOR COPPER ALLOYS

From time immemorial, waxes, oils, and natural resins have all been used to protect the surface of copper alloys from tarnishing, corrosion, or as a means of impregnation—that is, to totally immerse or saturate the object in the resin or wax to consolidate it and prevent disintegration into mineralized fragments. Late-nineteenth- and early-twentieth-century methods continued this tradition. Voss (1888), for example, used poppy seed oil and gum damar. Other materials commonly employed were shellac, fish glue, and beeswax. Paraffin wax was often used as well (Gilberg 1988), but it was eventually supplanted by cellulose nitrate and cellulose acetate, which were recommended by Rathgen (1905).

Coatings for outdoor bronzes were traditionally based on natural waxes and oils. Research into the suitability of these coatings was initiated during the 1860s by the Berlin Society for the Encouragement of the Arts (see CHAPTER 1). Natural waxes and oils have their drawbacks, though: they usually contain organic acids and esters that can interact with the bronze substrate, creating their own specific range of corrosion products on the objects they are supposed to be protecting. Until the advent of synthetic polymers and waxes, however, there was no other option available to conservators in this field.

Tatti (1985) and Veloz (1994) are of the opinion that minimal cleaning and hot waxing over the remaining corrosion layers continues to be an effective treatment. The approach taken by Tatti is to first clean away surface dirt using water and a nonionic detergent, rinse with clean water, and then eliminate entrapped moisture by heating the sculpture with a propane torch. The wax used is made from 85% Bareco Victory microcrystalline wax, 10% Bareco 2000 polyethylene wax, and 5% Cosmoloid 80H wax. (Similar wax mixtures are commonly used by the U.S. National Park Service for conservation of the monuments in its care.) Saturation of the patina with this wax minimizes the inherent color contrast on partially disfigured surfaces. Three coatings of wax are applied. After the final coat has dried overnight, the surface is buffed by hand with brushes and cloths, which allows highlights to be polished preferentially for aesthetic reasons. This approach retains the original patina, which is now covered with a coherent wax outer layer. Routine annual maintenance is necessary, however, to ensure that the treatment continues to be effective over time.

The history of some typical coatings used from 1939 to 1997 is documented by Shorer (1997). Beginning in 1939 an adhesive was made from Perspex (polymethyl methacrylate) by dissolving it in chloroform. By 1965 the hazards of chloroform had become widely known, and the solvent was changed to methylene dichloride. By the 1970s methylene dichloride was also found to be hazardous, and the use of dissolved Perspex gradually ceased. The following sections summarize the variety of coatings used since 1939.

Shellacs and lacquers | A common protective coating used in the 1940s was brown copal shellac dissolved in blue methylated spirits.[35] By the 1950s, however, this coating was found to be inadvisable because of the toxicity of pyridine, the dye, and other substances used, and Shorer changed the recipe to white shellac and colorless industrial methylated spirits (IMS).[36]

Another common lacquer used for metalwork before World War II was cellulose acetate made by dissolving celluloid strip film in acetone and iso-amyl acetate. This coating was borrowed from the aircraft industry, where shellac or celluloid was used to impregnate the cloth used in the manufacture of coverings for airplane wings.

Ercalene and Frigilene nitrocellulose lacquers (Agateen in the U.S.) were introduced in the 1960s and have continued to be popular in museum conservation for coating bronze, brass, and silver. Frigilene was supposed to be sulfur free, making it suitable for coating silver alloys. One of the attractions of these nitrocellulose (or cellulose nitrate) lacquers is that they can be easily applied by spraying, which produces an even polymer film; however, the polymer film is subject to degradation with exposure to sunlight or ultraviolet light, so these lacquers have gradually been replaced by acrylic resins.[37] There is now an acrylic IIMC analog, but its viscosity is hardly ideal.

Despite the problems with cellulose nitrate as a coating, if it is kept for a long time at low light levels, some polymer films made of this material have survived quite well for as long as sixty years (Selwitz 1988). There are instances where objects coated with nitrocellulose lacquer twenty-five years ago were delacquered with ease in 1996.

| *Resin coatings* | A resin coating popular from the early 1950s was Bedacryl 221X; |

however, the acrylic polymer base, butyral methacrylate in toluene, was not very stable and tended to cross-link on exposure to ultraviolet light. The use of this coating has been discontinued, along with that of soluble nylon, which ended up not being soluble at all. Another unsuitable material often used from the 1930s to the 1960s and now generally available only for thin films such as coin holders is polyvinyl chloride, or PVC. One common problem in using PVC coin holders is that bronze coins stored in them develop green stains. This corrosion is caused by the chloride ions in the material and by the plasticizers (such as phthalates), whose hydrolysis products can contain carboxylic acids. These holders have gradually been phased out in most major museum collections and replaced with polyethylene holders or foams. Because of dioxins created during the manufacture of PVC, this polymer is now banned from production in many European countries.

A much more satisfactory acrylic resin system is Paraloid B72, which has been manufactured continuously for more than thirty years by Rohm and Haas Inc. of Philadelphia. Known in the United States as Acryloid B72, it is a copolymer of ethyl methacrylate and methyl methacrylate and has much better aging properties than the butyl methacrylates. This resin is used extensively in bronze conservation work, both as an adhesive and as a coating.

| *Incralac* | During the 1960s the International Copper Research and Devel- |

opment Corporation in New York investigated suitable coatings for copper alloys. The result was Incralac, a product consisting of epoxidized soybean oil (as a leveling agent), benzotriazole (as a UV stabilizer — not, as is often stated, a corrosion inhibitor), ethyl methacrylate and butyl acrylate copolymer (known as B44, a copolymer from Rohm and Haas Inc.), toluene, and ethanol. The coating has become an industry standard for many outdoor applications, although it cannot be used as a coating for bronze sculpture without recognition of the fact that it will eventually break down and become insoluble.

Incralac was included in a study of the effectiveness of various plastic and wax coatings in protecting outdoor bronze sculpture (Beale and Smith 1987). Acrylic coatings performed well in a series of evaluation trials, although wax formulations were also reasonably effective. In this study two different environments were used: simulated acid rain and normal outdoor conditions. Cast bronze relief panels, with composition of 85Cu5Sn5Zn5Pb, were coated with the following:

1. Incralac
2. Sedonalacq (an ethylene glycol terephthalate)
3. benzotriazole
4. Butcher's bowling-alley-paste wax (carnauba wax;[38] natural and synthetic waxes in mineral spirits, also known as white spirit; and turpentine or a substitute usually made of hydrocarbons)
5. National Park Service wax mixture (82% Bareco Victory white microcrystalline wax; 15% Bareco 2000 polyethylene wax; and 3% Cosmoloid 80H microcrystalline wax with 3% benzotriazole added)
6. Tatti wax mixture (85% Bareco Victory brown microcrystalline wax; 10% Bareco 2000 polyethylene wax; and 5% Cosmoloid 80H microcrystalline wax)
7. no coating (controls)

The results of this study showed that the Incralac-coated panels, both spray- and brush-coated specimens, suffered some degradation during the sixteen weeks of exposure to both environments. There were no discernible differences between the wax mixtures with benzotriazole and those without. After sixteen weeks there was slightly more deterioration of the wax-coated samples exposed to the simulated acid rain than those exposed outdoors. After twenty-seven weeks of outdoor exposure, the wax-coated samples showed more corrosion than the samples coated with the acrylic materials. Many of the acrylics, however, had a tendency to become detached from the substrate; delamination of the coating from the substrate around edges of the coupons was a common problem.

In another study, Weil (1975) reported that Incralac gave good protection as a coating for outdoor bronzes for at least two years; when the Incralac coating was protected with a microcrystalline wax finish that was periodically reapplied, it performed well for about three years. The practical difficulties of maintaining Incralac coatings was highlighted by Erhardt and coworkers (1984). They examined the ten-year-old Incralac surface on four outdoor gold-plated bronze statues in Washington, D.C., and discovered it to be cracked and insoluble. Beale,[39] however, notes that two factors in connection with these bronzes were not addressed in this study: first, chemical residues were left on the surface from the on-site gold electroplating process used on the sculptures; second, the inappropriate use of Incralac over a highly reflective gilded surface contributed to this particular cross-linking of the Incralac polymer. These surface conditions not only subjected the coating to higher than normal temperatures but also nearly doubled the dose of UV radiation. The Incralac was removed by softening with paint remover incorporating methylene dichloride, followed by pressurized water spraying. Compared with fresh Incralac, the UV absorption of the weathered material was greater, and most of the benzotriazole content had been depleted. Benzotriazole is often stated as being added to this polymer

system as a corrosion inhibitor, but this is not the case. The benzotriazole is added to act as a UV absorber, so the loss of this compound from the coating implies that its stabilizer (BTA) has evaporated. Voorhees (1988) describes in detail a six-step process to remove aged Incralac. Bronze monuments were first treated with PMC protina solvent, which emulsified the lacquer so that it could be scrubbed off with clean burlap. This was followed by a thorough rinsing, then the procedure was repeated.

These studies show that, unfortunately, there is no easy way to combine reversibility and exceptional protection in an organic coating. In the absence of a maintenance or monitoring regime, there is no guarantee that any coating will perform as desired over a period of several years.

A recent study by Scott and Stulik (1998) of the corrosion crust on a statue of Alexander Hamilton by W. O. Partridge (1861–1930) investigated the ability of the new generation of electron microprobes to map elemental distributions. The statue, shown in PLATE 89, was unveiled in 1890 at Hamilton Grange, New York. It was treated by Weil (1985a) in 1978 by glass-bead peening, followed by repatination and then coating with Incralac. In 1980 the statue was maintained with a superficial cleaning and recoating with Incralac. Before any treatment was carried out, a core-drill sample was taken from the figure's right shoulder and analyzed using an electron microprobe; the resulting elemental distribution maps are shown in PLATE 90. These maps are of interest because they reveal that the distribution of tin within the corrosion crust is strongly influenced by the dendritic morphology of the underlying metal, which is not something that has been previously observed. Instead of becoming diffused throughout the patina through the process of corrosion, the tin oxides have preferentially followed a pseudomorphic morphology, which is preserved within the corrosion crust and which could not be detected by light microscopy or by point analysis (discrete analyses made in several different locations on the object). Also unexpected is a zone of tin enrichment toward the outermost layer of the patina, which encloses a zone that is high in chlorine, oxygen, and sulfur from the formation of the basic sulfates and chlorides. The tin enrichment is visible as a thin blue line in PLATE 90B. PLATE 90E shows the presence of zinc as a solid solution in the alloy and as a few scattered inclusions of zinc sulfide within the metallic matrix. This reveals that the zinc makes no contribution toward the development of the patina and that the zinc salts that form are washed away preferentially from the corrosion crust. Underlying the zone of tin enrichment and adjacent to the metal is a layer of cuprite; part of the reason for the striated appearance of the patina is the periodic precipitation of cuprite within this crust.

The elemental distribution maps for this sculpture are a record, frozen in time, of what the patina comprised in 1978 after nearly one hundred years of corrosion outdoors. It would be interesting to revisit this sculpture in 2078 and compare this record with the hundred years of patina growth since repatination.

Ormocer and other polymer coatings

For outdoor bronzes today, Incralac and synthetic waxes remain the most common choice, but recent research suggests that some of the Ormocer coatings may also provide good protection.

The Ormocer family of coatings was developed by the Fraunhofer Institute in Munich, Germany (Pilz and Römich 1997). The base material is a heteropolysiloxane, which is an organic-inorganic copolymer made by a sol-gel process. The two-component Ormocer lacquer GDiphenyl is synthesized from gamma-glycidoxypropyltrimethoxysilane and diphenylsilane-diol hydrolyzed with a stoichiometric quantity of water. This produces a transparent lacquer that can be stored safely for several months. It is cross-linked with an aminosilane hardener, stabilized by the addition of some suitable organic oligomer, which results in the system being reversible with organic solvents. The three most promising lacquers derived from this system are designated OR1, OR15, and OR16; the last two make use of a top coat, which is an acrylic resin applied over the polysiloxane system.

The polymer, mixed in butoxyethanol at high dilution, is applied using a spray gun, taking the appropriate safety measures, such as using a breathing apparatus. In a series of trials with this coating, monolayers 4–8 µm thick or bilayers 10–12 µm thick were applied to 90/10 bronze coupons. Adhesion properties to the bronze substrate were determined by the crosscut test (DIN 53131) and the pull-off test (ISO 4624). Good adhesion was achieved even after simulated weathering for 336 hours in a "weatherometer," or accelerated weather chamber, in which the relative humidity was periodically changed and the sulfur dioxide content maintained at a constant and high level, over 60% RH.

The corrosion resistance of samples with monolayer coatings depended strongly on the coating thickness. The monolayer treatments with OR1 provided good protection for surfaces with natural stable patinas. Some of the coupons that were not patinated before the experimental tests, however, and some of the bare metal coupons that were coated showed some corrosion of the metal surfaces. This indicated that a coating thickness of 4–8 µm was not sufficient. Bilayer coatings with OR15 and OR16 about 10 µm thick were very effective on both patinated and unpatinated cast bronze, by comparison.

Incralac was included in the general testing procedure, and it was found that coupons coated with Incralac showed some loss of adhesion after testing. Compared with Incralac, the Ormocer bilayer coatings showed no loss of adhesion after weathering. The natural patina color, however, was darkened by the Ormocer treatment, which produced a "wet" appearance. Bilayer coatings and Incralac both change the patina color, causing it to appear appreciably darker and glossy, and this places aesthetic limitations on the use of these coatings. A suitable wax finish over the Ormocer layer might improve the appearance.

The coatings in this study were also exposed to condensed moisture for 168 hours at 40 °C, after which time both the bilayer polymers and Incralac had turned milky; the monolayer Ormocer system remained in good condition.

A long-term outdoor trial of the polymer system initiated by the Fraunhofer Institute and the Public Works Department of Dublin City Council is being carried out on a large-scale public bronze sculpture in Dublin, Ireland, under the direction of the city's Office of Public Works. The sculpture was coated with Ormocer in 1996, and it will take a number of years before its effectiveness can be evaluated.

There is concern about the reversibility of these polymer systems. Over long periods of time, oligomer molecules may be leached from the polymer, and subsequent cross-linking may make the coating very difficult to remove. The bilayer systems can be removed with ethyl acetate, but the monolayer coatings require more aggressive solvents such as methylene chloride. Despite these limitations, there may be no adequate alternative to these coatings for the long-term maintenance of outdoor bronzes.

Another recent research effort to attempt to improve the way in which surface coatings are employed for the protection of outdoor bronzes was initiated by Brostoff and de la Rie (1997), who began a series of trials of different resin treatments for outdoor bronzes based on the industrial model of applying a primer, main coat, and then top coat. The primer promotes adhesion of the main coat to the substrate metal; different metals may require different primers to create an effective chemical bond. The main coat provides most of the protection from the environment, and the top coat is partly a sacrificial layer. A common approach to this industrial model already in use in conservation is to apply BTA as the primer, Incralac as the main coat, and a wax top coat.

A good example of this treatment method is described in the study by Marabelli and Napolitano (1991) on outdoor bronze statues in Rome. Laboratory tests by the Istituto Centrale del Restauro and the Selenia Company investigated the protective properties of multilayer treatments consisting of a blend of natural and synthetic waxes applied over acrylic coatings. The performance of these multilayer systems was compared with that of the acrylic coatings alone. Samples were exposed to a sequence of accelerated weathering tests, including a forty-five-day humidity cycle, exposure to UV radiation, and a one-hundred-hour acidified salt spray test. The acrylic-wax coatings gave a superior performance, and the best results were obtained with a double layer of Incralac followed by Reswax WH containing added benzotriazole.

Taking another approach to the problem of stabilization, Brostoff and de la Rie (1997) are evaluating organosilane coupling agents, corrosion inhibitors and their derivatives, and other materials such as acrylics. They are investigating main coats of both thermoplastic and thermosetting polymers, such as acrylics and acrylic urethanes, with wax as a possible top coat.

Problems with coatings | The combined effects of ultraviolet radiation, pollutants, snow, sun, rain, wind, and particulate matter present an extremely difficult set of problems for outdoor bronzes. Currently there is no accepted coating for these objects that does not require considerable maintenance to provide long-term protection of

the surface. In some harsh outdoor climates, as in Canada, for example, Incralac has performed poorly and is not generally recommended for use.

Reversibility of both wax and Incralac coatings is another serious problem. As noted previously, it can be very difficult to remove wax from porous or heavily corroded surfaces, and removing aged Incralac may entail the use of large quantities of toxic solvents. In terms of removal, Ormocer coatings may be no better.

The problems of coatings for outdoor statuary are so pervasive that, even in industry, there are no organic coating systems systems recommended for use on unprimed metal surfaces.

Coupling agents, designed to enhance the bonding of polymer systems to a metallic substrate, have become industrially important, but there are few accounts of their use in the treatment of copper or bronze sculpture. One coupling agent that has been used in a series of trials on copper objects by the Getty Conservation Institute and the Swedish Corrosion Insti tute is neopentyl (diallyl) oxy tri (dioctyl) pyro-phosphate titanate (Lica 38), which has the following structure:

$$CH_2 = CH\text{-}CH_2O\text{-}CH_2 \qquad\qquad 12.7$$
$$|$$
$$CH_3CH_2C\text{-}CH_2\text{-}O\text{-}Ti\{O\text{-}P(O)(OH)\text{-}O\text{-}P(O)[OC_8H_{17}]_2\}_3$$

This compound has two reactive ends. One end, the neopentyl (diallyl) oxy group, can react chemically with protons of the surface hydroxyl groups by an alcoholysis (sovolysis) mechanism. This results in the formation of a Cu-O-Ti linkage and the elimination of an alcohol, as shown in the following general reaction where M is the inorganic substrate and RO is the neopentyl (diallyl) oxo group:

$$MOH + RO\text{-}Ti\{O\text{-}P(O)(OH)\text{-}O\text{-}P(O)[OC_8H_{17}]_2\}_3 = \qquad 12.8$$
$$M\text{-}OTi\{O\text{-}P(O)(OH)\text{-}O\text{-}P(O)[OC_8H_{17}]_2\}_3 + ROH$$

On the second reactive end, the linkage between the metal and the titanto-phosphate groups provides a good substrate for polymer adhesion to the prepared metallic substrate, although the nature of the polymer used is critical to the success of the system. The coupling agent has to be chosen to match not only the metallic substrate but also the chemical groups of the polymer system with which it can bond most effectively.

A potential advantage of coupling agents for conservation treatments is that they can be used at very low concentrations, typically of the order of 0.25–0.5% (w/v) in ethanol. Even if the surface of a bronze is first prepared with a titanate coupling agent, however, the ability of the polymer to protect it from corrosion depends on an array of factors of which surface adhesion is only one. For example, if the polymer coat is too thin, oxygen and moisture may still be able to diffuse to the metal surface and cause general corrosion.

The phospho-titanate coupling agent Lica 38 is being tested—along with the performance of conventional corrosion inhibitors, such as BTA—as part of the outdoor exposure trials of coatings being conducted at the J. Paul Getty Museum site in Malibu, California; at the Swedish Corrosion Institute in Stockholm; and at a site in Tîrgu Jiu, Romania. About five hundred coated brass (80Cu20Zn) and bronze (87Cu12Sn, 0.3Fe, 0.6P, 0.1As) test panels were made, together with a series of controls of untreated or partially treated blanks of copper, bronze, and brass. Accelerated chamber testing with exposure to NO_2 and SO_2, "scab testing,"[40] and outdoor trials were initiated in November 1994 and were still in progress in 2000.

The abraded, polished, and cleaned panels were first treated with a variety of inhibitors: 0.25% (v/v) Lica 38 in ethanol; 3% (w/v) benzotriazole in ethanol; and 3% (w/v) tolyltriazole in ethanol. This was followed by two coats, using both brush and spray application, of the following:

1. 5% (w/v) Paraloid B72 in acetone
2. a wax mixture of 13 g Polywax 2000, 71 g Victory white, and 18 g Multiwax W-445 in white spirits, applied warm by brush
3. titanium nitride, a clear inorganic coating used commercially for brass
4. Autoclear (an automobile finishing top coat) based on a stabilized acrylic system with supposedly good UV stability
5. Ormocer A and Ormocer B (similar to OR1, described earlier) from the Fraunhofer Institute
6. Incralac in toluene[41]
7. a polyurethane-isocyanate used for coating boats that is supposedly UV stable

After one year of outdoor exposure, the Incralac, Autoclear, and Ormocer A coatings were still protecting the brass and bronze substrates from corrosion very well, but the others were beginning to fail. No noticeable beneficial effect was found when any of the inhibitors or coupling agents were used with the coatings compared with using the polymer coatings alone. After two years, the bronze panels were practically unchanged in color. Because of the greater propensity for copper-zinc alloys to corrode, however, the brass substrates had discolored, or they were beginning to discolor around the edges because moisture and oxygen were infiltrating under the coating and detaching it from the substrate metal. After three years of outdoor exposure, all of the coatings showed some signs of either deterioration or failure to protect the underlying brass panels from tarnishing.

At this stage, the best coatings appear to be Incralac and Ormocer A, with Ormocer A outperforming Incralac in both outdoor exposure trials and indoor accelerated weathering trials. Only tiny, light green spots had formed on the samples coated with Oromocer A after three years of exposure in Malibu, compared with some delamination and patchy discoloration of the samples coated with Incralac.

Clearly there is a need for continued research on polymer coatings and on methods to enhance their adherence to a metal substrate, especially for both patinated and unpatinated bronze. This work should also take into consideration recent industry advances in coating technology, such as embedding nanoclusters of copper in the polymer coating. The copper clusters act like "nanonails," anchoring the coating to the metal surface and forming stronger bonds than those created by other methods, such as surface roughening (Menezes 1997).

PASSIVE STABILIZATION

Bronze artifacts can be stabilized without invasive chemical or mechanical treatments by enclosing them in an environment that is oxygen free and with relative humidity strictly controlled. Some of these approaches are briefly presented here.

It is possible to create a variety of oxygen-free environments to meet the needs of individual artifacts. Most of the systems are for dry objects, but even marine or waterlogged finds can be stored in a closed container filled with an oxygen-free solution such as deaerated seawater or dilute solutions of sodium sulfite.

Typically, an enclosed system uses an inert gas, such as nitrogen, for the storage of objects. France-Lanord is credited with being the first to suggest this technique in the 1920s, and it is now used for a variety of treatment options, from storage of unstable iron artifacts to anoxia treatments for insect infestations in organic materials.

Simple systems make it possible to control the relative humidity in a storage environment, which should be kept below 45% RH. A typical system would use small bags of silica gel placed along with the object in a clear polyethylene container (a bag or box) with a tight-fitting lid or airtight seal. A relative-humidity recording strip placed inside the clear box, facing outward, can be read without opening the box. This type of enclosure can safely store bronze objects for several months until the silica gel requires regeneration. The bronze objects can be regularly inspected through the clear container, which makes them available for further treatment, if required. In sophisticated museums, unstable bronzes are safely exhibited without further treatment by enclosing them in display cases in which the relative humidity is controlled and monitored regularly.

Vapor-phase inhibitors (substances that volatilize easily and permeate a closed container with chemicals that retard corrosion) have been suggested from time to time for bronze storage, but this is not a popular option because these compounds are often carcinogenic. They are unlikely to be retained completely within small enclosures without risk to health from leaks, permeation, and handling.

The Mitsubishi Gas Chemical Company recently marketed a container system that includes a proprietary agent called RP that removes oxygen, moisture, and corrosive gases from sealed containers. The object to be stored is enclosed in a plastic bag with low oxygen and moisture permeability. Pouches of the RP reagent are added, and the bag is hermetically sealed. In less than an hour, the moisture content can drop below 20% RH; in twenty-four hours, oxygen levels can fall to below 0.1%; and after six hours, the concentrations of H_2S, SO_2, HCl, and NH_3 are less than 1 ppm. An oxygen indicator strip provides a ready confirmation of oxygen level.

The bag must be carefully selected for size appropriate to the object and may need to be specifically made by the conservator for the treatment at hand. The bag material should have low permeability to oxygen and moisture. A ceramic-deposited film called ESCAL is exceptionally good for this purpose and maintains the sealed environment for several years, whereas another polymer film called PTS may suffice for only one year. Polymers based on nylon, polyethylene, or polyvinylidene chloride are not suitable for containers. They all are highly permeable to both oxygen and water vapor. As long as the oxygen indicator shows that the interior environment is stable, corrosion of copper objects can be practically stalled using the Mitsubishi system.

NONDESTRUCTIVE TESTING

Over the last thirty years, radiography has been used to assess the condition of antiquities, the technology used in their manufacture, and their degree of mineralization. In recent years, Italian conservators have been especially active in the area of passive examination and monitoring techniques. Marabelli (1987), for example, discusses the application of radiographic examination, ultrasonic testing, infrared imaging, and acoustic emission analysis to the examination of sculpture. These techniques are briefly discussed here.

Radiographic examination | Radiographic examination of an object can be carried out using either a conventional X-ray tube or a gamma-ray source. An X-ray tube uses an applied potential to generate X-rays, while a gamma-ray source makes use of radioactive substances, which require constant shielding when not in use and are more difficult to maintain and operate safely.

One of the first references to the use of radiographic techniques in conservation is that of Gettens (1959), who perceived that by taking X-ray images of objects before treating them, it would be possible to determine the existence and extent of any remaining metallic core. Beale (1996) recounts Gettens's work on this topic, which dates from 1929, when he took corroded bronzes from the Freer Gallery of Art in Washington, D.C., for radiographic study at a U.S. military installation in Watertown, Massachusetts.

Although radiography has been useful for conservation studies, it should always be kept in mind that it is not a strictly passive technique for imaging hollow bronze sculpture. Any core

material remaining inside the object will receive a radiation dose, which renders any attempt at thermoluminescence dating quite meaningless. If such dating is required, the casting core of the bronze must be sampled before any radiographic work is done.

| IMAGING WITH X RAYS X-ray imaging is capable of recording differences in both the physical and chemical density of an object. The object's elemental composition and thickness determine the range of kilovolts (kV) and milliamperes per second (mA /s) to be used, as well as the characteristics of the film, filtering, or lead intensifying screens, all of which improve image quality. Although the kilovolts will determine the radiographic contrast—that is, which areas will be penetrated—the milliamperes per second determines the density of the image. It is possible to penetrate through objects using different ranges of kilovolts, milliamperes, and time, so that the image quality can be adjusted by altering these exposure conditions. Reducing the kilovolts somewhat while still maintaining penetration generally improves the contrast of the image, while short exposures at high kilovolts achieves better penetration but less contrast. The J. Paul Getty Antiquities Conservation Department X-ray radiography system in Malibu uses an IRT/Nicolet system with an X-ray tube made by Comet of Switzerland. Imaging with this system indicates that most hollow bronze castings require between 200 kV and 300 kV to penetrate the copper alloy. For exposures in the 120–2000 kV range, lead-foil screens in direct contact with the film aid in intensifying the contrast, and by absorbing scatter, they greatly improve image definition. Common X-ray film brands include Agfa DP4, Kodax CX2, and Kodax Industrex M. These films all have emulsions on both sides, unlike some medical X-ray film. This should be taken into account if fine-grain medical film is to be used for examination of bronzes because the exposure conditions will be quite different. High-contrast medical films, such as Agfa D, have also produced good results in conservation work.

A customary setup for X-raying artifacts is to load the film into cassettes lined with 2–5 mil of lead foil (1 mil = 0.0254 mm, or 1/1000 in.) at the tube side of the film and a 10 mil sheet at the back, with a 2 mm thick aluminum filter over the tube window. The aluminum filter is especially useful when X-ray radiographs are taken of three-dimensional objects at greater than 40 kV, since it reduces the scatter of soft radiation and greatly improves image resolution.

A range of exposure conditions are necessary to achieve good X-ray images. For example, a bronze sheet 1 mm thick may require 80–100 kV at 5 mA for 150 seconds, while a very heavy casting 3–6 mm thick would need 250–350 kV at 8–10 mA for 150 seconds in order to penetrate the alloy. If the alloy is a leaded tin bronze, then even higher accelerating voltages may be required. To X-ray small bronze antiquities and Renaissance statues at the GCI Museum Research Laboratory, the X-ray tube was placed 1 m from the object with a 2 mm aluminum filter on the tube. The film cassette was lined with 2 mil of lead foil at the front and 10 mil at the back. In some cases, better results were obtained using a double layer of 5 mil thick copper sheet in front of the tube rather than the 2 mm thick aluminum filter.

Renaissance bronzes at the Victoria and Albert Museum were imaged with a setup that placed the X-ray tube 1 m from the object. The exposure used 220 kV and 5 mA for a variety of exposure times. This will penetrate bronzes of up to 25 mm in thickness. The Metropolitan Museum of Art in New York has used 300–320 kV and 4–5 mA for 100–200 seconds under similar conditions and produced useful results with small Renaissance bronzes (Bewer 1996). The new GCI Museum Research Laboratory at the Getty Center used 300 kV and 5 mA for 120 seconds with an object-to-tube distance of 1.0–1.5 m.

IMAGING WITH GAMMA RAYS Gamma-ray sources (such as an iridium source), which are portable only under strictly controlled conditions because of their hazardous nature, provide a range of gamma ray energy roughly equivalent to 6 MeV (1 MeV = 100 kV), or 600 kV, while the usual range in energy of gamma rays can be from 500 kV to 2000 kV. The contrast and quality of the image that is achievable, however, are inferior to those of a skillfully taken X-ray image.

Because of the time-consuming nature of developing film and getting the exposure conditions right, there is an increasing use of digital imaging and computerized tomography in the field of X-ray radiography, which allows digital images of the objects to be captured on computer directly, where they can be manipulated and stored. In future work, these recent technologies will become increasingly important in museum X-ray radiography as their cost begins to decline.

Ultrasonic scanning | Scanning with a similar ultrasound device as that commonly used in medicine can be employed to survey the thickness of a bronze sculpture in particular areas or to map thickness profiles over the entire surface. Ultrasonic scans allow nondestructive identification of areas of porosity, patches, soldered joins, and cracks in an object. Scans of the equestrian sculpture of Marcus Aurelius in Rome (Marabelli, Mazzeo, and Morigi 1991), for example, revealed that the thickness of the horse's four legs was fairly constant, from 4 to 7 mm, with little variation from one leg to the other. In contrast, a band of solder joining two sections of the statue had a highly variable thickness, which is indicative of a substantial structural discontinuity between the castings and the joins.

Infrared imaging | Infrared imaging has also been applied to conservation work. It is normally used in a band between 2 and 5.6 μm in the short wave, which can achieve a resolution of about 0.2 °C. An infrared survey is carried out in the absence of direct solar radiation, for example, when the object is cooling down in the early evening. With this technique, it is possible to identify structural inhomogeneity in a bronze casting that corresponds to a variable thickness or to the remains of core material. Marabelli, Mazzeo, and Morigi (1991) also applied this method to the Marcus Aurelius statue and found

that there were differences in the filling of the left foreleg and the right hind leg (the two weight-bearing legs) compared with the left hind leg, where there was a cavity.

| *Acoustic emission analysis* | In acoustic emission analysis, the sound waves that emanate from bronze objects as they undergo different periods of heat-

ing or cooling can be used to investigate structural characteristics of the object. Highly stressed regions, for example, may emit a higher frequency or intensity of acoustic signals than areas that are relatively stress free, allowing an acoustic map of the object to be made.

Acoustic emission analysis was used by Accardo, Caneva, and Massa (1983) on the bronze portal of San Zeno church in Verona, Italy, to determine the periods of maximum environmental stresses on the work. The portal was studied in clear and cloudy weather and from the beginning to the end of a cycle of direct radiation; for comparison, nocturnal readings were also taken. The results of these studies showed that the maximum acoustic emissions, indicating stresses on the work, occurred in the morning, during the dynamic phase of maximum heating and drying of the wooden support on which the panels of the bronze portal were hung; at sunset, during the inverse phase; and between the hours of maximum exposure to the sun, from 2:00 to 3:00 P.M.

| *Other techniques* | Other advances in nondestructive testing include the work of Bartolini and colleagues (1997), who used resistance of polari-

zation (R_p) measurements on the interior of the Riace bronzes. These electrical measurements are taken from the surface of the bronze object and can reveal the resistance of the object to the electrical stimulation applied. For example, after corrosion inhibition treatment, one might expect the resistance of polarization measurement to increase. The measurements were taken before and after the bronzes had been given a corrosion inhibition treatment with BTA, which was applied with a paintbrush as a 10% ethanol solution at 40–50 °C for five minutes. The measurements were repeated after a second BTA application. The data indicated that the BTA treatment had a beneficial effect on the polarization resistance, which should mean better corrosion protection than before the treatment.

There are a number of other nondestructive testing or monitoring approaches that can be used to evaluate both structural condition and corrosion, such as sophisticated electrochemical sensors to measure corrosion rates, and these will undoubtedly be used on metallic works of art in the years to come.

Notes

1 Calgon is often stated to be sodium hexametaphosphate, but according to King (1996), it is not really a hexametaphosphate but rather a polyphosphate of composition $(NaPO_3)_{15-20}$.

2 Because of the widespread use of electrochemical and electrolytic techniques from 1910 to 1930, many of the stripped bronzes were subsequently repatinated as part of the conservation treatment. Plenderleith and Werner (1971) mention a simple method that was widely used for many years: the freshly cleaned bronze surface would be coated with warm Plasticine, a nondrying oil-based clay containing considerable amounts of sulfur, that was left on overnight. In the morning, the Plasticine would be removed with methylated spirit (denatured ethanol usually containing additions of pyridine, methanol, and a blue or pink dye), revealing a rich brown-black patina of copper sulfide. Such patinas also formed accidentally in old storage cabinets where Plasticine had been used previously as a mount or temporary gap-filling material. J. Twilley noted in a conversation with the author in 1998 that the whiskerlike crystal growth on metallographic sections stored on Plasticine-mounted glass slides was primarily chalcanthite.

3 In 1910 Henry Walters was in charge of the Walters Collection, later the Walters Art Gallery. On Walters's death in 1931, the gallery was bequeathed to the mayor and city council of Baltimore.

4 Formerly the National Museum of the American Indian, Heye Foundation, located in New York; now the National Museum of the American Indian in Washington, D.C., held in trust by the Smithsonian Institution for the State of New York.

5 A bronze vessel from the site of Hallstatt in the Austrian Salzkammergut, 30 miles east of Salzburg, famous for its salt mines and cemetery of three thousand graves dating to the twelfth century B.C.E.

6 The Vix krater is from a famous Celtic burial site of the Early Iron Age located at Châtillon-sur-Seine, Côte-d'Or, France. The krater is of Greek manufacture and stands 152.4 cm (5 ft.) high with a capacity of 1250 l.

7 Glass-bead peening—or air-abrasive cleaning using glass beads, as it is otherwise known— employs a compressor supplying a jet of air through which small particles, such as glass beads, crushed walnut shells, or alumina powder can be forced against the surface to be treated using an air pen, usually operated in a hood with gloves and glass screen between the operator and the object being treated.

8 In this treatment, an outer wax coating is applied that can be regarded as a sacrificial layer, in that it may be damaged by wear and can be reapplied at regular intervals before the underlying coatings are also damaged and require replacement.

9 Walnut shells of 60/200 mesh were used at a pressure of 40 psig.

10 Graphite anodes were used as an alternative, but any carbon that became attached to the object during treatment was very difficult to remove, and often it could not be removed safely.

11 This bronze was re-treated quite a few times employing mechanical cleaning methods, as discussed earlier; for localized bronze disease corrosion, some spots were also treated with the silver oxide paste in ethanol and water.

12 Susan L. Maish, conversation with the author, March 1996.

13 Ammonia is commonly available as a solution in water. The concentration of ammonium hydroxide solutions is conveniently measured by its specific gravity (SG), 0.88 being the most concentrated solution usually employed.

14 Josef Ternbach is one of the pioneers of mechanical cleaning at a time when most workers simply reached for the bottle of chemical reagent. Many bronzes were mechanically cleaned by him between 1950 and 1970.

15 H. B. Madsen, conversation with the author, Copenhagen, September 1981.

16 Electrolytic desalination is a process in which the bronze object is wired to a source of current and used as the cathode, with platinum- or molybdenum-stabilized stainless steel anodes. A low current is then generated and chlorides removed from the object.

17 Hykin has pointed out, however, that octylphenols are not biodegradable and are estrogen mimickers that have been shown to cause damage to fish and amphibians. Therefore, their use as a cleaning solution may not, in fact, be advisable at all, unless disposal options are carefully evaluated (Abby Hykin, letter to the author, 16 April 1998).

18 The core material is that part of the investment filled with a refractory substance that produces the hollow region in castings. The core, often of clay and charcoal, clay and sand, and sometimes with added organic temper such as straw, rice-husks, dung, etc., is generally removed after the object is cast, since it may absorb salts and create problems with the long-term stability of the object.

19 As has been discussed, these citric acid solutions are capable of changing the patina, so their use would need to be evaluated accordingly.

20 The use of Rochelle salt is surprising, since it was widely believed that sodium potassium tartrate was not only potentially aggressive to cuprite layers, but that the residues of the tartrate treatment solution were capable of causing problems in the long-term stability of an object. In some bronze objects there may be a danger of the reprecipitation of copper in solution resulting in patches of redeposited copper on the surface, which is also a potential problem with citric acid and sodium polyphosphate cleaning solutions.

21 Mauro Matteini, meeting on the conservation of Ghiberti's *Gates of Paradise,* Getty Conservation Institute, Los Angeles, March 1999.

22 R. C. Wolbers, conversation with Getty Conservation Institute gel-cleaning project team, Los Angeles, 16 June 1999.

23 Information on Crane's 1985 work is from Nicholas Veloz, letter to the author, 24 March 1996.

24 Packs of inert but porous materials such as clay or paper can be used to absorb chemical reagents from the surface of treated objects during cleaning.

25 In 1989 the *Times* newspaper of London described the auction at Sotheby's at which the sculpture was purchased by the J. Paul Getty Museum with the headline, "100 Pound Sterling Garden Ornament Fetches 6.82 Million Pounds Sterling in Sale."

26 Richard Stone, conversation with the author, New York City, 8 April 1990.

27 Arkon P-90 is a product of Arakawa Chemical Industries, Osaka, Japan, distributed in the United States by Arakawa Chemical (USA) Inc., Chicago.

28 Shellsol 71, Odorless Mineral Spirits, Petroleum Naphtha is distributed by Inland Leidy, Baltimore, Md.

29 Laropal aldehyde resin is distributed by BASF Corporation.

30 BTA is used on copper for industrial applications, and it has found some use as an effective vapor-phase inhibitor. For example, paper packing and storage materials are impregnated with 0.5–2% BTA by weight of paper, but because BTA vapors are hazardous, this application cannot be recommended for museum use.

31 Helen Ganiaris, letter to the author, 22 September 1997.

32 Sue Stock, letter to the author, 20 February 1999.

33 For general industrial applications, such as the treatment of copper roofing panels, the copper objects are immersed in a BTA solution in water at a concentration of 0.1–0.5% (w/v) with a 2–6 minute contact time at 60 °C. It is generally recognized that the degree of protection increases with increasing BTA concentration, solution temperature, and length of immersion in the solution (Notoya and Poling 1979). This industrial practice, however, is not applicable to archaeological material. Conservators have a natural reluctance to place any antiquity in a heated solution, especially one containing potentially hazardous compounds, such as benzotriazole, that volatilizes easily. Also, the use of heated solutions would considerably increase any health risks associated with this process.

34 Gerhardt Eggert, letter to the author, 6 June 1999.

35 This was ethanol denatured with methanol and pyridine to which a blue dye was added. In the United Kingdom, a pink dye was also used.

36 This was ethanol denatured by the addition of methanol and/or isopropanol.

37 Nitrocellulose continues to be used for adhesive purposes, however; the English adhesive known as HGM (named for its manufacturer, H. Marcel Guest) has remained very popular.

38 Carnauba wax is the exudate from the leaves of the Brazilian palm (*Copernica prunifera*) often added to other waxes to increase hardness and luster.

39 Arthur Beale, letter to the author, 16 May 1998.

40 An accelerated testing regime involving spraying the coupons with simulated aqueous media, typically using salt water.

41 An emulsion form of Incralac is now available in a water-based system that avoids the use of organic solvents, but once the curing of the polymer has begun it is apparently not readily removed.

Some Aspects of the Chemistry of Copper and Bronze
APPENDIX A

COPPER

Copper is a salmon pink or reddish element with a bright metallic luster. It is malleable, ductile, and a good conductor of heat and electricity, which is one of the principal reasons for its extensive use today. Like silver and gold, copper is a face-centered cubic metal. Its most important alloys are with arsenic, tin, antimony, and zinc, and these alloys often have added lead.

Large deposits of copper are now found in the United States, Chile, Zambia, Zaire, Peru, and Canada (Weast 1984). None of these locations were particularly important in ancient times with the exception of Peru, which was to become important during the Moche period in the early centuries C.E. for its copper-arsenic ores. In other parts of the world, small deposits of oxidized copper ores must have been much more widespread than they are now. These deposits are unknown to modern commercial copper mining either because they are too small or insignificant or because most of the copper minerals have already been exhausted from these locations.

Electronic configuration | Copper has a single s electron outside of a completed d shell. The filled d shell of copper is much less effective than that of a noble gas in shielding the s electron from the nuclear charge, so the first ionization potential of copper is higher than in the alkalies. The electrons of the d shell are involved in bonding, so the heat of sublimation and the melting point of copper are also much higher than the alkalies. Not only are these factors responsible for the more noble character of copper, but they also make copper compounds more covalent. The second and third ionization potentials of copper are much lower than those of the alkalies; they are also partly responsible for the transition metal nature of copper, which is characterized by colored paramagnetic ions and many complexes in

the (II) and (III) oxidation states (Cotton and Wilkinson 1967). Even in the (I) oxidation state there are many substances, such as benzotriazole or the olefins, that can complex with copper (I).

The standard electrode potentials for copper are

$$Cu^{2+} + 2e^- = Cu \qquad +0.34V$$

$$Cu^+ + e^- = Cu \qquad +0.54V$$

$$Cu^{2+} - e^- = Cu^+ \qquad +0.17V$$

The equilibrium constant between Cu(I) and Cu(II) is

$$2Cu^+ = Cu^{2+} + Cu \; K = a_{Cu}^{2+} / (a_{Cu}^+)^2 \simeq 1 \times 10^6 \text{ at } 25 \,°C$$

The constant for this reaction, K, therefore favors Cu(II) over Cu(I) under equilibrium conditions.

Although copper, silver, and gold are all face-centered cubic metals, there is only moderate similarity in their chemistry. In terms of metallic properties, however, they are all ductile, malleable, and good conductors, and all have similar casting and working properties.

Characteristics of copper compounds

The electronic structure of copper (I) compounds, or cuprous compounds, is $3d^{10}$. These compounds are diamagnetic and tend to be colorless or very pale, such as nantokite, cuprous chloride, which is colorless to pale green. The exception is when color results from the anion or charge-transfer bands, as in the case of cuprite, Cu_2O. Most cuprous compounds can be oxidized easily to cupric ones, but oxidation to tervalent copper (III) compounds is difficult; they are relatively rare, existing only in the laboratory.

The copper (II) compounds, or cupric compounds, make up the most important copper group and form a wide range of minerals. The Cu^{2+} ion, which has a $3d^9$ configuration, always exhibits Jahn-Teller effects. Consequently, instead of regular octahedral coordination, which is characteristic of many transition metal complexes, appreciable distortions of the regular octahedral coordination occur. Depending on the ligand, a wide range of geometries are found: tetrahedral, trigonal bipyramidal, square pyramidal, square, and distorted octahedral. In many compounds, the distortions are so great that the coordination is practically square. An example is chalcanthite, $CuSO_4 \cdot 5H_2O$, which has four oxygen atoms from the water molecules in one plane, forming the corners of a square, and oxygen atoms from sulfate groups occupying each axial position. The additional water molecule is hydrogen bonded between a second sulfate oxygen and a bound water molecule in the plane. Some copper compounds, such as neutral verdigris, are dimeric structures, although they may be partially dissociated in aqueous solution. The strength of the copper-to-copper bond in these carboxylates is only about 1 kcal/mol (4 kJ/mol). Thus the bond is weak, and the distance between the copper atoms is long compared with the

single-bond distance. Practically all cupric salts are blue or green. Exceptions are caused by strong ultraviolet absorption bands, charge-transfer bands, trailing off into the blue end of the spectrum and causing the salts to appear red or brown. For example, cupric oxide (tenorite), CuO, and some of the copper sulfides are almost black.

Some cupric salts, such as cupric chloride, dissolve easily in water. The basic compounds, however, such as the most common basic sulfate, brochantite, $Cu_4SO_4(OH)_6$, or the common basic chloride, paratacamite, $Cu_2(OH)_3Cl$, are practically insoluble. In water, the aquo ion of copper can be written as $[Cu(H_2O)_6]^{2+}$, with two of the water molecules farther from the metal atom than the other four. When ligands are added, some of these water molecules may be displaced. A classic example is ammonia. This ligand can displace up to five water molecules to make attractive dark blue solutions capable of dissolving cellulose.

Some ligands that coordinate through oxygen form a large number of cupric complexes that are difficult to characterize. For example, cleaning copper objects with citric acid or tartaric acid solutions may form polynuclear complexes of complicated or unknown structure. Oxalate, glycerol, and various thio compounds form cupric complexes as well, hence the ability of alkaline glycerol to dissolve copper salts when used to clean copper objects.

Cupric salts play an important role as catalysts in many systems where Cu^+–Cu^{2+} oxidation-reduction cycles are involved. Copper occurs in several enzymes, such as phenolase and laccase, and as cuprous copper in hemocyanin, an essential respiratory function in many invertebrate animals, such as crayfish.

BRONZE

Bronze is an alloy of copper with tin as the primary component; minor ones can be zinc, nickel, or lead. To understand the corrosion of bronze alloys, it is necessary to know something about the various phases that may be present in the alloy. These phases may corrode differently, depending on their composition and their environmental contexts. In the phase diagram for the copper-tin system, many reference books show a low-temperature region that contains an alpha solid solution and an epsilon phase. For ancient and historic bronze alloys with a composition of less than 28% tin, the epsilon phase is of no importance.

In the phase diagrams for the copper-tin system, which apply to practical alloys, the low-temperature-phase field of the alpha+epsilon is ignored in two sections of the diagrams. This is because the epsilon phase never appears in bronzes containing up to around 28% tin that have been manufactured by conventional means because it would require thousands of hours of annealing, which is unrealistic even for modern bronzes. Further information about the composition of the relevant phases and types of alloys can be found in Cottrell (1975), Scott (1991), Samans (1963), and Lechtman (1996).

The tin bronzes can be divided into two categories, the low-tin bronzes and the high-tin bronzes. Low-tin bronze contains less than 17% tin, the maximum theoretical limit of the solubility of tin in the copper-rich solid solution. In practice, the limit is closer to 14%, although it is rare to find a bronze with this tin content existing as a homogeneous single-phase alloy.

When a tin bronze is cast, the alloy is extensively segregated, usually with cored dendritic growth and an infill of the alpha+delta eutectoid surrounding the dendritic arms. The center of the dendritic arms is rich in copper, which has the higher melting point; the successive growth of the arms results in the deposition of more tin. At low tin contents, for example, between 2% and 5%, it may be possible for all the tin to be absorbed into the dendritic growth. This varies considerably, depending on the cooling rate of the bronze and on the kind of casting involved. If the cooling rate is very slow, there is a greater chance of reaching equilibrium, and the amount of the interdendritic delta phase will be greatly reduced or will disappear entirely. In antique castings with a reasonable amount of tin content, around 10%, complete absorption of the delta phase is highly unusual, and the dendrites will generally be surrounded by a matrix of the alpha+delta eutectoid.

As the tin content increases, the proportion of the interdendritic eutectoid also increases. If a homogeneous copper-tin alloy is worked by hammering and annealing, then the typical features seen in face-centered cubic metals will develop, namely, annealing twins, strain lines, progressively finer grains as a result of the working and flattened grains if left in the worked condition. The same features will develop if the alloy is two phased, although the eutectoid is moderately brittle and may be broken up to some extent. The usual microstructure shows the presence of small islands of the alpha+delta eutectoid between the recrystallized grains of the alpha solid solution. If coring in the original cast ingot was pronounced, then this may be carried over in the worked alloy as a faint or "ghost" dendritic pattern that is superimposed on the recrystallized grains. When a bronze section is etched with ferric chloride, this difference in alloy composition due to coring may be apparent only as vague differences in shading of the alloy; a dendritic outline of the shading may be difficult to see. Only with experience in examining bronzes is it possible to differentiate between uneven etching and uneven coloring of a specimen's surface due to coring.

Apart from complications introduced by other alloying elements, such as zinc, the features seen in most low-tin bronzes are the following:

1. homogeneous bronzes in which all the tin has dissolved with the copper, and no coring or residual cast features are displayed
2. cored bronzes in which there is an unequal distribution of copper and tin, and the eutectoid phase is absent

3. bronzes in which both the alpha phase and the eutectoid phase are present (representing most ancient bronzes in terms of components)

4. bronzes in which the alpha phase is extensively cored, and the eutectoid phase is present

Most ancient alloys have tin contents less than 17%. At this level, the bronzes can be cold-worked and annealed. If the tin content is between 17% and 19%, however, the alloy is unworkable; a film of the brittle delta phase coats the grain boundaries, causing the alloy to break into pieces. At more than 19% tin, however, the bronze can be hot-worked. Bells and mirrors were often made in antiquity of ternary tin bronzes consisting of around 20–25% tin, 2–10% lead, and the rest copper. Alloys of this type were almost invariably cast. Many binary tin bronzes containing more than 17% tin are often found to be made with tin contents in the range of 21–24% tin, and this approximately corresponds to the equilibrium value of the beta phase of the bronze system. At a temperature greater than 586 °C, a bronze in the beta region is readily worked. If allowed to cool slowly to room temperature, however, the bronze decomposes into alpha+delta phase and is impossible to work.

One advantage of bronzes with tin contents between 21% and 24% is that the beta phase can be retained by quenching the alloy from above 586 °C. This beta phase usually appears as a martensitic or acicular structure. These quenched beta bronzes are very hard but a lot less brittle than bronze of the same composition allowed to cool to room temperature. In this latter case, the alloy would contain substantial regions of the alpha+delta eutectoid phase, would be very brittle, and would not be able to be worked in the same way as the beta phase alloy.

Other than a few cast figurines, most artifacts with a beta bronze composition that were made in ancient times were worked in the following manner: (1) the alloy was made as accurately as the technology of the time allowed, (2) a blank was cast in the approximate form of the desired object, and (3) the object was shaped by hot-working at about 650 °C. At the end of the working process, the alloy was uniformly reheated to approximately the same temperature and then rapidly quenched to preserve the high-temperature phase and to produce a martensitic structure. Hammer marks and oxide scale were then removed by grinding with various grades of abrasives, often on a simple lathe, and the object was polished. Any surface decoration was cut with drills or an abrasive wheel before the object received its final polishing.

Tinned surfaces

Tin would be applied to the surface of a bronze primarily for decorative reasons. For food-preparation, cooking, and storage purposes, coating a bronze alloy bowl or vessel with tin avoids copper dissolution from acidic plant materials.

At high levels of tin, such as those encountered in tinned surfaces, there are three intermetallic phases of the copper-tin system that need to be taken into consideration:

1. the delta phase, $Cu_{31}Sn_8$, containing about 32.6% tin
2. the epsilon phase, Cu_3Sn, containing about 38.2% tin
3. the eta phase, Cu_6Sn_5, containing 61.0% tin

The epsilon phase that appears in these high-tin alloys is of importance in understanding the microstructure of tinned surfaces. When tin is applied to a bronze, layers of both the eta and the epsilon phases can develop, which is dependent on the time and temperature of the diffusion process. Interdiffusion between bronze and molten tin develops in the following sequence: surface tin, eta phase, epsilon phase, substrate bronze.

When viewed under the optical microscope, tin appears light colored and silvery; the eta phase has a slightly more gray-blue color; the epsilon phase is the darkest gray blue, and the delta phase is light blue. The range of microstructural features that can form on tinned surfaces is complicated; the eta phase, Cu_6Sn_5, is common and is often misidentified as tin. Further details on this subject can be found in Meeks (1986).

| *Leaded tin bronzes* | Many tin bronzes are leaded. In low-tin bronzes, typically used for castings, the lead does not alloy with the copper or the tin |

and occurs as small globules throughout the metallic structure. Some gravity segregation may cause the lead to settle into preferred regions in the casting, but generally the distribution of the lead globules is random, with particle sizes that range from a few microns across to large globules of 30–200 μm in diameter. With higher tin contents, the metallic structure of the bronze may be difficult to determine by optical metallography because the structure may become very fine-grained. Variations of the Widmanstätten structure are possible in quickly cooled bronzes.

Recipes

APPENDIX B

Except as otherwise indicated, all of the following recipes
were produced by the author and coworkers at the
Getty Conservation Institute (GCI) Museum Research Laboratory.

RECIPE 1 **JAPANESE PATINA FOR COPPER PATINATION**

Murakami (1993) made up a series of copper alloys containing 3% gold and 97% copper for most of the experimental work. After shaping, the alloys were polished to a mirror finish and carefully degreased. Traditionally, charcoal was used for the final polishing, and Japanese radish for degreasing. The samples were boiled for 30 minutes in a solution developed by the Tokyo National University of Fine Arts and Music. The solution contains 1.9 g of natural verdigris, 1.2 g of copper sulfate, and 0.2 g of potassium aluminium sulfate in 1 l of water. The pH is about 5.6. The characteristic color of each alloy did not appear until it was boiled in the coloring solution.

RECIPE 2 **CUPRITE PATINA FOR BRONZE**

Socha and colleagues (1980) obtained a cuprous oxide patina on the column of King Sigismund III in Warsaw with a solution containing 5 g of ammonium persulfate, 50 g of sodium hydroxide, and 5 g of mercuric chloride in 950 ml of water kept at 60 °C. This was applied for 1 hour to the cleaned metal surface in three to five operations. Between applications, the solution was mixed with sodium polysulfide (0.5 g/l) and sodium hydrogen carbonate (0.5 g/l) to remove superfluous salts.

RECIPE 3 **SYNTHETIC GEORGEITE**

Pollard, Thomas, and Williams (1991) prepared georgeite by stirring 0.8 g of cupric chloride dihydrate into a solution of 5.3 g of sodium chloride in 100 ml of water at 25 °C. A rapid reaction ensued, forming a blue precipitate that was isolated at the pump with a Büchner funnel, washed with water and then acetone, and dried in a vacuum over silica gel at room temperature. The metastable georgeite precipitate recrystallized to malachite within 3 hours at 20 °C.

RECIPE 4 **BLUE VERDITER**

There are practical difficulties in manufacturing blue verditer. Mactaggart and Mactaggart (1980) found that 15 g of cupric nitrate in 50 ml of water mixed with 5 g of chalk produced pale green rodlike birefringent crystals, unsuitable for use as a pigment. With 15 g of cupric nitrate in 800 ml of water and 5 g of chalk, kept between 6 °C and 20 °C for 24 hours, a green product was formed. This was synthetic malachite consisting of spherical particles with diameters between 2 and 15 μm. These particles were highly birefringent with a dark cross between crossed polars.

Finally, a blue verditer was produced on the third attempt using 200 ml of water and 15 g of cupric nitrate kept at below 12 °C and stirred at 1-minute intervals. It took 5–9 hours for blue crystals to form. Repeating the process using the first product formed as starting material caused the blue verditer particles to become better formed, and diameters up to 25 μm were produced. The low temperatures are probably needed to enable enough carbon dioxide to stay in solution to form a carbonic acid solution strong enough to influence the formation of the product within the azurite stability field rather than in the malachite field of stability predicted by the relevant Pourbaix diagrams.

RECIPE 5 **SYNTHETIC CONNELLITE**

Pollard, Thomas, and Williams (1990a) prepared connellite using 100 ml of water and, while stirring, adding 0.725 g of cupric chloride dihydrate, 1.6055 g of sodium chloride, and 0.7 g of sodium sulfate decahydrate. Carbon dioxide–free 0.05 mol sodium hydroxide solution was added until the pH rose to 7.2. The fast addition of hydroxide yields a blue phase of claringbullite, $Cu_8(OH)_{14}Cl_2 \cdot H_2O$. This precipitate will recrystallize to connellite within 48 hours if the mixture is kept in a sealed container to exclude CO_2, and it is regulated with a thermostat to 25 °C.

RECIPE 6 **SYNTHETIC POSNJAKITE AND MALACHITE**

The syntheses employed by Naumova, Pisavera, and Nechiporenko (1990) are described here, although not all of the reaction conditions were specified by the authors. Posnjakite was made by adding powdered sodium bicarbonate to copper sulfate solution at an initial pH of 6.4–6.6. Precipitation of posnjakite occurred in the broad range of pH from 5.7 to 9. The precipitate crystallized on the second day. From a solution with an initial pH 6.7, posnjakite was mostly precipitated as crystal twins and triplets and in the form of concretions. Posnjakite obtained from a near-neutral solution appeared as lamellar crystals of rhombic or pseudohexagonal form.

For the coprecipitation of posnjakite and malachite, a sulfate solution was prepared from copper sulfate containing 50 mg/l of copper. A sodium bicarbonate solution was poured into the sulfate solution and mixed with a magnetic stirrer. The sodium bicarbonate was used to

vary the initial pH values to between 6 and 7. Almost immediately, an emerald green precipitate formed, and this was filtered and dried several days later. Posnjakite appeared as lamellar, pale blue, rhombic and twinned crystals, while malachite formed in the usual spherulites.

The same copper sulfate solution was used to make atacamite, and from 1 to 7 g of sodium chloride was added to the solution. Atacamite precipitation occurred at about pH 8. This initial pH value was reached by adding the appropriate amount of 0.1 M sodium hydroxide.

To coprecipitate atacamite and malachite, 1 g of sodium chloride was introduced in powder form into the copper sulfate solution with stirring. By adding 0.1 M sodium hydroxide, the pH was raised to 8, and then sodium bicarbonate was poured in (the authors fail to give quantities or molar concentrations several times throughout these recipes). The atacamite and malachite were then filtered off.

RECIPE 7 PELIGOT BLUE
To make Peligot blue pigment, 250 ml of a 0.5 M solution of copper sulfate was placed in a 500 ml beaker and stirred while adding 3 ml of a 30% ammonium hydroxide solution, which formed a white precipitate. Then 10 ml of a 1 molar solution of potassium carbonate was added, drop by drop. After 24 hours, a light blue precipitate developed that was filtered, washed, and dried under reduced pressure. This yielded 2.48 g of a light blue powder. Debye-Scherrer powder X-ray diffraction showed that the preparation was a mixture of two phases: brochantite (ICDD 13–398) and copper sulfate hydroxide hydrate (ICDD 20–0357).

RECIPE 8 VERDIGRIS COMPOUND A
In the replication of compound A, $[Cu(CH_3COO)_2]_2 \cdot Cu(OH)_2 \cdot 5H_2$, using the method from Gauthier (1958), 200 ml of water was placed in an 800 ml beaker and stirred vigorously while 29.61 g of neutral verdigris was added at 20 °C. This solution is close to saturation. It was heated to around 90 °C and stirred while 6 M ammonium hydroxide was added drop by drop until a fine product began to precipitate from the clear blue solution. The solution was filtered immediately and allowed to cool slowly at 20 °C for 10 hours, after which the solution precipitated blue-white needles on the side of the beaker. This product was labeled A1. Crystallization also occurred on the bottom of the beaker, forming irregular crystals of a deep blue color. This product was labeled A3. The precipitated blue-white needles were collected, suction-filtered off, and then added to an equal volume of pure ethanol. After vigorous shaking, the mixture was allowed to settle for 12 hours and was then filtered and dried. This product was labeled A2.

Using a method derived from Rahn-Koltermann and coworkers (1991), compound A was replicated as follows: In a 1 l beaker, a 11.7% solution of neutral copper acetate monohydrate was made in 750 ml of water. While the solution was gently stirred and heated, a stoichiometric amount of 23.6 ml of a 24% ammonia solution was added drop by drop within 8 minutes.

A cloudy green precipitate developed. This was decanted, centrifuged, washed, and centrifuged again until a stable pH of 6.5 was reached. The product was dried over phosphorus pentoxide at 10.5 torr (1399.881 Pa). This yielded 17.68 g of a very fine green powder.

RECIPE 9 VERDIGRIS COMPOUND B

A laboratory replication of Schweitzer and Mühlethaler's (1968) method of producing compound B, $[Cu(CH_3COO)_2]Cu(OH)_2 \cdot 5H_2O$, is as follows: In a beaker, 11.22 g of neutral verdigris was dissolved in 150 ml of water with constant stirring. In a separate beaker, 1.12 g of sodium hydroxide was dissolved in 20 ml of water; this solution was added to the verdigris solution with constant stirring. A precipitate appeared, and the entire solution became soft and mushy. A stirring bar was kept moving in the solution for 8 hours, but the precipitate did not redissolve. For the next 4 hours, the solution was kept in a hood without any agitation and allowed to settle into two layers. The top portion consisted of a gel-like blue material, and the lower portion appeared a light cloudy blue. The cloudy solution was isolated with a Pasteur pipette and dried. A light blue powder (sample B1) was obtained after evaporation under vacuum. The beaker with the original gel was left for several days in air at 20 °C, and four different colored layers (B2, B3, B4, B5) appeared after the solution had dried. Starting with the uppermost layer and working down, the following samples were obtained: a purple-colored solid (sample B2); a dark blue-green material (sample B3); a bright light blue material (sample B5); and a light green compound (sample B4). Sample B4 proved to be an excellent match to a sample of medieval verdigris. All compounds were powdered and dried in vacuum for 1 day.

RECIPE 10 VERDIGRIS COMPOUND C

Gauthier's (1958) method for preparing compound C, $Cu(CH_3COO)_2[Cu(OH)_2]_2$, was replicated as follows: In a 300 ml Erlenmeyer flask, 5.91 g of neutral verdigris was dissolved in 65 ml of water. Cupric hydroxide was made by first dissolving copper sulfate in water and then adding 12 ml of 3 M sodium hydroxide. The precipitated cupric hydroxide was filtered, and 1.91 g of the product was then added to the neutral verdigris solution with constant stirring. The flask was heated to 65 °C and kept between 59 °C and 64 °C for 11 days. During heating, the color of the solution changed to a light blue-green. The precipitate was filtered and washed with 3% neutral verdigris solution (0.32 g/12 ml), 30 ml of pure methanol, and 30 ml of water before drying. The precipitate was labeled C2.

Another method to produce compound C involved the following sequence: In a beaker, 11.22 g of neutral verdigris was dissolved in 150 ml of water with constant stirring. In a separate beaker, 1.12 g of sodium hydroxide was dissolved in 20 ml of water. This was then added to the verdigris solution with stirring, and eventually a fine deposit appeared that went back into solution. The solution was covered and left for 4 days, after which blue crystals started to form,

and a fine white sediment settled out at the bottom of the beaker. The blue crystals were separated from the solution and formed into two small cakes that were allowed to air dry. An efflorescence of neutral verdigris formed on the outside of the cakes and was removed. It can take as many as 14 days for the cakes to dry sufficiently. The cakes were then crushed, and the green-blue crystals were washed and dried. This synthesis was not particularly successful because the cakes were too small to produce a discrete surface efflorescence. A second synthesis was made by dissolving 5.9 g of neutral verdigris in 65 ml of water in a 300 ml Erlenmeyer flask. Then 1.91 g of freshly precipitated cupric hydroxide was stirred into the solution, and the flask was covered and maintained at a temperature between 60 °C and 63 °C. The chemical changes were followed by observing the color changes of the salt. The sediment was agitated occasionally. The reaction took from 8 to 10 days to go to completion. The precipitate was washed first with a 3% neutral verdigris solution and then with water and alcohol and dried at 30 °C.

In the preparation by Rahn-Koltermann and coworkers (1991), 100 g of neutral copper acetate monohydrate (0.5 mol) was dissolved in 750 g of water. The solution was stirred vigorously and heated just until the boiling point was reached. After the solution cooled, 3 ml of a 24% ammonia solution was added drop by drop until a light green precipitate developed. This was filtered and then dried for 2 days under phosphorus pentoxide and a reduced pressure of 10 torr (1333.22 Pa).

The filtrate was next placed in a beaker under ethylene glycol at 40 °C. After 48–64 hours, a cloudy light blue precipitate appeared. The solution was decanted, and the residue centrifuged for 10 minutes, washed with water, and centrifuged again until a stable pH of 6.5 was reached. This step had to be done rapidly; otherwise the layered product would turn brown between solid and liquid phase after 15 minutes of standing. The products were dried in the usual way and produced 1.39 g of light blue product and 3.75 g of light green precipitate.

RECIPE 11 VERDIGRIS COMPOUND D

A laboratory experiment to replicate Schweitzer and Mühlethaler's (1968) method of making compound D, $Cu(CH_3COO)_2[Cu(OH)_2]_3 \cdot 2H_2O$, is as follows: In a 3 l beaker, 2000 ml of water was stirred while 127.7 g of neutral verdigris was added. The solution was then divided into two equal portions. To one portion, concentrated NH_3 solution was added drop by drop while stirring. After about 13 ml of the NH_3 had been added, a sediment formed that, when about 30 ml of the NH_3 solution had been added, was highly viscous; further additions dissolved it again. When about 80 ml of the NH_3 had been added, everything was in solution again. While this solution was vigorously stirred, the second portion of neutral verdigris was added. This homogenized the precipitating gel-like sediment. The mixture was left to stand, and after about 4 to 5 days, beautiful deep green crystals formed at the bottom of the beaker. The solution above them was clear. The crystals were washed with water and alcohol.

Using the method from Rahn-Koltermann and coworkers (1991), 12 g of neutral copper acetate monohydrate was dissolved in 200 ml of water in a 500 ml beaker. Then 15.4 ml of a 16.6% solution of ammonia was added. An initial precipitate formed and redissolved as the ammonia was added. Next, 200 ml of a 6% neutral copper acetate monohydrate solution was added, during which time a gelatinous precipitate developed. The mixture was allowed to stand for 48 hours at room temperature. Within the first 24 hours, a blue precipitate developed that turned green over the remaining 24 hours. A gelatinous layer appeared above this precipitate. The contents of the beaker were allowed to stand for 18 weeks. The green material did not change, but within the solution above the green precipitate, a thin layer of a blue substance developed. The precipitates were separated, washed with water, and dried. This yielded 9.17 g of a green material and 110.7 mg of a blue product.

In the GCI Museum Research Laboratory, it was possible to make so many different basic copper acetates that another series of studies was undertaken, varying the conditions as follows: six flasks were made up containing 12 g of neutral copper acetate dissolved in 200 ml of distilled water. Six different concentrations and volumes of ammonium hydroxide were then added drop by drop to each flask. The volume per volume (v/v) hydroxide concentrations were

1. 15% v/v NH_4OH using 15 ml solution
2. 10% v/v NH_4OH using 15 ml solution
3. 20% v/v NH_4OH using 15 ml solution
4. 25% v/v NH_4OH using 15 ml solution
5. 30% v/v NH_4OH using 15 ml solution
6. 30% v/v NH_4OH using 30 ml solution

After slowly mixing the solutions, the pH of the resultant mother liquor in each flask was, respectively, (1) pH 5; (2) pH 6; (3) pH 8; (4) pH 8.5; (5) pH 9.5; and (6) pH 10.

The activity in each flask was as follows:

Flask 1 Immediately after mixing, a light blue precipitate formed. This had turned light green 24 hours later. Eight days later, the solution had turned to a jelly and included some light blue needlelike masses. Deep green crystals of the neutral acetate formed on the surface of the beaker. Two weeks later, the remaining bulk of the solution became gelatinous, and this gelatinous mass was covered with light blue needle-shaped crystals. The pH was about 6. Three weeks later, the solution had dried. The upper part was covered by neutral copper acetate, and the lower region was filled with light blue crystals that were partially covered with a darker blue deposit. The light blue and dark blue products were collected, washed, and then dried over silica gel under reduced pressure. X-ray diffraction analysis of the blue materials showed very similar peaks to those found for compound B by Schweitzer and Mühlethaler (1968).

Flask 2 After mixing, a light blue precipitate immediately formed. The precipitate had changed to a light green 24 hours later and underwent no further change over the next 8 days. The solution was examined after the 8 days had passed, and there was a clear separation between blue liquor and light green precipitate. After drying and filtering, the products were a fine, light green precipitate with some associated blue particles. The light green precipitate was identified by X-ray diffraction as compound D; the blue particles were also compound D but with a few extra lines.

Flask 3 After mixing, a dark blue precipitate formed. The solution began to gel 24 hours later. Eight days later, the precipitate had turned to a light green with brown-blue spots. After 3 weeks, the final products were a turquoise blue membrane, some fine green particles, and a variegated precipitate of green, blue, and brown. All products were collected and dried under silica gel. The turquoise blue material had some similarities in X-ray diffraction pattern to compound H or A with some high d-spacings around 16 Å. The fine green particles were compound C, and the final crop of green particles obtained were similar to compound D with several unidentified peaks.

Flask 4 After mixing, a dark blue voluminous precipitate formed that underwent no further change over 8 days. Two weeks later, the precipitate had altered to a light blue color, and shiny, thin, dark blue films had formed on the surface of the liquid. The pH was 7. Three weeks later, there were no more changes. The final products were a deep blue film and a light blue precipitate with a gel-like quality that was hard to filter. All products were dried under reduced pressure. The deep blue material gave high d-spacings at 16 and 11 Å and may correspond to either compound A or H. The light blue product was cupric hydroxide with some additional peaks at 16 Å.

Flask 5 After mixing, small amounts of a white-blue precipitate formed, and 24 hours later a deep blue membrane developed in the upper part of the liquid. Eight days later, the deep blue precipitate had turned blue black, and the film had not altered. Two weeks later, dark brown and black particles had become attached to the inside of the beaker. The pH was 7.5. After 3 more weeks, with no further change, the products were a deep blue-black film and a variegated precipitate of brown, gray, and green. These were dried under reduced pressure. The deep blue-black film gave an X-ray diffraction pattern suggestive of either compound A or H. The second material looked like contaminated cupric hydroxide, similar to what was seen in flask 4.

Flask 6 After mixing, no reaction was observed, but 24 hours later a small quantity of deep blue crystals had formed. Eight days later, very tiny deep blue crystals formed inside the beaker, and a thin, deep blue, matte film formed on the surface of the liquid. Two weeks later, a deep blue film covered the surface of the liquid, and vivid blue particles were attached to the inside of the beaker. The pH was 8. Three weeks later, no further change had occurred. The products obtained

were a dark blue film and a vivid blue granular precipitate. These were dried under reduced pressure. The dark blue material was a close match to the data for compound A that were obtained by van T'Hul-Ehrenreich and Hallebeek (1972). The vivid blue precipitate matched either compound A or H, again with high d-spacings at 16 Å.

RECIPE 12 **PLINY'S VERDIGRIS**

To replicate Pliny's verdigris recipe from his *Natural History* (Pliny 1979:34.28), two mixtures were made using a copper mortar and pestle: (1) potassium aluminium sulfate and sodium carbonate and (2) potassium aluminium sulfate and sodium chloride. Each mixture was ground with enough distilled vinegar to make a paste. Over the next 5 days, more distilled vinegar was added to the mixtures, which were ground with the pestle until a light green paste developed. The paste made with sodium carbonate had dried to a pale blue powder that gave an X-ray diffraction pattern matching chalconatronite. The mixture with sodium chloride gave atacamite. This last recipe was repeated, yielding a light blue powder that possibly contained a basic verdigris as well as atacamite.

RECIPE 13 **THEOPHILUS'S "VIRIDE SALSUM"**

Theophilus's recipe (35) for "viride salsum" was replicated using a box approximately 10 by 8 cm hollowed out of a piece of oak. Copper strips with honey and salt were placed inside, spaced by small twigs; 60 ml of warm wine vinegar was poured over them, and the box was sealed up for 4 weeks (28 days). The product appeared to be a mixture of two phases: a light blue product identified as a basic copper acetate (compound B); and the principal product, shown by X-ray diffraction to be the neutral copper acetate monohydrate.

RECIPE 14 **CALCIUM COPPER ACETATE HEXAHYDRATE FROM THE *MAPPAE CLAVICULA***

In replicating recipe 3 from the *Mappae clavicula*, solutions (0.25 M) of calcium acetate and copper acetate reagents were made up with distilled water. One hundred milliliters of each solution was poured into two wide, open glass beakers and stirred. This resulted in a clear blue solution. One beaker was placed in an oven at 40 °C, and the other was left in a fume hood to evaporate. After 3 days, the oven solution had reduced in volume by 50%. Crystals, identified as calcium acetate, had formed around the sides of the beaker above the solution, which was by then of a viscous gel consistency. There were some crystals on the surface of the gel as well. The solution in the fume hood was unchanged. The oven beaker was transferred to the fume hood as well, to slow the evaporation. Two weeks from the start of the experiment, the contents of the oven beaker were heterogeneous: a blue-and-white granular area; a dark blue gel; some blue-green crystals; and a fine, light blue powdery area. The fume hood beaker contained a dark blue liquid with some long, fibrous, light blue precipitate. One week later, the fume hood sample was nearly dried and consisted of a light blue fibrous residue; blue-green grains (probably unreacted

copper acetate); light blue and white grains (unreacted calcium acetate); and a dark blue gel with some dark blue crystals that were analyzed and identified as calcium copper acetate hexahydrate The product in the oven beaker, which had been moved into the fume hood, was now completely dry and adhering to the glass. Distilled water was added to this, and the mixture was stirred. This resulted in a deep blue paste, which became a pale blue powder after the beaker was placed on a hot plate and the liquid had evaporated.

A new solution was made of 1 M calcium acetate (9.7 g in 50 ml H_2O) and 0.25 M copper acetate (2.72 g in 50 ml H_2O). This was left in the fume hood to evaporate. Ten days later, the solution had precipitated four large, flat, 1 cm square dark blue crystals that were in a lighter blue liquid. A small amount of light blue granular precipitate was also present. A portion of one crystal was ground up, yielding a light blue water-soluble powder. This was analyzed and identified as calcium copper acetate hexahydrate.

RECIPE 15 ROUEN GREEN FROM THE *MAPPAE CLAVICULA*

The *Mappae clavicula* recipe for Rouen green (recipe 6) was replicated by taking two copper foil sheets, smearing them with Ivory soap, and placing them in a glass jar half filled with red wine vinegar. The copper sheets were positioned so that one was immersed completely in the vinegar, and the other was only half submerged. The jar was sealed and placed in an oven at 40 °C for 15 days. When the jar was removed from the oven, the copper that had been entirely under the vinegar had a dark tarnished appearance but was otherwise uncorroded. The bottom half of the second sheet that had been in the vinegar had the same tarnished surface. The top half, which had not been in direct contact with the vinegar, was covered on both sides with blue-green material that retained the consistency of the smeared soap. Within this coating, there were several small patches of light blue corrosion; after this sheet had been stored in a petri dish for 1 week, there were dark blue-green crystals as well. A sample of the light blue material was analyzed and was found to be basic verdigris.

RECIPE 16 *MAPPAE CLAVICULA* RECIPE 221-D

To reproduce recipe 221-D from the *Mappae clavicula,* a series of copper foil strips, each measuring 1 cm by 3 cm by 0.002 cm and consisting of 99.98% copper, were suspended in four closed glass flasks above 50 ml of one of the following (showing original acidity percentages):

1. distilled clear vinegar, grain derived, "5% acidity"
2. balsamic vinegar, red wine derived, "6% acidity"
3. red wine vinegar, "5% acidity"
4. brown malt vinegar, barley and corn derived, "5% acidity"

The four flasks were placed in an oven at 40 °C for 3 weeks, after which all copper strips were covered with varying degrees of blue-green corrosion. Corrosion from flask 1, with distilled clear vinegar, was analyzed and identified as neutral verdigris.

A second set of experiments was done, substituting bronze strips (6 cm by 1 cm by 0.3 cm) that were suspended in closed flasks above, but not touching, 50 ml of the different vinegars. When removed 1 week later, the bronze strips were covered with bright green, bulky, powdery corrosion. Much more corrosion had been produced than with the copper foil and vinegar. A sample from the red wine vinegar was analyzed by X-ray diffraction and identified as neutral verdigris, copper acetate monohydrate.

A third set of experiments was done using brass strips that were kept in the flasks for 4 weeks. The reaction was slow with these brass samples. Neutral verdigris resulted from exposure to red wine vinegar and balsamic vinegar, but the product produced with the clear vinegar was a mixture of two forms of copper acetate.

RECIPE 17 *MAPPAE CLAVICULA* RECIPE 80

This recipe from the *Mappae clavicula* was replicated using 8 g of coiled copper foil placed in a glass jar and mixed with 12 g of sodium chloride. Some red wine vinegar was poured over this mixture, and the jar was covered. The middle portion of the copper coil began to form green corrosion products after 1 hour; after 1 month, the amount of corrosion had increased but was limited. The experiment was repeated using 2 g of copper foil and 4 g of sodium chloride. Red wine vinegar was poured on top so that all of the ingredients were in contact. After 3 weeks, the parts of the copper foil above the solution had began to corrode. The green product was analyzed by X-ray diffraction and shown to be atacamite.

RECIPE 18 BASIC VERDIGRIS: MACTAGGART METHOD

To replicate the Mactaggart method of making basic verdigris, a thick cotton cloth was soaked with malt vinegar, packed in a plastic pot with sheets of copper foil, covered, and left at room temperature in the lab for six weeks. When the jar was opened, it was found that the copper sheets had reacted to varying degrees. The top sheet, which had been in complete contact with the vinegar-soaked cloth, showed no reaction other than tarnishing; the middle sheets had large areas of very dark blue-green corrosion; and the bottom sheet, which had the least contact with the vinegar-soaked cloth, had reacted strongly. Approximately 50% of the metal was gone, and the remainder of the sheet was covered in very dark blue corrosion with well-formed crystals. A sample of these crystals—which appeared dark blue-green when dried—was ground, analyzed (GCI XRD no. 619), and identified as neutral verdigris. Another verdigris sample prepared by the same method and provided by Mactaggart was analyzed as well (GCI XRD no. 587) and produced a very different pattern, probably that of basic verdigris. A second attempt at making

verdigris with the Mactaggart method was tried, using the same ingredients but with burial in earth of the copper foil wrapped in the vinegar-soaked cloth. This successfully produced crystals of both neutral verdigris and the lighter blue basic verdigris salts, which were characterized as being similar to compound B.

RECIPE 19 BLUE PIGMENT FROM MS 1243

This recipe from the fifteenth-century MS 1243 in the Biblioteca Riccardiana, Padua, Italy, was replicated as follows: A saturated solution of potassium carbonate (the "oil of tartar" cited in the original recipe) was prepared with distilled water. Three grams of reagent cupric acetate monohydrate and 1 g of ammonium chloride (sal ammoniac) were mixed to a paste consistency in an agate mortar with the addition of a small amount of the potassium carbonate solution. This resulted in a dark blue paste, which was placed in a glass jar that was sealed and placed in an oven at 40 °C. A large proportion of the paste had turned green by the end of the day. After 5 days in the oven, the sample was a highly granular paste, predominantly green, but with some dark blue patches and small areas of bright, lighter blue grains. One of the bright blue grains was ground and analyzed (GCI XRD no. 552). The spectrum obtained was a possible match with potassium copper acetate, ammonium chloride, and /or ammonium copper acetate acetic acid. The X-ray diffraction data are shown in APPENDIX D, TABLE 18.

RECIPE 20 BLUE PIGMENT USING VERDIGRIS FROM
THE *RICITTE PER FAR OGNI SORTE DI COLORI*

For this recipe from the seventeenth-century manuscript *Ricitte per far ogni sorte di colori* in the library of the University of Padua (MS 992, recipe 20), 5 g of neutral verdigris was mixed with 20 ml of a 15% w/v solution of potassium carbonate and 5 g of potassium aluminium sulfate. The principal product was determined to be brochantite by Debye-Scherrer powder X-ray diffraction.

RECIPE 21 VERDIGRIS "PIGMENT" FROM THE *RICITTE PER FAR OGNI SORTE DI COLORI*

In this recipe from the *Ricitte per far ogni sorte di colori* (University of Padua, MS 992, recipe 17), both sides of a piece of copper foil were covered with honey, after which the copper foil was attached to the inside of the lid of a glass jar filled with hot balsamic vinegar. The heat from the vinegar caused a lot of condensation to collect at the top of the jar and on the foil, and this may have dissolved much of the honey. The jar was left in an oven at 40 °C for 1 month. At the end of this time, the surface of the copper was tarnished in some areas and had developed a green patination in others. There was no bulk corrosion. The experiment was repeated as above but without heating the vinegar. This second piece of copper ended up covered lightly with a blue

green corrosion of varying texture. A sample from the second experiment was identified as a mixture of two types of copper acetate. This method, however, appeared more likely to create a patina than to be a useful means of producing verdigris pigment.

RECIPE 22 SYNTHETIC BLUE PIGMENT FROM CHINA

An ancient Chinese recipe for blue pigment (Needham 1974:244) was replicated using 1.5 g of cuprite powder, 8.5 g of ammonium chloride, and 25 ml of distilled water. These ingredients were mixed in a flask and then heated on a hot plate. After 10 minutes the solution became very dark blue. Some unreacted cuprite was still present. The solution was stirred, and another 0.5 g of ammonium chloride was added. Five minutes later, light blue crystals formed on the surface of the solution, and on further boiling, all of the copper oxide dissolved. Three hours later, a precipitate collected on the bottom of the flask. Filtration of the contents of the flask produced a clear blue liquid and a small amount of grayish green solid. Cold distilled water was added to the blue liquid, which immediately formed a large amount of bright blue precipitate, identified as atacamite.

RECIPE 23 "ZANGAR" PIGMENT FROM THE *ASRARUL KHAT*, INDIA

The Indian recipe for "zangar" (verdigris) from the Indian *Asrarul Khat* manuscript of 1690 (Bukhari 1963) was reproduced using a large mortar and pestle to combine 7.2 g of ammonium chloride with 3.6 g of copper turnings and some red wine vinegar. There was no immediate reaction. The mixture was left overnight, and by the next day it had formed a dark green paste that still included some unreacted copper filings. During the following week, the sample was ground, and more red wine vinegar was added as it dried out. Gradually the metallic copper disappeared. The final result was a large mass of a dark blue-green granular solid that, when ground, produced a pale blue-green powder. This was analyzed by X-ray diffraction and shown to be neutral verdigris with some ammonium chloride.

RECIPE 24 BRUNSWICK GREEN

Brunswick green pigment was made by adding copper filings to a strong solution of ammonium chloride and leaving the mixture in a closed glass flask. By the next day, the solution, which was originally clear, had become a dark blue, but the copper filings were unchanged. After 3 days, a lighter blue precipitate had formed on the surface of the dark blue solution, and the copper filings were dissolving. One week from the start of the experiment, a blue-green precipitate had collected at the bottom of the flask. This was filtered off, washed with water, and dried at room temperature. The blue-green material was analyzed by X-ray diffraction and shown to be atacamite.

RECIPE 25 **COPPER ORTHOARSENITE**

Copper orthoarsenite was made in the laboratory following Gmelin's (1965) recipe as follows: In a 3 l beaker, 56.2 g of $CuSO_4 \cdot 5H_2O$ was dissolved in 375 ml of water and heated to boiling. In an 800 ml beaker, 13.33 g of As_2O_3 and 7.16 g of Na_2CO_3 (hydrate) were dissolved in 585 ml of water. The As_2O_3 and Na_2CO_3 solution was gently heated to the boiling point until all the As_2O_3 had dissolved. The solution was then allowed to cook for 5 minutes to expel all of the free CO_2. A heated solution of copper sulfate was added to the first solution drop by drop until a precipitate had formed. This fine green powder precipitate was cooked in suspension for another 5 minutes, then cooled, filtered off, and washed well with hot water. Finally, the product was dried at 100 °C.

RECIPE 26 **COPPER DIARSENATE I**

Copper diarsenate I was made in the laboratory following Gmelin's (1965) recipe, as follows: In a 3 l beaker, 100 g of $CuSO_4 \cdot 5H_2O$ was dissolved in 364 ml of cold water (the solution is nearly saturated). A solution of $NaAsO_2$ was prepared with 12.73 g of Na_2CO_3 and 23.75 g of As_2O_3 in 312 ml of water, expelling the CO_2 by gently bringing the solution to a boil and cooking for 5 minutes. The solution was then cooled to room temperature and precipitated at 22–24 °C. The precipitated product was allowed to stand overnight. Because the suspension is very difficult to filter, it is easier to make the precipitate into a paste. Water was added to the paste twice, then decanted. This washing process does not take too long because the product hydrolyzes easily. The product was dried at 100 °C.

RECIPE 27 **EMERALD GREEN, BEARN'S METHOD**

Emerald green was made in the laboratory, following Bearn's (1923) recipe by dissolving 2.5 g of sodium carbonate in 100 ml of water and slowly stirring in 5 g of arsenious oxide, which dissolves with heating in about 30 minutes. Next, 6.25 g of cupric sulfate was dissolved in 180 ml of water and heated to about 90 °C. Adding the sodium arsenite solution precipitated the copper arsenite, which was redissolved in dilute acetic acid (15% v/v). The resulting solution was gently boiled and then cooled, at which point the bright green salt of the acetoarsenite (emerald green) separated out. This was filtered, washed in hot water, and dried.

RECIPE 28 **EMERALD GREEN, GMELIN'S RECIPE 1**

Emerald green was synthesized using Gmelin's (1965) recipe 1 as follows: In a three-necked flask of about 250 ml capacity and equipped with a thermometer and stirrer, 7.8 g of neutral verdigris was dissolved in 100 ml of water, and the solution was heated to 70 °C. With stirring, 7.8 g of arsenious oxide was added, which took about 10 minutes. The solution was heated to boiling

with a reflux condenser for about 2 hours. The solution tended to foam greatly and needed to be cooled to 50 °C, then neutralized with about 10 g of calcium hydroxide to a pH of 6.5, followed by cooling to 30 °C. The suspension was then filtered and washed with 200 ml of 10% acetic acid. Water was not used for the first washing because of the risk of hydrolysis, although afterward the precipitate was washed very briefly with water and dried.

RECIPE 29 EMERALD GREEN, GMELIN'S RECIPE 2

Emerald green was synthesized using Gmelin's (1965) recipe 2 as follows: In a three-necked flask of 150 ml capacity, 2.6 g of acetic acid was dissolved in 28 ml of water, giving about an 8% solution. With stirring, 3.2 g of cupric oxide in the form of a very fine powder was added, and the solution heated to 80 °C; within 2–3 minutes of reaching this temperature, 6 g of arsenious oxide was added. The solution was stirred thoroughly to avoid leaving cupric oxide particles on the inner wall of the flask. The suspension, which initially is brown black, was boiled for 5 hours with a reflux condenser. The color then changed slowly to olive gray, then to green. The solution was cooled down and filtered, and the product was washed with 100 ml of a 10% acetic acid solution followed by a brief washing with water.

Some Copper Minerals and Corrosion Products

APPENDIX C

TABLE 1	MINERAL FORMULAS AND ICDD REFERENCE NOS.	

MINERAL NAME	CHEMICAL FORMULA	ICDD FILE REFERENCE NO. (as of 1997)
anarakite	$(Cu,Zn)_2(OH)_3Cl$	actually paratacamite
anilite	Cu_7S_4	24-58 and 33-489
anthonyite	$Cu(OH,Cl)\cdot3H_2O$	15–670
antlerite	$Cu_3SO_4(OH)_4$	7-407
arzrunite	$Cu_4Pb_2SO_4(OH)_4Cl_6\cdot2H_2O$	inadequate data
atacamite	$Cu_2(OH)_3Cl$	25-269
aurichalcite	$(Cu,Zn)_5(CO_3)_2(OH)_6$	17-743
azurite	$2CuCO_3\cdot Cu(OH)_2$	11-682
beaverite	$Pb(FeCuAl)_3(SO_4)_2(OH)_6$	17-476
bisbeeite	$CuSiO_3\cdot H_2O$	same as chrysocolla
boleite	$Pb_9Cu_8Ag_8Cl_{21}(OH)_{16}\cdot2H_2O$	27-1206
bonatite	$CuSO_4\cdot3H_2O$	22-249
bornite	Cu_5FeS_4	14-323 and 34-135
botallackite	$Cu_2(OH)_3Cl$	8-88
brochantite	$Cu_4SO_4(OH)_6$	13-398
buttgenbachite	$Cu_{18}(NO_3)_2(OH)_{32}Cl_3\cdot H_2O$	8-136 and 34-181
caledonite	$Cu_2Pb_5(SO_4)_3CO_3(OH)_6$	29-565
calumetite	$Cu(OH,Cl)_2$	15-669
chalcanthite	$CuSO_4\cdot5H_2O$	11-646
chalcocite, low	Cu_2S	33-490
chalcocite, high	Cu_2S	29-578
chalcocite	Cu_2S	33-490
chalcocyanite	$CuSO_4$	15-775
chalconatronite	$Na_2Cu(CO_3)_2\cdot3H_2O$	22-1458
chalcopyrite	$CuFeS_2$	35-752 and 37-471
chenevixite	$Cu_2Fe_2(AsO_4)_2(OH)_4\cdot H_2O$	29-553
chenite	$CuPb_4(SO_4)_2(OH)_6$	39-350
chloroxiphite	$CuPb_3Cl_2O_2(OH)_2$	33-467 and 8-112

MINERAL NAME	CHEMICAL FORMULA	ICDD FILE REFERENCE NO. (as of 1997)
christelite	$Zn_3Cu_2(SO_4)_2(OH)_6 \cdot 4H_2O$	no entry
chrysocolla	$(Cu,Al)_2H_2Si_2O_5(OH)_4 \cdot xH_2O$	27-188
claraite	$(Cu,Zn)_3(CO_3)(OH)_4 \cdot 4H_2O$	35-549
claringbullite	$Cu_4Cl(OH,Cl)_7 \cdot nH_2O$	29-539
clinoatacamite	$Cu_2(OH)_3Cl$	new data (no entry)
clinoclase	$Cu_3(AsO_4)(OH)_3$	37-447
connellite	$Cu_{19}(OH)_{32}Cl_{14}SO_4 \cdot 3H_2O$	35-538 and 8-135
cornetite	$Cu_3PO_4(OH)_3$	9-495; 37-449; and 37-483
cornubite	$Cu_5(AsO_4)_2(OH)_4$	12-288
cornwallite	$Cu_5(AsO_4)_2(OH)_4$	12-287
covellite	CuS	6-464
cubanite	$CuFe_2S_3$	9-324 and 24-213
cumengite	$Pb_4Cn_4Cl_8(OH)_8$	27-174
cuprite	Cu_2O	5-667
cuprocassiterite	$(Cu,Fe,Zn)Sn(OH)_6$	no entry
cuprocopiapite	$CuFe_4(SO_4)_6(OH)_2 \cdot 20H_2O$	19-394
cuprorivaite	$CaCuSi_4O_{10}$	12-512
delafossite	$CuFeO_2$	12-752
devilline	$CaCu_4(SO_4)_2(OH)_6 \cdot 3H_2O$	35-561
diaboleite	$Pb_2CuCl_2(OH)_4$	21-468
digenite, low	$Cu_{1.8}S$	23-962
digenite, high	$Cu_{1.8}S$	26-476
dioptase	$CuSiO_3 \cdot H_2O$	33-487
djurleite	$Cu_{1.96}S$	23-959 and 34-660
elyite	$CuPb_4SO_4(OH)_8$	25-293
enargite	Cu_3AsS_4	35-580 and 35-775
eriochalite	$CuCl_2 \cdot 2H_2O$	33-451
faustite	$(Zn,Cn)Al_6(PO_4)_4(OH)_8 \cdot 4H_2O$	6-216
fukuchilite	Cu_3FeS_8	24-365
geerite	$Cu_{1.6}S$	33-491
georgeite	$CuCO_3 \cdot Cu(OH)_2$	no entry
gerhardtite	$Cu_2(NO_3)(OH)_3$	14-007
gilalite	$Cu_5Si_6O_{17} \cdot 7H_2O$	35-468
guildite	$CuFe(SO_4)_2(OH) \cdot 4H_2O$	23-217 and 33-464
haycockite	$Cu_4Fe_5S_8$	25-289
idaite	Cu_3FeS_4	13-161

TABLE 1 *continued*

MINERAL NAME	CHEMICAL FORMULA	ICDD FILE REFERENCE NO. (as of 1997)
isocubanite	$CuFe_2S_3$	27-166
jalpaite	$Ag_{1.55}Cu_{0.45}S$	12-207
kipushite	$(Cu,Zn)_6(PO_4)_2(OH)_6 \cdot H_2O$	38-375
krohnkite	$Na_2Cu(SO_4)_2 \cdot 2H_2O$	25-826
ktenasite	$(Cu,Zn)_5(SO_4)_2(OH)_6 \cdot 6H_2O$	29-591
lammerite	$Cu_3(AsO_4)_2$	35-497
langite	$Cu_4(SO_4)(OH)_6 \cdot 2H_2O$	12-783
lautenthalite	$PbCu_4(SO_4)_2(OH)_6 \cdot 3H_2O$	no entry
lavendulan	$NaCaCu_5(AsO_4)_4Cl \cdot 5H_2O$	31-1280
libethenite	$Cu_2(PO_4)(OH)$	33-481 and 36-404
likasite	$Cu_3NO_3(OH)_5 \cdot 2H_2O$	30-497 and 33-479
linarite	$CuPb(SO4)(OH)_2$	30-493
lindackerite	$Cu_5As_4O_{15} \cdot 9H_2O$	11-166
ludjibaite	$Cu_5(PO_4)_2(OH)_4$	polymorph of pseudomalachite
malachite	$CuCO_3 \cdot Cu(OH)_2$	10-399
mckinstryite	$(Ag,Cu)_2S$	19-406
melanothallite	Cu_2OCl_2	35-679
mooihoekite	$Cu_9Fe_9S_{16}$	25-286
moolooite	$Cu(COO)_2 \cdot nH_2O$	21-297
nakauriite	$Cu_8(SO_4)_4(CO_3)(OH)_6 \cdot 48H_2O$	25-538
namuwite	$(Zn,Cu)_4SO_4(OH)_6 \cdot 4H_2O$	35-528
nantokite	$CuCl$	6-344
olivenite	$Cu_2(AsO_4)(OH)$	42-1353
paratacamite	$Cu_2(OH)_3Cl$	25-1427 and 25-325
plancheite	$Cu_8(Si_4O_{11})_2(OH)_4 \cdot H_2O$	29-576
posnjakite	$Cu_4(SO_4)(OH)_6 \cdot H_2O$	20-364
pseudoboleite	$Pb_{31}Cu_{24}Cl_{62}(OH)_{48}$	22-470
pseudomalachite	$Cu_5(OH)_4(PO_4)_2$	36-408
putoranite	$Cu_{1.1}Fe_{1.2}S_2$	41-1404
ramsbeckite	$(Cu,Zn)_{15}(SO_4)_4(OH)_{22} \cdot 6H_2O$	no entry
reichenbachite	$Cu_5(PO_4)_2(OH)_4$	40-502
rosasite	$(Cu,Zn)_2CO_3(OH)_2$	35-502; 18-1095; and 36-1475

MINERAL NAME	CHEMICAL FORMULA	ICDD FILE REFERENCE NO. (as of 1997)
roxbyite	$Cu_{1.78}S$	23-958
sampleite	$NaCaCu_5(PO_4)_4Cl \cdot 5H_2O$	11-349
schulenbergite	$(Cu,Zn)_7(SO_4,CO_3)_2(OH)_{10} \cdot 3H_2O$	38-349
shattuckite	$Cu_5(SiO_3)_4(OH)_2$	20-356
spangolite	$Cu_6Al(SO_4)Cl(OH)_{12} \cdot 3H_2O$	5-142
spertiniite	$Cu(OH)_2$	35-505
spionkopite	$Cu_{1.32}S$	36-380
stromeyerite	$CuAgS$	26-553; 9-499; and 12-156
synthetics	Cu_2ZnSiS_4	26-574
	$CuSn(PO_4)_2 \cdot 3H_2O$	38-598
	Ca_2CuO_3	34-282 and 19-218
	$CuPO_3$	no entry
tagilite	$Cu_2PO_4(OH) \cdot H_2O$	same as pseudomalachite
tennantite	$(Cu,Fe)_{12}As_4S_{13}$	11-102 and 29-569
tenorite	CuO	5-661
tolbachite	$CuCl_2$	35-690
trippkeite	$CuAs_2O_4$	31-451
tsumebite	$Pb_2Cu(PO_4)(SO_4)(OH)$	29-568
turquoise	$CuAl_6(PO_4)(OH)_8 \cdot 4H_2O$	6-214
unnamed 508	$(Zn,Cu)_7(SO_4)_2(OH)_{10} \cdot 3H_2O$	no entry
unnamed 512	$(Zn,Cn)_5(SO_4)_2(OH)_6 \cdot 6H_2O$	no entry
wheatleyite	$Na_2Cu(COO)_4 \cdot 2H_2O$	39-1500
wroewolfeite	$Cu_4SO_4(OH)_6 \cdot 2H_2O$	27-1133
yarrowite	$Cu_{1.2}5$	36-379
zapatalite	$Cu_3Al_4(PO_4)_3(OH)_9 \cdot 4H_2O$	25-261
zincrosasite	$(Zn,Cu)_2CO_3(OH)_2$	36-1475
copper(I) formate	$Cu(HCOO)$	14-804
copper(II) formate	$Cu(HCOO)_2$	14-708
copper(II) formate	$Cu(HCOO)_2 \cdot 2H_2O$	16-954
copper(II) acetate	$Cu(CH_3COO)_2 \cdot H_2O$	27-145

The optical characteristics and crystallographic group of some of the minerals in this appendix are compiled in TABLE 2 on the following pages. The majority of the data were obtained from Fleischer, Wilcox, and Matzko 1984, which is a useful source of information on optical characteristics.

TABLE 2 **CRYSTAL SYSTEMS AND REFRACTIVE INDICES**

MINERAL NAME	CRYSTAL SYSTEM	REFRACTIVE INDICES (RI)
antlerite	orthorhombic	α 1.726 β 1.739 γ 1.788
atacamite	orthorhombic	α 1.831 β 1.861 γ 1.880
aurichalcite	orthorhombic	α 1.658 β 1.746 γ 1.751
azurite	monoclinic	α 1.73 β 1.838 γ 1.758
botallackite	monoclinic	α 1.775 β 1.800 γ 1.846
brochantite	monoclinic	α 1.728 β 1.771 γ 1.800
calumetite	uncertain	α 1.666 β 1.690 γ 1.690
chalcocite	hexagonal	opaque
chalconatronite	monoclinic	α 1.483 β 1.530 γ 1.576
chrysocolla	orthorhombic	α 1.575 β 1.597 γ 1.598
clinoatacamite	monoclinic	α 1.842 β 1.842 γ 1.848
connellite	hexagonal	ω 1.736 ε 1.756
cornetite	orthorhombic	α 1.762 β 1.820 γ 1.825
covellite	hexagonal	opaque ω 1.45 (Na)
cuprorivaite	tetragonal	α 1.589 β 1.627 γ 1.628
dioptase	rhombohedral	β 1.656
djurleite	monoclinic	opaque
enargite	orthorhombic	α 2.82 β 2.93 γ 3.14
eriochalite	orthorhombic	α 1.646 β 1.685 γ 1.745
geerite	cubic	opaque
georgeite	amorphous	RI 1.593
gerhardtite	orthorhombic	α 1.703 β 1.713 γ 1.722
langite	monoclinic	α 1.654 β 1.713 γ 1.722
libethenite	orthorhombic	α 1.703 β 1.746 γ 1.789
linarite	monoclinic	α 1.809 β 1.838 γ 1.859
malachite	monoclinic	α 1.655 β 1.875 γ 1.909
melanothallite	orthorhombic	not known
moolooite	orthorhombic	not known
namuwite	hexagonal	RI 1.577
nantokite	cubic	RI 1.93
paratacamite	rhombohedral	ω 1.842 ε 1.848
phthalocyanine blue		RI 1.38
posnjakite	monoclinic	α 1.624 β 1.679 γ 1.705

MINERAL NAME	CRYSTAL SYSTEM	REFRACTIVE INDICES (RI)
pseudomalachite	monoclinic	α 1.80 β 1.86 γ 1.88
sampleite	orthorhombic	α 1.629 β 1.677 γ 1.679
Scheele's green	various compounds	RI greater than 1.662
Schweinfurt green	not known	RI 1.71; 1.78
turquoise	triclinic	α 1.612 β 1.620 γ 1.648
verdigris	various	RI ca. 1.54–1.55 (Gettens 1965)
neutral verdigris	compound	RI well below 1.662
basic verdigris[a]	$Cu(CH_3COO)_2 \cdot Cu(OH)_2 \cdot 5H_2O$	one RI 1.548 one RI close to 1.53
basic verdigris[a]	$Cu(CH_3COO)_2 \cdot [Cu(OH_2)]_2$	one RI 1.580 one RI close to 1.560
basic verdigris[a]	$Cu(CH_3COO)2 \cdot [Cu(OH)_2]_3 \cdot 2H_2O$	one RI 1.56
neutral copper(II) formate	monoclinic	α 1.414 β 1.542 γ 1.557
basic copper(II) formate	$2Cu(HCOO)_2 \cdot Cu(OH)_2 \cdot 2H_2O$	RI less than 1.662
basic copper(II) formate	$Cu(HCOO)_2 \cdot Cu(OH)_2$	RI less than 1.662
basic copper(II) formate	$Cu(HCOO)_2 \cdot 2Cu(OH)_2$	RI less than 1.662

[a] As the crystal system is not known, the formula is given in its place.

X-Ray Diffraction Studies

APPENDIX D

TABLE 1	X-RAY DIFFRACTION DATA FOR THE SYNTHESIS OF A CHINESE RECIPE USING CUPRITE DISSOLVED IN ALUM TO WHICH A SOLUTION OF NATRON IS ADDED, COMPARED WITH CHALCONATRONITE (ICDD 22-1458)

Cu$_2$O + ALUM AND NATRON (synthetic mixture of Na$_2$CO$_3$, NaCl, and Na$_2$SO$_4$)		CHALCONATRONITE Na$_2$Cu(CO$_3$)$_2$·3H$_2$O (ICDD 22-1458)		Cu$_2$O + ALUM AND NATRON (synthetic mixture of Na$_2$CO$_3$, NaCl, and Na$_2$SO$_4$) continued		CHALCONATRONITE Na$_2$Cu(CO$_3$)$_2$·3H$_2$O (ICDD 22-1458)	
Intensity	d-spacing	d-spacing	Intensity	Intensity	d-spacing	d-spacing	Intensity
		8.06	30			3.37	40
		7.82	50			3.29	10
100	7.0	6.90	100			3.17	20
		5.59	40			3.12	40
50	5.28	5.18	70			3.04	10
		4.85	30			3.00	50
		4.81	30			2.98	40
		4.57	40			2.91	50
50	4.25	4.21	40			2.89	60
		4.18	80			2.852	70
		4.10	50	10	2.846	2.847	50
		4.05	20			more d-values	
		3.91	30	10	2.595	2.590	20
		3.80	30			more d-values	
20	3.70	3.68	90	10	2.438	2.430	60
		3.63	40			more d-values	
		3.45	40			1.800	40
		3.41	30				

TABLE 2 **X-RAY DIFFRACTION DATA FOR NEWLY CHARACTERIZED CLINOATACAMITE**

ANARAKITE			ZINCIAN PARATACAMITE			CLINOATACAMITE		
Intensity	d-spacing	hkl[a]	Intensity	d-spacing	hkl	Intensity	d-spacing	hkl
65	5.476	200	100	5.48	101	100	5.47	101,011
15	4.697	002	40	4.69	003	5	5.03	
10	3.429	311	5	4.52	012	30	4.68	101
20	2.901	220	15	3.424	110	4	4.54	110
100	2.755	022	5	3.019	104	20	3.406	112,020
15	2.739	400	30	2.890	021	10	2.887	121,103
10	2.342	114	75	2.759	113	60	2.767	110
70	2.263	222	20	2.726	202	70	2.742	013,202
10	2.215	422	10	2.343	006	10	2.713	022
10	2.042	402	65	2.263	024	20	2.339	202
10	2.035	114	5	2.210	211	60	2.266	220
15	1.904	204	10	2.035	205	50	2.243	004
20	1.824	600	5	1.930	116	5	2.208	213
20	1.817	333	10	1.901	107	5	2.045	301
30	1.708	040	25	1.817	033	10	2.027	123
10	1.514	602	5	1.751	125	4	1.940	310
15	1.496	043	35	1.708	220	5	1.907	301
10	1.384	622	5	1.661	027	10	1.895	213
			5	1.630	131	20	1.817	231
			5	1.601	223	10	1.807	033,105
			7	1.509	208	3	1.748	231
			10	1.494	217	50	1.704	224,040
			5	1.471	401	3	1.664	321
			5	1.447	042	5	1.626	223
			5	1.420	119	5	1.516	400,402
			15	1.380	226	10	1.504	224,411
			10	1.362	404	10	1.487	233,125
			5	1.350	321	5	1.471	305
			3	1.311	045	5	1.445	241
			10	1.270	021	10	1.387	422
			15	1.244	143	5	1.377	242
						10	1.368	026,404
						5	1.356	044
						3	1.346	234,051
						10	1.271	422
						5	1.260	206,017

From Jambor et al. 1996. The original data included calculated as well as measured d-spacings. Only the measured d-spacings are shown.

[a] Indicates Miller indices originating from or assigned to a particular d-spacing.

TABLE 3

X-RAY DIFFRACTION DATA FOR CORROSION SAMPLE FROM AN EGYPTIAN BRONZE[a]

EGYPTIAN BRONZE CORROSION		CONNELLITE REFERENCE DATA (ICDD 35-538)		EGYPTIAN BRONZE CORROSION *continued*		CONNELLITE REFERENCE DATA (ICDD 35-538)	
Intensity	d-spacing	d-spacing	Intensity	Intensity	d-spacing	d-spacing	Intensity
70	13.4	13.66	75			2.525	2
100	7.97	7.89	100	10	2.488	2.494	25
10	6.66	6.83	4			2.454	3
		5.464	20	20	2.379	2.37	7
		5.165	30			2.343	3
		4.555	12	20	2.276	2.277	36
20	4.33	4.317	15			2.246	15
		3.942	5	10	1.962	1.966	5
20	3.8	3.787	18	10	1.732	1.748	6
		3.499	3	10	1.675	1.668	2
		3.414	17			1.642	2
		3.219	19	10	1.603	1.609	12
20	3.19	3.198	15	4	1.605	1.606	3
		2.732	38			1.598	5
20	2.614	2.618	12			1.577	6
		2.582	16				

[a] Egyptian bronze from the collections of the Fitzwilliam Museum, Cambridge, England (no. gr.14.1931). This blue-green corrosion was identified as connellite, the complex copper-chloro-sulfate hydrated basic salt (ICDD 35-538).

TABLE 4 X-RAY DIFFRACTION DATA FOR NEW COMPOUND $Cu_{2.5}(OH)_3SO_4 \cdot 2H_2O$

Intensity	d-spacing	Intensity	d-spacing	Intensity	d-spacing
100	10.8	28	2.69	5	1.9
47	5.39	23	2.65	5	1.85
17	5.16	4	2.6	5	1.79
12	4.42	26	2.58	2	1.74
11	4.13	10	2.48	7	1.73
6	3.94	31	2.42	4	1.72
9	3.92	20	2.35	4	1.68
22	3.59	2	2.26	6	1.6
12	3.52	3	2.23	6	1.59
3	3.43	10	2.21	4	1.58
13	3.35	12	2.19	16	1.54
7	3.16	16	2.16	6	1.52
4	2.96	8	2.09	5	1.51
5	2.9	11	2.03	3	1.5
8	2.75	6	1.96	7	1.48

From data of Strandberg, Langer, and Johansson (1995).

TABLE 5 X-RAY DIFFRACTION DATA FOR CORROSION ON A CLOCK IN THE WALLACE COLLECTION[a]

CLOCK CORROSION		NAMUWITE (ICDD 35-0528)		CLOCK CORROSION continued		NAMUWITE (ICDD 35-0528)	
Intensity	d-spacing	d-spacing	Intensity	Intensity	d-spacing	d-spacing	Intensity
100	10.75	10.59	100	5	2.34		
10	5.36	5.31	15	1	2.26	2.22	4
5	4.77			2	2.08	2.06	10
10	4.15	4.15	25	2	1.99	1.99	1
10	3.88	3.86	14	1	1.9	1.93	2
2	3.56	3.51	1	2	1.83	1.88	5
5	3.28	3.25	10	1	1.79	1.78	7
2	3.13	3.14	10	1	1.75		
1	3.02			1	1.64		
2	2.93	2.96	2	1	1.61		
1	2.81			1	1.57		
20	2.7	2.71	40	1	1.55		
20	2.57	2.63	40	1	1.51		
5	2.51	2.5	10	1	1.43		
1	2.4	2.41	20	1	1.39		

[a] Gilded brass clock, French, ca. 1781. Wallace Collection, London (clock F269). Bequest of Lady Wallace (see CHAPTER 6, FIGURE 6.3).

TABLE 6 X-RAY DIFFRACTION DATA FOR SAMPLEITE

SAMPLE 1 ICDD 11-349		SAMPLE 2[a] BM 1959, 405		SAMPLE 3[b] MEM84: soft green corrosion 1		SAMPLE 4 MEM84: soft green corrosion 2		SAMPLE 5 RAT86:1709 diffractometer		SAMPLE 5 RAT86:1709 diffractometer *continued*	
d-sp	I	d-sp	I	d-sp	I	d-sp	I	d-sp	I	d-sp	I
9.60	100	9.69	100	9.83–9.31	VS	9.72	VS	9.68	100	1.930	8
6.85	70	6.81	30	6.81	M	6.81	W-M	6.844	6	1.902	8
4.73	40	4.74	<10	4.67	W-M	4.75	VW	4.844	1	1.872	2
4.30	80	4.30	10	4.32	S	4.29	M	4.721	2	1.797	4
3.89	70	3.88	<10	3.91	W-M	3.92	W	4.473	3	1.711	25
		3.35	10	3.36	M	3.35	W	4.337	7	1.688	2
3.23	50	3.20	10			3.19	W	4.229	4	1.614	8
3.04	100	3.03	60	3.04	S	3.03	S	3.946	2	1.589	2
2.89	50	2.89	30	2.89	M	2.89	W	3.873	2	1.569	4
2.80	50	2.79	<10			2.79	W	3.227	5	1.516	7
2.69	50	2.66	25	2.68	M	2.66	W-M	3.036	30	1.504	4
2.57	50	2.57	25	2.59	M	2.57	W-M	2.970	3	1.463	3
2.40	50	2.41	30	2.43	M-S	2.41	W-M	2.900	10	1.446	4
		2.16	10	2.17	M	2.16	W	2.820	5	1.370	7
1.91	50	1.90	<10	1.90	M	1.93	VW	2.670	6	1.321	5
1.79	70	1.79	<10	1.80	W	1.80	VW	2.612	8	1.305	2
1.71	80	1.71	40	1.71	S	1.71	M-S	2.576	6	1.287	1
1.61	50	1.61	20	1.61	M	1.61	W-M	2.429	8	1.236	6
		1.51	20	1.51	M	1.51	W-M	2.411	11	1.211	6
1.45	70			1.45	W-M			2.351	8		
1.44	70	1.44	10			1.44	W	2.291	3		
1.37	70	1.37	10	1.37	M	1.37	W	2.170	7		
		1.23	<10	1.24	W-M	1.24	VW	2.114	4		
1.21	50	1.21	<10	1.21	W-M	1.21	W	1.985	6		

Key

d-sp d-spacing
I intensity
vs very strong
s strong
M-s medium to strong
M medium
w-M weak to medium
w weak
vw very weak

[a] Type sample from the British Museum (Natural History).

[b] Samples 3–5 are from bronze objects recovered in Memphis, Egypt.

TABLE 7

X-RAY DIFFRACTION DATA FOR A GREEN BEAD FROM DOS CABECAS, LA MIÑA, PERU, COMPARED WITH REFERENCE DATA FOR TURQUOISE AND FAUSTITE

SAMPLE[a]				TURQUOISE		FAUSTITE	
Intensity	4 Θ	Θ	d-spacing	d-spacing	Intensity	d-spacing	Intensity
10	26.41	6.6025	6.70			6.7	7
20	28.76	7.19	6.16	6.17	7	6.14	7
10	37.02	9.255	4.79	4.8	6		
100	48.39	12.0975	3.68	3.68	10	3.68	10
20	51.86	12.965	3.44	3.44	7	3.44	6
20	54.79	13.6975	3.26	3.28	7	3.28	6
2	57.79	14.4475	3.09				
50	61.43	15.3575	2.91	2.91	8	2.89	8
10	71.36	17.84	2.52				
10	79.02	19.755	2.28				
10	81.28	20.32	2.22				
2	83.6	20.9	2.16				
2	6.04	21.51	2.10				
2	88.28	22.07	2.05			2.05	7
2	90.38	22.595	2.01	2.02	6		
2	95.66	23.915	1.90				

[a] GCI Lab no. 2 HIR5 B1.

TABLE 8 **X-RAY DIFFRACTION DATA FOR CHRYSOCOLLA SAMPLES**[a]

LA MIÑA GREEN, PERU		GLOBE MINE, ARIZONA		ICDD 27-188		ICDD 11-322		NICKEL & NICHOLS[b]	
Intensity	d-spacing	Intensity	d-spacing	Intensity	d-spacing	Intensity	d-spacing	Intensity	d-spacing
50	11.586	60	16.8	80	17.9				
50	7.17	40	7.3	60	7.9	60	8.3		
10	4.454	20	4.4	20	4.45	30	5.72		
70	3.503	10	3.89	60	4.07	10	4.43	100	4.39
70	3.336	45	2.8	80	2.9	5	3.57	50	2.8
80	2.815	30	2.45	70	2.56	80	2.92	40	2.6
10	2.702	60	1.63	40	1.602	45	2.49	10	2.42
60	1.999	60	1.49	100	1.486	45	1.638	10	2.32
10	1.823	25	1.03			100	1.494	30	1.6
50	1.484	5	0.98			30	1.334	80	1.482
60	1.262	5	0.78			5	0.957	20	1.321
						5	0.879		

[a] La Miña green in a pigment sample from a first-century C.E. Moche site in Peru (Scott, Doughty, and Donnan 1998).
 Note that the three reference sets of data are all different.
[b] From Nickel and Nichols 1991.

TABLE 9

X-RAY DIFFRACTION DATA FOR SOME NEUTRAL AND BASIC COPPER FORMATES

I. NEUTRAL COPPER FORMATES

$Cu(HCOO)_2 \cdot 2H_2O$ (ICDD 16-954)		$Cu(HCOO)$ (ICDD 14-804)		$Cu(HCOO)_2$ (ICDD 14-708)		$Cu(HCOO)_2$ (ICDD 32-331)		$Cu(HCOO)_2$ (ICDD 32-332)		$Cu(HCOO)_2$ (ICDD 46-867)	
d-sp	I	d-sp	I	d-sp	I	d-sp	I	d-sp	I	d-sp	I
4.88	100	7.08	100	4.9	100	5.24	100	7.09	50	5.21	100
4.68	65	5.23	10	4.6	70	3.969	2	5.56	70	4.8	88
4.56	85	4.54	30	4.29	45	3.444	3	4.81	100	3.468	37
4.31	10	3.01	10	3.6	12	3.348	4	4.47	40	3.229	36
4.22	4	2.86	30	3.39	12	3.282	10	4.15	2	3.065	43
3.63	10	2.68	40	2.84	18	3.184	2	3.79	5	2.877	28
3.56	10	2.59	10	2.61	70	3.063	25	3.64	2	2.482	29
3.51	6	2.39	15	2.44	12	2.8553	6	3.546	50	2.34	34
3.41	20	2.36	10	2.2	12	2.6688	2	3.519	7	2.075	32
3.33	18	2.27	10	2.12	6	2.5579	20	3.474	50	2.06	31
3.28	4	2.14	10	2.02	6	2.5061	6	3.299	60		
3.14	6	2.1	25	1.95	12	2.4894	10	3.235	30		
3.05	8	1.81	10	1.81	12	2.4212	8	2.884	20		
2.836	20	1.59	10	1.75	12	2.275	2	2.781	8		
2.622	40	1.44	10	1.64	6	2.2254	7	2.748	10		
2.6	20	1.27	10	1.53	6	2.1994	2	2.718	3		
2.559	6					2.1324	7	2.643	6		
2.439	10					2.1002	3	2.555	4		
2.341	6					2.0741	5	2.538	6		
2.303	6					2.046	1	2.517	4		
2.281	6					1.996	7	2.484	25		
2.239	6					1.9815	<1	2.366	4		
2.208	18					1.905	7	2.339	40		
2.128	6					1.8681	2	2.288	5		
2.081	6					1.861	8	2.249	2		
2.02	6					1.8175	<1	2.144	1		
1.955	10					1.799	12	2.081	20		
1.905	6					1.765	<1	2.073	8		
1.874	1					1.7460	5	2.06	10		
1.848	6					1.7208	5	1.983	2		
1.819	10					1.7039	3	1.922	3		
1.757	8					1.6822	5	1.886	6		
1.73	6					1.6695	2	1.867	1		

Key

d-sp d-spacing

I intensity

continued

I. NEUTRAL COPPER FORMATES *continued*

Cu(HCOO)$_2$·2H$_2$O (ICDD 16-954)		Cu(HCOO) (ICDD 14-804)		Cu(HCOO)$_2$ (ICDD 14-708)		Cu(HCOO)$_2$ (ICDD 32-331)		Cu(HCOO)$_2$ (ICDD 32-332)		Cu(HCOO)$_2$ (ICDD 46-867)	
d-sp	I	d-sp	I	d-sp	I	d-sp	I	d-sp	I	d-sp	I
1.711	4					1.6626	4	1.853	5		
1.665	4					1.6407	<1	1.774	30		
1.652	6					1.5989	4	1.749	1		
1.643	4					1.5926	1	1.741	2		
1.626	6					1.5452	3	1.734	20		
1.59	4					1.5405	<1	1.69	1		
1.529	2							1.6743	2		
								1.6493	10		
								1.6247	2		
								1.592	6		
								1.5431	1		
								1.5152	2		
								1.5074	10		
								1.4895	1		
								1.4598	7		
								1.4421	2		
								1.4265	2		
								1.4192	10		
								1.3859	4		
								1.3737	1		
								1.3693	1		
								1.3608	3		
								1.2969	2		
								1.2913	1		
								1.2815	2		
								1.2593	2		
								1.2221	1		
								1.2164	3		
								1.1827	1		
								1.1658	1		
								1.1063	1		
								1.0999	4		

Key

d-sp d-spacing

I intensity

II. BASIC COPPER FORMATES

Film XRD 770 light green		Film XRD 772 green		Film XRD 778 green		Film XRD 770 light green *continued*		Film XRD 772 green		Film XRD 778 green	
d-sp	I	d-sp	I	d-sp	I	d-sp	I	d-sp	I	d-sp	I
7.35	3	6.19	10	8.54	100	2.14	3	1.68	10		
6.64	100	5.90	10	6.28	30	2.02	15	1.61	10		
5.39	5	5.31	80	5.54	10	1.95	30	1.55	5		
4.52	5	4.50	30	5.08	5	1.87	10	1.48	3		
4.08	10	3.97	50	4.70	10	1.83	15				
3.82	5	3.61	10	4.40	5	1.68	5				
3.71	3	3.29	20	3.82	5	1.64	5				
3.37	60	3.08	100	3.27	5	1.61	5				
3.31	2	2.87	20	2.98	5	1.59	15				
3.19	5	2.62	20			1.55	15				
3.05	2	2.48	10			1.52	10				
2.94	5	2.28	20			1.51	10				
2.79	40	2.22	10			1.48	15				
2.70	3	2.13	5			1.44	10				
2.65	50	2.05	10			1.40	5				
2.59	5	1.99	20			1.38	5				
2.46	40	1.93	5			1.33	10				
2.36	80	1.87	5			1.29	10				
2.30	10	1.82	10			1.26	5				
2.23	15	1.76	5			1.25	5				

Key

d-sp d-spacing

I intensity

TABLE 10

X-RAY DIFFRACTION DATA FOR SOME VERDIGRIS SYNTHESES COMPARED WITH NEUTRAL COPPER ACETATE (ICDD 27-145)

BLUE-GREEN CORROSION FROM COPPER FOIL AND VINEGAR EXPERIMENT (distilled clear vinegar)		NEUTRAL COPPER ACETATE (ICDD 27-145)		BLUE-GREEN CORROSION FROM COPPER FOIL AND VINEGAR EXPERIMENT (distilled clear vinegar) *continued*		NEUTRAL COPPER ACETATE (ICDD 27-145)	
Intensity	d-spacing	d-spacing	Intensity	Intensity	d-spacing	d-spacing	Intensity
100	6.81	6.91	100	5	2.674	2.688	2
70	6.14	6.17	35			2.645	2
		5.87	25			2.609	2
70	5.77	5.75	16			2.592	2
70	5.32	5.38	25			2.576	<1
10	4.26	4.28	2	5	2.534	2.543	4
		4.09	4			2.510	2
10	4.05	4.05	2			2.495	2
		3.588	12			2.425	2
		3.527	20			2.393	4
90	3.49	3.455	4	10	2.380	2.387	4
10	3.42	3.434	4	10	2.317	2.330	8
10	3.28	3.292	4			2.290	10
10	3.08	3.087	4	50	2.279	2.279	4
		3.033	2			2.226	4
		2.967	2	10	2.215	2.222	4
		2.875	2			2.186	2
		2.773	2			2.149	<1
		2.723	2			2.137	2

Intensity	d-spacing	d-spacing	Intensity
		2.035	2
20	2.027	2.027	1
		1.976	<1
20	1.964	1.963	4
		1.952	2
20	1.921	1.928	2
		1.891	2
		1.874	2
		1.830	2
		1.802	<1
		1.794	<1
		1.774	2
5	1.763	1.763	4
		1.753	<1
		1.718	<1
		1.710	2
5	1.699	1.695	2
5	1.662	1.666	2
		1.632	<1

Intensity	d-spacing	d-spacing	Intensity
		1.616	<1
		1.600	<1
5	1.567	1.567	2
		1.544	<1
		1.513	<1
		1.511	<1
		1.505	<1
		1.483	<1
		1.452	<1
		1.428	2
		1.421	<1
		1.411	<1
		1.410	<1
		1.392	2
		1.387	<1
		1.381	<1
		1.373	2

TABLE 11

SOME X-RAY DIFFRACTION DATA FOR BASIC VERDIGRIS SALTS (COMPOUNDS F, B, AND D)

	COMPOUND F (ICDD 27-145) Neutral acetate		NATIONAL GALLERY COMPOUND B		NATIONAL GALLERY COMPOUND D	
	Intensity	d-spacing	d-spacing	Intensity	d-spacing	Intensity
	100	6.91	6.91	100	6.94	100
	35	6.17	6.23	20	6.23	40
	25	5.87	5.87	20	5.90	40
	16	5.75	5.37	20	5.36	40
	25	4.28	4.29	5	4.20	10
	2	4.09	4.10	5		
	4	4.05				
	2	3.588	3.62	20		
	12	3.527			3.54	50
	20	3.455	3.47	15		
	4	3.434				
	4	3.292	3.30	10	3.30	5
	4	3.087	3.10	5	3.09	15
	4	3.033				
	2	2.967	2.96	3		
	2	2.875				
	2	2.773				
	2	2.723				
	2	2.688				
	2	2.645			2.67	5
					2.56	10
			2.41	10	2.40	10
			2.30	10	2.30	40
			2.22	10	2.03	3
			2.04	5	1.95	5

TABLE 12

SOME X-RAY DIFFRACTION DATA FOR BASIC VERDIGRIS SALTS (COMPOUNDS A, B, AND C) MADE BY DIFFERENT SYNTHESES

COMPOUND A [a]		COMPOUND B		COMPOUND C [b]		COMPOUND C [c]		COMPOUND C2	
Intensity	d-spacing	Intensity	d-spacing	Intensity	d-spacing	Intensity	d-spacing	Intensity	d-spacing
40	17.3	40	8.4	15	14.97	20	15.42	3	7.71
70	12.3	5	6.7	100	10.55	100	10.52	50	6.34
80	11.9	5	5.8	5	7.75	15	6.54	50	5.35
100	9.3	6	4.8	15	6.37	10	5.39	1	4.97
90	8.5	8	4.08	20	5.30	2	4.03	80	3.88
60	8.2	30	3.88	5	4.55	5	3.50	70	3.20
40	7.83	8	3.56	20	4.04	10	3.44	10	2.91
50	4.48	80	3.45	20	3.53	5	3.12	60	2.68
70	4.11	70	3.31	5	3.13	3	2.90	100	2.51
20	3.80	90	3.10	3	2.92	40	2.78	3	2.38
40	3.42	50	2.83	15	2.79	3	2.46	3	2.27
20	3.21	10	2.73	3	2.53	10	2.41	5	2.19
50	3.06	10	2.64	3	2.49	10	2.20	1	2.14
50	2.40	10	2.48	5	2.39	2	2.00	1	2.09
10	2.32	60	2.21	5	2.23			1	2.02
30	2.16	10	2.11	3	2.11			3	1.96
50	2.03	5	2.06	5	1.99			1	1.82
50	1.71	10	1.86	5	1.79			15	1.74
30	1.52			5	1.69			5	1.60
				3	1.63			5	1.56
				3	1.62			3	1.63
				3	1.58			1	1.47
				3	1.36			1	1.44
				2	1.42			1	1.41
								1	1.37
								1	1.34

[a] Compounds A and B synthesized by van T'Hul-Ehrenreich and Hallebeek (1972).

[b] Compounds C and C2 synthesized by Taniguchi and Scott (1998).

[c] Compound C synthesized by Schweizer and Mühlethaler (1960).

TABLE 13 SOME X-RAY DIFFRACTION DATA FOR A VARIETY OF BASIC VERDIGRIS SALTS OF GROUP B WITH ONE RESULT FOR GROUP A

	MÜHLETHALER B NATIONAL GALLERY LIGHT SKY BLUE		VERDIGRIS A #685 BLUE GREEN		VERDIGRIS B1 #689 LIGHT SKY BLUE	
	Intensity	d-spacing	Intensity	d-spacing	Intensity	d-spacing
	60	10.66	5	11.27	10	11.06
	50	9.18	5	10.52	100	10.04
	100	8.45	5	9.70	100	8.45
	5	7.35	5	8.24	15	7.12
	2	6.50	100	6.93	15	6.55
	1	6.15	10	6.17	10	5.77
	10	5.17	10	5.79	10	5.16
	2	4.47	10	5.28	5	4.87
	1	4.05	30	3.54	20	4.60
	10	3.72	5	3.29	35	3.93
	2	3.62	10	3.08	15	3.54
	1	3.40	5	2.67	10	3.40
	2	3.20	5	2.56	5	3.25
	1	2.98	5	2.41	10	3.00
	10	2.77	10	2.29	10	2.87
	5	2.61	5	2.20	10	2.75
	2	2.44	5	2.03	2	2.67
	5	2.35	1	1.97	10	2.53
	1	2.23	1	1.93	5	2.47
	1	2.11			5	2.39
	1	2.04			5	2.33
					2	2.19
					2	2.10
					2	2.03
					5	1.86

VERDIGRIS B2 #690 LIGHT SKY BLUE		VERDIGRIS B3 #691 BLUE GREEN		VERDIGRIS B4 #692 LIGHT BLUE		VERDIGRIS B5 #696 LIGHT BLUE	
Intensity	d-spacing	Intensity	d-spacing	Intensity	d-spacing	Intensity	d-spacing
100	11.32	5	9.24	80	11.13	10	11.37
100	10.02	100	6.88	10	8.05	5	10.11
100	8.32	20	6.23	30	6.49	100	9.18
10	7.18	20	5.83	10	6.04	10	8.31
10	6.50	20	5.38	5	3.81	80	6.89
10	5.84	5	4.22	100	3.64	40	6.18
10	5.15	40	3.52	5	3.58	10	5.80
5	4.84	10	3.06	1	3.24	15	5.52
10	4.59	10	2.64	10	3.06	20	3.64
30	3.96	10	2.31	5	2.71	10	3.31
40	3.60	5	1.97	20	2.63	10	3.06
5	3.38	5	1.87	20	2.47	10	2.63
10	3.24			5	2.40	5	2.40
10	3.01			20	2.31	10	2.30
25	2.87			1	2.24	5	2.04
20	2.75			1	2.24	5	1.92
20	2.63			5	2.16	5	1.82
25	2.47			1	2.13	5	1.71
25	2.32			3	2.03		
5	2.15			1	1.99		
10	2.02			10	1.93		
10	1.92			20	1.81		
15	1.81			10	1.74		
10	1.66			10	1.65		
5	1.56			1	1.57		
5	1.43			5	1.44		

TABLE 14 SOME X-RAY DIFFRACTION DATA FOR VERDIGRIS SALTS (COMPOUND D) SYNTHESIZED BY DIFFERENT ROUTES

COMPOUND D NATIONAL GALLERY		SCHWEIZER AND MÜHLETHALER D NATIONAL GALLERY GREEN		COMPOUND D Dyt[a]		COMPOUND D Ayt2[b]	
d-spacing	Intensity	Intensity	d-spacing	Intensity	d-spacing	Intensity	d-spacing
				3	14.95		
9.137	100	100	9.29	100	9.25	100	9.38
5.211	5	5	5.09	3	5.12		
4.676	15	80	4.64	30	4.67	23	4.67
4.004	10	10	4.04	5	4.07		
3.362	5	3	3.67	3	3.68		
3.094	15	3	3.39	3	3.42		
2.788	10	60	3.13	20	3.11	9	3.11
2.626	10	3	3.02	5	2.78		
2.448	5	3	2.90	10	2.67	0.6	2.63
2.303	5	10	2.79	5	2.58		
2.170	5	40	2.64	15	2.45	0.5	2.45
2.011	3	2	2.47	10	2.29	0.4	2.31
1.865	5	20	2.34	5	2.17	0.3	2.18
1.584	5	30	2.20	2	2.01		
1.522	5	10	2.18	10	1.89	0.7	1.87
1.442	5	15	2.02	5	1.58	0.4	1.56
1.339	5	2	1.88	5	1.52		
1.260	3	5	1.76	3	1.45		
		5	1.64				
		5	1.60				
		5	1.58				
		5	1.56				
		5	1.53				
		5	1.50				
		5	1.46				
		2	1.39				

[a] Taniguchi synthesis of compound D.

[b] Taniguchi synthesis of compound A, sample 2.

| TABLE 15 | | COMPARISON OF X-RAY DIFFRACTION DATA FOR GREEN PIGMENT FROM A FIFTEENTH-CENTURY GERMAN MANUSCRIPT BY RUDOLF VON EMS[a] COMPARED WITH BASIC VERDIGRIS (COMPOUND B4) | | |

VERDIGRIS B4		GERMAN MANUSCRIPT PIGMENT		
Intensity	d-spacing	Intensity	d-spacing	
		80	11.3	
		10	8.05	
80	6.47	30	6.49	
10	6.10	10	6.04	
2	3.80	5	3.81	
100	3.64	100	3.64	
2	3.54	5	3.58	
1	3.24	1	3.24	
20	3.05	10	3.06	
1	2.69	5	2.71	
80	2.63	20	2.63	
100	2.48	20	2.47	
5	2.39	5	2.40	
50	2.30	20	2.31	
		1	2.395	
		1	2.389	
20	2.16	5	2.16	
		1	2.13	
2	2.03	3	2.03	
		1	1.99	
10	1.93	10	1.93	
10	1.81	20	1.81	
2	1.74	10	1.74	
15	1.66	10	1.65	
7	1.58	1	1.57	
		5	1.44	

[a] Rudolf von Ems (Austrian, ca. 1200–1254), *Barlaam und Josaphat*, 1492, vellum manuscript produced in Germany, collections of the J. Paul Getty Museum (83.MR.179).

TABLE 16

X-RAY DIFFRACTION DATA FOR A RECIPE FOR BASIC VERDIGRIS FROM THE *MAPPAE CLAVICULA* COMPARED WITH SYNTHESES OF COMPOUND B AND COMPOUND A AND SYNTHESIS BY MACTAGGART

MAPPAE CLAVICULA RECIPE 6[a]		COMPOUND B (SCHWEIZER AND MÜHLETHALER)[b]		COMPOUND A (AUTHOR'S SYNTHESIS)[c]		MACTAGGART SYNTHESIS[d]	
d-spacing	Intensity	d-spacing	Intensity	d-spacing	Intensity	d-spacing	Intensity
11.5	100	11.4	100			11.9	100
9.34	20	9.27	90	9.3	100	8.26	90
8.16	80	8.18	50			7.06	50
6.92	70	7.23	40	6.98	40	5.97	40
6.26	40	6.13	60	6.27	20	5.48	10
5.88	30	5.44	5	5.79	20	4.97	70
5.44	30	5.11	5	5.44	20	4.61	70
4.88	10	4.88	5	5.17	20	4.19	10
4.14	10	4.50	20	4.72	90	3.75	10
3.63	10	4.01	20	4.34	10	3.54	70
3.47	10	3.64	10	4.11	30	3.29	10
3.33	20	3.47	30	3.75	10	3.15	70
3.12	30	3.24	10	3.55	10	3.01	10
2.56	10	3.05	40	3.40	10	2.93	10
2.40	20	2.890	20	3.16	80	2.81	10
2.53	20	2.820	20	3.04	10	2.67	10
2.30	20	2.615	30	2.826	30	2.54	10
2.24	10	2.415	30	2.666	70	2.42	20
2.04	10	2.242	30	2.498	60	2.29	20
1.99	10	2.129	5	2.352	50	2.21	20
1.57	10	2.042	50	2.235	60	7.98	10
		1.781	10	2.172	60	1.77	5
		1.745	5	2.044	30		
				1.987	5		
				1.944	30		
				1.885	30		
				1.762	20		

[a] *Mappae clavicula* (Smith and Hawthorne 1974 : sec. 6). GCI Lab no. 606.

[b] GCI Lab no. 624.

[c] GCI Lab no. 625.

[d] Peter Mactaggart. GCI Lab no. 587.

TABLE 17

X-RAY DIFFRACTION DATA FOR CALCIUM COPPER ACETATE HYDRATE FROM LABORATORY SYNTHESIS COMPARED WITH ICDD 32–159

DARK BLUE CRYSTALS FROM CALCIUM ACETATE + COPPER ACETATE (4 Ca:1 Cu) MOLAR SOLUTIONS			CALCIUM COPPER ACETATE HYDRATE $(CH_3COO)_4CaCu6H_2O$ (ICDD 32-159)	
Intensity	4 Θ	d-spacing	d-spacing	Intensity
5	18.44	9.6	9.2	1
100	21.28	8.3	8.11	12
100	23.27	7.6	7.89	100
40	30.43	5.82		
40	32.47	5.46	5.58	30
10	36.16	4.91	4.77	2
10	37.81	4.69	4.60	1
			4.06	1
20	47.55	3.74	3.67	12
90	49.56	3.59	3.611	11
40	50.96	3.50	3.528	35
20	52.91	3.37		
20	54.53	3.27	3.284	4
			3.236	1
20	57.57	3.10		
20	59.09	3.02	3.040	6
10	61.91	2.889		
20	63.45	2.820	2.831	3
30	67.09	2.671	2.687	11
			2.670	1
			2.628	2

DARK BLUE CRYSTALS FROM CALCIUM ACETATE + COPPER ACETATE (4 Ca:1 Cu) MOLAR SOLUTIONS *continued*			CALCIUM COPPER ACETATE HYDRATE $(CH_3COO)_4CaCu6H_2O$ (ICDD 32-159)	
Intensity	4 Θ	d-spacing	d-spacing	Intensity
10	70.33	2.552	2.561	1
10	72.20	2.488	2.495	4
5	73.87	2.434	2.447	1
20	77.71	2.318	2.2995	2
10	81.40	2.217	2.2108	1
			2.1882	3
40	85.07	2.125	2.1261	6
20	87.96	2.059	2.0663	1
20	89.50	2.025	2.0312	4
20	91.60	1.981	1.9721	1
			1.9693	1
50	94.61	1.922	1.9266	3
			1.9136	5
10	97.90	1.861	1.8595	2
50	102.97	1.775	1.7742	1
			1.7643	3
			1.7602	3
20	104.87	1.745	1.7375	2
			more d-values	
			1.5473	1

TABLE 18 SOME X-RAY DIFFRACTION DATA FOR LABORATORY SYNTHESES OF AMMONIUM AND POTASSIUM COPPER ACETATES

BRIGHT BLUE GRAINS FROM COPPER ACETATE REAGENT + AMMONIUM CHLORIDE + POTASSIUM CARBONATE EXPERIMENT		POTASSIUM COPPER ACETATE $2K(CH_3COO)$; $Cu(CH_3COO)_2$ (ICDD 21-301)		AMMONIUM CHLORIDE, NH_4Cl (ICDD 34-710)		AMMONIUM COPPER ACETATE ACETIC ACID $C_{14}H_{50}CuN_4O_{20}$ (ICDD 20-1499)	
Intensity	d-spacing	d-spacing	Intensity	d-spacing	Intensity	d-spacing	Intensity
10	11.3	11.6	60			11.3	80
10	9.4	9.58	100				
		8.33	60			8.02	60
50	7.91	7.88	40				
		7.48	40				
70	6.30	6.30	80				
		5.89	60				
10	5.71					5.66	40
		5.32	40			4.71	40
		5.02	40			4.34	40
60	4.29						
90	3.92						
		3.85	60	3.876	80	3.76	40
						3.70	40
		3.63	60			3.67	60
						3.47	100
		3.22	40			3.20	80
		3.15	40				
		3.03	40				
100	2.922					2.93	40
		2.88	40				
60	2.780			2.747	100		
90	2.669	2.67	40			2.69	100
		2.61	40				
40	2.528	2.53	40			2.58	40
		2.43	40				
60	2.342	2.36	40			2.32	40
50	2.210	2.20	40			2.23	40
50	2.065	2.06	40			1.96	40
70	1.968	1.95	40	1.930	60	1.92	40
50	1.761			1.724	50	1.75	40
40	1.625					1.65	40
40	1.579			1.577	70	1.56	40
				more d-values			

TABLE 19

DEBYE-SCHERRER POWDER X-RAY DIFFRACTION DATA FOR SYNTHESIS OF VERDIGRIS WITH LEMON JUICE TO MAKE A GREEN PIGMENT

	VERDIGRIS PIGMENT IN LEMON JUICE		COPPER CITRATE $C_{12}H_{10}Cu_4O_{14} \cdot 5H_2O$ (ICDD 1-191)		
	Intensity	4 Θ	d-spacing	d-spacing	Intensity
	10	21.55	8.2		
	70	24.58	7.2	7.4	25
	100	31.43	5.64	5.6	100
	10	33.56	5.28		
	10	35.64	4.98		
	60	38.67	4.59	4.55	25
	60	45.93	3.87	3.85	25
	10	49.28	3.61		
	10	50.69	3.51	3.56	12
	10	56.86	3.14	3.13	8
	10	61.13	2.925	2.92	8
	10	67.52	2.655	2.66	8
	10	71.34	2.517	2.49	4
				2.19	8
	10	86.90	2.083		
	10	90.41	2.006	1.99	8
	10	93.58	1.941	1.93	8
	10	96.50	1.886	1.88	6
	10	99.55	1.832	1.82	4
	10	106.94	1.714	1.70	4
	10	110.76	1.659	1.66	4
	5	112.98	1.629		
				1.56	2
	5	123.92	1.498		
	10	127.95	1.455		
	10	130.18	1.433		
	10	132.23	1.413		
	10	136.06	1.370		
	10	141.62	1.331	1.33	2

Procedure from *Ricitte per far ogni sorte di colori* (Library of the University of Padua, MS 992), recipe 33 (Merrifield 1849 : 664).

TABLE 20 **X-RAY DIFFRACTION DATA FOR FITZWILLIAM MUSEUM SAMPLE F4 (BLUE SALTS FROM HEAD OF MIN-AMUN)**[a]

	BLUE CORROSION FROM MIN-AMUN		CHALCONATRONITE (ICDD 22-1458)		
	Intensity	d-spacing	d-spacing	Intensity	
	80	8.8	8.06	30	
	100	7.6	7.82	50	
	70	6.76	6.9	100	
	30	5.56	5.59	40	
			5.18	70	
	10	4.89	4.85	30	
	20	4.16	4.18	80	
			4.1	50	
			4.05	20	
			3.91	30	
			3.8	30	
			3.68	90	
			3.63	40	
	30	3.44	3.45	40	
			3.41	30	
			3.37	40	
	20	3.04	3.04	10	
			3	50	
			2.98	40	
			2.91	50	
	40	2.866	2.89	60	
			2.853	70	
			2.847	50	
	10	2.782	2.78	30	
			2.69	30	
	20	2.66	2.673	50	
	10	2.56	2.59	20	
	20	2.452	2.43	60	
	10	2.362	2.395	40	
			2.31	20	
	10	2.275	2.28	30	
	5	2.141	2.135	40	
	5	1.954	1.969	30	
			1.86	40	
			1.8	40	
	5	1.719			
	10	1.593			

[a] Head of Min-Amun, Egyptian bronze. Fitzwilliam Museum (acc. no. EGA.4376.1943).

TABLE 21

X-RAY DIFFRACTION DATA FOR CORROSION ON A BRONZE
FROM KELVINGROVE, SCOTLAND,[a] COMPARED WITH ICDD 28-746

	LIGHT BLUE CORROSION, KELVINGROVE SAMPLE, VERY GRAINY FILM		POTASSIUM COPPER CARBONATE HYDROXIDE HYDRATE $K[Cu_2(CO_3)_2(OH)]\cdot 4H_2O$ (ICDD 28-746)		
	Intensity	d-spacing	d-spacing	Intensity	
	100	10.6	10.7	100	
	60	8.57			
	50	7.46			
	50	6.79			
			6.18	30	
	40	5.92			
	10	5.21			
	10	4.84	4.77	5	
	5	4.44	4.35	25	
	10	4.17			
	20	3.80	3.77	15	
			3.72	55	
	10	3.61	3.56	55	
	50	3.44			
	50	3.32			
	50	3.18			
	20	3.04	3.08	70	
	20	2.958			
	70	2.811	2.83	65	
	10	2.689	2.67	30	
	10	2.456	2.498	25	
	10	2.311	2.373	50	
	10	2.220	2.215	16	
	10	2.151	2.178	15	
			2.166	3	
			2.052	7	
	10	1.973	1.979	4	
			1.940	13	
	10	1.895	1.879	12	
	10	1.802	1.822	8	
	10	1.759	1.779	20	
	10	1.728	1.726	17	
			1.711	11	
	10	1.687	1.685	4	

[a] Kelvingrove no. A6082 BF, Kelvingrove, Scotland. GCI XRD no. 612.

TABLE 22	**X-RAY DIFFRACTION DATA FOR SAMPLE OF BRONZE CORROSION FROM THE BURRELL COLLECTION COMPARED WITH SODIUM COPPER CARBONATE ACETATE**

	BURRELL COLLECTION LIGHT BLUE GRAINS[a]		**NEWLY IDENTIFIED SODIUM COPPER CARBONATE ACETATE**[b]		
	Intensity	d-spacing	d-spacing	Intensity	
	100	10.5	10.5	100	
	10	9.87	10.0	40	
	10	9.25	9.00	20	
	50	8.01	8.00	70	
	30	7.36	7.20	60	
	50	6.7	6.50	50	
	20	5.93	5.80	10	
			5.50	20	
			5.54	20	
			5.00	10	
	20	4.76	4.70	10	
	20	4.22	4.30	30	
			4.00	20	
	10	3.76	3.72	10	
	20	3.56	3.65	10	
	20	3.34	3.52	30	
			3.31	10	
	10	3.24	3.23	10	
	20	3.12	3.10	30	
			3.03	30	
	20	2.892	2.92	10	
	10	2.811	2.84	10	
			2.75	10	
	10	2.681	2.67	10	
	20	2.575	2.55	10	
	10	2.43	2.44	10	
	10	2.243	2.38	10	
			2.32	10	
			2.13	10	
			2.02	10	
			2.00	10	
	5	1.87			
	5	1.786			
	10	1.674			
	5	1.609			

[a] Burrell Collection (acc. no. 13.199), Glasgow, Scotland.

[b] Egyptian artifact in the collections of the British Museum (Thickett and Odlyha 2000).

TABLE 23 **X-RAY DIFFRACTION DATA OF PALE BLUE CORROSION FROM EGYPTIAN BRONZES IN BRITISH MUSEUM, IDENTIFIED AS A SODIUM COPPER ACETATE CARBONATE (HYDRATE)**

Intensity	d-spacing	
100	10.5	
40	10	
20	9	
70	8	
60	7.2	
50	6.5	
10	5.8	
20	5.5	
20	5.4	
10	5	
10	4.7	
30	4.3	
20	4	
10	3.72	
10	3.65	
30	3.52	
10	3.31	
10	3.23	
30	3.1	
30	3.03	
10	2.92	
10	2.84	
10	2.75	
10	2.67	
10	2.55	
10	2.44	
10	2.38	
10	2.32	
10	2.13	
10	2.02	
10	2	

From Thickett and Odlyha 2000.

BRUNSWICK GREEN COPPER FILINGS AND AMMONIUM CHLORIDE EXPERIMENT

ATACAMITE $Cu_2(OH)_3Cl$ (ICDD 25-269)

Intensity	d-spacing	d-spacing	Intensity
80	6.33		
60	5.51	5.480	100
20	5.06	5.030	70
		4.560	4
70	4.30		
		4.050	12
80	3.91		
		3.430	1
		3.220	7
		3.040	5
		3.010	8
100	2.932		
		2.836	50
60	2.775	2.779	50
		2.759	55
		2.742	25
		2.711	20
80	2.651	2.641	14
		2.525	14
10	2.512	2.515	40
20	2.346		

BRUNSWICK GREEN COPPER FILINGS AND AMMONIUM CHLORIDE EXPERIMENT *continued*

ATACAMITE $Cu_2(OH)_3Cl$ (ICDD 25-269)

Intensity	d-spacing	d-spacing	Intensity
10	2.277	2.278	70
		2.265	45
		2.220	1
10	2.199	2.198	17
		2.141	11
		2.130	25
10	2.055	2.043	17
		2.029	5
20	1.963	1.964	12
10	1.826	1.829	11
		more d-values	
10	1.759	1.758	10
		more d-values	
10	1.627	1.625	3
		more d-values	
10	1.573	1.563	13
		more d-values	
5	1.387	1.390	25
		more d-values	
		1.225	3

TABLE 25

X-RAY DIFFRACTION DATA FOR TRIPPKEITE AND TWO SAMPLES OF SCHEELE'S GREEN FROM THE FORBES COLLECTION

TRIPPKEITE (ICDD 31-0451)[a]		SCHEELE'S GREEN FROM THE FORBES COLLECTION (IFA-NYU sample)[b]		SCHEELE'S GREEN FROM THE FORBES COLLECTION (GCI sample)[c]	
d-spacing	Intensity	Intensity	d-spacing	Intensity	d-spacing
6.07	55	100	10.3	30	4.61
4.30	14	10	4.66	20	4.18
3.84	8	20	4.48	30	4.03
3.40	3	5	4.02	100	3.11
3.16	100	20	3.46	10	2.79
3.04	45	20	3.11	1	2.69
2.79	6	80	2.713	1	2.62
2.72	35	10	2.500	70	2.49
2.53	15	5	1.773	60	2.39
2.44	1	5	1.693	10	2.31
2.38	1	10	1.571	1	2.13
2.34	35			30	2.08
2.26	15			60	1.95
2.19	3			1	1.70
2.15	1			30	1.67
2.08	2			30	1.64
2.05	2			20	1.47
2.00	7			10	1.44
1.95	35			20	1.39
1.92	7			30	1.33
1.82	3				
1.81	2				
1.72	1				
1.70	11				
1.67	14				
1.64	25				
1.47	10				
1.44	11				
1.39	16				

[a] Courtesy of the Smithsonian Institution, Washington, D.C.

[b] Institute of Fine Arts, New York University (Weber Forbes).

[c] Forbes Sackler Gallery Collection 9.06.7.

TABLE 26 X-RAY DIFFRACTION DATA FOR SOME COPPER ARSENITE PIGMENTS (EMERALD GREEN)

SCHWEINFURT GREEN As_2O_3 + CuO + Dilute CH_3COOH		COPPER ACETATE-ARSENITE $C_4H_6As_6Cu_4O_{16}$ (ICDD 1-51)		COPPER ACETATE-ARSENITE (ICDD 31-448)		COPPER ACETATE-ARSENITE (ICDD 31-448) *continued*	
d-spacing	Intensity	d-spacing	Intensity	d-spacing	Intensity	d-spacing	Intensity
10.5	100	10.0	100	9.71	100	2.63	9
9.21	100			6.76	25	2.62	40
6.67	10			5.36	5	2.58	20
4.68	50			4.86	9	2.55	35
4.48	50	4.55	12	4.70	11	2.49	25
3.91	50	3.99	12	4.53	100	2.48	2
3.46	50	3.48	8	3.93	95	2.46	9
3.35	30			3.71	5	2.43	5
3.27	30	3.30	4	3.48	80	2.41	60
3.04	70	3.06	20	3.38	55	2.38	12
2.667	80	2.68	24	3.28	70	2.36	6
2.403	20	2.40	4	3.18	8	2.31	7
2.254	10			3.09	45	2.26	14
1.772	5			3.07	60	2.25	65
1.698	10	1.69	8	3.06	80	2.18	17
1.623	10	1.62	4	2.98	10	2.15	5
1.566	10	1.55	8	2.73	55	2.12	10
1.457	10	1.45	4	2.71	80	2.11	16
				2.69	19	2.07	12
				2.68	100	2.00	16
				2.67	20		

TABLE 27

X-RAY DIFFRACTION DATA FOR SAMPLES OF EMERALD GREEN USED BY CLAUDE MONET AND FERNAND LÉGER COMPARED WITH COPPER ACETATE-ARSENITE

CLAUDE MONET'S EMERALD GREEN[a]		FERNAND LÉGER'S EMERALD GREEN[b]				COPPER ACETATE-ARSENITE (ICDD 31-448)		COPPER ACETATE-ARSENITE (ICDD 31-448) *continued*	
		LIGHT GREEN		BRIGHT GREEN					
d-spacing	Intensity	d-spacing	Intensity	d-spacing	Intensity	d-spacing	Intensity	d-spacing	Intensity
7.5	10	4.68	1	7.65	1	9.71	100	2.31	7
6.7	10	4.53	50	6.73	3	6.76	25	2.26	14
4.83	3	4.33	1	4.70	1	4.86	9	2.25	65
4.67	3	3.96	10	4.54	40	4.70	11	2.18	17
4.54	75	3.88	10	4.42	1	4.66	13	2.15	5
4.28	10	3.57	5	4.33	3	4.53	100	2.12	10
3.95	30	3.48	15	4.25	1	3.93	95	2.11	16
3.47	30	3.44	30	3.96	25	3.71	5	2.07	12
3.37	25	3.30	75	3.89	25	3.48	80	2.00	16
3.29	25	3.08	100	3.58	25	3.38	55		
3.06	100	2.83	15	3.48	20	3.28	70		
2.76	10	2.75	1	3.43	40	3.18	8		
2.68	50	2.71	25	3.31	50	3.09	45		
2.55	10	2.67	25	3.27	30	3.07	60		
2.47	5	2.55	1	3.09	100	3.06	80		
2.41	25	2.47	1	2.97	1	2.98	10		
2.24	5	2.41	1	2.83	10	2.73	55		
2.18	3	2.32	1	2.76	1	2.71	80		
2.11	3	2.21	40	2.72	30	2.69	19		
2.06	3	2.09	40	2.68	30	2.68	100		
1.89	5	2.04	1	2.62	10	2.67	20		
1.69	10	1.85	5	2.56	3	2.63	9		
1.62	10			2.48	8	2.62	40		
1.56	10			2.41	5	2.58	20		
1.53	5			2.32	1	2.55	35		
1.45	10			2.27	1	2.49	25		
				2.23	1	2.48	25		
				2.20	1	2.46	9		
				2.12	40	2.43	5		
				2.09	40	2.41	60		
				2.05	5	2.38	12		
				1.85	10	2.36	6		

After Fiedler and Bayard 1997.

[a] Claude Monet (French, 1840–1926), *Rocks at Belle Isle*, collections of the Art Institute of Chicago.

[b] Fernand Léger (French, 1881–1955), *Follow the Arrow*, collections of the Art Institute of Chicago.

TABLE 28

DEBYE-SCHERRER POWDER X-RAY DIFFRACTION DATA[a] FOR EMERALD GREEN PIGMENT FROM *CHRIST'S ENTRY INTO BRUSSELS IN 1899* BY JAMES ENSOR COMPARED WITH DATA FOR COPPER ACETATE-ARSENITE

JAMES ENSOR'S EMERALD GREEN[b]		COPPER ACETATE-ARSENITE (ICDD 31-488)		JAMES ENSOR'S EMERALD GREEN[b] *continued*		COPPER ACETATE-ARSENITE (ICDD 31-488)	
Intensity	d-spacing	Intensity	d-spacing	Intensity	d-spacing	Intensity	d-spacing
100	9.6	100	9.71	20	2.707	80	2.71
10	6.7	25	6.76	30	2.679	90	2.68
3	5.4	5	5.36	5	2.639	9	2.63
5	4.83	9	4.86	4	2.606		
8	4.67	11	4.70	60	2.564	20	2.58
70	4.53	100	4.53	10	2.477	25	2.48
10	4.14			8	2.408	60	2.41
60	3.95	95	3.93	5	2.250	65	2.25
10	3.73	5	3.71	5	2.191	17	2.18
45	3.49	80	3.48	4	2.132	10	2.12
10	3.36	55	3.38	15	1.915		
40	3.29	70	3.28	5	1.704		
10	3.105	8	3.18	5	1.628		
40	3.067	60	3.07	5	1.566		
5	2.965	10	2.98	5	1.383		
30	2.820			4	1.362		
20	2.753	55	2.73				

[a] Nickel-filtered copper k-alpha radiation: 10 hours exposure; 30 kV, 40 mA.

[b] James Ensor (Belgian, 1860–1949), *Christ's Entry into Brussels in 1889*, 1888, collections of the J. Paul Getty Museum (87.PA.96). See PLATE 63.

TABLE 29

X-RAY DIFFRACTION DATA FOR SAMPLE OF BLACKISH CORROSION CRUST FROM THE *JUGGLING FIGURE*[a] BY ADRIAEN DE VRIES COMPARED WITH DATA FOR BROCHANTITE

DE VRIES SAMPLE		BROCHANTITE (ICDD 13-398)		DE VRIES SAMPLE *continued*		BROCHANTITE (ICDD 13-398)	
Intensity	d-spacing	d-spacing	Intensity	Intensity	d-spacing	d-spacing	Intensity
20	7.9	7.8	8	20	2.397	2.386	14
20	7.15			20	2.284	2.3	8
70	6.43	6.38	40			2.282	1
20	5.97	5.89	5			2.266	14
		5.45	1	20	2.205	2.207	5
70	5.42	5.36	40			2.202	2
		5.15	6			2.19	14
		5.05	5	20	2.15	2.14	10
10	4.99	4.93	6			2.127	2
		4.77	1	20	2.096	2.099	2
40	4.36	4.38	1			2.079	8
		4.25	1	10	2.031		
100	3.93	3.9	85			2.016	8
10	3.57					2.002	2
10	3.37			10	1.975	1.969	8
60	3.22	3.19	40	10	1.828	1.885	4
10	2.982	2.983	1	60	1.748		
10	2.937	2.923	20	10	1.721		
20	2.81	2.813	4	10	1.682		
60	2.702	2.678	50	10	1.643		
		2.628	8	10	1.604		
10	2.617	2.601	18	10	1.568		
100	2.541	2.521	100	10	1.543		
60	2.481	2.466	10	10	1.512		

[a] Adriaen de Vries (Dutch, 1546–1626), *Juggling Figure*, ca. 1610–15, bronze, collections of the J. Paul Getty Museum (90.SB.44). See PLATE 85.

References

Accardo, G., C. Caneva, and S. Massa
1983 Stress monitoring by temperature mapping and acoustic emission analysis: A case study of Marcus Aurelius. *Studies in Conservation* 28:67–72.

Adib, D., and J. Ottemann
1972 Ein neues mineral, $(Cu,Zn)_2(OH)_3Cl$, aus der Kali-Kafi mine, Provinz Anarak, zentral Iran. *Neues Jahrbuch für Mineralogie: Monatschefte* 9:335–38.

Agricola, Johann
[1546] 1955 *De natura fossilum*. Trans. M. C. Bandy and J. A. Bandy. Geological Society of America Special Paper 63. Reprint, New York: Geological Society.

Albertus Magnus
1569 *De mineralibus et rebus metallicis*. Cologne, Germany: Apud I. Birckmannum and T. Baumium.

Aldaz, A., T. Espana, V. Montiel, and M. Lopez-Segura
1986 A simple tool for the electrolytic restoration of archaeological metallic objects with localized corrosion. *Studies in Conservation* 31:175–76.

Alexander, P., R. F. Hudson, and C. Earland
1963 *Wool: Its Chemistry and Physics*. London: Chapman and Hall.

Allen, I. M., D. Britton, and H. H. Coghlan
1970 *Metallurgical Reports on British and Irish Bronze Age Implements and Weapons in the Pitt Rivers Museum*. Occasional Papers in Technology Series no. 10. Oxford: Pitt Rivers Museum, University of Oxford.

Alunno-Rossetti, V., and M. Marabelli
1976 Analyses of the patinas of a gilded horse of St. Mark's Basilica in Venice: Corrosion mechanisms and conservation problems. *Studies in Conservation* 21:161–70.

Angelini, E., P. Bianco, E. D'Amicone, and L. Vigna
1990 Plasma-source mass spectrometric analysis of ancient Egyptian pigments. In *Pigments et colorants de l'antiquité et du moyen âge*, 117–26. Paris: Editions du Centre National de la Recherche Scientifique.

Aoyama, Y.
1960 Concerning green copper corrosion. *Die Naturwissenschaften* 47:202–3.

Apals, J., and Z. Apals
1998 Araisi Lake Fortress: A wet site excavation, preservation, and reconstruction project in Latvia. In *Hidden Dimensions: The Cultural Significance of Wetland Archaeology*, ed. K. Bernick, 123–43. Vancouver: Univ. of British Columbia Press.

Applebey, M. P., and K. W. Lane
1918 Double carbonates of sodium and potassium with the heavy metals. *Journal of the Chemical Society Transactions* 113:609–22.

Armenini, G. B.
1977 *On the True Precepts of the Art of Painting*. Trans. E. J. Olszewski. New York: Burt Franklin and Co.

Arwidsson, G., and G. G. Berg
1983 *The Mastermyr Find: A Viking Age Tool Chest from Gotland*. Kungl. Vitterhets Historie och Antikvitets Akademien. Stockholm: Almqvist and Witsell International.

Asmus, J. F.

1987 Lasers in conservation. *Conservation News* 34:9–10.

Avery, C.

1996 Lecture on Soldani's patination technique. Symposium, Von allen Seiten schoen, Berlin.

Baas Becking, L. G., I. R. Kaplan, and D. Moore

1960 Limits of the natural environment in terms of pH and oxidation-reduction potentials. *Journal of Geology* 68:243–84.

Balboian, R., and E. B. Cliver

1986 Corrosion on the Statue of Liberty: Part 1. *Materials Performance* 25:80.

Bandy, M. C., and J. A. Bandy, trans.

1955 *Agricola: De natura fossilum.* Geological Society of America Special Paper 63. New York: Geological Society.

Banik, G.

1989 Discoloration of green copper pigments in manuscripts and works of graphic arts. *Restaurator* 10:61–73.

1990 Green copper pigments and their alteration in manuscripts or works of graphic arts. In *Pigments et colorants de l'antiquité et du moyen âge,* 89–102. Paris: Editions du Centre National de la Recherche Scientifique.

Banik, G., H. Stachelberger, and O. Wächter

1982 Investigation of the destructive actions of copper pigments on paper and consequences for conservation. In *Science and Technology in the Service of Conservation,* 75–78. London: International Institute for Conservation of Historic and Artistic Works (IIC).

Barbour, D., and H. Lie

1987 Examination of plastic blasting media for use on outdoor bronzes. Report, Center for Conservation and Technical Studies, Harvard University Art Museums, Cambridge, Mass., June.

Barnard, N.

1961 *Bronze Casting and Bronze Alloys in Ancient China.* Monumenta Serica Monograph Series, no. 14. Canberra: Australian National University.

Bartolini, M., B. Colombo, M. Marabelli, A. Marano, and C. Parisi

1997 Non-destructive tests for the control of ancient metallic artifacts. In *Metal 95: Proceedings of the International Conference on Metals Conservation,* ed. I. D. MacLeod, S. L. Pennec, and L. Robbiola, 43–49. London: James and James.

Bassett, J.

1996 Treatment report on *Juggling Figure* by de Vries. Internal report, Department of Decorative Arts and Sculpture, J. Paul Getty Museum, Los Angeles.

Beale, A.

1975 A technical view of nineteenth-century sculpture. In *Metamorphoses in Nineteenth-Century Sculpture,* 29–56. Cambridge, Mass.: Fogg Art Museum, Harvard University.

1996 Understanding, restoring, and conserving ancient bronzes with the aid of science. In *The Fire of Hephaistos: Large Classical Bronzes from North American Collections,* 65–80. Cambridge, Mass.: Harvard University Art Museums.

Beale, A., and R. Smith

1987 An evaluation of the effectiveness of various plastic and wax coatings in protecting outdoor bronze sculpture exposed to acid deposition: A progress report. In *Conservation of Metal Statuary and Architectural Decoration in Open-Air Exposure,* 99–124. Rome: International Centre for the Study of the Preservation and the Restoration of Cultural Property (ICCROM).

Bearn, J. G.

1923 *The Chemistry of Paints, Pigments, and Varnishes.* London: Ernest Benn.

Benhamou, R.

1984 Verdigris and the entrepreneuse. *Technology and Culture* 25:171–81.

Benner Larsen, E.

1984 *Electrotyping.* Copenhagen: School of Conservation, Royal Art Academy.

1987 SEM-identification and documentation of tool marks and surface textures on the Gundestrup Cauldron. In *Recent Advances in the Conservation and Analysis of Artifacts,* comp. J. Black, 393–408. London: Summer Schools Press.

Bernardini, G. P., M. Corazza, F. Olmi, C. Sabelli, M. C. Squarcialupi, and R. Trosti-Ferroni

1992 The *Incredulità di San Tommaso* by Verrocchio: A mineral study of alteration patinas. *Science and Technology for Cultural Heritage* 1:177–89.

Berthelot, M. P. E.

1894 Sur l'altération lente des objets de cuivre, au sein de la terre et dans les musees. *Comptes Rendus Hebdomadaires des Séances de l'Académie des Sciences* 118:768–70.

1895 Etude sur les métaux qui composent les objets de cuivre de bronze d'étain d'or et d'argent, découverts dans les fouilles de Dahchour, ou provenant du Musée de Gizeh. In *Fouilles à Dahchour,* ed. J. de Morgan, 131–46. Vienna: A. Holzhausen.

1901 Sur l'altération lente des alliages métalliques contenant du cuivre, au contact simultané de l'air et des chlorures alcalines. *Annales de Chimie et de Physique Séries 7* 22:457–60.

Bertholon, R., B. Bell, J-M. Blengino, and N. Lacoudre
1997 Stabilisation de la corrosion d'un objet archéologique en alliage cuivreux par électrolyse à faible polarisation dans le sesquicarbonate de sodium: Dernières expériences. In *Metal 95: Proceedings of the International Conference on Metals Conservation,* ed. I. D. MacLeod, S. L. Pennec, and L. Robbiola, 209–19. London: James and James.

Bertholon, R., L. Garenne-Marot, J.-M. Blengino, and E. Durand
1995 De nouvelles approches de la lecture du rouleau de cuivre de Qumran; re-restauration minimale, radiographie-x et traitement d'image, moulage et galvaoplastie. In *Colloque sur la conservation et restauration des biens culturels,* 295–306. Paris: Association des restaurateurs d'art et d'archéologie de formation universitaire (ARAAFU).

Bewer, F. G.
1996 A study of the technology of Renaissance bronze statuettes. Ph.D. diss., Department of Conservation and Materials Science, Institute of Archaeology, University College, London.

Bewer, F. G., and D. A. Scott
1996 A bronze sculpture by Boizot and platinum coating. *Archaeometry* 34:125–311.

Bezur, A., and D. A. Scott
1996 Report on nauwamite as a corrosion on a Wallace Collection clock mount. Internal report, file no. 1103O96, GCI Museum Research Laboratory, Getty Conservation Institute, Los Angeles, June.

Bianchi, G., and P. Longhi
1973 Copper in seawater, potential-pH diagrams. *Corrosion Science* 13:853–64.

Bicchieri, M., and S. Pepa
1996 The degradation of cellulose with ferric and cupric ions in a low-acid medium. *Restaurator* 17:165–83.

Biestek, T., and M. Drys
1974 Corrosion products formed on copper in natural corrosion environments. *Powloki Ochronne* 2:21–24.

Birelli, G.
1601 *Opera.* Bk. 2, 369–70. Florence: G. Marescottus.

Birnie, L.
1993 Special finishes on non-ferrous metals at the National Maritime Museum. In *Metal Plating and Patination,* ed. S. LaNiece and P. Craddock, 148–54. Oxford, England: Butterworth-Heinemann.

Blattner, R., and R. J. Ferrier
1985 Effects of iron, copper, and chromate ions on the oxidative degradation of cellulose model compounds. *Carbohydrate Research* 138:73–82.

Block, I., N. Jensen, S. M. Sommer, and W. F. Buckingham
1987 Chloride leaching from outdoor bronzes. In *ICOM Committee for Conservation Preprints, 8th Triennial Meeting, Sydney, Australia, 6–11 September, 1987,* 1057–62. Marina del Rey, Calif.: Getty Conservation Institute.

Bockris, J. O.
1971 Potential-pH diagrams and the teaching of corrosion. *Corrosion Science* 11:889–92.

Bolingtoft, P., and M. C. Christensen
1993 Early Gothic wall paintings: An investigation of painting techniques and materials of 13th-century mural paintings in a Danish village church. In *ICOM Committee for Conservation 10th Triennial Meeting, Washington, D.C., USA, 22–27 August 1993, Preprints,* vol. 2:531–35. Paris: International Council of Museums.

Bomford, D., J. Kirby, J. Leighton, and A. Roy
1990 *Art in the Making: Impressionism.* London: National Gallery.

Born, H.
1993 Multi-colored antique bronze statues. In *Metal Plating and Patination,* ed. S. LaNiece and P. Craddock, 19–29. Oxford, England: Butterworth-Heinemann.

Bowron, E. P.
1999 A brief history of European oil paintings on copper. In *Copper as Canvas: Two Centuries of Masterpiece Paintings on Copper, 1575-1775, [organized by] Phoenix Art Museum,* 9–30. New York: Oxford Univ. Press.

Braithwaite, R. S. W.

1981 Turquoise crystals from Britain and a review of related species. *Mineralogical Record* 12:349–53.

Bridge, P. J., J. Just, and M. H. Hey

1979 Georgeite, a new amorphous copper carbonate from the Carr Boyd mine, Western Australia. *Mineralogical Magazine* 42:97–98.

Bridge, P. J., M. W. Pryce, R. M. Clarke, and M. B. Costello

1978 Sampleite from Jingemia cave, western Australia. *Mineralogical Magazine* 42:369–71.

Bridgman, C. F., P. Michaels, and H. F. Sherwood

1965 Radiography of a painting on copper by electron emission. *Studies in Conservation* 10:1–7.

Brill, R. H, S. S. C. Tong, and D. Dohrenwend

1991 Chemical analyses of some early Chinese glasses. In *Scientific Research in Early Chinese Glass*, ed. R. H. Brill and J. H. Martin, 31–64. New York: Corning Museum of Glass.

Brimblecombe, P.

1990 The composition of museum atmospheres. *Atmospheric Environment* 24B:1–8.

Bristow, I. C.

1996 *Architectural Color in British Interiors, 1615–1840*. London: Paul Mellon Centre for Studies in British Art; New Haven, Conn.: Yale Univ. Press.

Brostoff, L. B.

1997 Investigation into the interaction of benzotriazole with copper corrosion minerals and surfaces. In *Metal 95: Proceedings of the International Conference on Metals Conservation*, ed. I. D. MacLeod, S. L. Pennec, and L. Robbiola, 99–108. London: James and James.

Brostoff, L. B., and R. de la Rie

1997 Research into protective coating systems for outdoor bronze sculpture and ornamentation. In *Metal 95: Proceedings of the International Conference on Metals Conservation*, ed. I. D. MacLeod, S. L. Pennec, and L. Robbiola, 242–44. London: James and James.

Brown, B. F., H. C. Burnett, W. T. Chase, M. Goodway, J. Kruger, and M. Pourbaix, eds.

1977 *Corrosion and Metal Artifacts: A Dialogue between Conservators and Archaeologists and Corrosion Scientists*. National Bureau of Standards Special Publication no. 479. Washington, D.C.: U.S. Department of Commerce.

Brunner, M.

1993 Die Konservierung von Bronzeobjekten mit der AMT-Methode — eine Versuchsreihe. *Arbeitsblätter für Restauratoren* 26:268–69.

Brusic, V., M. A. Frisch, F. Novak, F. Kaufman, B. Rush, and G. Frankel

1991 Copper corrosion with and without inhibitors. *Journal of the Electrochemical Society* 138:2253–59.

Buck, R. D.

1970 Domenichino's copper plate. *Bulletin of the American Group, International Institute for Conservation* 2(1):12–15.

Bukhari, Y. K.

1963 Pigments. *Marg* (Bombay). Supplement to 16(2), sec. 7:ii–iii.

Burmester, A., and J. Koller

1985 Die romanischen Domtüren am Dom zu Augsburg. *Maltechnik Restauro* 4:9–23.

1987 Known and new corrosion products on bronzes: Their identification and assessment particularly in relation to organic protective coatings. In *Recent Advances in the Conservation and Analysis of Artifacts*, comp. J. Black, 97–103. London: Summer Schools Press.

Burmester, A., and C. Krekel

1998 The relationship between Albrecht Dürer's palette and fifteenth/sixteenth century pharmacy price lists: The use of azurite and ultramarine. In *Painting Techniques: History, Materials and Studio Practice*, ed. A. Roy and P. Smith, 101–5. IIC Dublin Conference. London: IIC.

Burnham, J.

1920 *A Classical Technology Edited from Codex Lucensis 490*. Boston: R. G. Badger.

Burton, Richard, trans.

[1886] 1974 *The Perfumed Garden of Shaykh Nefzawi*. Reprint, London: Neville Spearman.

Caley, E. R.

1926 The Leyden Papyrus X: An English translation with brief notes. *Journal of Chemical Education* 3:1149–66.

Camitz, G., and T. G. Vinka

1992 Corrosion of copper in Swedish soils. In *12th Scandinavian Corrosion Congress*, 1:729–38. Stockholm: Eurocorr.

Campbell, H. S., and D. J. Mills
1977 A marine treasure trove: A metallurgical examination. *The Metallurgist and Materials Technologist* 9:551–56.

Carabatos, C., M. Diffine, and M. Sieskind
1968 Fundamental vibrational bands of the cuprite lattice. *Journal de Physique* 29:529–33.

Cennini, Cennino d'Andrea
[1437] 1960 *The Craftsman's Handbook.* Trans. Daniel V. Thompson Jr. Reprint, New York: Dover Publications.

Chakrabarti, D. J., and D. E. Laughlin
1983 The copper-sulfur system. *Bulletin of Alloy Phase Diagrams* 4:254–70.

Chambers, E.
1738 *Cyclopaedia: An Universal Dictionary of Arts and Sciences,* s.v. "verdegrease." London: Midwinter.

Chaptal, J.
1809 Sur quelques couleurs trouvées à Pompeï. *Annales de Chimie* 70:22–31.

Chase, W. T.
1971 Egyptian blue as a pigment and ceramic material. In *Science and Archaeology,* ed. R. H. Brill, 80–90. Cambridge, Mass.: MIT Press.

1994 Chinese bronzes: Casting, finishing, patination, and corrosion. In *Ancient and Historic Metals, Conservation and Scientific Research,* ed. D. A. Scott, J. Podany, and B. B. Considine, 85–118. Marina del Rey, Calif.: Getty Conservation Institute.

Chase, W. T., and W. Quanyu
1997 Metallography and corrosion product studies on archaeological bronze fragments from the Qu Cun site. In *Materials Issues in Art and Archaeology,* vol. 5, ed. P. B. Vandiver, J. R. Druzik, J. F. Merkel, and J. Stewart, 73–80. Pittsburgh: Materials Research Society.

Chen, H. L., K. A. Jakes, and D. W. Foreman
1996 SEM, EDS, and FTIR examination of archaeological mineralized plant fibers. *Textile Research Journal* 66:219–24.

Christensen, C.
1993 The painting materials and techniques of Paul Gauguin. In *Studies in the History of Art 41: Conservation Research,* 63–103. Monograph Series no. 2. Washington, D.C.: National Gallery of Art.

Christman, B.
1989 Condition report for the Nike. In *The Gods Delight: The Human Figure in Classical Bronze,* ed. A. P. Kozloff and D. G. Mitten. Exhibition catalogue. Cleveland: Cleveland Museum of Art.

Church, A. H.
1865 Notes on a Cornish mineral of the atacamite group. *Journal of the Chemical Society,* 3d ser., 18:212–14.

1915 *The Chemistry of Paints and Painting.* 4th ed. London: Seeley, Service and Co.

Clark, S.
1998 The conservation of wet collodion positives. *Studies in Conservation* 43:231–41.

Coedes, G.
1923 Bronzes Khmers. *Ars Asiatica* 5:13–16.

Collins, W. F.
1934 The mirror-black and "quicksilver" patinas of certain Chinese bronzes. *Journal of the Royal Anthropological Institute* 64:69–79.

Comizzoli, R. B., R. P. Frankenthal, R. E. Lobing, G. A. Peins, L. A. Psota-Kelty, D. J. Siconolfi, and J. D. Sinclair
1993 Corrosion of electronic materials and devices by submicron atmospheric particles. *Interface News* 23:314–19.

Cooke, R. B. S., and S. Aschenbrenner
1975 The occurrence of metallic iron in ancient copper. *Journal of Field Archaeology* 2:251–66.

Cooney, J. D.
1966 On the meaning of hasty km. *Zeitung für Ägyptische Sprache und Altertumskunde* 93:43–47.

Corfield, M.
1993 Copper plating on iron. In *Metal Plating and Patination,* ed. S. LaNiece and P. Craddock, 276–83. Oxford, England: Butterworth-Heinemann.

Costas, L. P.
1982 Atmospheric corrosion of copper alloys exposed for 15 to 20 years. In *Atmospheric Corrosion of Metals,* ed. S. W. Dean Jr. and E. C. Rhea, 60–84. Philadelphia: ASTM.

Cottam, C. A., D. C. Emmony, J. Larson, and J. Newman
1997 Laser cleaning of metals at infra-red wavelengths. In *Lacona 1: Lasers in the Conservation of Artworks,* 95–98. Vienna: Mayer and Co.

Cotton, F. A., and G. Wilkinson

1967 *Advanced Inorganic Chemistry: A Comprehensive Text.* London: Interscience Publishers.

Cotton, J., and I. Scholes

1967 Benzotriazole and related compounds as corrosion inhibitors for copper. *British Corrosion Journal* 2:1–5.

Cottrell, A.

1975 *An Introduction to Metallurgy.* London: Edward Arnold.

Craddock, P. T.

1995 *Early Metal Mining and Production.* Edinburgh: Edinburgh Univ. Press.

Craddock, P. T., and A. Giumlia-Mair

1993 Hsmn-Km, Corinthian bronze, Shakudo: Black patinated bronze in the ancient world. In *Metal Plating and Patination,* ed. S. LaNiece and P. Craddock, 101–27. Oxford, England: Butterworth-Heinemann.

Crosland, M. P.

1962 *Historical Studies in the Language of Chemistry.* Cambridge, Mass.: Harvard Univ. Press.

Dahlen, M. A.

1939 The phthalocyanines: A new class of synthetic pigments and dyes. *Industrial and Engineering Chemistry* 31:839–47.

Daniels, V., and M. Leese

1995 The degradation of silk by verdigris. *Restaurator* 16:45–63.

Daniels, V., and S. Ward

1982 A rapid test for the detection of substances which will tarnish silver. *Studies in Conservation* 27:58–60.

Daubree, A.

1875 Sur la formation contemporaine dans la source thermales de Bourbonne-les-Bains (Haute Marne) de diverses espèces minerales cristallisées, notamment du cuivre gris antimonial (tetraedrite), de la pyrite de cuivre (chalkopyrite), du cuivre panache (philippsite) et du cuivre sulfure (chalkosine). *Comptes Rendus Hebdomadaires des Séances de l'Académie des Sciences* 80:461–69.

1881 Cuivre cristallisé (cupreine), formé aux dépens de médailles antiques, en dehors de sources thermales, à Flines-les-Roches, départment du Nord. *Comptes Rendus Hebdomadaires des Séances de l'Académie des Sciences* 93:572–74.

Davy, Humphry

1815 Some experiments and observations on the colors used in painting by the ancients. *Philosophical Transactions of the Royal Society of London* 105:97–124. London: W. Nichol.

1824 On the corrosion of copper sheeting by sea water and on methods of preventing this effect. *Philosophical Transactions of the Royal Society of London* 115:151–58. London: W. Nichol.

Davy, John

1826 Observations on the changes which have taken place in some ancient alloys of copper. *Philosophical Transactions of the Royal Society of London,* pt. 3, 116:55–59. London: W. Nichol.

Dawson, J.

1988 Ulick Evans and the treatment of bronze disease in the Fitzwilliam Museum, 1948–1980. In *Early Advances in Conservation,* ed. V. Daniels, 71–80. British Museum Occasional Paper no. 65. London: British Museum

Dean, S. W., Jr., and E. C. Rhea, eds.

1982 *Atmospheric Corrosion of Metals.* American Society for Testing and Materials Special Technical Publication 767. Philadelphia: ASTM.

De Gouvernain

1875 Die Sulfatbildung auf Kupfer und Eisen durch lange Lagerung in den heissen Quellen von Bourbon-l'Archambault. *Comptes Rendus Hebdomadaires des Séances de l'Académie des Sciences* 80:1297–1300.

Dei, L., A. Ahle, P. Baglioni, D. Dini, and E. Ferroni

1998 Green degradation products of azurite in wall paintings: Identification and conservation treatment. *Studies in Conservation* 43:80–88.

Del Bino, G., ed.

1997 *European Cultural Heritage Newsletter on Research, 10.* European Commission Directorate General, sect. 12: Science, Research and Development. Brussels: Environment and Climate Research Programme, European Commission.

Delbourgo, S. R.

1980 Two Far Eastern artefacts examined by scientific methods. In *International Symposium on the Conservation and Restoration of Cultural Property: Conservation of Far Eastern Art Objects,* 163–79. Tokyo: Tokyo National Research Institute of Cultural Property.

de Meester, P., S. R. Fletcher, and A. C. Skspski

1973 Refined crystal structure of tetra-μ-acetato-bisdiaquocopper (II). *Journal of the Chemical Society: Dalton Transactions* 46:2575–78.

Dews, H. C.

1930 *The Metallurgy of Bronze.* Vol. 1. London: Pitman and Sons.

Dickson, M. B., and S. C. Welch

1981 Appendix 1: The canons of painting by Sadiqi Bek. In *The Houghton Shahnameh,* vol. 1, 259–69. Cambridge, Mass: Harvard Univ. Press.

Dioscorides, Pedanius, of Anazarbos

[1933] 1968 *The Greek Herbal of Dioscorides.* Reprint, London and New York: Hafner Publishing.

Dodwell, C. R., ed.

1961 *Theophilus: De diversis artibus.* London: Thomas Nelson.

Drayman-Weisser, T.

1994 A perspective on the history of the conservation of archaeological bronze objects in the United States. *Journal of the American Institute for Conservation* 33:141–52.

Drayman-Weisser, T., ed.

2000 *Gilded Metal Surfaces: Proceedings of the AIC Conference, St. Paul, Minnesota, 4–6 June 1995.* London: Archetype Books.

Duncan, S. J., and H. Ganiaris

1987 Some sulfide corrosion products on copper alloys and lead alloys from London waterfront sites. In *Recent Advances in the Conservation and Analysis of Artifacts,* comp. J. Black, 109–18. London: Summer Schools Press.

Eastlake, C. L.

1847 *Materials for a History of Oil Painting.* London: Longman, Brown, Green, and Longmans.

Ebbell, B.

1937 *The Papyros Ebers.* London: Oxford Univ. Press.

Ebers, G.

1875 *Papyrus Ebers: Das hermetische Buch über die Arzneimittel der Alten Ägypter in hieratischer Schrift.* Leipzig, Germany: Verlag Engelmann.

Edmonds, P.

1997 A technical examination, investigation, and treatment of a fifteenth-century Sienese polychrome terra-cotta relief. In *Conservation Research 1996/1997,* 67–92. Studies in the History of Art 57. Washington, D.C.: National Gallery of Art.

Eggert, G.

1996 The enigmatic "battery of Baghdad." *Skeptical Inquirer* 20(3):31–34.

Eggert, G., H. Kutzke, and G. Wagner

1999 The use of sulphur in hollow ancient gold objects. *Journal of Archaeological Science* 26:1089–92.

El Goresy, A., H. Gasket, M. A. Razek, and K. L. Weiner

1986 *Ancient Pigments in Wall Paintings of Egyptian Tombs and Temples: An Archaeometric Project.* Heidelberg, Germany: Max Planck Institute für Kernphysik.

Encyclopedia Britannica

1898 9th ed. Edinburgh: Adam and Charles Black.

Erhardt, D., W. Hopwood, T. Padfield, and N. F. Veloz

1984 The durability of Incralac: Examination of a ten year old treatment. In *ICOM Committee for Conservation 7th Triennial Meeting, Copenhagen, 10–14 September 1984 Preprints,* 84.22.1–3. Paris: ICOM Committee for Conservation.

Ericsson, R., and T. Sydberger

1977 Corrosion products formed on copper exposed to humid SO_2-containing atmospheres. *Werkstoffe und Korrosion* 28:755–57.

Eriksson, P., L.-G. Johansson, and J. Gullman

1993 A laboratory study of corrosion reactions on statue bronze. *Corrosion Science* 34:1083–97.

Eriksson, P., L.-G. Johansson, and H. Strandberg

1993 Initial stages of copper corrosion in humid air containing SO_2 and NO_2. *Journal of the Electrochemical Society* 140:53–59.

Evans, U. R.

1951 The corrosion situation: Past, present and future. *Chemistry and Industry* 70 (25 August):706–11.

1960 *The Corrosion and Oxidation of Metals: Scientific Principles and Practical Applications.* London: Edward Arnold.

Fabrizi, M., H. Ganiaris, S. Tarling, and D. A. Scott

1989 The occurrence of sampleite, a complex copper phosphate, as the principal corrosion product on ancient Egyptian bronzes from Memphis, Egypt. *Studies in Conservation* 34:45–51.

Fabrizi, M., and D. A. Scott

1987　Unusual copper corrosion products and problems of identity. In *Recent Advances in the Conservation and Analysis of Artifacts,* comp. J. Black, 131–33. London: Summer Schools Press.

Faltermeier, R. B.

1995　The evaluation of corrosion inhibitors for application to copper and copper alloy archaeological artefacts. Ph.D. diss., Institute of Archaeology, University College, London.

Fang, G., Z. Liu, Z. Zhang, Y. Hu, I. A. Ashur, and K. L. Yao

1996　Preparation of SnO_2-CuO nanocrystalline powders in two different ways by the sol-gel method. *Physicia Status Solidi,* ser. A, 156:15–22.

Fang, S. B., C. Olson, and D. Lynch

1986　A photoemission study of benzotriazole on clean copper and cuprous oxide. *Surface Science* 176:476–90.

Federici, V.

1969　*Le porte bizantine di San Marco.* Venice: Edizioni dello Stadium Cattolico Veneziano.

Fiedler, I., and M. A. Bayard

1986　Cadmium yellows, oranges and reds. In *Artists' Pigments,* vol. 1, ed. R. L . Feller, 65–108. Cambridge: Cambridge Univ. Press; Washington, D.C.: National Gallery of Art.

1997　Emerald green and Scheele's green. In *Artists' Pigments,* vol. 3, ed. E. W. Fitzhugh, 219–72. Oxford: Oxford Univ. Press; Washington, D.C.: National Gallery of Art.

Field, G.

1835　*Chromatography; or, a Treatise on Colours and Pigments and of Their Powers in Painting.* London: Charles Tilt.

Finger, L. W., R. M. Hazen, and R. J. Hemley

1989　$BaCuSi_2O_6$: A new cyclosilicate with four-membered tetrahedral rings. *American Mineralogist* 74:952–55.

Fink, C. G.

1948　Periodic formation of corrosion products. In *The Corrosion Handbook,* ed. H. H. Uhlig, 103. New York: John Wiley and Sons.

Fink, C. G., and C. D. Polushkin

1936　Microscopic study of ancient bronze and copper. *Transactions of the American Institute of Mining and Metallurgy* 122:90–120.

Fiorentino, P., M. Marabelli, M. Matteini, and A. Moles

1982　The condition of the *Door of Paradise. Studies in Conservation* 27:145–53.

Fishlock, D.

1976　*Metal colouring.* Middlesex, England: R. Draper.

Fitzhugh, E. W.

1979　A pigment census of ukiyo-e paintings in the Freer Gallery of Art. *Ars Orientalis* 11:27–38.

1988　Appendix 9: Study of pigments on selected paintings from the Vever Collection. In *An Annotated and Illustrated Checklist of the Vever Collection,* ed. G. D. Lowry and M. C. Beach. Washington, D.C., Seattle, London: Arthur M. Sackler Gallery, Univ. of Washington Press.

Fitzhugh, E. W., and L. Zycherman

1992　A purple barium copper silicate pigment from early China. *Studies in Conservation* 37:145–54.

Fjaestad, M., A. G. Nord, and K. Tronner

1997　The decay of archaeological copper-alloy artefacts in the soil. In *Metal 95: Proceedings of the International Conference on Metals Conservation,* ed. I. D. MacLeod, S. L. Pennec, and L. Robbiola, 32–35. London: James and James.

Fleischer, M., R. E. Wilcox, and J. J. Matzko

1984　*Microscopic Determination of the Nonopaque Minerals.* U.S. Geological Survey Bulletin 1627. Washington D.C.: U.S. Government Printing Office.

Flieder, F.

1968　Mise au point des techniques d'identification des pigments et des liants inclus dans la couche picturale des enluminures de manuscrits. *Studies in Conservation* 13:60–62.

Florian, M-L. E.

1987　The underwater environment. In *The Conservation of Marine Archaeological Objects,* ed. C. Pearson, 1–20. London: Butterworths.

Foley, R. T.

1977　Measures for preventing corrosion of metals. In *Corrosion and Metal Artifacts: A Dialogue between Conservators and Archaeologists and Corrosion Scientists,* ed. B. F. Brown, H. C. Burnett, W. T. Chase, M. Goodway, J. Kruger, and M. Pourbaix, 67–76. National Bureau of Standards Special Publication no. 479. Washington, D.C.: U.S. Department of Commerce.

Fontana, F.

1778 Analyse de la malachite. *Journal de Société Française de Physique* 11:509–21.

Foord, E. E., and J. E. Taggart

1998 A re-examination of the turquoise group: The mineral aheylite, planerite (redefined), turquoise and coeruleolactite. *Mineralogical Magazine* 62:93–111.

Formigli, E.

1991 Die Restaurierung einer griechischen Groß-bronze aus dem Meer von Riace/Italien. In *Archaeologische Bronzen. Antike Kunst, moderne Technik,* ed. H. Born, 168–74. Berlin: Dietrich Reimer Verlag.

Fougue, M. F.

1889 Sur le bleu égyptien ou vestorien. *Bulletin de la Société Française de Minéralogie* 12:36–38.

Fowles, G.

1915 Note on the basic copper formates. *Journal of the Chemical Society* 107:1281–82.

Fox, C.

1946 *A Find of the Early Iron Age from Llyn Cerrig Bach, Anglesey.* Cardiff: National Museum of Wales.

Fox, G. L.

1995 A note on the use of alkaline dithionite for treatment ancient bronze artifacts. *Studies in Conservation* 40:139–42.

France-Lanord, A.

1952 Les techniques métallurgiques appliquées à l'archéologie. Bronze anciens: corrosion et conservation. *Revue de Métallurgie* 49:411–22.

1965 Savoir "interroger" l'objet avant de le restaurer. *Archeologia* 6:8–13.

Franey, J. P., and M. E. Davis

1987 Metallographic studies of the copper patina formed in the atmosphere. *Corrosion Science* 27:659–68.

Freestone, I. C.

1987 Composition and microstructure of early opaque red glasses. In *Early Vitreous Materials,* ed. M. Bimson and I. C. Freestone, 173–91. British Museum Occasional Paper 56. London: British Museum.

Freestone, I. C., and D. J. Barber

1992 The development of the color of sacrificial red glaze with special reference to a Qing dynasty saucer dish. In *Chinese Copper Red Wares,* ed. R. E. Scott, 53–62. Percival David Foundation of Chinese Art Monograph Series no. 3. London: University of London.

Frondel, C.

1950 On paratacamite and some related copper chlorides. *Mineralogical Magazine* 29:34–45.

Frondel, C., and R. J. Gettens

1955 Chalconatronite, a new mineral from Egypt. *Science* 122:75–76.

Gale, N. H., Z. A. Stos-Gale, P. Woodhead, and K. Annetts

1997 Tin and copper isotope anomalies in archaeology. In *Archaeology at Oxford: Report of the Committee for Archaeology 1995-6,* vol. 32. Oxford, England: University of Oxford.

Galen

1928 *Galeni Opera Omni.* Trans. J. Walsh. Vol. 12, chap. 3, bk. 9. Leipzig, Germany: Lipsiae Knoblech.

Ganorkar, M. C., V. Pandit Rao, P. Gayathri, and T. A. Sreenivasa Rao

1988 A novel method for conservation of copper-based artifacts. *Studies in Conservation* 32:97–101.

Garrels, R. M.

1954 Mineral species as functions of pH and oxidation-reduction potentials, with special reference to the zone of oxidation and secondary enrichment of sulfide ore deposits. *Geochimica et Cosmochimica Acta* 5:153–68.

Garrels, R. M., and C. L. Christ

1965 *Solutions, minerals and equilibria.* Harper International Student Reprint. New York: Harper and Row.

Garrels, R. M., and R. M. Dreyer

1952 Mechanism of limestone replacement at low temperatures and pressures. *Bulletin of the Geological Society of America* 63:325–80.

Garrels, R. M., and F. T. Mackenzie

1971 *Evolution of Sedimentary Rocks.* New York: W. W. Norton.

Gates, C. B.

1911 The replacement of the metals in non-aqueous liquids and the solubility of metals in oleic acid. *Journal of Physical Chemistry* 15:97–146.

Gaurico, Pomponio

1969 *De sculptura, 1504: Pomponius Gauricus.* Ed. and trans. André Chastel and Robert Klein. Hautes études médiévales et modernes, no. 5. Geneva, Switzerland: Droz.

Gauthier, J.

1958 Etude de quelques propriétés des sels neutres et basiques de cuivre des acides formique, acétique, propionique & Propositions données par la Faculté. Ph.D. diss., Procede Sertic, l'Université de Paris, Lyons, 17–19, 27– 43.

Geilmann, W.

1956 Verwitterung von Bronzen im Sandboden. *Angewandte Chemie* 68:201–12.

Geilmann, W., and K. Meisel

1942 Röntgenographische Untersuchungsmethoden in der Vorgeschichtsforschung: Libethenite, ein Mineral der Patinabildung. *Nachrichtenblatt für Deutsche Vorzeit* 18:208–12.

Gentele, J. G.

1906 *J. G. Gentele's Lehrbuch der Farbenfabrikation. Anweisung zur Darstellung, Untersuchung und Verwendung der im Handel vorkommenden Malerfarben.* 3d ed. Vol. 2, rev. A. Buntrock, 309–401. Braunschweig, Germany: Vieweg.

Gettens, R. J.

1933 Mineralization, electrolytic treatment, and radiographic examination of copper and bronze objects from Nuzi. *Technical Studies in the Field of Fine Arts* 1:119–42.

1959 The Freer Gallery laboratory for technical studies in Oriental art and archaeology. *Studies in Conservation* 4:140–45.

1963a The corrosion products of metal antiquities. In *Annual Report to the Trustees of the Smithsonian Institution for 1963,* 547–68. Washington, D.C.: Smithsonian Institution.

1963b Addendum to "Mineral alteration products on ancient metal objects." Paper presented at the 4th joint meeting of the ICOM Committee for Museum Laboratories and of the Sub-Committee for the Care of Paintings, 16–23 September, Leningrad/Moscow.

1964 The corrosion products of metal antiquities. In *Smithsonian Report for 1963,* 547–68. Publication 4588. Washington, D.C.: Smithsonian Institution.

1969 *The Freer Chinese Bronzes*. Vol. 2, *Technical Studies.* Washington, D.C.: Freer Gallery of Art, Smithsonian Institution.

Gettens, R. J., and E. W. Fitzhugh

1966 Azurite and blue verditer. *Studies in Conservation* 11:54–61.

1974 Malachite and green verditer. *Studies in Conservation* 19:2–23.

Gettens, R. J., and C. Frondel

1955 Chalconatronite: An alteration product on some ancient Egyptian bronzes. *Studies in Conservation* 2:64–75.

Gettens, R. J., and G. Stout

1966 *Painting Materials: A Short Encyclopedia.* New York: Dover Publications.

Giangrande, C.

1987 Identification of bronze corrosion products by infrared absorption spectroscopy. In *Recent Advances in the Conservation and Analysis of Artifacts,* comp. J. Black, 135–48. London: Summer Schools Press.

Gilberg, M.

1988 The history of bronze disease and its treatment. In *Early Advances in Conservation,* ed. V. Daniels, 59–70. British Museum Occasional Paper no. 65. London: British Museum.

Gillard, R. D., and S. M. Hardman

1996 Investigation of fiber mineralization using Fourier transform infrared microscopy. In *Archaeological Chemistry,* ed. M. V. Orna, 173–86. ACS Symposium Series no. 625. Washington D.C.: American Chemical Society.

Gillard, R. D., S. M. Hardman, R. G. Thomas, and D. E. Watkinson

1994 The mineralization of fibres in burial environments. *Studies in Conservation* 39:132–40.

Giumlia-Mair, A.

1996 Das Krokodil und Amenemhat III aus el-Faiyum. *Antike Welt* 4:313–21, 340.

1998 Hellenistic niello. In *Proceedings of the Fourth International Conference on the Beginning of the Use of Metals and Alloys,* 109–14. Tokyo: Japan Institute of Metals.

Giumlia-Mair, A., and S. LaNiece

1998 Early niello decoration on the silver rhyton in the Trieste Museum. In *The Art of the Greek Goldsmith,* 139–45. London: British Museum Publications.

Giumlia-Mair, A., and M. Lehr

1998 Patinating black bronzes: Texts and tests. In *Proceedings of the Fourth International Conference on the Beginning of the Use on Metals and Alloys,* 103–8. Tokyo: Japan Institute of Metals.

Giumlia-Mair, A., and S. Quirke

1997 Black copper in Bronze Age Egypt. *Revue d'Egyptologie* 48:95–108.

Gmelin

1955 *Gmelins Handbuch der anorganischen Chemie.*
Sect. 1, s.v. "Kupfer: Systemnummer 60 Bd. Cu."
Weinheim, Germany: Verlag Chemie.

1965 *Gmelins Handbuch der anorganischen Chemie.*
Vol. B, sect. 3, s.v. "Kupfer: Systemnummer 60 Bd. Cu.
[B]," 962–67. Weinheim, Germany: Verlag Chemie.

1966 *Gmelins Handbuch der anorganischen Chemie.*
Vol. B, sect. 4, s.v. "Kupfer: Systemnummer 60 Bd. Cu.
[B]," 1555–64. Berlin and New York: Springer-Verlag.

Goble, R. J.

1980 Copper sulfides from Alberta: Yarrowite and
spionkopite. *Canadian Mineralogist* 18:511–18.

Goodburn-Brown, D.

1996 The effect of various conservation treatments
on the surface of metals from waterlogged sites in
London. In *Archaeological Conservation and Its Conse-
quences: Preprints of the Contributions to the Copen-
hagen Congress, 26–30 August 1996,* ed. A. Roy and
P. Smith, 59–64. London: IIC.

1997 Surface studies on metals from waterlogged
sites. In *Metal 95: Proceedings of the International
Conference on Metals Conservation,* ed. I. D. MacLeod,
S. L. Pennec, and L. Robbiola, 61–66. London: James
and James.

Graaf, J. A. van de

1958 *Het De Mayerne Manuscript als bron voor de
schildertechnick van de barok.* British Museum, Sloane
manuscript 2052. Mijdrecht, Netherlands: Drukkerij
Verweij.

1972 Development of oil paint and the use of metal
plates as a support. In *Conservation and Restoration
of Pictorial Art,* ed. N. Brommelle and P. Smith, 43–53.
London: Butterworths.

Graedel, T. E.

1987a Copper patinas formed in the atmosphere 2:
A qualitative assessment of mechanisms. *Corrosion
Science* 27:721–40.

1987b Copper patinas formed in the atmosphere 3: A
semi-quantitative assessment of rates and constraints
in the greater New York metropolitan area. *Corrosion
Science* 27:741–70.

Graedel, T. E., C. McCrory-Joy, and J. P. Franey

1986 Potential corrosion of metals by atmospheric
organic acids. *Journal of the Electrochemical Society*
133:452–53.

Graedel, T. E., K. Nassau, and J. P. Franey

1987 Copper patinas formed in the atmosphere 1:
An introduction. *Corrosion Science* 27:685–94.

Granger, A.

1933 Le bleu assyrien. *Revue d'Assyrologie*
30:150–51.

Green, L. R.

1995 Recent analysis of pigments from ancient
Egypt. In *Conservation in Ancient Egyptian Collec-
tions,* ed. C. E. Brown, F. Macalister, and M. M.
Wright, 85–92. London: Archetype Publications.

Green, L. R., and D. Thickett

1995 Testing materials for use in the storage and
display of antiquities—a revised methodology. *Studies
in Conservation* 40:145–53.

Grzywacz, C. M.

1993 Using passive sampling devices to detect pol-
lutants in museum environments. In *ICOM Committee
for Conservation 10th Triennial Meeting, Washington,
D.C., USA, 22–27 August 1993, Preprints,* vol. 2, 610–
15. Paris: ICOM Committee for Conservation.

Grzywacz, C. M., and N. H. Tennent

1994 Pollution monitoring in storage and display
cabinets: Carbonyl pollutant levels in relation to arti-
fact deterioration. In *IIC Ottawa Congress, 12–16 Sep-
tember 1994,* 12–16. London: IIC.

Guardian Weekly Newspaper

1997 26 October, vol. 157, no. 17, 15–16.

Guthrie, R. E., and S. H. Laurie

1968 The binding of copper (II) to mohair keratin.
Australian Journal of Chemistry 21:2437–43.

**Gutscher, D., B. Mühlethaler, A. Portmann, and
A. Reller**

1989 Conversion of azurite into tenorite. *Studies in
Conservation* 34:117–22.

Haber, G. J., and M. Heimler

1994 Kupfergalvanoplastik: Geschichte, Herstel-
lungstechniken und Restaurierungproblematik kunst-
industrieller Katalogware. In *Metallrestaurierung:
Beiträge zur Analyse. Konzeption und Technologie,* ed.
P. Heinrich, 160–81. Munich: Georg D. W. Callwey.

Hack, H. P.

1987 Evaluation of galvanic corrosion. In *Metals
Handbook,* 9th ed., vol. 13, 234–38. Metals Park, Ohio:
ASM International.

Halpine, S. M.

1996 An improved dye and lake pigment analysis method for high-performance liquid chromatography and diode-array detector. *Studies in Conservation* 41:76–94.

Harbottle, G., and P. C. Weigard

1992 Turquoise in Pre-Columbian America. *Scientific American* 266:78–85.

Harley, R. D.

1970 *Artists' Pigments, c. 1600–1835.* London: IIC and Butterworths.

Harris, R.

1994 The treatment of outdoor metal sculpture in the United States. *Conservation News* 54:15–17.

Hawley, J. K.

1996 Celtic finds in Basel: Testing the conservator's stamina. In *Archaeological Conservation and Its Consequences,* ed. A. Roy and P. Smith, 76–81 London: IIC.

Heidersbach, R. H., and E. D. Verink

1972 Dezincification of alpha and beta brasses. *Corrosion* 28:397–418.

Helmi, F. M., and N. Y. Iskander

1985 X-ray study, treatment and conservation of Rameses the II's stove from the Egyptian Museum, Cairo. *Studies in Conservation* 30:23–30.

Henderson, J.

1991 Analysis of Roman enamels from Britain. In *Archaeometry 90,* ed. E. Pernicka and G. A. Wagner, 285–94. Basel, Switzerland: Birkhauser Verlag.

Herrmann, J. J., Jr.

1988 Entries 63–65 in *The Gods Delight: The Human Figure in Classical Bronze,* ed. A. P. Kozloff and D. G. Mitten. Exhibition catalogue. Cleveland: Cleveland Museum of Art.

Hill, J. W., S. J. Baum, and D. M. Feigl

1997 *Chemistry and Life: An Introduction to General, Organic and Biological Chemistry.* 5th ed. Upper Saddle River, N.J.: Prentice Hall.

Hill, L. L.

1854 *Photographic Researches and Manipulations Including the Author's Former Treatise on Daguerreotype.* 2d ed. Philadelphia: Myron Shew.

Hiorns, A. H.

1892 *Metal Coloring and Bronzing.* London: Macmillan.

Hjelm-Hansen, N.

1984 Cleaning and stabilization of sulfide-corroded bronzes. *Studies in Conservation* 29:17–20.

Hollander, O., and R. C. May

1985 The chemistry of azole copper corrosion inhibitors in cooling water. *Corrosion* 41:39–45.

Holm, R., and E. Mattsson

1982 Atmospheric corrosion tests of copper and copper alloys in Sweden: 16 year results. In *Atmospheric Corrosion of Metals,* ed. S. W. Dean Jr. and E. C. Rhea, 85–104. Philadelphia: ASTM.

Horie, C. V., and J. A. Vint

1982 Chalconatronite: A by-product of conservation? *Studies in Conservation* 27:185–86.

Horovitz, I.

1986 Paintings on copper supports: Techniques, deterioration and conservation. *Conservator* 10:44–48.

1999 The materials and techniques of European paintings on copper supports. In *Copper as Canvas: Two Centuries of Masterpiece Paintings on Copper, 1575–1775, [organized by] Phoenix Art Museum,* 9–30. New York: Oxford Univ. Press.

Howe, E.

1994 Examination and treatment report for nose ornament. Internal report, acct. no. 1979.206.1230, Department of Primitive Art, The Metropolitan Museum of Art, New York.

Hughes, R.

1993 Artificial patination. In *Metal Plating and Patination,* ed. S. LaNiece and P. Craddock, 1–18. Oxford, England: Butterworth-Heinemann.

Hughes, R., and M. Rowe

1982 *The Coloring, Bronzing, and Patination of Metals: A Manual for the Fine Metal Worker and Sculptor.* London: Crafts Council.

Hummer, C. W., C. R. Southwell, and A. L. Alexander

1968 Corrosion of metals in tropical environments: Copper and wrought copper alloys. *Materials Protection* 7:41–47.

Hunt, L. B.

1973 The early history of gold plating: A tangled tale of disputed priorities. *Gold Bulletin* 6:16–27.

Hunt, W. H.

1880 The present system of obtaining materials in use by artist painters, as compared with that of the old masters. *The Journal of the Society of Arts* 28:485–99.

Hurlbut, C. S., Jr.
1942 Sampleite, a new mineral from Chuquica-mata, Chile. *American Mineralogist* 27:586–89.

Imhoff, C. E.
1953 Identification of corrosion products according to crystal structure. *Corrosion* 9:209-13.

International Centre for Diffraction Data (ICDD)
1982 *ICDD Powder Diffraction File—Organic Phases.* Joint Committee on Powder Diffraction Standards. Swarthmore, Penn.: ICDD.

1989 *ICDD Powder Diffraction File—Inorganic Phases.* Joint Committee on Powder Diffraction Standards. Swarthmore, Penn.: ICDD.

Ives, D. J. G., and A. E. Rawson
1962 Copper corrosion. *Journal of the Electrochemical Society* 109:447-65.

Jack, J. F. S.
1951 The cleaning and preservation of bronze statues. *Museum Journal* 50:231-33.

Jaeschke, H., and R. Jaeschke
1988 Early conservation techniques in the Petrie Museum. In *Conservation of Ancient Egyptian Materials,* ed. S. C. Watkins and C. E. Brown, 17-24. London: Institute of Archaeology Publications.

Jaffé, D.
1989 Two bronzes in Poussin's *Studies of Antiquities. J. Paul Getty Museum Journal* 17:39-46.

Jambor, J., J. Dutrizac, A. Roberts, J. Grice, and J. Szymanski
1996 Clinoatacamite, a new polymorph of $Cu_2(OH)_3Cl$, and its relation to paratacamite and "anarkite." *Canadian Mineralogist* 34:61-65.

Jedrzejewska, H.
1976 A corroded Egyptian bronze: Cleaning and discoveries. *Studies in Conservation* 21:101-14.

Johansson, E.
1998 Corrosivity measurements in indoor atmospheric environments: A field study. Licentiate thesis, Department of Materials Science and Engineering, Division of Corrosion Science, Royal Institute of Technology, Stockholm.

Johansson, E., B. Rendahl, and V. Kucera
1998 Field exposure in indoor environments as a basis for the development of a classification system for atmospheric corrosivity. In *Corrosion '98,* 359/1-12. Houston: National Association of Corrosion Engineers.

Johnson, R. P.
1941 *"Compositiones variae" from Codex 490 Biblioteca Capitolare, Lucca, Italy: An Introductory Study.* Urbana: Univ. of Illinois Press.

Jones, D. A.
1992 *Principles and Prevention of Corrosion.* New York: Macmillan.

Jones, J. P., and J. P. Snow
1965 Amino acids released during germination of S^{35}-labeled crown rust spores. *Phytopathology* 55:499-503.

Kaczmarczyk, A., and R. E. M. Hedges
1983 *Ancient Egyptian Faience: An Analytical Survey of Egyptian Faience from Predynastic to Roman Times.* Warminster, England: Aris and Phillips.

Keeley, H. C. M., G. E. Hudson, and J. Evans
1977 Trace element contents of human bones in various states of preservation, 1: The soil silhouette. *Journal of Archaeological Science* 4:19-24.

Kerber, G., M. Koller, and F. Mairinger
1972 Studies of blue-green alterations into Austrian mediaeval wallpainting. Paper presented at ICOM Committee for Conservation 3rd Triennial Meeting, 2-8 October, Madrid.

Kerr, R.
1990 *Later Chinese Bronzes.* London: Victoria and Albert Museum.

Keyser, P. T.
1993 The purpose of the Parthian galvanic cells: A first century A.D. electric battery used for analgesia. *Journal of Near Eastern Studies* 52:81-98.

Khandekar, N., and A. Phenix
1999 Some observations on the effects of a selection of pigments on an artificially aged egg tempera paint film. Typescript, GCI Museum Research Laboratory, Los Angeles, May.

King, R. B., ed.
1996 *Encyclopedia of Inorganic Chemistry.* CD-ROM version. Bognor Regis, England: John Wiley.

Kingery, K., and P. Vandiver
1986 *Ceramic Masterpieces: Art, Structure and Technology.* Cambridge, Mass.: MIT Press.

Knoll, H., A. Kussner, A. Locher, H. Newesely, F. Preusser, E. L. Richter, U. Ripka, P. Rosumek, R. Rottlander, O. Schaaber, G. Schulze, G. Strunk-Lichtenberg, H. Vetters, and U. Weser
1985 *Plinius der Ältere: Über Kupfer und Kupfer-legierungen.* Berlin: Georg Agricola Gesellschaft.

Knotkova-Cermakova, D., and K. Barton
1982 Corrosion aggressivity of atmospheres (derivation and classification). In *Atmospheric Corrosion of Metals,* ed. S. W. Dean Jr. and E. C. Rhea, 225–49. Philadelphia: ASTM.

Kobert, R.
1895 Über den jetzigen Stand der Frage nach den pharmakologischen Wirkungen des Kupfer. *Deutsche Medikale Wochenschrift* 21:5–7.

Kockaert, L.
1979 Note on the green and brown glazes of old paintings. *Studies in Conservation* 24:69–74.

Komkov, A. I., and E. I. Nefedov
1967 Posnjakite, a new mineral (in Russian). *Zapiski Vsesoyuznogo Mineralogicheskogo Obsch-chestva (Transactions of the All-Union Mineralogical Society* 122 (1): 58–64. Summary in *American Mineralogist* 52 (1972): 1582–83.

König, W.
1938 Ein galvanisches Element aus der Partherzeit? *Forschungen und Fortschritte* 14:8–9.

Koucky, F., and A. Steinberg
1982a Comment on criticism of their paper by L. U. Salkield. In *Early Pyrotechnology: The Evolution of the First Fire-Using Industries,* ed. T. A. Wertime and S. F. Wertime, 247–49. Washington, D.C.: Smithsonian Institution Press.

1982b Ancient mining and mineral dressing on Cyprus. In *Early Pyrotechnology: The Evolution of the First Fire-Using Industries,* ed. T. A. Wertime and S. F. Wertime, 149–180. Washington, D.C.: Smithsonian Institution Press.

Krefting, A.
1892a Om nogle Metallers Oxydation ved noitrale Saltes Medvirken. *Christiania Videnskabs-Selskabs, Forhandlinger* 16:1–11.

1892b Om Konservering af Jordfundne Jernsager. *Christiania Videnskabs Selskabs, Forhandlinger* 16:51–57.

Krishnan, S., F. D. Gnanam, P. Ramasamy, and G. S. Laddha
1982 Anomalous stratification of copper carbonate in agar gel. *Crystal Research and Technology* 17:307–12.

Kühn, H.
1970 Verdigris and copper resinate. *Studies in Conservation* 15:81–88.

1993 Verdigris and copper resonate. In *Artists' Pigments: A Handbook of Their History and Characteristics,* ed. A. Roy, vol. 2, 131–58. Washington, D.C.: National Gallery of Art.

Kumanotani, J.
1981 High durability and structure of Japanese lac and attempts to synthesize it. *American Chemical Society: Division of Organic Coatings and Plastics Chemistry* 45:643–48.

1982 Chemistry and archaeology of urushi lacquers. *Zairyo Kagaku* 19:88–95.

1988 The chemistry of Oriental lacquer (*Rhus verniciflua*). In *Urushi: Proceedings of the Urushi Study Group, June 10–27, 1985, Tokyo,* ed. N. S. Brommelle and P. Smith, 243–51. Marina del Rey, Calif.: Getty Conservation Institute.

Lacome, M. S.
1910 *Nouveau manuel complet de bronzage des métaux et du plâtre. Debonliez et Malpeyre, nouvelle édition, revue, classée et augmentée.* Paris: Encyclopédie Roret.

Lacroix, A.
1909 Sur un nouveau cas de formation de chalcosite aux dépens de monnaies romaines immergées dans une source thermale. *Bulletin Société Française de Minéralogie* 32:333–35.

1910 Sur quelques minéraux formés par l'action de l'eau de mer sur des objets métalliques romains trouvés en mer au large de Mahdia (Tunisie). *Comptes Rendus Hebdomadaires des Séances de l'Académie des Sciences* 151:276–79.

Lambert, J. B.
1997 *Traces of the Past.* Reading, Mass.: Helix Books, Addison-Wesley.

Langenegger, E. E., and R. Callaghan
1972 A study of the dezincification of brasses. *Corrosion* 28:245–51.

Langs, D. A., and C. R. Hare
1967 Crystal structure of calcium copper acetate hexahydrate and its isomorph cadmium acetate hexahydrate. *Chemical Communications* 17:890–91.

LaNiece, S., and G. Martin
1987 The technical examination of bidri ware. *Studies in Conservation* 32:97–101.

Larsen, E. B.

1984 *Electrotyping.* Copenhagen: School of Conservation, The Royal Art Academy.

Latimer, W. M.

1952 *The Oxidation States of the Elements and Their Potentials in Aqueous Solution.* 2d ed. New York: Prentice Hall.

Laurie, A. P.

1914 *The Pigments and Mediums of the Old Masters.* London: Macmillan.

1935 *New Light on Old Masters.* London: Sheldon Press.

Le Bas, A., R. Smith, N. Kennon, and N. Barnard

1987 Chinese bronze vessels with copper inlaid decor of Ch'un-Ch'iu times. In *Archaeometry: Further Australasian Studies,* ed. W. R. Ambrose and J. M. J. Mummery, 312–19. Canberra: Australian National Univ. Printing Press.

Lechtman, H. N.

1979 A Pre-Columbian technique for electrochemical replacement plating of gold and silver on copper objects. *Journal of Metals* 31:154–59.

1996 Copper-arsenic bronze alloys. *Journal of Field Archaeology* 31:512–32.

Lechtman, H. N., A. Erlij, and E. J. Barry

1982 New perspectives on Moche metallurgy: Techniques of gilding copper at Loma Negra, Northern Peru. *American Antiquity* 47:3–30.

Lee, L. R., and D. Thickett

1996 *Selection of Materials for the Storage or Display of Museum Objects.* British Museum Occasional Paper 111. London: British Museum.

Leidheiser, H., Jr.

1979 *The Corrosion of Copper, Tin and Their Alloys.* New York: Robert E. Krieger.

Leonardo da Vinci

[1651] 1956 *Treatise on Painting.* Vol. 1. Trans. A. P. McMahon. Reprint, Princeton: Princeton Univ. Press.

Leoni, M., and C. Panseri

1972 Il danneggiamento delle opere d'arte metalliche per corrosione atmosferica. *Metallurgia Italia Atti e Notizie* 27:157–59.

Lewin, S. Z.

1973 A new approach to establishing the authenticity of patinas on copper-base artifacts. In *Application of Science in Examination of Works of Art,* ed. W. J. Young, 62–66. Boston: Museum of Fine Arts.

Li, W., F. X. Xu, Z. Yifan, and L. Dugang

1998 A new technical study on the preservation of bronze cultural relics treated by AMT composite reagent. In *Proceedings of the Fourth International Conference on the Beginning of the Use on Metals and Alloys,* 145–51. Tokyo: Japan Institute of Metals.

Liebig, J. von

1823 Sur une couleur verte. *Annales de Chimie* 23:412–13.

Liesegang, R. E.

1896 Ueber einige Eigenschaften von Gallerten. *Naturwissenschaftliche Wochenschrift* 11:353–62.

Lindgren, W.

1933 *Mineral Deposits.* 4th ed. New York: McGraw-Hill.

Lindsay, W. L.

1979 *Chemical Equilibria in Soils.* New York: Wiley-Interscience.

Lins, A.

1992 The cleaning of weathered bronze monuments: A review and comparison of current corrosion removal techniques. In *The Conservation of Bronze Sculpture in the Outdoor Environment: A Dialogue among Conservators, Curators, Environmental Scientists, and Corrosion Engineers,* ed. T. Drayman-Weisser, 209–30. Houston: National Association of Corrosion Engineers.

Lins, A., and T. Power

1994 The corrosion of bronze monuments in polluted urban sites: A report on the stability of copper mineral species at different pH levels. In *Ancient and Historic Metals: Conservation and Scientific Research,* ed. D. A. Scott, J. Podany, and B. B. Considine, 119–51. Marina del Rey, Calif.: Getty Conservation Institute.

Lobnig, R. E., R. P. Frankenthal, D. J. Siconolfi, and J. D. Sinclair

1993 The effect of submicron ammonium sulfate particles on the corrosion of copper. *Journal of the Electrochemical Society* 140:1902–7.

Lucas, A.

1934 *Ancient Egyptian Materials and Industries.* 1st ed. London: Edward Arnold.

1962 *Ancient Egyptian Materials and Industries.* 4th ed. Reprint, revised and enlarged by J. R. Harris. London: Edward Arnold.

Lucey, V. F.
1972 Developments leading to the present understanding of the mechanism of pitting corrosion of copper. *British Corrosion Journal* 7:36–41.

Lucretius
1961 *The Nature of the Universe.* Trans. R. E. Latham. Middlesex, England: Penguin Books.

Mach, M., U. Reinhardt, and R. Snethlage
1987–88 Elementverteilungsbilder von Querschnitten durch Bronze und Kupferpatina von Objekten im Freien. *Wiener Berichte über Naturwissenschaft in der Kunst* 4/5:214–19.

MacLeod, I. D.
1981 Bronze disease: An electrochemical explanation. *Bulletin of the Institute for the Conservation of Cultural Property* 7:16–26.

1982 Formation of marine concretions on copper and its alloys. *International Journal of Nautical Archaeology* 11:267–75.

1985 The effects of concretion on the corrosion of non-ferrous metals. *Corrosion Australasia* 10:10–13.

1987a Conservation of corroded copper alloys: A comparison of new and traditional methods of removing chloride ions. *Studies in Conservation* 32:25–40.

1987b Stabilization of corroded copper alloys: A study of corrosion and desalination mechanisms. In *ICOM Committee for Conservation 8th Triennial Meeting, Sydney, Australia, 6–11 September 1987, Preprints,* 1079–85. Marina del Rey, Calif.: Getty Conservation Institute.

1991 Identification of corrosion products on non-ferrous metal artifacts recovered from shipwrecks. *Studies in Conservation* 36:222–34.

MacLeod, I. D., and N. A. North
1979 Conservation of corroded silver. *Studies in Conservation* 24:165–70.

Mactaggart, P., and A. Mactaggart
1980 Refiners' verditer. *Studies in Conservation* 21:37–45.

1988 *A Pigment Microscopist's Notebook.* Welwyn, England: Mac and Me, Ltd.

Madsen, H. B.
1967 A preliminary note on the use of benzotriazole for stabilizing bronze objects. *Studies in Conservation* 12:163–67.

1977 Mikrobiologisk angreb på bronzerne fra Budsene brønden. *Meddelelser om Konservering* 2:265–70.

1985 Benzotriazole: A perspective. In *Corrosion Inhibitors in Conservation,* ed. S. Keene, 19–21. UKIC Occasional Paper 5. London: UKIC.

Madsen, H. B., and N. Hjelm-Hansen
1982 Black spots on bronzes—a microbiological or chemical attack. In *The Conservation and Restoration of Metals: Edinburgh Symposium,* 33–39. Edinburgh: Scottish Society for Conservation and Restoration (SSCR).

Maekawa, S., and H. Mori
1965 *Theophilus, De diversis artibus: A Japanese Translation of the First Volume.* Tokyo: Bijyutsushi.

Magalhaes, M. C. F., J. Pedrosa de Jesus, and P. A. Williams
1986 Stability constants and formation of Cu(II) and Zn(II) phosphate minerals in the oxidized zone of base metal orebodies. *Mineralogical Magazine* 50:33.

Magaloni, D. I. K.
1996 Materiales y técnicas de la pintura mural Maya. Ph.D. diss., Facultad de Filosofía y Letras, Universidad Nacional Autónoma de México, Mexico City.

Magnus, G.
1864 Über den Einfluss der Zusammensetzung der Bronzen auf die Erlangung einer schönen grünen Patina. *Polytechnisches Journal* 172:370–76.

Mairinger, F., G. Banik, H. Stachelberger, A. Vendl, and J. Ponahle
1980 The destruction of paper by green copper pigments, demonstrated by a sample of Chinese wallpaper. In *Conservation within Historic Buildings,* 180–85. London: IIC.

Maiti, G. C., and S. K. Ghosh
1983 Studies on the thermal decomposition of organic acid salts of copper by high temperature X-ray diffractometry. *Fertiliser Technology* 20:55–57.

Mann, A. W., and R. L. Deutscher
1977 Solution geochemistry of copper in water containing carbonate, sulfate and chloride ions. *Chemical Geology* 19:253–65.

Mansour, S. A. A.

1996 Thermoanalytical investigations of the decomposition course of copper oxy salts 3: Copper (II) acetate monohydrate. *Journal of Thermal Analysis* 46: 263–74.

Mao, Y.

1999 Lead alkaline glazed Egyptian faience: Technical investigation of Ptolemaic period faience in the collection of the Walters Art Gallery. Typescript, Conservation Laboratory, Walters Art Gallery, Baltimore.

Marabelli, M.

1987 Characterization and conservation problems of outdoor metallic monuments. In *Conservation of Metal Statuary and Architectural Decoration in Open-Air Exposure*, 209–34. Rome: ICCROM.

Marabelli, M., R. Mazzeo, and G. Morigi

1991 Caratterizzazione dei prodotti di alterazione e della vernice nera dei bronzi della Fontana del Nettuno. *OPD restauro: Rivista dell'Opificio delle pietre dure e Laboratorio di restauro di Firenze* 3:57–62, 141.

Marabelli, M. and G. Napolitano

1991 Nuovi sistemi protettivi applicabili su opere o manufatti in bronzo esposti all'aperto. *Materiali e Strutture* 1:51–56.

Marchesini, L., and L. Badan

1979 Corrosion phenomena on the Horses of San Marco. In *The Horses of San Marco, Venice*, ed. G. Perocco, 200–210. Milan and New York: Olivetti.

Maruyasu, T., and T. Oshima

1965 Photogrammetry in the precision measurements of the Great Buddha at Kamakura. *Studies in Conservation* 10:53–63.

Maryon, H.

1959 *Metalwork and Enamelling*. London: Chapman and Hall; reprint, New York: Dover Publications, 1971.

Masri, M. S., and M. Friedman

1974 Effect of chemical modification of wool on metal ion bonding. *Journal of Applied Polymer Science* 18:2367–77.

Mass, J. E., R. E. Stone, and M. T. Wypyski

1997 An investigation of the antimony-containing minerals used by the Romans to prepare opaque colored glasses. In *Materials Issues in Art and Archaeology*, vol. 5, ed. P. B. Vandiver, J. R. Druzik, J. F. Merkel, and J. Stewart, 193–204. Pittsburgh: Materials Research Society.

Matsuda, S., and S. Aoki

1996 Analysis of corrosion products formed on the Great Buddha image of Kotoku-in Temple in Kamakura (in Japanese). *Science for Conservation* 35:1–20.

Matteini, M., and A. Moles

1981 Kinetic reactivity of some formulations utilized for the cleaning of bronze works of art. In *ICOM Committee for Conservation 6th Triennial Meeting, Ottawa, 21–25 September 1981, Preprints*, vol. 4, 81/23/4/1–8. Paris: ICOM Committee for Conservation.

1982 Corrosion rates for copper alloys. In *Atmospheric Corrosion*, ed. W. H. Ailor, 365–81. New York: John Wiley.

Mattsson, E., A. G. Nord, K. Tronner, M. Fjaestad, A. Lagerlöf, I. Ullen, and G. H. Borg

1996 *Deterioration of Archaeological Material in Soil: Results on Bronze Artefacts*. RIK Monograph no. 10. Stockholm: Central Board of National Antiquities and the National Historical Museums.

Maxwell-Hyslop, R.

1971 *Western Asiatic Jewellery, c. 3000 B.C.–612 B.C.* London: Baker.

May, R.

1953 Some observations on the mechanism of pitting corrosion. *Journal of the Institute of Metals* 82:65–74.

Mayerne, T. de

[1620] 1847 *Pictoria, Sculptoria, Tinctoria, et quae subalternarum Artium spectantia in Lingua Latina, Gallica, Italica, Germanica conscripta, a Petro Paulo Rubens, Van Dyke, Somers, Greenberry, Jansen, &c.* Trans. Eastlake. Sloane manuscript 2052, folio 19, British Library. Reprint, London: British Museum.

Mazzeo, R., G. Chiavari, and G. Morigi

1989 Identificazione ed origine di patine ad ossalato sui monumenti bronzei: Il caso del portale centrale del duomo di Loreto (AN). In *Le pellicole ad ossalati: Origine e significato nella conservazione delle opere d'arte*, 271–80. Proceedings. Milan: Centro C.N.R. "Gino Bozza" Politecnico di Milano.

McKee, R., D. Dunne, N. Kennon, and N. Barnard

1987 Free copper particles in archaeological bronze artefacts. In *Archaeometry: Further Australasian Studies*, ed. W. R. Ambrose and J. M. J. Mummery, 320–30. Canberra: Australian National University and Australian National Gallery.

McNeil, M. B., and B. J. Little
1992 Corrosion mechanisms for copper and silver in near-surface environments. *Journal of the American Institute for Conservation* 31:355–66.

McNeil, M. B., and D. W. Mor
1992 Sulfate formation during corrosion of copper alloy objects. In *Materials Issues in Art and Archaeology,* vol. 3, ed. P. B. Vandiver, J. R. Druzik, G. S. Wheeler, and I. C. Freestone, 1047–53. Materials Research Society Symposium Proceedings 267. Pittsburgh: Materials Research Society.

Meeks, N.
1986 Tin-rich surfaces on bronze—Some experimental and archaeological considerations. *Archaeometry* 28:133–62.

1988a A technical study of Roman bronze age mirrors. In *Aspects of Ancient Mining and Metallurgy: Acta of the British School at Athens Centenary Conference, Bangor, 1986,* ed. J. Ellis-Jones, 66–79. Bangor, Wales: British School at Athens.

1988b Surface studies of Roman bronze mirrors, comparative high-tin bronze Dark Age material and black Chinese mirrors. In *Proceedings of the 26th International Archaeometry Symposium,* ed. R. M. Farquhar, R. G. V. Hancock, and L. A. Pavlish, 124–27. Toronto: Univ. of Toronto Press.

1993a Patination phenomena on Roman and Chinese high-tin bronze mirrors and other artefacts. In *Metal Plating and Patination,* ed. S. LaNiece and P. Craddock, 63–84. Oxford: Butterworth-Heinemann.

1993b Surface characterization of tinned bronze, high-tin bronze, tinned iron and arsenical bronze. In *Metal Plating and Patination,* ed. S. LaNiece and P. Craddock, 247–75. Oxford: Butterworth-Heinemann.

Mehra, V. R.
1970 Note on the technique and conservation of some Thang-ka paintings. *Studies in Conservation* 15:206–14.

Meijers, H. J. M., K. A. N. Abelskamp, R. Leenheer, and H. Kars
1997 Conservation and restoration of archaeological material in the Netherlands with special regard to metal objects. In *Metal 95: Proceedings of the International Conference on Metals Conservation,* ed. I. D. MacLeod, S. L. Pennec, and L. Robbiola, 27–31. London: James and James.

Mellaart, J.
1967 *Çatal Hüyük: A Neolithic Town in Anatolia.* London: Thames and Hudson.

Mellor, J. W.
1928 *A Comprehensive Treatise on Inorganic and Theoretical Chemistry.* London: Longmans, Green and Co.

Menezes, M.
1997 Copper clusters cure bonding blues. *Chemistry in Britian* 33(9):16.

The Merck Index: An Encyclopedia of Chemicals, Drugs and Biologicals
1983 10th ed. Ed. Martha Windholz. Rahway, N.J.: Merck.

Merk, L. E.
1978 A study of reagents used in the stripping of bronzes. *Studies in Conservation* 23:15–22.

1981 Effectiveness of benzotriazole in the inhibition of corrosive behaviour. *Studies in Conservation* 26:73–76.

Merrifield, M. P.
1849 *Original Treatises on the Arts of Painting.* London: John Murray.

Meyers, P.
1977 Technical examination of an Achaemenid bronze mirror, from the collection of Norbert Schimmel. In *Bibliotheca Mesopotamia,* vol. 7, ed. Giorgio Buccellati, 196–98. Malibu, Calif.: Undena Publications.

1996 Entry s.v. "vessel." In *Ancient Art from the Shumei Family Collection,* ed. J. P. O'Neill, 171. Exhibition catalogue. New York: The Metropolitan Museum of Art.

Mierzinski, S.
1881 *Die Erd-, Mineral- und Lack Farben, Darstellung, Prüfung und Anwendung.* Weimar, Germany: Bernhard Friedrich Voigt.

Miller, F. P., J. E. Foss, and D. C. Wolf
1981 Soil surveys: Their synthesis, confidence limits and utilization for corrosion assessment of soil. In *Underground Corrosion,* ed. E. Escalante, 3–23. American Society for Testing and Materials Special Technical Publication 741. Philadelphia: ASTM.

Mills, J. S., and R. White
1977 Natural resins of art and archaeology: Their sources, chemistry and identification. *Studies in Conservation* 22:12–31.

1987 *The Organic Chemistry of Museum Objects.* London: Butterworths.

Minguzzi, C.
1938 Cuprorivaite: Un nuovo minerale. *Periodico di Mineralogia* 8:333–45.

Moffett, E. A.
1996 Wax coatings on ethnographic metal objects: Justifications for allowing a tradition to wane. *Journal of the American Institute for Conservation* 35:1–7.

Moffett, E. A., J. P. Sirois, and J. Miller
1997 Analysis of the paints on a selection of Naskapi artifacts in ethnographic collections. *Studies in Conservation* 42:120–25.

Mond, C., and G. Cuboni
1893 Sopra la cosi della rogna dei bronzi antichi. *Atti della Reale Accademia dei Lincei*, ser. 5, 2:498–99.

Montet, J.
1757 Second mémoire sur le vert de gris. In *Histoire et mémoires de l'Académie Royale des Sciences*, 1753:609–11.

Moore, W. J.
1968 *Physical Chemistry*. London: Longmans.

Moorey, P. R. S.
1994 *Ancient Mesopotamian Materials and Industries*. Oxford: Clarendon Press.

Mor, E. D., and A. M. Beccaria
1972 The corrosion of copper in seawater. In *Proceedings of the 3rd International Congress on Marine Corrosion Fouling*. National Bureau of Standards Special Publication. Gaithersburg, Maryland: NBS.

Mori, W., M. Kishita, and M. Inoue
1980 Synthesis of the basic formate Cu(HCOO)(OH). *Inorganica Chimica Acta* 42:11–13.

Morin, H.
1874 Über chinesische und japanische Bronzen mit dunkler Patina. *Comptes Rendus Hebdomadaires des Séances de l'Académie des Sciences* 78:811–14.

Muhly, J. D.
1986 The beginnings of metallurgy in the Old World. In *The Beginning of the Use of Metals and Alloys: Papers from the Second International Conference on the Beginning of the Use of Metals and Alloys, Zhengzhou, China, 21-26 October 1986*, ed. R. Maddin, 2–20. Cambridge, Mass.: MIT Press.

Muller, A. J., and C. McCrory-Joy
1987 Chromatographic analysis of copper patinas formed in the atmosphere. *Corrosion Science* 27:695–701.

Murakami, R.
1993 Japanese traditional alloys. In *Metal Plating and Patination*, ed. S. LaNiece and P. Craddock, 85–94. Oxford: Butterworth-Heinemann.

Murakami, R., S. Niiyama, and M. Kitada
1988 Characterisation of the black surface layer on a copper alloy colored by traditional Japanese surface treatment. In *The Conservation of Far Eastern Art: Preprints of the Contributions to the Kyoto Congress, September 1988*, ed. J. S. Mills, P. Smith, and K. Yamasaki, 133–36. London: IIC.

Musiani, M., G. Mengoli, M. Fleischmann, and R. Lowry
1987 An electrochemical and SERS investigation of the influence of pH on the effectiveness of soluble corrosion inhibitors of copper. *Journal of Electroanalytical Chemistry and Interfacial Electrochemistry* 217:187–202.

Nagano, M., and M. Greenblatt
1988 High temperature superconducting films by sol-gel preparation. *Solid State Communications* 67:595–602.

Napier, J.
1857 *A Manual of Electro-Metallurgy: Including the Applications of the Art to Manufacturing Processes*. 3d ed. London and Glasgow: Richard Griffin.

Naude, V. N., and G. Wharton
1995 *Guide to the Maintenance of Outdoor Sculpture*. 2d ed. Washington, D.C.: AIC.

Naumova, M. M., and S. A. Pisareva
1994 A note on the use of blue and green copper compounds in paintings. *Studies in Conservation* 39:277–83.

Naumova, M. M., S. A. Pisareva, and G. O. Nechiporenko
1990 Green copper pigments of old Russian frescoes. *Studies in Conservation* 35:81–88.

Needham, J.
1974 *Science and Civilization in China 5: Chemistry and Chemical Technology*. Pt. 3, sect. 33. Cambridge: Cambridge Univ. Press.

Neumann, B., and G. Kotyga
1925 Antike Gläser, ihre Zusammensetzung und Farbung. *Zeitschrift für angewandte Chemie* 38:857–64.

Newman, H.
1987 *An Illustrated Dictionary of Jewelry*. London: Thames and Hudson.

REFERENCES

474

Newton, R. G., and S. Davison
1987 *The Conservation of Glass.* Sevenoaks, England: Butterworths.

Nicholson, W. E.
1898 Bacteria on an ancient bronze implement. *Nature* 58 (1490): 51–52.

Nickel, E. H., and M. C. Nichols
1991 *Mineral Reference File.* Livermore, Calif.: Aleph Enterprises; New York: Van Nostrand Reinhold.

Nielsen, N. A.
1977 Corrosion product characterization. In *Corrosion and Metal Artifacts: A Dialogue between Conservators and Archaeologists and Corrosion Scientists,* ed. B. F. Brown, H. C. Burnett, W. T. Chase, M. Goodway, J. Kruger, and M. Pourbaix, 17–37. National Bureau of Standards Special Publication no. 479. Washington, D.C.: U.S. Department of Commerce.

Noggerath, J.
1825 Die Umwandlung von metallischen Kupfer in kristallines Kupferoxid. *Journal für Chemie und Physik,* n.s. 13, 43:129–36.

Noll, W.
1979 Anorganische Pigmente in Vorgeschichte und Antike. *Fortschritte der Mineralogie* 57:203–63.

1981 Zur Kenntnis altaegyptischer Pigmente und Bindemittel. *Neues Jahrbuch für Mineralogie: Monatshefte* 5:209–14.

Noll, W., and K. Hangst
1975 Grün- und Blaupigmente der Antike. *Neues Jahrbuch für Mineralogie: Monatshefte* 12:529–40.

Nord, A. G., K. Lindahl, and K. Tronner
1993 A note on spionkopite as a corrosion product on a marine copper find. *Studies in Conservation* 38:133–35.

Norman, M.
1988 Early conservation techniques and the Ashmolean. In *Conservation of Ancient Egyptian Materials,* ed. S. C. Watkins and C. E. Brown, 7–16. London: Institute of Archaeology Publications.

North, N. A., and I. D. MacLeod
1987 Corrosion of metals. In *Conservation of Archaeological Objects,* ed. C. Pearson, 68–98. London: Butterworths.

Notoya, T., and G. W. Poling
1979 Protection of copper by pretreatment with benzotriazole. *Corrosion* 35:193–200.

Oddy, W. A.
1972 On the toxicity of benzotriazole. *Studies in Conservation* 17:135.

1973 An unsuspected danger in display. *Museums Journal* 73:27–28.

1974a Corrosion of metals on display. Lecture presented at the Department of Conservation and Materials Science, Institute of Archaeology, University College London, March.

1974b Toxicity of benzotriazole. *Studies in Conservation* 19:188–89.

1975 The corrosion of metals on display. In *Conservation in Archaeology and the Applied Arts,* 235–37. IIC Stockholm Congress. London: IIC.

Oddy, W. A., M. Bimson, and S. LaNiece
1983 The composition of niello decoration on gold, silver and bronze in the antique and mediaeval periods. *Studies in Conservation* 28:29–35.

Oddy, W. A., and M. J. Hughes
1970 The stabilisation of "active" bronze disease and iron antiquities by the use of sodium sesquicarbonate. *Studies in Conservation* 15:183–89.

Oddy, W. A., and N. D. Meeks
1981 Pseudo-gilding: An example from the Roman period. *MASCA Journal* 1 (7): 211–13.

1982 Unusual phenomena in the corrosion of ancient bronzes. In *Science and Technology in the Service of Conservation,* ed. N. S. Brommelle and Garry Thomson, 119–24. London: IIC.

Ogden, J.
1982 *Jewellery of the Ancient World.* London: Trefoil Books.

O'Keeffe, M.
1963 Infrared optical properties of cuprous oxide. *Journal of Chemical Physics* 39:1789–93.

O'Neil, I.
1971 *The Art of the Painted Finish for Furniture and Decoration.* New York: William Morrow.

Oppenheim, A. L., R. H. Brill, D. Barag, and A. Von Salden
1970 *Glass and Glass-Making in Ancient Mesopotamia.* London and Toronto: Corning Associated Univ. Presses.

Organ, R. M.
1961 A new treatment of bronze disease. *Museums Journal* 61:54–56.

1963a Aspects of bronze patina and its treatment. *Studies in Conservation* 8:1–9.

1963b The examination and treatment of bronze antiquities. In *Recent Advances in Conservation*, ed. G. Thomson, 107–8. London: Butterworths.

1981 Appendix 1. In K. C. Lefferts, L. J. Majewski, E. V. Sayre, and P. Meyers, Technical examination of the Classical bronze horse from the Metropolitan Museum of Art. *Journal of the American Institute for Conservation* 21:1–42.

Orna, M. V.
1996 Copper-based synthetic medieval blue pigments. In *Archaeological Chemistry*, chap. 9, 107–15. Washington, D.C.: American Chemical Society.

Orna, V. A., M. J. D. Low, and N. S. Baer
1980 Synthetic blue pigments: Ninth to sixteenth centuries, 1—literature. *Studies in Conservation* 25:53–63.

Orna, V. A., M. J. D. Low, and M. M. Julian
1985 Synthetic blue pigments: Ninth to sixteenth centuries, 2—"silver blue." *Studies in Conservation* 30:155–60.

Osborn, L.
1845 *Handbook of Young Artists and Amateurs in Oil Painting.* New York: Wiley and Putnam.

Oswald, H. R., and J. R. Guenter
1971 Crystal data on paratacamite, $Cu_2(OH)_3Cl$. *Journal of Applied Crystallography* 4:530–31.

Ottaway, P.
1992 *Anglo-Scandinavian Ironwork from Coppergate*, 466–67. York, England: York Archaeological Trust for Excavation and Research.

Otto, H.
1959 Röntgenfeinstrukturuntersuchungen an Patinaproben. *Freiberger Forschungshaften*, ser. B, 37:66–77.

1961 Über röntgenographisch nachweisbare Bestandteile in Patinaschichten. *Die Naturwissenschaften* 48:661–64.

1963 Das Vorkommen von Connellit in Patinaschichten. *Die Naturwissenschaften* 50:16–17.

Pabst, A.
1959 Structures of some tetragonal sheet silicates. *Acta Crystallographia* 12:733–39.

Palache, C., H. Berman, and C. Frondel, eds.
1951 *Dana's System of Mineralogy.* 7th ed. New York: John Wiley and Sons.

Palomino de Castro y Velasco, A.
[1715–23] 1944 *El museo pictórico y escala óptica.* 2 vols. Buenos Aires: Editorial Poseidon.

Paradies, H. H., I. Hansel, W. Fischer, and W. Wagner
1987 *Microbiologically Induced Corrosion of Copper Pipes.* International Copper Research and Development Association (INCRA) Report no. 404. New York: INCRA.

Parker, W.
1812 *An Improvement in the Making or Manufacture of Green Paint.* British Patent 3594, 8 September 1812. London.

Partington, J. R.
1935 *Origins and Development of Applied Chemistry.* London: Longmans, Green and Co.

1961 *A History of Chemistry.* 3 vols. London: MacMillan.

Pasterniak, I.
1959 Infrared absorption spectrum of cuprous oxide. *Optics and Spectroscopy* 6:64–67.

Paszthory, E.
1989 Electricity generation or magic? The analysis of an unusual group of finds from Mesopotamia. *MASCA Research Papers in Science and Archaeology* 6:31–38.

Payen, A.
1835 Vert de Scheele. In *Dictionnaire Technologique: ou Nouveau dictionnaire universel des arts et métiers, et de l'économie industrielle et commerciale*, vol. 22, 237–38. Paris: Thomine et Fortic.

Penny, N.
1993 *The Materials of Sculpture.* New Haven and London: Yale Univ. Press.

Pernice, E.
1910 Untersuchungen zur antiken Toreutik, V. Natürliche und künstliche Patina im Altertum. *Jahreshefte des Österreichischen Archäologischen Institutes in Wien* 13:102–7.

Pey, I.
1998 The Hafkenscheid collection. In *Looking through Paintings*, ed. E. Hermens, A. Ouwerkerk, and N. Costaras, 465–500. London: Archetype Publications.

Phillips, A.
1911 *The Electro-plating and Electro-refining of Metals.* London: Crosby Lockwood and Son.

Photos, E., R. E. Jones, and T. Papadopoulos
1994 The black inlay decoration on a Mycenean bronze dagger. *Archaeometry* 36:267–75.

Pilz, M., and H. Römich
1997 A new conservation treatment for outdoor bronze sculptures based on Ormocer. In *Metal 95: Proceedings of the International Conference on Metals Conservation,* ed. I. D. MacLeod, S. L. Pennec, and L. Robbiola, 244–250. London: James and James.

Piqué, F.
1992 Scientific examination of the sculptural polychromy of cave 6, Yungang. Master's thesis, Courtauld Institute of Art, University of London.

Plenderleith, H. J.
1956 *The Conservation of Antiquities and Works of Art: Treatment, Repair, and Restoration.* 1st ed. London, New York: Oxford Univ. Press.

Plenderleith, H. J., and A. E. A. Werner
1971 *The Conservation of Antiquities and Works of Art: Treatment, Repair, and Restoration.* 2d ed. London, New York: Oxford Univ. Press.

Pliny the Elder
1979 *Natural History.* 10 vols. Trans. H. Rackham. Cambridge: Harvard Univ. Press; London: William Heinemann.

Plutarch
1984 *Plutarch's Moralia.* Vol. 5. Trans. F. C. Babbitt, 351C–438E, 264–65. Cambridge: Harvard Univ. Press; London: William Heinemann.

Podany, J.
1988 Condition reports for the Roma, Togati and Demeter. In *The Gods Delight: The Human Figure in Classical Bronze,* ed. A. P. Kozloff and D. G. Mitten. Exhibition catalogue. Cleveland: Cleveland Museum of Art.

Podany, J., and D. A. Scott
1997 Looking through both sides of the lens: Why scientists and conservators should know each other's business. In *The Interface between Science and Conservation,* ed. S. Bradley, 211–20. British Museum Occasional Paper no. 116. London: British Museum Press.

Pogue, J. E.
1915 The turquoise: A study of its history, mineralogy, geology, ethnology, archaeology, mythology, folklore, and technology. *National Academy of Sciences Memoirs* 12(2):1–207.

Pollard, A. M., R. G. Thomas, and P. A. Williams
1990a Connellite: Stability relationships with other secondary copper minerals. *Mineralogical Magazine* 54:425–30.

1990b Mineralogical changes arising from the use of aqueous sodium carbonate solutions for the treatment of archaeological copper objects. *Studies in Conservation* 35:148–53.

1991 The synthesis and composition of georgeite and its reactions to form other secondary copper (II) carbonates. *Mineralogical Magazine* 55:163–66.

1992a The stabilities of antlerite and $Cu_3SO_4(OH)_4 \cdot 2H_2O$. *Mineralogical Magazine* 56:359–62.

1992b The copper chloride system and corrosion: A complex interplay of kinetic and thermodynamic factors. In *Dialogue/89: The Conservation of Bronze Sculpture in the Outdoor Environment—A Dialogue among Conservators, Curators, Environmental Scientists and Corrosion Engineers,* ed. T. Drayman-Weisser, 123–33. Houston: National Association of Corrosion Engineers.

Polo, Marco
[1579] 1937 *The Most Noble and Famous Travels of Marco Polo.* Trans J. Frampton and N. M. Penzer. Reprint, London: R. Newbery.

Pourbaix, M.
1973 *Lectures on Electrochemical Corrosion.* Trans. J. A. S. Green and R. W. Staehle. New York: Plenum Press.

1976 Some applications of potential-pH diagrams to the study of localized corrosion. *Journal of the Electrochemical Society* 123:25c–37c.

1977 Electrochemical corrosion and reduction. In *Corrosion and Metal Artifacts: A Dialogue between Conservators and Archaeologists and Corrosion Scientists,* ed. B. F. Brown, H. C. Burnett, W. T. Chase, M. Goodway, J. Kruger, and M. Pourbaix, 1–16. National Bureau of Standards Special Publication no. 479. Washington, D.C.: U.S. Department of Commerce.

Proudfoot, T., K. Garland, and J. Larson
1988 The examination and conservation of a collection of Gandharan sculptures from Antony House, Cornwall. In *The Conservation of Far Eastern Art: Preprints of the Contributions to the Kyoto Congress,*

September 1988, ed. J. S. Mills, P. Smith, and K. Yamasaki, 113–19. London: IIC.

Puhringer, J., and B. Johnsson
1990 An alternative preservation method for corroded outdoor bronzes. In *ICOM Committee for Conservation 9th Triennial Meeting, Dresden, German Democratic Republic, 26–31 August 1990, Preprints,* ed. K. Grimstad, 748–53. Los Angeles: ICOM Committee for Conservation.

Purinton, N., and M. Watters
1991 A study of the materials used by medieval Persian painters. *Journal of the American Institute for Conservation* 30:125–44.

Radosavljevic, V.
1972 Conservation of miniatures. Paper presented at ICOM Committee for Conservation 3rd Triennial Meeting, 2–8 October, Madrid.

Rahn-Koltermann, G., D. H. Buss, R. Fuchs, and O. Glemser
1991 Zur Kenntnis basischer Kupferacetate. *Zeitschrift für Naturforschung* 46b:1020–24.

Rajagopalan, K. S., M. Sundaram, and P. L. Annamalai
1959 Corrosion of metals at Mandapam Camp, India. *Corrosion* 15:631–35.

Rapp, G., Jr.
1986 On the origins of copper and bronze alloying. In *The Beginning of the Use of Metals and Alloys: Papers from the Second International Conference on the Beginning of the Use of Metals and Alloys, Zhengzhou, China, 21–26 October 1986,* ed. R. Maddin, 21–27. Cambridge, Mass.: MIT Press.

Rathgen, F.
1889 Über eine neue Anwendung des elektrischen Stromes zur Conservierung antiker Bronzen. *Prometheus* 1:196–98.

1898 *Die Konservierung von Altertumsfunden.* Berlin: Königliche Museen zu Berlin.

1905 *The Preservation of Antiquities: A Handbook for Curators.* Trans. G. A. Auden and H. A. Auden. London: Cambridge Univ. Press.

1924 *Die Konservierung von Altertumsfunden mit Berücksichtigung ethnographischer und kunstgewerblicher Sammlungsgegenstande II und III.* Laboratory handbook. Berlin: W. de Gruyter.

Ray, P.
1956 *History of Chemistry in Ancient and Mediaeval India.* Calcutta: Indian Chemical Society.

Rewitzer, C., and R. Hochleitner
1989 I minerali delle antiche scorie di Lavrion, Grecia: Parte I. *Rivista Mineralogica Italiana* 13:21–38.

Rice, D. W., P. Peterson, E. B. Rigby, P. B. P. Phipps, R. J. Capell, and R. Tremoureux
1981 Atmospheric corrosion of copper and silver. *Journal of the Electrochemical Society* 128:275–84.

Richter, E. L.
1988 Seltene Pigmente im Mittelalter. *Zeitschrift für Kunst Technologie und Konservierung* 2:171–77.

Richter, G.
1915 *The Metropolitan Museum of Art: Greek, Etruscan and Roman Bronzes.* New York: Gilliss Press.

Rickerby, S.
1991 Heat alterations to pigments painted in the fresco technique. *Conservator* 15:39–44.

Rieck, F., and O. Crumlin-Pedersen
1988 *Både fra Danmarks Oldtid.* Roskilde, Denmark: Vikingeskibshallen.

Riederer, J.
1985 Untersuchungen zur Farbgebung des Tempels. In *Der ältere Porostempel der Aphaia auf Ägina,* ed. E. L. Schwandner, 136–40. Berlin: W. De Gruyter.

1988 Die Erhaltung von Metallskulpturen im Freien. *Praxis der Naturwissenschaften* 8:11–19.

1997 Egyptian blue. In *Artists' Pigments,* vol. 3, ed. E. W. Fitzhugh, 23–46. Oxford: Oxford Univ. Press; Washington, D.C.: National Gallery of Art.

Riffault, J. D. R., A. D. Vergnand, and G. A. Toussaint
1874 *A Practical Treatise on the Manufacture of Colors for Painting.* Trans. A. A. Fesquet. Philadelphia: Henry Carey Baird; London: Sampson Low, Marston, Low and Searle.

Robbiola, L.
1990 Caractérisation de l'altération de bronzes archéologiques enfouis à partir d'un corpus d'objets de l'Age du Bronze: Mécanismes de corrosion. Ph.D. diss., Université de Paris 6—Pierre et Marie Curie, Paris.

Robbiola, L., C. Fiaud, and S. Pennec
1993 New model of outdoor bronze corrosion and its implications for conservation. In *ICOM Committee for Conservation 10th Triennial Meeting, Washington D.C., USA, 22–27 August 1993, Preprints,* vol. 2, 796–802. Paris: ICOM Committee for Conservation.

Roberts, J. D., and M. C. Caserio
1964 *Basic Principles of Organic Chemistry*. New York: W. A. Benjamin.

Roberts, W. L., G. R. Rapp, Jr., and J. Weber
1974 *Encyclopedia of Minerals*. New York: Van Nostrand Reinhold.

Robie, R. A., B. S. Hemingway, and J. R. Fisher
1978 Thermodynamic properties of minerals and related substances at 298.15K and 1 bar pressure and at higher temperatures. *Geological Society Survey Bulletin* 1452. Washington, D.C.: U.S. Government Printing Office.

Rogers, T. H.
1948 The promotion and acceleration of metallic corrosion by micro-organisms. *Journal of the Institute of Metals* 75:19–27.

Romanoff, M.
1957 Underground corrosion. *NBS Report 579*. Washington, D.C.: National Bureau of Standards, U.S. Government Printing Office.

Roosen-Runge, H.
1967 *Farbgebung und Technik frühmittelalterlicher Buchmalerei*. 2 vols. Munich and Berlin: Deutscher Kunstverlag.

Rose, H.
1851 Ueber den Einfluss des Wassers bei chemischen Zersetzungen. *Annalen der Physik und Chemie* 84:461–85.

Roseleur, A.
1872 *Galvanoplastic Manipulations*. Trans. A. A. Fesquet. Philadelphia: Henry Carey Baird.

Rosenberg, G.
1917 *Antiquités en fer et en bronze, leur transformation dans la terre contenant de l'acide carbonique et des chlorures, et leur conservation*. Copenhagen: Glydendalske Boghandels Sortiment.

Rosenquist, A. M.
1959 Analyser av skerd og skjold fra Bofunnet. *Viking* 12:33–34.

Rossi, G.
1987 Die Restaurierung des Pieta-Freskos von Masolino aus Empoli. *Maltechnik-Restauro* 93:9–16.

Rothenberg, B.
1990 *The Ancient Metallurgy of Copper*. London: Institute for Archaeometallurgical Studies, Institute of Archaeology, University College London.

Roy, A., ed.
1993 *Artists' Pigments: A Handbook of Their History and Characteristics*. Vol. 2. Washington, D.C.: National Gallery of Art.

Sage, M.
1779 Observations sur la mine rouge de Cuivre. *Observations sur la Physique, sur l'Histoire Naturelle et sur les Arts* 14:155–57.

Salter, T. W., ed.
1869 *Field's Chromatography; or, a Treatise on Colours and Pigments, as Used by Artists*. London: Winsor and Newton.

Samans, C.
1963 *Metallic Materials in Engineering*. New York: Macmillan.

Savage, G., and H. Newman
1985 *An Illustrated Dictionary of Ceramics*. London: Thames and Hudson.

Sax, N. I.
1976 *Dangerous Properties of Industrial Materials*. 4th. ed. New York: Van Nostrand Reinhold.

Schaller, W. T.
1912 Crystallized turquoise from Virginia. *American Journal of Science* 33:35–40.

Scharff, W., and I. A. Huesmann
1997 Accelerated decay of metal soil finds due to soil pollution. In *Metal 95: Proceedings of the International Conference on Metals Conservation*, ed. I. D. MacLeod, S. L. Pennec, and L. Robbiola, 17–20. London: James and James.

Schiegel, S., K. L. Weiner, and A. El Goresy
1989 Discovery of copper chloride cancer in ancient Egyptian polychromic wall paintings and faience: A developing archaeological disaster. *Naturwissenschaften* 76:393–400.

Schilling, M.
1988 Identification of pigments of the tomb of Queen Nefertari. Internal report, 530S88, Getty Conservation Institute, Marina del Rey, Calif.

Schnorrer-Kohler, G., R. Standfuss, and L. Standfuss
1982 Connellit, Botallackit, Paratacamit und Leadhillit in den antiken Bleischlacken Laurions. *Aufschluss* 33:3–6.

Schoep, A.
1925 Sur la buttgenbachite, à nouveau minéral. *Comptes Rendus Hebdomadaires des Séances de l'Académie des Sciences* 181:142–43.

Schrenk, J. L.
1991 Corrosion and past "protective" treatments of the Benin "bronzes" in the National Museum of African Art. In *Materials Issues in Art and Archaeology*, vol. 2, ed. P. B. Vandiver, J. Druzik, and G. S. Wheeler, 805–12. Materials Research Society Symposium 185. Pittsburgh: Materials Research Society.

Schumacher, M.
1979 *Seawater Corrosion Handbook*. Park Ridge, N.J.: Noyes Data Corp.

Schweizer, F.
1994 Bronze objects from lake sites: From patina to "biography." In *Ancient and Historic Metals, Conservation and Scientific Research*, ed. D. A. Scott, J. Podany, and B. B. Considine, 33–50. Marina del Rey, Calif.: Getty Conservation Institute.

Schweizer, F., and B. Mühlethaler
1968 Einige grüne und blaue Kupferpigmente: Herstellung und Identifikation. *Farbe und Lack* 74:1159–73.

Scott, A.
1921 *The Cleaning and Restoration of Museum Exhibits: Report upon Investigations Conducted at the British Museum*. London: H.M.S.O. Press.

1926 *The Cleaning and Restoration of Museum Exhibits, Third Report*. London: Department of Industrial and Scientific Research.

Scott, D. A.
1977 The corrosion and conservation of bronze materials from Trondheim, Norway. Department of Conservation, DKNVS Museet: Trondheim, Norway. Report, University College, Institute of Archaeology, Dept. of Conservation and Materials Science, London.

1985 Periodic corrosion phenomena in bronze antiquites. *Studies in Conservation* 30:49–57.

1990 Bronze disease: A review of some chemical problems and the role of relative humidity. *Journal of the American Institute for Conservation* 29:193–206.

1991 *Metallography and Microstructure of Ancient and Historic Metals*. Marina del Rey and Santa Monica, Calif.: Getty Conservation Institute and J. Paul Getty Museum, in association with Archetype Books.

1994a An examination of the patina and corrosion morphology of some Roman bronzes. *Journal of the American Institute for Conservation* 33:1–23.

1994b Investigation of the corrosion of two Moche copper masks from Peru. Report SA 143. GCI Museum Research Laboratory, Getty Conservation Institute, Los Angeles.

1997a Report on corrosion of a gilt stag in the Getty Museum by Johann Ludwig Biller the Elder. Internal report, file no. 1559D97, GCI Museum Research Laboratory, Getty Conservation Institute, Los Angeles.

1997b Report concerning the identity of blue and green corrosion products on bronze objects in some museum collections. Internal report, file no. 1786O97, GCI Museum Research Laboratory, Getty Conservation Institute, Los Angeles.

1999 Report on the analysis and metallographic study of some Greek Neolithic copper artefacts. Report to the Thessaloniki Museum. Thessaloniki, Greece.

Scott, D. A., and A. Bezur
1996 Corrosion products on brasses from the Wallace Collection. Internal report to the Wallace Collection, London.

Scott, D. A., D. H. Doughty, and C. B. Donnan
1998 Moche wallpainting pigments from La Miña, Jequetepeque, Peru. *Studies in Conservation* 43:177–83.

Scott, D. A., N. Khandekar, N. Turner, M. Schilling, and H. Khanjian
2001 Technical examination of a 15th century German illuminated manuscript on paper: A case study in the identification of materials. *Studies in Conservation* 46:93–108.

Scott, D. A., V. Kucera, and B. Rendahl
1999 Infinite columns and finite solutions. In *Mortality Immortality? The Conservation of 20th-Century Art*, ed. Miguel Angel Corzo, 107–112. Los Angeles: Getty Conservation Institute.

Scott, D. A., and J. O'Hanlon
1987 The analysis of copper trihydroxychlorides and their occurrence as corrosion products on bronze antiquities. Internal report, Department of Chemistry, University College, London.

Scott, D. A., and J. Podany
1990 Ancient copper alloys: Some metallurgical and technological studies of Greek and Roman bronzes. In *Small Bronze Sculpture from the Ancient World: Papers Delivered at a Symposium Organized by*

the Departments of Antiquities and Antiquities Conservation, Held at the J. Paul Getty Museum, March 16–19, 1989, ed. M. True, 31–60. Malibu, Calif.: J. Paul Getty Museum.

Scott, D. A., and M. Schilling
1991 The pigments of the Canosa vases: A technical note. *Journal of the American Institute for Conservation* 30:35–40.

Scott, D. A., and D. Stulik
1998 Electron microprobe study of some outdoor bronze patinas. Report AE56497. GCI Museum Research Laboratory, Getty Conservation Institute, Los Angeles.

Scott, D. A., and Y. Taniguchi
1998 Metal corrosion and textile remains on a Lydian bed of the 6th century B.C. Internal report, file no. 1706A98, GCI Museum Research Laboratory, Getty Conservation Institute, Los Angeles.

1999 X-ray diffraction studies of some patina compositions from bronzes of Francavilla Marittima, south Italy. Internal report, file no. FVIA-XRD, GCI Museum Research Laboratory, Getty Conservation Institute, Los Angeles.

Sease, C.
1978 Benzotriazole: A review for conservators. *Studies in Conservation* 23:76–85.

Sekino, M.
1965 Restoration of the Great Buddha at Kamakura. *Studies in Conservation* 10:30–46.

Selwitz, C. M.
1988 *Cellulose Nitrate in Conservation.* Research in Conservation Series no. 2. Marina del Rey, Calif.: Getty Conservation Institute.

Selwyn, L. S., N. E. Binnie, J. Poitras, M. E. Laver, and D. A. Downham
1996 Outdoor bronze statues: Analysis of metal and surface samples. *Studies in Conservation* 41:205–29.

Selwyn, L. S., D. A. Rennie-Bissaillion, and N. E. Binnie
1993 Metal corrosion rates in aqueous treatments for waterlogged wood-metal composites. *Studies in Conservation* 38:180–97.

Sereda, P. J., S. G. Croll, and H. F. Slade
1982 Measurement of the time-of-wetness by moisture sensors and their calibration. In *Atmospheric Corrosion of Metals,* ed. S. W. Dean, Jr. and E. C. Rhea, 267–85. Philadelphia: ASTM.

Shahani, C. J., and F. H. Hengenihle
1986 The influence of copper and iron on the permanence of paper. In *Historic Textile and Paper Materials,* ed. H. L. Needles and S. H. Zeronian, 387–410. Washington, D.C.: American Chemical Society.

Shalov, S., and J. P. Northover
1993 The metallurgy of the Nahal Mishmar hoard reconsidered. *Archaeometry* 35 (February): 35–48.

Sharkey, J. B., and S. Z. Lewin
1971 Conditions governing the formation of atacamite and paratacamite. *American Mineralogist* 56:179–92.

Sharma, V. C., and B. V. Kharbade
1994 Sodium tripolyphosphate—a safe sequestering agent for the treatment of excavated copper objects. *Studies in Conservation* 39:39–44.

Sharma, V. C., U. Shankar Lal, and M. V. Nair
1995 Zinc dust treatment: An effective method for the control of bronze disease on excavated objects. *Studies in Conservation* 40:110–19.

Shier, D., J. Butler, and R. Lewis
1996 *Hole's Human Anatomy and Physiology.* Chicago: W. C. Brown.

Shorer, P. T.
1979 Romano-British bronze parade helmet and mask from Ribchester. In *Problems of the Completion of Art Objects: Proceedings of the Second International Restorer Seminar, Veszprem,* 255–59. Budapest: Institute of Conservation and Methodology of Museums.

1997 Observations of fifty years conservation at the British Museum. In *Metal 95: Proceedings of the International Conference on Metals Conservation,* ed. I. D. MacLeod, S. L. Pennec, and L. Robbiola, 6–10. London: James and James.

Shrier, L. L.
1977 *Corrosion.* London: Butterworths.

Shumei Foundation
1996 *Ancient Art from the Shumei Family Collection.* Exhibition catalogue, 20 June–1 September. New York: The Metropolitan Museum of Art.

Silman, H., G. Isserlis, and A. F. Averill
1978 *Protective and Decorative Coatings for Metals.* London: Finishing Publications.

Simpson, D. R., R. Fisher, and K. Libsch
1964 Thermal stability of azurite and malachite. *American Mineralogist* 49:1111–14.

Smeaton, W. A.

1978 Early methods of cladding base metals with platinum. *Platinum Metals Review* 22:61–67.

Smith, C. S.

1971 Art, technology and science: Notes on their historical interactions. In *Perspectives in the History of Science and Technology,* ed. D. Roller, 129–65. Norman: Univ. of Oklahoma Press.

1973 An examination of the arsenic-rich coating on a bronze bull from Horoztepe. In *Application of Science in the Examination of Works of Art,* ed. W. J. Young, 96–102. Boston: Museum of Fine Arts.

1977 Some constructive corrodings. In *Corrosion and Metal Artifacts: A dialogue between conservators and archaeologists and corrosion scientists,* ed. B. F. Brown, H. C. Burnett, W. T. Chase, M. Goodway, J. Kruger, and M. Pourbaix, 143–54. National Bureau of Standards Special Publication no. 479, Washington, D.C.

1978 The beginnings of industrial electrometallurgy. In *Selected Topics in the History of Electrochemistry,* ed. G. Dubpernell and J. H. Westbrook, 360–405. Princeton, N.J.: Electrochemical Society.

Smith, R., J. H. Carlson, and R. M. Newman

1987 An investigation into the deterioration of painted Limoges enamel plaques c. 1470–1530. *Studies in Conservation* 32:102–13.

Smith, C. S., and J. G. Hawthorne

1974 *Mappae clavicula: A little key to the world of medieval techniques. Transactions of the American Philosophical Society,* n.s., 64:3–127.

Smithells, C. J.

1937 *Gases and Metals.* London: Chapman and Hall.

1983 *Smithells Metals Reference Book,* ed. Eric A. Brandes. 6th ed. London; Boston: Butterworths.

Socha, J., M. Lesiak, S. Safarzynski, and K. Lesiak

1980 Oxide coating in the conservation of metal monuments: The column of King Sigismundus III in Warsaw. *Studies in Conservation* 25:14–18.

Spurrell, F. C. J.

1895 Notes on Egyptian colors. *Archaeological Journal* 52:222–39.

Staffeldt, E. E., and O. H. Calderon

1967 Possible degradation of metals by microorganisms. In *Developments in Industrial Microbiology,* vol. 8, 321–32. 23rd General Meeting of the Society for Industrial Microbiology. Washington, D.C.: American Institute of Biological Sciences.

Staffeldt, E. E., and A. Paleni

1978 *Chalconatronite: A New Material from St. Mark's Basilica in Venice.* Modena, Italy: Editore Poligrafico Artioli.

Stambolov, T.

1985 *The Corrosion and Conservation of Metallic Antiquities and Works of Art.* Amsterdam: Central Research Laboratory for Art and Science.

Standage, H. C.

1887 *The Artist's Manual of Pigments, Showing Their Composition and Conditions of Permanency.* 2d ed. London: Crosby Lockwood and Co.

Stavenhagen, A.

1895 Beiträge zur Kenntniss der Arsenite. *Journal für Praktische Chemie* 51 ser. 2:1–42.

Stetter, C.

1993 *The Secret Medicine of the Pharaohs.* Chicago, Berlin, Moscow, Tokyo: Edition Q.

Stodulski, L., E. Farrell, and R. Newman

1984 Identification of ancient Persian pigments from Persepolis and Pasargade. *Studies in Conservation* 29:143–54.

Stone, R., R. White, and N. Indictor

1990 The surface composition of some Italian Renaissance bronzes. In *ICOM Committee for Conservation 9th Triennial Meeting, Dresden, German Democratic Republic, 26–31 August 1990, Preprints,* 568–73. Paris: ICOM Committee for Conservation.

Strandberg, H.

1997 Perspectives on bronze sculpture conservation: Modelling copper and bronze corrosion. Ph.D. diss., Avdelningen for Oorganisk Kemi, Göteborgs Universitet, Gothenburg, Sweden.

Strandberg, H., and L.-G. Johansson

1997a Role of O_3 in the atmospheric corrosion of copper in the presence of SO_2. *Journal of the Electrochemical Society* 144:2334–42.

1997b Some aspects of the atmospheric corrosion of copper in the presence of sodium chloride. *Journal of the Electrochemical Society* 144:3443–49.

1997c The formation of black patina on copper in humid air containing traces of SO_2. *Journal of the Electrochemical Society* 144:81–89.

1997d The effects of air pollutants on cultural objects. In *Metal 95: Proceedings of the International Conference on Metals Conservation,* ed. I. D. MacLeod, S. L. Pennec, and L. Robbiola, 83–85. London: James and James.

Strandberg, H., L.-G. Johansson, and O. Lindqvist
1997 The atmospheric corrosion of statue bronzes exposed to SO_2 and NO_2. *Material Corrosion* 48 (11): 721–30.

Strandberg, H., V. Langer, and L.-G. Johansson
1995 Structure of $Cu_{2.5}(OH)_3SO_4 \cdot 2H_2O$: A novel corrosion product of copper. *Acta Chemica Scandinavica* 49:5–10.

Stranmanis, M., and A. Circulis
1935 Über das gelbe Kupfer(1)-Oxyd. *Zeitschrift für Anorganische und Allgemeine Chemie* 224:107–12.

Stronge, S.
1993 Bidri ware of India. In *Metal Plating and Patination*, ed. S. LaNiece and P. Craddock, 133–147. Oxford: Butterworth-Heinemann.

Stulik, D., E. Porta, and A. Palet
1993 Analyses of pigments, binding media and varnishes. In *Art and Eternity: The Nefertari Wall Paintings Conservation Project, 1986–1992*, ed. M. A. Corzo and M. Afshar. Marina del Rey, Calif.: Getty Conservation Institute.

Sun, S., Z. Ma, L. Jin, H. Rubin, and T. Ko
1992 The formation of black patina on bronze mirrors. Paper given at the 1992 Archaeometry Conference, Institute of Archaeology, UCLA, in conjunction with the Getty Conservation Institute, April.

Symes, J. L., and D. A. Kester
1984 Thermodynamic stability studies of the basic copper carbonate mineral, malachite. *Geochimica et Cosmochimica Acta* 48:2219.

Tamura, H., O. Kazuhide, M. Wasuke, and K. Michihiko
1981 Molecular and crystal structure of $Cu(HCOO)(OH)$. *Inorganica Chimica Acta* 54:L87–L90.

Taniguchi, Y., and D. A. Scott
1999 Laboratory data for the synthesis of verdigris compound C. Report. GCI Museum Research Laboratory, Getty Conservation Institute, Los Angeles.

Tatti, S. A.
1985 Bronze conservation: Fairmont Park 1983. In *Sculptural Monuments in an Outdoor Environment*, 59–66. Philadelphia: Pennsylvania Academy of Fine Arts.

Taube, M., A. H. King, and W. T. Chase III
1997 Investigation of the altered layer on ancient Chinese bronze mirrors and model high-tin bronzes. In *Materials Issues in Art and Archaeology*, vol. 5, ed. P. B. Vandiver, J. R. Druzik, J. F. Merkel, and J. Stewart, 19–24. Pittsburgh: Materials Research Society.

Taubes, F.
1976 *Restoring and Preserving Antiques.* New York: Watson-Guptill.

Tennent, N. H., and K. M. Antonio
1981 Bronze disease: Synthesis and characterization of botallackite, paratacamite and atacamite by infra-red spectroscopy. In *ICOM Committee for Conservation 6th Triennial Meeting, Ottawa, 21–25 September 1981, Preprints*, vol. 4, 81/23/3/1–11. Paris: ICOM Committee for Conservation.

Tennent, N. H., and T. Baird
1992 The identification of acetate efflorescence on bronze antiquities stored in wooden cabinets. *Conservator* 16:39–43.

Tennent, N. H., B. G. Cooksey, D. Littlejohn, B. J. Ottaway, S. E. Tarling, and M. Vickers
1993 Unusual corrosion and efflorescence products on bronze and iron antiquities stored in wooden cabinets. In *Conservation Science in the UK: Preprints of the Meeting Held in Glasgow, May 1993*, ed. N. H. Tennent, 60–66. London: James and James Science Publishers.

Ternbach, J.
1972 Restoration of bronzes—ancient and modern. *Bulletin of the American Group-IIC* 12(2):110–16.

Theophilus, Presbyter
1961 *The Various Arts.* Trans. from the Latin with introduction and notes by C. R. Dodwell. London, New York: T. Nelson.

Theophrastus on Stones
1956 Edited with introduction, Greek text, English translation, and commentary by E. R. Caley and J. F. C. Richards. Graduate School Monographs, Contributions in Physical Science, no. 1. Columbus: Ohio State Univ.

Thickett, D., S. Bradley, and L. Lee
1998 Assessment of the risks to metal artifacts posed by volatile carbonyl pollutants. In *Metal 98*, ed. S. Pennec and I. D. MacLeod, 260–64. London: James and James.

Thickett, D., and C. Enderly
1997 The cleaning of coin hoards: The benfits of a collaborative approach. In *The Interface between Science and the Conservator*, 183–92. British Museum Occasional Paper 16. London: British Museum.

Thickett, D., and M. Odlyha
2000 Note on the identification of an unusual pale blue corrosion product from Egyptian copper alloy artifacts. *Studies in Conservation* 45:63–67.

Thomas, R. G.
1990 Studies of the corrosion of the copper. Ph.D. diss., School of Chemistry and Applied Chemistry, University of Wales, Cardiff.

Thompson, D. V.
1932 *Cennino d'Andrea Cennini da Colle di Val d'Elsa. Il libro dell'arte.* New Haven, Conn.: Yale Univ. Press.

Tidblad, J., and C. Leygraf
1995 Atmospheric corrosion effects of SO_2 and NO_2: A comparison of laboratory and field exposed copper. *Journal of the Electrochemical Society* 142:749–55.

Tidblad, J., C. Leygraf, and V. Kucera
1991 Acid deposition effects on materials: Evaluation of nickel and copper. *Journal of the Electrochemical Society* 138:3592–98.

Tidblad, J., A. A. Mikhailov, and V. Kucera
1998 A relative humidity and temperature model for time of wetness prediction. In *Swedish Corrosion Institute ICP Report 1998-03-30.* Stockholm: Swedish Corrosion Institute.

Tite, M. S.
1972 *Methods of Physical Examination in Archaeology.* London: Seminar Press.

1983 Egyptian faience: An investigation of the methods of production. *Archaeometry* 25:17–27.

1984 Technological examination of Egyptian blue. In *Archaeological Chemistry*, vol. 3, 215–42. Advances in Chemistry Series. Washington, D.C.: American Chemical Society.

1987 Identification of early vitreous materials. In *Recent Advances in the Conservation and Analysis of Artifacts*, comp. J. Black, 81–85. London: Summer Schools Press.

Tite, M. S., and M. Bimson
1986 Faience: An investigation of the microstructures associated with the different methods of glazing. *Archaeometry* 28:69–78.

Tite, M.S., M. Bimson, and M. R. Cowell
1987 The technology of Egyptian blue. In *Early Vitreous Materials*, ed. M. Bimson and I. C. Freestone, 39–46. British Museum Occasional Paper 56. London: British Museum.

Tite, M. S., M. Bimson, and N. D. Meeks
1981 Technological characterisation of Egyptian blue. In *Revue d'Archéométrie. Actes du XX Symposium International d'Archéométrie*, vol. 3, 297-302.

Tite, M. S., I. C. Freestone, and M. Bimson
1983 Egyptian faience: An investigation of the methods of production. *Archaeometry* 25:17-27.

Tite, M. S., A. J. Shortland, P. T. Nicholson, and C. Jackson
1999 The use of copper and cobalt colorants in vitreous materials in ancient Egypt. Typescript, Oxford Research Laboratory for Archaeology and the History of Art, University of Oxford, England.

Toishi, K.
1965 Radiography of the Great Buddha at Kamakura. *Studies in Conservation* 10:47-52.

Townsend, J. H.
1993 *Turner's Painting Technique.* Exhibition catalogue. London: Tate Gallery.

Tracy, A. W.
1951 Historic church's copper roof good after 213 years. *Corrosion* 7:373-75.

Tubb, K. W.
1987 Conservation of the lime plaster statues of ʿAin Ghazal. In *Recent Advances in the Conservation and Analysis of Artifacts*, comp. J. Black, 131-33. London: Summer Schools Press.

Turner, N.
1998 The recipe collection of Johannes Alcherius and the painting materials used in manuscript illumination in France and Northern Italy, c. 1380-1420. In *Painting Techniques: History, Materials and Studio Practice*, ed. A. Roy and P. Smith, 45-50. IIC Dublin Conference. London: IIC.

Turovets, I., M. Maggen, and A. Lewis
1998 Cleaning of daguerreotypes with an excimer laser. *Studies in Conservation* 43:89-100.

Tweddle, D.
1992 The Anglian helmet from Coppergate. In *The Archaeology of York*, vols. 17-18. London: Council for British Archaeology.

Tylecote, R. F.
1976 *A History of Metallurgy.* London: Metals Society.

Ucko, P. J., and A. Rosenfeld
1967 *Palaeolithic Cave Art.* World University Library Series. New York: McGraw-Hill.

Ullrich, D.

1987 Egyptian blue and green frit: Character-
ization, history and occurrence, synthesis. *PACT*
17:323–32.

Ultsch, P.

1987 Wilhelm Sattler (1784–1859) Der frankische
Farbenpionier. In *Veröffentlichungen zur bayerischen
Geschichte und Kultur,* vol. 7, ed. C. Grimm, 328–35.
Munich: Haus der bayerischen Geschichte.

Uminski, M., and V. Guidetti

1995 The removal of chloride ions from artifi-
cially corroded bronze plates. *Studies in Conservation*
40:274–78.

Uno, D.

1929 Künstliche Korrosion von japanischen Spe-
ziallegierungen. *Korrosion und Metallschutz unter
Einbeziehung des allgemeinen Metallschutzes* 5(6):121–
30, 147–56.

Vallat, F.

1983 Un fragment de tablette achéménide et la tur-
quoise. *Akkadica* 33:63–68.

Vandiver, P.

1982 Technological change in Egyptian faience.
In *Archaeological Ceramics,* ed. J. S. Olin and A. D.
Franklin, 167–79. Washington, D.C.: Smithsonian
Institution.

Vandiver, P. B., M. Fenn, and T. A. Holland

1992 A third millennium B.C. glazed quartz bead
from Tell Es-Sweyhat, Syria. In *Materials Issues in
Art and Archaeology,* vol. 3, ed. P. B. Vandiver, J. R.
Druzik, G. S. Wheeler, and I. C. Freestone, 519–25.
Materials Research Society Symposium Proceedings
267. Pittsburgh: Materials Research Society.

van Eikema Hommes, M.

1998 Painters' methods to prevent color changes
described in sixteenth to early seventeenth century
sources on oil painting techniques. In *Looking through
Paintings,* ed. E. Hermens, A. Ouwerkerk, and N.
Costaras, 91–131. London: Archetype Publications.

Vanino, L., and E. Seitter

1903 *Die Patina, ihre natürliche und künstliche
Bildung auf Kupfer und dessen Legierungen.* Vol. A.
Hartleben Chemische-technische Bibliothek Series
no. 26. Vienna: A. Hartleben.

van T'Hul-Ehrenreich, E. H., and P. B. Hallebeek

1972 A new kind of old green pigment found.
Paper presented at ICOM Committee for Conserva-
tion 3rd Triennial Meeting, 2–8 October, Madrid.

Vasari, Giorgio

[1907] 1960 *Vasari on Technique: Being the Intro-
duction to the Three Arts of Design, Architecture,
Sculpture and Painting, Prefixed to the Lives of the
most Excellent Painters, Sculptors, and Architects.*
Trans. Louisa S. Maclehose, ed. G. Baldwin Brown.
Reprint, New York: Dover Publications.

Veloz, N. F.

1994 Practical aspects of using walnut shells for
cleaning outdoor sculpture. *APT Bulletin* 25:70–76.

Veloz, N. F., A. W. Ruff, and W. T. Chase

1987 Successful use of soft abrasives (walnut shells)
for cleaning outdoor bronze sculpture by air jets. In
*Old Cultures in New Worlds: 8th General Assembly
ICOMOS Council on Monuments and Sites,* 492–98.
Washington, D.C.: International Council on Monu-
ments and Sites (ICOMOS).

Vendl, A.

1999 *The ISCA/Copal Exposition Program.* Vienna:
University of Applied Arts and The Institute of Silicate
Chemistry and Archaeometry.

Vernon, W. H. J.

1932a The open-air corrosion of copper, 3: Artificial
production of green patina. *Journal of the Institute of
Metals* 49:153–67.

1932b Recent investigations on the atmospheric
corrosion of copper. *Korrosion und Metallschutz*
8:141–47.

1933 Note on the green patina on copper:
Examples from Elan Valley (Wales) and Dundalk
(Ireland). *Journal of the Institute of Metals* 50:93–100.

Vernon, W. H. J., and L. Whitby

1930 The open-air corrosion of copper, part 2:
The mineralogical relationships of corrosion products.
Journal of the Institute of Metals 44:389–96.

Vitruvius

1931 *De architectura.* Ed. F. Granger. Cambridge,
Mass.: Harvard Univ. Press; London: W. Heinemann.

Voelcker, A.

1864 On the injurious effect of smoke on certain
building stones and on vegetation. *Journal of the Soci-
ety of Arts* 12:146–51.

Voorhees, A.

1988 Incralac can be removed from bronze monu-
ments. *CRM Bulletin* 11:18.

Voss, A.

1888 *Merkbuch, Alterthümer aufzugraben und auf-
zubewahren. Eine Anleitung für das Verfahren bei
Aufgrabungen sowie zum Konservieren vor- und früh-
geschichtlicher Alterthümer.* Hrsg. auf Veranlassung
das Herrn Ministers der geistlichen, Unterrichts- und
Medizinal-Angelegenheiten-mit acht Steindrucktafeln
Series. Berlin: E. S. Mittler.

**Wagner, D., F. Dakoronia, C. Ferguson, W. R. Fischer,
C. Hills, H. Kars, and R. Meijers**

1997 "Soil archive" classification in terms of
impacts of conservability of archaeological heritage.
In *Metal 95: Proceedings of the International Confer-
ence on Metals Conservation,* ed. I. D. MacLeod, S. L.
Pennec, and L. Robbiola, 244–250. London: James and
James.

**Wainwright, I. N. M., E. A. Moffatt, P. J. Sirois, and
G. S. Yount**

1997 Analysis of wall painting fragments from
Dunhuang. In *Conservation of Ancient Sites on
the Silk Road: Proceedings of an International
Conference on the Conservation of Grotto Sites,* 107–8.
Los Angeles: Getty Conservation Institute.

Wallert, A.

1995 The Libro Secondo de diversi colorie sise da
mettere a oro: A Fifteenth-century technical treatise
on manuscipt illumination. In *Historical Painting
Techniques, Materials and Studio Practice,* ed. A. Wal-
lert, E. Hermens, and M. Peek, 38–47. Marina del Rey,
Calif.: Getty Conservation Institute.

Walsh, J.

1929 Galen visits the Dead Sea and the copper
mines of Cyprus. *Bulletin of the Geographical Society
of Philadelphia* 25:92–110.

Waterman, L.

1931 *Preliminary Report upon the Excavations at
Tel Umar.* Vol. 1. Ann Arbor: University of Michigan.

Watkins, K. G.

1997 A review of materials interaction during laser
cleaning in art restoration. In *Lacona 1: Lasers in the
Conservation of Artworks,* 7–15.Vienna: Mayer and Co.

Weast, R. C., ed.

1984 *CRC Handbook of Chemistry and Physics.*
65th ed. Boca Raton, Fla.: CRC Press.

Weil, P. D.

1975 The approximate two-year lifetime of Incra-
lac on outdoor bronze sculpture. In *ICOM Committee
for Conservation 4th Triennial Meeting, Venice, 13–
18 October 1975, Preprints,* 75.22.21–24. Paris: ICOM
Committee for Conservation.

1976 Conservation of outdoor bronze sculpture.
National Sculpture Review 25:26–30.

1980 The conservation of outdoor bronze sculp-
ture: A review of modern theory and practice. In
*American Institute for Conservation of Historic and
Artistic Works: Preprints of Papers Presented at the
Eighth Annual Meeting, San Francisco, California,
22-25 May 1980,* 129–40. Washington, D.C.: AIC.

1983 Toward ethical, adequately researched, ade-
quately documented, appropriate, and maintainable
treatments for the conservation of outdoor bronze
sculpture. In *Bronze and Masonry in the Park Envi-
ronment: Preprints of a Conference Held in New York
City, October 20-21, 1983,* 13–20. New York: Center
for Building Conservation.

1985a Patina: Historical perspective on artistic
intent and subsequent effects of time, nature and
man. In *Sculptural Monuments in an Outdoor Envi-
ronment,* 21–27. Philadelphia: Pennsylvania Academy
of Fine Arts.

1985b Conservation of bronze sculpture: A series of
case studies. In *Sculptural Monuments in an Outdoor
Environment,* 67–77. Philadelphia: Pennsylvania Acad-
emy of Fine Arts.

1996 A review of the history and practice of patina-
tion. In *Historical and Philosophical Issues in the Con-
servation of Cultural Heritage,* ed. N. Stanley-Price,
M. K. Talley, Jr., and A. M. Vaccaro, 394–414. Los
Angeles: Getty Conservation Institute.

**Weil, P. D., P. Gaspar, L. Gulbransen, R. Lindberg, and
D. Zimmerman**

1982 The corrosive deterioration of outdoor bronze
sculpture. In *Science and Technology in the Service of
Conservation: Preprints of the Washington Conference,*
130–34. London: IIC.

Weisser, T. D.

1987 The use of sodium carbonate as a pretreat-
ment for difficult-to-stabilise bronzes. In *Recent
Advances in the Conservation and Analysis of Arti-
facts,* comp. J. Black, 105–08. London: Summer
Schools Press.

Werner, A. E.

1972 Conservation and display, 1: Environment
control. *Museums Journal* 72:58–60.

Wershaw, R. L.

1992 Membrane-micelle model for humus in soils and sediments and its relation to humidification. In *United States Geological Survey Open File Report 91–513*. Denver: United States Geological Survey.

Weser, U.

1987 Biochemical basis of the use of copper in ancient Egyptian and Roman medicine. In *Recent Advances in the Conservation and Analysis of Artifacts,* comp. J. Black, 189–93. London: Summer Schools Press.

Weyl, W. A.

1981 *Colored Glasses.* Sheffield, England: Society of Glass Technology.

Wharton, G.

1984 Technical examination of Renaissance medals: The use of Laüe back-reflection X-ray diffraction to identify electroformed reproductions. *Journal of the American Institute of Conservation* 23:88–100.

White, J. M., and E. C. Bunker

1994 *Adornment for Eternity.* Denver: Denver Art Museum, Woods Publishing.

Wiedemann, H. G., and G. Bayer

1982 The bust of Nefertiti. *Analytical Chemistry* 54:619A–628A.

1992 Approaches to ancient Chinese artifacts by means of thermal analysis. *Thermochimica Acta* 200:215–55.

1997 Formation and stability of Chinese barium copper silicate pigments. In *Conservation of Ancient Sites on the Silk Road: Proceedings of an International Conference on the Conservation of Grotto Sites,* 379–87. Los Angeles: Getty Conservation Institute.

Wilkins, R. A., and R. H. Jenks

1948 Copper. In *The Corrosion Handbook,* ed. H. H. Uhlig, 61–68. New York: J. Wiley and Sons.

Williams, R. J. P.

1967 Schwermetalle in biologischen Systemen. *Endeavour* 26:96–100.

1993 Copper-protein compounds. In *The Chemistry of the Copper and Zinc Triads,* ed. A. J. Welch and K. Chapman. Cambridge, England: Royal Society of Chemistry.

Williams, R. J. P., and J. J. R. da Silva Frausto

1996 *The Natural Selection of the Chemical Elements.* Oxford: Oxford Univ. Press.

Williams, S. A.

1963 Anthonyite and calumetite, two new minerals from the Michigan copper district. *American Mineralogy* 48:614–19.

Windholz, M., ed.

1983 *The Merck Index: An Encyclopedia of Chemicals, Drugs and Biologicals.* 10th ed. Rahway, N.J.: Merck.

Woods, T. L., and R. M. Garrels

1986 Phase relations of some cupric hydroxy minerals. *Economic Geology* 81:1989.

Woudhuysen-Keller, R.

1995 Aspects of painting technique in the use of verdigris and copper resinate. In *Historical Painting Techniques, Materials and Studio Practice,* ed. A. Wallert, E. Hermens, and M. Peek, 65–69. Marina del Rey, Calif.: Getty Conservation Institute.

Woudhuysen-Keller, R., and P. Woudhuysen

1998 Thoughts on the use of the green glaze called "copper resinate" and its colour-changes. In *Looking through Paintings,* ed. E. Hermens, A. Ouwerkerk, and N. Costaras, 133–44. Baarn: De Promo.

Yamanaka, S.

1996 Preparation and properties of anion-exchangeable layered basic salts (in Japanese). *Nippon Ion Kokan Gakkaishi* 7:8–17.

Zachmann, D. W.

1985 Untersuchung der Mineralbildung in der Patina (Korrosionsschicht) der Braunschweiger Burlöwen. In *Der Braunschweiger Löwe,* ed. G. Speis, 207–32. Occasional Offprint Series no. 6. Braunschweig, Germany: Stadtischen Museum.

Zenghelis, G.

1930 Study of antique bronzes. *Chimie et Industrie* 33:556–63.

Zhao X.

c.1230 *Dong tian qing lu ji.* Shanghai. Quoted in R. Kerr, *Later Chinese Bronzes.* London: Victoria and Albert Museum, 1990.

Zhu, S., and T. He

1993 Studies of ancient Chinese mirrors and other bronze artefacts. In *Metal Plating and Patination,* ed. S. LaNiece and P. Craddock, 50–62. Oxford: Butterworth-Heinemann.

Name Index

A

Abelskamp, K. A. N., 80
Accardo, G., 395
Adib, D., 124
Agrawal, O. P., 292, 316
Ahle, A., 98, 110, 111
Albertus Magnus, 225
Alcherius, J., 288
Aldaz, A., 304, 365
Alexander, tenth Duke of Hamilton, 351
Alexander, A. L., 68
Alexander, P., 73
Allen, I. M., 84
Alunno-Rossetti, V., 305
André, A., 356
Angelini, E., 245
Annamalai, P. L., 52, 53
Annetts, K., 9
Ansari wal Faruqi, Fadlu'llah, 291
Antico (Pier Jacopo Alari Bonacolsi), 330
Antonio, K. M., 128, 129, 337, 380
Aoki, S., 116, 160, 161, 162, 167
Aoyama, Y., 251
Apals, J., 350
Apals, Z., 350
Applebey, M. P., 111
Aristonidas, 325
Armenini, G. B., 296
Arwidsson, G., 19
Aschenbrenner, S., 325

Ashur, I. A., 88
Asmus, J. F., 362
Averill, A. F., 19
Averlino, A., 331
Avery, C., 331

B

Baden, L., 149
Baer, N. S., 96, 284, 286
Baglioni, P., 98, 110, 111
Baird, T., 299, 302
Balboian, R., 149
Baldinucci, F., 329
Bandinelli, B., 330
Bandy, J. A., 147
Bandy, M. C., 147
Banik, G., 75, 119, 165, 246, 251, 281, 282, 292, 293
Barag, D., 93
Barber, D. J., 92, 93
Barbour, D., 361
Barnard, N., 86, 103, 345, 347
Barry, E. J., 360
Bartholdi, F.-A., 167
Bartolini, M., 395
Barton, K., 58
Barye, A. L., 333
Bass Becking, L. G., 34, 37
Bassett, J., 376
Bayard, M. A., 308, 312, 314, 453
Bayer, G., 263, 266
Beale, A., 22, 327, 351, 355, 384, 385, 392, 397

Bearn, J. G., 306, 311, 314, 416
Beccaria, A. M., 70, 112
Beckford (alderman), 351
Beckford, W., 351
Bek, S., 292
Bélanger, F.-J., 234
Bell, B., 368, 369
Benhamou, R., 276, 278
Berg, G. G., 19
Berman, H., 11, 101, 102, 105, 116, 123, 138, 139, 142, 228, 247, 248, 250
Bernardini, G. P., 158, 305
Berthelot, M. P. E., 126, 127, 144
Bertholon, R., 25, 368, 369
Beudant, F. S., 100
Bewer, F. G., 21, 330, 332, 394
Bezur, A., 154, 233
Bianchi, G., 68, 69
Bianco, P., 245
Bicchieri, M., 76
Biestek, T., 152
Biller the Elder, J. L., 119
Bimson, M., 238, 261, 264
Binnie, N. E., 71, 142, 143, 150, 153, 154, 158, 163, 232, 243, 305
Birelli, G., 297
Biringuccio, V., 316
Birnie, L., 349
Blattner, R., 76
Blengino, J.-M., 25, 368, 369
Block, I., 163
Blunt, A., 351

Bockris, J. O., 35
Boizot, S.-L., 170
Bolingtoft, P., 110
Bomford, D., 310
Bonacolsi, P. J. A., 330
Borg, G. H., 40, 165, 241, 243, 246
Born, H., 333
Boucher, F., 114
Bowron, E. P., 317
Bradley, S., 300
Braithwaite, R. S. W., 248
Brancusi, C., 163, 195
Bridge, P. J., 102, 246
Bridgman, C. F., 319
Brill, R. H., 93, 267
Brimblecombe, P., 59, 60
Brinsco, A., 330
Bristow, I. C., 115
Britton, D., 84
Bronzino, A., 165
Brostoff, L. B., 377, 379, 388
Brown, B. F., 11
Brunner, M., 382
Brusic, V., 379
Buchner, J. A., 278
Buck, R. D., 318
Buckingham, W. F., 163
Bukhari, Y. K., 291, 292, 415
Bunker, E. C., 103
Burmester, A., 109, 159, 305
Burnett, H. C., 11
Burnham, J., 18, 284, 285
Burton, R., 267
Buss, D. H., 271, 272, 273, 406, 408, 409
Butler, J., 280

C

Calder, A. M., 149, 361
Calder, A. S., 149
Calderon, O. H., 63
Caley, E. R., 236
Callaghan, R., 29
Cambyses II of Persia, 144
Camitz, G., 35
Campbell, H. S., 71
Campbell, S. N., 251
Caneva, C., 395
Capell, R. J., 61
Carabatos, C. M., 84
Carlson, J. H., 321
Caserio, M. C., 74, 315
Castro y Velasco, P., 292
Cennini, C., 294, 296, 298, 316, 317
Chacon, P., 329

Chakrabarti, D. J., 226
Chambers, E., 278
Chaptal, J., 259
Chase, W. T., 11, 12, 14, 42, 83, 85, 86, 88, 262, 343, 348, 360–61
Chen, H. L., 74
Chiavari, G., 305
Childe, G., 4
Christ, C. L., 37, 111
Christensen, C., 110, 314
Christman, B., 334
Church, A. H., 125, 309
Ciacconius, P., 329
Circulis, A., 92
Clark, S., 143
Cliver, E. B., 149
Coedes, G., 275
Coghlan, H. H., 84
Collins, W. F., 340
Colombo, B., 395
Comizzoli, R. B., 62
Cooke, R. B. S., 325
Cooksey, B. G., 299, 301
Cooney, J. D., 324
Corazza, M., 158, 305
Corfield, M., 18, 19
Cortés, H., 249
Cossa, F. del, 114
Costas, L. P., 54
Cottam, C. A., 362
Cotton, F. A., 399
Cotton, J., 376
Cottrell, A., 400
Cowell, M. R., 261
Craddock, P. T., 5, 88, 90, 238, 324
Crane, J., 375, 397
Crawford, T., 374
Croll, S. G., 58
Crosland, M. P., 285
Crumlin-Pedersen, O., 350
Cuboni, G., 126

D

D'Amalfi, P., 331
D'Amicone, E., 245
da Silva Frausto, J. J. R., 76
Dahlen, M. A., 315
Dakoronia, F., 41, 42
Dandridge, A. G., 315, 316
Daniel, G., 4
Daniels, V., 61, 76
Daubree, A., 228, 229
Davidson, S., 94
Davis, F., 351
Davis, M. E., 54, 232

Davy, H., 7, 64, 258–59
Davy, J., 7, 85, 122, 144
Dawson, J., 303
de Compeigne, A., 288
de Gouvernain, 147
de la Rie, R., 388
de Mayerne, T. T., 294, 295
de Meester, P., 286
de Vries, A., 221, 375, 455
de Weldon, F., 360
Dean, S. W., Jr., 11
Dei, L., 98, 110, 111
Del Bino, G., 63
Delbourgo, S. R., 134
Deutscher, R. L., 111
Deville, J. A., 121
Dewe, H. C., 328
Dickson, M. B., 292
Diffine, M., 84
Dini, D., 98, 110, 111
Dionisy, 165
Dioscorides, P., 104, 146, 167, 225, 268, 270, 279, 280, 316
Dodwell, C. R., 326
Dohrenwend, D., 267
Domenichino, 318
Donatello, 210, 331, 351
Donnan, C. B., 430
Doughty, D. H., 430
Downham, D. A., 142, 143, 150, 153, 154, 158, 163, 232, 243, 305
Drayman-Weisser, T., xiii, 355
Drescher, H. A. E., 316
Dreyer, R. M., 164, 165, 253
Drys, M., 152
Dugang, L., 382
Duncan, S. J., 153, 229, 235
Dunne, D., 86
Durand, E., 25
Dutrizac, J., 110, 124, 144, 425
Dutta, C., 224, 239

E

Earland, C., 73
Eastlake, C. L., 293, 294, 295
Ebbell, B., 278
Ebers, G., 278
Edmonds, P., 115
Eggert, G., 18, 236, 397
Eitel, A. G., 167
El Goresy, A., 259, 262, 263, 265, 266
Emmony, D. C., 362
Ems, R. von, 274, 441
Enderly, C., 372
Ensor, J., 206, 312, 454

Erhardt, D., 385
Ericsson, R., 45
Eriksson, P., 45, 47, 48
Erlij, A., 360
Espana, T., 304, 365
Evans, J., 39
Evans, U. R., 11, 88, 95, 303
Eyck, J. van, 296

F

Fabergé, P. C., 102
Fabrizi, M., 244, 251
Faltermeier, R. B., 379
Fang, G., 88
Fang, S. B., 379
Faruqi, Fadlu'llah Ansari wal, 291
Farrell, E., 258
Federici, V., 331
Fenn, M., 256
Ferguson, C., 41, 42
Ferrier, R. J., 76
Ferroni, E., 98, 110, 111
Fiaud, C., 150
Fiedler, I., 308, 312, 314, 453
Field, G., 315
Filarete, 331
Finger, L. W., 267
Fink, C. G., 327, 336, 363
Fiorentino, P., 251
Fischer, W., 41, 42, 153
Fisher, J. R., 136
Fisher, R., 113
Fishlock, D., 22, 80
Fitzhugh, E. W., 106, 114, 137, 138,
 139, 166, 266, 267, 314
Fjaestad, M., 40, 41, 165, 241, 243, 246
Fleischer, M., 253, 421
Fleischmann, M., 379
Fletcher, S. R., 286
Flieder, F., 299
Florian, M.-L. E., 228
Foggini, G. B., 210, 331
Foley, R. T., 18
Fonduli, G., 330
Fontana, F., 102
Foord, E. E., 247, 250, 251
Foreman, D. W., 74
Formigli, E., 120, 328, 370
Foss, J. E., 35
Fougue, M. F., 259
Fowles, G., 270
Fox, C., 19, 371–72
France-Lanord, A., 358, 368, 369, 391
Francesco I de' Medici, 330
Franey, J. P., 54, 55, 232, 269

Frankel, G., 379
Frankenthal, R. P., 62
Freestone, I. C., 91, 92, 93, 264
Friedman, M., 77
Frisch, M. A., 379
Frondel, C., 11, 101, 102, 105, 116,
 117, 120, 123, 124, 125, 138,
 139, 142, 228, 247, 248, 250,
 364
Fuchs, R., 271, 272, 273, 406, 408,
 409

G

Gaddi, N., 351
Gale, N. H., 9
Galen, 147
Galvani, L., 17
Ganiaris, H., 153, 229, 235, 244, 397
Ganorkar, M. C., 381–82
Garenne-Marot, L., 25
Garland, K., 136
Garrels, R. M., 37, 38, 111, 136, 164,
 165, 253
Gasket, H., 259, 263, 265
Gaspar, P., 361, 374
Gates, C. B., 293
Gauguin, P., 314
Gaurico, P., 331
Gauricus, P., 329, 331
Gauthier, J., 271, 272, 273, 406, 407
Gayathri, P., 381
Geber, 225, 239
Geilmann, W., 37, 42, 243, 337, 338,
 340–43
Gentele, J. G., 309, 314
Gerhardt, C.-F., 250
Gettens, R. J., xiii, 13, 106, 108, 110,
 114, 116, 117, 120, 124, 125,
 137, 142, 149, 166, 228, 251,
 254, 312, 314, 315, 355, 364,
 392
Ghiberti, L., 149, 251, 373
Ghosh, S. K., 276
Giambologna, 332
Giangrande, C., 84, 131
Gilberg, M., 126, 382
Gillard, R. D., 72, 73
Giumlia-Mair, A., 88, 89, 90, 238,
 324
Glemser, O., 271, 272, 273, 406, 408,
 409
Gmelin, 9, 76, 82, 269, 308, 311,
 416–17
Gnanam, F. D., 106
Goble, R. J., 229
Goodburn-Brown, D., 350, 369

Goodway, M., 11
Graaf, J. A. van de, 295, 318
Graedel, T. E., 46, 55, 56, 152, 269
Granger, A., 258
Gravenhorst, 306
Green, L. R., 61, 137, 262
Greenblatt, M., 2
Grice, J., 110, 124, 144, 425
Grzywacz, C. M., 61, 300
Guenter, J. R., 124
Guest, H. M., 397
Guidetti, V., 372
Gulbransen, L., 361, 374
Gullman, J., 47
Guthrie, R. E., 76
Gutscher, D., 96, 110

H

Haber, G. J., 26
Hack, H. P., 16
Hallebeek, P. B., 137, 411, 437
Halpine, S. M., 77
Hamilton, Alexander, tenth Duke
 of, 351
Hangst, K., 263
Hansel, I., 153
Harbottle, G., 249
Hardcastle, K., 316
Hardman, S. M., 72, 73
Hare, C. R., 282
Harley, R. D., 114, 254, 255, 316
Harris, R., 80, 362
Hawley, J. K., 382
Hawthorne, J. G., 19, 225, 237, 274,
 282, 283, 284, 286, 442
Hazen, R. M., 267
He, T., 339, 345
Hébert, L.-P., 143, 153
Hedges, R. E. M., 262
Heidersbach, R. H., 30
Heimler, M., 26
Helmi, F. M., 141
Hemingway, B. S., 136
Hemley, R. J., 267
Henderson, J., 94
Hengenihle, F. H., 76
Hérbert, L.-P., 143, 153, 190, 243
Herrmann, J. J., Jr., 334
Hey, M. H., 102, 246
Hhienepann, 291
Hill, L. L., 26, 27
Hills, C., 41, 42
Hiorns, A. H., 21, 22, 48, 50, 80
Hiroshige, 314
Hjelm-Hansen, N., 232

Hochleitner, R., 142
Holland, T. A., 256
Hollander, O., 377
Holm, R., 52–54
Hommes, V. E., 166
Hopwood, W., 385
Horie, C. V., 117, 118, 303, 364
Horovitz, I., 318, 319
Howe, E., 245
Hu, Y., 88
Hudson, G. E., 39
Hudson, R. F., 73
Huesmann, I. A., 41
Hughes, M. J., 120, 363
Hughes, R., 91, 106, 250, 299, 330, 333, 347
Hummer, C. W., 68
Hunt, L. B., 22
Hunt, W. H., 314
Huntington, H. E., 351
Hurlbut, C. S., Jr., 244
Hurtrelle, S., 330
Hykin, A., 396

I

ibn Muhammed al-Nefzawi, S. U., 267
Imhoff, C. E., 250
Indictor, N., 330, 332
Inoue, M., 269
Iskander, N. Y., 141
Ives, D. J. G., 107

J

Jack, J. F. S., 366
Jackson, C., 264
Jaeschke, H., 354, 355
Jaeschke, R., 354, 355
Jaffé, D., 329
Jakes, K. A., 74
Jambor, J., 110, 124, 144, 425
Jedrzejewska, H., 357
Jenks, R. H., 37
Jensen, N., 163
Jin, L., 340
Johannson, E. R., 62
Johansson, L.-G., 45, 46, 47, 48, 150, 153, 154, 155, 156, 157
Johnson, R. P., 18
Johnsson, B., 375
Jones, D. A., 11, 31
Jones, J. P., 63
Jones, R. E., 238
Just, J., 102, 246

K

Kaczmarczyk, A., 262
Kadashman-Turgu of Babylon, King, 248
Kaplan, I. R., 34, 37
Kars, H., 41, 42, 80
Kaufman, F., 379
Kazuhide, O., 270
Keeley, H. C. M., 39
Kennon, N., 86, 103
Kerber, G. M., 137
Kerr, R., 9, 80, 344
Kester, D. A., 136
Keyser, P. T., 17, 18
Khandekar, N., 77, 299, 316
Khanjian, H., 299, 316
Kharbade, B. V., 367
King, A. H., 343
King, R. B., 396
Kingery, K., 91, 307
Kirby, J., 310
Kishita, M., 269
Kitada, M., 88
Klaproth, M. H., 291
Knight, B., 144
Knoll, H., 225
Knotkova-Cermakova, D., 58
Ko, T., 340
Kobert, R., 278
Kockaert, L., 296
Koller, J., 159, 305
Koller, M., 137
Komkov, A. I., 152
König, W., 17, 18
Kotyga, G., 255
Koucky, F., 147
Krefting, A., 354
Krekel, C., 109
Krishnan, S., 106
Kruger, J., 11
Kucera, V., 45, 58, 62, 163
Kühn, H., 137, 275, 277, 297
Kumanotani, J., 77
Kussner, A., 225
Kutzke, H., 236

L

Lacome, M. S., 333
Lacoudre, N., 368, 369
Lacroix, A., 228
Laddha, G. S., 106
Lagerlöf, A., 40, 165, 241, 243, 246
Lambert, J. B., 6, 29, 349
Landseer, E. H., 310
Lane, K. W., 111
Langenegger, E. E., 29

Langs, D. A., 282
LaNiece, S., 238, 348, 349
Larsen, E. B., 25, 350
Larson, J., 136, 362
Latimer, W. M., 133
Lauber, D., 274
Laughlin, D. E., 226
Laurie, A. P., 109, 114, 121, 277, 295, 299
Laurie, S. H., 76
Laver, M. E., 142, 143, 150, 153, 154, 158, 163, 232, 243, 305
Le Bas, A., 103
Lebègue, J., 114
Lechtman, H. N., 20, 360, 400
Lee, L. R., 61, 300
Leenheer, R., 80
Leese, M., 76
Léger, F., 312, 453
Lehr, M., 89, 90
Leidheiser, H., Jr., 12, 36, 63, 65, 67, 232, 233
Leighton, J., 310
Leonardo da Vinci, 293, 297, 318
Leoni, L., 329
Leoni, M., 159
Lepaute, J.-B., 234
Lesiak, K., 91, 404
Lesiak, M., 91, 404
Leuchtenberg, M. H. von, 22
Lewin, S. Z., 108, 128, 129, 131, 134, 136
Lewis, A., 362
Lewis, R., 280
Leygraf, C., 45
Li, W., 382
Lian, G., 344
Libsch, K., 113
Lie, H., 361
Liebig, J. von, 307, 310
Liesegang, R. E., 86
Lindahl, K., 229
Lindberg, R., 361, 374
Lindgren, W., 111
Lindqvist, O., 45
Lindsay, W. L., 37
Lins, A., 149, 150, 361
Little, B. J., 65, 71
Littledale, W. A., 121, 254
Littlejohn, D., 299, 301
Liu, Z., 88
Lobnig, R. E., 62
Locher, A., 225
Longhi, P., 68, 69
Lopez-Segura, M., 304, 365
Low, M. J. D., 96, 284, 286

Lowry, R., 379
Lucas, A., 96, 103, 108, 238, 249, 256, 265
Lucey, V. F., 27, 71, 132
Lucretius, xii
Lynch, D., 379

M

Ma, Z., 340
Mach, M., 57
Mackenzie, F. T., 38
MacLeod, I. D., 68, 70, 71, 95, 98, 112, 133, 135, 139, 142, 228, 229, 367, 370, 371, 372, 373, 380
Mactaggart, A., 105, 108, 109, 115, 285, 405
Mactaggart, P., 105, 108, 109, 115, 185, 274, 316, 405, 442
Madsen, H. B., 232, 368, 376, 379, 396
Maekawa, S., 281
Magalhaes, M. C. F., 136, 241
Magaloni, D. I. K., 109, 119
Maggen, M., 362
Magnus, G., 48
Mairinger, F., 75, 137
Maish, S. L., 396
Maiti, G. C., 276
Manet, E., 310
Mann, A. W., 111
Mansour, S. A. A., 276
Mao, Y., 264
Marabelli, M., 159, 251, 305, 388, 392, 394, 395
Marano, A., 395
Marchesini, L., 149
Martin, G., 348, 349
Maruyasu, T., 160
Maryon, H., 321
Masolino da Panicale, 111
Masri, M. S., 77
Mass, J. E., 256
Massa, S., 395
Matsuda, S., 116, 160, 161
Matteini, M., 251, 366, 397
Mattsson, E., 40, 42, 52–54, 165, 241, 243, 246
Matzko, J. J., 253, 421
Maxwell-Hyslop, R., 103
May, R., 132, 377
Mazzeo, R., 159, 305, 394
McCrory-Joy, C., 55, 269
McKee, R., 86
McNeil, M. B., 65, 71, 112, 152
Meeks, N., 229, 232, 339, 345, 346, 403

Mehra, V. R., 312
Meijers, H. J. M., 80
Meijers, R., 41, 42
Meisel, K., 243
Mellaart, J., 108
Mellor, J. W., 9, 121, 225
Menezes, M., 391
Mengoli, G., 379
Merck Index, 315
Merk, L. E., 366
Merk-Gould, L., 362
Merrifield, M. P., 285, 286–87, 288, 290, 297, 445
Meyers, P., 141, 249
Michaels, P., 319
Michihiko, K., 270
Mierzinski, S., 310
Mikhailov, A. A., 58
Miller, F. P., 35
Miller, J., 298
Mills, D. J., 71
Mills, J. S., 296, 297, 298
Minguzzi, C., 259
Moffett, E. A., 134, 298, 304
Moles, A., 251, 366
Mond, C., 126
Monet, C., 312, 453
Montet, J., 276
Montiel, V., 304, 365
Moore, D., 34, 37
Moore, W. J., 11
Moorey, P. R. S., 103, 121, 248, 254, 262
Mor, D. W., 112, 152
Mor, E. D., 70, 112
Morgan, J. P., 351
Mori, H., 281
Mori, W., 269
Morigi, G., 159, 305, 394
Morin, H., 339
Mühlethaler, B., 96, 110, 273, 307, 407, 408, 409, 437
Muhly, J. D., 4
Muller, A. J., 55
Murakami, R., 88, 89, 404
Musiani, M., 379

N

Nagano, M., 2
Nair, M. V., 364, 365
Napier, J., 23
Napolitano, G., 388
Nassau, K., 55
Naude, V. N., 362
Naumova, M. M., 115, 137, 138, 141, 165, 166, 246, 292, 405

Nechiporenko, G. O., 115, 137, 141, 165, 166, 246, 405
Needham, J., 89, 109, 118, 291
Nefedov, E. I., 152
Nefzawi, S. U. ibn M. al-, 267
Neumann, B., 255
Newesely, H., 225
Newman, H., 91, 93, 94, 104, 255
Newman, J., 362
Newman, R., 258, 321
Newton, R. G., 94
Nichols, M. C., 234, 254, 364, 430
Nicholson, P. T., 264
Nickel, E. H., 234, 254, 430
Nielsen, N. A., 142
Niiyama, S., 88
Noggerath, J., 82
Noll, W., 258, 263
Nord, A. G., 40, 41, 165, 229, 241, 243, 246
Norman, M., 354
North, N. A., 68, 370
Northover, J. P., 89
Notoya, T., 397
Novak, F., 379

O

O'Hanlon, J., 380
O'Keeffe, M., 84
O'Neil, I., 102
Oddy, W. A., 61, 120, 229, 232, 238, 299, 300, 363, 381
Odlyha, M., 302, 448, 449
Ogden, J., 103, 104, 236
Olmi, F., 158, 305
Olson, C., 379
Oppenheim, A. L., 93
Organ, R. M., 83, 127, 219, 229, 364
Orna, M. V., 282, 285
Orna, V. A., 96, 284, 286
Osborn, L., 315
Oshima, T., 160
Oswald, H. R., 124
Ottaway, B. J., 299, 301
Ottaway, P., 350
Ottemann, J., 124
Otto, H., 139, 246, 250

P

Pabst, A., 266
Pacheco, F., 109, 121
Padfield, T., 385
Palache, C., 11, 101, 102, 105, 116, 123, 138, 139, 142, 228, 247, 248, 250
Paleni, A., 117, 364

Palet, A., 263
Pandit Rao, V., 381
Panseri, C., 159
Papadopoulos, T., 238
Paracelsus, 278
Paradies, H. H., 153
Parisi, C., 395
Parker, W., 310
Partington, J. R., 4, 95, 103, 255, 316
Partridge, W. O., 223, 386
Pasterniak, I., 85
Paszthorny, E., 18
Payen, A., 309
Pedrosa de Jesus, J., 136, 241
Peins, G. A., 62
Peiresc, N. C. F. de, 329
Péligot, E.-M., 166
Pennet, S., 150
Penny, N., 324
Pepa, S., 76
Périnet, G., 228
Pernice, E., 326
Peterson, P., 61
Pey, I., 270
Phenix, A., 77
Phillips, A., 19
Phipps, P. B. P., 61
Photos, E., 238
Pilz, M., 387
Pinchbeck, C., 9
Piqué, F., 134, 136
Pisanello, 24
Pisano, A., 24
Pisareva, S. A., 115, 137, 138, 141,
 165, 166, 246, 292, 405
Plenderleith, H. J., 355, 363, 379, 396
Pliny the Elder, 3, 9, 10, 79, 81, 90,
 99, 100, 121, 146, 167, 224–
 25, 236, 239, 247, 248, 251,
 254, 270, 278, 279–80, 316,
 324, 325, 326, 351, 411
Plutarch, 43, 80, 90, 99, 145, 167,
 323, 325, 351
Podany, J., 23, 334
Poelenburgh, C. van, 319
Pogue, J. E., 251
Poitras, J., 142, 143, 150, 153, 154,
 158, 163, 232, 243, 305
Poling, G. W., 397
Pollard, A. M., 98, 102, 128, 129,
 135, 136, 139, 140, 141, 154,
 242, 243, 404, 405
Polo, M., 248, 251
Polushkin, E. P., 327, 336
Ponahle, J., 75
Porta, E., 263

Portmann, A., 96, 110
Pourbaix, M., 11, 85, 97, 130, 134,
 135, 151
Poussin, N., 329
Power, T., 149, 150
Preusser, F., 225
Priestley, J., 316
Proudfoot, T., 136
Psota-Kelty, L. A., 62
Puhringer, J., 375
Purinton, N., 165, 292

Q

Quanyu, W., 42
Quirke, S., 89

R

Radosavljevic, V., 292
Rahn-Koltermann, G., 271, 272, 273,
 406, 408, 409
Rajagopalan, K. S., 52, 53
Ramasamy, P., 106
Raphael, 205, 296, 297, 298
Rapp, G., Jr., 11, 226
Rathgen, F., 48, 49, 52, 126, 354, 358,
 363, 382
Rawson, A. E., 107
Ray, P., 146, 167, 224, 239
Razek, M. A., 259, 263, 265
Reinhardt, U., 57
Reller, A., 96, 110
Rendahl, B., 62, 163
Reni, G., 318
Rennie-Bissaillion, D. A., 71
Rewitzer, C., 142
Rhea, E. C., 11
Riccio, A., 330
Rice, D. W., 61
Richter, E. L., 225, 315, 323–24
Rickerby, S., 113
Rieck, F., 350
Riederer, J., 54, 110, 250, 258, 261
Riffault, J. D. R., 115, 117, 166, 306,
 308, 314
Rigby, E. B., 61
Ripka, U., 225
Robbiola, L., 12, 88, 150
Roberts, A., 110, 124, 144, 425
Roberts, J. D., 74, 315
Roberts, W. L., 11
Robie, R. A., 136
Robinson, E., 355–56
Rodin, A., 43, 172, 351, 374
Rogers, R., 374

Rogers, T. H., 65
Romanoff, M., 35
Römich, H., 387
Roosen-Runge, H., 299
Rose, H., 113
Roseleur, A., 21, 23
Rosenberg, G., 367–68
Rosenfeld, A., 106, 108
Rosenquist, A. M., 258
Rosi, G., 111
Rosumek, P., 225
Rothenberg, B., 104
Rottlander, R., 225
Rowe, M., 91, 106, 250, 299, 330,
 333, 347
Roy, A., 115, 273, 306, 310, 316
Rubin, H., 310
Rutt, A. W., 360–61
Rush, B., 379
Ruskin, J., 357

S

Sabelli, C., 158, 305
Safarzynski, S., 91, 404
Sage, B.-G., 7
Sage, M., 82
Salter, T. W., 315
Samans, C., 12, 400
Sansovino, J., 330
Sattler, W., 310
Savage, G., 91, 93, 94
Sax, N. I., 381
Schaaber, O., 225
Schaller, W. T., 248
Scharff, W., 41
Scheele, C. W., 307, 316
Schiegel, S., 262, 265, 266
Schilling, M., 259, 263, 299
Schnorrer-Kohler, G., 125
Schoep, A., 139
Scholes, I., 376
Schrenk, J. L., 304
Schulze, G., 225
Schumacher, M., 11, 66, 67, 68
Schweizer, F., 33, 153, 165, 230–31,
 273, 307, 407, 408, 409, 437
Scott, D. A., 2, 14, 21, 23, 37, 80, 86,
 87, 106, 117, 119, 141, 142,
 154, 163, 215, 233, 244, 245,
 249, 251, 254, 259, 299, 305,
 324, 325, 334, 336, 337, 344,
 350, 351, 354, 363, 380, 386,
 400, 420, 427
Scribonius Largus, 18
Sease, C., 381

Seeley, N. J., 234, 239
Seitter, E., 50
Sekino, M., 160
Selwitz, C. M., 384
Selwyn, L. S., 71, 142, 143, 150, 153,
154, 158, 163, 232, 243, 305
Sereda, P. J., 58
Shahani, C. J., 76
Shalov, S., 89
Shankar Lal, U., 364, 365
Sharkey, J. B., 128, 129, 134, 136
Sharma, V. C., 364, 365, 367
Sherwood, H. F., 319
Shier, D., 280
Shorer, P. T., 25, 383
Shrier, L. L., 35
Siconolfi, D. J., 62
Sieskind, M., 84
Silanion of Athens, 324
Silman, H., 19
Simpson, D. R., 113
Sinclair, J. D., 62
Sirois, J. P., 134, 298
Skspski, A. C., 286
Slade, H. F., 58
Smeaton, W. A., 21
Smith, C. S., 19, 23, 107, 225, 237,
274, 282, 283, 284, 286, 322,
327, 442
Smith, R., 103, 321, 384
Smithells, C. J., xii
Snethlage, R., 57
Snow, J. P., 63
Socha, J., 91, 404
Soldani, M., 331
Sommer, S. M., 163
Southwell, C. R., 68
Spon, E., 18
Spurrell, F. C. J., 254
Squarcialupi, M. C., 158, 305
Sreenivase Rao, T. A., 381
Stachelberger, H., 75
Staffeldt, E. E., 63, 117, 364
Stambolov, T., 38, 351
Standage, H. C., 315
Standfuss, K., 125
Standfuss, L., 125
Stavenhagen, A., 307
Steinberg, A., 147
Stetter, C., 278
Stock, S., 143, 144, 376, 397
Stodart, J., 21
Stodulski, L., 258

Stone, R., 256, 330, 332, 375–76,
397
Stos-Gale, Z. A., 9
Stout, G., 110, 254, 312, 315
Strandberg, H., 45, 46, 47, 48, 51,
80, 150, 153, 154, 155, 156,
157, 167, 316
Stranmanis, M., 92
Stronge, S., 348
Strunk-Lichtenberg, G., 225
Stulik, D., 263, 386
Sun, S., 340
Sun, S.-M., 118, 291
Sundaram, M., 52, 53
Susini, F., 330
Sydberger, T., 45
Symes, J. L., 136
Szymanski, J., 110, 124, 144, 425

T

Taggart, J. E., 247, 250, 251
Tamura, H., 270
Taniguchi, Y., 142, 305, 344, 437
Tarling, S., 244, 299, 301
Tatti, S. A., 383
Taube, M. A., 343
Taubes, F., 333
Teniers, D., II, 318
Tennent, N. H., 128, 129, 141, 144,
299, 300, 301, 302, 337,
380
Ternbach, J., 366, 396
Theophilus, P., 19, 137, 235, 236–37,
239, 281, 282, 316, 317, 326,
351, 411
Theophrastus, 105, 254, 270
Thickett, D., 61, 137, 300, 302, 372,
448, 449
Thomas, J., 136, 316
Thomas, R. G., 72, 73, 98, 102, 128,
129, 135, 139, 140, 141, 154,
242, 243, 404, 405
Thompson, D. V., 114, 294
Tidblad, J., 45, 58
Tite, M. S., 256, 260, 261, 262, 264,
266
Toishi, K., 160
Tong, S. S. C., 267
Toussaint, G. A., 115, 117, 166, 306,
308, 314
Townsend, J. H., 312
Tracy, A. W., 52, 54
Tremoureux, R., 61

Tronner, K., 40, 41, 165, 229, 241,
243, 246
Trosti-Ferroni, R., 158, 305
Tubb, K. W., 255
Turner, J. M. W., 312
Turner, N., 288, 299
Turovets, I., 362
Tweddle, D., 229
Twilley, J., 99, 316, 396
Tylecote, R. F., 5

U

Ucko, P. J., 106, 108
Ullen, I., 40, 165, 241, 243, 246
Ullrich, D., 263, 264
Ultsch, P., 310
Uminski, M., 372
Uno, D., 89

V

Vagbhata, 146, 166, 167
Vallat, F., 248
van Hoogstraten, S., 294
van Mieris the Elder, F., 208, 320
van T'Hul-Ehrenreich, E. H., 137,
411, 437
Vandiver, P., 91, 256, 264, 307
Vanino, L., 50
Vasari, G., 329, 331, 351
Velázquez, D., 121
Veloz, N., 360–61, 383, 385, 397
Vendl, A., 57, 75, 152
Vergnand, A. D., 115, 117, 166, 306,
308, 314
Verink, E. D., 30
Vernon, W. H. J., 50, 51, 54, 55, 148,
152, 232
Verrocchio, A. del, 158
Vetters, H., 225
Vickers, M., 299, 301
Vigna, L., 245
Vinka, T. G., 35
Vint, J. A., 117, 118, 303, 364
Vitruvius, 257, 258, 267
Vittoria, A., 210, 331
Voelcker, A., 43
Vollard, A., 314
Volta, A., 17, 22
Von Hochstetter, F., 228
von Liphart, E., 277
Von Salden, A., 93
Voorhees, A., 386
Voss, A., 382
Vries, A. de, 221

W

Wächter, O., 75
Wagner, D., 41, 42
Wagner, G., 236
Wagner, W., 153
Wainwright, I. N. M., 134
Wallert, A., 282, 283, 316
Walsh, J., 147
Walters, H., 355, 396
Ward, S., 61
Wasuke, M., 270
Waterman, L., 17
Watkins, K. G., 362
Watkinson, D. E., 72, 73
Watling, A., 121
Watters, M., 165, 292
Weast, R. C., xii, 0, 11, 136, 308
Weber, J., 11
Weigard, P. C., 249
Weil, P. D., 165, 223, 329, 331, 333,
 360, 361, 374, 385, 386
Weiner, K. L., 259, 262, 263, 265,
 266
Weisser, T. D., 98, 304, 367, 379
Welch, S. C., 292
Werner, A. E., 299, 379, 396
Wershaw, R. L., 42
Weser, U., 225, 277, 278
Weyl, W. A., 255
Wharton, G., 24, 362
Whitby, L., 50, 152, 232
White, J. M., 103
White, R., 296, 297, 298, 330, 332
Wiedemann, H. G., 263, 266
Wilcox, R. E., 253, 421
Wilkins, R. A., 37
Wilkinson, G., 399
Williams, P. A., 98, 102, 128, 129,
 135, 136, 139, 140, 141, 154,
 241, 242, 243, 404, 405
Williams, R. J. P., 76
Wolbers, R. C., 397
Wolf, D. C., 35
Woodhead, P., 9
Woods, T. L., 136
Woudhuysen, P., 295
Woudhuysen-Keller, R., 295, 296
Wypyski, M. T., 256

X

Xu, F. X., 382

Y

Yamanaka, S., 275
Yao, K. L., 88
Yifan, Z., 382
Yount, G. S., 134
Yüan, H.-T., 72, 80

Z

Zachmann, D. W., 153
Zampieri, D., 318
Zenghelis, G., 328, 356
Zhang, Z., 88
Zhao X., 1
Zhu, S., 339, 345
Zimmerman, D., 361, 374
Zoffany, J., 115
Zycherman, L., 266, 267

Subject Index

Note: Page numbers followed by the letters f, n, and t
indicate figures, endnotes, and tables, respectively.

A

A soil horizon, 38
abrasive cleaning techniques,
 360–61
acanthite, in niello, 238–39
acetaldehyde, atmospheric concen-
 trations of
 conversion factors for, 44t
 modern, 44t
acetic acid
 atmospheric concentrations of
 conversion factors for, 44t
 modern, 44t
 in indoor environment, 299–300
acetonitrile, aqueous, 372
acid precipitation, and burial
 environment, 41
Acontium velatum Morgan, 65
acoustic emission analysis, 395
Acryloid B72, 380, 384
aerogel silica, 380
The Age of Bronze (Rodin), 351n14
agriculture, and soil acidity, 42
aheylite, composition of, 247
air pollution
 atmospheric, 43–47
 and chloroxiphite, 143
 history of, 43
 modern concentrations of,
 44t, 45–47
 recent changes in, 43–45
 indoor, 59–60
 concentrations of, 59–60, 60t
 from woods, 299–300
alkylalkoxysilanes, 375

alkyltrialkoxysilanes, 375
alloys. See copper alloys
alum, 287, 290, 316n19
Amenhotep (Amenophis) II,
 tomb of, 96
Amenhotep III, mafek use by, 103
American Society for Testing
 and Materials (ASTM),
 standards of, 80n18
1-amido-1-cyanoethylene,2,2-
 disodium thiolate, 232
5-amino-2-mercapto-1,3,4-thiadia-
 zole (AMT), 381–82
ammonia
 atmospheric concentrations of,
 conversion factors for, 44t
 in cleaning treatments, 366, 370
 and indoor corrosion rates, 61, 62
ammonium, indoor deposition
 of, 62
ammonium chloride, X-ray diffrac-
 tion data for, 444t
ammonium copper acetate acetic
 acid, X-ray diffraction data
 for, 444t
ammonium copper sulfate hydrate
 in patinas, 158
 properties of, 148t
ammonium hydroxide, 366
ammonium tetrachlorocuprate(II)
 dihydrate, 143
ammonium tricitrate, 366
AMT (5-amino-2-mercapto-1,3,4-
 thiadiazole), 381–82

anarakite. See also paratacamite
 properties of, 123t
 X-ray diffraction data for, 425t
 as zincian paratacamite, 123,
 144n2
anilite
 in niello, 238
 properties of, 226, 227t
anionic control, corrosion under,
 12–13
anthonyite, 142
antlerite, 147–52
 as corrosion product, 149, 230
 as corrosivity indicator, 150
 fog exposure and, 55, 56f
 in patinas
 artificial, 152
 examples of, 149
 Pourbaix diagrams for, 135f
 properties of, 148–49, 148t
 rainwater pH and, 149–52
 stability of, 140f, 150, 151f
 thermodynamic data for, 136t
aqueous environments. See also
 marine environment
 black patinas in, 328–29
 Pourbaix diagrams for, 32–34,
 33f, 34f
The Archduke Leopold Willen in
 His Painting Gallery in
 Brussels (Teniers), copper
 support in, 318
arid environments, sampleite in,
 243–46
Arkon P-90, 376, 397n27

arsenic
coating of, as patina, 327
in pigments, 307
plating with, 22, 80n6
arsenic-copper alloys, 3, 5
arsenic oxide, in bronzing solutions, 22
Art and Archaeology Technical Abstracts (AATA), 106, 121n4
Asia, verdigris recipes from, 291–93
Aspergillus amstelodami, 63
Aspergillus niger, 63
Asrarul Khat manuscript, verdigris recipe in, 291–92, 415
ASTM. See American Society for Testing and Materials
atacamite, 124
formation of
from azurite, 110
and bronze disease, 128–29
in marine burial environments, 112
in seawater, 68, 69f
in patinas
and authenticity verification, 131
of Great Buddha, 160
as pigment
in art, 134–37
synthesis of, 137–38
Pourbaix diagrams for, 130f
properties of, 123t, 124, 138, 138f, 187p
recipes for, 406, 413, 415
spherulitic form of, 138
synthetic form of, 137–38, 142, 306
thermodynamic data for, 136t
in verdigris synthesis, 281, 284
X-ray diffraction data for, 450t
atmospheric gas concentrations
conversion factors for, 44t
modern, 44, 45–47
atmospheric marine zone, 66t, 67
atmospheric pollution. See air pollution
atramentum, 147
atramentum sutorium, 147
Augsburg, Cathedral of (Germany), copper salts on bronze doors of, 305
aurichalcite
as corrosion product, 116
properties of, 100, 102t, 116
Australia House (England), patina on, 50t–51t, 51

Autoclear, 390
aventurine glass, 94
azure, recipe for, 286
azurite, 108–11
artificial. See blue verditer
atacamite formation from, 110
clinoatacamite formation from, 110
conservation issues with, 110–11
as corrosion product, 100, 108
crystal forms for, 100, 101f, 184p
decomposition by heat, 113
decorative uses of, 121n6
fingerprinting of, 110
formation in solution, 108, 111–13
malachite formation from, 108, 111
as pigment, 6, 100, 106, 108–10, 113–14
properties of, 100, 102t, 108, 184p
sources of, 109–10
stability of, 113, 140f
tenorite formation from, 96, 97f, 110
thermodynamic data for, 136t
transformation of, 110–11
in verdigris synthesis, 277, 291

B

B70 method, 370
B soil horizon, 38
bacteria
marine, 65–67
sulfate-reducing, 65–67
and copper sulfide production, 227–28
Barlaam und Josaphat manuscript
copper proteinates in, 299
verdigris in, 273–74, 277, 441t
Batavia (ship)
conservation methods at, 370
tenorite patina on, 95
batteries, primitive wet-cell, 16–18, 79–80n5
beads
faustite, 250, 429t
malachite, 103–104
turquoise, 248
beaverite
on Great Buddha, 162
properties of, 116t
Bedacryl 221X, 384
Belousov-Zhabotkinskii reactions, 86

Benedict XV, Pope, shrine of, 91
Benin bronzes, copper salts on, 304
benzotriazole (BTA)
and bronze disease, 380
in conservation treatment, 373, 376–81
as corrosion inhibitor, 376–81
in Incralac, 385–86
industrial applications for, 376, 397n30, 397n33
precautions for using, 381
reaction products of, 377–79, 378t–79t
recommendations on, 380–81
safety of, 381
standard practice for, 380
beta phase, 339, 351n18, 402
bidri ware
composition of, 348–49
patinas on, 348–49
bitumen, as conservation treatment, 326
biuret, 73
black, ivory, 166
black asem, 236
black fuzzies, 232–35
black patinas
in aqueous environment, 328–29
example of, 90, 179p
treatment for development of, 90
blaubleibender covellite, 226
blue(s)
ashes, 115
Bremen, 306
copper, 115
Egyptian, 96, 201p, 257–62, 265–66
Han, 202p, 266
Mayan, 109, 121n8
Monastral, 315
mountain, 115, 121n14
Peligot, 166, 406
phthalocyanine, 208p
recipes for, 414–15
ultramarine, 109
vitriol, 146
blue verditer, 114–16
in art, 114–15
early use of, 114
properties of, 115, 185p
recipe for, 114, 405
synthesis of, 114, 115–16, 405
BNFMRA. See British Non-Ferrous Metals Research Association

Bodleian Library, patina on, 50t–51t
boleite, cumengite and, 142
bonatite
 in patinas, 153
 properties of, 148t
bornite
 in copper smelting, 226
 as corrosion product, 229
botallackite, 125
 formation of, 128
 natural occurrences of, 123
 as pigment, 134, 139
 properties of, 123t, 125, 138–39, 188p
 synthetic, 139, 188p
 thermodynamic data for, 136t
brass
 development of, 5–6
 dezincification of, 11, 27–32, 54, 234
 stress-corrosion cracking in, 31–32
Brazilian palm, 397n38
Bremen blue, 306
Bremen green, 306–307
Brighton Pavilion, patina on, 50t–51t
British Museum
 conservation treatment at, 355
 patina on roof of, 50t–51t
British Non-Ferrous Metals
 Research Association
 (BNFMRA)
 on burial corrosion rates, 35, 36t
 on marine bacteria, 67
brochantite, 147–52
 as corrosion product, 305
 in patinas, 152, 160
 as pigment, 165, 166
 posnjakite and, 152–53
 properties of, 147–48, 148t, 190p
 rain exposure and, 55, 56f
 rainwater pH and, 149–52
 recipe for, 414
 stability of, 140f, 150, 151f
 thermodynamic data for, 136t
 X-ray diffraction data for, 375, 455t
bronze(s)
 ancient
 early analysis of, 7
 modern analysis of, 7–8
 patinas on, 7–9
 chemistry of, 400–403

definition of, xii, 3
history of, 5
leaded, 403
low-tin vs. high-tin, 401–402
patinas on. See bronze patinas
phases of, 400–403
properties of, 400
Renaissance, xii, 329–33
tinned surfaces on, 402–403
variation in, xiii
bronze disease
 AMT and, 381
 benzotriazole and, 380
 causes of, 123, 125, 126–27
 copper chlorides and, 122, 125–34
 definition of, 125
 reactions in, 126–28
 research on, 126–29
 symptoms of, 126, 186p
 treatment for, 98, 367–68, 380, 381
bronze patinas, 322–50
 alloy composition and, 324–25
 ancient, 7–9
 arsenic in, 327
 artificial, 323–24, 344–48
 attitudes toward, 333
 black, 90, 179p, 328–29
 changing views of, 323–26
 on Chinese mirrors, 339–49
 coatings and, 327, 329–32
 complexity of, 322–23
 finishes on, 349
 Indian, 348–49
 lead and, 328
 during nineteenth century, 333
 preserved structures in, 349–50
 during Renaissance, 329–33
 Roman, 334–38
 structures of, classification of, 336–37
 treatments for prevention of, 326
 variation in, 327–29
brown copal shellac, 383
brown copper pigments, 315
brown fuzzies, 232–35
Brunswick green, 306–307
 recipe for, 306–307, 415
 use of, 306
 X-ray diffraction data for, 306, 450t
BTA. See benzotriazole
Buddha at Kamakura, Great, 160–62, 193p

burial environment, 35–42
 atacamite formation in, 112
 carbon dioxide in, 37
 carbonized material in, 40
 Chinese bronze mirrors in, 340–44
 copper phosphate corrosion in, 243
 copper sulfate deposition in, 164–65
 copper sulfide formation in, 227–31
 fire and, 40
 human impact on, 39
 malachite formation in, 112–13, 164–65
 marine, 112–13
 mechanisms of corrosion in, 38–39
 moisture in, 40
 organic materials with copper in, 72
 phosphates in, 37, 41, 243
 rates of corrosion in, 35–37, 36t
 recent changes in, 41
 research on, problems for, 42
 short-term vs. long-term
 exposure to, 36–37
 soil in
 acidity of, 40–42
 buffering capacity of, 41–42
 horizons of, 38
 properties of, 35–37
Burrell Collection, bronze corrosion in, 302–303, 448t
buttgenbachite
 connellite and, 139
 properties of, 250, 251t
Byzantine green, recipe for, 283

C
C soil horizon, 38
calcium copper acetate hexahydrate
 recipe for, 282, 411–12
 X-ray diffraction data for, 443t
calcium copper tetrasilicate, 259
caledonite
 in patinas, 162
 properties of, 148t
Calgon, 355, 366, 375, 396n1
calumetite, 141–42
 as corrosion product, 141–42
 as pigment, 141
Canosa vase, Egyptian blue in, 201p, 259–60, 260f

Cappella del Tesoro of San Gennaro (Italy), altarpiece for, copper support in, 318–19
carbon, isotope ratios of, 107
carbon dioxide
 atmospheric concentrations of, 44t, 47
 in burial environment, 37
 in copper carbonate formation, 111–13
 and corrosion rates, 47
carbonates, basic copper, 100–20. See also specific types
carbonized material, in burial environment, 40
carbonyl sulfide, atmospheric concentrations of
 conversion factors for, 44t
 modern, 44t
carnauba wax, 385, 397n38
cassiterite, in Egyptian green, 263
Cat, Statuette of a, 217p
 conservation treatment of, 217p, 353
Cathedral of Augsburg (Germany), copper salts on bronze doors of, 305
Cathedral of the Nativity of the Virgin, Ferapontov Monastery (Russia)
 langite in, 165
 pseudomalachite in, 246
 synthetic malachite in, 115–16
cationic control, corrosion under, 12
Ceder green, 254
celadon ware, sanggam, 91
cellulose, mineralization of, 73, 74–76
cellulose acetate, 383
cellulose nitrate lacquers, 383–84
ceramic(s)
 broken, conservation of, 94
 copper colorants in, 91, 93
 glazes on, 93–94
Ceres or Juno, statuette of, 334
 patina on, 334
chalcanthite
 historical references to, 146, 147
 as pigment, 146
 properties of, 148t, 399
 stability-field diagrams for, 140f
 thermodynamic data for, 136t
chalcanthum, 146
chalcitis, 147

chalcocite
 as corrosion product, 228, 230, 232
 in niello, 238
 properties of, 226, 227t
 thermodynamic data for, 136t
chalconatronite, 117–20
 as corrosion product, 119–20, 301
 formation of
 sodium sesquicarbonate and, 118, 119–20, 364
 in solution, 111
 as pigment, 119
 properties of, 100, 102t, 117, 118
 synthesis of, 118–19
 use of, 119
 in verdigris synthesis, 291
 X-ray diffraction data for, 424t, 446t
chalcopyrite
 as corrosion product, 196p, 197p, 229, 230
 formation of, 230
chalcosiderite
 properties of, 241, 242t
 turquoise and, 247
chalitis, 146
chemical alteration, in laboratory, 363–64
chemical cleaning treatments, 362–69
 general, 363–64
 localized, 364–65
 reagents for, 366–69
chemical corrosion reactions, 14
chemical formulas, list of, 418t–21t
chessylite. See azurite
China, synthetic blue pigment in, 291, 415
Chinese bronze(s)
 ancient, early study of, 1
 ion transport in, 12–13
Chinese bronze mirrors
 composition of, 339
 examples of, 214p, 215p, 216p, 339
 patinas on, 339–49
 burial environment and, 340–44
 mechanisms of corrosion and, 310
 replication of, 344–48
 structure of, 214p, 216p, 339
Chios, 325, 351n4
chlorargyrite, 239

chloride(s), copper. See copper chloride(s); specific types
chloride ions
 in burial environment, 40
 role in corrosion, 129–31, 130f
chlorine, and indoor corrosion rates, 61
chloroform, 383
chloroxiphite, 143
Christ's Entry into Brussels in 1889 (Ensor), 207p
 emerald green in, 207p, 312, 454t
chromotropic acid test, 61
chrysocolla, 253–55
 as pigment, 252, 254–55
 properties of, 201p, 253–54, 253t, 267n1
 in reaction soldering of gold, 254
 X-ray diffraction data for, 253–54, 430t
cities
 air pollution in, 43–45
 outdoor corrosion rates in, 53–54, 53t
 sulfides in patinas in, 232
citric acid, 366, 367, 370–71
 buffered, 366
Cladosporium aeris, and bronze disease, 126
claraite, properties of, 100, 102t, 116
claringbullite, 141
clay, burials in, 38
Clean Air Act, 80n13
cleaning
 chemical, 362–69
 mechanical, 357–62
cleaning solutions. See also specific types
 and chalconatronite formation, 119–20
clinoatacamite, 124–25
 formation from azurite, 110
 vs. paratacamite, 125
 properties of, 123t, 125
 X-ray diffraction data for, 425t
clocks, in Wallace Collection
 brown fuzzies on, 333–34, 331f
 X-ray diffraction data for, 427t
coatings, 382–91
 arsenic, 327
 on bronzes, 327, 329–32
 metallic, 163–64
 for paintings on copper, 317–18
 polymer, 387–88

coatings (*continued*)
 problems with, 388–90
 research needed on, 391
 resin, 384
 reversibility of, 388, 389
 wax, 360, 382–83, 385, 396 n8,
 397 n38
cobalt, in blue glazes, 255
Codex Lucensis 490. See Lucca
 manuscript
colloidal hard soldering, 254
colophony, in copper resinates,
 295, 316 n23
Compositiones variae. See Lucca
 manuscript
connellite, 139–41
 carbonatian, 139
 properties of, 139
 recipe for, 405
 stability of, 140 f, 141
 thermodynamic data for, 136 t
 X-ray diffraction data for, 426 t
conservability, definition of, 80 n11
conservation treatments, 352–95
 aesthetic considerations in, 358
 and chalconatronite formation,
 119–20
 chemical, 362–69
 coatings and, 382–91
 corrosion inhibitors and, 376–82
 cuprite patinas as, 91
 documentation of, 353
 drying and sealing methods in,
 355–56
 history of, 353–57
 for marine artifacts, 71–72, 356,
 369–73
 mechanical, 357–62
 nondestructive testing before,
 392–95
 and organic copper salts,
 303–305
 patina-stripping in, 353–55
 preservation without, 357
 problems associated with, 98
 repatination after, 374–76,
 396 n2
 residues of, in indoor environ-
 ment, 63
 stabilization in, 370–33
 passive, 391–92
 for wood-metal artifacts, 71–72
continental shelf, 66 t, 67
Copernica prunifera, 397 n38
copiapite, 147
copper
 chemistry of, 398–400

compounds, properties of,
 399–400
electronic configuration of,
 398–99
geographic distribution of, 398
history of use of, xii, 2, 3–6
isotopes of, 2
in mythology, 3–4
native, 2–3, 2 f, 3 f
properties of, 2–3, 398
publications on conservation of,
 xiii–xiv, xiv f
redeposition in cuprite patinas,
 85–86, 178 p
copper acetate(s), 270–78. See also
 verdigris
 decomposition of, 276
 properties of, 271–72, 271 t,
 272 t, 274
 synthesis of, 268
 X-ray diffraction data for,
 434 t–35 t
copper(I) acetate, properties of,
 271, 272 t
copper(II) acetate
 basic
 properties of, 271–72, 271 t,
 436 t–42 t
 synthesis of, 273–74
 neutral, properties of, 271, 272 t
copper acetate-arsenite, X-ray dif-
 fraction data for, 312,
 452 t–54 t
copper(II) acetate hydrate, proper-
 ties of, 272–73, 272 t, 436 t
copper alloys
 with arsenic, 3, 5
 coatings for, 382–91
 with tin. See bronze
 variation in behavior of, 11
 variation in corrosion of, 7, 8 f
 with zinc. See brass
copper arsenite. See Scheele's
 green
copper blue, 115
copper carbonates, basic, 100–20.
 See also specific types
 formation in solution, 111–13
 mixed-cation, 116–17
copper chloride(s), 122–43. See
 also specific types
 basic, 139–43
 as alteration products, 265
 as pigments, 134–38, 265
 and bronze disease, 122, 125–34
 chloride ions and, 129–31

mixed-cation, 143
and patina authenticity, 131
as pigments, 122, 134–38
 vs. alteration products, 265
 morphology of, 138–39
 problems with, 122
 synthesis of, 137–38
 in pitting corrosion, 132–34,
 135 f, 135 t
copper(I) chloride, and tenorite
 formation, 98
copper(II) chloride, thermody-
 namic data for, 136 t
copper citrate
 recipe for, 288
 visible spectra for, 288, 289 f
 X-ray diffraction data for, 445 t
copper compounds, properties of,
 399–400
copper(I) compounds, properties
 of, 399
copper(II) compounds, properties
 of, 399
copper diarsenate I, recipe for,
 308, 416
copper diarsenite, properties of,
 205 p, 309
copper emerald, 255
copper formate(s), 269–70
 as corrosion product, 269
 properties of, 269, 269 t
 X-ray diffraction data for,
 431 t–33 t
copper(I) formate, properties
 of, 269 t
copper(II) formate
 basic, 269–70, 269 t
 properties of, 269–70, 269 t
copper green, 91
copper(II) hexakis-cyanoferrate, 315
copper hydroxide(s), 81–98. See
 also specific types
copper(II) ions, spot test for
 presence of, 79 n3
copper lusterware, 93
copper nitrates, 250–51
 as corrosion products, 250–51
 properties of, 250–51, 251 t
copper orthoarsenite
 color-reflectance data for, 312,
 313 f
 properties of, 206 p, 309, 312
 recipe for, 416
copper oxalates, as corrosion
 product, 305
copper phosphates, 240–50. See
 also specific types
 blanching of, 241

in burial environment, 243
chemistry of, 241
as corrosion products, 240, 241
in outdoor environment, 243
as pigments, 240
properties of, 240–41, 242t
copper phthalocyanine, 315
chlorinated, 315
properties of, 208p, 315
copper proteinates, 298–99
copper resinate(s), 294–99
chemistry of, 297–98
detection of, 297–98
as pigment, 204p, 205p
properties of, 205p
synthesis of, 294–97
uses of, 295–96
copper salts, organic, 268–315. See
also specific types
and bronze corrosion, 299–303
conservation treatments and,
303–305
of higher acids, 298
as pigments, 306–15
properties of, 400
copper silicates, 252–67. See also
specific types
in glasses, 255–56
properties of, 252, 253t
synthetic, as pigments, 257–66
copper sulfate(s), basic, 145–66.
See also specific types
atmospheric, 154–59
case studies on, 159–64
as corrosion products, 145, 147
deposition in burial environ-
ments, 164–65
historical references to, 146–47
medicinal uses of, 147
in microenvironments, 158–59
in outdoor environment,
49–50, 147
in patinas, 49–50
as pigments, 146, 165–66
properties of, 148t
solubility of, 150
stability of, 150
copper(II) sulfate pentahydrate,
146
copper sulfides, 224–39. See also
specific types
chemistry of, 226
as corrosion products, 228
formation of, 227–35
from atmospheric exposure,
232

equations for, 234–35
from indoor museum
pollution, 232–35, 233f
in reducing environments,
227–31
identification of, 226
medicinal uses of, 225–26
and niello, 235–39
properties of, 224, 226, 227t
recipes for, 225
copper trihydroxychlorides
crystallization of, 128
natural occurrences of, 123
types of, 122–25
copper-zinc carbonates, mixed,
116–17
copper-zinc chlorides, mixed, 143
Coppergate burial site (England),
Anglian helmet from, 229
Coram Rege Rolls
folio 1013 of, verdigris in, 277
folio 1826 of, blue verditer in, 114
core material, 369, 396n18
cornetite
as corrosion product, 243
properties of, 240–41, 242t
stability of, 241, 242f
thermodynamic data for, 136t
Coronation of the Virgin (Reni),
copper substrate of, 317–18
corrosion
anatomy of, 11–16
classification of, 12–13
definitions of, 10, 322
history of exploitation of, 16–32
as interphase interfaces, 322
vs. patina, 10
vs. substrate–media reactions,
321n1
corrosion inhibitors, 72, 376–82
corrosion products
importance of identifying, 9
as minerals, 79
corrosivity
antlerite as indicator of, 150
assessment of, 58–59
of metal species, 58–59
of outdoor environment, 58
couperose, 166
coupling agents, 389–90
covellite
blaubleibender, 226
as corrosion product, 228, 229, 32
as pigment, 96
properties of, 226, 227t
thermodynamic data for, 136t
crystal systems, 422t–23t

Culross manuscript, azurite in, 109
cumengite, 142–43
as corrosion product, 142–43
properties of, 142
cupric. See copper(II) compounds
cupric ferrocyanide. See copper(II)
hexakis-cyanoferrate
cupric oxide. See tenorite
cuprite, 82–94
absorption band of, 84–85
in alum and natron, X-ray dif-
fraction data for, 424t
in bronze disease, 127–28
dichroism of, 92, 180p
formation of, 83–84, 112
in glasses, 91–94
opaque red, 91 93
stained window, 94
in glazes, 91
red, 93–94
in niello, 238
in patinas
banding in, 86–87, 106–107,
178p
as conservation treatment, 91
copper crystal deposition in,
85–86, 178p
environmental disruption
of, 87
imitative, 91
intentional, 88–91
malachite formed from, 106
modern artificial, 91
natural, 85–88
prevalence of, 81
recipe for, 404
removal of, 87–88
treatments for development
of, 90–91, 179p
as pigment, 81
Pourbaix diagrams for, 130f, 135f
properties of, 82–85, 82t,
177p, 178p
rainwater pH and, 149
recipe for, 404
relative molar volume of, 88
in solution, 112
stability of, 112
thermodynamic data for, 136t
cupro-ammonium salts, mixed, 143
cuprorivaite
vs. Egyptian blue, 259
as pigment, 252
properties of, 253t
cuprous. See copper(I) compounds
Cyprus, 3

D

daguerreotype process, 26–27
Dalziel family vaults, 200p
 gerhardtite in, 200p, 251
David (Donatello), 210p, 351n14
 lacquer on, 331
Dead Sea Scrolls, conservation
 re-treatment of, 25–26
Dead Youth, Statuette of a, 169p
 patina on, 7, 169
deep ocean zone, 66t, 67
depolymerization, 76
deposition, definition of, 80n15
desalination, electrolytic, 368,
 396n16
devilline, properties of, 148t, 158
dezincification of brasses, 27–32
 in ancient *vs.* modern alloys,
 29, 32
 effects of, 11
 and namuwite formation, 234
 potential regions for, 29–30, 30f
 reaction sequences of, 29–30
 resistance to, 29
 zinc content and, 54
digenite
 as corrosion product, 228
 in niello, 238
 properties of, 226, 227t
Dionysis, statue of, patina on, 333
dioptase, 255
 decorative uses of, 252
 as pigment, 255
 properties of, 253t, 255
disodium ethylene diamine tetra-
 acetic acid (EDTA), 366, 374
djurleite
 as corrosion product, 228, 230,
 232
 in niello, 238
 properties of, 227t
drying and sealing methods,
 355–56
DTPA. See sodium diethylene
 triaminepentaacetic acid
Dundas, Lawrence, portrait of
 (Zoffany), green verditer
 in, 115
Duo Win, tomb of, patinas in, 348
dyeing processes, mordant, 74

E

EDTA. See ethylene diamine
 tetra-acetic acid
Egyptian blue, 257–62
 in artifacts, 256f–57f, 257,
 259–60, 260f
 chemical formulation of, 259–62
 degradation of, 96, 262, 265–66
 frits of, 265
 geographic distribution of, 258
 properties of, 201p, 261–62
 synthesis of, 257, 258–29, 261–62
 in wall paintings, 258
Egyptian green, 263–64
 degradation of, 265–66
 identification of, 263
 synthesis of, 263–64
 in wall paintings, 202p, 263
Egyptian tombs, pigment deterio-
 ration in, 265–66
Eh. See oxidation-reduction power
electrochemical corrosion
 reactions, 14
electrochemical plating, early
 history of, 20–26
electrochemical reduction, for
 bronze disease, 367–68
electrochemical replacement,
 20–21
electrochemical series, 15–16
electrode potential
 for copper, 399
 in Pourbaix diagrams, 32
electrolysis
 for bronze disease, 368–69
 corrosion removal with, 365
electrolytic desalination, 368,
 396n16
electrolytic reduction, 363
electroplating, in ancient world, 18
electrotyping, 22–26
 identification of, 23–24
 in museums, 25
 in photography, 26–27
 structure of copper after,
 23–24, 172p
 technique for, 22–23
Elsener green, synthesis of, 314–15
émail brun, 326
emerald, copper, 255
emerald (Schweinfurt) green,
 310–14
 color-reflectance data for,
 312, 313f
 parrot green and, 270
 problems with, 314

 properties of, 207p, 311–12
 recipes for, 310–11, 416–17
 use of, 207p, 312–14
 X-ray diffraction data for,
 311–12, 452t–54t
enamel, on copper, 321
enargite, in copper smelting, 226
Encyclopaedia Britannica, 22–23
environment(s), 10–79. See also
 specific types
ephebe of Marathon, 351n9
 black patina on, 328
epitaxy, 13
Ercalene nitrocellulose lacquer, 383
eriochalite, properties of, 244
ethylene diamine tetra-acetic acid
 (EDTA), 366, 374
Europe, outdoor corrosion
 rates in, 53t

F

face mask, Moche, sampleite in,
 199p, 245
faience, 264
fang lei (wine vessel)
 malachite in, 103, 182p, 357
 preservation of, 357
faustite
 occurrences of, 250
 properties of, 241, 242t
 turquoise and, 247
 X-ray diffraction data for, 429t
Ferapontov Monastery (Russia),
 Cathedral of the Nativity
 of the Virgin at
 langite in, 165
 pseudomalachite in, 246
 synthetic malachite in, 115–16
finishes, 349
fire, and burial environments, 40
fish, electric, 18
Fitzwilliam Museum (England),
 conservation treatment
 at, 354
flambé glazes, 94
Florentine tint, 333
fog, and urban corrosion, 55, 56f
Follow the Arrow (Léger), emerald
 green in, 312, 453t
formaldehyde
 atmospheric concentrations of
 conversion factors for, 44t
 modern, 44t
 in museum environment,
 299–300

formic acid
 atmospheric concentrations of
 conversion factors for, 44 t
 modern, 44 t
 as cleaning reagent, 366
 in museum environment,
 299–300
formulas, chemical, list of,
 418 t–21 t
Fourier transform infrared
 spectroscopy (FTIR), 7, 9 n5
freirinite, 251 n2
French green, 374
freshwater, corrosion rates in, 70
Frigilene nitrocellulose lacquer, 383
FTIR. See Fourier transform
 infrared spectroscopy
fungi, in indoor environment, 63

G

galena, in niello, 239
gamma-ray imaging, 394
garlic, and copper substrates for
 paintings, 319
Gates of Paradise (Ghiberti)
 antlerite on, 149
 conservation treatment of, 373
 copper nitrate on, 251
geerite
 as corrosion product, 229, 232
 properties of, 227 t
gels, cleaning, 373
georgeite
 as malachite isomer, 100, 102
 properties of, 102, 102 t
 recipe for, 404
 vs. spertiniite, 98
 stability of, 112
gerhardtite
 in patinas, 250–51
 as pigment, 251
 properties of, 250, 251 t
German Bronze Age tumuli,
 compositional analysis of,
 340–43, 342 t, 343 t
Germany
 azurite in, 109
 electrotyped statues in, 26
 study of patinas in, 48–49
Getty bronze athlete, 218 p
 conservation treatment of, 218 p,
 359, 369–70
Gettysburg National Military Park
 bronzes, 163
Gibbs free energy of reaction,
 14, 79 n4

glass(es)
 aventurine, 94
 broken, conservation of, 94
 copper colorants in, 91–94
 copper silicates in, 255–56
 cuprite in, 91–94
 opaque red, 91–93
 stained window, 94
glass-bead peening, 360–61, 396 n7
glass-fiber brushes, cleaning
 with, 369
glaze(s)
 copper colorants in, 91, 93–94
 red, 93–94
glazed stones, 265
Globe mine site (Arizona),
 chrysocolla at, 254, 430 t
glycerol, alkaline, 366
Going to School (Turner), emerald
 green in, 312
gold
 vs. brass, 6
 in intentional cuprite patinas,
 88–89
 plating with, 20
 reaction soldering of, 121 n12, 254
gold aventurine, 94
grapes, in verdigris synthesis, 276,
 316 n7
Great Buddha at Kamakura,
 160–62, 193 p
 corrosion products on,
 160–62, 161 t
 restoration of, 162
Greek box mirror, electrotyping
 of, 22 f, 23–24, 172 p
green(s)
 bice, 294, 316 n22
 Bremen, 306–307
 Brunswick, 306–307, 415, 450 t
 Byzantine, 283
 Ceder, 254
 copper, 91
 Egyptian, 202 p, 263–64
 Elsener, 314–15
 emerald (Schweinfurt),
 207 p, 270, 310–14, 416–17,
 452 t–54 t
 French, 374
 parrot, 270
 Rouen, 283, 412
 Scheele's, 205 p, 208 p, 307–10,
 312, 451 t
 Spanish, 282
 stannate, 314

green verditer, 114–16
 in art, 114–15
 early use of, 114–15
 properties of, 114, 115, 184 p
 synthesis of, 115–16
greenstone, 254
groundwater
 ions in, 37
 phosphate in, 37
Guardian Weekly Newspaper, 47
guildite
 as corrosion product, 153, 230
 properties of, 148 t

H

Hadrian, Emperor, bronze head of,
 83, 176 p
haematinon glass, 91
haematinum glass, 91
Hafkenscheid collection, 270
Hallstatt site, 358, 396 n5
Hamilton, Alexander, statue of
 (Partridge), 222 p
 conservation treatment of, 386
 elemental distribution maps for,
 223 p, 386
Han blue, 266
 properties of, 202 p, 266
Han purple, 266–67
 pigment stick of, 203 p, 267
 properties of, 203 p, 267
 synthesis of, 267
Herm, sculpture of, 170 p
 patina on, 7, 170, 325
Herminie (ship), covellite in, 228
The Holy Family (Bronzino),
 langite in, 165
The Holy Family (Raphael), 204 p
 copper resinates in, 204 p,
 205 p, 298
Hopewell Culture, 5
Horses of San Marco, antlerite
 on, 149
Horus, bronze casting of, 83, 176 p
Hostacor KS1, 72
Howard, Oliver O., statue of,
 corrosion products on, 163
Hsin-ju wei-tso manuscript, on
 artificial patinas, 346–47
hsmn-km bronzes, patinas on,
 88, 324
Hsuan-lu po-lun manuscript, on
 artificial patinas, 347–48
human habitation, and burial
 environments, 39
human remains, in burial environ-
 ments, 39

humic acids, and bronze corrosion, 343

humidity, relative, and corrosion rates, 45–46

humus
function of, 42
structure of, 42

Hungary, azurite in, 109

hydrogen chloride, modern atmospheric concentrations of, 44t

hydrogen peroxide, modern atmospheric concentrations of, 44t

hydrogen sulfide
atmospheric concentrations of
conversion factors for, 44t
modern, 44t
and copper sulfide production, 227–28, 232, 233f

hydroxides, 81–98. See also specific types

I

iarin, synthesis of, 284–85

ICDD reference numbers, list of, 418t–21t

Liber de coloribus illuminatorum sive pictorum manuscript, on copper resinate, 294–95

Incralac, 384–86
adhesion loss with, 387
benzotriazole and, 380
composition of, 384
development of, 384
effectiveness of, 384–86, 390
after glass-bead peening, 360
vs. Ormocer coatings, 387
in repatination, 374
solvents for, 397n41

L'incredulità di San Tommaso (Verrocchio), corrosion products on, 158–59

India
patinas in, 348–49
verdigris in, 291–92, 415

indicator-paper test, 61

indoor environment, 59–64
air pollution in, 59–60, 60t, 299–300
molds in, 63
monitoring of, 63–64
organic salts of copper in, 299–303
outdoor patina in, 375–76
particulate matter deposition in, 62–63

rates of corrosion in, 61–62
sulfide formation in, 232–35, 233f
testing material damage in, 61
treatment residues in, 63

industrial areas, outdoor corrosion rates in, 53, 53t, 54

Infinite Column (Brancusi), 163–64, 194p
darkening of, 163–64
metallic coating on, 163–64

infrared imaging, 394–95

Instrument Society of America (ISA), on indoor environment classification, 61–62

International Centre for Diffraction Data (ICDD), 9, 269

International Organization for Standardization (ISO), corrosivity standards of, 58, 80n18

ion transport, corrosion classification by, 12–13

Iraq, primitive wet-cell batteries in, 16–17, 17f

iron
copper plating of, 18–19
in copper sculptures, 325
as copper substitute, xii

ISA. See Instrument Society of America

ISO. See International Organization for Standardization

isotope(s), copper, 2

isotope ratios, and corrosion environment, 107

ivory black, 166

J

jade, identification of, 254

jalpaite, as corrosion product, 228

Japan, Great Buddha at Kamakura in, 160–62, 193p

Japanese paintings, Utagawa School of, 114, 137, 187p

Japanese patina, recipe for, 404

Jingemia cave (Australia), sampleite in, 246

Juggling Figure (de Vries), 220p
conservation treatment of, 375–76
elemental distribution maps for, 221p, 375
outdoor patina on, 221p, 375–76
X-ray diffraction data for, 375, 455t

K

Kamakura, Japan, Great Buddha at, 160–62, 193p

Kelvingrove, Scotland, bronze corrosion in, 301–302, 447t

kinetics
of corrosion, 14
in Pourbaix diagrams, 34–35

Kirillo-Belozersky Monastery (Russia), posnjakite in, 166

Krefting's method, 354

krohnkite, 153

Kronan (ship), copper sulfides on, 229

ktenasite, as corrosion product, 153–54

L

La Miña site (Peru)
chrysocolla at, 254, 430t
faustite at, 249–50, 429t

laccase, copper in, 77

lacquer(s), 383–84
on bronze, 330–31
nitrocellulose, 383–84
Oriental, 77
recipes for, 349
on scientific instruments, 349

lacquer tree, polymerization of, 77

lake patinas, composition of, 230

land patinas, composition of, 230

Landscape with Bathing Nudes (Poelenburgh), copper support in, 319–20

langite
as pigment, 165
posnjakite and, 152
properties of, 148t

Laocoön (Foggini), 210p
patina on, 210p, 331

Laropal aldehyde resin, 376, 397n29

laser cleaning, 362

Laüe back-reflection X-ray diffraction, 24

lautenthalite, 153

lavendulan, 251n2

Lávrion mines (Greece), alteration products in, 142–43

lead
atmospheric, and chloroxiphite, 143
and bronze patinas, 328
in faience, 264
in Great Buddha, 162, 167n12
in niello, 239
in tin bronzes, 403

Levant mines (England), botallack-
ite in, 138, 188 p
Leyden Papyrus manuscript, niello
recipes in, 236
libethenite
as corrosion product, 240, 243
properties of, 197 p, 240, 241,
242 t
stability of, 242 f
thermodynamic data for, 136 t
libraries. See indoor environment
*Libro Secondo de Diversi Colorie
Sise da Mettere a Oro*
(Simone manuscript),
282–83
Lica 38, 380–00
Liesegang phenomena, 86–87, 178 p
likasite, properties of, 250, 251 t
Littledale process, 121 n12, 254
Lucca manuscript
copper plating recipe in, 18–19
verdigris recipe in, 284–85
ludjibaite, properties of, 241, 242 t
Lui Sheng, tomb of, patinas in, 348
lusterware, copper, 93
Luttrell Psalter manuscript, azurite
in, 109

M

MacDonald, John A., statue of,
libethenite on, 243
Macedon (ship)
connellite in, 139
conservation methods at, 370
Madame de Pompadour (Boucher),
blue verditer in, 114
mafek, 103
malachite, 102–107
artificial. See green verditer
as copper ore, 104
as corrosion product, 100, 102,
105–106
crystal forms for, 100, 101 f,
183 p, 184 p
decomposition by heat, 113
decorative uses of, 103–104
deposits of, 102
formation of
from azurite, 108, 111
in burial environments,
112–13, 164–65
in marine environments,
112–13
in solution, 111–13
georgeite as isomer of, 100, 102
isotope ratios and, 107
natural, 102, 181 p

nomenclature confusion
regarding, 104–105
in patinas, 106–107
artificial, 333, 344
banding of, 86–87, 106–107,
178 p
cuprite transition to, 106
in marine environments,
68, 69 f
in outdoor environments,
48, 50
as pigment, 106
alteration products of, 265
history of, 6, 100, 106
with posnjakite, 166
transition to synthetics from,
6, 113–14
Pourbaix diagrams for, 135 f
properties of, 100, 102, 102 t,
105–106, 183 p, 184 p
recipe for, 405–406
scarcity of, 6
stability-field diagrams for, 140 f
thermodynamic data for, 136 t
Mappae clavicula manuscript
on azure, 286
on Byzantine green, 283
on calcium copper acetate hexa-
hydrate, 411–12
on copper plating of iron, 19
on copper sulfide, 225
on niello, 237
on Rouen green, 283, 412
urine in recipes of, 284
on verdigris, 274, 282–84, 411–
13, 442 t
Marathon, ephebe of, 351 n9
black patina on, 328
Marcus Aurelius, equestrian
monument of
antlerite on, 149
copper oxalates on, 305
infrared imaging of, 394–95
thickness of, 394–95
ultrasonic scanning of, 394
marine environment, 64–72
atacamite formation in, 112
biological factors in, 65–67,
74–75, 174 p
burial, 112–13
conservation treatment after,
71–72, 356, 369–73
malachite formation in, 68, 69 f,
112–13
rates of corrosion in, 67–71
rates of corrosion near, 53,
53 t, 54

seawater in
components of, 64
oxygen in, 67, 70
pH of, 64, 68
pollution in, 67
salinity of, 64
stability diagrams for, 68, 69 f
stabilization after, 370–73
sulfide formation in, 227–31
wood-metal artifacts in, 71–72
zones of, 66 t, 67
Mayan blue, 109, 121 n8
mechanical cleaning, 357–62
and evidence preservation,
357–58
modern techniques of, 358–62
problems with, 357–58, 359–00
Medea Rejuvenating Aeson
(Boizot), 171 p
plating on, 21, 170
melaconite. See tenorite
melanteria, 147
melanterite, 147
mercury
in patinas, 345–46
plating with, 22, 80 n6
Mercury (Vittoria), 211 p
patina on, 211 p, 331–32
mercury salts, in patination
solutions, 22
Mesopotamian mythology, 4
metal(s), corrosivity of, assessment
of, 58–59
metallography, 77–78, 175 p
metavoltine, 147
methylene dichloride, 383
microbially influenced corrosion
(MIC), 11, 65–67
microenvironments, copper
sulfates in, 158–59
Middle East
turquoise in, 248–49
verdigris recipes from, 291–93
Min-Amun, bronze head of, X-ray
diffraction data for,
301, 446 t
mineralization, 72–77
of cellulose, 73, 74–76
definition of, 72
mechanism of, 72–73
of proteins, 73, 76–77
rates of, 73
Miniature Portrait Bust of a
Woman, ii f, iii f, 219 p
mechanical cleaning of, 219 p,
359

mirrors
Chinese bronze, 214p, 215p, 216p, 339–49
Greek box, 22f, 23–24, 172p
misy, 147
Moche face mask, sampleite in, 199p, 245
Mogao grottoes (China), cave 328 of, 186p
botallackite in, 134, 187
moisture, in burial environment, 40
molds, in indoor environment, 63
Monastral blue, 315
monument(s)
patinas on, 55
studies of, 55
Monument to Sir George Étienne Cartier (Hébert), 191p
ammonium copper sulfate hydrate on, 158
posnjakite on, 153, 190
moolooite, 158, 305
mordant dyeing processes, 74
mountain blue, 115, 121n14
mud marine zone, 66t, 67
museums. See indoor environment
Music in the Tuileries Gardens (Manet), Scheele's green in, 310
Mystic Lamb (Eyck), resinate in, 296
mythology, copper in, 3–4

N

namuwite
as corrosion product, 153–54, 234, 234f–35f
formation of, 234
properties of, 233–34
X-ray diffraction data for, 427t
nantokite, 123
and bronze disease, 125–28
Pourbaix diagrams for, 130f, 135f
properties of, 123, 123t
significance of, 131
thermodynamic data for, 136t
in verdigris synthesis, 281
Naskapi Indian artifacts, copper salts of higher acids in, 298
National Bureau of Standards (NBS), on burial corrosion rates, 35–36, 36t
National Museum of the American Indian, 356, 396n4
native copper, 2f
properties of, 2–3, 3f

natron, in chalconatronite synthesis, 118–19
NBS. See National Bureau of Standards
Nefertari, Queen, tomb of, Egyptian green in, 202p, 263
neodymium laser, 362
Neolithic cultures, 4
neopentyl (diallyl) oxy tri (dioctyl) pyro-phosphate titanate (Lica 38), 389–90
Neptune fountain (Italy), bronze group of, black varnish on, 159
Nessus and Dejanira (Giambologna)
coating on, 332
patina on, 332
provenance of, 351n15
Neuchâtel, Switzerland, patinas found near, 230–31, 231f
niello, 235–39
chemistry of, 238–39
decorative uses of, 224, 235, 236, 238–39
identification of, 238
recipes for, 236–37
synthesis of, 224, 235, 236–37
nikomi-chakushoku, 90
nitric acid, modern atmospheric concentrations of, 44t
nitrocellulose lacquers, 383–84
nitrogen dioxide
atmospheric concentrations of conversion factors for, 44t
modern, 44t, 45
and corrosion rates, 46, 46f, 47, 57
nitrogen oxides
atmospheric concentrations of, 46
and corrosion rates
indoor, 61, 62
outdoor, 47
nondestructive testing, 392–95
North America
copper use in, 5
turquoise in, 249

O

occidental turquoise, 247
ocean. See also marine environment
deep zone of, 66t, 67
Oddy tests, 61
oils, and outdoor patinas, 48–49

oleic acid, reaction of copper with, 293
ore, copper, malachite as, 104
organic materials, copper in contact with, 72–77, 74f–75f, 174p
Oriental lacquer, 77
oriental turquoise, 247
original surfaces, 52, 80n16
Ormocer coatings, 387–88, 390
Osiris, figurine of, chalconatronite in, 117
outdoor environment, 43–59
air pollution in, 43–47
assessment of corrosivity of, 58
coatings in, 382–91
copper phosphate corrosion in, 243
copper sulfide formation in, 232
indoor bronze in, 375–76
mechanical cleaning in, 360
monuments in, 55
patinas in
composition of, 48–52, 50t–51t, 55–57
copper sulfates in, 147
cuprite, 87
repatination after cleaning, 374–75, 396n2
thickness profiles of, 54
rates of corrosion in, 52–54
regional differences in, 43–45, 52–54, 53t
studies on corrosion in, 47–48
Ovoid Lekythos, Egyptian blue in, 201p, 259–60, 260f
oxalic acid, modern atmospheric concentrations of, 44t
oxidation-reduction power (Eh), 79n2
oxides, 81–98. See also specific types
oxygen
isotope ratios of, 107
in marine environment, 67, 70
in soil, 38
oxygen-free environments, 391
ozone, atmospheric concentrations of
conversion factors for, 44t
modern, 44t, 46–47
and corrosion products, 156t, 157f
and corrosion rates
indoor, 61
outdoor, 46, 46f, 47, 57, 154
with sulfur dioxide, 47, 155, 155f, 156t, 157f

P

Paecilomyces varioti Bain, 63
paintings, copper as substrate for, 317–21
 analysis of, 319–20
 early coatings on, 317–18
 enamel on, 321
 fabrication of, 318–19
PAN. See peroxyacetyl nitrates
Panama, outdoor corrosion rates in, 53t
papegaaigroen, 270
paper, degradation of, 75–76
Papyrus Ebers, 278
Paraloid B72, 380, 384
paratacamite, 124–25
 benzotriazole and, 379
 and bronze disease, 128–29
 classification of, 124
 vs. clinoatacamite, 125
 and patina authenticity, 131
 as pigment, 134, 139, 190p
 Pourbaix diagrams for, 135f
 properties of, 123t, 124, 139, 190p
 stability-field diagrams for, 140f
 thermodynamic data for, 136t
 X-ray diffraction data for, 425t
 zincian, 123, 124, 144n2, 425t
Paris green. See emerald green
parrot green, 270
particulate matter deposition, in indoor environment, 62–63
passive stabilization, 391–92
patinas. See also bronze patinas
 vs. corrosion, 10
 definitions of, 10, 329
 early use of term, 329
 land *vs.* lake, 231
 removal during conservation treatment, 353–55
 repatination after cleaning, 374–76, 396n2
 water, 11
PEG (polyethylene glycol) 400, 71–72
Peligot blue, 166
 recipe for, 166, 406
Penicillium brevicompactum, 63
Penicillium cyclopium, 63
Penn, William, statue of (Calder)
 antlerite on, 149
 conservation treatment of, 361
peroxyacetyl nitrates (PAN), 48
Perspex, 383

Petrie Museum (England), conservation treatment at, 354–55
pH
 in Pourbaix diagrams, 32
 of rainwater, 149–52
 of seawater, 64, 68
 of soil, 40
phosphate(s)
 in burial environment, 37, 41
 copper, 240–50
 in groundwater, 37
 hydrated synthetic basic, 242t
photochemical smog, and corrosion rates, 47
photography, early, copper in, 26–27
phthalocyanine blue, 208p
Pictura (An Allegory of Painting) (van Mieris), 209p
 on copper sheet, 209p, 320
pien yao glazes, 94
pigments, 6, 79. See also specific pigments
pine resin, in copper resinates, 295–96
pisanite, 146, 147
pitting corrosion, 132–34, 135f, 135t
plancheite, 252
 properties of, 253t
planerite, 247
plant fibers, mineralization of, 74–75
Plasticine, 396n2
plates, 169–223
plating
 arsenic, 22
 copper, 18–19
 electrochemical, 20–26
 electroless, 20
 electroplating, 18
 gold, 20
 on iron, 18–19
 mercury, 22, 80n6
platinum, deposition technique for, 21
polarization, resistance of, 395
polishing techniques, 78
pollution
 air. See air pollution
 water, 67
polyethylene glycol 400 (PEG 400), 71–72
polymer coatings, 387–88
polymerization, 76
polyvinyl chloride (PVC), 384

positive replacement, 72–77
posnjakite, 152–53
 as corrosion product, 230
 in patinas, 152–53
 as pigment, 165, 166
 properties of, 148t, 152
 recipe for, 405–406
potassium aluminum sulfate, 287
potassium copper acetates, X-ray diffraction data for, 444t
potassium copper carbonate hydroxide hydrate, X-ray diffraction data for, 447t
potassium hydroxide, as drying agent, 355–56
potential(s)
 corrosion, 17
 in electrochemical series, 16–17
 electrode, 32, 399
Pourbaix diagrams
 for aqueous environments, 32–34, 33f, 34f
 definition of, 32
 function of, 32
 limitations of, 34–35
 local conditions in, 34
precipitation. See rain
preservation
 of evidence, with mechanical cleaning, 357–58
 without treatment, 357
"A prostitute of the highest class (*oiran*) in a garden," 190p
protein(s), mineralization of, 73, 76–77
proteinates, copper, 298–99
pseudoboleite, cumengite and, 142
pseudomalachite, 246
 as corrosion product, 241
 as pigment, 240, 241, 246
 properties of, 241, 242t
 stability of, 242f
 vs. tagilite, 241, 251n1
 thermodynamic data for, 136t
Ptah, statuette of, 90, 179p
purple, Han, 203p, 266–67
PVC (polyvinyl chloride), 384
pyrrhotite
 as corrosion product, 230
 formation of, 230

Q

Queen Victoria at Osborne (Landseer), Scheele's green in, 310

R

radiographic examination, 392–94
rain
 acid, and burial environment, 41
 and patina composition, 55, 56f
 pH of, and corrosion products,
 149–52
Rapid (ship), 195p
 cassiterite on, 71
 copper sulfides on, 196p, 228
 leaded brass nail from, 196p, 229
 paratacamite on, 71
 tenorite patina on, 95
 working conditions for exami-
 nation of, 195p, 228–29
reaction soldering, of gold
 chrysocolla in, 254
 malachite in, 121n12
recipes, 404–17
reconstructive events, in corrosion
 classification, 14
red glass, opaque, 91–93
red glazes, 93–94
redox potential, 79n2
refractive indices (RI), 422t–23t
relative molar volumes (RMV), 88
Relief Fragment of Two Men
 (Togati bronze), 213p, 334
 patina on, 214p, 334–35, 335f,
 336, 337, 338f
Renaissance bronzes, xii
 patinas on, 329–33
repatination, of cleaned surfaces,
 374–76, 396n2
replacement
 electrochemical, 20–21
 positive, 72–77
resin(s)
 coatings with, 384
 Laropal aldehyde, 376, 397n29
 pine, 295–96
resinates, copper, 204p, 205p,
 294–99
resistance of polarization measure-
 ments, 395
Rest on the Flight into Egypt
 (Domenichino), copper
 support in, 318
Rhus verniciflua, polymerization
 of, 77
RI. See refractive indices
Riace bronzes, 351n11
 black patina on, 328–29
 conservation treatment of, 370
 corrosion products on, 120,
 328–29

resistance of polarization
 measurements for, 395
Ricitte per Far Ogni Sorte di Colori
 manuscript, verdigris in,
 286–88, 414–15, 445t
RMV. See relative molar volumes
roch alum, 287
Rochelle salt, alkaline, 355, 366,
 372–73, 397n20
Rocks at Belle Isle (Monet), emerald
 green in, 312, 453t
Roma or Virtus, statuette of,
 212p, 334
 hexagonal network structure
 of, 213p, 334, 336
 patina on, 213p, 334, 336
Roman bronzes, patinas on, 334–38
Roman mythology, 3
romerite, 147
rosasite
 formation of, 116
 on Great Buddha, 162
 properties of, 100, 102t, 116
Rouen green, recipe for, 283, 412
roxbyite, properties of, 227t
RP (reagent), 392
rue, 290, 316n20
rural areas, outdoor corrosion rates
 in, 53, 53t, 54

S

Saint John the Baptist Preaching
 (Raphael), copper
 resinates in, 297–98
Saint Mark's Basilica (Italy)
 bronze horses of, copper
 oxalates on, 305
 copper pin from, chalconatron-
 ite on, 364
Saint Peter's Basilica (Italy), doors
 of, patina on, 331
salts. See copper salts; specific
 types
sampleite, 243–46
 in arid environments, 243–46
 as corrosion product, 198p,
 199p, 241, 243–46
 properties of, 198p, 241, 242t,
 244–45, 245f
 stability of, 242f, 243–44, 244f
 thermodynamic data for, 136t
 X-ray diffraction data for, 244,
 246, 428t
San Michele church (Italy), door
 of, 331
San Pietro church (Italy), wall
 paintings of, 111

San Zeno church (Italy), portal
 of, 395
sang de boeuf glazes, 94
sang de pigeon glazes, 94
sanggam celadon ware, 91
sasyaka, 146
Saturn Devouring a Child
 (Hurtrelle), shellac on, 330
scab testing, 390, 397n40
Scheele's green, 307–10
 color-reflectance data for,
 310, 313f
 vs. emerald green, 312
 properties of, 205p, 208p,
 309, 312
 recipes for, 308–309
 synthesis of, 307–309
 use of, 310
 variants of, 310
 X-ray diffraction data for,
 309, 451t
schulenbergite, 162
 properties of, 148t
Schweinfurt green. See emerald
 green
scientific instruments, finishes
 on, 349, 351n22
sealing methods, 355–56
seawater
 components of, 64
 oxygen in, 67, 70
 pH of, 64, 68
 pollution in, 67
 salinity of, 64
Sekmet, figurine of, chalconatron-
 ite in, 117, 364
serpentite, in seawater, 68, 69f
Shahnama manuscript, 189p
shakudo alloys, patinas on, 88–89
shallow marine zone, 66t, 67, 68
shattuckite, 252
 properties of, 253t
shellacs, 383–84
Shellsol 71, 376, 397n28
shi-kin alloy, 89
shipwreck sites, 71
 cassiterite at, 71
 connellite at, 139
 conservation methods at, 370
 covellite at, 228
 paratacamite at, 71
 spertiniite at, 98
 sulfides at, 228–29
 tenorite at, 95
siderite, as corrosion product, 229
Sigismund III, King, column of,
 patina on, 404

silicates, copper. See copper silicates
silk, mineralization of, 73, 76
silver
 in blue pigment recipes, 286
 in copper sculptures, 324
silver chloride, treatment with, 364
silver oxide, treatment with,
 364 – 65
Simone manuscript, 282 – 83
sinnerite, as corrosion product, 230
smaragdus, 105
smelting, copper
 bornite in, 226
 early evidence of, 5
 enargite in, 226
smog, photochemical, and corro-
 sion rates, 47
smoke, and air pollution, 43
sodium azide test, 61
sodium carbonate solution, treat-
 ment with, 98, 367
sodium chloride
 and corrosion rates, 47 – 48
 and deposition rate, 48
sodium copper carbonate.
 See chalconatronite
sodium copper carbonate acetate,
 302
 X-ray diffraction data for,
 302, 448t
sodium copper carbonate acetate
 (hydrate), 302
 X-ray diffraction data for,
 302, 449t
sodium diethylene triaminepenta-
 acetic acid (DTPA), 369
sodium dithionite, alkaline, 367,
 371 – 72
sodium hydroxide, treatment with,
 98, 354, 363, 366, 371
sodium sesquicarbonate treatment
 and chalconatronite formation,
 118, 119 – 20, 364
 chemistry of, 363 – 64
 for marine artifacts, 370 – 71, 373
 problems with, 354, 368 – 69
sodium tripolyphosphate, 367
soil(s)
 acidity of, 40 – 42
 buffering capacity of, 41 – 42
 corrosion rates in, 35 – 37, 36t
 horizons of, 38
 human impact on, 39
 moisture of, 40
 properties of, 35 – 37
soil silhouette, 39, 80n9
soldering, reaction, 121n12, 254

Solovetsky Monastery (Russia),
 frescoes at, calumetite
 in, 141
sory, 147, 225
South America
 azurite in, 109
 copper use in, 5
 turquoise in, 249
spangolite, 162
 properties of, 148t
Spanish green, 282
spertiniite, 98
 properties of, 82t, 98
spionkopite
 as corrosion product, 229
 properties of, 226, 227t
splash marine zone, 66t, 67
stabilization, 370 – 73
 passive, 391 – 92
stained window glass, copper
 and cuprite in, 94
stalacton, 146
stannic acid, 38
Statue of Liberty, 159 – 60, 192p
 corrosion of, 159 – 60
 patinas on, 159 – 60
 antlerite in, 149
 components of, 57, 160
 oxalates in, 305
 thickness of, 159 – 60
 pollution exposure of, 55
Statue of a Victorious Youth, 218p
 conservation treatment of, 218p,
 359, 369 – 70
Statuette of a Cat, 217p
 conservation treatment of,
 217p, 353
Statuette of a Dead Youth, 169p
 patina on, 7, 169
steatite, properties of, 265
stellacyanin, 77
stones, glazed, 265
Strandberg's compound, properties
 of, 148t
stromeyerite
 as corrosion product, 228
 in niello, 239
Studies of Antiquities (Poussin),
 patina on, 329
sulfate(s), copper. See copper
 sulfate(s)
sulfate ions, deposition in indoor
 environment, 62
sulfate-reducing bacteria, 65 – 67
 and copper sulfide production,
 227 – 28

sulfides, copper. See copper
 sulfides
sulfur
 and air pollution, 43
 deposition in indoor environ-
 ment, 62
sulfur dioxide, atmospheric, 154 – 55
 concentrations of
 conversion factors for, 44t
 modern, 44t, 45 – 46
 and corrosion products, 155,
 156t, 157f
 and corrosion rates
 indoor, 61
 outdoor, 46, 46f, 47 – 48,
 57, 155
 deposition rates of, 48, 154 – 55,
 155f
 with ozone, 47, 155, 155f, 156t,
 157f
sulfuric acid, treatment with,
 355, 366
surmoulage, 332
Susanna Van Collen (Poelenburgh),
 copper support in, 319
Sutton Hoo estate, 229, 239n6
Swann Fountain (Calder), antlerite
 on, 149

T
tagilite
 properties of, 242t
 vs. pseudomalachite, 241, 251n1
Tanalith process, 314
technologies, early, with copper
 and iron, 18 – 19
tenorite, 95 – 96
 azurite and, 96, 97f, 110
 cuprous chloride and, 98
 formation of, 95 – 96, 97f, 110
 in patinas, 95 – 96, 181p
 Pourbaix diagrams for, 35,
 130f, 135f
 prevalence of, 95
 properties of, 82t, 95
 relative molar volume of, 88
 thermodynamic data for, 136t
tersitu preparations, 93
textile fibers, mechanical cleaning
 and, 360
Thames River bronzes, corrosion
 products on, 196p, 197p,
 229 – 30
thang-ka paintings, greens in, 312
thermal spraying, 163, 167n14
thermodynamics, of corrosion, 14

The Thinker (Rodin), 173p
 cleaning of, 374
 patina on, 43, 172
thiourea, 24–25
thymiaterion (incense burner),
 95, 181p
tidal zone, 66t, 67
time-of-wetness (TOW)
 and corrosion rates, 58
 definition of, 58
 limitations of, 58
 measurement of, 58
 models for, 58
tin bronze. See bronze
tin(IV) oxide, hydrated, 38
ting yao ware, 94
tinned surfaces, on bronze,
 402–403
tinthotype, 26
Togati bronze, 213p, 334
 patina on, 214p, 334–35, 335f,
 336, 337, 338f
tomb(s)
 of Amenhotep II, 96
 of Duo Win, 348
 Egyptian, pigment deterioration
 in, 265–66
 of Lui Sheng, 348
 of Queen Nefertari, 202p, 263
tool marks, preservation of, in
 patinas, 349–50
topotaxy, 13
Torpedo ocellata, 18
TOW. See time-of-wetness
treatments. See also conservation
 treatments
 for cuprite patina development,
 90–91, 179p
trippkeite
 properties of, 309–10
 X-ray diffraction data for,
 309, 451t
Triton x-100, 369
tumuli, German Bronze Age,
 compositional analysis of,
 340–43, 342t, 343t
Tung-t'ien ch'ing-lu scroll, on
 artificial patinas, 345
turpentine, Venice, 295–96
turquoise, 246–50
 blanching of, 241
 chemistry of, 247–48
 in eastern hemisphere, 248–49
 history of, 248–50
 mineralogy of, 247–48
 occidental, 247
 oriental, 247

 as ornamental stone, 246–47,
 248–50, 251n3
 properties of, 240, 241, 242t,
 247–48
 in western hemisphere, 249–50
 X-ray diffraction data for, 429t
Tutton's salt
 in patinas, 158
 properties of, 148t

U
Ukiyo-e paintings, basic copper
 chloride in, 137, 187p
ultramarine blue, 109
ultrasonic scanning, 394
United Kingdom
 air pollution in, 43, 45, 80n14
 bronze maintenance in, 80n14
United Nations, test panels of, 59
United States, outdoor corrosion
 rates in, 53t
urban areas
 air pollution in, 43–45
 outdoor corrosion rates in,
 53–54, 53t
 sulfides in patinas in, 232
urine, in pigment recipes, 280, 284
Utagowa School of Japanese
 paintings
 basic copper chloride in,
 137, 187p
 green verditer in, 114

V
vapor-phase inhibitors, 391
Venice turpentine, 295–96
verdigris, 270–94
 basic, 203p, 271–73, 274–75,
 413–14
 cellulose degradation by, 75
 chemistry of, 270–76
 in copper resinates, 294–99
 as corrosion product, 270
 distilled, 203p, 288–90
 history of, 276–78
 impurities in, testing for, 280
 medicinal uses of, 270,
 277–78, 291
 neutral, 271–73, 274
 as pigment, 270, 271, 276,
 277, 291
 problems with, 293–94
 properties of, 203p, 270, 271,
 274–75
 protein degradation by, 76, 77
 recipes for, 279–94, 406–15

 from Asia and Middle East,
 291–93, 415
 late-medieval, 285–90, 414–15
 variants of, 281–93
 synthesis of
 new, 273–74
 process for, 276–77
 visible spectra for, 288, 289f
 X-ray diffraction data for,
 273–74, 434t–45t
verditer
 blue, 114–16, 185p, 405
 green, 114–16, 184p
Victoria, Queen, statue of (Hébert)
 chloroxiphite on, 143
 posnjakite on, 153
Victorious Youth, Statue of a, 218p
 conservation treatment of, 218p,
 359, 369–70
Victory with Cornucopia, 213p, 334
 malachite in, 184p, 212
 patina on, 334
Vincent Ferrer, Saint, painting
 of (Cossa), green verditer
 in, 114
viride hispanicum, synthesis of, 282
viride salsum, synthesis of, 137–38,
 281, 411
Vix krater, conservation of, 358,
 396n6
volatile organic compounds (VOCs),
 in indoor environment,
 63–64

W
Wallace Collection, clocks in
 brown fuzzies on, 233–34, 234f
 X-ray diffraction data for, 427t
walnut shells, crushed, cleaning
 with, 360–61
water. See also marine environ-
 ment
 fresh, 70
 ground, 37
 sea, 64, 67, 68, 70
water blasting, 361–62
water patina, 11
water pollution, 67
wax coatings, 382–83
 application technique for, 383
 carnauba, 385, 397n38
 after glass-bead peening, 360,
 396n8
 problems with, 382
weddellite, 158
wet-cell batteries, primitive, 16–18,
 79–80n5

whewellite, 158

wind direction, in patina
formation, 51

window glass
broken, restoration of, 94
stained, 94

Witcamine RAD 1100, 71

wollastonite
in Egyptian blue, 259
in Egyptian green, 263

wood
indoor air pollution from,
299–300
mineralization of, 74f–75f, 75

wood-metal artifacts, in marine
environment, treatment
solutions for, 71–72

wool, mineralization of, 73, 77

X

X-ray diffraction
Laüe back-reflection, 24
results of studies on, 424t–55t

X-ray imaging, 393–94

xuan xi, 345–46

Xylene, 376

Y

yarrowite, properties of, 227t

Yungang grottoes (China),
atacamite in, 134–36

Z

*Zahhak Enthroned with Two
Sisters,* brochantite in, 165

zangar, recipe for, 291–92, 415

zapatalite
as corrosion product, 241, 243
properties of, 241, 242t

Zeus, statue of, 351n10
black patina on, 328

zinc
in conservation treatment, 354,
364–65, 368
dezincification of brass, 11, 27–
32, 54, 234
in Great Buddha, 162

zinc carbonates, mixed copper,
116–17

zinc chlorides, mixed copper, 143

zinc-copper alloy. See brass

zinc salts, synthetic pigments
with, 117

zinc sulfate, 234

zinc sulfite, 234

zincian paratacamite, 123, 124,
144n2, 425t

Illustration Credits

Grateful acknowledgment is extended to the following institutions and individuals for permission to reproduce the illustrations in this volume.

FIGURES

FIGURE 2a Sample courtesy of Margaret MacLean. Photo: Louis Meluso.

FIGURE 1.3 Photo: Louis Meluso.

FIGURES 1.5, 6.1 Reprinted by permission of François Schweizer, Ville de Genève, Geneva.

FIGURE 1.7 Reprinted by permission of Helena Strandberg, Göteborg University, Göteborg, Sweden.

FIGURE 1.8 Reprinted from *Corrosion Science* 27, T. E. Graedel, "Copper Patinas Formed in the Atmosphere 2," 733, 735, © 1987, by permission of Elsevier Science.

FIGURE 1.9 Reprinted from *Corrosion Science* 13, G. Bianchi and P. Longhi, "Copper in Seawater," 859–60, © 1973, by permission of Elsevier Science.

FIGURES 2.1, 4.1, 4.2, 5.1 Diagrams after M. Pourbaix, by permission of Marcel Pourbaix.

FIGURES 3.1, 4.4 Reprinted from C. Palache, H. Berman, and C. Frondel, eds., *Dana's System of Mineralogy*, 7th ed., © 1951, by permission of J. Wiley & Sons, Inc.

FIGURES 4.3, 4.5, 4.6, 7.1, 7.2 Reprinted from A. M. Pollard, R. G. Thomas, and P. A. Williams, "The Copper Chloride System and Corrosion," 123–33, © 1992, by permission of Mark Pollard, University of Bradford, Bradford, England.

FIGURES 5.2, 5.3 Reprinted from *Journal of the Electrochemical Society* 144, H. Strandberg and L.-G. Johansson, "Role of O_3 in the Atmospheric Corrosion of Copper in the Presence of SO_2," 2334–42, © 1997, by permission of Helena Strandberg.

FIGURE 6.2 Reprinted from H. Leidheiser, Jr., *The Corrosion of Copper, Tin and Their Alloys*, © 1979, by permission of J. Wiley & Sons, Inc.

FIGURE 6.3 Reproduced by permission of the Trustees of the Wallace Collection, London. Photos: Paul Tear.

FIGURE 7.3 Courtesy of Ellen Howe and the Department of Conservation, The Metropolitan Museum of Art, New York.

FIGURES 11.1, 11.2 Photomicrographs: Eric Doehne.

PLATES

PLATES 3, 17, 63, 69, 70, 85 Photos: Louis Meluso.

PLATES 5, 68 Photos courtesy of Scala/Art Resource, New York.

PLATE 6 Courtesy of Kathy Tubb, Department of Conservation and Materials Science, Institute of Archaeology, University College London.

PLATES 7a, b; 13 Samples courtesy of Rasoul Vatandoost, Iran Bastian Museum, Iran.

PLATE 8 © The British Museum, London.

PLATE 9 Courtesy of the Shumei Cultural Foundation, Shiga, Japan.

PLATE 12 Sample courtesy of Marga Foley, Queens University, Ulster Museum Conservation Department, Northern Ireland.

PLATE 14a Sample courtesy of Lutfi Khalil, University of Amman, Jordan.

PLATES 15, 81 Courtesy of the Ashmolean Museum, University of Oxford, Oxford, England.

PLATE 16 Courtesy of John Twilley, Conservation Center, Los Angeles County Museum of Art.

PLATE 18 Photo: Louis Meluso.

PLATE 19 Courtesy of the Shinji Shumeikai Collection, Kyoto, Japan

PLATES 22, 74 Leonard C. Hanna, Jr. Fund, 1984.25. Copyright the Cleveland Museum of Art.

PLATE 25 Samples courtesy of Peter Mactaggart.

PLATES 28, 31, 33, 52–54 Courtesy of Elizabeth West Fitzhugh, Department of Conservation and Scientific Research, Arthur M. Sackler Gallery, Freer Gallery of Art, Smithsonian Institution.

PLATE 32 Courtesy of the Arthur M. Sackler Gallery, Smithsonian Institution.

PLATE 33 Courtesy of the Canadian Conservation Institute, Department of Canadian Heritage, 1030 Innes Road, Ottawa, Ontario, K1A 0M5 Canada. Photo: Carl Bigras.

PLATE 36 Courtesy of the Statue of Liberty National Monument, New York.

PLATE 37 Courtesy of the Department of Restoration Techniques, Tokyo National Research Institute of Cultural Properties, Tokyo, Japan.

PLATE 38 Photo: Vladimir Kucera, Swedish Corrosion Institute, Stockholm.

PLATE 39 Courtesy of Ian Macleod and the Western Australian Maritime Museum. Photo: P. Baker.

PLATE 40 Courtesy of Ian Macleod and the Western Australian Maritime Museum.

PLATES 41–43 Courtesy of Helen Ganiaris, Department of Conservation, Museum of London.

PLATE 46 Courtesy of Helen Ganiaris and the Egypt Exploration Society, London.

PLATE 47 Courtesy of the Santa Barbara Museum of Art, Santa Barbara, Calif.

PLATE 48 Photo: Valerie A. Scott, London.

PLATE 51 Photo: Guillermo Aldana.

PLATE 59 Photomicrograph: Narayan Khandekar.

PLATES 78, 79 Courtesy of Paul Jett and the Freer Gallery of Art, Smithsonian Institution.

PLATES 87, 88, 90 Photos: Dusan Stulik.

PLATE 89 Courtesy of Phoebe Dent Weil and Washington University Conservation Associates, St. Louis, Mo.

DAVID A. SCOTT is a senior scientist at the Getty Conservation Institute and head of the GCI Museum Research Laboratory at the Getty Center, Los Angeles. He earned his B.Sc. degree in chemistry from the University of Reading and his B.A. degree in archaeological conservation from the Department of Conservation and Materials Science, Institute of Archaeology, London. He completed his Ph.D. in ancient metallurgy at University College, London, in 1982, and was then appointed lecturer in conservation at the Institute of Archaeology, London. In 1987 he joined the Getty Conservation Institute, where he became head of the GCI Museum Services Laboratory based at the J. Paul Getty Museum in Malibu. He has published more than eighty articles in the areas of metallurgy and metals conservation and research, and has edited several conference proceedings, including *Ancient and Historic Metals* (Getty Conservation Institute, 1994). He is also the author of *The Metallography and Microstructure of Ancient and Historic Metals* (Getty Conservation Institute, 1991). In 1984 Dr. Scott was appointed an editor for *Studies in Conservation*, in 1992 was elected as a Fellow of the Royal Society of Chemistry, and in 1994 became a Fellow of the International Institute for Conservation. His primary areas of research are ancient and historic metallic artifacts, particularly ancient Ecuadorian and Colombian metals, but also Greek, Roman, and Etruscan; the analysis of corrosion products of works of art; and the characterization of pigments from a variety of cultures.